Latin American Art
in the Twentieth Century

Edited by Edward J. Sullivan

Latin American Art
in the Twentieth Century

Mexico
TERESA DEL CONDE

Central America
MONICA KUPFER

Cuba
GIULIO BLANC AND GERARDO MOSQUERA

Dominican Republic
JEANNETTE MILLER

Puerto Rico
ENRIQUE GARCÍA-GUTIÉRREZ

Colombia
IVONNE PINI

Venezuela
RINA CARVAJAL

Ecuador
LENÍN OÑA

Peru
NATALIA MAJLUF

Brazil
IVO MESQUITA

Bolivia
PEDRO QUEREJAZU

Paraguay
TICIO ESCOBAR

Uruguay
ALICIA HABER

Argentina
MARCELO PACHECO

Chile
MILAN IVELIC

Phaidon Press Limited
Regent's Wharf
All Saints Street
London, N1 9PA

Phaidon Press Inc.
180 Varick Street
New York, NY 10014
www.phaidon.com

First published 1996
Reprinted in paperback
(with revisions) 2000,
2004, 2006, 2011

© 1996, 2000
Phaidon Press Limited

ISBN 978 0 7148 3980 6

A CIP catalogue
record for this book
is available from the
British Library

Printed in Hong Kong

English-language
versions of the
following texts from
the Spanish were done
by Edward J. Sullivan:
Mexico, Cuba 1950–
2000, Dominican
Republic, Puerto Rico,
Venezuela, Colombia,
Ecuador, Bolivia,
Paraguay, Peru,
Uruguay, Argentina
and Chile. Translation
of the essay on Brazil
was done by Michael
Reade. The original
versions of the essays
on Cuba 1900–1950,
Central America and
Chicano Art were
written in English.

In as many cases as
possible dates for
artists mentioned
in the texts have
been supplied by the
authors. In some
instances the dates
were unavailable or
unknown.

Preface

In 1992 I was approached by Phaidon Press to write a history of twentieth-century art in Latin America. I declined but persuaded them, instead, to allow me to be the co-ordinator of a volume written by art historians from Latin America itself. I felt that since so much of the recent organization of exhibitions and scholarship in the field of modern Latin American art had been done by European and North American critics, the 'voice' of Latin America itself was not always heard as strongly as it should be in English-speaking countries. I believed that a book such as this could be the vehicle through which Anglo-American audiences could attain a greater under-standing of the field in which I had been involved for such a long time. I envisaged my role in this case not as an interpreter but as a facilitator in bringing information about the art of Latin America to a wider public.

In my teaching and scholarship I have always been aware of the lack of a serious, well-illustrated volume that would chart, even in a schematic way, the history of modern Latin American art. I hope that this book will fill at least a small portion of this lacuna. It should be emphasized that it is written from a uniquely Latin American perspective. Each of the authors has attempted to cover a vast territory in their essays. Their texts, combined with the large number of illustrations, will, I believe, make this volume highly valuable for a wide Anglo-American audience of those people interested in Latin American art and who come to the subject through any number of doors.

The texts in this book constitute an overview of artistic activity in Latin America in the twentieth century in a way not dissimilar to well-established narrative patterns for other Western traditions. Readers will find many strengths and an equal number of limitations. The essays tend to concentrate and privilege the arts of painting and, to a lesser extent, sculpture, the graphic and decorative arts. Conceptual art, installations and other forms that have developed over the past several decades are included, while photography is dealt with only tangentially and architecture not at all. Folk or popular arts, which in many Latin American societies constitute a highly significant contribution to visual tradi-tions, are also not examined. For the most part, theoretical concerns regarding power structures, gender issues, ethnicity or questions of national-ism are implicit, although sometimes dealt with directly.

Each author was given complete liberty to characterize the art of his or her nation with editorial guidelines suggested rather than strictly imposed. Readers will find a diversity of approach in each of these essays (written expressly for this book), reflecting the enormous contrasts of aesthetic strategies inherent in the artistic production described.

In the preparation of this book many people have contributed valuable information and materials. The authors themselves are owed, obviously, the greatest debt of thanks. All have contributed valuable documents charting the course of art in their respective nations in this century. I am grateful to all who generously provided photographic material. The editors at Phaidon Press – especially Bernard Dod as well as former Phaidon editor Marc Jordan – have been enormously helpful as has Anna Kobryn who did invaluable picture research. I must also thank Clayton C. Kirking for his limitless intelli-gent comments and suggestions as well as his unceasing kindness and patience during the preparation of this book.

Introduction

Edward J. Sullivan

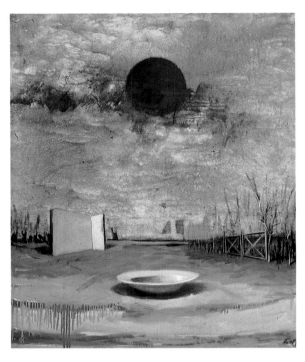

1. Emilio Torti – Untitled, from Jardin Primitivo series, 1994. acrylic on canvas, 200 x 164.5 cm. private collection

Latin American Art in the Twentieth Century presents a panoramic view of its subject in a series of essays on the art of the Spanish and Portuguese-speaking nations in North, Central and South America as well as the Caribbean. There is, in addition, a chapter on the Chicano art movement in the United States from the 1960s to the present. Each of these articles is written by one of the leading scholars in their respective areas. The essays are straightforward and informative. They will be useful for those persons who have had fairly little exposure to Latin American art and who are searching for an introduction to the complexities of the many styles, movements and genres that have developed there throughout the twentieth century. The expert in the field will also encounter in this volume a broad compendium of information which is difficult, if not impossible, to find in one place.

Latin American art, as I will again stress later in this introduction, is a field that has long been considered marginal or peripheral by the 'academy'. In the past, canonical histories of Western art invariably mentioned Latin America in passing, if at all. Only in the latest editions of these survey books, published to meet the growing demand for multiculturalism, are we given at least a notion that art by Latin Americans has truly made an impact upon the Western aesthetic imagination. In virtually no other area of art-historical research is there such a pressing need for a comprehensive overview as Latin America. Latin America (whose existence as a cultural or aesthetic entity itself is very much open to question) is still a relatively little-understood series of geographical regions whose enormous diversity, in geography, politics and socio-economic situations as well as language, is often ignored by large sectors of literate and cultured Anglo-Americans (and others). For that reason, the notion of a compendium of studies such as these, providing a diverse and coherent picture of many (but by no means all) of the elements that make up the rich panorama of twentieth-century art history in Latin America, is a valid one and has served as the guiding force for the compilation of this book. The influential critic and art historian Shifra Goldman has stated in the introduction to the recent anthology of her essays, *Dimensions of the Americas*, that 'Until a coherent, detailed, and socially framed history of modern Latin American, Brazilian and Caribbean art becomes available in English ... one is hard put to acquire more substantial information ... lacking histories, biographies, encyclopedias, and a literature of criticism or discourse.'[1] She contrasts the lack of serious writing in English on Latin American art history to the depth of information one can obtain in, for example, the literature, anthropology or sociology of the area. It is hoped that the present volume may fill, at least partially, the need articulated by Goldman.

As in any study of art divided according to geographical confines, there are invariably certain spurious limits or false borders set up between the countries. Artists travel widely, especially in the later twentieth century, and a style or thematic preoccupation that may typify the art of a certain place and time is by no means limited by geography. The reader is called upon to draw his or her own conclusions regarding the links which, in many cases, bind some of the nations in an inextricable cultural bridge.

One of the intentions of this volume is to help dispel the essentially false notion of the existence of a monolithic Latin American culture. As has been stated on many occasions, the term 'Latin America' itself is a questionable one.

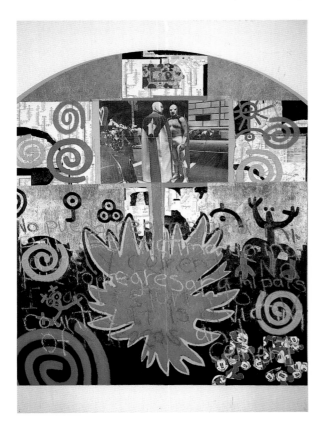

2. Juan Sánchez – Confused Paradice [*sic*], *1995. oil and mixed media on shaped wood, 198 x 167.5 cm. private collection*

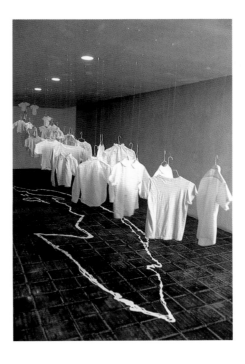

3. Ernesto Pujol – Los hijos de Peter Pan (The Children of Peter Pan), *1995. mixed media installation. Casa de las Américas, Havana*

Invented in France around 1860, it has been often misused to denote a common cultural heritage. Regarding the visual arts, the worst stereotypes have emerged, especially among European and North American audiences, from the deformation of this term. Critics such as Shifra Goldman, Susana Torruella Leval, Efraín Barradas, myself and others have written on this phenomenon.[2] The notion that Latin American art of the twentieth century embodies an inherent surrealistic personality (first articulated by the French Surrealists such as André Breton in the 1930s), accompanied by an exuberant use of colour, has been the most widespread and most vexatious of these clichés. The term 'Magic Realism', devised by Cuban novelist Alejo Carpentier to describe a fairly specific genre of literature, has been mistakenly employed during the last several decades to define far too many aspects of culture in Latin America.

One of the most widely discussed exhibitions organized in the 1980s promoted the notion of Latin American art as pervasively surrealistic. *Art of the Fantastic*, seen at The Indianapolis Museum of Art and elsewhere in the United States in 1987, while important for

the large number of works and artists it introduced to a wide public, was severely criticized for its promotion of stereotypical concepts of the art of Latin America. Indeed, many of the works in the exhibition had little or nothing to do with Surrealism or fantastic art. A number of Latin American artists, none the less, define their own artistic personalities through their interests in heightened reality. A good example of this may be found in the work of Argentinian painter Emilio Torti (b. 1952), who combines vast areas of empty, abstracted space in his dream-like compositions. At times fences or other barriers are included in his paintings, which are often reminiscent of the vast, open plains (pampas) of Argentina, Uruguay and Brazil (fig. 1).

When referring to the range of cultural expressions in Latin America we must be extremely careful regarding definitions. Some would state that there is no Latin American culture *per se*. Convincing arguments have been made for a definition by country or region. It is well known that the Argentine critic Marta Traba attempted a convincing delineation of Latin American art along the lines of what she termed 'open' and 'closed' countries. Regarding the

'open' countries, Traba referred to nations such as Brazil, Venezuela, Argentina, Uruguay and Chile which have been traditionally sensitive and receptive to European (and, to a much lesser extent, North American) artistic forms, absorbing and transforming them to create their own visual expressions. The 'closed' countries, according to Traba, are those which continue to be nurtured, to a greater or lesser degree, by the indigenous elements that have characterized their cultures since colonial times. These may include some of the Andean nations (Peru, Bolivia, Ecuador) as well as Mexico and some of the Central American countries (particularly Guatemala).

Jean Franco, in her ground-breaking study, *The Modern Culture of Latin America*, took the important step of underlining, for English-speaking audiences, many of the most salient points where art, literature, music and other areas diverge from the notions and ideals of culture in other parts of the Western world. Franco stresses the moral and socially committed nature of much of Latin America's cultural manifestations. She states: 'In countries like those of Latin America, where national identity is still in the process of definition and where social and

Introduction

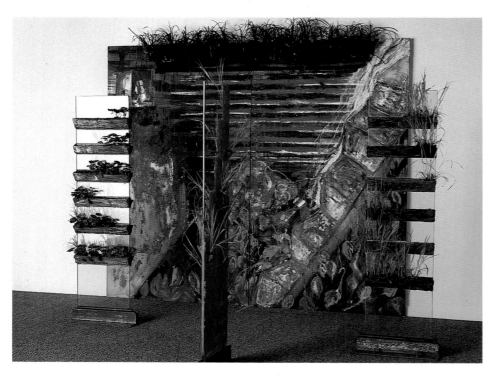

4. SOLEDAD SALAMÉ – GARDEN OF THE SACRED LIGHT, 1994.
mixed media installation Gómez Gallery, Baltimore, Maryland

political problems are both huge and inescapable, the artist's sense of responsibility toward society needs no justification.'³ Indeed, many of the artists included in this volume derive their imagery from, and comment upon, political situations.

The gradual politicization of art in Latin America as the twentieth century progressed is an issue dealt with by virtually all of the authors of these essays, in one form or another. Enrique García-Gutiérrez, for example, places particular emphasis on this aspect of the art of Puerto Rico. He deals specifically with those Puerto Rican artists living and working on the island. There are, in addition, highly important figures whose careers have developed in such United States urban centres as New York. Juan Sánchez (b. 1954) consistently deals with the subject of the socio-political identity of Puerto Rico in his paintings (which often include collage and photography). Symbols drawn from the iconography of the long-ago massacred Taíno peoples of the Caribbean underscore the poignant meanings of his statements regarding the United States imperialism on the island (fig. 2). The subject of exile is certainly one of the quintessential themes in

politically committed Latin American art. Cuban artists, both those living on the island as well as those who have formed part of the diaspora (eloquently described in Gerardo Mosquera's essay) have, understandably, made this subject one of their favoured motifs. Ernesto Pujol (b. 1957) left Cuba at the age of four. He lived with his family first in Puerto Rico and now resides in New York. His 1995 installation at the Casa de las Américas in Havana represented the only exhibition, apart from one of the work of Ana Mendieta in the early 1980s, organized in Cuba of the art of a Cuban-American (fig. 3). Pujol dealt with themes relating to political exile and personal displacement in these works, touching as well on the subject of homosexuality. The politics of homosexuality and particularly the effects of AIDS are central to the subtly lyrical art of Juan González (1942–93), referred to by Mosquera in his discussion of some of the principal figures in the Cuban-American artistic community (fig. 5).

Some of the most critical issues in Latin American politics revolve around questions of ecology. Many artists have dealt, for example, with the wholesale destruction of the rainforests,

particularly those of the Amazon region. The Chilean installation artist Soledad Salamé (b. 1954) has confronted the need for a global consciousness regarding the preservation of our natural resources. This has led to the creation of what she terms her 'living paintings', which combine architectural forms with plant life, incorporating nature and its processes (fig. 4). Laura Anderson Barbata (b. 1958) of Mexico has, over the course of the last several years, lived and worked among the Yanomami and other indigenous groups in the Venezuelan Amazon. She has carried out projects with them to record their fast-disappearing myths and legends. Her own abstract compositions (fig. 6) often contain intimations of the untamed nature of the landscape in which she works.

In any discussion of the culture of Latin America the question of diversity must be stressed. Each region has witnessed distinct patterns of development and a wide variety of elements has gone into the cultural fabric of individual places. The African heritage of the island nations of the Caribbean, the eastern coast of Mexico, Central America, Colombia, Venezuela and Brazil is of enormous importance to a

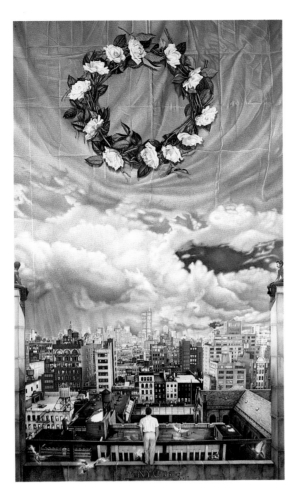

5. Juan González – New York, Year 1986, *1986.*
watercolour and gouache on paper, 125 x 75 cm.
private collection

comprehension of the cultural frameworks of those countries. The African impact is felt in virtually all realms, from religion to language, music to clothing, visual to culinary art. Many contemporary artists, especially in Cuba, the Dominican Republic and Puerto Rico, appropriate visual symbols and subjects from the rich repository of Afro-Caribbean forms. The Cuban graphic artist Belkis Ayón Manzo (1967–99) whose work is based on the iconography of the Afro-Cuban Abakoa religion, employs these signs and symbols to create a modern commentary on the syncretic practices in worship (fig. 8).

In cities such as Buenos Aires, Montevideo and São Paulo, large numbers of people from Italy as well as Eastern and Central Europe began arriving at the end of the nineteenth century. They made healthy contributions to the developing arts in these capitals, as authors Marcelo Pacheco, Alicia Haber and Ivo Mesquita suggest. Some of the artists have dealt with the immigrant experience in their work. The contemporary Argentinian painter José Marchi (b. 1956) draws inspiration from yellowed, crumbling photographs in family albums which depict members of families who went from poverty in Italy to Buenos Aires. His paintings invariably offer haunting, enigmatic references to the life of the turn-of-the-century ancestors of many Argentinians (fig. 9).

The art of Marchi represents a dialectic which examines the essential qualities of remembrance. Mexican painter Elena Climent (b. 1955) creates what she terms the 'nostalgia of the present'. Her work often depicts unadorned, unidealized views of everyday objects painted in a way that evokes the in-focus/out-of-focus aspects of a dream (fig. 7). Similarly, Rodolfo Morales defines, in somewhat more fanciful terms, his nostalgic remembrances of a childhood in a small Mexican town (fig. 10).

Throughout the twentieth century the art of Latin America has played a role, sometimes significant, at other times less so, in the cultural consciousness of Europe and the United States. During the 1920s and 1930s the interest was particularly acute, especially in the United States. The physical proximity of Mexico as well as the ambitious government-sponsored art programmes brought the art of that country to the attention of audiences north of the Río Grande River. This attention was focused on both modern and pre-Hispanic art. The 1920s witnessed such ambitious projects as the Carnegie Institute's archaeological expeditions to Mexico and Guatemala. Many of the most important pre-Columbian collections were formed by North American museums in this era of few laws regulating archaeological patrimony. The modern art of Mexico became well known in the United States in the 1930s when many Mexican artists, including Diego Rivera, José Clemente Orozco and David Alfaro Siqueiros, came to the US to work. Their art stimulated an entire generation of American painters associated with the Works Progress Administration or WPA (whose efforts to relieve artists' financial difficulties during the Depression included ambitious mural projects). Numerous exhibitions of Mexican art were organized during the 1930s in such cities as New York, Los Angeles, Detroit, Boston and Philadelphia. Meanwhile, artists from other parts of Latin America came to study and work in New York in the 1920s and 1930s.[4] Europe (especially Paris), however, was the goal for many more who desired experience abroad.

The interest in Latin American art in the United States continued throughout the early

Introduction

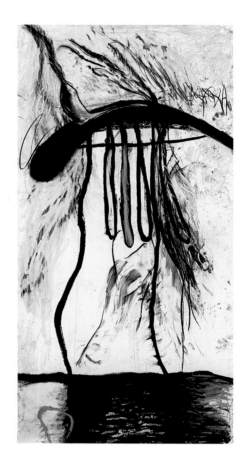

6. LAURA ANDERSON BARBATA – PLANTA MÁGICA KAAHL (MAGIC PLANT KAAHL), *1994. mixed media on paper, 175 x 85 cm. private collection*

1940s. It diminished, however, in the later years of the decade as fewer and fewer shows were organized and more attention was paid to the young painters of the Abstract Expressionist mode (many of whom, such as Jackson Pollock, had been inspired by the Mexicans). In Europe, the 1950s and 1960s were a time of increased Latin American presence. Paris was again the city of choice for many artists from Mexico to the southern cone of South America. Such important figures as Alejandro Otero from Venezuela, Eduardo Ramírez Villamizar from Colombia, Julio LeParc from Argentina or Sérgio Camargo from Brazil have spent many years of their careers in Paris where successful exhibitions of their work have been organized in galleries and museums.

The Cold War in the 1960s was a period of greater US government support for cultural projects concerning Latin America. While the CIA supported language-learning centres (with Portuguese receiving special backing), other government agencies promoted exhibitions of Latin American art in major cities of the United States and sent shows of American artists to the capitals of Latin America. Perhaps the most

significant event of the 1960s was the ambitious exhibition organized by Stanton L. Catlin and Terence Grieder at the Yale University Art Gallery, documenting *Latin American Art since Independence* (1966), the first serious attempt to survey the history of modern Latin American art from the early nineteenth to the mid-twentieth century. Thomas Messer of New York's Guggenheim Museum organized another noteworthy show in 1966: *The Emergent Decade: Latin American Painters and Painting in the 1960s* surveyed contemporary art in many of the nations from Mexico to the southern cone. Gilbert Chase's 1970 volume *Contemporary Art in Latin America* provided the first comprehensive overview in English of art throughout Latin America from 1920 onwards.

At the end of the 1970s, some attention began to be paid to a few individual Latin American artists, most notably Frida Kahlo. The appearance of several paintings by her in the exhibition *Women Artists 1550–1950* (1976, Los Angeles) and the monographic exhibition organized for a US tour by Hayden Herrera in 1978 foreshadowed the enormous vogue for her art that would later develop in both the United States

and Europe. Frida Kahlo has become, in the last decades of the twentieth century, the widest-known, most recognized and most imitated Latin American artist. The question of the role that women artists have played in the development of Latin American art has been brought to the fore relatively recently in Europe and the United States. In 1990 I curated and wrote, along with Linda Nochlin, the catalogue for an exhibition entitled *Women in Mexico /La mujer en México*, seen in New York, Mexico City and Monterrey (Mexico). In 1994 an ambitious show, *Latin American Women Artists 1915–1995* opened at the Milwaukee Art Museum. The exhibition, curated by Geraldine Biller, and the catalogue, written by several scholars (including myself) from the US and Latin America, brought important images by a large number of women from all over Latin America to the attention of a United States public.

The 1980s represented a 'boom' for Latin American art in the United States (and, to a somewhat lesser extent, in Europe). Organized in 1987, the same year as the above-mentioned *Art of the Fantastic*, the exhibition entitled *Latin American Artists in New York since 1970*, curated

7. Elena Climent – *Librero (Book Shelf)*, 1994. oil on canvas, 45.7 x 61 cm. private collection

for the Archer M. Huntington Art Gallery of the University of Texas at Austin by Jacqueline Barnitz, presented valuable information on many of the figures who had formed an integral part of the New York art scene for several decades. This theme was later taken up by the curators of a more ambitious travelling exhibition, *The Latin American Spirit: Art and Artists in the United States, 1920–1970* (The Bronx Museum of the Arts, New York, 1988).

Other exhibitions of the 1980s and early 1990s such as *Images of Mexico*, organized in 1988 for the Schirn Kunsthalle, Frankfurt, by Erika Billeter, *Latin American Art: the Modern Era*, curated by Dawn Ades for the Hayward Gallery, London (1989), or the ambitious *America: Bride of the Sun* seen at the Royal Museum of Fine Arts, Antwerp, in 1992 attempted to show a wide range of work from a variety of periods. Some of these shows were more successful than others. Their catalogues, mostly by European and American scholars, contributed often valuable information to a public whose interest in this field was evidently growing. One of the most satisfying of the European exhibitions of the 1990s was the show organized by the Centro Atlántico de Arte

Moderno in Las Palmas de Gran Canaria (Canary Islands) and the Casa de América in Madrid. Entitled *Voces de ultramar* (*Voices from across the Sea*), it attempted to survey modern art throughout Latin America (and the Canary Islands) from 1900 to 1960. The participation of many Latin American art historians and critics both in the exhibition and its catalogue was important in presenting a balanced view of developments in the visual arts in the many countries with which it dealt.

One of the largest and most controversial Latin American exhibitions of recent times was *Latin American Artists of the Twentieth Century*, curated by Waldo Rasmussen of the Museum of Modern Art, New York, and seen in Seville, Cologne, Paris and New York (1992–3). The catalogue for the New York showing, written by a variety of European, Latin American and US scholars, documents the many works in the show and offers numerous essays on a variety of topics. As is the case with all exhibition catalogues, however, it was limited to the areas surveyed by the exhibition.

For the most part, Anglo-American audiences are not as aware as they might be of the

highly significant scholarship being done in Latin America itself. Several Latin American scholars have written or co-ordinated general histories of Latin American art, including Damián Bayón, Juan Acha and Marta Traba. Very few of these are currently accessible in any language, and only Marta Traba's *Art in Latin America, 1900–1980* has recently become available in English. Virtually every nation in Latin America has a substantial, or at least growing, body of literature on the history of its art. Among the most outstanding of these surveys have been written by Raquel Tibol (Mexico), Alfredo Boulton (Venezuela), Germán Rubiano (Colombia), Gaspar Galaz and Milan Ivelic (Chile) or Mirko Lauer (Peru). None of these, unfortunately, has been translated into any language from their original Spanish.

The scholarship in English on Latin American art is gaining in both quality and quantity, yet there is still a very long way to go. There are few universities in the United States or Britain where a student can find in-depth instruction in the arts of Latin America. Although the field of pre-Columbian art has long been well-established, the number of serious scholars in

Introduction

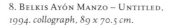

8. BELKIS AYÓN MANZO – UNTITLED,
1994. collograph, 89 x 70.5 cm.

the areas of colonial or modern art is still very small when compared with most other branches of the disciplines of art history or art criticism. A prejudice against Latin American art still exists within the 'academy', where it has long been considered, within the Eurocentric framework of art history, as 'exotic', or 'derivative' of European or North American forms. Earlier in this century the Brazilian critic and philosopher Oswald de Andrade articulated the notion that much of the originality in Latin American culture derives from the skilful transformations and refashionings of elements from abroad to create new forms which conform to the exigencies of the nations of the so-called New World. This is often misapprehended by the 'centre', which considers anything at the 'periphery' of secondary or tertiary importance. Andrade wrote about the need to 'cannibalize' from Europe in his *Anthropophagite Manifesto* (1928), in which he emphasized the necessity to appropriate and reconstruct, in a revolutionary way, both ideas and images from elsewhere. This notion has little or nothing to do with eclecticism. Indeed, from cultural cannibalism come the highly defined profiles of the traditions described in the following pages.

Although still few in number, the outstanding Anglo-American critics and historians of Latin American art have contributed significantly to our understanding of this field. I have already mentioned Jean Franco who has published on a wide variety of cultural manifestations. Shifra Goldman's remarks on the general historical patterns of Latin American and the development of Latin American art, articulated in her latest volume of essays, are invaluable. Among other scholars writing in the English language who have made important inroads in specific areas are Mari Carmen Ramírez, whose studies of the art of Joaquín Torres-García and his school as well as the modern art of Puerto Rico, are invaluable sources. Laurance Hurlburt's studies of Mexican muralism, Guy Brett's writings on the conceptual art of Latin America, Jacqueline Barnitz's essays on Latin American artists in the US, Luis Camnitzer and Giulio Blanc's studies of modern and contemporary Cuban art and Charles Merewether's writings on socio-economic determinants in Latin American culture have all enriched this field. Other authors have contributed significantly with their studies of individual artistic personalities in twentieth-

century Latin American art. These include, among others, Hayden Herrera and Sarah Lowe with their biographies of Frida Kahlo, and Lowe with her life of the photographer Tina Modotti. Lucy Lippard has long offered a model of insight and sensitivity in tackling a wide variety of cultural and social issues that have included Latin America.

Each essay in this volume touches upon issues of diversity, attempting to arrive at a consensus of understanding regarding the contributions of the various components of the 'cultural fabric' of the respective countries and cultures. It is hoped that through the texts and juxtapositions of images the reader will be able to better comprehend a number of the factors that define modern art in Latin America.

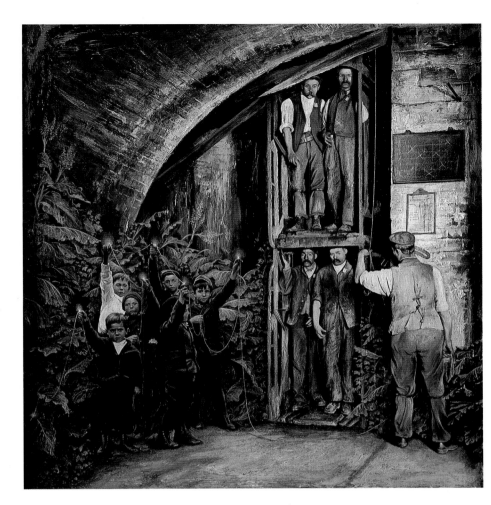

9. JOSÉ ALBERTO MARCHI – OBSERVADORES
SUBTERRÁNEOS (SUBTERRANEAN OBSERVERS),
1994. acrylic on board, 30 x 28 cm. private collection

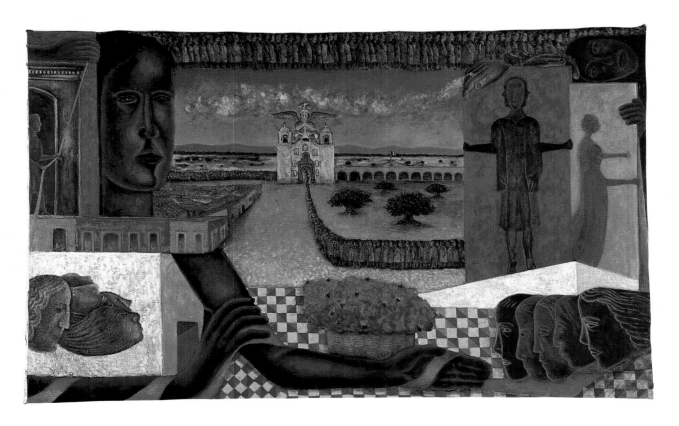

10. RODOLFO MORALES – JUICIO FINAL (LAST JUDGEMENT), *1988.*
oil on canvas, 132 x 215 cm. private collection

Mexico

LATIN AMERICAN ART IN THE TWENTIETH CENTURY

Teresa del Conde

Mexico

The Beginnings of Modernity

As in the case of other countries, the history of Mexican art of the twentieth century does not begin precisely in the year 1900. According to one's point of view, it starts earlier or much later than this. If we consider the nationalistic elements – essential components of some of the principal sources of Mexican art – there are almost innumerable precursors. Yet if we look at Mexican art from the vantage point of its relationship to the European avant-garde, there appear to be very few antecedents. There was a strong sense of regionalism in Mexico, as, for example, in Italy, which acted as a buffer against influences from the outside world. With the exception of a few cases the repercussions of its contact with Europe are not found until the early 1920s. However, there are points of convergence when certain *fin-de-siècle* styles such as Symbolism (whose roots are found in literature) come to the fore in both France and Mexico at the same time.

Around 1874, independent Mexico began to reap the fruits of a serious and solidly based interest in art. Ida Rodríguez Prampolini has pointed out that Mexicans not only wished to employ European elements in their art but, by appropriating them, they were able to universalize Mexican values. The writer and Supreme Court magistrate Manuel de Olaguíbel (1845–1900) inspired artists with speeches such as one which contained the following exhortations: 'Artists, work! You will be great because your field is vast: for your history painting you may count on sublime heroes to portray; for genre painting you have interesting types and for landscape, a virgin nature.'[1]

Olaguíbel was not only referring to pre-Hispanic art – a field which did not enjoy widespread appreciation at that time. What this author fought for was a nationalist art garbed in neo-classical trappings. One can observe in the words quoted above an obvious celebration of those elements peculiar to the nation. Expressed in conservative language, these ideals are close to those of the Academia de Bellas Artes de San Carlos, the first official art school in Latin America, established in 1785 along lines similar to those of Madrid's Academia de San Fernando.

After the turn of the century, a movement opposed to this conservative nationalist sensibility came into being and existed for many years alongside that which had been championed by Olaguíbel. In Mexico, Symbolism (which, as in other Latin American countries, was called *Modernismo*) had many proponents. The *Modernistas* constituted an élite movement which would expand in later decades. This movement flourished simultaneously with that in Europe and, in a few cases, even anticipated some of the European Symbolist trends. The paradigmatic artist of Mexican Symbolism was Julio Ruelas (1870–1907) who had studied at the Academy in Danzig, Germany. Ruelas, who had a taciturn, bohemian temperament, was an excellent draughtsman and was admired by poets and thinkers. He returned to the Mexican capital in 1895 but spent the last three years of his life in France, living on a modest government stipend in Paris, where he died of tuberculosis. It was there, working in the studio of the painter Joseph Marie Cazin, that he created his nine etchings; though few in number, his prints were magisterial in quality. Ruelas was the principal illustrator of the *Revista Moderna*, the magazine that enjoyed great esteem in all Spanish-speaking nations. In certain ways, this publication could be compared with *The Yellow Book*, publishing excellent Spanish translations of Novalis, Edgar Allan Poe and Charles Baudelaire, the poetry of Rubén Darío, essays on architecture, the esoteric or occult sciences, the Pre-Raphaelites, J. M. W. Turner, the French avant-garde artists and fantastical or decadent stories in the style of Joris Karl Huysmans, all of which excited the imagination of the *Modernistas*. The *Revista Moderna* was similar to other like-minded European reviews, even in terms of its graphic design, yet it did not pretend to have a massive distribution as it was a publication for artists and intellectuals.

The great muralist José Clemente Orozco recalls in his *Autobiography* of 1945 a dispute which took place between the exquisite, French-influenced proponents of Symbolist *Modernismo* and some of the younger artists who had assimilated the spirit of modernity in the context of the rising nationalism in Mexican art in the early twentieth century: 'There was a very sharp public controversy between Dr Atl and the friends of Julio Ruelas. It was one of many conflicts between the Romantics (who were the Symbolists) and the moderns. Ruelas was a painter of cadavers, hanged satyrs, fantasies of lovers' suicides, while Dr Atl made use of the palette of the Impressionists and all the other audacious traits of the members of the School of Paris. Ruelas had done a magnificent self-portrait which showed a monstrous insect driving a colossal nail into his head (fig. 11). The insect represented the critics. He did other etchings in which devils appeared as succubuses feasting on the brains of human victims. But in the years that followed there would be no room for such imagery; the succubuses would be replaced by violence and terror.'[2]

The career of Ruelas runs parallel to that of his fellow graphic artist José Guadalupe

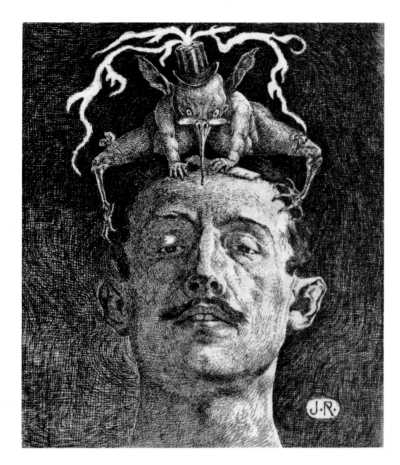

11. JULIO RUELAS – LA CRÍTICA
(CRITICISM), *1906. etching, 18 x 15 cm.*

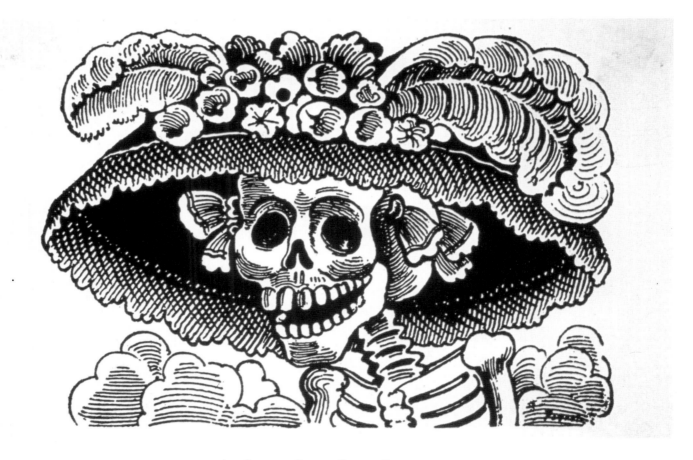

12. JOSE GUADALUPE POSADA – CALAVERA CATRINA
(CATRINA SKELETON), *1913. zinc etching, 11 x 15 cm.*

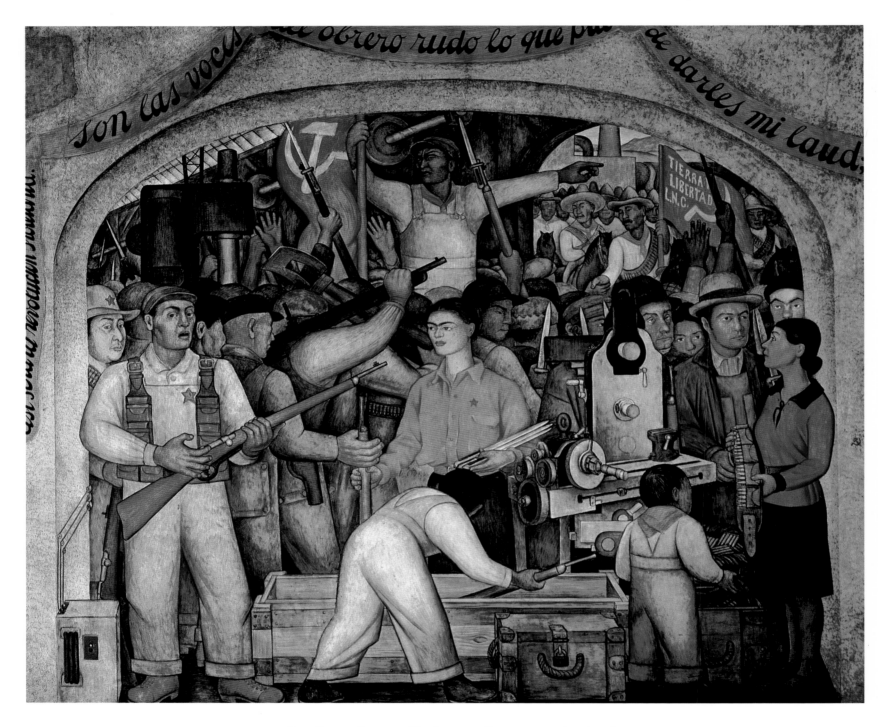

13. DIEGO RIVERA – EL ARSENAL (THE ARSENAL OR DISTRIBUTION OF ARMS), 1928.
mural. south wall, Courtyard of the Fiestas, Ministry of Public Education, Mexico City

Mexico

Posada (1852–1913), creator of more than 20,000 zinc engravings masterfully printed on single sheets by Antonio Venegas Arroyo. These prints gave visual substance to the vice, misery, political miscalculations, natural catastrophes, crimes of passion and extraordinary events in Mexican society during the years of the presidency of Porfirio Díaz (1876–80 and 1884–1911). The immortal artist of the *Calaveras* (*Skeletons*; fig. 12) was greatly admired by the next generation. It was under Posada's influence that Diego Rivera (1886–1957) utilized the image of the *Catrina Skeleton* in his 1947–8 fresco *Sueño de una tarde dominical en la Alameda Central* (*Dream of a Sunday Afternoon in the Alameda*) in Mexico City, in which the artist paints himself as a fat little boy beside the figure of his wife Frida Kahlo, flanking the figure of Catrina who occupies the centre of the composition. Frida stands shoulder to shoulder with President Francisco I. Madero (1911–13) and in the foreground we see a modernized version of a prostitute from pre-Hispanic times. There are allusions to the famous hot-air balloon known as the 'Globo de Cantoya' as well as to the exaggerated French fashions popular in Mexico at the turn of the century in this humorous and highly effective historical pastiche by Rivera.

The Consequences of Revolution

On 20 November 1910 the eleven-year-long armed conflict which would come to be known as the Mexican Revolution broke out. Those artists who were not in Europe embarked on a variety of politically-oriented endeavours: illustrating revolutionary publications, joining one of the military legions (as was the case with Francisco Goitia (1882–1960) and David Alfaro Siqueiros) or creating images from which a new concept of national consciousness could emerge.

This latter activity was realized by Saturnino Herrán (1888–1918), who foreshadowed the Mural Movement in his monumental drawings for the unexecuted frieze of *Nuestros dioses* (*Our Gods*) which was designed for the then unfinished Palacio de Bellas Artes in Mexico City. Herrán had considered depicting the union of the Mexican races in two panels showing processions, one of the Indians, the other of the Creoles displaying symbols of the ancient religions of Mexico as well as those of Christianity.

An important political event in the sphere of the fine arts occurred on 28 July 1911 when the students of the Academia de San Carlos went on strike against the director Antonio Rivas Mercado. The strike, which lasted two years, was in part inspired by the multifaceted painter Gerardo Murillo (1875–1964), who had adopted the pseudonym of Dr Atl. In 1913 the painter Alfredo Ramos Martínez (1875–1946), recently arrived from Europe, took up the directorship of the Academy. At the same time he laid the foundations for the Escuelas de Pintura al Aire Libre (Open-Air Schools of Painting), which trained students to work outdoors, *en plein air*, and would have important consequences for Mexican art. The first of these schools, located in the district of Santa Anita Ixtapalapa, was given the name 'Barbizon', even though the working methods had little to do with those practised by the French Barbizon artists. This was followed by others in the Mexico City suburbs of Xochimilco, Coyoacán, Chimalistac, Churubusco and Tlalpan. Even as late as 1932, after the heroic phase of Mexican Muralism was over, a similar school was opened in Taxco in the state of Guerrero. A large travelling exhibition of paintings done in the Open-Air Schools was organized and, in 1926, was sent to Berlin and subsequently to cities in

France and Spain, 'provoking great interest and surprise', in the opinion of observers. It was said, for example, that Tsuguharu Foujita and Raoul Dufy were fascinated by the exhibition. Whether they viewed the Mexican experiment as something exotic, created in a nation which they regarded as 'tropical' in its entirety, or whether it prefigured the interest of Michel Seuphor and Jean Dubuffet in what was to be called *art brut*, we do not know.

The Open-Air Movement formed part of a wider national educational programme initiated at the end of the Revolution in 1920. Along with the so-called Talleres Libres de Expresión Artística (Free Studios of Artistic Expression), formed at the same time, the Open-Air Schools were applauded by some and decried by others. The aim was to establish an aesthetic consciousness among representatives of all social classes. Especially targeted were very young students, but workers and young women from the middle classes also studied at these schools. A need was felt to 'reinvigorate national art' (although, in truth, the importance of art in Mexico had never declined, even though artistic production may have been slowed down by the nineteenth-century Wars of Independence with Spain). The end result was, above all, the institutionalization of a combination of modernist and popular elements championed by the well-known painter and art educator Adolfo Best Maugard (1891–1964). Best Maugard had sought to introduce a rational method of drawing into the curriculum of primary schools. Some of the original Open-Air Schools closed and others opened during the period 1920–37. It is important to note that there was virtually no significant painter of this period who had not been employed as a teacher in the Escuelas al Aire Libre, the

Mexico

history of which has been chronicled by such scholars as Laura González Matute.[3]

On 1 December 1920, General Alvaro Obregón assumed the presidency of the Republic. This effectively marked the end of a long period of civil wars and factional violence provoked by rebels, known as Constitutionalists, in various parts of the country under strong leaders such as Francisco (Pancho) Villa and Emiliano Zapata. Obregón's contingent eventually triumphed over the Constitutionalists and sought to bring order to the war-ravaged country. After an initial four-year presidency, Obregón was elected for a second term beginning on 1 July 1928. Two weeks afterwards he was assassinated by José de León Toral outside a restaurant known as La Bombilla in Mexico City, later the site of the impressive Art Deco monument which was dedicated to him. This work, done in the 1930s, is an example of the integration of sculpture and architecture and was based on similar monuments erected at the site of the Suez Canal.

Shortly after Obregón's initial nomination in 1920, the then-vacant post of Secretary of Public Education was filled by the Rector of the University of Mexico, José Vasconcelos (1882–1959). A plan for the 'Salvation and Regeneration of Mexico through Culture' was initiated by Vasconcelos. Culture, for the new minister, equalled 'Spirit'. From this belief was derived the motto of the university: 'The Spirit will speak through my race.' Vasconcelos, like Goethe, believed that the 'aesthetic' was the superior side of mankind, but he also believed that an *estética bárbara* (wild aesthetic) had to be created in order to overcome decadence and to affirm the vigour of the New World. Vasconcelos stated: 'The important thing is to produce symbols and myths, to imagine a heroic past and make it speak

in a Wagnerian way through the twilight gods such as Coatlicue.'[4]

The Escuela Mexicana de Pintura (Mexican School of Painting) was born with Vasconcelos. In its earliest phase it saw the creation of the Mexican Mural Movement which was meant, in theory at least, to generate an awareness of patriotic values amongst the masses as well as among members of the indigenous races. Yet it was precisely these groups of people who would be least interested in seeing themselves portrayed as suffering torture and tyranny at the hands of their oppressors (as can be seen, for example, in Rivera's murals in the Palacio de Cortés in Cuernavaca), even if these images had been created with the noble purpose of 'consciousness-raising'. The social demands of the indigenous peoples were, and still are, much more pressing.

During the decades following its appearance, mural painting in Mexico enjoyed a type of prestige and influence in other countries that no other American art movement had ever before experienced. A great deal has been written about this movement that produced so many well-known works, a number of which have assumed a leading position on the list of masterpieces that comprise the history of art due to their iconographic content as well as their solutions to formal problems.

Mexican Muralism did not possess anything like a fully formed theory or a common aesthetic programme, even in its initial phases. Each of the participants in the movement was an intellectual, imbued with Marxist theories (although these were, for the most part, acquired second hand). At the beginning of the 1930s it was almost obligatory for painters to belong to the Communist Party if they wished to receive

mural commissions or participate in important exhibitions. None the less, each artist expressed him- or herself with their own stylistic individuality, while pursuing appropriate thematic motives. Subject-matter was usually linked to the combat phase of the Revolution: scenes of the Spanish conquest, the ever-present power of the Church in the colonial period, class struggle, social customs, myths and rites, popular festivals, geography, landscape, ethnic differences and Mexico's pre-Hispanic past. The pre-Columbian period was conceived of as a glorious era of harmony, something like a Golden Age, the Arcadia of the nation. At that time there was little awareness of the expansionist politics of the ancient Mexican Empire.

The 'essence of nationhood' was expressed in Muralism through easy-to-decipher allegories and symbols, even though in reality such a concept of nationalism had never existed. Muralism can therefore be considered as one of the grand utopian movements of the twentieth century, a fact which accounts for much of its greatness as well as that of its proponents. It should be understood that, despite the diversity of temperaments and differences in artistic aims and even ideological positions of those involved in the Muralist Movement, there was, among its leaders, a notion of a cohesive group embarking on a campaign to realize common goals. The term 'Mexican Mural Renaissance', coined by the Frenchman Jean Charlot to apply to the first phase of Muralism, is a fitting nomenclature. Italian murals of the Early and High Renaissance and the Baroque served to educate illiterate people about religion and, at the same time, raised the consciousness of both leaders and led, and enhanced the nobility of the cities where these works of art were located. Something

14. Agustín Lazo – Mujer en un paisaje
(Woman in a Landscape), *1935. oil on canvas,*
45 x 38.8 cm. private collection, Mexico City

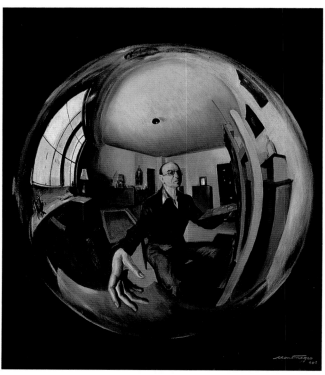

15. Roberto Montenegro – Autorretrato
(Self-Portrait), *1942. oil on canvas, 69 x 59 cm.*
Instituto Nacional de Bellas Artes (Instituto
Nacional de Bellas Artes – hereafter abbreviated as
INBA), Museo de Arte Moderno, Mexico City

Mexico

similar happened in the new Mexico, the nation born after the Revolution of 1910–20. Rivera and Siqueiros, each in his own way, thought of the situation in these terms while they were travelling in Italy. Jean Charlot, who arrived in Mexico at the beginning of 1921 and became an active participant in the Mural Movement, put these concepts into words: 'With the acquired mystery of an undefined antiquity and the air of many empires reduced to dust, the archaeological remains of the indigenous peoples served the same purpose for Mexicans as the ruins and fragments of the Greco-Roman cultures for the Italian Renaissance.'[5]

At that time the anthropologist Manuel Gamio had revealed the importance of the remains of the pre-Hispanic past, which, during the 1920s, were being re-evaluated throughout the world by archaeologists and anthropologists employing new techniques and methods.[6] Attracted to this subject, artists began making study trips of their own, capturing the expressions of the people, the colours of their feast days and the enormous richness of Mexican folk traditions which, while hybrid, still transmit something of their remote origins. All these elements, together with a faith in future salvation through technological advancement, the world of machines and the basic theories of the Historical Materialism of Karl Marx, formed a rich vocabulary which could be altered according to the individual artist's needs. Among the subjects explored in mural art were the origins and the evolution of the human race as a model for the sources and flowering of the Revolution; the genetic beginnings of the Two Americas (the Latin and the Anglo-Saxon); man as the new Zeus controlling the universe; internal struggles; the birth of an independent nation. Specific themes

included pyramids, allegories of everyday life in antiquity, images of the god Tlaloc, plumed serpents, tiger-horsemen, Mayan women wearing beautiful embroidered *huipiles*, the torture of Cuauhtémoc as well as human sacrifices – ennobled so as to assume an acceptably heroic tone. Diego Rivera's handling of this thematic repertoire undoubtedly represented the most effective mode of vision and attracted the largest number of followers. Each of the *Tres Grandes* (the 'Three Great Ones') – Orozco, Rivera and Siqueiros – and their disciples executed many murals both within and outside Mexico. Throughout the 1930s the repercussions of their art were felt in the United States by the Federal Art Project of the WPA (Works Progress Administration). Their work had an equal impact upon the other mural movements that arose in Latin America, even though these were of less significance than Muralism in Mexico.

The Minister of Public Education Vasconcelos (denounced by Rivera in one of the mural panels in the Ministry of Education building in which he appears as a caricature of himself, seated with his back towards the viewer upon a diminutive elephant, an allusion to his taste for Eastern philosophy) possessed the intelligence and the foresight necessary to introduce an educational and artistic programme on a grand scale. Shortly after assuming office Vasconcelos brought both Diego Rivera and Roberto Montenegro (1886–1968; fig. 15) back from Europe, offering them the walls of public buildings to paint, while respecting their individual ideological and stylistic stances (and those of the other artists of the Mural Movement). In late December 1922 the artists organized themselves into the Sindicato de Obreros Técnicos, Pintores y Escultores (Syndicate of Technical Workers,

Painters and Sculptors) under the leadership of Siqueiros. The newspaper *El Machete*, which served as the organ to disseminate the Syndicate's ideas, published its first issue in March 1924, just before Vasconcelos resigned his post when Plutarco Elías Calles came to power as leader of the Revolution. By that time Muralism had already developed its own dynamic, which it would later lose, for various reasons including the institutionalization of its programmes and the unpersuasive and incessant repetition of its rhetoric by lesser artists of succeeding generations.

In 1923 the Syndicate issued a manifesto directed at 'the humiliated indigenous race' as well as at all those who had not been compromised by bourgeois ideals. This manifesto severely criticized canvas painting as 'an art form of the inner circles of the ultra-intellectuals' while, at the same time, exalting monumental (mural) art as 'serving a public utilitarian purpose'.

The Muralists covered, in effect, kilometre after kilometre of wall, charging by the square metre as if they were house painters. Fortunately canvas painting was never abandoned. It continued to be practised for two reasons. The first was that artists had to earn a living; the flow of mural commissions to painters (except Diego Rivera, who continued to work on the frescos for the Ministry of Public Education; fig. 13) had come to a halt in 1924, only to be resumed some years later. The second reason was that many painters of this period were not adept at, or did not wish to paint, murals. Painting on canvas by members of the Mexican School therefore became rich in its diversity. The need was not felt to transmit social or historical messages and the means of representation were not limited to the strictly realistic.

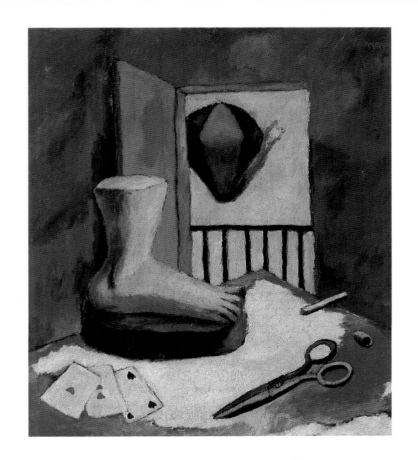

16. RUFINO TAMAYO – NATURALEZA MUERTA CON PIE (STILL LIFE WITH A FOOT), *1928. oil on board, 60 x 46 cm. private collection*

The Mexican School

The majority of painters who began their professional careers in Mexico during the first phase of Muralism saw themselves as necessarily enveloped in the grand mosaic that comprised the Mexican School, whether or not they sympathized with its aims. Those artists who continued to share the same political concerns banded together during the 1930s as the founders of Liga de Escritores y Artistas Revolucionarios or LEAR (Revolutionary League of Writers and Artists) and members of the Taller de la Gráfica Popular or TGP (Popular Graphics Workshop). Other artists lived for long periods abroad without completely giving up their identification with the Mexican culture; such was the case with Rufino Tamayo (1899–1992; fig. 16). There were still others who later, during the 1940s, remained close to those Muralists of the second and third generations, travelling to various places within the country to work on mural projects. The Guatemalan-Mexican artist Carlos Mérida (1891–1984), who was also an important art critic, collaborated in this nationalist programme. He was equally receptive to new tendencies in art and gave up his membership of the Syndicate of Technical Workers to travel to Paris in 1927, having had his first exhibition in New York the previous year. When he finally returned to Mexico in 1929 he dedicated himself primarily to painting on canvas for the rest of his career (fig. 17). His geometric forms, inspired by Maya textiles, were well in advance of their time.

Roberto Montenegro amassed an important collection of folk art about which he composed a treatise, while, at the same time, practising his own form of avant-garde artistic expression. His most successful works are paintings that demonstrate his affinities with

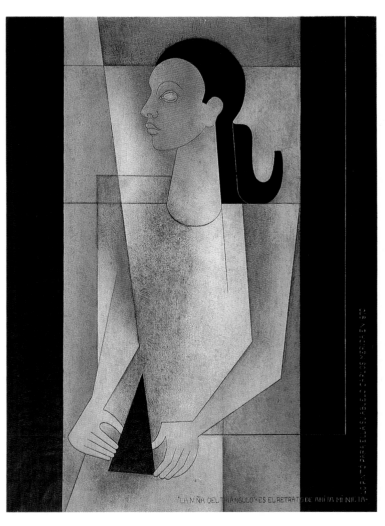

17. CARLOS MÉRIDA – RETRATO DE MI NIETA, ANA LUNA, LA NIÑA DEL TRIÁNGULO (PORTRAIT OF MY GRANDDAUGHTER ANA LUNA, THE GIRL OF THE TRIANGLE), *1970. mixed media on wood, 77 x 57 cm. private collection, Mexico City*

Mexico

18. ALFONSO MICHEL – LA CARTA
(THE LETTER), 1936.
oil on canvas, 46 x 53 cm.
private collection, Mexico City

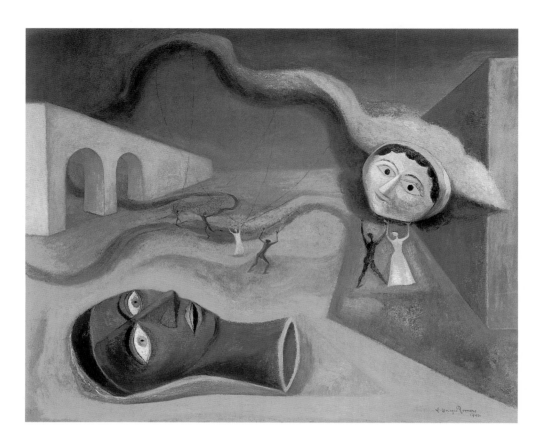

20. CARLOS OROZCO ROMERO – SUEÑO (DREAM), 1940.
oil on canvas, 73 x 83 cm. private collection, Mexico City

19. JULIO CASTELLANOS – EL BOHIO MAYA
(THE MAYAN SHACK), *1942. oil on canvas, 56 x 71 cm.*
INBA, Museo de Arte Moderno, Mexico City

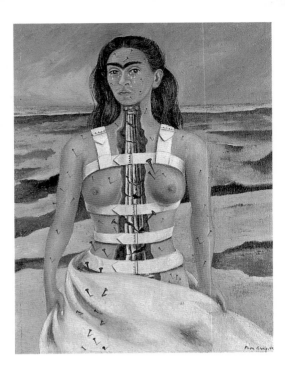

21. FRIDA KAHLO – LA COLUMNA ROTA
(THE BROKEN COLUMN), *1944.
oil on board, 40 x 31 cm. Museo Fundación
Dolores Olmedo Patiño, Mexico City*

Surrealism. Agustín Lazo (1896–1971; fig. 14) was more interested in studying his favourite painters – Renoir, Seurat, Max Ernst, de Chirico, Picasso – than in participating in the debates initiated by Rivera or Siqueiros. There are numerous examples of artistic careers which developed along independent lines at this time and yet remained within the framework of the Mexican School. Many of these artists participated in exhibitions which travelled abroad; a number of these were co-ordinated by Inés Amor, the owner of Mexico's first independent art gallery, the Galería de Arte Mexicano, which opened its doors to the public in 1935 and remains one of the most significant galleries in Mexico City.

Some of the painters who rejected the idea of producing art with a message were closely associated with those writers and poets known as the *Contemporáneos* (Contemporaries) who were the heirs of the tradition of the *Modernistas.* These people considered themselves as 'spirits possessed by the divine'. The *Contemporáneos* constituted a 'group without a group' – a communion of independent libertarians who had a considerable impact upon Mexican culture. The writers included Carlos Pellicer, José Gorostiza, Salvador Novo, Jorge Cuesta, Gilberto Owen and Xavier Villaurrutia who, like Cuesta, was also an art critic. The painters associated with the *Contemporáneos* formed a 'sub-' or 'counter-current', according to the critic Jorge Alberto Manrique; they were also possessed of a nationalist spirit but were reluctant to express it. A number of them were interested in fantastical realism, a de Chirico-like metaphysical style, or in Surrealism. Among them were Lazo and Antonio Ruiz, called El Corzo (1895–1964). Other members of this group included Carlos

Orozco Romero (1898–1984; fig. 20), Julio Castellanos (1905–47; fig. 19), Alfonso Michel (1898–1958; fig. 18), Jesús Guerrero Galván (1910–73) and María Izquierdo (1902–56; fig. 25). The work of Frida Kahlo (1907–54) should be considered as lying between one tendency and the other. Her position as wife of Diego Rivera, as well as her own sentiments, place her in the forefront of the defenders of nationalism. On the other hand, her work comprises an incalculably valuable pictorial autobiography (fig. 21) as she tended to distance herself from any element which did not specifically refer to herself as the main subject.

The poet and essayist Octavio Paz began making the acquaintance of these writers and painters after 1950 and wrote about a number of them. Even though he made the following statement many years later (when he was about eighty), it remained his opinion that those associated with the *Contemporáneos* shared many affinities: 'They all maintained an attitude of intelligent independence before the ideological art of Rivera and Siqueiros as well as the Expressionism of Orozco.'[7]

It is worth examining the Expressionism of José Clemente Orozco (1883–1949; fig. 22), the only Muralist who has been unanimously respected by recent generations of Mexican artists and whose work has influenced many of them. Orozco's Expressionist disposition first became evident in his series of watercolours featuring brothels, known as *Casas del llanto* (*Houses of Weeping*). Even though there are many similarities between his work and that of his German contemporaries Emil Nolde or Max Beckmann, it is virtually impossible that he could have seen even reproductions of their paintings. Orozco, a native of the state of Jalisco, attended

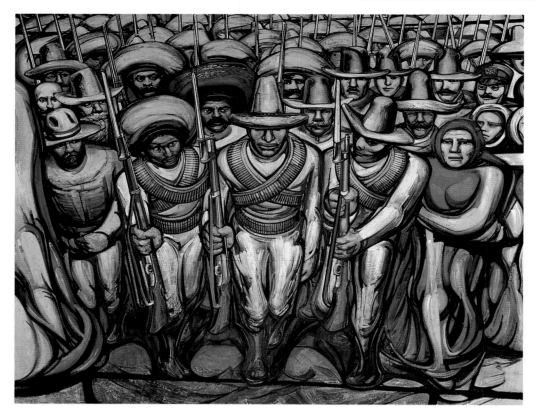

23. DAVID ALFARO SIQUEIROS
– LOS REVOLUCIONARIOS
(THE REVOLUTIONARIES), 1957–65.
mural. Hall of the Revolution,
National History Museum,
Chapultepec Castle, Mexico City

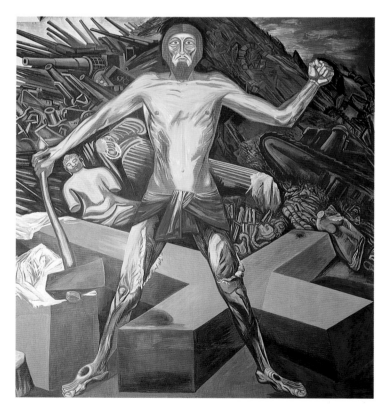

22. JOSÉ CLEMETE OROZCO – CRISTO DESTRUYE
SU CRUZ (CHRIST DESTROYING HIS CROSS), 1932–4.
mural. Dartmouth College, Hanover, NH

24. JOSE LUIS CUEVAS – INTOLERANCIA
(INTOLERANCE), 1986.
etching and aquatint, 93 x 152.5 cm.

Mexico

25. María Izquierdo – El idilio (The Idyll), 1946.
oil on canvas, 75.5 x 60.5 cm. private collection, Mexico City

the Academia de San Carlos at an early age and lost his left arm while experimenting with dynamite when he was only sixteen. In consequence he seems to have developed a method of overcompensation that ultimately led him, together with Rivera and Siqueiros, to form the triumvirate known as the *Tres Grandes*, who wielded a power not unlike that exerted in Renaissance Italy by Leonardo da Vinci, Michelangelo and Raphael. Orozco did not enter into polemical discussions with the other members of the trio; in fact, they did not share the same affinities. His tendency to glorify the grotesque, the dramatic and even the sinister went hand in hand with a disenchanted view of history, as in the mural *Catarsis* (*Catharsis*), painted in 1934 for the recently finished Palacio de Bellas Artes, in which the masses are seen burning in a purifying fire. Several harrowing figures of prostitutes, based on drawings that Orozco had done from a model, can be observed in the foreground. In these drawings the tendency to distortion takes an attenuated form.

Orozco was profoundly sceptical, even of the movement of which he was the head. He spent a long time in New York but he did not achieve the fame there that Rivera had. His concept of history and his political ideas were diametrically opposed to Rivera's utopian views. Today we would be inclined to regard him as an anarchist who anticipated Post-modernism by almost half a century. His particular emblem was Prometheus, the central personage of the mural executed for Pomona College in Claremont, California, in 1930 and who reappears as the central figure in the famous *Hombre en llamas* (*Man of Fire*), the culmination of Orozco's fresco cycle painted for the Hospicio de Cabañas, Guadalajara, in 1938–9. In the dome of the

former chapel in the Hospicio this work acts as a symbol mediating between religion and metaphysics, given the fact that fire purifies, regenerates and, at the same time, destroys. Orozco was the first of the 'catastrophists', an iconographical approach that was adopted by artists throughout the world in the 1980s. In Mexico, forty years earlier, it had acquired complex shades of meaning which are pervasive even today.

One artist who, later in the century, felt the strong impact of the art of Orozco was José Luis Cuevas (b. 1934; fig. 24). That this is also the case with many younger Mexican artists at the present time is perhaps because Expressionism may be seen as a constant which intensifies at certain moments throughout the history of Mexican art. It may also be analogous to the phenomenon of Baroque art. A hybrid style *par excellence*, the Baroque assumed some of its most complex manifestations in Mexico. Even today the Baroque can be said to be grafted on to various forms of contemporary Expressionism. Just as there are multiple forms of the Baroque, Expressionism can be said to adopt a variety of shades of subtlety. None the less, when considering the term 'Baroque', with its immense variety of connotations, the artist who comes most readily to mind is not Orozco but David Alfaro Siqueiros (1896–1974) whose expertise at foreshortening, accentuated perspectives and grandiloquence of expression, remains unequalled (fig. 23). By comparison with Orozco and Siqueiros, Rivera is a classic artist, beginning with his Cubist phase. In the realm of the figurative, Rivera's work sometimes bears a resemblance to that of Ingres, especially his drawings and canvas paintings. Rufino Tamayo, who created an amalgam of ancient Mexican sculpture grafted on to the lessons derived from Picasso,

could also be called a classic artist, yet in the contemporary sense of the term. While there is no naturalism to be found in Tamayo's work, it contains echoes of Cubism as well as the synthesizing power of ancient Mexican sculpture. Tamayo created a cult of form balanced by his extraordinary adeptness as a colourist. He combined subtlety and audacity without losing the effect of his palette.

No matter what combination of colours Tamayo uses, his paintings epitomize harmonic unity. His works are never strident, unlike those of one of his principal followers and most ardent admirers, the Zacatecas-born Pedro Coronel (1923–85) who, like Tamayo, re-created and utilized certain codes and signs derived from ancient cultures, omitting anything that tended towards the anecdotal or the archaic (fig. 27). Coronel expressed his admiration for Tamayo on a number of occasions and created a series of paintings entitled *Tamayanas* in which he paid him homage. None the less, the two artists are markedly different from one another in style and personality.

Foreign Artists in Mexico

From 1936 to 1942 various European intellectuals and artists arrived in Mexico, refugees from the Spanish Civil War and the Second World War. Among them were three women painters: the Spanish born Remedios Varo (1908–63; fig. 26), Leonora Carrington (born in England in 1915; fig. 28) and Alice Rahon (1904–87) from France. They each developed distinct careers, without striving for fame, recognition or even a lucrative market for their work. The first two became very well known, however. Remedios Varo's art continues to appeal to large numbers of people from all social strata, a fact

Mexico

that was reaffirmed at the time of her major retrospective exhibition held at the Museo de Arte Moderno in Mexico City in the spring of 1994. There was a symbiosis between Varo and Carrington. They were close friends who emerged from the Surrealist milieu and shared ideas and working methods. Varo had been championed by Benjamin Peret and, in her youth, Carrington had been a disciple and companion of Max Ernst. Both made Mexico their adopted country and did the bulk of their mature work in Mexico City. Neither artist was in sympathy with Frida Kahlo. They may have disliked the openness of Kahlo's self-examinations in her work. They may also have found the circles in which Kahlo moved (despite what many have said, her art was very well recognized during her lifetime) too much at odds with the quiet and intimate image which they wished to maintain. Frida, with her undeniable genius, her extraordinary regional clothing and her courageous and non-judgemental attitude, may possibly have intimidated them.

It was said, even at the beginning of the 1950s, that Frida and Diego Rivera were like the two great volcanoes near Mexico City, Popocatépetl and Iztaccíhuatl. They frequently appeared in the newspapers and there were few public events at which they were not present. This notoriety created a situation in which other artists, especially foreigners, felt excluded from the group of nationalist-leaning painters who were at the summit of Mexican cultural life. It was exacerbated by the fact that any discussion of art in Mexico invariably involves politics or the politics of culture.

In any event, at the end of the 1940s and the beginning of the 1950s this triumphant nationalist fervour was the rule and a certain air

of rejection (if not overt, at least psychological and social) hung over anything thought to be tainted with foreignness. Yet there were many foreign painters in Mexico. The muralist Pablo O'Higgins (1904–83), originally from Salt Lake City, and the Parisian Jean Charlot (1898–1979) are prototypical examples, but they were both completely assimilated into the Muralist environment. Both Charlot and O'Higgins were more fervent supporters of Mexico, and knew more about the country, than many Mexicans. They were also supporters of the graphic movements which formed a tradition parallel to that of painting and was even more radical in terms of its social and nationalist content.

Artists' Movements of the 1920s and 1930s

Within the context of this period a number of other artists' movements or manifestations should be mentioned. The movement known as *Estridentismo* (Stridentism), which has been amply studied by Luis Mario Schneider and the researchers associated with the Museo Nacional de Arte (MUNAL) in Mexico City, introduced its manifesto during the last days of 1921; printed on a single sheet. The manifesto was entitled *Actual número 1* (*The Present, No. 1*) and signed by Manuel Maples Arce.[8] It paid homage to the Italian Futurists and proposed that their philosophy (disdain of the past and the future and glorification of the present) be used as the basis for the Stridentist aesthetic. The *Estridentista* group, like the *Contemporáneos*, was predominantly composed of writers and poets but joined by a few artists such as the sculptor Germán Cueto (1893–1975), the printmaker Leopoldo Méndez (1902–35) and Jean Charlot. All of these artists, each maintaining his own

26. REMEDIOS VARO – LA HUIDA (THE FLIGHT), *1961. oil on board, 123 x 98 cm. INBA, Museo de Arte Moderno, Mexico City*

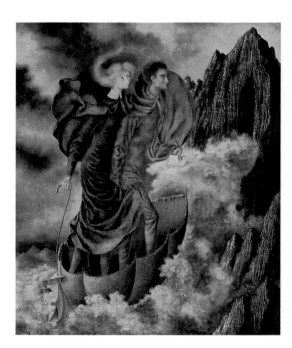

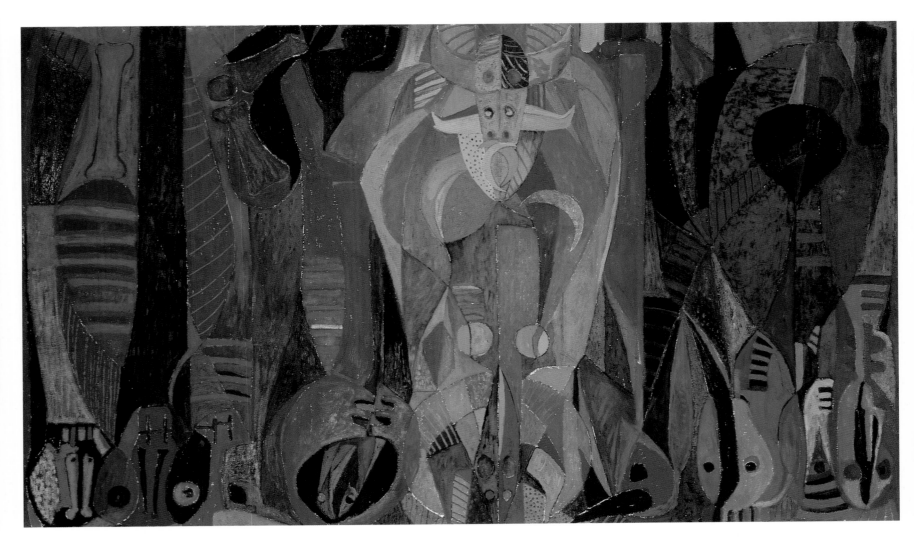

27. PEDRO CORONEL – EL ADVENIMIENTO DE ELLA (HER
COMING), 1966. oil on canvas, 182 x 303 cm.
INBA, Museo de Arte Moderno, Mexico City

28. LEONORA CARRINGTON – ARE YOU REALLY SYRIUS?, 1953.
oil on canvas, 53.5 x 91.5 cm. Museo de Arte Moderno, Mexico City (on loan)

Mexico

particular style, had a strong impact upon design and the graphic arts which reached a peak of quality in Mexico at this time.

The graphic arts associated with the *Estridentista* movement were advanced by comparison with the output, more than a decade later, of the Taller de la Gráfica Popular but the work produced by the latter workshop had a wider diffusion and influence. In *Estridentismo* a thorough assimilation of Dadaist principles can be observed. Elements of the two principal German Expressionist movements (Die Brücke and Der Blaue Reiter), as well as of Futurism, went into the creation of *Estridentismo*, whose modernizing stance was given official sanction around 1926. Another group that developed during these years was that known as 30–30!, comprising virtually the same artists as those involved in the enterprises of Muralism, public sculpture and magazine publication. One can detect an almost limitless number of options in the history of Mexican art of this period, although all of the artistic paths were mainly travelled by the same people. Groups like the *Estridentistas* and 30–30! had, in fact, been formed according to the political-cultural dictates of the Revolution.

Sculpture

Thus far sculpture has been mentioned only in passing. In view of the glorious past that this medium had enjoyed in Mexico – from the rich pre-Hispanic tradition to the retables, atrial crosses and elaborate jewellery of the colonial era to the flowering of neo-classical monumental sculpture in the nineteenth century – one would expect it to have enjoyed a continuing importance in the first half of the present century. Yet this was not the case. Each city square, public garden or important street in Mexican cities has been

provided with statues (usually cast bronze, but sometimes of stone or marble) of popular heroes. Yet these effigies usually derive from the same models, even though they are the work of twentieth-century artists. The development of public sculpture in Mexico is not unlike that in the former Soviet Union, where the wide demand for multiple images of national heroes prohibited any sort of experimentation.

During the first half of the century the most advanced Mexican sculpture was inspired by the work of Maillol and Bourdelle. This appeared after the 1920s concurrently with the assimilation, by many notable architects, of the Art Deco style with which the two French sculptors were associated and which had such a strong flowering in Mexico that it was much more than a formalistic trend.

A Mexican school of sculpture did exist, however, but it was not as strongly tied to the principles of the 1910 Revolution as was the case with mural painting.[9] This may have been because sculpture does not possess the same scenographic qualities as painting (with the exception of some high reliefs). The sculpture of the Mexican School, exemplified by such a work as the *Anciano sentado* (*Old Man Seated*, fig. 30) by Mardonio Magaña (1866–1947), revolves around three or four basic themes. These include the peasant with his machete, the mother with her child (alive or dead, deriving from the Pietà iconography) and the sensual, robust tropical woman relaxing in her hammock among other subjects.

In one way or another the most astute critics of sculpture were the artists themselves. For example, the sculptor Guillermo Ruiz (1894–1965), in response to a survey, replied that 'no sculpture exists that represents our revolu-

tionary period', and the painter Fermín Revueltas (1902–35) exaggeratedly affirmed that 'sculpture does not exist'. The only two sculptors who participated in the nationalist art programme of Vasconcelos were Ignacio Asúnsulo (1890–1965), creator of many ornamental sculptural projects as well as the previously mentioned monument to Alvaro Obregón, and Fidias Elizondo (1891–1979), sculptor of portraits, nudes, doorways, ceilings, and several public monuments including the twenty-metre-high *Christ the King* which stands on the summit of the mountain known as the Cerro del Cubilete, located at the geographic centre of the state of Guanajuato. Asúnsulo was more versatile than Elizondo. He had studied in Europe and experimented with the avant-garde, later teaching at the Academia de San Carlos where he helped to shape the careers of a generation of students. Of equal importance was Luis Ortiz Monasterio (1906–90), whose impressive depth of knowledge led him to create a body of work in which a wide variety of historical styles had been assimilated.

The Mexican government did not support sculptors with the same enthusiasm with which they promoted the Mural Movement. Sculpture depends a great deal upon official commissions and there were few of these by comparison with the support given by the government to painting. This fact explains, in part, the relative impoverishment of sculpture in Mexico compared with other areas of the visual arts. The situation changed, little by little, during the second half of the century, which witnessed a variety of sculptural projects undertaken by artists sensitive to the language of Expressionism (incorporating, for instance, the canons of such masters as Barlach or Gaudier-Brzeska) as well as

29. Manuel González Serrano – Aprendices de toreo
(Bullfighters' Apprentices), *1948. oil on wood, 60 x 80 cm.*
private collection

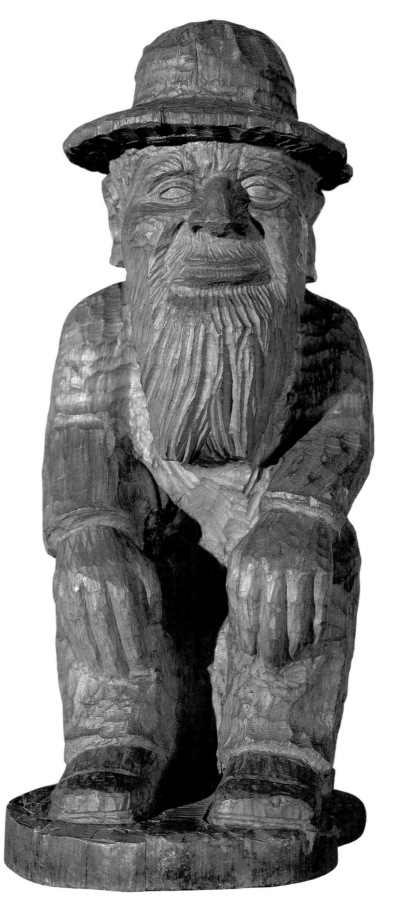

30. Mardonio Magaña – Anciano sentado
(Old Man Seated), *n. d. wood, 45.5 x 18 x 19.5 cm.*
INBA, Museo Nacional de Arte, Mexico City

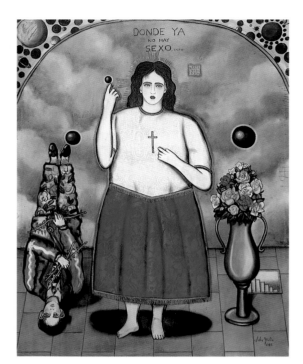

Mexico

31. Julio Galán – Donda ya no hay sexo
(Where There is No Sex), *1985.oil on canvas,*
215 x 185 cm. private collection

32. Enrique Guzmán – Paisaje interior (Interior Landscape),
1975. oil on canvas, 50 x 60 cm. private collection, Mexico City

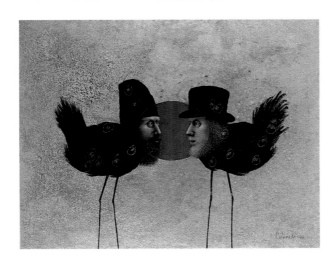

33. ALFREDO CASTAÑEDA – DIÁLOGO DE DOS POETA DISFRAZADOS DE AVES (DIALOGUE OF TWO POETS DISGUISED AS BIRDS), *1988*. *oil on canvas, 40 x 50 cm.* *Galería de Arte Mexicano, Mexico City*

the type of sculptural synthesis observed in the relief figures on the Monument to the Revolution in Mexico City, executed by Oliverio Martínez (1901–38). Martínez could be considered as the predecessor of the well-known sculptor Francisco Zúñiga (1912–98), a native of Costa Rica who served as his assistant. The sculptures of Zúñiga include indigenous matrons – images of the imposing women from the Isthmus of Tehuantepec who are guardians of their matriarchy and appear as strong and impassive as ancient goddesses. Zúñiga has gained a wide reputation, as well as financial success, through both his sculptures and his graphic work. He and his various followers have succeeded in creating a school whose trademark is its unmistakable 'style'. Despite its commercial viability both within Mexico and abroad, however, this style has become aesthetically enfeebled, except in the hands of Zúñiga himself.

Surrealism and Fantastic Art in Mexico

In 1938 the high priest of Surrealism, André Breton (1896–1966), came to Mexico with the intention of aligning himself with Leon Trotsky and Diego Rivera and thus furthering his idea of securing the links between Surrealism and Revolution. This did not happen (although the three men did meet in Pátzcuaro in the state of Michoacán where they drafted a manifesto). Breton found in Mexico a Surrealist country *par excellence*. This was not such an extraordinary discovery given the fact that 'abnormal' or 'fantastical' elements have formed an integral part of the visual repertory of Mexican artists and artisans for over a thousand years. In fact, the ability to subtly illuminate hidden or unsuspected aspects of everyday life is a constant factor in Mexico. This is linked to the perpetual cult of

death, with the beliefs of the Catholic Church and the polytheism that has developed among the Mexican people who have cultivated a natural syncretism within the canons of the Catholic Church. Given the rich variety of attributes in the pre-Hispanic pantheon, it was only logical that Christian saints would be considered as minor gods in post-Conquest times. In fact, there now exists a renewed 'Post-modernist' consciousness of this syncretistic reality. A number of younger artists work with religious and ritual elements in their art. At times these elements are simply presented for themselves; at other times their original meanings are subverted in order to transmit a variety of messages.

It is clear that, in the majority of cases, Surrealism and fantastical art in Mexico were more directly influenced by Mexican writers and poets close to Breton's movement than by those artists associated with orthodox European Surrealism. The search for the fantastic and even the irrational fits hand in glove with the idiosyncrasies of Mexico.

Frida Kahlo was, in many respects, the prototype of Breton's vision. Even before he compared her to a bomb with a ribbon around it, Antonin Artaud had seized upon the work of María Izquierdo as an example of Surrealism. To these artists could be added many other painters with similar sensibilities who were not known to either Breton or Artaud; one such is Manuel González Serrano (1917–60; fig. 30). Other contemporary artists such as Enrique Guzmán (1952–86; fig. 31), Nahum B. Zenil (b. 1947; fig. 34), Julio Galán (b. 1959; fig. 32) and Rocío Maldonado (b. 1951) practise 'surreality' in exploring their own Mexican roots. As Edward J. Sullivan points out, they examine the contradictions implicit in the term *mexicanidad*

(Mexicanness) 'under the sceptical microscope of our time'.[10] Something similar has happened with the majority of those involved in the *Arte-objeto* (Art-object) movement, as well as with some of the contemporary installation artists. Some of the artists of the *Arte-objeto* movement create assemblages using diverse objects which, as in the case of the art of Joseph Cornell, are often presented in boxes. Others make volumetric pieces assembled from found objects. These works, which also recall theatrical scaffoldings, are not conceived by their artists as sculptures *per se*, so much as symbolic stage-settings. Installation has become a very popular art form in Mexico in the 1990s and a wide variety of types are practised. For example, Carlos Aguirre (b. 1948) is a neo-conceptual artist who avoids all forms of Baroque exaggeration. Eloy Tarciso (b. 1955), on the other hand, could be called a romantic installationist whose art refers to various moments in Mexican history, while Gabriel Orozco (b. 1962), also of the conceptual tendency, places emphasis not on the object or the scene itself but, rather, on the documentation referring to the process of installation. In Orozco's case, semantic articulation is the most important aspect.

Perhaps René Magritte is the European Surrealist who has had the greatest impact on those Mexican artists whose careers began in the early 1960s and who were not attracted by the concept of *mexicanidad*. There are hints of the Belgian artist's work in that of Gelsen Gas (b. 1933), Alfredo Castañeda (b. 1938; fig. 33) and Xavier Esqueda (b. 1943). Francisco Toledo (b. 1940; fig. 35), a native of Juchitán, Oaxaca, is a case apart. Since his first solo exhibitions in 1959 (in Mexico and the United States) he has attracted the attention of critics of all nationalities who

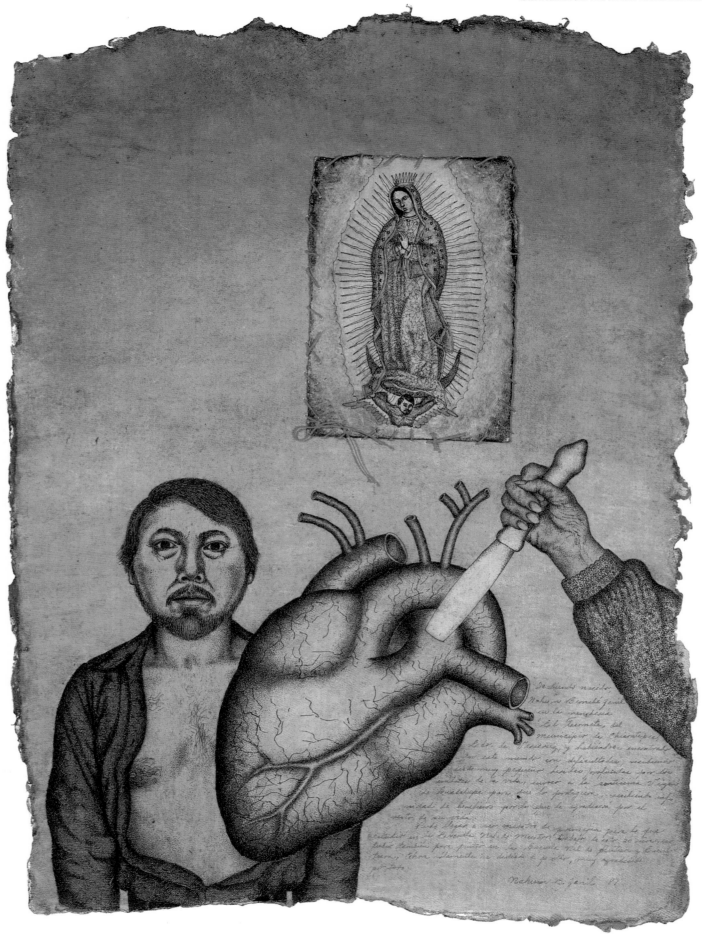

34. NAHUM B. ZENIL – EX VOTO, 1987.
mixed media on paper, 53.3 x 38 cm. private collection, New York

Mexico

35. Francisco Toledo – Tortuga (Turtle), 1963.
oil and sand on canvas, 94 x 74 cm. private collection

Mexico

36. MANUEL FELGUÉREZ – COATLICUE 3, 1994.
oil on canvas, 200 x 240 cm. collection of the artist

37. MATHIAS GOERITZ – EL ÍDOLO (THE IDOL), 1955.
wood with 42 nails, 62 x 21 x 24 cm. private collection

38. Juan Soriano – Apolo y las musas (Apollo and the Muses), 1954. tempera and oil on canvas, 119 x 205 cm. INBA, Museo de Arte Moderno, Mexico City

have come into contact with his work, not only because of his perfectionism in the many genres that he cultivates (painting, drawing, assemblage, ceramics, graphic art). Toledo's regionalism, combined with universalist connotations and the genial amalgamation of eroticism with his own personal system of myth and legend (all done in a strictly contemporary idiom), define him as the quintessential representative of Magic Realism. Having spent long periods in Paris and New York, Toledo now lives in Oaxaca where, against his will, he has acquired a large following of disciples who are themselves well accepted by the public at large and also by collectors. The most outstanding of the younger Oaxacan artists both for his originality and for his ability to go beyond the world of Toledo, is Sergio Hernández (b. 1959).

Currents of Renewal:
the 1950s and 1960s

Returning to the subject of the impact of artists living in exile in Mexico, it is important to mention that their influence was not felt immediately. The 1940s was a time of stagnation for Mexican art; those who held power in the art world did their utmost to retain their positions. In 1944 Siqueiros published a defence of Muralism in a magazine with a wide distribution, penning the now-famous phrase: '*No hay más ruta que la nuestra*' ('There is no other route but ours'). This text soon took on the status of a manifesto among Mexicans, who are as susceptible as Italians to the power of this form of pronouncement. To which route is Siqueiros referring? Naturally it is socially committed art. It was now that the subject of the 'officialization' (for better or for worse) of Mexican art began to be debated. The question continued to be analysed, especially

among young artists who saw everything with sceptical eyes, as was the case with Juan Soriano (b. 1920; fig. 38) who, during the 1940s, was considered an *enfant terrible*.

At the end of the decade the German artist Mathias Goeritz (1915–91; fig. 37) arrived in Mexico to teach visual education in the Faculty of Architecture at the University of Guadalajara. At the same time Henry Moore made his first trip to Mexico. It is well known that for many years Moore had been fascinated with pre-Hispanic sculpture and especially that of the reclining male Chac-Mool, the rain-god image from Mayan civilization. Goeritz supported the creation of the experimental Museo del Eco in Mexico City, whose life was brief but significant. At this time many other changes were brought about: new galleries opened, exhibitions came to Mexico from other countries, young artists talked less about politics and more about going to Europe to perfect their respective arts. More importantly, they travelled abroad to observe the latest developments. Even though Mexican artists benefited from the high quality of art education, especially in the realm of the traditional academic techniques, many felt cut off (as José Luis Cuevas admitted in a text published in 1958) not by an iron curtain but by one of cactus. They felt that they had to take control of what was called the 'marble bastion' (the Palacio de Bellas Artes in Mexico City, then the site of the most important art exhibitions) and open new exhibition spaces.[11]

Rufino Tamayo had returned to Mexico at the beginning of the 1950s to undertake two murals in the 'marble bastion' itself. He was firm in his resolve that the subjects of these works and the methods used in creating them should have nothing to do with the 'new democracy' (socialism), the breaking of the chains that had bound

Mexico

the people to slavery, or the rise of the bourgeoisie. It was then that the movement which has come to be known as the Ruptura (Rupture) was conceived. Despite its name, this was not intended to make a break with the previous era, some said, but was an attempt on the part of younger artists to express their individualities, their respective ways of assimilating international artistic vocabularies and their desire to offer an alternative to the Escuela Mexicana, the institutionalized form of art in Mexico.

There were others besides Tamayo who were involved in the poetic currents of contemporary art. Among them were Alfonso Michel, Cordelia Urueta (b. 1915) and such young artists as Vladimir Kibalchin Russakov, known as Vlady (b. Leningrad, 1920), Héctor Xavier (b. 1921), Alberto Gironella (1929–99) and Enrique Echeverría (1923–72). Along with the always precocious José Luis Cuevas, they met together at the Galería Prisse in Mexico City to discuss European art reviews and their own work.

The artists of the 1950s who set the wheels of change in motion were individualists whose sensibilities were far removed from mural painting or from the iconography of a classless society. The atmosphere in which they functioned was a fruitful one for the development of polemical discussions and for bringing about change.

It was as a response to their efforts that Manuel Felguérez (b. 1928; fig. 36) and Lilia Carrillo (1930–74; fig. 41) returned to this ambience from their respective study trips to Europe, declaring their fidelity to abstract art, and Vicente Rojo (b. 1933 in Spain; fig. 40) forsook the image at the beginning of the 1970s, beginning his serial compositions corresponding to specific cycles. Fernando García Ponce (1933–87;

39. FERNANDO GARCÍA PONCE – MANCHAS AZULES SOBRE OCRE Y GRIS (BLUE STAINS ON OCHRE AND GREY), *c.1985. collage, 126 x 157 cm. private collection*

40. Vicente Rojo – Estudio, México bajo la lluvia (homenaje a Orozco) (Study, Mexico in the Rain (homage to Orozco)), 1979–80. oil on canvas, 160 x 160 cm. Galería Juan Martín, Mexico City

41. Lilia Carrillo– Sin título (Untitled), 1961. oil and gouache on panel, 41 x 56 cm. private collection, Mexico City

Mexico

42. Brien Nissen – Volcán flotante (Floating Volcano), 1992.
mixed media on canvas, 142 x 148 cm. private collection

43. Gunther Gerzso – Naranja-azul-verde (Orange-Blue-
green), 1972. *oil on board, 50 x 56 cm. private collection, Mexico City*

44. Arnold Belkin – Serie Marat 2
(Marat Series 2), *1971. acrylic
on canvas, 178 x 140 cm. INBA, Museo
de Arte Moderno, Mexico City*

fig. 39) assimilated certain aspects of Abstract Expressionism as well as the matter painting then practised in Barcelona, linking these influences with his propensity for an architectural substructure in painting. In fact, Spanish masters such as Antoni Tàpies, Antonio Saura and Josep Guinovart, well known in Mexico, had numerous followers who continued to be influenced by their manner of abstraction well into the 1970s. Textile artists also felt the impact of these Spanish *Informalistas*, as was the case with Marta Palau (b. 1934).

Returning to the *Ruptura*, Enrique Echeverría, who was at the outset of his career a figurative painter (influenced by the semi-figuration of Nicolas de Staël and Jean Fautrier), turned to colour abstraction. In 1957, the Swiss painter Roger von Gunten (b. 1930) arrived in Mexico, followed by the British-born artist Brien Nissen (b. 1940; fig. 42), both of whom aligned themselves with the young artists of the *Ruptura* without abandoning their own non-traditional figuration. Gunther Gerzso (b. 1915; fig. 43), who had painted only occasionally and was mainly known for his work in the cinema (where he acted as artistic director on numerous films), decided to dedicate himself to full-time painting after a trip to Italy in 1953, developing an abstract style in which he has continued to evolve with some variations.

During the 'existential' years of the 1960s, the forms of expression in terms of painting as well as sculpture and the graphic arts in Mexico were as diverse as the individuals who practised them. The options included Neo-Expressionism, Post-Romanticism, lyrical abstraction, combine art, etc. Alberto Gironella was the creator of a sort of Pop Surrealism, while practitioners of magic, mythical or fetishistic

realism such as Emilio Ortiz (1936–86) and Francisco Toledo were also absorbed into the existing currents, even though they had spent much of that decade in Paris.

In the mid-1970s José Luis Cuevas, who has always been known for his extraordinary talent as a draughtsman and printmaker, vigorously championed abstract art. He was particularly vehement in his defence of abstraction when the merits of both Lilia Carrillo and Fernando García Ponce were questioned in 1965 after they had won prizes in the competition sponsored by the oil company Esso and held at the recently opened Museo de Arte Moderno in Mexico City.

The artists of the *Ruptura* opened doors to a multiplicity of aesthetic options which still exist as signposts for Mexican art. At the same time, however, there was an opposing current to which a number of artists adhered, styling themselves 'Neo-humanists'. The principal figure in this movement was the Canadian-born Arnold Belkin (1930–92; fig. 44) who, in his early years, studied at the experimental workshop of Siqueiros. Both Belkin, champion of Neo-figuration, and the *Ruptura* artist Felguérez launched a new mural movement, unsanctioned by officialdom, realizing numerous wall paintings in public spaces. Other figurative painters of the time, Francisco Corzas (1936–83) and Rafael Coronel (b. 1932; fig. 46), developed their art with vocabularies that had nothing to do with traditional Mexican forms and bore striking similarities to European forms of Neo-Romanticism.

The most outstanding public sculpture project was that set up in the outdoor Espacio Escultórico (Sculpture Space) in the University City, completed around 1979. This group project was undertaken in response to a competition held by the university. The artists involved

Mexico

included Mathias Goeritz, Helen Escobedo
(b. 1936), Manuel Felguérez, Hersúa (b. 1945;
fig. 45), Federico Silva (b. 1923) and Enrique
Carbajal, called Sebastián (b. 1947). The project
resembles a ring of battlements, like a cromlech,
which limits and preserves the natural land
formations and the exterior nature within its
circular structure. In the area of this 'ecological
ring' there are specific sculptures by each one
of the participants in the project. Thus this site
serves as both a natural preserve and a sculpture
park in which the works function in harmony
with the neighbouring architecture of the
University City.

Art in Mexico: the 1970s to the 1990s

The decade of the 1970s witnessed the
mellowing of this energetic generation of artists
who are still very important in the panorama
of contemporary art in Mexico. The careers of
numerous younger artists who would later attract
the attention of critics and show their work in
the most prestigious galleries were stimulated,
during the 1970s and 1980s, by the national
competitions held each year in Aguascalientes as
well as by other biennial exhibitions sponsored
by the Instituto Nacional de Bellas Artes. All
artistic trends were represented at these events.
The continuing strength of abstraction is
represented by the art of Irma Palacios (b. 1943;
fig. 47) and Francisco Castro Leñero (b. 1956;
fig. 48). Various approaches to realism and
hyper-realism form a rich panorama in Mexican
art, from the deeply introspective work of Arturo
Rivera (b. 1946; fig. 50) to the Postmodern illu-
sionism of Rafael Cauduro (b. 1950), to name but
a few of many examples.

One of the major factors in Mexican art
today concerns the rebirth of painting as a genre

45. HERSÚA (JOSÉ DE JESÚS HERNÁNDEZ SUÁREZ) – OVI,
*1986. iron, cement and copper plate, 340 x 370 x 980 cm.
INBA, Museo de Arte Moderno, Mexico City*

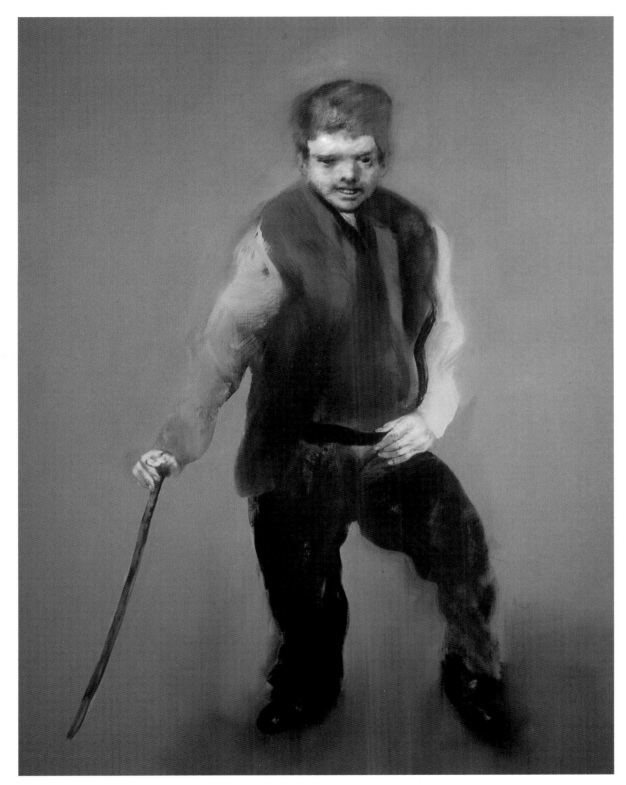

46. Rafael Coronel – Retrato de 'el compas' (Portrait of 'The Compass'), 1973. *acrylic on canvas, 200 x 150 cm. private collection*

47. Irma Palacios – Espejo de la tierra (Mirror of the Earth), 1992. *oil on canvas, 110 x 80 cm. private collection*

Mexico

48. FRANCISCO CASTRO LEÑERO – BLANCO Y NEGRO
(BLACK AND WHITE), *1992. acrylic on wood, 90 x 60 cm.*
private collection, Mexico City

49. ALBERTO CASTRO LEÑERO – EL HOMBRE DE KENIA
(THE MAN FROM KENYA), *1987, 1992. oil on canvas (diptych), 160*
x 220 cm. Embassy of the United States of America, Mexico City

50. Arturo Rivera – *Santiago, 1981.*
mixed media, wood and paper, 33 x 42.5 cm.
private collection, Mexico City

of the utmost significance, rich in symbols and nuances. The work of Alberto Castro Leñero (b. 1951) has served as a model for many younger artists (fig. 49). Without forsaking the figure or the primacy of formal values, the latter is able to create a language rich in symbols and metaphors, utilizing techniques that derive from Abstract Expressionism and incorporating found elements in his paintings.

The great impact of the earthquake in Mexico City on 19 September 1985 traumatized the capital. As a consequence, a multitude of artists matured and reaffirmed the importance in their art of what we might call an iconography of catastrophe.

Finally, the 'Post-modern condition' to which Jean-François Lyotard has referred,[12] proclaiming the end of history conceived as progress, has had an effect on an infinite number of artistic manifestations in the most recent generations, from the apocalyptic compositions of Germán Venegas (b. 1959; fig. 51) who practises a combination of painting and sculpture, to the archaic terracotta figures of Adolfo Riestra (1944–89) or the 'mannerisms' of the sculptor Javier Marín (b. 1962; fig. 52).

Although conceptualism was practised by artists working in collective groups to create examples of ephemeral art, especially in the 1970s, there is now a stronger desire among Mexican artists to seek the objectification of the concept. The physical realization of art has a higher priority than the mere expression of the desire to make it. This impulse has had the effect of a constant renewal, to which we have frequently alluded in this chronicle of the history of modern Mexican art. In 1993 the Dutch critic Willie van den Busshe noted, in an essay about contemporary Mexican art, that 'everyday reality

and the historical past are united in the conviction that mystery acts as a unifying element'.[13] To a perceptive foreign critic, it might seem as if Mexican artistic creativity were based upon a cult of the mysterious or the ineffable. Yet for the individual artists who make up the complex panorama of contemporary art, mystery becomes an everyday thing and thus loses its enigmatic quality. We can, however, speak of cults surrounding certain artists, such as that which grew up around Joseph Beuys, especially after his death in 1986. Reference should also be made to the subverted incorporation by artists of rites and myths, as well as the opposite tendency – the search for structure and the most rational modes of reason. But the fact remains that the best Mexican art today, like that of other periods, seeks sustenance above all from itself.

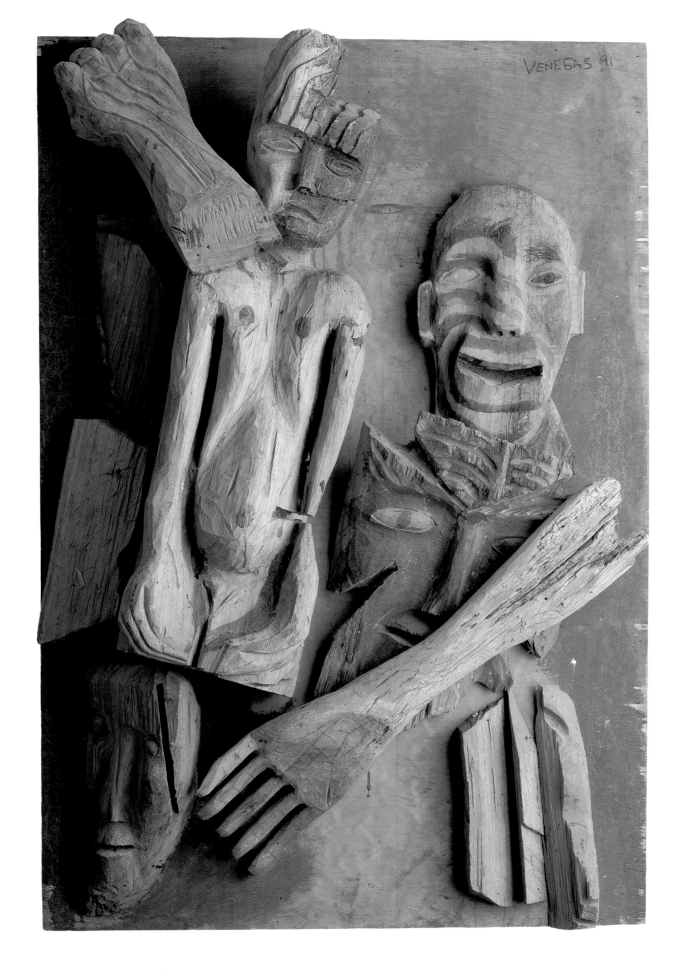

51. Germán Venegas – Color natural (Natural Colour),
1991. wood relief, 122 x 82 cm. collection of the artist

Mexico

52. Javier Marín – Este corazón no es mío (This Heart is not Mine), 1995. Clay from Oaxaca and Zacatecas, 150 x 80 x 40 cm. The Robert Gumbiner Foundation, Long Beach, California

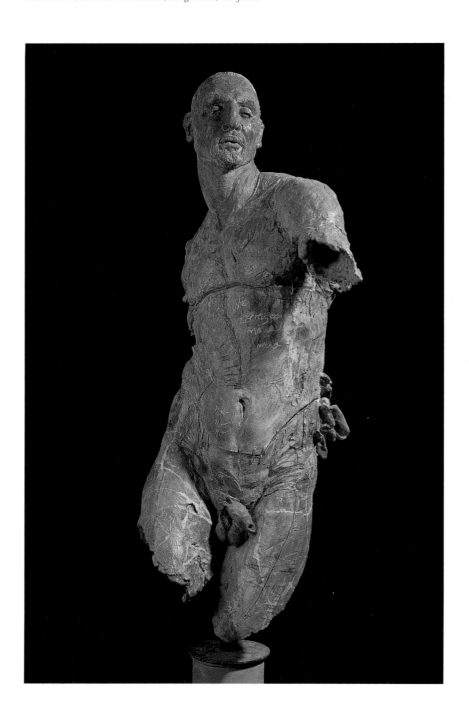

Central America

Latin American Art in the Twentieth Century

Monica E. Kupfer

Central America

The small nations of Central America – Guatemala, Honduras, El Salvador, Nicaragua, Costa Rica and Panama[1] – are among the most strife-ridden in the American continents. Their histories have been characterized by poverty and social injustice; dictatorships, political repression and civil wars; colonialism, foreign intervention and invasions. Although Central America is well-known for its political problems, there is a dearth of knowledge about the cultural developments of these countries. The lack of funds for culture, the inadequacy of the local art institutions, and the paucity of published information have all contributed to the fact that most discussions of modern Latin American art do not take into consideration the contemporary art being produced in Central America; it has only recently become the subject of serious research.

Central America is a region of great natural beauty, with long coastlines on the Atlantic and Pacific Oceans, tropical jungles, mountain ranges and volcanoes. It has a rich pre-Columbian heritage, from the Mayan monuments in Guatemala and Honduras to the petroglyphs of Nicaragua, and the extraordinary artifacts in clay, gold and jade from Costa Rica and Panama. The presence of native indigenous populations continues to be part of everyday reality, and although Indians often represent the poorest sector of society, their contribution to the cultural identity of these countries has been enormous, most noticeably in Guatemala.

Guatemala was a major centre of colonial art, as the magnificent architecture of the town of Antigua testifies. There were centres for making *imaginería*, carved religious figures, in both Guatemala and Honduras. The countries further south, particularly Costa Rica with its small Indian workforce, and Panama, which was

important to the Spaniards mainly as a point of transit and commercial centre, had only a limited production of colonial art and most of the religious sculptures found there were imported from other colonies.

Although geographically united to the rest of Central America, Panama has remained separate both historically and politically. During the colonial period, while the other countries formed part of the Captaincy General of Guatemala, Panama was linked to the South American colonies. This link continued even after independence from Spain in the 1820s when the five northernmost countries formed the Central American Confederation of Nations and Panama became part of Gran Colombia, from which it gained independence in 1903.

As in the rest of Latin America, during the 1800s there were numerous travelling artists in Central America, such as Frederick Catherwood, famous for his drawings of Mayan monuments. In the late nineteenth century, with the growth of agricultural exports, especially coffee, and the rise of the local land-owning bourgeoisie, a demand was created for portraits, landscapes and historical paintings. European artists were commissioned to decorate the new public buildings and record images of the rising heroes of these young republics. Since the élite interested in art sought to follow the fashions and refinements of Europe, Central America languished in a state of provincialism and the development of national artistic traditions was delayed well into the twentieth century. It was not until the 1920s and 1930s, with the return of a first generation of artists from studies in Europe, that art began to develop in Central America. However, in contrast to Mexico, Argentina and Brazil where artistic revolutions were taking

place at this time, the move in most of Central America was from nineteenth-century academic styles to regionalist themes inspired by Post-Impressionism. During the 1930s and 1940s, with the worldwide recession affecting the price of coffee and bananas, the Central American countries experienced a period of economic setbacks and social upheavals, which led some artists to turn to Mexican social realist art as a model and an inspiration. It was finally in the 1940s and 1950s that artists in Central America began to employ more contemporary 'languages' in their painting and sculpture. Exceptions were provided by a few progressive figures, notably Carlos Mérida, whose early work had already placed him among the great figures of Latin American art.

Unlike the fine arts, literature in Central America was closer to the forefront of cultural life. In 1888, the Nicaraguan poet and national hero, Rubén Darío, had published his book *Azul*, which proclaimed the rise of literary Modernism, Latin America's first modern artistic movement. Even a century later, Nicaragua is widely referred to as 'a nation of poets' and a number of its contemporary writers have achieved international reputations. Many of Central America's best writers have developed their careers in exile or had their works published abroad, among them the Salvadorean poet Roque Dalton and the Nobel prize-winning Guatemalan novelist Miguel Angel Asturias. Embracing issues of importance to Central Americans in his writing, Asturias denounced dictatorships in his novel *El Señor Presidente* (1946), and spoke from the perspective of the Mayan Indians in *Hombre de maíz* (1949).

Long dictatorships like those of Estrada Cabrera (1898–1920) and Jorge Ubico (1931–44)

in Guatemala, Tiburcio Carías in Honduras (1932–49), Hernández Martínez in El Salvador (1931–44), the Somoza family in Nicaragua (1937–79), and the military governments of Omar Torrijos and Manuel Antonio Noriega in Panama (1968–89) have deeply influenced cultural development in the region. Throughout this century, artists have been affected not only by political oppression, but also by the long and violent civil wars waged for over thirty years by the guerrilla insurgents in Guatemala, the Frente Martí Liberación Nacional in El Salvador, and the Sandinistas and later the Contras in Nicaragua.

Another significant prevailing circumstance in Central American history has been colonial domination, imposed successively by Spain, the United Kingdom and the United States. The interference of the United States in the affairs of Central America began as early as the 1820s with the announcement of the Monroe Doctrine. From the occupation of Nicaragua by US marines in 1912 to the invasion of Panama in 1989, US military presence has continued to be a part of the region's reality and 'a thorn in its side' for most of the twentieth century. At times, however, Central American artists have benefited from their relationship with the United States. As Marta Traba described in her *Arte de América latina*, the expansion and efflorescence which took place in Latin American art during the 1950s and 1960s received vital recognition and impulse through the numerous exhibitions held in the United States. This was particularly evident in the exhibitions organized by José Gómez Sicre as Director of Visual Arts at the Pan American Union (today the OAS) in Washington, DC, where he promoted the careers of some of the best Central American painters and sculptors active at the time.

As in the rest of Latin America, controversial juried exhibitions sponsored by the local subsidiaries of multinational corporations contributed to the emergence of contemporary art, although they clearly promoted art in line with the prevalent international abstract and semi-abstract tendencies rather than encouraging local artistic traditions. The Esso Company backed a Central American competition in 1964, and the Xerox Corporation organized one in Panama in 1969, which was extended to include the rest of the region in the 1970s. In later years, local companies or institutions took over the role of supporting these events by establishing yearly salons or national art biennials in most of the Central American countries. Additional opportunities for exhibiting art were offered by the commercial art galleries which began to flourish in the region's capitals from the start of the 1970s.

In spite of the increase in artistic activity, to this day, artists in Central America share a sense of isolation from the world art centres. They crave international exposure and a broader audience, particularly because the social structure in their native countries has tended to be of small educated élites and large underprivileged masses, providing limited cultural environments. It is not surprising, therefore, that the Central American artists with the greatest international reputations are those who, in self-imposed or obligatory exile, developed their careers abroad.

The cultural isolation and multiracial society of Central America have made it the breeding ground for a special kind of artist, affected as much by the native landscape, the rich Indian heritage, the social injustices and violent wars, as by contemporary international artistic trends and the art market. In spite of all the

difficulties, over the last few decades and into the 1990s, Central America's more notable artists have interpreted the region's harsh reality and bravely criticized it by employing realism, symbolism, fantasy and even humour in their works of art, both figurative and abstract. Although these six countries coincide in some of their social and historical circumstances, one cannot speak of a Central American art *per se*, but rather of parallel histories and of individuals who, often in the midst of political turmoil, have developed differently from artists in other places and must be recognized for their aesthetic, formal and philosophical contributions to twentieth-century art.

Guatemala

The site of spectacular Mayan ruins, splendid colonial churches and beautiful religious art, Guatemala has the richest artistic tradition in Central America. Today, in spite of thirty years of internal strife, Guatemala boasts a dynamic contemporary art scene, in addition to the exuberant folklore and varied cultural heritage kept alive by the country's large and long-suffering Indian population.

Artistic activity in Guatemala was relatively limited until the 1890s when the national government commissioned European sculptors to create monuments for the capital's avenues. The first art schools were established by two immigrants: the academic Spanish painter Justo de Gandarias and the Venezuelan sculptor Santiago González. Their students included Rafael Rodríguez Padilla (1890–1929), who founded Guatemala's official Academia Nacional de Bellas Artes in 1920 (later renamed Escuela Nacional de Artes Plásticas) where most of the country's modern artists began their careers.

Central America

53. RODOLFO ABULARACH – ORFEO (ORPHEUS),
1979. engraving, 10.1 x 12 cm.

54. EFRAÍN RECINOS – MÚSICA GRANDE (GRAND MUSIC), *1970. wood
sculpture, 2.4 x 4.5 x 1.5 m. Museo de Arte Moderno, Guatemala City*

The most significant intellectual stimulus at the beginning of the twentieth century was provided by the arrival of Jaime Sabartés, a friend of Picasso. Sabartés was responsible for introducing local artists to the exciting concepts of early modernism and encouraging their travels to Europe. Among them were two good friends: Carlos Mérida (1891–1984) and Carlos Valenti (1888–1912) who both left for Paris in 1910.

Valenti's promising career was cut short by early death, but Mérida became a major figure in Latin American art. With a highly personal visual language relating both to Surrealism and to geometric abstraction, Mérida interpreted themes and colours inspired by Mayan art and Guatemalan popular culture. Although he moved to Mexico in 1919 and lived there for the rest of his life, he never lost contact with Guatemala where he is considered the patriarch of modern art (fig. 56).

Merida's stylized intellectual compositions stood alone in Guatemalan art, where landscapes and genre paintings were favoured for most of the first half of this century, especially during the dictatorships of Manuel Estrada Cabrera (1898–1920) and Jorge Ubico (1931–44), neither of whom promoted internationalism or modernity. In styles ranging from realism to Post-Impressionism, artists such as Humberto Garavito (1897–1970), for many years the Director of the Escuela Nacional de Artes Plásticas, Antonio Tejeda Fonseca (1908–66), and Alfredo Gálvez Suárez (1899–1946) depicted the country's scenery and romanticized the lives of its Indians. The watercolourist Carmen de Pettersen (b. 1900) was another popular naturalist of this period.

A nationalist trend also developed in Guatemalan poetry and literature during the 1930s, following the publication of Miguel Angel Asturias's *Leyendas de Guatemala* in 1927. Moreover, international interest in the Mayan ruins of Tikal and the founding of the National Archaeological Museum stimulated a renewed interest in native cultures. Meanwhile, the important artists Rodolfo Galeotti Torres (b. 1912) and Rafael Yela Gunther created massive sculptures inspired by the forms of pre-Hispanic art, exerting a strong influence on younger Guatemalan artists, many of whom began to gather in artists' groups from 1935.

The nationalism of the 1930s set the stage for political changes culminating in the fall of Ubico and the Revolution of 1944 introducing a decade of democratic leadership under Juan José Arévalo and later Jacobo Arbenz. It was a period characterized by socialist reforms (including social security provision, land redistribution, and the formation of labour unions), greater freedom of expression, and government support for the arts.

The artists who were later known as the 'Generación del 40' received numerous grants for studies abroad and were responsible, upon their return, for breaking with the academic tradition in Guatemalan painting. The 'Generación del 40' included artists of different tendencies such as the Expressionistic sculptor Guillermo Grajeda Mena (b. 1918), as well as the semi-abstract Dagoberto Vásquez (b. 1922) and the social-realist painter Juan Antonio Franco (b. 1920), who studied in Chile and Mexico, respectively. A leading member of this generation was the talented Roberto González Goyri (b. 1924), who became one of Guatemala's most outstanding sculptors, the creator of strong figurative reliefs and free-standing pieces in stone or metal, such as his *Cabeza de lobo* (*Wolf's Head*)

of 1950. Later in his career, González Goyri left sculpture to concentrate mainly on painting in a semi-abstract style of intense colours for which he continued to be well known in the 1990s. González Goyri had spent his student years in New York with Roberto Ossaye (1927–54) whose outstanding drawings and paintings of that time were characterized by social content and Cubist influence. Arturo Martínez (1912–56), one of the few members of this generation who never ventured abroad, shared with the others an interest in themes drawn from local culture, which together with his ingenuous style influenced his famous student Elmar Rojas (b. 1939).

It was also during these years that Guatemala's naïve art began to flourish. Consisting mostly of compositions depicting Indian life and rural scenes, it developed mainly in the provincial towns of Comalapa and Santiago Atitlán. Andrés Curruchiche (b. 1891), Juan Sisay (b. 1921) and Santiago Tuc Tuc (b. 1920) are among its best exponents, although their work remains unknown outside the country.

Since the 1950s, emphasis in Guatemala has been placed – more than anywhere else in Central America – on the integration of the fine arts and architecture, a concept which undoubtedly echoes Mayan tradition. Mosaic, enamel and relief murals by Mérida, Grajeda Mena, Vásquez, and González Goyri form integral parts of the buildings in Guatemala City's Civic Centre, begun under the pro-US government installed after the infamous invasion of Guatemala in 1954. One of the greatest promoters of the integration of the arts has been Efraín Recinos (b. 1928) whose masterpiece is Guatemala City's National Theatre. He has also created relief murals and original sculptures like the monumental wooden *Música grande* (*Grand Music*)

Central America

of 1970 (fig. 54), which gives the simultaneous impression of soldiers in an armoured vehicle and musicians gathered around a marimba, the traditional Guatemalan musical instrument. Recinos's lyrical paintings combine symbols and imaginary characters in a style so charged with colours and forms that Recinos himself describes it as 'modern Baroque'.

During the 1950s and 1960s, artists in Guatemala, as elsewhere in Central America, enjoyed increased contact with international contemporary art and explored styles ranging from Neo-figuration, with the most adherents, to complete abstraction. Rodolfo Abularach (b. 1933), the remarkable draughtsman, painter and printmaker, became internationally famous for his thematic obsession with eyes, a subject through which he explored the effects of light and a sense of infinity. In his extraordinary prints, Abularach created eyes in countless variations with titles often related to literature or mythology, as in the 1979 engraving *Orfeo* (*Orpheus*; fig. 53). Later, in the 1980s, he turned to painting erupting volcanoes as symbols of nature and metaphors of human purgatory. Abularach and Rodolfo Mishaan (b. 1924), a painter of symbolic abstractions in flat, bright colours, both moved to the United States in the 1960s, when Guatemala's political difficulties were increasing. Others who developed their careers abroad were Rina Lazo (b. 1933) in Mexico, and César Izquierdo (b. 1937), who was to play a significant role as part of Nicaragua's Praxis group.

In 1969, social and political issues brought Elmar Rojas, Marco Augusto Quiroa (b. 1937) and Roberto Cabrera (b. 1937) together as the Grupo Vértebra, which announced its existence through an artistic manifesto. In dramatic figurative paintings of strong textures and coarse incisions, Rojas initiated the group's denunciation of the prevailing military despotism, ethnic oppression and political violence. The group was short-lived but significant, and its members have remained prominent figures in Guatemalan art.

Although Quiroa moved on from using metallic tones and left behind the social criticism of his earlier paintings, he continued to focus on the plight of Guatemalan Indians. The intellectual Cabrera (who later moved to Costa Rica) sought to express political concepts and existential anguish with a daring style, at times related to Expressionism, Informalism and Pop art. The dark, critical early works of Elmar Rojas gave way to increasingly poetic and technically refined paintings with an exquisite sense of colour. During the 1980s, he painted works conveying magical atmospheres, such as *Ultimos temas de los espantapájaros* (*Last Images of the Scarecrows*, 1985; fig. 57), which is peopled by scarecrows, fishermen, mythical 'fire-bulls' and other dream-like figures stemming from Guatemala's popular culture. These works have brought him international success and produced numerous imitators.

In total opposition to the Grupo Vértebra were the two experimental and mostly abstract artists, Luis Díaz (b. 1939) and Margot Fanjul (b. 1932). They shocked the public in the 1970s with their proposals for an art beyond the painted canvas. Díaz gained prominence with his early environmental installations and the political statements in works like the prize-winning polyptych *Guatebalas* (*Guatebullets*) of 1971. Even today, Díaz continues to employ industrial materials and pure design concepts in his two- and three-dimensional pieces. Fanjul began with hard-edge geometric abstractions of vibrant colours, later turning to three-dimensional art.

Using her real name Margarita Azurdia, she now pursues self-expression through dance, poetry and autobiographical drawings. Other artists who have been working since the 1970s are Manolo Gallardo (b. 1936), known for his hyper-real portraits of Maya-Quiche Indians, and Arnoldo Ramírez Amaya (b. 1944) whose excellent drawings often protest against social injustice.

In the 1970s and 1980s, the country experienced escalating military repression and violence, during which artistic activities received much censure and little support from the government. However, the cultural scene was enhanced during these years by the establishment of new art galleries. Gallery exhibitions gave exposure to the colourful paintings of Rolando Ixquiac Xicará (b. 1947) and Zipacná De León (b. 1948), as well as the stylized bronze pieces by Luis Carlos (b. 1952), one of the few Guatemalan artists working in sculpture. Also present in the contemporary art scene since the 1980s are the Expressionist, critical images of Eugenia Beltranena and the more lyrical, figurative paintings of Magda Eunice Sánchez (b. 1946).

In addition to exhibiting in galleries, from 1978 onwards, local painters began to take part in the influential, privately funded Paiz Biennials which encouraged the participation of artists from all over Guatemala. Noteworthy among the contributing artists from outside the capital is a group of young painters from the town of Quetzaltenango, including Rolando Aguilar (b. 1957) and Rolando Pisquiy (b. 1955), whose works are characterized by a common dream-like quality and varying forms of representation. Over the years, many of Guatemala's artists have gained initial prominence through these Paiz Biennials.

Elections held in 1985 and the subse-

55. Moisés Barrios – Antes de conocerte (Before Meeting You), 1994. oil on canvas, 110 x 150 cm. private collection

56. Carlos Mérida – detail of Sacerdotes danzantes mayas (Dancing Mayan Priests), 1968. mural, glass enamel on copper. Banco de Guatemala, Centro Cívico, Guatemala City

57. Elmar Rojas – Últimos temas de los espantapájaros (Last Images
of the Scarecrows), 1985. oil on canvas, 80 x 70 cm. private collection

Central America

quent transfer to civilian rule marked the beginning of another chapter in national history. In these more open times, the major figures in Guatemalan art share a commitment to making statements about the country's atrocious recent history and tenuous present peace. The Neo-Expressionist printmaker and painter Moisés Barrios (b. 1946) has created powerful woodcuts which make ironic commentaries on Guatemala's darker moments. *Antes de conocerte* (*Before Meeting You*, 1994; fig. 55) is one of Barrios's many paintings of common people focusing on the country's social realities and contradictions, and the legacy of violence. Pablo Swezey (b. 1959) is a sculptor, and Erwin Guillermo (b. 1951) is a painter and printmaker, who, while tending towards a Magic Realism, reveals in the subjects and symbols of his compositions a concern for Guatemala's plight.

Another critical view of society and history is apparent in the extraordinary photographs by Luis González Palma (b. 1957). His nostalgic, sepia-toned images bear witness to the power of religious imagery in Spanish America, and to the cultural identity and suffering of the indigenous population. Equally disturbing are the dense and anguished images of metamorphosed human bodies, beasts, and creatures in the paintings of Isabel Ruiz (b. 1946) which seem aimed at exorcizing some of the ghosts of past cruelty and violence.

As seen in the works of the newer generation of artists, as in those of the masters of this century, Guatemala's artistic tradition – as well as the powerful heritage, popular traditions and socio-political problems which have so often nurtured it – seems as vital as ever.

Honduras

Although Honduras was the site of the great Mayan city of Copán, and during the colonial period silver was mined and religious painting flourished, the continuous political upheavals and socio-economic problems suffered since independence in the 1820s have restricted its cultural growth. In this impoverished and isolated nation, modern art developed very slowly.

During the second half of the nineteenth century, travelling artists recorded the landscape and portrait painters worked in the service of the newly independent society. The first art school in Tegucigalpa was founded in 1890 by the immigrant European painter Tomás Mur, but was short-lived and did not produce artists of merit. Unfortunately, Honduras did not develop a broad local land-holding élite which could support and encourage the arts. The country's economy, based mostly on banana exports, became increasingly controlled by US companies whose domineering presence has lasted throughout the century.

The beginning of a national art movement took place in the 1920s with the return of several influential artists from their studies in European academies. Significant, in spite of their early deaths, were Pablo Zelaya Sierra (1896–1933) who introduced the lessons of Post-Impressionism, and Confucio Montes de Oca (1896–1925) known for his landscapes and realist images of workers such as the famous *El Forjador* (*The Blacksmith*, 1921; fig. 62). Max Eueda (1891–1987) and Carlos Zúñiga Figueroa (1884–1964) painted outstanding portraits of both society figures and street people, and dedicated many years to teaching. Among their students was Teresita Fortín (1885–1982),

Central America

one of the few women artists in Honduras. Active from the 1930s, Fortín painted genre scenes and vast landscapes in a highly personal naïve style. However, José Antonio Velásquez (1906–1983) is by far the most famous naïve painter in Honduras. A barber and self-taught artist, Velásquez concentrated throughout his career on creating detailed colourful scenes of rural life in his native village of San Antonio de Oriente. His disproportionate international fame came about through exhibitions in the United States which turned his peaceful images into symbols – however misleading – of Honduras (fig. 59).

It was during the 1940s that artists first sought a departure from tradition, partly as a consequence of the activities developed at Tegucigalpa's Escuela Nacional de Bellas Artes (ENBA), founded in 1940. Its main promoter was Arturo López Rodezno (1908–75) who had been educated in Havana and Paris. With most of the country's respected artists among its teachers and directors, the school became the breeding ground for successive generations. In contrast to the cultural standstill during the dictatorship of Tiburcio Carías (1932–1949), from 1950 many of the school's graduates received government stipends to continue their education abroad. They, in turn, were responsible for introducing contemporary trends to Honduras.

Curiously, one of the first to explore abstraction in Honduras was a self-taught painter who never left the country. During the 1940s, Ricardo Aguilar (1915–51) experimented with styles ranging from Expressionism to geometric abstraction. Others like Dante Lazzaroni, (b. 1929), Alvaro Canales (1919–83) and Miguel A. Ruíz Matute (b. 1928), studied in Mexico and were influenced by Muralism and social realism. Canales remained close to his sources, even

painting murals himself, and Lazzaroni developed an Expressionism of bright colours during a long teaching career. Over time, colour and dynamism came to match dramatic religious subject-matter in Ruíz Matute's compositions, like his series of Lazarus unwinding his shroud, and of Jesus carrying the cross, as in his *El contemplado* (*The Beheld One*, 1983; fig. 60).

Among the artists who came to the fore in the 1950s were Mario Castillo (b. 1932), Arturo Luna (1927–78), Moisés Becerra (b. 1929), and Benigno Gómez (b. 1934), all of whom studied in Italy and, upon returning to Honduras, became instructors at the Escuela de Bellas Artes. As a teacher and Director of the School, Castillo exerted a major influence with his early Impressionistic landscapes and later with his dynamic version of Cubism. He also developed into Tegucigalpa's pre-eminent portrait painter, a career he pursued for decades, while still creating other more personal compositions such as his sensitive image *Familia* (*Family*, 1994; fig. 61). Luna specialized in enamel work and ceramics, later founding a workshop for ceramicists. Becerra returned to Europe in the early 1960s, where he continues to paint along figurative lines, and Gómez developed an unusual style combining realism with colourful organic patterns in crowded compositions.

During the 1960s, a group of painters, mostly ENBA graduates, rebelled against the cultural establishment and promoted a more contemporary approach to art. In 1974, under the leadership of Virgilio Guardiola (b. 1947), about a dozen artists including César Rendón (b. 1941), Mario Mejía (b. 1946) and Dino Fanconi (b. 1950) formed the Taller La Merced, an association named after the colonial building in which they had studios. Socially and politically engaged,

their paintings denounced – in a style sometimes described as 'critical Expressionism' – the conflicts and the repression imposed by the military regimes of the 1960s and 1970s. Disbanded due to government pressure in 1976, they regrouped with new members as the Taller Dante Lazzaroni from 1982 to 1985. Individually, some of these artists continued to use art as a way of protesting against political atrocities and social injustices. This is particularly true of the striking and openly critical images by the Neo-Expressionist painter Ezequiel Padilla (b. 1944). Whereas paintings such as his *Marginalidad* (*Marginalization*, 1994; fig. 58) make reference to concepts, in this case Honduras's well-marked class divisions, other images illustrate specific situations in recent Honduran history.

Political statement and social commentary are also inherent in the careful drawing and expressive colour of Anibal Cruz (b. 1943), as well as in his titles which make reference to violence and corruption. Influenced by Cubism in their handling of space and the human figure, dramatic early works of Luis H. Padilla (b. 1947) have given way to milder, monochrome compositions dominated by the female figure. In Guardiola's paintings, simultaneous, superimposed images and hidden meanings have been a constant, although his style has become less aggressive over time.

While some artists have denounced the country's harsh realities, other contemporary Honduran painters have escaped to unreal, imaginary worlds. Julio Visquerra (b. 1943) and Gregorio Sabillón (b. 1945) both spent many years in Spain, where they developed precise, realistic styles for rendering unsettling, surreal images. Sabillón alters reality by repeating or separating the body parts of his figures for

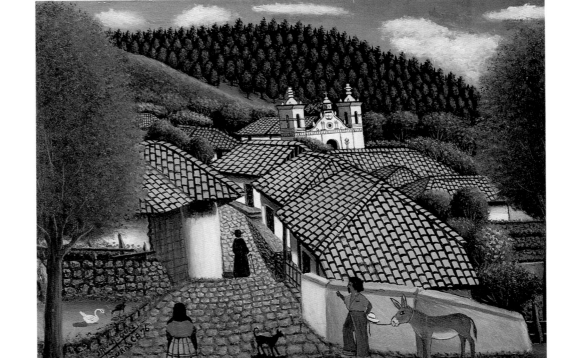

58. EZEQUIEL PADILLA – MARGINALIDAD
(MARGINALIZATION), 1994. *acrylic on canvas,
121 x 146 cm. private collection*

59. JOSÉ ANTONIO VELÁSQUEZ – PAISAJE (LANDSCAPE),
1976. oil on canvas,67 x 89 cm. private collection

60. MIGUEL ANGEL RUIZ MATUTE – EL CONTEMPLADO (THE
BEHELD ONE), *1983. oil on canvas, 80 x 118 cm. private collection*

Central America

symbolic effect. Visquerra paints fantastic creatures or models in elaborate costumes, often in armour, in mysterious paintings that parody Baroque portraits and ridicule the ostentatious life of high society. Images of fruit and animals are essential elements in Visquerra's iconography, apparent reminders of the cycle of life and death.

In a different kind of social satire, Felipe Burchard (b. 1946) creates dream-like and sometimes grotesque visions of humanity. Lutgardo Molina (b. 1948) also follows a Surrealist vein, often placing his figures or still lifes in vast empty landscapes, and Hermes Armijo Maltéz (b. 1951), who studied in Mexico, concentrates on Indigenist themes while continuously reducing his images to their essential lines.

Other painters active in the Honduran art scene during the last two decades include Juan Ramón Laínez (b.1939) and Rony Castillo (b. 1944) who have explored different trends, finally opting for a whimsical sort of figuration, even when dealing with serious subjects as in Castillo's paintings of elderly people. Maury Flores (b. 1950) has achieved commercial success with his stylized, colourful market scenes. Also popular among Hondurans is Carlos Garay (b. 1943) who paints local landscapes and genre scenes in rich colour and thick impasto.

During the late 1980s, in addition to the continued activity of most of the established older artists, the Magic Realist trend found a recruit in Armando Lara (b. 1959) who began with Surrealist paintings with references to the Mayan past, turning later to richer textures and colours, as well as symbolic content, in mysterious images often based on biomorphic shapes and human figures. There is also great promise in the vehement Neo-Expressionism and

large, daring paintings of Xenia Mejía (b. 1958), who embraces contemporary themes and social issues.

As in the past, sculpture continues to be practically non-existent with the exception of a few artists working with wood and clay, especially among the professors at ENBA which continues to be a focal point. Oscar Obed Valladares (1955–94) stands out from other artists for his exceptional sculptures: three-dimensional pieces in wood and terracotta, with social and ecological commentary at their heart.

Honduran artists have had limited opportunities to exhibit their work at home. There is an exhibition space in the Tegucigalpa's Honduran Institute of Interamerican Culture, which has organized national art salons since the 1960s. In more recent years, several professional art galleries have opened in Tegucigalpa. However, to this day, governmental support for the arts continues to be limited, and Honduras has yet to establish an art museum.

El Salvador

The smallest and most densely populated country in Central America, El Salvador has several archaeological sites as well as some religious sculpture which attest to its pre-Columbian and colonial past. In the nineteenth century, coffee exports enriched a local oligarchy – the famous 'fourteen families' – which looked to Europe for cultural direction. Typically, traditional portraits, religious images and genre paintings were favoured at the turn of the century.

The return of Pedro Angel Espinoza (1899–1939), Miguel Ortiz Villacorta (1887–1963) and Carlos Alberto Imery (1879–1949) from academic sojourns in Europe in the early twentieth century marked the real beginning of

Salvadorean art. Espinoza became a chronicler of the country's native people and countryside, rendered in his work with strong, thick strokes. Influenced by Impressionism, the well-travelled Ortiz Villacorta painted portraits and luminous landscapes. Most influenced by European art was Imery, who made his greatest contribution as the founder (and director from 1911 to 1949) of El Salvador's first art academy, the Escuela de Dibujo y Pintura, later renamed Escuela Nacional de Artes Gráficas.

In their romantic landscapes and genre scenes, many of Imery's students showed a preference for indigenous themes and a desire to express a sense of national identity through art. Luis Alfredo Cáceres (1908–52) was known for his paintings of Salvadorean mestizo types like the young students in his *Escuela bajo el amate* (*School under the Fig-Tree*) of 1939. After studying in Mexico during the heyday of Muralism, the multifaceted José Mejía Vides (1903–93) became a promoter of *plein-air* landscape painting in El Salvador. Other graduates of Imery's school who went on to study in Mexico were Mario Escobar (1915–1982), Camilo Minero (b. 1917) and Luis Angel Salinas (b. 1928).

The 1930s were dramatic years in El Salvador's history, remembered primarily for the peasant uprising of 1932 under the legendary Agustín Farabundo Martí. There were grave consequences when the military responded by executing the rebel leader and killing thirty thousand people in a massacre which became known as 'La Matanza'. Although there was violence in the countryside, it was not reflected in the work of the artists active in the capital city of San Salvador, where in 1935 the country's second major art school was founded by the much-admired Spanish painter Valero Lecha

62. Confucio Montes de Oca – El forjador (The Blacksmith),
1921. oil on canvas, 74 x 65 cm. private collection

61. Mario Castillo – Familia (Family), *1994.*
oil on canvas, 102 x 121 cm. private collection

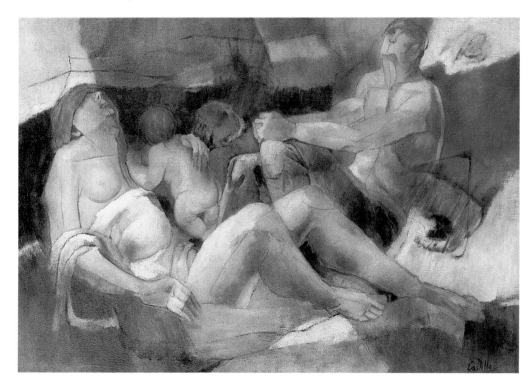

Central America

(1894–1976). For the next forty years, until the school closed in 1968, Lecha was responsible for training (with strict adherence to academic standards), many of the artists who would shape modern Salvadorean art.

Working independently, the influential writer Salarrué (Salvador Salazar Arrué, 1899–1975) became an active painter in the 1930s. Salarrué created a style combining black outlines, intense colours and vernacular subjects with fantasy (his books are considered part of literary Indigenism). A sense of mystery enveloped many of his later compositions. There were other notable artists in Salarrué's family: his wife Zelie Larde (1901–74) and his daughter Maya Salarrué (b. 1924) are among El Salvador's best naïve painters, and his cousin, the draughtsman and caricaturist Toño Salazar (1897–1985), developed a successful artistic career in Europe.

In spite of these exceptions, cultural isolation reigned and modernist trends were not introduced by Salvadorean artists until the late 1940s. In 1947, under the leadership of the painter Carlos Cañas (b. 1924), a group of students from Imery's school, including Camilo Minero and Mario Escobar, formed the Grupo de Pintores Independientes, an association committed to combining social causes with new aesthetic ideas. Their approach came into confrontation with the academic tradition followed at the time by Valero Lecha's students Julia Díaz (b. 1917), Raúl Elas Reyes (b. 1918), Noé Canjura (1924–70), and Mario Araujo Rajo (1919–70). Although they called themselves the *Académicos*, these graduates of Valero Lecha's school continued their studies abroad and, after absorbing the lessons of modernism, returned to introduce these new trends in the 1950s. The socially conscious Julia Díaz became an admired portrait artist and painter of maternity scenes and sensitive images of children. Noé Canjura and Elas Reyes studied in Mexico and later in Paris. Canjura remained in France for the rest of his life, developing an increasingly abstract style of luminous colours and diffused shapes, whereas Elas Reyes returned to El Salvador, where he concentrated on painting the local landscape.

The academic background provided by Valero Lecha did not limit the potential of another of his noteworthy students, the painter Rosa Mena Valenzuela (b. 1924), whose mystical figures, intense Expressionism and dynamic calligraphic strokes make her unique in Salvadorean art. Typically, Mena Valenzuela's *Retrato de Valero Lecha* (*Portrait of Valero Lecha*, 1970; fig. 64) combines a sense of the subject's character with the frenzied energy of her brushstrokes and an absolute freedom with colour.

At the other end of the spectrum are the almost monochrome paintings of Mauricio Aguilar (1919–78), an exceptional Salvadorean painter who spent most of his life in Paris and New York. Aguilar's works in mixed media consist mainly of neutral, roughly textured, repetitive images of simple objects such as bottles, glasses or fruit, reduced to their essential forms, which reflect his European experience.

During the 1960s, Salvadorean painters consciously sought an encounter with the international avant-garde. The Spanish-trained Carlos Cañas explored many styles and as an artist and a teacher became a pivotal figure in the move toward contemporary trends. The greatest promoter of modern art was Julia Díaz, who founded Galería Forma in 1958 as the country's first permanent exhibition space. Twenty-five years later it would become the Museo Forma, the only museum of twentieth-century painting and sculpture in the country.

There have been few sculptors in El Salvador. The traditional Spanish-trained Valentín Estrada (1902–86) was the only important sculptor active before 1960. Interest increased after 1963, when the Spaniard Benjamín Saúl (1924–80) established a school where numerous Salvadoreans were exposed to three-dimensional art for the first time. One of his students, Leonidas Ostorga (b. 1944) who established the country's only bronze foundry, is the most productive sculptor in El Salvador today.

Other students of Saúl were the versatile painter and writer Armando Solís (b. 1940), and more notably, Benjamín Cañas (1933–87), who was to become the country's most internationally acclaimed artist. Described by Marta Traba as the most important painter of the fantastic in Latin America, Cañas joined the Neo-figurative trend, after an initial phase of abstractions in mixed media on wood during the 1960s. With fine drawing, translucent oils and classical technique, he created a fascinating surreal world of distorted perspectives, and disquieting, often erotic characters, as in his *El perro verde* (*The Green Dog*, 1982; fig. 63). Cañas's paintings always depict human beings and often make reference to the artist and his model, as well as to historic, mythological or religious figures. Like Benjamín Cañas, who spent much of his life in the United States, his contemporary Ernesto San Avilés (b. 1932) pursued a career abroad. Working in Spain, San Avilés followed the realist tradition and developed a surreal quality of delicately painted images and mysterious settings. The draughtsman and printmaker Antonio García Ponce (b. 1938) began as an abstractionist and in the 1970s turned to creating images of distorted human beings in a style reminiscent

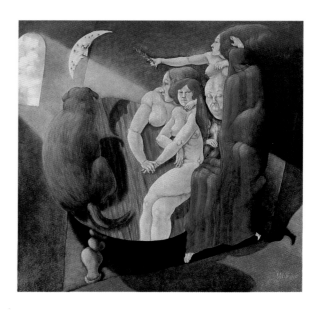

63. Benjamín Cañas – El perro verde
(The Green Dog), 1982. oil on wood,
122 x 122 cm. private collection

of the Mexican José Luis Cuevas.

In the 1970s, the poverty, landlessness, class divisions, military regimes, and political repression which characterized El Salvador reached a peak, triggering a period of civil unrest and later a violent civil war lasting for more than a decade. While the right-wing government with its death-squads battled against the armed insurrection of the guerrilla FMLN (Frente Martí de Liberación Nacional), many innocent people were killed and thousands of Salvadoreans fled the country. In spite of the violence during the 1970s and 1980s, construction boomed and art prospered in San Salvador. Ironically, among the rich, the war promoted a desire to safeguard their money and to invest in paintings, maybe as an escape into the imaginary world they represented. Galleries were founded, private art collections developed, and a large and diverse group of artists held exhibitions.

Roberto Galicia (b. 1945) first created compositions inspired by Mayan subjects, but became known for his series of white-on-white paintings of layered papers in dramatic chiaroscuro. Affected by the country's instability and suffering, in 1984 he painted *Bandera* (*Flag*; fig. 65), in which the Salvadorean flag appears twisted, almost tortured, and precariously held up by a thin knotted rope. His later, more brightly coloured works maintain a thematic connection with El Salvador's cultural roots and its volcanic landscape.

An artist of impeccable technique much influenced by his studies in Japan, Roberto Huezo (b. 1947) has pursued a variety of styles and recurrent themes. He first painted poor urban landscapes and later compositions of smooth, realistic eggs against textured backgrounds. However, Huezo is best known abroad for his hyper-real paintings of wrinkled cloth or paper, and of light-reflecting drops of water on smooth canvases.

Other artists have found their source of inspiration in El Salvador's landscape, traditions and society. This is the case with the naïve painters José Nery Alfaro (b. 1951), and Fernando Llort (b. 1949), known as the founder of a popular arts workshop in La Palma where artisans reproduce his folkloric designs. More serious interpretations of Salvadorean themes have been offered by Bernardo Crespín (b. 1949), whose expressive landscapes and genre scenes relate to Post-Impressionism, and his brother Augusto Crespín (b. 1956), who conveys social criticism in his ink drawings and paintings of ordinary people. Mauricio Mejía (b. 1956) is known for his portraits of gaunt Indian women. Negra Alvarez (b. 1948), who began with paintings of sad children and still lifes, has recently turned to working with the organic shapes found in wood to create her distinctive painted sculptures, usually of women carrying fruit.

Among contemporary painters, César Menéndez (b. 1954) stands out as the one with the most international exposure. His exceptional paintings depict a surreal world, reflecting personal experiences and a tortured preoccupation with death and tragedy. *La fiesta en el pozo* (*The Party at the Well*) of 1991 records the discovery of the dead bodies of rebels and peasants in a well in the Salvadorean countryside, the horrendous aftermath of a massacre by the ruling military power during the guerrilla struggle of the 1980s. Linked to Benjamín Cañas in his poetic use of colour and haunting vision of humanity, Menéndez's subjects often convey political and social meaning, as in his paintings of military helicopters, circus life, and El Salvador's

Central America

crowded buses and abandoned trains.

Even more aggressive are the crude paintings of Antonio Bonilla (b. 1954), who satirizes the sordid social, political and military circumstances of life in El Salvador through grotesque figures. In a style related to popular traditions and to the work of artists like Max Beckmann and James Ensor, Bonilla's garish colours and bizarre images of animals and human beings present an ironic view of life, a disturbing black humour reflecting and criticizing the sad realities of his country.

El Salvador finally began negotiations for peace in the early 1990s. In spite of the country's devastating experience, the younger Salvadorean artists who began to exhibit during the 1980s did not paint the horrors of the war. On the contrary, most of them have followed the path of more personal, poetic forms of expression. Among the most promising are Luis Lazo Chaparro (b. 1960), a painter of semi-abstract forms and diffused colours; Rodolfo Molina (b. 1959) whose apparently peaceful landscapes contain ambiguous juxtapositions which bring them close to Surrealism; and Mauricio Linares (b. 1966) who has focused on the concept of space, first in stark interiors and, more recently, in large, cosmic landscapes. These talented painters present new imagined worlds which, like much of the art of this century, offer respite from the political strife which has so often characterized life in El Salvador.

Nicaragua

During the nineteenth and the early twentieth century, art in Nicaragua was limited to traditional academic painting, exemplified by the portraits and atmospheric landscapes of Juan Bautista Cuadra (1877–1952) and the very European-looking still lifes of Alejandro Alonso Rochi (1898–1973). Although a literary avant-garde had developed in the city of Granada by the 1930s, only rarely did visual artists explore modernist trends. Within the provincial artistic environment of the 1940s, the intellectual gatherings promoted by the art collector Enrique Fernández Morales (1918–82) helped to prepare the ground for modern art in Nicaragua.

The kind of artistic renewal which most Latin American countries experienced in the 1920s did not take place in Nicaragua until much later, owing to the political instability which characterized the first half of this century. The overthrow of the dictator José Santos Zelaya in 1909 and a military intervention by the United States in 1912 marked the beginning of an occupation by US Marines which lasted for two decades. In addition to the continued fighting between Liberals and Conservatives from 1928 to 1933, Nicaragua experienced a guerrilla struggle led by the legendary Augusto César Sandino against US domination. In the 1930s, Anastasio Somoza rose to power, beginning the Somoza family's dictatorial rule of Nicaragua which lasted until the late 1970s.

Modern art in Nicaragua began in 1948 with the return from Europe of Rodrigo Peñalba (1908–1979) who, as Director of the Escuela Nacional de Bellas Artes, was responsible for training several generations of artists, promoting in them the freedom to experiment with content and technique. Peñalba's own expressive style, in addition to his ideas about the subjective interpretation of landscape and the expression of cultural identity through painting, were to change the course of Nicaraguan art. A fellow teacher at the school was the much-admired painter of naturalistic landscapes, Fernando Saravia (b. 1922). Still active today, Saravia also became one of the country's best sculptors.

Among Peñalba's students was Armando Morales (b. 1927) who is Nicaragua's most acclaimed artist although he has lived abroad since the 1960s. After powerful early abstractions of neutral colours, Morales turned to painting still lifes and the human figure, mostly sensuous female nudes, set in metaphysical spaces or in dusty grey landscapes reminiscent of his native Granada on Lake Nicaragua, as exemplified by the *Hombre y mujer* (*Man and Woman*) paintings of the early 1980s (fig. 68). Over time, Morales enriched his palette and broadened his themes to include figures and events from Nicaraguan history, as in his series on the famous Sandino, and more recently, his large canvases of dark tropical jungles. Throughout his career, Morales has maintained a technical mastery and an ability to balance figuration and abstraction and these, along with the beautiful, mysterious nature of his compositions, have brought him well-deserved international recognition and numerous followers.

Around 1963, another outstanding artist, Alejandro Aróstegui (b. 1935), together with the painter César Izquierdo (b. 1937, Guatemala) and the writer Amaru Barahona, founded a movement called Praxis. The group of artists who gathered under this name – as well as its homonymous gallery and publications – proved pivotal to the art of this century in Nicaragua. The Praxis artists rebelled against the political and cultural status quo, particularly the social injustices caused by the Somoza regime, and also against the traditional attitudes which still dominated the art scene. They promoted an art which fused contemporary international trends with an awareness of the Nicaraguan reality. In a

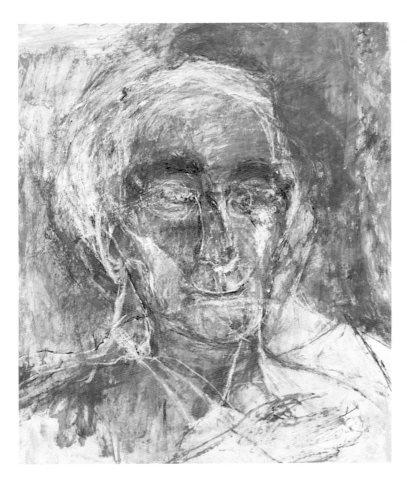

64. Rosa Mena Valenzuela – Retrato de Valero Lecha
(Portrait of Valero Lecha), 1970. *mixed media on paper,
65 x 52 cm. Museo Forma, San Salvador*

65. Roberto Galicia – Bandera (Flag), 1984.
oil on canvas, 120 x 120 cm. private collection

Central America

66. ALEJANDRO ARÓSTEGUI – PLANO GRIS CON
TRES OBJETOS (GREY PLANE WITH THREE OBJECTS),
*1987. oil and mixed media on canvas, 123.5 x 98 cm.
Museo de Arte Contemporáneo, Panama City*

style reminiscent of Dubuffet and Spanish Informalism, they painted abstractions, still lifes and landscapes with references to Nicaragua's pre-Hispanic heritage. They also created thick gestural collages with earthy colours and unusual materials like sand, glass, burlap, mechanical parts and rubbish. The members of this group represented the best of Nicaraguan art in subsequent decades.

The leading figure, Alejandro Aróstegui, has achieved international fame with the refined compositions, steely colours and sandy textures of his paintings. His monolithic images, landscapes with the silhouetted volcanoes of Lake Managua, and almost abstract still lifes such as *Plano gris con tres objetos* (*Grey Plane with Three Objects*; fig. 66) are unique both in style and because he incorporates found objects, predominantly flattened cans or scraps of metal. These are poetic visions criticizing the ills of consumerism and the lack of ecological concern.

The Praxis painter and sculptor Orlando Sobalvarro (b. 1943) is noteworthy for his subtle use of colour and for the symbolic power of his organic abstractions, in which he interprets nature and Nicaraguan myths and traditions. The moons and bones in his *Cegua de Peñas Blancas, Santo Domingo de Chontales* (1984; fig. 70) evoke the 'cegua', a popular mythical character believed to haunt lonely roads after dark. The extraordinary draughtsman, Leoncio Sáenz (b. 1936) employed dynamic design, bright colours and flat figures in his visions of local folklore. Arnoldo Guillén (b. 1941) followed the Praxis vein in his landscapes, but after the Sandinista victory in 1979 turned to expressing his convictions through political images. These gave way to a more subdued nationalism in his later paintings

of Nicaragua's volcanoes such as *Coloso VIII* (*Colossus VIII*, 1993; fig. 67).

For other artists in the Praxis group, texture became the main element of self-expression. The thick incisions of César Izquierdo's paintings and the large dramatic planes of blacks, browns and whites in the works by Leonel Vanegas (b. 1942) are typical. On the other hand, Luis Urbina (b. 1937) and Genaro Lugo (b. 1933) pursued an increasingly stylized and often lyrical figuration. The last to join the group was Roger Pérez de la Rocha (b. 1949) who did not share the typical 'earthy' quality of other Praxis painters, but whose Expressionist style and social conscience make him one of the country's most interesting artists.

In 1972, Nicaragua was rocked by a devastating earthquake which marked a turning point in the country's history. Perhaps as a creative response to the catastrophe, several Praxis artists turned to the pre-Columbian roots of Nicaragua's mestizo culture. Inspired by ancient petroglyphs, they created paintings and murals with incised anthropomorphic and zoomorphic signs and spirals reminiscent of the stylized geometry and mythical discourse of pre-Hispanic iconography.

On the political front, Somoza's misuse of the international aid which came into Nicaragua after the earthquake served to increase the already widespread opposition to his government, and the following years brought increasing violence. Despite this, the 1970s were characterized by fertile artistic activity, the growth of an internal art market, and the establishment of art galleries. The most influential was the Tagüe Gallery under the visionary direction of Mercedes Gordillo.

Among the works by new artists who

67. ARNOLDO GUILLÉN – COLOSO VIII (COLOSSUS VIII), *1993. acrylic on canvas, 106 x 160 cm. Empresa Nicaragüense de Electricidad, Managua*

began to exhibit in the 1970s, the ink drawings of houses and rooftops, and characters from local folklore drawn by Carlos Montenegro (b. 1942) stand out as examples of thoroughly Nicaraguan subjects. The work of the well-established art professor Julio Vallejo (b. 1942), is characterized by a stylized figuration, as seen in his paintings of monumental fruit and full-figured mestizo women. The paintings of metal scraps, ceramic vessels and giant flowers by Ilse Manzanares (b. 1941), Claudia Lacayo (b. 1938) and Rosario Chamorro (b. 1949) represent post-Praxis inroads towards abstraction.

Partly due to the country's difficult political situation, some well-known Nicaraguan artists developed their careers abroad. Bernard Dreyfus (b. 1940), who later moved to France, made an early name for himself in Nicaragua with his innovative 'Volume Paintings' – large lacquered cubes combining Minimalism and gestural painting. Omar De León (b. 1929) started as an Expressionist in Nicaragua but moved to the United States where he adopted a more stylized language, apparent in his render-ings of sensuous tropical fruit. Hugo Palma's (b. 1942) classical approach to human and animal forms stems from a long time spent in Italy. Alberto Ycaza (b. 1945), who resides in Costa Rica, has become successful with his highly ornate, neo-Baroque images based on esoteric and historical subjects.

The numerous killings and injustices of the 1970s led to even greater violence and culminated in the general revolt of the Frente Sandinista de Liberación Nacional against the Somoza government. The victory of the Sandinista Revolution in 1979, and its period in government until 1990, brought many changes to Nicaragua, including great strides forward in

the cultural sphere. Almost immediately, the new government created the Ministry of Culture and the Sandinista Association of Cultural Workers (ASTC) through which more exhibitions of Nicaraguan art were sent abroad than ever before. No particular style was imposed on the artists, but in keeping with the socialist ideal of an art for and by the people, the popular arts, Muralism and naïve painting received almost excessive support during those years.

Although Muralism had only few prece-dents in Nicaraguan art, this public art form was enthusiastically promoted during the 1980s with Mexican Muralism providing the closest model. A school was established and murals were produced by international volunteers, by Nicaraguan easel painters such as Leonel Cerrato (b. 1946) and Alejandro Canales (1945–90), and by naïve artists organized into 'painting brigades'. Unfortunately, many of these murals were obliterated by order of the new government after the Sandinistas' electoral defeat in 1990. Naïve painting – called 'primitivist' in Nicaragua – has boomed there more than in any other Central American country. Its initiator, the famous Asilia Guillén (1887–1969) began to paint in the 1950s by transferring her embroi-dered images to canvas. As depicted in her *Autorretrato de le artista pintando* (*Self-Portrait of the Artist Painting*, 1954; fig. 69), Guillén was a painter of the simple, rural life and natural land-scape of Nicaragua. She achieved an interna-tional reputation through her exhibitions abroad, most notably one at the Pan American Union in 1962.

Primitivist art had another major stimu-lus from 1966, when the poet-priest and sculptor Ernesto Cardenal (b. 1925) began to promote painting among peasants and farmers in the

Archipelago of Solentiname, where he had estab-lished an artistic and religious retreat. With Cardenal's appointment as Minister of Culture in 1979, the painting of Solentiname developed into an unprecedented artistic movement with national and international exhibitions. This brought success to many artists, including Eduardo Arana (b. 1940), Alejandro Guevara (1949–93), Marina Ortega (b. 1950), Yelba Ubau (b. 1959), and Marina Silva (b. 1961).

The number of naïve painters in other regions of Nicaragua also increased. For example, the images of June Beer (1935–86) reflected the Afro-Caribbean culture of the Atlantic coast, and Julie Aguirre (b. 1954) and Thelma Gómez (b. 1950) became 'urban primi-tivists' working in Managua and Masaya. In addi-tion, a new trend of sophisticated innocence was pursued by two self-taught Nicaraguan artists living in Costa Rica: Johnny Villares (b. 1948) and Celia Lacayo (b. 1945), who often depict the lifestyles of the bourgeoisie with careful detail and humour.

In spite of the country's economic hard-ships, the art community and its international exposure developed at an accelerated pace during the years of the Sandinista government. Exploring contemporary styles, some artists remained faithful to the ideals of the Praxis generation, while others went beyond its influ-ence. For example, the Praxis legacy permeates the abstract interpretations of metal fences and other scraps of city life by Rafael Castellón (b. 1956), whereas the scenes of marginal sectors of urban society by Pablo Beteta (b. 1957), partic-ularly the tin shacks around Managua, combine social statement with hyper-realism.

There is an active exploration of women's issues and of the line between realism and

Central America

fantasy in the (sometimes haunting) paintings by María Gallo (b. 1954) and Patricia Belli (b. 1964). A stark existential statement is prevalent in the bold signs which dominate the paintings and prints of María José Zamora (b. 1962). David Ocón (b. 1949) recently turned away from his nostalgic early still lifes to paint mockingly bright and colourful versions of the dramatic religious images which are so prevalent in Latin America. The Expressionist paintings and intentionally primitive sculptures of Aparicio Arthola (b. 1951) reveal a saddened and critical view of humanity, while the assemblages of Raúl Quintanilla (b. 1954) challenge Nicaragua's history and the issue of cultural identity from the perspective of the 1990s.

By contrast, Denis Núñez (b. 1954) paints animated all-over compositions with sandy textures and incised calligraphic, often biomorphic, signs and images. Equally promising are large, poetic abstractions by the newcomer Bayardo Blandino (b. 1969). These two young artists, together with the older 'maestros' who have continued their artistic evolution tenaciously, constitute today's surprisingly active, albeit isolated, Nicaraguan art world.

Costa Rica

Except for a few isolated portrait painters and sculptors, Costa Rican art did not come into its own until the end of the nineteenth century, when a social class made affluent through the exportation of coffee, and stimulated by its increased contact with Europe, developed an interest in culture. During the 1890s, paintings, busts, public monuments, and buildings were commissioned from European artists and architects, and the nation's first art academy, the Escuela de Bellas Artes, was established in

San José in 1897 under the direction of the Spanish neo-classical painter Tomás Povedano (1857–1943). At the turn of the century, the most respected artists in Costa Rica were figures such as Enrique Echandi (1866–1959), whose austere realist paintings reflected his German academic background; the Italian-trained sculptor Juan Ramón Bonilla (1882–1944), commissioned to make numerous commemorative bronze busts; and the German painter and botanist Emilio Span (1869–1944) who concentrated on landscapes and meticulous studies of orchids. Their work, and that of other painters and sculptors active in Costa Rica during the first three decades of the twentieth century, continued to follow nineteenth-century trends.

The dominance of academic tradition was finally broken in the late 1920s by the artists of the so-called 'nationalist generation', which was led by the much-admired Teodorico Quirós (1897–1975), and included the portrait painter Gonzalo Morales Alvarado (1905–86) and the landscapists Fausto Pacheco (1899–1966), Manuel de la Cruz González (1909–86), and Francisco Amighetti (b. 1907). These regionalist painters assimilated the stylistic advances from Europe, the United States and Mexico, and in the following decades applied them to their depictions, even idealizations, of the local peasant and of the tranquillity of rural life as symbols of Costa Rica's national identity. In a luminous style influenced by Post-Impressionism, they painted Costa Rica's landscape and its characteristic adobe houses, such as those in Quirós's *Caserío* (*Village*, 1946; fig. 72), establishing a trend which the critic Carlos F. Echeverría has so accurately described as 'Creole Impressionism'.

Costa Rica developed a much stronger tradition in sculpture than any other of the

Central American countries. In the 1930s and 1940s, sculptors such as Juan Rafael Chacón (1894–1982), Nestor Zeledón Varela (b. 1903), and more successfully, Juan Manuel Sánchez (b. 1907) as well as Francisco Zúñiga (b. 1912) expressed their sense of cultural identity by reinterpreting the aesthetics of pre-Hispanic art in modern sculptures. Carving wood and stone, they created strong and often Expressionistic renderings of Costa Rica's rich fauna, as well as of religious and social themes. Sánchez is admired in Costa Rica for the power of his carving, apparent even in small, intimate pieces like his *Los amantes* (*The Lovers*, 1934; fig. 71). However, the most famous of these sculptors is undoubtedly Zúñiga, who in 1936 moved permanently to Mexico and became known for his popular drawings and sculptures of Mayan Indian women as symbols of mestizo beauty and fertility.

More attached to his native Costa Rica is the great artist Francisco Amighetti, who was active as a teacher for many years, and has continuously explored the subject of common people in everyday activities in his drawings, paintings and prints. A self-taught artist, Amighetti absorbed and reinterpreted the lessons of German Expressionism, Mexican art, and Japanese prints, to become one of the outstanding printmakers in Latin America. Amighetti's compositions reflect a concern with social issues, the desire to achieve a psychological understanding of his models, and a synthetic, dramatic style which is most evident in his extraordinary colour xylographs, such as *Toro y gente* (*Bull and People*, 1969; fig. 73), one of many produced during a career that has spanned six decades.

Although the positive outlook of regionalism characterized most of Costa Rican art from the late 1920s to the 1950s, the economic reces-

68. Armando Morales – Hombre y mujer III (Man and
Woman III), 1981. oil on canvas, 127 x 101.5 cm. private collection

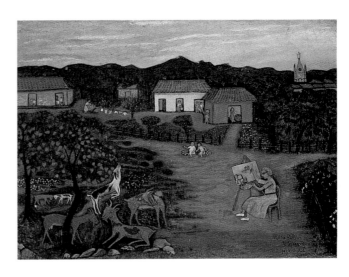

69. Asilia Guillén – Autorretrato de la artista
pintando (Self-Portrait of the Artist Painting),
1954. oil on canvas, 35 x 45 cm. private collection

70. Alejandro Sobalvarro – Cegua de Peñas Blancas,
Santo Domingo de Chontales, ('Cegua' from Peñas
Blancas, Santo Domingo de Chontales), 1984.
oil on canvas, 165 x 65 cm. private collection

Central America

71. JUAN MANUEL SÁNCHEZ – LOS AMANTES
(THE LOVERS), *1934. carved wood, 86 x 16 x 14 cm.
Museo de Arte Costarricense, San José*

sion of the 1930s with its labour strikes and social problems had an impact on the arts, which began to show the influence of Mexican social realism. In addition, the successful annual national Salons spearheaded by Teodorico Quirós and sponsored by the newspaper *Diario de Costa Rica*, which had done much to activate the local art scene since 1928, came to an end in 1937. With the election of President Rafael Calderón Guardia in 1940, a process of social change began and reforms were introduced to allow workers' unions, minimum wages and a social security system. Always socially committed, Amighetti painted several murals for public buildings at this time, including one in collaboration with Margarita Bertheau (1913–75), a legendary painter and teacher, credited with raising watercolour painting to the prestigious position which it still holds within Costa Rican art.

Another artist active in the 1940s was Luisa González de Sáenz (1899–1986), who began as a painter of rural landscapes but later in her career turned to anguished and symbolic compositions rendered in a romantic, Surrealist style. Within the relatively inactive artistic environment of the 1940s, two exhibitions stand out: one by Margarita Bertheau in 1947 and one by the well-travelled poet, painter and sculptor Max Jiménez (1900–47), considered Costa Rica's first avant-garde artist. His gargantuan feminine figures, often based on the Afro-Caribbean racial type, caused a scandal when they were first exhibited in 1946 at the University of Costa Rica in San José.

The late 1940s brought major political changes to Costa Rica, where in 1948 an armed civil conflict introduced the government of José Figueres and with it a new constitution and the abolition of the army, along with other reforms.

72. Teodorico Quirós – Caserío (Village), 1946.
oil on canvas, 82.5 x 92.5 cm. private collection

Although the 1950s were years of economic growth and modernization for the country, there were no major innovations in the arts until 1958, when Lola Fernández (b. 1926), Rafael Angel (Felo) García (b. 1928) and Manuel de la Cruz González, all three of whom had just returned to Costa Rica from living abroad, held exhibitions of abstract painting at the Museo Nacional in San José. It was in these three one-man shows that local audiences were first exposed to abstract art.

The oldest and most intellectual of these painters was González, who had been active as a landscape painter since the 1930s and had gone into exile in 1948, first to Cuba and later to Venezuela. Influenced by the Cuban Wifredo Lam and the Venezuelan abstract avant-garde of the 1950s, González's *œuvre* developed slowly through an Expressionist phase towards pure geometric abstraction. His lacquered hard-edge and highly simplified compositions like *Amarillo contínuo* (*Continuous Yellow*, 1971; fig. 75) constitute highlights in the history of Costa Rican art.

The paintings of Lola Fernández and Felo García followed a more lyrical vein, and fluctuated between figuration and abstraction during the 1960s. Together with Manuel de la Cruz González and other artists such as César Valverde (b. 1928), Guillermo Jiménez (b. 1922) and Nestor Zeledón Guzmán (b. 1933), they belonged to the Grupo Ocho, which was established in 1961 through García's initiative. The Grupo Ocho was significant for helping to break the entrenched regionalist tradition by introducing the formal languages of post-war contemporary art. Unfortunately, the international styles they followed were foreign to the social and cultural reality of Costa Rica and only a few of its members continued to produce interesting works.

The Latin American Neo-figurative tendency of the 1960s also had its exponents in Costa Rica. Rafa Fernández (b. 1935), who enjoys great success today, began with tragic figures in his paintings which later became increasingly colourful depictions of ethereal feminine figures. The strong drawings of grotesque humanoid characters by Carlos Poveda (b. 1940), which were exhibited at the Pan American Union in Washington, DC, as early as 1964, brought him immediate international recognition. He was to develop the rest of his career in Venezuela, where the aggressiveness of those early works gave way to much subtler images of skies and landscapes. Most remarkable are the daring Informalist compositions and conceptual installations of Juan Luis Rodríguez (b. 1934), created while the artist was living in Paris in the 1960s. Although he abandoned these experiments upon his return home in 1971, he played a major role in establishing an influential graphic arts workshop at the University of Costa Rica.

The foreign investment and economic development programme which characterized Costa Rica during the 1970s brought with it a surge of cultural activity and governmental support for the arts. The Ministry of Culture, Youth and Sports was created, annual national Salons were initiated, and the important (and controversial) First Bienal Centroamericana de Pintura was held in San José in 1971. The Museum of Costa Rican Art was founded in 1978 and, a year later, the Lachner & Saenz Corporation began its programme of art collection, soon followed by the influential Lachner & Saenz Bienals for contemporary artists.

During the 1970s and early 1980s, figurative trends dominated Costa Rican art, where some of the Grupo Ocho artists continued

to be active, while new artists appeared on the scene. The detailed paintings of Spanish-trained hyper-realist Gonzalo Morales received immediate acceptance in Costa Rica, and Rolando Cubero (b. 1957) became known for the realistic nudes in his surreal paintings. However, there was greater innovation in the paintings of Gerardo González (b. 1947), and a challenging view of humanity in the dramatic work of both Fernando Carballo (b. 1941) and Fernando Castro (b. 1955), whose anguished figures and expressive styles link them to the Neo-figurative artists active in Guatemala. Also related to Guatemalan art is Rodolfo Stanley (b. 1950) whose Magic Realist paintings reflect his admiration for Elmar Rojas (see p. 56 above).

Working mainly in wood and stone, sculptors have focused mostly on the human figure – often producing works with social overtones or an earthy quality – and on a variety of stylized animals, as seen in the work of José Sancho (b. 1935), for example. Aquiles Jiménez (b. 1954), a creator of deconstructivist pieces in marble, has developed his career in Carrara, Italy. Equally noteworthy is the work of Marisel Jiménez (b. 1947) whose wood carvings and installations are autobiographical in character.

In 1987, in a move unusual among contemporary artists in Central America, several Costa Rican painters gathered to form the Bocaracá Group with the purpose of exhibiting together, although they each continued to evolve along individual paths. José Miguel Rojas (b. 1959) is a Neo-Expressionist whose daring, often political images make reference to man's role in society. Views which challenge society and religious traditions are also apparent in the mysterious and ritual-like installations of Rafael Ottón Solís (b. 1946). In another form of social

Central America

criticism, Roberto Lizano (b. 1951) applies a distinctly personal twist to Arte Povera in his unusual portraits done on packing cardboard. Within this group, Fabio Herrera (b. 1954) stands out for his steadfast self-expression and his dramatic Informalist explorations of colour and texture, ranging from oversize abstract canvases to very small compositions (fig. 74). Other artists in the group who have followed the line of non-objective painting are Mario Maffioli (b. 1960) and Pedro Arrieta (b. 1954), whereas the coloured patterns in the paintings of Luis Chacón (b. 1953) and the rhythmic, batik-like motifs in the drawings of Ana Isabel Marten (b. 1961) remain barely within the realm of figuration. Leonel González (b. 1962) began with brightly coloured figures of the black people who live along Costa Rica's coasts, images which he reduced over time to a few essential, poetic, black shapes on enormous canvases. Florencia Urbina (b. 1964) and Miguel Hernández (b. 1961) have also focused on the human figure in works which fluctuate between reality and symbolism.

Among the artists working independently in San José today, Ana Griselda Hine (b. 1950) and Gioconda Rojas (b. 1967) share a lyrical, *intimiste* perspective in their paintings of women, interiors and symbolic interpretations of people's living spaces. By contrast, the installations and fierce animals by Neo-Expressionist painter Manuel Zumbado (b. 1964) are much more aggressive. Finally, in addition to the emergence of new artists, in the early 1990s Costa Rica has experienced another surge in private and official sponsorship for the arts. This is demonstrated by the inauguration of two cultural centres with several theatres, a children's museum, and the new Museo de Arte y Diseño Contemporáneo.

Panama

Panama had numerous travelling artists during the nineteenth century, because of its geographical position and its history as a country of transit. They recorded genre scenes, the building of the trans-Isthmian railroad in the 1850s, and the ill-fated French Canal in the 1880s. However, the precedents for the development of a national artistic tradition are found in the work of academic portrait painters active during the latter part of the nineteenth century, including the respected Colombian-born Epifanio Garay (1849–1903), Sebastián Villalaz (1879–1919), and the relatively unknown Wenceslao de la Guardia (1859–1941).

During the first decades of its independence from Colombia (achieved in 1903 with the support of the United States), and after the opening of the Panama Canal in 1914, the new Republic of Panama had only a few noteworthy artists. Trained in France, the much-admired Roberto Lewis (1874–1949) became the first prominent figure in Panamanian art. He painted portraits of the nation's leaders and allegorical images to decorate public buildings, most notably those in Panama's Presidencia dating from 1936. His best-known easel paintings are the numerous landscapes with tamarind trees, which reflect his contact with Post-Impressionism (fig. 76).

A more daring artist was Manuel Amador (1869–1952), whose sojourns in Germany and New York reinforced the breadth of his culture and the gestural style of his drawings and paintings, the best of which dealt with the human figure. Rubén Villalaz (1897–1994), who was active from the 1920s, employed watercolours for his genre scenes of life in rural areas.

As Directors of Panama's first art

academy from 1913 until mid-century, Lewis and his successor Humberto Ivaldi (1909–47) educated a generation of artists. Ivaldi was trained in Madrid and his portraits and landscapes from the 1940s were characterized by expressive brush-strokes and an atmospheric quality. Among the school's students were Juan Manuel Cedeño and Isaac Benítez, as well as the painters who would come to the fore in the 1950s and 1960s. This group included Alfredo Sinclair, Guillermo Trujillo, Ciro Oduber, Eudoro Silvera, Adriano Herrerabarría, and Manuel Chong Neto, all of whom went on to study abroad and began to exhibit in Panama upon their return. Still active today, these artists shared the role of breaking with academic tradition and introducing modern art to Panama, although they did not work together or follow similar styles.

Throughout his long career, Juan Manuel Cedeño (b. 1914) was both an influential teacher (he directed the Escuela Nacional de Pintura, later renamed the Escuela Nacional de Artes Plásticas, from 1950 to 1967) and Panama's official portrait painter until the 1990s. However, his most dynamic paintings were stylized compositions influenced by Cubism and based on themes drawn from Panamanian folklore or religious traditions, such as the procession in his *Viernes santo* (*Good Friday*) from the early 1950s. During his short career, Isaac Benítez (1927–68) produced Expressionistic ink drawings, portraits, watercolours and oils of stark contrasts and thick strokes, which were unusual in Panamanian art.

One of the country's most admired artists, Alfredo Sinclair (b. 1915), whose career has spanned fifty years, was the first Panamanian to explore Abstract Expressionism. After initially working with neon lights, and an early period of experimentation with collages and mixed media,

74. Fabio Herrera – Sin título (Untitled), 1991.
acrylic on canvas, 35 x 25 cm. private collection

Sinclair's style matured into a refined lyrical abstraction based on broad areas of luminous colours, as in his *Movimientos de un río* (*Movements of a River*, 1980; fig. 78). Although his compositions often include figurative references such as still lifes or faces, Sinclair is considered the patriarch of abstraction in Panama. His contemporary, Eudoro Silvera (b. 1917), was more influenced by Cubism, as reflected in his paintings of Indians and musicians, as well as still lifes with local fruit or fish, which show his commitment to creating modern art related to Panama's cultural identity.

The most outstanding and influential Panamanian artist is the tireless painter, printmaker, ceramicist and sculptor Guillermo Trujillo (b. 1927), whose personal iconography is rooted in Panama's pre-Columbian history and Indian mythology, its landscape and flora. One of many paintings produced during a long career, *Nuestra Señora de los Nuchos* (*Our Lady of the 'Nuchos'*, 1989; fig. 80) reflects the way Trujillo re-creates nature and reinterprets indigenous folklore, inventing his own spiritual and pictorial reality. With a rich and versatile *œuvre* ranging from social satires to imagined landscapes and delicate semi-abstractions, Trujillo has achieved international success as a painter. As a professor, he promoted a lasting interest in watercolour painting, ceramics and printmaking in Panama.

A rebellious painter, Adriano Herrerabarría (b. 1928) made a contribution to Panamanian art as the promoter of the establishment of art schools outside the capital. As a painter, after studying in Mexico, he initially followed social realism, later developing a form of biomorphic Surrealism. Two other artists who trained in Mexico are Desiderio Sánchez (b. 1929) who has followed an Expressionist

75. Manuel de la Cruz González – Amarillo contínuo (Continuous Yellow), 1971. lacquer on wood, 100 x 100 cm. Museo de Arte Costarricense, San José

76. Roberto Lewis – Tamarindos (Tamarind Trees),
1948. oil on canvas, 92 x 183.5 cm. private collection

77. Antonio Alvarado – Composición en celeste (Composition in Light Blue),
1978. oil on canvas, 60 x 76 cm. Banco Nacional de Panamá, Panama City

Central America

tendency and has been widely exhibited, and the painter and printmaker Manuel Chong Neto (b. 1927) whose voluminous and often erotic female figures are a leitmotif, which he surrounds with mysterious characters such as voyeurs and owls.

The generation active since the mid-century has included only a few women painters. British-born Trixie Briceño (1911–85) employed geometry and bright colours in her unique blend of naïve, Surreal, and even humorous styles. Olga Sánchez (b. 1921) started as a painter of strong Expressionist human figures, but later became more involved in ceramics.

Three outstanding Panamanians of this generation moved to Spain, where they have remained: the Surrealist/hyper-realist Pablo Runyan (b. 1925); Ciro Oduber (b. 1921), who is known for his dynamic ink drawings; and Panama's most recognized and prolific print-maker, Julio Zachrisson (b. 1930), whose satirical and sometimes grotesque etchings and paintings are inspired by literature, mythology and urban folklore. Having trained in Spain, the widely exhibited Alberto Dutary (b. 1932) returned to Panama and has played a significant role as a teacher and promoter of modern art. Over the years, the phantasmagoric creatures of his paintings of the 1960s have been replaced by increasingly realistic images of women and mannequins.

Panama has had relatively few sculptors in the twentieth century. One of the earliest was Guillermo Mora Noli (1923–81), who invented 'Cilindrismo', an art theory which he applied to large-scale public sculptures in the 1940s. Carlos Arboleda (b. 1929) and Mario Calvit (b. 1933) have been active as painters and as sculptors since the late 1950s. Arboleda's best sculptures

were based on Indigenist themes and Calvit created dynamic iron constructions; powerful three-dimensional works which, in both cases, bear little resemblance to the lyrical realism of their paintings. Meanwhile Justo Arosemena (b. 1929) developed a successful career in Colombia, and the prominent young sculptor, Susie Arias (b. 1953) who lives in California, has become known for her innovative sculptures of unusual materials and painted surfaces.

During the past decades, most of Panama's best artists have held exhibitions at the Instituto Panameño de Arte, a private, non-profit-making organization founded in 1962, which became the Museo de Arte Contemporáneo in 1983. Since the 1960s, juried shows sponsored by US corporations, and later by local companies, has given many Panamanian painters opportunities to exhibit and to gain international exposure.

Influenced by Japanese art and Abstract Expressionism, the fine abstractionist Antonio Alvarado (b. 1938) has explored pure colour and form throughout his career, and created a great number of non-objective paintings such as his *Composición en celeste* (*Composition in Light Blue*, 1978; fig. 77). Coqui Calderón (b. 1937), who was initially influenced by Pop art, pursued a semi-abstraction of geometric patterns and subdued tones, turning later to luminous still lifes, land-scapes, and even works of political protest. Teresa Icaza (b. 1940) became known for the rough textures and mysterious light in her outer-space-like abstractions, but in the 1980s adopted a brighter palette and focused on painting imaginary landscapes.

In spite of the continued presence of the US armed forces in the Panama Canal Zone since the early part of this century, over the years Panama's National Guard grew more powerful

and, in 1968, triggered a coup which deposed the country's democratically elected president. Under the leadership of Omar Torrijos, this coup marked the beginning of two decades of military government which at first did much to modern-ize the country and promote culture, including the establishment of the National Institute of Culture in 1974. Politically, Torrijos can take the credit for having achieved a new Panama Canal treaty with the United States, which came into effect in 1979. During the 1970s, the first galleries were opened in Panama City and many young artists began to exhibit. Luis Aguilar Ponce (b. 1943) came on to the scene with his semi-abstract airbrush renderings of sensuous torsos. After studying in Italy, Emilio Torres (b. 1944) shocked the public with his Minimalist and conceptual pieces, as well as his daring state-ments. Antonio Madrid (b. 1949) painted lyrical abstractions into which he inserted references to Panamanian folklore. Manuel Montilla (b. 1950) started along the path of Pop art, turning later to conceptualism and political protest, often against US intervention. Tabo Toral (b. 1950) shifted from a pure geometry of vibrant colours and philosophical content, to graffiti-like figures and murals after he moved to the United States.

In spite of the dictatorship under Manuel Antonio Noriega who came to power in 1983, the art market flourished during the 1980s. The flow of money through Panama's banking centre helped to increase both private and corporate art collecting. There was a rise of interest in paint-ings of Panama's local scenery, as reflected in the exhibitions of exuberant tropical landscapes by Ignacio Esplá (b. 1946) and folkloric images by Al Sprague (b. 1938). The boom in the art market slowed down as political repression increased, and came to a standstill when Panama entered an

Central America

economic crisis due to international sanctions and increasing anti-government demonstrations, a situation which peaked with the US invasion of Panama in 1989.

Although there are some significant exceptions, most contemporary Panamanian artists have not concentrated on political subjects. However, it is noteworthy that during the 1980s, many artists turned to figuration and a focus on the human condition. The earlier still lifes of Amalia Tapia (b. 1947) gave way to collages and paintings of everyday objects charged with symbolism and even protest. Sandra Eleta (b. 1942) created audiovisual works about Panama's painted buses and its Afro-Caribbean people. David Solís (b. 1953), who moved to France in 1975, dedicated many years to drawing, and later to painting a dark world of Goya-like figures with references to religious and cultural archetypes. Society, religion and politics are also represented, and mocked, in the work of the outstanding figurative painter Brooke Alfaro (b. 1949), who has achieved international recognition with his classical technique and surreal paintings. In his narrative, nightmarish images and his disturbing visions of common people or figures of authority, the highly imaginative Alfaro seems to explore reality by deforming it (fig. 79). It was also during the 1980s that Raúl Vásquez (b. 1954), gained prominence with his poetic images of incised shapes in sandy textures, Tamayo-like colours, and characters reminiscent of cave paintings and a simpler world. Vásquez's ideas and technique, as well as a shared admiration for Mexican art, influenced several painters from Panama's provinces of Los Santos and Herrera. Including the promising Roosevelt Díaz (b. 1963), they form part of an unofficial group often referred to as the 'Escuela de Azuero'.

During the last decade, Olga Sinclair (b. 1957), who began with *intimiste* images of languid, reclining figures in almost abstract environments of soft colours, has moved towards ever increasing figuration and more intense hues. The Neo-Expressionist Isabel De Obaldía (b. 1957) painted violent tropical interpretations of people, landscape and, towards the end of the 1980s, the country's political events. After the invasion of Panama, Vicky Suescum (b. 1961) turned away from landscape painting to creating more conceptual, symbolic works. As Panama approaches the end of the century and awaits the transfer of the administration of the Panama Canal, major political changes are bound to affect the evolution of the country in all spheres, including the arts.

78. ALFREDO SINCLAIR – MOVIMIENTOS DE UN RÍO (MOVEMENTS OF A RIVER), 1980. *oil on canvas, 127.5 x 127.5 cm. Museo de Arte Contemporáneo, Panama City*

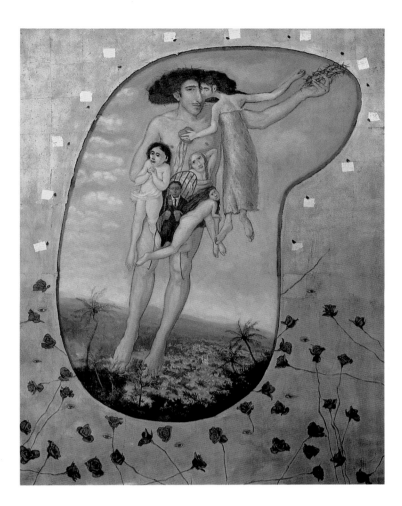

79. Brooke Alfaro – Un gran personaje y los que con él se tuvieron que ir (A Great Character and those who had to Leave along with him), 1990. *oil and gold leaf on canvas, 180 x 140 cm. private collection*

80. Guillermo Trujillo – Nuestra Señora de los Nuchos (Our Lady of the 'Nuchos'), 1989. *oil on canvas, 76.5 x 61.2 cm. private collection*

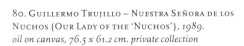

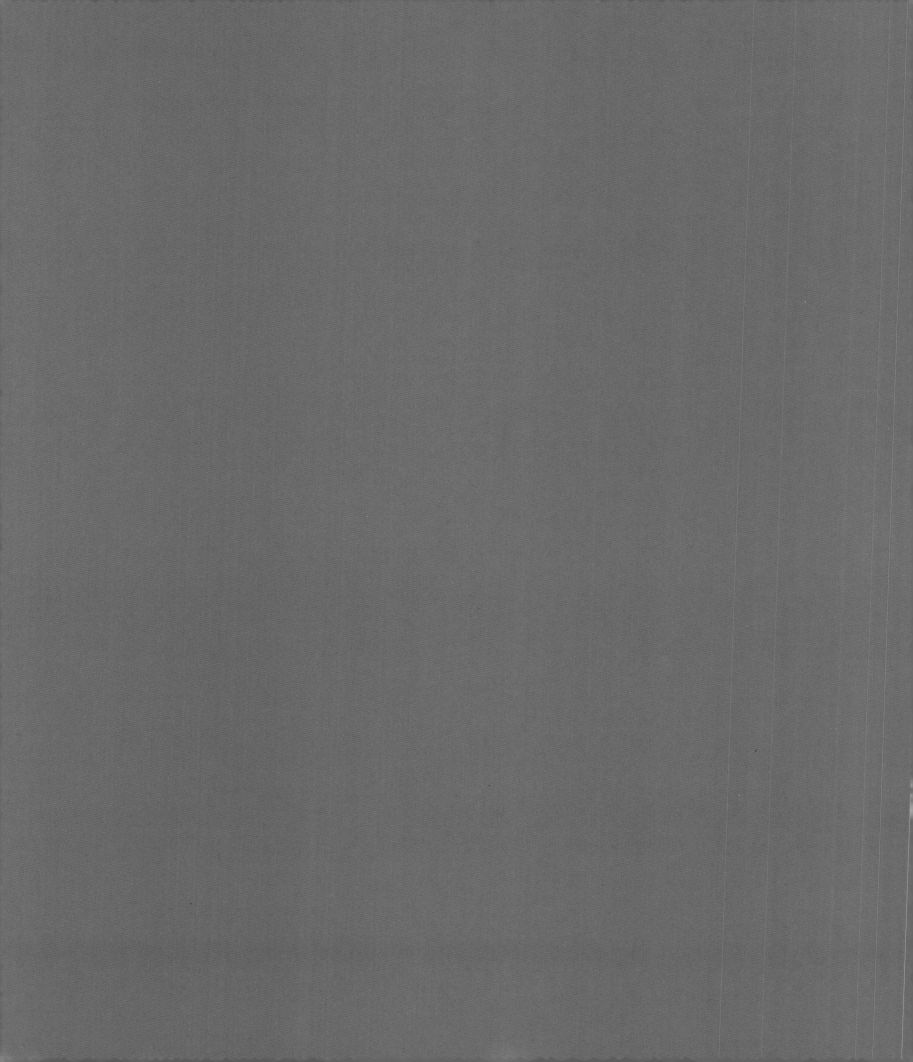

Cuba

Latin American Art in the Twentieth Century

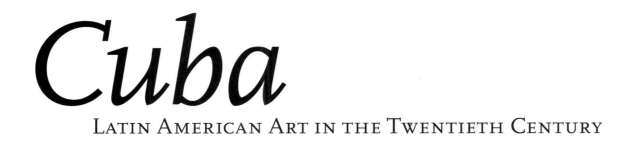

Giulio Blanc (1900-1950)

Gerardo Mosquera (1950-2000)

Cuba

I Cuba 1900–1950

The formal teaching of painting and sculpture in Cuba began in 1818 with the founding of the officially sponsored Academia de San Alejandro. It was here that many of the island's nineteenth-century artists were trained by European teachers as well as by Cuban-born artists who had themselves been students at the Academy.[1] One such influential Cuban instructor was Leopoldo Romañach (1862–1951), who had received part of his training in Spain and Italy and whose style may be characterized as romantic realism. He was always conscious of the time-honoured methods of the old masters, and his paintings did not stray far from tradition. However, his exposure to Impressionist-influenced artists in Europe did lead to a looseness of brush-stroke and an understanding of the effect of natural light on colour.

Romañach is best known for his studies of anonymous individuals engaged in mundane tasks, melodramatic children and beggars, portraits of matrons of the Cuban bourgeoisie, and landscapes. In *Cruzando el río* (*Fording the River*, c.1900; fig. 82) Romañach depicts a *quitrín*, a type of Cuban carriage. In the background we see a clump of bamboo, a sugar mill and palms.

The rise of modernism in Cuba was a reaction against the Academy, but it must also be seen in a wider historical context. Avant-garde styles and an interest in portraying popular life in a sympathetic, non-anecdotal manner were inseparable from the liberal, reformist views of the young intellectuals of the 1920s. Among these were a number of the artists who brought about radical changes in Cuban art. This decade was also marked by economic prosperity, widespread governmental corruption, and political and economic dependence on the United States.

By the 1930s violent political unrest erupted, and at the same time the island was deeply affected by the Great Depression.

Aware of avant-garde movements in Europe and of the officially encouraged cultural nationalism of Diego Rivera and other Mexican painters, the young artists of the 1920s began to question the validity and relevance of traditional approaches to style and content. Travelling in Europe, the *vanguardia* (avant-garde) artists studied at first hand the works of the Fauves, Cubists and Surrealists.[2] Those artists who were unable to leave Cuba sought out illustrations of modernist works in magazines and other publications. The cultural atmosphere in Cuba itself contributed to the eagerness of artists to seek new horizons. As in Mexico, Peru and other Latin American countries, during this period a new generation of novelists, poets, composers and folklorists sought to create a Cuban nationalist identity. They explored the rich African heritage of the island as well as the white and mixed-race culture of the small rural farmers, the *guajiros*. This search for an authentic national expression was notably successful in the paintings of the avant-garde artists.

Victor Manuel García (1897–1969), usually referred to simply as Victor Manuel, is generally considered the initiator of Cuban modernism. A student of Romañach at the Academy, he was respectful of his teacher's skills and even assisted at the Academy for a time as a drawing instructor. Extended stays in Paris in 1925 and 1929 opened Victor Manuel's eyes to the European artists of the late nineteenth and twentieth centuries. He became especially interested in Paul Gaugin and his depiction of French and South Seas scenes in which forms and compositions were simplified and colour took on a

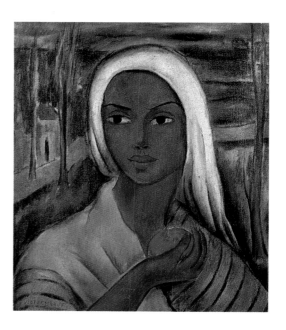

81. VICTOR MANUEL GARCÍA – MUCHACHA CON MANZANA ROJA (GIRL WITH RED APPLE), *c.1940. oil on canvas, 55 x 47 cm. private collection*

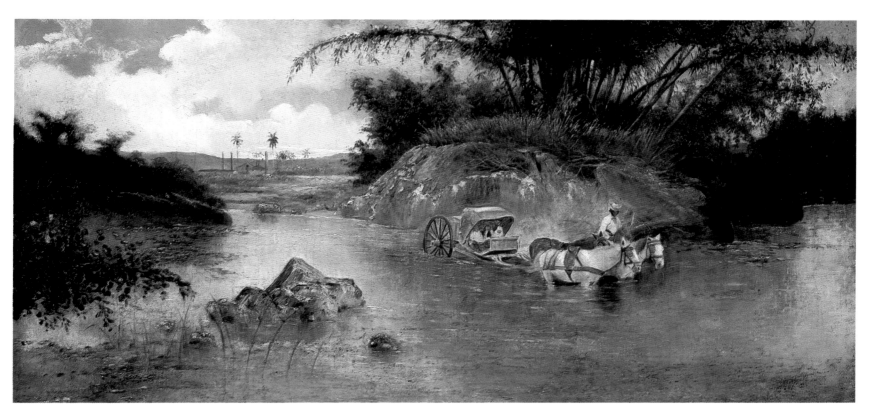

82. Leopoldo Romañach – Cruzando el río (Fording the River),
c.1900. oil on canvas, 34.3 x 67.6 cm. private collection

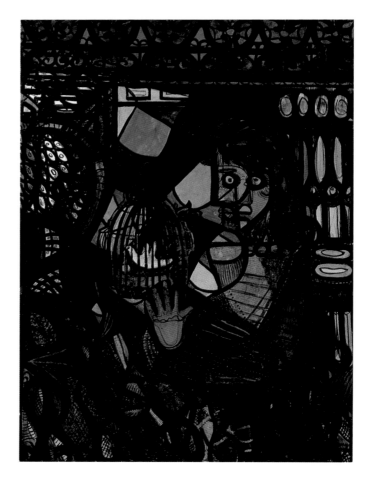

83. Amelia Peláez – Mujer con pájaro amarillo
(Woman with Yellow Bird), *1945. oil on paper laid
down on canvas, 121.6 x 94 cm. private collection*

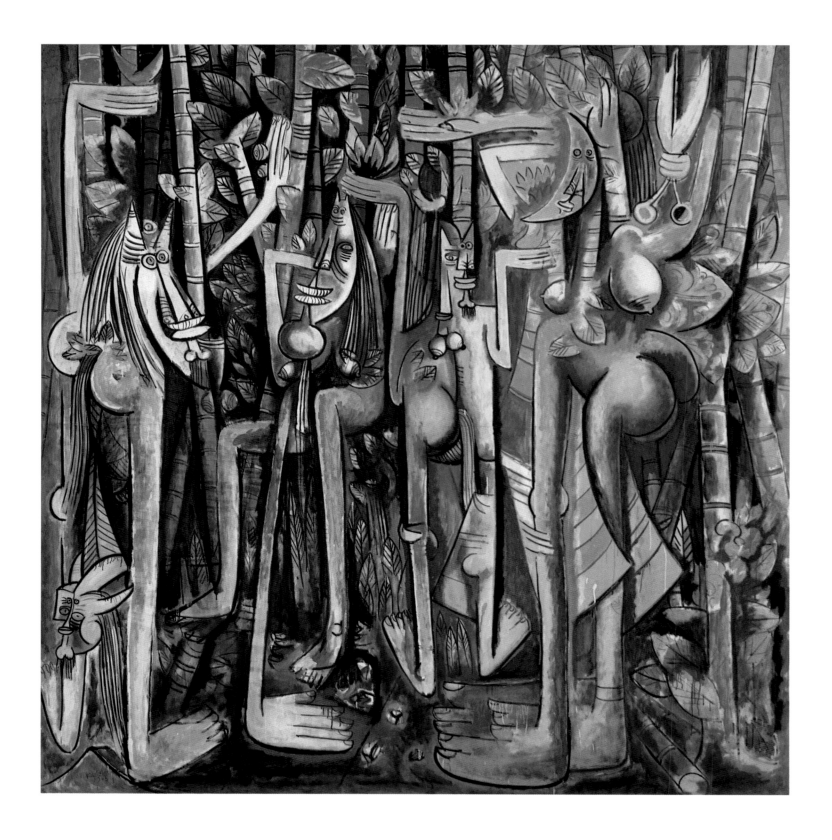

84. WIFREDO LAM – LA JUNGLA (THE JUNGLE), *1943.*
oil on reinforced paper, 239.4 x 229.9 cm.
The Museum of Modern Art, New York

Cuba

two-dimensional character. The artist also looked to medieval and early Renaissance models, particularly Madonnas. Like Gauguin, he sought to create images that would reflect an aesthetic different from that of traditional European painting. In Victor Manuel's case it was the life of the small farmer, views of Havana street life, and serene landscapes dotted with flowering trees and palms that became the principal subject-matter. The archetypal Cuban peasant girl, as in *Muchacha con manzana roja* (*Girl with Red Apple*, c.1940; fig. 81), of mixed race and possessing an aura of seductive beauty and unspoiled innocence, appears throughout Victor Manuel's long career, acquiring an iconic quality.

Amelia Peláez (1896–1968) was a star pupil of Leopoldo Romañach at the Academia de San Alejandro. Graduating in 1926, she left for Paris in 1927 and remained there until 1934, studying at La Grande Chaumière and other schools and also with the Russian Constructivist Alexandra Exter. Abandoning her academic style, during her Paris years Peláez developed a monochromatic Expressionism. Her favourite subjects were still lifes of fruits and flowers, and women. After returning to Cuba, Peláez rediscovered the architecture and decorative arts of the island. Much of this was a legacy of the Spanish colonial past but had a distinctly Cuban flavour. Wrought-iron balconies and window guards, stained-glass fanlights, elaborately decorated columns and balustrades and wicker furniture were among the elements which Peláez found of interest. The exotic tropical fruits and flowers of the island also attracted her attention.

Using her Parisian training, during the 1940s Peláez created a style best characterized as tropical Cubism. Avoiding the picturesque, she merged style and subject-matter in a kaleido-scopic celebration of ordinary Cuban motifs. In *Mujer con pájaro amarillo* (*Woman with Yellow Bird*, 1945; fig. 83) Peláez takes a woman on a balcony contemplating a caged bird and renders it as a semi-abstract, two-dimensional composition in which the sinuous black line of the ironwork interacts with the curves of a wicker chair, the green leaves and the blue of a stained-glass window. Peláez's style would always retain this tension between exuberance of line and colour and a rigorous sense of compositional balance.

Wifredo Lam (1902–92) is surely the most internationally recognized of the Cuban modernists. Like Victor Manuel and Amelia Peláez, he studied at the Academy in Havana before leaving for Spain in 1923 for further study. During the late 1930s Lam's style underwent a radical change, and his paintings from this period reflect the simplified forms of African sculpture. Of mixed African, Chinese, and Spanish background, Lam perceived the necessity of forging a style that would adequately embody the Afro-Cuban heritage of his country in an innovative manner. European modernism was crucial to this development. Coming into close contact with Pablo Picasso and with André Breton and the Surrealist Movement after moving to Paris from Spain in 1938, Lam found himself in a supportive milieu. Both Picasso and the Surrealists acknowledged the value of so-called primitive cultures and their belief systems and art.

Lam's return to his native land in 1941 was revelatory. He re-immersed himself in the religion and folk culture that he had left behind as a young man. Although Lam never formally joined the Afro-Cuban *Santería* religion or any of the other cults of African origin prevalent in Cuba, he approached the Afro-Cuban culture in a sympathetic manner and incorporated it in his art.

La jungla (*The Jungle*; fig. 84), painted in 1943, is without a doubt Lam's masterpiece. Drawing on Afro-Cuban myth and ritual, it is a hallucinatory composition in which sugar cane stalks merge with figures possessing human and animal characteristics. Horses' heads, outsize breasts, buttocks and limbs emerge from the darkness. The figures appear to be gathering leaves for use in ceremonies. In this painting and in other compositions of the 1940s and later, Lam, instead of creating anecdotal images, interprets the spirit of magic and pantheism underlying the Afro-Cuban world-view. For the Afro-Cuban, the everyday world is permeated with gods and spirits that must be appeased through animal sacrifices. In addition, in a ritual involving frenzied dancing to the sound of drums and chants, the devotee is believed to become possessed by a deity. This interaction between perceived reality and the supernatural became the central theme of Lam's paintings.

Carlos Enríquez (1900–57) was another Cuban who encountered Surrealism during his European sojourn. Enríquez received no formal training apart from lessons at high-school level. In 1920 he was sent by his family to study business in Philadelphia and in 1924 he attended the Pennsylvania Academy of Art for a short period. Living in Paris from 1930 to 1933, he came into contact with the Surrealist Movement. His works from these years, and indeed throughout his career, reflect a knowledge of such Surrealist techniques as double images, superimposed silhouettes, disembodied body parts and dreamlike images. Enríquez returned to Havana in 1934 and began to study the legends and folklore of the Cuban countryside which he depicted at its most

Cuba

lawless and untamed. In his *œuvre*, he elaborated his concept of the romance of the Cuban peasant. Central to this were the horse and the woman, symbols of the machismo and eroticism which he considered to be key elements for an understanding of his country's national character.

Bandolero cubano (*Cuban Outlaw*, 1943; fig. 85) is an important example of Enríquez's style and thematic concerns. In this painting, a fugitive bandit rides a horse that is transformed into a woman. The bandit's phallic gun and the eroticized leaves of the surrounding plants contribute to a composition which pulsates with energy and motion. It is painted in lurid tones of green and red.

Fidelio Ponce de León (1895–1949), who changed his name from Alfredo Fuentes Pons, began his career at the Academia de San Alejandro in the second decade of this century. He had a thorough understanding of the principles of the Academia's professors but quickly diverged from their styles. Ponce de León never left Cuba and, in his avoidance of Cuban subject-matter and his lack of interest in strong primary colours, stands in contrast to his modernist contemporaries. Most of his works, done in an Expressionist style, are monochromatic, painted in tones of off-white and ochre with occasional highlights of green. His compositions include sickly women and children, saints, swaying nuns, and underwater views of fish and marine plants. Ponce was probably familiar with the great Spanist Mannerist El Greco and certainly there are similarities, in terms of style and content, between these two artists.

Cinco mujeres (*Five Women*, 1941; fig. 86) is a key work in Ponce's career. It was purchased by the film director Alfred Hitchcock and featured by him in his movie *Rope*, a tale of

murder and deception. This composition, of a group of ghostly women, a sinister glove and a vase of anaemic flowers, is permeated with a mood of introspection and foreboding.

A number of other modernists who emerged during the 1920s and early 1930s deserve mention. Eduardo Abela (1889–1965), Antonio Gattorno (1904–81), Enrique Riverón (b. 1902), Domingo Ravenet (1905–69), Jaime Valls (1883–1955), Jorge Arche (1905–56) and Lorenzo Romero Arciaga (b. 1905) all took an interest in peasant and/or Afro-Cuban folk culture. Arístides Fernández (1904–34) and Marcelo Pogolotti (1902–88) are notable for their depictions of political and social injustices and the struggles of the common man.

Sculpture in Cuba during the first half of the twentieth century was markedly conservative. The field was dominated by sculptors who taught at the Academy and provided official statuary for public buildings. These sculptures never strayed far from European academic models, although an awareness of such innovators as Aristide Maillol and Wilhelm Lehmbruck is evident from the reductive and expressive treatment of the human anatomy. Some Cuban sculpture of this period also reflects the streamlined aesthetic of European Art Deco and Moderne styles.

Juan José Sicre (1898–1972) was the most prominent sculptor of this era. Teodoro Ramos Blanco (1902–72; fig. 87) and Florencio Gelabert (b. 1904), both of Afro-Cuban heritage, are known for their faithful representations of black Cubans.

The late 1930s and the 1940s, a period of relative political and economic stability in Cuba, witnessed the rise of the second generation of modernists. The contributions made by the first avant-garde artists, and the fact that they were

85. CARLOS ENRÍQUEZ – BANDOLERO CUBANO (CUBAN OUTLAW), *1943. oil on canvas, 121.2 x 88.6 cm. private collection*

86. Fidelio Ponce de León – Cinco mujeres (Five Women), 1941.
oil on canvas, 84.2 x 112 cm. private collection

87. Teodoro Ramos Blanco – Old Black Woman, 1939. *acana*
wood, height 28.3 cm. The Museum of Modern Art, New York

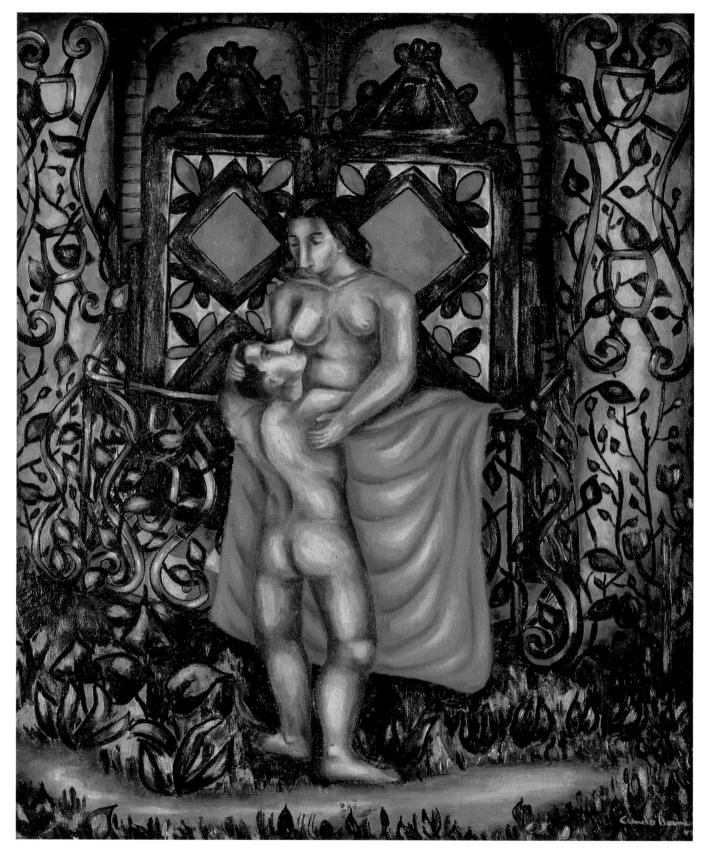

88. Cundo Bermúdez – Romeo y Julieta (Romeo and Juliet),
1943. oil on canvas, 95.2 x 76.2 cm. private collection

Cuba

creating some of their most outstanding works at this time, was a particular stimulus to the new generation. The achievements of Mexican cultural nationalism and its encouragement of public art (especially murals) and of the teaching of art at a popular level were also emulated.

In 1937 the short-lived government-sponsored Estudio Libre de Arte y Escultura opened, staffed by a number of avant-garde artists. An alternative to the Academy, it made art training accessible to the general public. That same year the first two groups of murals painted by Cuban modernists were created at the Escuela José Miguel Gómez in Havana and the Escuela Normal in Santa Clara.

In 1942 Alfred H. Barr Jr., director of New York's Museum of Modern Art, visited Cuba and purchased works by most of the avant-garde artists. In 1944, in collaboration with Cuban critics, collectors and artists, Barr organized the critically acclaimed exhibition *Modern Cuban Painters* at MoMA.

Cundo Bermúdez (b. 1914) briefly attended the Havana Academy and in 1938 travelled to Mexico, studying at the Academia de San Carlos and seeing the work of the Muralists at first hand. This Mexican apprenticeship had an impact on Cundo (as he is commonly referred to), but the example of Amelia Peláez was of greater significance for him. *Romeo y Julieta* (*Romeo and Juliet*; fig. 88), painted in 1943, is based on a cigar-box decoration for the brand of that name. Colonial Cuban fanlights, balconies and columns are enlivened by jarring primary colours. The Italian dress and architecture of the label have been abandoned for an almost caricatural vision of nakedness in the midst of Caribbean splendour. Besides pairs of lovers, Cundo depicted musicians, acrobats and scenes of

popular life in a faux-naïve style filled with humour and fantasy.

The work of Mario Carreño (b. 1913), which had been influenced by the Renaissance, Surrealism and Picasso's classical period, evolved in the direction of an epic, expressive style reminiscent of that of his friend David Alfaro Siqueiros and other Mexicans. Like Siqueiros, he experimented with industrial nitrocellulose pigments such as the Dupont brand 'Duco' as a medium for some of his most ambitious paintings. Carreño's works of the first half of the 1940s were concerned with such themes of cultural nationalism as Afro-Cuban rituals, sugar-cane harvesting – as in the 1943 *Los cortadores de caña* (*Sugar-Cane Cutters*; fig. 89) – and scenes of daily life. These were painted in intense tropical colours. During the second half of the 1940s, Carreño's work became increasingly Cubistic, with two-dimensional, carefully structured compositions. In the 1950s the artist abandoned figuration in favour of hard-edge abstraction.

René Portocarrero (1912–85) attended the Havana Academy for only a year. Although he had not yet been to Mexico, his first significant paintings from the late 1930s were Cuban versions of the themes painted by the Mexicans of the same period, mainly peasant families engaged in the mundane pursuits of their daily lives. His massive figures have the same quality of simple dignity and rootedness in the land as do those of Diego Rivera. In this respect they are also similar to those of his contemporaries, Cundo Bermúdez, Mario Carreño and Mariano Rodríguez. All of these artists depicted the common people of the island as noble, hardy individuals, the very salt of the earth.

Portocarrero's style became more whim-

sical during the 1940s, the artist delighting in colourful, pointillist depictions of the quaintly colonial interiors of his youth, as in *Interior del Cerro* (*Cerro Interior*, 1943; fig. 90). Nostalgic and intimate in their evocation of a rapidly fading past, Portocarrero's 'Cerro interiors' (the Cerro was the nineteenth-century aristocratic suburb of Havana) are among the finest evocations of the Cuban spirit by a modernist artist. As in the case of Cundo Bermúdez, Portocarrero's discovery of the formal and thematic possibilities to be found in the island's traditional architecture owed a great deal to Amelia Peláez. The artist also portrayed Afro-Cuban deities and their priests, and the riotous carnivals of Havana. Exuberance and Baroque excess were to be the hallmark of Portocarrero's style throughout his long career.

The paintings of Mariano Rodríguez (1912–90) are perhaps the clearest examples of the ultimate goals of the first- and second-generation modernists. This artist's experience of the Academia de San Alejandro was as frustrating as it had been for his colleagues, and in 1936 he travelled to Mexico where he studied with Manuel Rodríguez Lozano at the Academia de San Carlos. He also studied fresco painting with Pablo O'Higgins. After his return to Havana, during the 1940s Mariano (as he signed himself and as he is known) devoted himself almost exclusively to three themes: roosters, the life of the small farmers, and lovers. His expressive, colourful, roosters – as in *El gallo pintado* (*The Painted Cock*, 1941; fig. 91) – became symbols of national pride, assertiveness, and independence.

Luís Martínez-Pedro (1910–89) emerged in the early 1940s as an outstanding draughtsman. Martínez-Pedro, influenced by Surrealism, created elegant pencil-and-ink drawings of subjects from Greek mythology, as well as scenes

Cuba

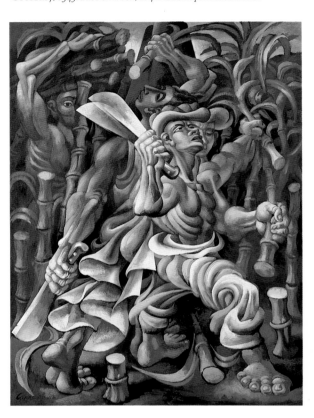

of Afro-Cuban rituals. He was the sole Cuban modernist to acknowledge seriously, and seek inspiration in, the pre-Columbian past of the island's Taíno Indians in a series of fanciful depictions of Taíno chiefs and their legends, of which *Giadrunama y el pájaro* (*Giadrunama and the Bird*, 1947; fig. 92) is an example.

Other artists of the 1940s include Roberto Diago (1920–57), Daniel Serra-Badue (b. 1914), Felipe Orlando (b. 1911) and Alfredo Lozano (b. 1913).

Art in Cuba from around 1900 to 1950 saw the rejection of the Academy in favour of styles based on European modernism. The search for national identity was a primary concern for most of the artists who have been discussed here. In his comments on the landmark *Modern Cuban Painters* exhibition at the Museum of Modern Art in 1944, Alfred H. Barr Jr. noted: 'There is almost no painting of the Cuban scene comparable to our often literal or sentimental painting of the American scene and there is little obvious regional and nationalistic feeling. Cuban colour, Cuban light, Cuban forms and Cuban motifs are plastically and imaginatively assimilated rather than realistically represented.'[3]

Although Barr underestimated the strength of cultural nationalism in modern Cuban art he did understand that the Cuban modernists were not interested in tepid imitations of foreign styles, or in picturesque, anecdotal depictions of their country.

In the decade after 1950 a third generation of Cuban modernists would emerge. Many of these artists would seek new horizons, including abstraction, but the interpretation and definition of national culture continued to be an important goal.

90. RENÉ PORTOCARRERO – INTERIOR DEL CERRO (CERRO INTERIOR), 1943. *gouache on paper, 60.3 x 36.2 cm. private collection*

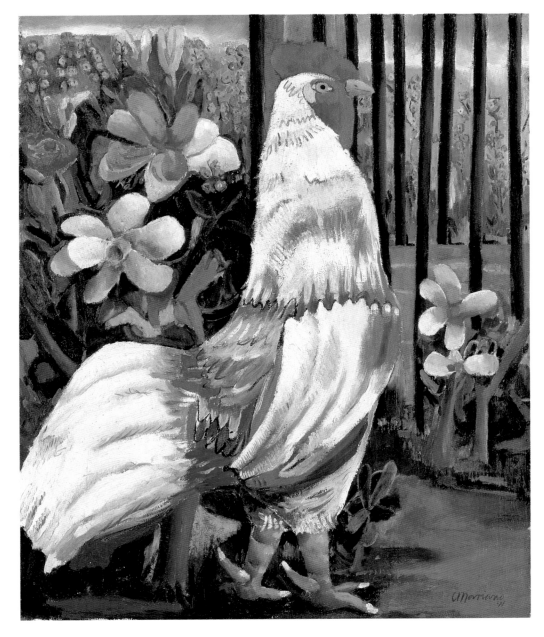

91. Mariano Rodríguez – El gallo pintado (The Painted Cock), 1941. *oil on canvas, 65.4 x 53.3 cm. private collection*

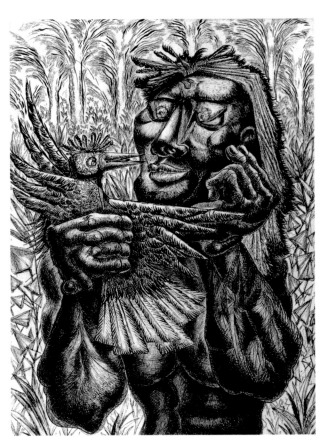

92. Luis Martínez-Pedro – Giadrunama y el pájaro (Giadrunama and the Bird), 1945. *ink on paper, 40.6 x 27.9 cm. private collection*

Cuba

II Cuba 1950–2000

At the beginning of the 1950s Cuban art inclined towards a type of mannerism characterized by bright colours as well as 'gaiety, candour and exuberance', as Alfred Barr had described it in his 1944 essay on the 'Havana School'. A number of the artists who made up this group continued to enjoy a certain success. However, the general evolution of Cuban art seemed by then to have arrived at a dead end, which helped to account for the sharp rise of abstraction under the influence of North American Abstract Expressionism. Younger painters aspired to enter into a more international discourse, and their rejection of 'tropicalist sweetness' corresponded to a shift in artistic paradigms or models for avant-garde art as the United States supplanted Europe in the position of hegemony. Aside from developing its own poetic principles, Cuban abstraction represented a rebellion against the art establishment of the country.

The young abstract artists, including Hugo Consuegra (b. 1929), José Antonio Díaz Peláez, Fayad Jamis (1930–88), Guido Llinás (b. 1923), Raúl Martínez (1927–95), Tomás Oliva and Antonio Vidal (b. 1928), formed part of the group known as Los Once (The Eleven). They exhibited together from 1953 to 1958. Their art of avant-garde rebellion was also linked to a rejection of the dictatorship of Fulgencio Batista, who had abruptly seized power in 1952. These artists refused to take part in official exhibitions or competitions and organized their own 'counter-exhibitions'. Apart from the influence of the North American avant-garde, the directions taken by these artists were inspired initially by the work of Julio Girona (b. 1914), a Cuban artist living in the United States who had played a marginal role in the New York School.

Parallel to the accomplishments of Los Once was a tendency towards Concrete art and geometric abstraction. Sandú Darié (1908–91) was the only radical participant in the Concrete art movement, remaining faithful until his death to his interest in art as a 'new reality', including his creation of participatory works in an urban environment. The foremost geometric abstractionists, Salvador Corratgé (b. 1928), Darié, Luis Martínez Pedro (1910–88), Pedro de Oraá (b. 1931) and Loló Soldevilla (b. 1922), briefly grouped themselves together in the exhibition *10 Pintores Concretos* (*10 Concrete Painters*) held in 1960. At its zenith, the non-figurative movement also included older artists such as Mario Carreño, Mariano Rodríguez (1912–90), José Mijares (b. 1922)and others who had changed their style to fit in, if only temporarily, with the new trends. In Cuban art in general at this time, artists gravitated towards geometric synthesis, as in the work of Mirta Cerra (1906–86), Wifredo Lam, Amelia Peláez or René Portocarrero.

The predominance of abstract art in Cuba was brief and produced few works of note. The most significant figure in this idiom was Agustín Cárdenas (b. 1927), who had been a member of Los Once and who, around the year 1953, introduced an African-inspired aesthetic into non-figurative Western sculpture (fig. 93). He developed this further after establishing himself in Paris shortly thereafter. In a way similar to Lam, Cárdenas internalized his African sources to create formalist modernist works without making direct references to any specific African theme. Martínez Pedro stands out for his series *Aguas territoriales* (*Territorial Waters*), based on the poetical suggestions of the sea. Painted in the early 1960s, they are conceived in a purified geometric mode.

The Communist Revolution of 1959 that brought Fidel Castro to power did not signify a rupture with the past. Specific guidelines or rules were not issued, but on the other hand there were no great figures such as those that had existed at the time of the Russian Revolution. There were no Tatlins or Rodchenkos committed to the dream of transforming culture. Modern art had already been well integrated within both society and politics, as evidenced by its direction towards nationalist affirmation and socially conscious subject-matter. The Revolution charted the course of art, without making the sort of great changes that one might have expected.

Fidel Castro proclaimed his allegiance to Marxist-Leninist Communism on 16 April 1961. Relations gradually strengthened with the Soviet Union but worsened with the United States, which had broken diplomatic ties with Cuba on 3 January 1961. Matters deteriorated further after the failed invasion of Cuba by CIA-backed anti-Castro exiles at the Bay of Pigs in April 1961. The following year the United States imposed a trade blockade which has never been lifted. Cuba developed a centralized bureaucratic economy which ruined the country after Soviet support ended in the late 1980s.

The new direction in politics resulted in strong state support for culture through the establishment of cultural spaces, institutions and events. Government support for artistic workshops accounted for a resurgence in the arts of printing, ceramics and other genres which had been previously practised on a small scale. Of greatest importance was the establishment of a system of free art instruction which laid the groundwork for the artistic explosion of the 1980s. Notwithstanding the political violence and the difficulty of change, the 1960s was a time

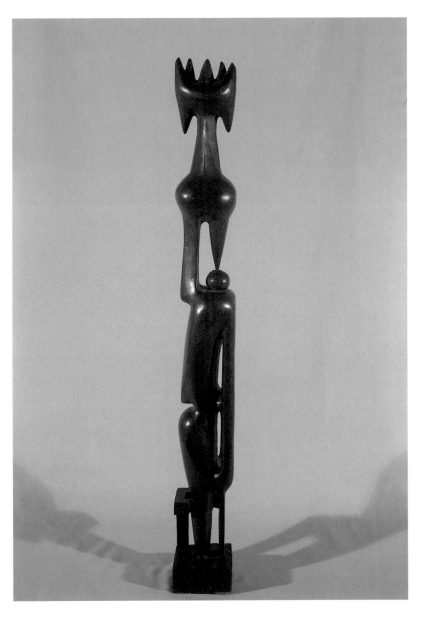

93. Agustín Cárdenas – Sin título (Untitled), 1953.
wood, 108 x 33 x 33 cm. National Museum of Cuba, Havana

94. Raúl Martínez – Fénix (Phoenix), 1968. oil on
canvas, 200 x 160 cm. National Museum of Cuba, Havana

95. Angel Acosta León – La nave (The Ship), 1961. oil on board, 122.5 x 234 cm. National Museum of Cuba, Havana

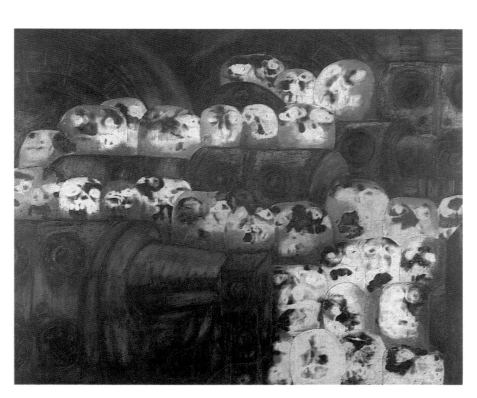

96. Antonia Eiriz – Cristo saliendo de Juanelo (Christ Leaving Juanelo), 1966. oil and collage on canvas, 192.5 x 244.5 cm. National Museum of Cuba, Havana

of cultural splendour during which a plurality of artistic tendencies flourished.

Paradoxically, the Revolution's most important cultural consequence came in the form of the mass emigration of Cubans, causing a consolidation of Cuban culture in the United States and other countries. Miami became 'Cuba's second city' in terms of population. This diaspora caused a diversification of cultural output both inside and outside Cuba. Many artists left during the first years of the Revolution, among them Cundo Bermúdez, Alfredo Lozano, José Mijares and most of the Abstract Expressionist painters as well as other young artists like Agustín Fernández (b. 1928). The art of the majority of these (with the exception of Fernández) only developed in a minor way after leaving Cuba. The government prohibited emigration at the end of the 1960s, putting an effective stop to this diaspora.

In the heat of the Revolution a few artists, including Mariano Rodríguez, attempted to create an epic art inspired by contemporary politics. Yet most of them soon developed along other lines. Only Servando Cabrera Moreno (1923–81) achieved something interesting in this vein. The visual image of the Revolution would ultimately come, unexpectedly, from the hands of Raúl Martínez (1927–95). Within a few years he followed the route from Robert Motherwell to Andy Warhol, from abstraction to Pop art via Jasper Johns and Robert Rauschenberg. He finally embraced a unique type of Pop imagery to construct a grandiose, positive revolutionary iconography based on daily life. His imagery had virtually nothing of an official or didactic nature and was inspired by popular art with certain touches of the grotesque, as in his portrait of Che Guevara (fig. 94). Martínez's paintings expressed

Cuba

both the utopia and the reality of those years.

Martínez – together with such others as René Azcuy (b. 1939), Félix Beltrán (b. 1938), Eduardo Muñoz Bachs (b. 1937), Umberto Peña (b. 1937) and Alfredo Rostgaard (b. 1933) – was also one of the leaders of the extraordinary resurgence in graphic design that took place in the 1960s. With the inspiration of Pop art and the lessons of Polish poster art, these Cubans succeeded in creating their own style, noted for its convincing metaphorical messages as well as its fresh approach to political propaganda and its cultural influence. Yet the international success of this movement did not prevent its decline in the following decade, a victim of bureaucratic control. During its high point, this political art also included numerous multi-disciplinary participatory projects.

There was also an artistic photographic movement that accompanied the Revolution, combining reportage, aesthetics and humour. It had the same popular spontaneity of those years, but also demonstrated great formal care. Raúl Corral (b. 1925) was the most important artist of this movement, which also included Mario García Joya (b. 1938) and Alberto Díaz Gutiérrez, called Korda (b. 1928), well known for a photograph of Che Guevara which became a world-recognized icon. At the end of the decade documentary photography also succumbed to bureaucratic control.

José Masiques developed a bizarre form of psychedelic painting. Pop art combined with a type of Expressionism characterized the paintings and prints of Umberto Peña. New Figuration was one of the major directions taken by Cuban art in the 1960s. Antonia Eiriz (1931–95) is the best representative of this mode with her highly influential paintings and

grotesque assemblages distilling the violence of these years. In a complex allusion to the work of Belgian Symbolist painter James Ensor as well as to the Revolutionary marches that took place in Cuba, Eiriz painted a scene of Christ leaving a working-class neighbourhood of Havana (fig. 96). Cabrera Moreno developed a softer and more formalistic manner, becoming the country's foremost erotic artist. A sarcastic approach to eroticism was meanwhile taken by Peña, and with humour by the draughtsman Chago Armada (b. 1937). Additionally, Cabrera Moreno and Peña dealt with the question of homosexuality for the first time in Cuban art. Alfredo Sosabravo (b. 1930) created highly imaginative sculptural ceramics, which often incorporated metal components. The pioneer of the Neo-Expressionist boom was Raúl Milián (1908–84), with his small pen drawings, alternating with a delicate, mysterious type of abstraction.

Pop art and New Figuration, as well as the dialogue between them, formed the guideposts for art in the 1960s. However, these were tempered by a curious reinterpretation and enrichment of the international styles in a local vein in the midst of the revolutionary atmosphere; Cuban culture has been known for its lack of adherence to specific schools or tendencies. The career of Angel Acosta León (1932–64), an artist of great importance, developed at this time. His paintings, both child-like and grandiose, constitute a poetic mythicization of the objects of his own humble reality. They take, at times, the form of ships or other phantom-like shapes (fig. 95). These works, expressions of his anguished personality, took on a tragic quality following his suicide. Jorge Camacho (b. 1934) also painted within the Surrealist mode. He

established himself in Paris where he followed the lessons of Lam, in his own, more 'European' way. The self-taught painters and draughtsmen of the province of Las Villas, promoted by Samuel Feijoó (b. 1914) and including Benjamín Duarte (b. 1909), developed along even more fantastical lines, along with another group of artists who were inspired by the folklorist José Seoane.

Manuel Mendive (b. 1944), the first artist to emerge from the traditional Afro-Cuban milieu, also produced his most significant paintings and assemblages during the 1960s. Initiated into the rites of *Santería* (the Cuban version of the Yoruba religion brought from West Africa), Mendive was the first artist to project his interpretation of the mythical elements of the world on to Western art. He began by presenting Yoruban mythology with a self-consciously 'primitivizing' visual vocabulary, later connecting it with historical themes (fig. 98) and everyday subjects, finally creating his own mythology. If Wifredo Lam had opened up modernism as a space for the expression of Afro-Cuban cultures, and Cárdenas introduced an African sensibility into abstraction, Mendive was the first to express a non-Western vision of the cosmos.

The failure of the Cuban-backed guerrilla movement in Latin America, and the economic and administrative chaos of the nation, led the government to abandon its independent position and to enter into the orbit of the Soviet Union at the beginning of the 1970s. This effectively put an end to the pluralistic scene which, until that time, had prevailed as an intense and semi-autonomous entity in Cuba. No official style was dictated but the practice of using culture to further ideological propaganda was demanded along with the promotion of a stereotyped form of nationalism. Many of the most important intel-

Cuba

lectuals were marginalized for 'ideological' or 'moral' reasons. As a silent symbol of protest, both Eiriz and Peña stopped painting.

The 1970s was a dark period when an apathetic sort of art was created in a climate of officialdom and opportunism. None the less, some valiant artists continued to work along their own lines, even though they could rarely exhibit. A few others even achieved the highest point in their careers at this moment. Such was Gilberto de la Nuez (b. 1937), who succeeded in connecting political propaganda with imagination in paintings in the manner of didactic retables (resembling traditional religious ones) that described the events of the day with a miniaturist's eye for detail. Osneldo García (b. 1931) developed his kinetic-erotic sculpture not without difficulties with the censors, while Reinaldo Calvo (b. 1937) distinguished himself with his ceramics. Ever Fonseca (b. 1938), a painter from the interior who had studied in the new art schools, created a personal mythology associated with peasant folklore.

From the art schools emerged a group of young Neo-Expressionists under the tutelage of Eiriz and Cabrera. Yet cultural strictures obliged them to adapt to the dictates of official taste. Only Tomás Sánchez (b. 1948) continued making his Expressionist prints, resisting the pressure to depict militiamen and peasants. The traditions of both printmaking and drawing became stronger through the efforts of younger artists such as Manuel Castellanos, Nelson Domínguez (b. 1947), Roberto Fabelo (b. 1950) and Zayda del Río (b. 1954).

In the mid-1970s the widespread success of photo-realism signalled a change. Painters such as Flavio Garciandía (b. 1954) and Rogelio López Marín, called Gory (b. 1953) injected a

youthful freshness into this idiom. Sánchez switched from printmaking to painting and developed a subjective photo-realistic mode of expression, creating spiritualized representations of the Cuban landscape (fig. 99). His works represent a landmark in this genre, blending the mystical with the mundane.

This decade also witnessed the rise of those Cubans whose art had been formed in the United States. Juan González (1942–93) and Julio Larraz (b. 1944) both approached Surrealism from very different angles: González with his intimate drawings and collages delicately interwoven with autobiographical elements (see fig. 5), and Larraz with a more realistic mode in his disquietingly atmospheric depictions. Luis Cruz Azaceta (b. 1942) revived the ethical role of Expressionism, creating autobiographical images dealing with the social realities and the tragedy of exile, violence and solitude (fig. 97). The painter of this contemporary Babylon incorporates elements of Pop, comic-strip art and graffiti, denouncing New York as a symbol of all great metropolitan centres, and expressing the love/hate feelings of the immigrant for that city.

Ana Mendieta (1948–85) is a symbol of both exile and the desire for a re-encounter with the homeland. She and her sister were sent by themselves as young girls to the United States as part of an operation to save children during a fearful period in the Revolution. Mendieta never recovered from this trauma, and her work became a compensatory rite referring to her personal exile, in psychological, social and cultural terms. It consisted of a singular gesture – that of merging her being with nature through a mystical act of return to primary existence. Mendieta superimposed her silhouette on earth

97. LUIS CRUZ AZACETA – MAN CARRYING HIS COUNTRY III, 1993. *acrylic on canvas, 304 x 304 cm. private collection*

98. Manuel Mendive – Barco negrero (Slave Ship), 1976. *casein and carving on wood, 102.5 x 126 cm. National Museum of Cuba, Havana*

99. Tomás Sánchez – Buscador de bosques (Seeker of Forests), 1991. *acrylic on canvas, 60.2 x 121 cm. private collection*

100. ANA MENDIETA – FROM THE PORTFOLIOS
SILUETA WORKS IN MEXICO, *1973–7*, AND SILUETA
WORKS IN IOWA, *1976–8*.

SILUETA WITH FIREWORKS AND BAMBOO,
Oaxaca, Mexico, summer 1976.
colour photograph, 34.2 x 50.7 cm.

BLACK IXCHELL, Iowa, 1976. *figure wrapped
in black cloth with imprints of hands on cloth,
colour photograph, 50.7 x 34.2 cm.*

UNTITLED, *Iowa, c.1978. earth and body work with
gunpowder, colour photograph, 40.6 x 50.7 cm.*

UNTITLED, *Cuilapan Monastery, Oaxaca, Mexico,
c.1975. armature of twigs and branches, colour
photograph, 50.7 x 34.2 cm.*

Cuba

and rocks, burning it so that it dissolved into the atmosphere and implanted itself on to the ground and grass grew around the shape of her outline. She later exhibited the photographs that she had made of these acts, testifying to her evolving ecological communion with nature (fig. 100). The artist was able to visit Cuba in the early 1980s to participate in a meeting between exiles and members of the Cuban government. There she established strong ties intensified by her contact with other artists who, in turn, were nurtured by their connections with her.

The careers of these younger artists had been completely formed during the revolutionary period. They wished to be able to make art without official controls and open themselves up to the world at large. The firmness of their resolve allowed them to succeed despite the hostility around them. A rather more liberal atmosphere prevailed, however, after the founding of the Cuban Ministry of Culture in 1977. As a result of this, a number of artists were able to effect a revival in all realms of Cuban culture based on their innovations in art. The exhibition entitled *Volumen I* (*First Volume*) of 1981 stands as a signal of this change. By symbolic coincidence Ana Mendieta was working during this same year for the first (and only) time in Cuba. These events marked the beginning of what has been called the 'Cuban Renaissance'.

These new artists came from different sectors of lower- and middle-class society, and they continued to identify with their respective social backgrounds. Active participants in folklore, and at the same time professionals whose aesthetic production was formed thanks to the free school system, they created a 'high' art corresponding to their own sensibilities, visions, and the values of the social strata from which they

each emerged. The point of their work was not to create primitivizing art within a 'high art' context but to create a new vernacular idiom itself. Rubén Torres Llorca (b. 1957) and Garciandía began a reappraisal of popular kitsch. Their efforts were enhanced by those of Adriano Buergo (b. 1964), Ciro Quintana (b. 1964) and Antonio Eligio Fernández, called Tonel (b. 1958), and practised with irony in Miami by the Cuban-American artist César Trasobares (b. 1949). But the most radical change of perspective came from those artists who were themselves practitioners of Afro-Cuban religions and who grew up in the ambience of their rites. José Bedia, Juan Francisco Elso, Ricardo Rodríguez Brey (b. 1955), Marta María Pérez (b. 1959) and others employed installation and conceptual methods to create an avant-garde idiom derived from those non-Western philosophical, ethical and cosmogonic principles which were inherent in Afro-American cultures. They worked within the context of these cultures rather than borrowing elements from them, as earlier artists had done. José Bedia (b. 1959) is the author of a vast body of interpretative poetical work relating to humanity's place in the vast ecumenical and contradictory web of existence, his principal aim is to enter directly into the discourse of the 'primitive'. Taken as a whole, Bedia's work constitutes a cosmogonic system, an anthropology and an ethic analysing the relationship between human beings and the universe. His installations are based upon a complex codification of materials and techniques and include large wall drawings (fig. 102).

Juan Francisco Elso (1956–88), who like Mendieta died at an early age, has also become a cult figure. His work represented a mystical process of identification with the world through a cosmic vision of Latin America; a sort of spiritual

apprenticeship linked to the intimacy of his life and thoughts. His example made it possible for artists to return to religious procedures and to transcendental spirituality. He created a mystical vision of the Americas from their cultural, historical, religious and political diversity. At the heart of his work is the sculpture entitled *Por América* (*For America*), a portrait of José Martí, the poet and Cuban national hero (fig. 101). In this sculpture he is at once a revolutionary icon, an Afro-Cuban receptacle of power and a Saint in the popular Catholic Baroque manner.

If conceptual concerns predominated in Cuban art during the first half of the 1980s, the second part of the decade witnessed a resurgence of parody in an art of renewed carnival-like allegorical Expressionism but without sacrificing the conceptual concerns that marked the new Cuban forms of expression. The exuberant paintings and installations of Segundo Planes (b. 1965) are a good example of this. At the same time there arose a desire to blend artistic practices with social usefulness, as seen in the work of Abdel Hernández (b. 1964) and his project *Hacer* (*To Do*). Feminist art also developed for the first time, although its practitioners often reject the term itself. Among the first feminist artists were Ana Albertina Delgado (b. 1963) and Marta María Pérez (b. 1959). Later, Yaqueline Abdalá (b. 1968), Sandra Ramos (b. 1969) and Magalis Reyes (b. 1968) employed their bodies and intimate experiences as the basis for an extended discourse upon the mystical, existential and cultural aspects of society. Pérez connects her feminism with Afro-Cuban religions, employing her body as an altar, when, for example, she displays it covered with the thorns of the sacred *ceiba* (cottonwood) tree (fig. 103). Consuelo Castañeda (b. 1958) is an important painter of

Cuba

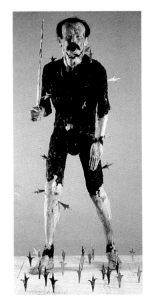

101. JUAN FRANCISCO ELSO – POR AMÉRICA (FOR AMERICA),
1986. installation, 180 x 150 x 200 cm. private collection

appropriation, creating humorous parodies of art history.

Carlos José Alfonzo (1950–91), one of Cuba's new artists, went to Miami in 1981, successfully developing a fable-based Neo-Expressionist mode of painting, while at the same time integrating aspects of Cuban pictorial traditions. In New York Félix González-Torres (1957–95) joined the Group Material artists, known for their large-scale installations with strong political messages. Later he continued working on his own in the realm of political conceptualism, creating art that sought a greater direct social role. His intelligence and sense of humour have lent his work a deep significance.

Social criticism in Cuban art became the dominant concern from the mid-1980s and has continued until the present. Art has even assumed the roles that have traditionally been assigned to the press, other means of mass communication and public assemblies. Art in Cuba has become a focal point for the free expression of ideas and given impetus to a critical voice in its culture. Lázaro Saavedra (b. 1964), who if allowed could have become a brilliant humorist as a newspaper caricaturist, worked instead on installation art, also exhibiting his drawings. Glexis Novoa (b. 1964) and Carlos Rodríguez Cárdenas (b. 1963) sarcastically deconstructed official rhetoric in their critiques of political imagery. Tomás Esson (b. 1963) carried grotesque sexuality to an extreme in the best 'high' painting tradition. Tonel metaphorically synthesized the grave problems that Cuba faced in his installations. The sculptor Alejandro Aguilera (b. 1964) questioned both the history as well as the myths of the Revolution. The group Arte Calle (Street Art) organized performances that seemed almost like demonstrations.

Eduardo Ponjuan (b. 1956) and René Francisco Rodríguez (b. 1960), working together, even used the image of Fidel Castro himself in their highly politicized art that delved into the nation's complex dilemmas. Tanya Angulo (b. 1968), Juan Ballester (b. 1966), José Toirac (b. 1966) and Ileana Villazón (b. 1969), acting both together and individually, subtly employed image appropriation to deconstruct the mechanisms of power. Exhibitions of work by these last six artists provoked strong reactions in Cuba and they experienced many difficulties with censorship at the end of the 1980s, leading to a renewed but more undefined cultural repression.

This situation, together with the economic, moral and social crises in Cuba caused by the ending of Soviet economic subvention, as well as a renewed international interest in new Cuban art, has caused the emigration of even more artists and intellectuals. Yet despite the 'blood-letting' on the island, cultural energy in Cuba continues to remain at a high level thanks to the strong artistic personalities who continue to emerge despite great difficulties. The theme of exodus continues to occupy the imagination of Kcho (Alexis Leiva, b. 1970), Sandra Ramos, and Tania Bruguera (b. 1968) among others. Ramos, along with Ibrahim Miranda (b. 1969), has been responsible for the renewed emphasis on print-making. Art of social criticism continues, although its parameters are more subtle and more cynical, as seen in the sculpture of Oscar Aguirre Comendador (b. 1965) and Esterio Segura (b. 1970), as well as in the painting (and sculpture) of Fernando Rodríguez (b. 1970) or in the conceptual art of Carlos Garaioca (b. 1967). Recently a number of underground publications have emerged and galleries have opened. Utopia may have died, but metaphors continue.

102. JOSÉ BEDIA – LLEGÓ BUEN AMIGO LLEGÓ: HOMAGE TO
LYDIA CABRERA, *1993. installation, 3.7 x 3.7 x 2.4 m. Museum
of Art, Fort Lauderdale, Florida (destroyed)*

103. Marta María Pérez – Protección
(Protection), 1990. photograph, 40 x 50 cm.

Dominican Republic

Latin American Art in the Twentieth Century

Jeannette Miller

Dominican Republic

The Dominican Republic is located in the Antilles, sharing the island of Hispaniola (of which it occupies the eastern two-thirds) with Haiti. In 1822, while still under Spanish jurisdiction, the eastern portion of the island was taken over by Haiti, which itself was just becoming fully independent from France. A separatist movement, however, was successful twenty-two years later and on 27 February 1844 the Dominican Republic achieved its independence. However, a subsequent war with Haiti and a search for foreign protection led the Dominican Republic again to come under Spanish rule, which lasted until 1865.

Since the mid-nineteenth century Dominican culture has been marked by a search for *dominicanidad*, or the examination of Dominican roots, which appears throughout its history in the form of the blending of both Spanish and African races and societies. Black slaves supplanted the indigenous peoples as workers after 1518. The Taíno Indian population was exterminated by the Spaniards and after the seventeenth century it no longer existed. 'Dominican-ness' may be observed in speech, education, theatre, literature, the visual and even the culinary arts.

After the Spaniards were expelled from the island in 1865, the task of restoring social, political and economic order was undertaken by the leaders of the various levels of Dominican society, and the effects of the re-establishment of national identity may be observed in Dominican art. Those painters whose careers developed during the second half of the nineteenth century reflected a nationalist fervour. In their paintings, subjects related to Dominican history were the preferred themes. These were done in the prevailing neo-classical, romantic and naturalist modes

of the period. Artists at that time also cultivated landscape, portraiture and still life as well as genre scenes featuring romanticized images of the Taíno Indians. Techniques were learned by copying other works of art. European artists came to the Dominican Republic from time to time. During their usually brief sojourns they helped to form the careers of some of the island's early painters, including Leopoldo Navarro, Abelardo Rodríguez Urdaneta and several others.

A modern spirit entered Dominican painting through the influence of what these and other artists saw on their travels to Europe and the United States at the end of the nineteenth and the beginning of the twentieth century. Navarro, Celeste Woss y Gil and Federico García Godoy display stylistic elements in their art derived from realism, Art Nouveau and Impressionism. Leopoldo Navarro (1865–1908) was a member of the Renaissance Group which had been formed after 1865, embodying a new feeling of strength and vitality in Dominican arts and letters. He spent time in Europe where he absorbed aspects of Impressionism and introduced it to his native country. The careers of Woss y Gil (1891–1985), the first modern woman painter of the Dominican Republic, and García Godoy (1885–1947), a somewhat lesser figure, developed in the 1920s. Woss y Gil studied in the United States and, on returning home in 1924, began painting in a Post-Impressionist style, depicting the female nude, concentrating (as no other painter had) on the mulatta model, as in the 1941 canvas *Mujer en reposo* (*Woman in Repose*; fig. 104). She also did numerous works employing the tropical light and warm colours of the island. In 1924 Woss y Gil opened an academy of painting and drawing in Santo Domingo where she introduced the study of the live model,

causing a scandal at the time. Many important artists studied with Woss y Gil who, in 1942, was appointed professor at the Escuela Nacional de Bellas Artes.

The forty years between 1870 and 1910 were marked by short-lived democratic governments and long dictatorships. Agriculture and commerce began to develop with the introduction of the railway and telegraph, and the growth of a middle class. The presence in the Dominican Republic of the Puerto Rican educationalist Eugenio María de Hostos, from 1875 until 1903 (the year of his death), was a catalyst for the growth of Dominican culture. Hostos advocated the formation of a federation of the Antilles which would include Puerto Rico, Cuba and the Dominican Republic. While in the Dominican Republic he founded the first normal school and introduced more sophisticated methods of teaching. His career reflected the positivist philosophies so popular in Latin American countries in the late nineteenth and early twentieth centuries which rejected speculation in favour of secular empirical investigation.

The dawn of the twentieth century was marked by almost constant social instability and a series of political insurrections in the Dominican Republic. Internal struggles were common and an enormous foreign debt was incurred. The United States established a growing presence in the Caribbean during this time. In 1916, to ensure repayment of the Dominican debt, US forces invaded the country and remained there until 1924, provoking nationalist reactions on the part of the populace. A number of well-known artists alluded to these events in their work, among them Rodríguez Urdaneta (1870–1933) who designed numerous protest posters.

It was also at this time, when more

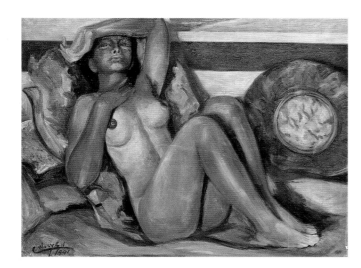

104. CELESTE WOSS Y GIL – MUJER EN REPOSO
(WOMAN IN REPOSE), *1941. oil on canvas, 66 x 85 cm.*
Museo de Arte Moderno, Santo Domingo

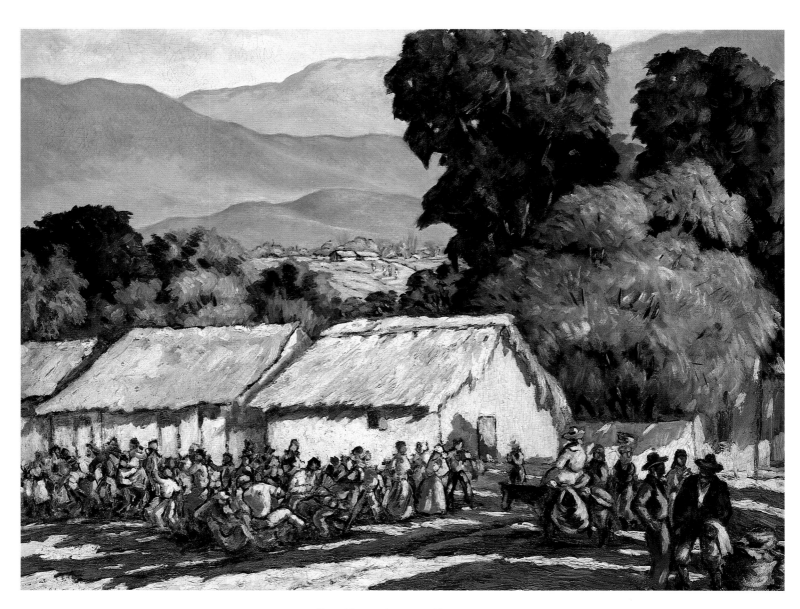

105. YORYI MOREL – A LA FIESTA (AT THE
FIESTA), *1948. oil on canvas, 82 x 105 cm.*
Museo Juan José Bellapart, Santo Domingo

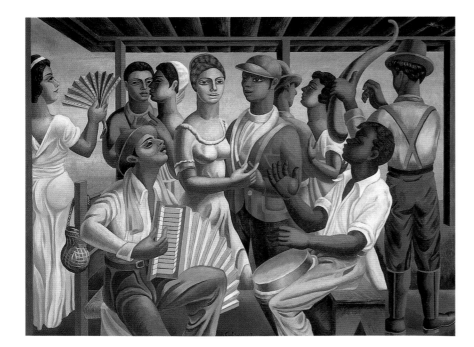

106. Jaime Colson – Merengue, 1937. *tempera on board, 51 x 67 cm. Museo Juan José Bellapart, Santo Domingo*

serious interest in education was growing, that a number of art academies opened both in the capital and in the interior. Among the most important were the schools founded by García Godoy in La Vega (1930), by Woss y Gil in Santo Domingo (1924) and by Juan B. Gómez (1874–?) in Santiago (1920). In all of these academies painting and drawing were taught. The styles advocated in these schools all followed conventional modes ranging from neo-classicism, through Romanticism and Impressionism to Art Nouveau. However, artists eventually became more interested in copying from nature. It was in a more realistic manner that they depicted numerous themes associated with daily life in the country, evoking a sense of *dominicanidad*.

Between 1910 and 1940 positivism grew in importance among intellectual Dominicans. A more fully developed capitalist economy began to evolve due to the success of the sugar industry. Both of these factors accounted, in part, for a rise of self-awareness and self-confidence, resulting in a strong sense of national identity. This process had begun in the nineteenth century and was strengthened during the period of invasion by the United States. Then, in 1930, the catastrophe of the San Zenón cyclone caused mass destruction in the city of Santo Domingo. The need to reconstruct the capital coincided with the call for a leader who could reorganize the political and economic life of the nation. In 1930 Rafael Trujillo, who had risen through the ranks from police officer to army commander, was elected President and his long rule, which lasted until 1961, proved to be one of the bloodiest dictatorships known to the Americas. After rebuilding the devastated city, repaying the debt to the United States and restoring control of the Customs from the United States to the

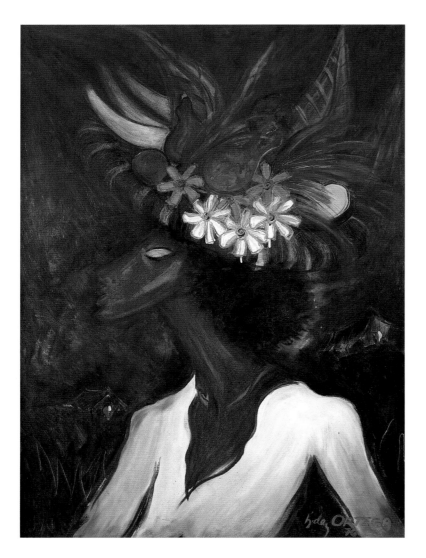

107. Gilberto Hernández Ortega – Sin título (Untitled), 1976. *oil on canvas, 117 x 88 cm. Museo Juan José Bellapart, Santo Domingo*

Dominican Republic

Dominican government, Trujillo began a slaughter of Haitians in the Dominican Republic which horrified the civilized world.

In addition to being a period of human rights abuse, the Trujillo era was one of economic expansion. As has happened throughout history, both the visual arts and literature, whose evolution is often stimulated by the tensions experienced by society, flourished during these troubled times. In the 1930s three artists arose who were important for the development of a recognizably 'Dominican' spirit in painting. Yoryi Morel (1901–78) developed an Impressionist mode in his painting, as seen in the 1948 canvas *A la fiesta* (*At the Fiesta*; fig. 105). Jaime Colson (1901–75) worked in what could be described as a neo-classical Surrealist manner, as in the 1937 painting entitled *Merengue* (fig. 106). The career of Darío Suro (b. 1917) was more complex, passing through phases of Impressionism, neo-realism and, finally, abstraction. Each of these masters integrated into his art recognizable racial types and references to Dominican geography and popular customs as well as the light and colours of the island.

From 1940 onwards Spaniards fleeing the Civil War in their country and Jews seeking asylum from persecution by the Nazis were welcomed as refugees in the Dominican Republic. Among them were several artists of note who soon made a place for themselves in the panorama of Dominican art. They included José Gausachs (1889–1959), Eugenio Fernández Granell (b. 1912) and José Vela Zanetti (b. 1913), among others. Their impact on Dominican painting in the 1940s was, in some cases, considerable.

Trujillo agreed to the founding of the Escuela Nacional de Bellas Artes (ENBA) in 1942 (the same year as the first of the Bienal Nacional exhibitions was inaugurated). This was the first art school to function as a true academy, offering its pupils a complete curriculum of art education. Dominican artists such as Morel, Colson, Suro and Woss y Gil, who had already become instrumental in promoting modern styles of painting, joined the faculty of the school.

Among the first artists to emerge from the ENBA were Gilberto Hernández Ortega, Marianela Jiménez (b. 1925), Antonio Prats-Ventós, Luichy Martínez Richiez and Clara Ledesma (b. 1924). They joined a core of painters, sculptors and draughtsmen trained at the Escuela who expressed the contemporaneity of their art through images of street vendors, practitioners of sorcery, blacks and mulattos, all painted with a visual vocabulary derived from their adaptations of stylistic forms that had emerged somewhat earlier in Europe. These artists created a vision of Dominican modernity based upon their own fantastical vision of the terrors of living under a harsh dictatorship.

The most prominent figures of this group were the painter and draughtsman Gilberto Hernández Ortega (1924–79), disciple of the Catalan artist Gausachs, and Woss y Gil. Hernández Ortega began his career as a painter of realistic scenes, switching later to what might be called a Magic-Realist mode similar to that of many Latin American artists who exaggerated the mundane qualities of everyday imagery, adding to them a note of the unreal, improbable, or 'super real'. In many of his images the human figure appears to be enveloped by the landscape. In his art of this period, close in style to that of Cuban artist Wifredo Lam, Hernández Ortega employed a type of bravura brushwork akin to that of such a Baroque artist as Peter Paul Rubens. This characteristic is present in his untitled composition of 1976 (fig. 107). During the 1960s Hernández Ortega became director of the Escuela Nacional de Bellas Artes.

The rise of Abstract Expressionism in the Dominican Republic could be seen as a way of registering dissent over the humiliation and repression of the dictatorship which, especially in its later years, effectively prevented artists from expressing social or political realities in their work. The first exhibition of abstract art to be held in the Caribbean took place under the directorship of Joseph Fulop (1898–?) in Santo Domingo in 1945. A German-Jewish painter and professor at the newly opened Escuela Nacional, Fulop remained in the country with his wife, the painter Mounia L. André (1911–?), until 1949.

The artists who emerged in the Dominican Republic in the 1950s all embodied a serious commitment to modernism in their work. Cubism was one of the styles that most appealed to them and it was developed with enthusiasm by many. They did not paint, however, in simple imitation of the Europeans who had developed Cubism many decades earlier. Instead, they infused it with elements borrowed from Africa or the geometric qualities found in pre-Columbian art. Among these artists were Eligio Pichardo, Paul Giudicelli, Domingo Liz, Fernando Peña Defilló, Silvano Lora, Gaspar Mario Cruz, Antonio Toribio, Ada Balcácer and Guillo Pérez.

Almost all of these young artists of the 1950s exiled themselves from the Dominican Republic at one point or another, finding homes in Madrid, Paris, London, New York and other cities. Before this dispersion began, however, Eligio Pichardo (1930–84) and Paul Giudicelli (1921–65) had established a distinctive approach to modernist representation. Both of these men

Dominican Republic

were firmly trained in the academic manner but soon departed from traditional representationalism in their many paintings derived from recognizably national subject-matter. Giudicelli based many of his canvases on geometric abstract principles. Pichardo created exaggerated geometric–Expressionist images. These were the fruits of a visual dialogue between the art of the European painters who had settled on the island in the 1930s and 1940s and the Dominican artists who had begun to discover the inherent beauties of their native country.

El sacrificio del chivo (*The Sacrifice of the Goat*, 1958; fig. 110) by Eligio Pichardo, a work bordering on geometric abstraction through its reduction of the figures to planes, won the First Prize for Painting at the 1958 Bienal Nacional. Based on the representation of a popular ritual in which the misery of much Dominican life is implicit, this painting marked a watershed in Dominican art and was highly influential for the subsequent development of painting.

In his art Giudicelli (who painted with pigments of his own making) often employed motifs derived from the pictographs of the Taíno Indians, the island's original inhabitants. He created a body of work dealing with the national past, yet at the same time experimenting with geometric abstraction. In his 1958 painting *El soldado que hirió a Cristo* (*The Soldier who Wounded Christ*; fig. 109) texture and colour are used to dilute the geometric structure, making the viewer feel the red of the blood. The painting of Giudicelli (who never left the Dominican Republic) was highly innovative and seriously studied by younger painters who were interested in both his subjects and techniques.

The sculptors Antonio Prats-Ventós, Luichy Martínez Richiez, Antonio Toribio

(b. 1934) and Domingo Liz (b. 1931) also worked in abstraction during the 1950s. Prats-Ventós (b. 1925), who influenced many younger sculptors during his long career, remained faithful, in his stone, wood and metal pieces, to a type of organic abstraction. The spiritual qualities of his art are perfectly embodied in his 1979 sculpture entitled *Familia* (*Family*; fig. 108). Sensuously defined totemic images characterize the sculpture of Martínez Richiez (b. 1926).

The modern spirit in Dominican art, initiated in the 1940s, was consolidated in the 1950s. The 1960s represented a period of transformation throughout the world. In the Dominican Republic three important political and social changes occurred, contributing to a general metamorphosis: the assassination of the dictator Trujillo in 1961, the fall, in 1963, of the first democratically elected government, headed by the writer and politician Juan Bosch, and the Revolution of April 1965 which erupted out of a demand for a return to the constitutionality represented by Bosch. The major consequence of this revolutionary movement was the second intervention in the Dominican Republic by the United States, which lasted from 28 April 1965 until 21 September 1966.

Industrial and commercial growth due to the development of the import–export business paralleled a marked polarization of leftist and rightist politics. The brief duration of the governments between 1961 and 1966 was the clearest indicator of a society in a convulsive transitional state. The first demands for liberty gave way to a call for social justice. In the elections of 1966, Joaquín Balaguer, an intellectual who had collaborated with the past regime, rose to power where he remained during three lengthy periods of presidential tenure between 1966 and 1978,

108. ANTONIO PRATS-VENTÓS – FAMILIA (FAMILY), *1979. mahogany, 54 x 26 x 26 cm. collection of the artist*

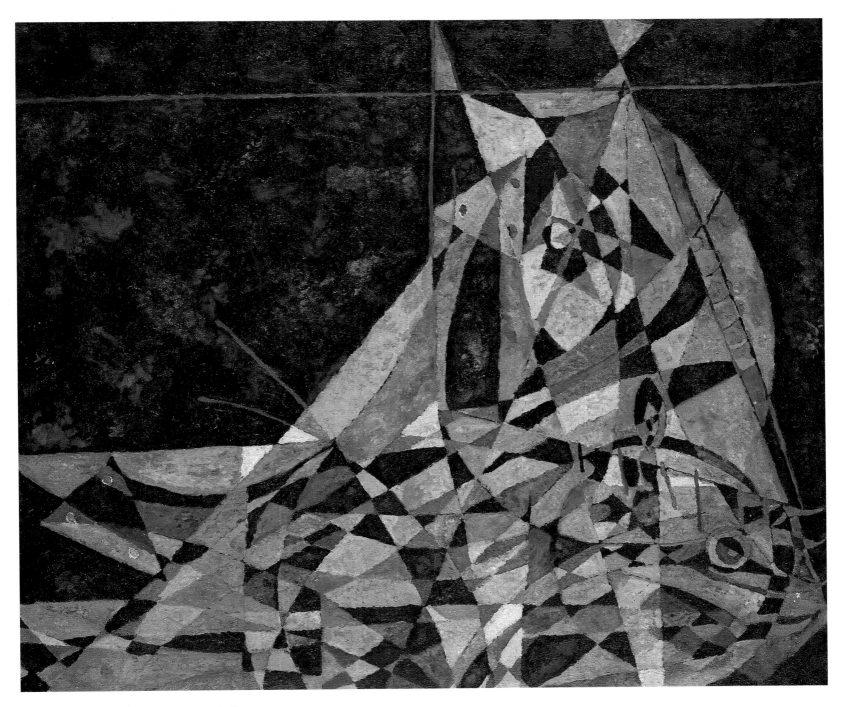

109. Paul Giudicelli – El soldado que hirió a Cristo
(The Soldier who Wounded Christ), 1958. *mixed media
on canvas, 90 x 100 cm. private collection, Santo Domingo*

110. Eligio Pichardo – El sacrificio del chivo
(The Sacrifice of the Goat), 1958. *oil on canvas,
117 x 154 cm. Museo de Arte Moderno, Santo Domingo*

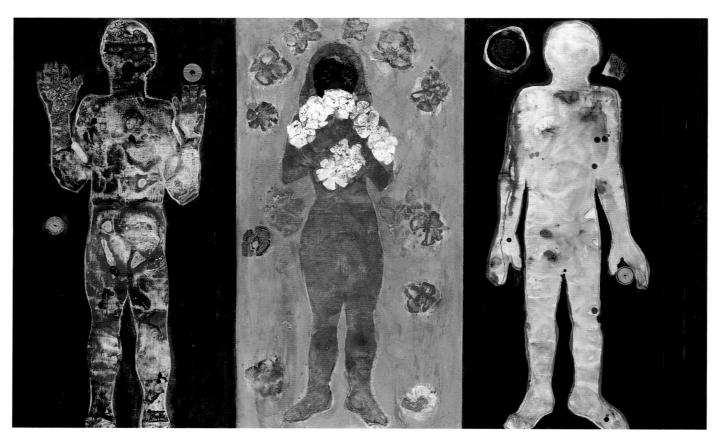

111. Fernando Peña Defilló – La ofrenda (The Offering),
1993. oil and acrylic on canvas, 126 x 166 cm. private collection

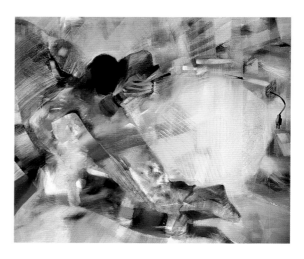

112. Domingo Liz – Ciclista (Cyclist), 1994. acrylic on
canvas, 76 x 102 cm. collection of the artist

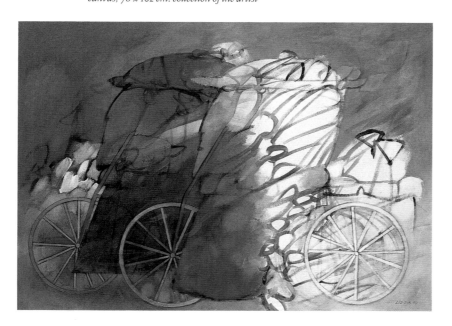

113. Ada Balcácer – Anunciación de la luz
por micrófono (Annunciation of the Light by
Microphone), 1993. mixed media and relief on canvas,
154 x 180 cm. collection of the artist

Dominican Republic

spearheading the transition from dictatorship to democracy.

Dominican artists, most of whom identified with the oppressed classes, were an integral part of this process. Since the assassination of Trujillo, both self-taught and academically trained artists participated in creating a new tradition of (often huge) political posters and banners replete with striking images executed in markedly Expressionist or social-realist idioms. Faces contorted in pain, hands holding rifles raised in defiance, mothers with dead children in their arms and cityscapes with buildings in flames were the hallmarks of this mode.

The 1960s was also an era of artistic and intellectual openness. Until then the Escuela Nacional de Bellas Artes had largely set the parameters for art. From now on, artists of greater spontaneity began to play roles as important as those of the academicians. At the time of Trujillo's death those artists who had gone into voluntary exile returned and were reintegrated into the artistic life of the nation, contributing to it an up-to-date version of the artistic trends that they had observed in the large cities of Europe and North and South America.

Fernando Peña Defilló (b. 1928) and Silvano Lora (b. 1931) worked in the Informalist abstract manner of Paris and Madrid and brought these new tendencies back to the Dominican Republic. Their art experienced a rather dramatic shift towards figuration, however, when confronted with the political and economic turmoil of their country.

Peña Defilló has been profoundly concerned with popular syncretism as practised by black and white cultural groups on the island. Working in both abstract and figurative styles, he creates images of spiritualized figures in his large-format canvases where texture plays a key role. An example of this is his 1993 painting *La ofrenda* (*The Offering*; fig. 111).

Gaspar Mario Cruz (b. 1929) and Domingo Liz, both sculptors (Liz is also a painter and draughtsman), remained in the country and developed a body of work with strong references to life in the Dominican city and countryside. Cruz evolved a personal system of syncretistic mythology expressed in totemic images. In his abstract sculpture, Liz devised an organic-mystical synthesis of diverse elements. In his drawings and paintings, however, he continued to employ the figure (depicted in a mode ultimately related to Cubism) in images such as his 1994 canvas entitled *Ciclista* (*Cyclist*; fig. 112) which are sharp critiques of the social ills of the cities' *barrios* (working-class neighbourhoods).

Guillo Pérez (b. 1926), from the city of Santiago de los Caballeros, was a student of Yoryi Morel. For many years he worked in an Abstract Expressionist mode. He has recently turned towards figuration, working in a style which he has defined as 'tropical structuralism'.

Ada Balcácer (b. 1930), painter and printmaker, returned from New York in 1960 to the Dominican Republic where she practised her art and also became active as a teacher. In 1965 Balcácer began her series known as *Bacá*, based upon a popular myth symbolizing oppression and abuse. Bacá is a man who is turned into an animal in order to guard the possessions of the landowners, attacking or killing any intruder. After this work, Balcácer's canvases depicted local flora in an expressive manner which displayed a deeply conceptual approach to tropical light, as in her 1993 canvas *Anunciación de la luz por micrófono* (*Annunciation of the Light by Microphone*; fig. 113).

The painters whose careers developed in the 1960s interacted vigorously with those who had come to the fore in the previous decade. In general, Dominican painting of the 1960s can be characterized as possessing a strong figurative Expressionism coupled with a dramatic use of colour to define themes with serious social content. During this time the number of artists also increased. Later, however, the Escuela Nacional de Bellas Artes began to decline and the Bienal Nacional exhibitions were suspended from 1963 to 1972. The E. León Jiménes Art Competition (which served as something of a private biennial) operated between 1964 and 1971, starting up again in 1981. In 1971 the Universidad Autónoma de Santo Domingo created its department of art.

The need for change compelled artists to experiment in areas which had already been developed abroad: Informalist abstraction, collage and other techniques. For the first time the national traditions forged by Morel, Colson and the Europeans working at the Escuela Nacional de Bellas Artes and which had been transformed by artists such as Suro, Hernández Ortega, Giudicelli, Eligio Pichardo and others, were intentionally subverted. The artists' group known as Proyecta incorporated both younger and older artists, including Balcácer, Liz, Cruz and Peña Defilló (more often associated with the 1950s) and Ramón Oviedo, Félix Gontier, called Cocó (b. 1941), Thimo Pimentel (b. 1941) and Leopoldo Pérez, called Lepe (b. 1938), (representative of the 1960s) in a search for new forms of expression. The 1960s and 1970s saw the emergence of social Expressionism, Informalist abstraction and post-Picasso neo-classicism.

Ramón Oviedo (b. 1927), a self-taught painter and muralist, and José Rincón Mora

Dominican Republic

(b. 1938), painter, printmaker and designer of stained glass, emerged from the ENBA in 1962. Both created in their art terrifying simulacra of the fear and death that were part of everyday life in the post-Trujillo era. Dramatic figures defined by strong colouring characterize the work of Oviedo, who has consistently employed social criticism in his art. In his latest pieces, geometric forms and references to Taíno Indian themes make their appearance, as in the 1994 *Baiohabao* (fig. 114). In the Expressionist work of Rincón Mora we observe gestural energy, suggestions of movement through colour, the use of gold, cross shapes and thick areas of black, as in his untitled painting of 1988 (fig. 115).

Iván Tovar (b. 1942), also a former student at the ENBA, went to Paris where he stayed for twenty years, gaining a reputation as one of the most significant Neo-Surrealists. Cándido Bidó (b. 1936) and Elsa Núñez (b. 1943), students of Gilberto Hernández Ortega at the ENBA, are also outstanding artists. Bidó is well known for his genre paintings in which he depicts the classic working-class types. Núñez has often painted the female form. In her early years she employed a dramatic figurative Expressionism, whereas she has recently developed a more lyrically abstract mode in which the figure and the landscape are blended together. In the city of Santiago de los Caballeros, Danilo de los Santos, called Dánicel (b. 1944) also paints women – often the large bulky forms of peasant women of African descent – defined with a poetic aura. He is currently engaged in creating sculpture and installations in a geometric mode, imbuing them with references to ritualistic practices. The depictions of the types of people seen on the streets of Dominican cities as well as the urban views of José Cestero (b. 1937) are executed

in a Neo-realist or even Post-Impressionist manner. Jorge Severino (b. 1935) creates images of Afro-Caribbean women based on Pop as well as Art Nouveau styles. The work of all of these artists demonstrates the diversity of artistic languages produced during the 1960s.

Soucy Pellerano (b. 1928) studied with Paul Giudicelli, from whom she absorbed much about the geometric structure of art. In 1978 this painter and teacher revolutionized Dominican sculpture when she created her *Maquinotrón* (*Machineotron*), a gigantic movable assemblage made from discarded metal. She has also been a pioneer in the arts of installation (fig. 116) and stage design in the Dominican Republic.

The transition from the legacy of the Trujillo dictatorship to democracy continued throughout the mid-1970s, when a wide variety of changes occurred in Dominican society. These transformations were signalled by the massive migration of farmworkers to the city, the growth of industry and the privatization of many businesses, the increase of facilities for education, agrarian reform and the building of new housing. The steady rise of the middle class occasioned a greater demand for consumer goods, including works of art, stimulating the growth of the art market and accounting for a larger number of practising artists.

The artists of this period formed themselves into distinct groups: Reflejo (1971), Atlantes (1972) and Grupo 6 (1976). The Reflejo Group reaffirmed academic values; its most outstanding members were the printmaker Rosa Tavárez and the sculptor Joaquín Ciprián (b. 1950) who works in bronze, creating solid large-scale figures. The Atlantes group was founded to bridge the gap between academics and self-taught artists; its leader, Alberto Bass

(b. 1949), studied at the Art Students' League in New York and was the first to develop the photo-realist style. The Grupo 6 was established to promote artistic co-operation; its members included José García Cordero (b. 1951), Manuel Montilla, Alberto Ulloa (b. 1950) and Alonso Cuevas, all of whom went to Madrid and Paris. García Cordero works in a fantastic-realist mode, while Manuel Montilla (b. 1948) creates surreal images with symbols of childhood as well as references to Taíno culture. Alonso Cuevas (b. 1953) produces enormous abstract canvases in which he features ethnic symbols.

Among other artists of the 1970s is Vicente Pimentel (b. 1947), an abstract painter and former professor at the ENBA. He currently lives in Paris and is known for his paintings that constitute a philosophical commentary on the black culture of the island. José Perdomo (b. 1943) lived in the United States and returned to the Dominican Republic at the beginning of the 1980s as a creator of Abstract Expressionist paintings with strong colouring. He later included figurative elements derived from Taíno symbolism.

Among other figurative painters are Fernando Ureña Rib (b. 1951), Dionisio Blanco (b. 1954) and Antonio Guadalupe (b. 1941). José Miura (b. 1948) has worked in both figurative and abstract modes. These artists, all of whom have been inspired by Colson, Giudicelli and Pichardo, have developed along diverse paths.

The renaissance of printmaking owes much to the efforts of Rosa Tavárez (b. 1939), who developed aggressive images relating to the subjugation of women and political oppression. Professor of graphic arts at the ENBA, Tavárez has taught some of the most outstanding printmakers of the younger generation.

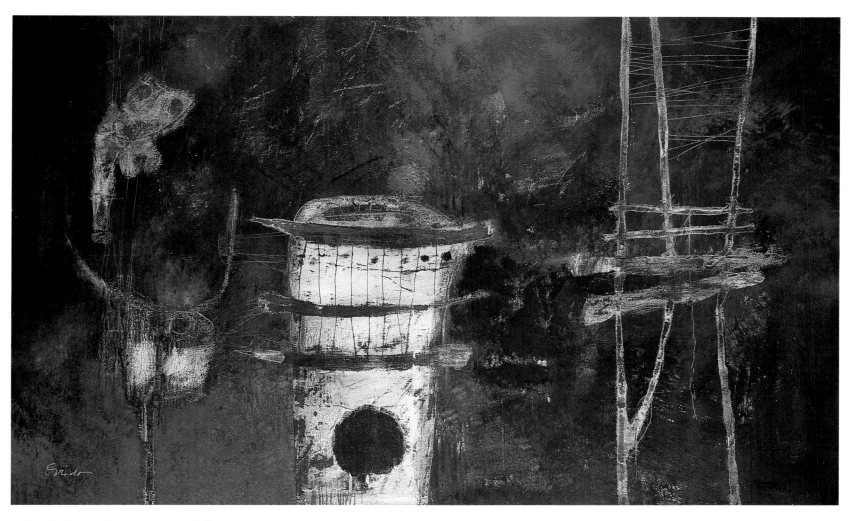

114. Ramón Oviedo – Baiohabao, 1994. *mixed
media on canvas, 50 x 80 cm. private collection*

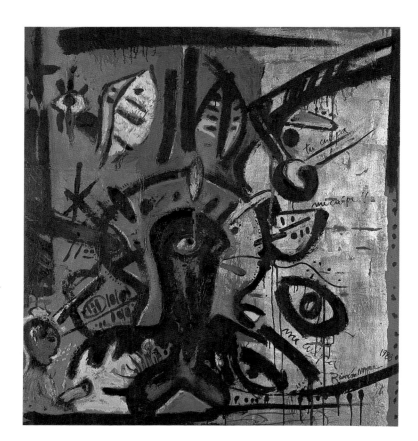

115. José Rincón Mora – Sin título
(Untitled), 1988. *mixed media on canvas,
105 x 100 cm. private collection*

Dominican Republic

During the 1970s Dominican artists returned to figuration. Much stimulus came from the sudden development of the gallery system, establishing the making of art as a commercial venture in the seventies and especially in the eighties when a number of art schools and private art academies were opened.

In 1978 the democratic PRD (Partido Revolucionario Dominicano) Party came to power and retained its authority until 1986 under the rule of various presidents. The PRD promoted liberal economic policies. In the 1980s the middle class sought alternative sources of income; among the most popular was tourism. The decade also saw a large migration of the working classes to the United States, while Haitian labourers entered the Dominican Republic at ever-increasing rates, fleeing the traumatic social and economic conditions in their country.

The art market flourished in this atmosphere. The price of paintings soared, creating a marked disparity between this and other forms of art. Poor-quality painting proliferated, responding to the demands of the market. Serious artists were overshadowed by those who produced purely commercial work. Those who remained faithful to aesthetic integrity sought to create art with an aggressive visual and symbolic impact, experimenting with a wide variety of media including site-specific installations and sculptures both movable and penetrable, relief and ceramic.

The national biennial exhibitions expanded their categories, admitting both video and (as of 1984) architectural projects. In La Romana, a province in the eastern part of the Dominican Republic popular with tourists, the Gulf & Western Corporation opened a School of

116. Soucy Pellerano – Estructo-palanca-maquinorum, 1990. iron, aluminium and rubber, 225 x 450 x 200 cm. Museo del Hombre Dominicano, Santo Domingo

117. Carlos Despradel – Ataduras (Cords),
1990. ceramic and rattan, 90 x 45 x 45 cm. collection
of the artist

Dominican Republic

Design and an exhibition hall with modern facilities and international connections. The old state institution, ENBA, continued to exist in a reorganized form, yet lack of funds and materials threatened its vitality.

Carlos Despradel (b. 1951) studied at the Escuela de Diseño in Altos de Chavón as well as in Italy, becoming the country's first ceramic sculptor. His work combines organic elements with religious imagery, reminding us of the vessels of the extinct indigenous population of the island. His 1990 ceramic and rattan sculpture entitled *Ataduras* (*Cords*; fig. 117) is a good example of his art. Carlos Santos (b. 1956), painter of over-sized geometric canvases, has become the leader of his generation's abstractionists. The importance of matter in his paintings is attested to by the 1988 work *Presencia* (*Presence*; fig. 118). Working in a neo-figurative mode with a strong drawing base, Jesús Desangles (b. 1961) merges both Greco-Latin and African references in his art, at the same time evoking Taíno shamans and contemporary television personalities. His painting suggests a ritual dialogue between man, animal and nature.

Interest in installation as an art form was stimulated in the Dominican Republic through the pioneering efforts of Geo Ripley (b. 1950) and Soucy Pellerano and through those of the Argentine artist Leopoldo Mahler, who had been director of the Escuela de Diseño de Altos de Chavón since it was established in 1983, remaining in this position until 1985. Among the younger artists who have worked in this mode are Belkis Ramírez (b. 1957) and Tony Capellán (b. 1955). Ramírez is principally a printmaker who employs this medium in her installations. Her figurative work criticizes the marginalization of women in Latin countries, as may be observed in her installation *Intolerancia* (*Intolerance*) of 1994 (fig. 119).

The decade of the 1990s represents another era of political crisis. Joaquín Balaguer, leader of the Partido Reformista, returned to power for several consecutive terms (beginning in 1986), maintaining a conservative economic–political stance and commissioning, at the same time, sumptuous official architectural projects. Tourism has continued to flourish in the Dominican Republic and tax-free zones have been established. Art created to respond to the needs of the tourist industry has threatened the integrity of numerous young artists' work, causing understandable tensions. It is the older artists, of the generation that arose in the 1950s and 1960s, who have most vigorously resisted the demands created by indiscriminate consumerism. Serious art criticism in the Dominican Republic has existed since 1940, with the writings of Díaz Niese and Manuel Valldeperes. Today, despite their limited audience, art critics play an important role in maintaining a critical dialogue among the visual arts.

In the early 1990s the Dominican economy became centred upon tourism, communications and duty-free zones. The currency was stabilized, customs duties were slowly eliminated and the nation entered, little by little, into a free-market system. International corporate chains began to appear and a system of tax exemptions was adapted in the commercialization of goods and services. The energy crisis became acute, and there was a shortage of drinking water and a breakdown of garbage disposal. The population became more economically divided, which affected both the middle class and the art market. Internalization had an effect on artistic production. The presidential elections of 1994 were declared invalid and a political solution was evolved whereby the new term of President Dr Balaguer would last for only two years, while new elections were being planned.

At the beginning of the 1990s the Balaguer government, realizing the value of art as a tool of propaganda, started to use the Galería de Arte Moderno (now the Museo de Arte Moderno or MAM) in Santo Domingo as a base for operations. In 1992 the Bienal del Caribe was established and the Premio Nacional de Artes Plásticas (National Visual Arts Prize) was instituted the following year. The first Bienal del Caribe was held at the same time as the nineteenth Bienal Nacional. The latter event was seriously jeopardized by a controversy arising from irregularities on the part of the authorities of the MAM regarding the final recognition of the awards given by an independent jury. These problems were exposed by the sculptor Domingo Liz, who published his doubts about the ethics of the competition in the press. Over forty well-known artists subsequently denounced the enterprise, proposing an abstention from the activities of the Museo de Arte Moderno where the Bienal Nacional was held. This protest was ignored by the Government.

Despite these difficulties, Dominican art has recently found new outlets abroad for its endeavours. The number of exhibitions of Dominican artists in Puerto Rico, New York, Miami, Mexico and Europe is growing. At the end of the twentieth century it is possible to say that Dominican artistic activities have become sufficiently diversified to reflect a serious interest in innovation and experimentation that characterizes our age. Painting, however, is still the country's most favoured medium.

118. CARLOS SANTOS – PRESENCIA (PRESENCE),
1988. oil, sand and varnish on canvas, 102 x 127 cm.
private collection, Santo Domingo

119. BELKIS RAMÍREZ – INTOLERANCIA (INTOLERANCE),
1994. installation, wood and stone, 244 x 290 x 168 cm.
collection of the artist

Puerto Rico

LATIN AMERICAN ART IN THE TWENTIETH CENTURY

Enrique García-Gutiérrez

Puerto Rico

In 1898, when Francisco Oller y Cestero (1833–1917) took refuge with his family in the Hacienda Aurora (fig. 120), fleeing the invading United States troops, he probably had no idea of what the nation's future would be. He also could not know that, in painting this scene, he was creating an image that would become identified with the beginnings of art on the island of Puerto Rico.[1] It would come to be an icon in the search for, and definition of, national and cultural identity.

The consequences of the invasion are well known. After the end of the Spanish–American War, Puerto Rico passed to United States control as war booty. This marked an end to four centuries of colonial domination by Spain. It also signalled the beginnings of colonial status under the United States. Although some Puerto Ricans undoubtedly hoped that the island would gain independence, few were able to predict the unfortunate socioeconomic and political changes caused by the exploitation of the island by the United States during the first four decades of the twentieth century. Puerto Ricans had been granted US citizenship in 1917 yet it was not until 1948 that the island had a Puerto Rican governor. The nation achieved 'Commonwealth' status in 1952, by which it was granted internal democratic self-government, while ultimate legislative authority remained in the hands of the United States Congress in Washington.

It was not until the 1940s that the real history of modern art in Puerto Rico began. Two separate factors were fundamental in determining the definition of Puerto Rican art: the ambiguous political relationship with the United States and the geographical position of the island, the smallest of the four Greater Antilles and, ever since her discovery in 1493, coveted by larger powers for her strategic position as a choice site for military installations.

The Beginnings of Puerto Rican Art

In 1862 Francisco Oller was living in Paris where he established a friendship with Paul Cézanne who had recently arrived in the French capital from Aix-en-Provence. Among Oller's other artist friends at the time were Camille Pissarro, Claude Monet, Antoine Guillemet and Antoine Guillaumin.[2] This was Oller's second trip to Europe. He had spent the years 1851–3 in Madrid, studying at the Real Academia de Bellas Artes de San Fernando under its director Federico de Madrazo. Yet during this first Paris sojourn he became intimately acquainted with some of the principal artists of the avant-garde and showed two of his works with them in the Salon of 1865. Although he returned twice to Paris (in 1874–8 and 1895–6), it was this first trip which helped to form the intellectual and aesthetic approach that characterized his art for the rest of his life. Oller's main source of influence did not come from the French painters mentioned above but from the master of nineteenth-century realism, Gustave Courbet. He identified himself as a disciple of Courbet, whose socially engaged principles would be at the heart of Oller's concerns thereafter.[3]

Among the numerous works by Oller painted in the Impressionist style – and especially his landscapes such as the *Hacienda Aurora, c.*1898–9 – his representations of nature were linked to 'the good of humanity' and not to any dissident or revolutionary formal modes of the avant-garde painters of the day. The work in which Oller shows himself most faithful to the canons of mid-nineteenth-century realism is his impressive painting (considered by many to be his masterpiece) entitled *El velorio* (*The Wake*) which he showed at the Paris Salon of 1895. Unique in his *œuvre* for its monumental proportions, *El velorio*, which depicts the wake of a small child in the Puerto Rican countryside, was clearly intended as a manifesto of the painter's intellectual and artistic concerns.

More than Oller the painter, it was Oller the abolitionist, the reformer, the educator and the man of culture who struggled against social ills and who is reflected in this painting. The creative focus of his art was inseparable from the didactic mission which, for Oller, was the true responsibility of art. It was also the authentic beginning of Puerto Rican painting.

The events of 1898 not only dashed hopes of the autonomy for which Puerto Ricans had been fighting throughout the nineteenth century. The autonomy that the Spanish government had been obliged to grant to Puerto Rico, only one year before the American invasion, became a dead issue after the Spanish–American War, which turned the country into a state marked by an 'imperialism of abandon', in the words of historian Gordon K. Lewis. Puerto Rico then felt the effects of excessive power wielded by corporations far removed from the island, the insensitive political agenda of Americanization and disconcerting social problems such as growing unemployment, poverty, poor health and living conditions as well as emigration.[4]

Within this panorama it is not difficult to understand the virtual lack of artistic production in Puerto Rico after the death of Oller. His efforts to develop art schools and the means of studying the visual arts bore little real fruit. Among the few who could be considered his followers were those who chose to continue painting in an

120. Francisco Oller y Cestero –
Hacienda Aurora, c.1898–9. oil on
board, 30.5 x 55.8 cm. Museo de Arte de Ponce

academic realistic mode which was essentially a
nineteenth-century style, such as Ramón Frade
León and Miguel Pou Becerra.

In 1904–5 Frade (1875–1954) painted his
El pan nuestro (*Our Daily Bread*; fig. 121) and
submitted it for a government fellowship which
would consist of 'a pension of sixty dollars per
month, for five years … to travel to the city of
Rome with the intention of studying and perfect-
ing my efforts in the art of painting'.[5] His petition
was denied, but two years later he was able to go
to Rome for four months. Since the nineteenth
century, the image of the *jíbaro* – the peasant of
the hills – was identified with that of Puerto Rico
itself. In *Our Daily Bread*, Frade extends to the
bananas (the staple of the *jíbaro* diet) that the
poor man carries the symbolic power of a
suffering people, which is embodied in the man
himself. His presentation as a monumental
form, silhouetted against the earth with which
he is identified, gives this humble character a
heroic quality. As is the case with Oller's *The
Wake*, Frade's picture has become the subject of
many reinterpretations and appropriations up to
the present time, all of which reaffirm its status
as a national icon of an agrarian society which
had disappeared by the second half of the
twentieth century.

In *La promesa* (*The Promise*; fig. 122) of
1928 by Miguel Pou (1880–1968), the feminine
counterpart to the *jíbaro* is seen in a woman with
an intense gaze, carrying an image of the Virgin
of Mount Carmel. Her simple habit-like dress
suggests that she has made a promise to the
Virgin for a favour received by her. Popular reli-
gious fervour, the source of both resignation and
hope, is personified in this work, which evokes
the generations of Puerto Ricans who wait for a
miracle to relieve them from their abject misery.

121. Ramón Frade – El pan nuestro (Our Daily Bread), c.1905.
oil on canvas, 152.2 x 98.3 cm. Instituto de Cultura Puertorriqueña, San Juan

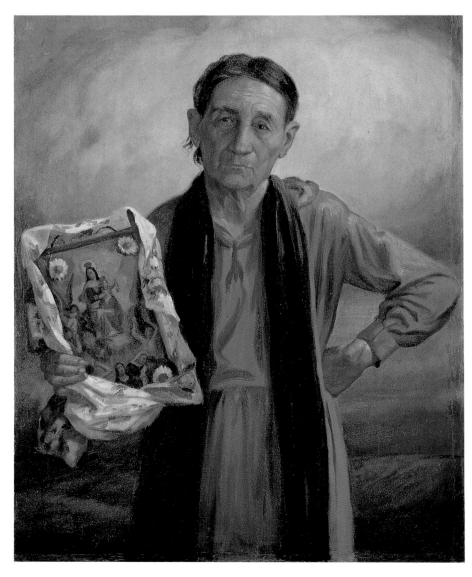

122. MIGUEL POU – LA PROMESA (THE PROMISE), 1928.
oil on canvas, 64 x 52.6 cm. Museo de Arte de Ponce

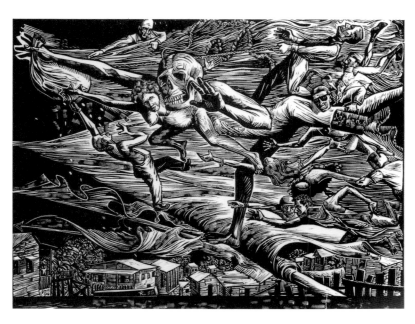

123. CARLOS RAQUEL RIVERA – HURACÁN DEL NORTE (HURRICANE
FROM THE NORTH), 1955. linocut, 30.8 x 40.5 cm.

Puerto Rico

The contrast between the grimy reality experienced by this woman and celestial beauty is suggested by the halo-like configuration of clouds that surrounds her.

Puerto Ricans were not given the opportunity to see twentieth-century art on the island until the 1930s, and this was thanks to the initiative of Walt Dehner, an American painter and art teacher. The exhibitions he organized at the University of Puerto Rico, in which the works of such artists as Picasso, Joan Miró, Stuart Davis, José Clemente Orozco, Diego Rivera and David Alfaro Siqueiros, as well as that of the Puerto Ricans José Campeche and Oller, were presented for the first time on the island, succeeded in attracting thousands of spectators.[6] However, it was only thirty years after the first exhibition of Puerto Rican painters held in 1936 (in which sixty artists participated) that a real relationship was established between what was happening on the island and any of the avant-garde movements of the twentieth century.

The 1930s were difficult years, plagued by the effects of the Depression. There were, none the less, some artists who were able to take advantage of scholarships offered by the Americans which allowed them to travel and study abroad. Due to the many radical political changes that took place in Puerto Rico after 1948, the year the island elected its first Puerto Rican governor, Luis Muñoz Marín, a new artistic personality was able to emerge on the island, forming the basis for an authentic form of national expression.

The First Artistic Movements in Puerto Rico: 1948–1968

The plan for industrial development, begun in 1947 under the name Operación Manos a la Obra (Operation Bootstrap), was responsible for the phenomenon of industrialization that transformed Puerto Rican society from rural-agrarian to one defined by large urban concentrations. As part of the project the Government established, in 1949, the División de Educación de la Comunidad (Division of Community Education or DIVEDCO), bringing together artists of different disciplines (writers, painters, photographers and cineastes) in order to produce illustrated books, posters and films that would help to educate the rural population during these difficult years of social change. DIVEDCO was one of the principal focal points of group work from which socially committed art emerged. Oller would have heartily approved of these efforts in the fields of silk-screen posters, woodcuts and linocuts which reached a high point with the work of the artist members of this governmental institution.

Operation Bootstrap commissioned murals in factories and government buildings, and its efforts were principally aimed at a mass public that had been marginalized from an élitist society.

The rise of art as a means of education and as a conduit to the realization of a national cultural heritage accounted for the creation of institutions such as the Museum of Anthropology, History and Art of the University of Puerto Rico, established by the Puerto Rican legislature in 1952. The Institute of Puerto Rican Culture was created to safeguard the island's cultural patrimony and to promote art in general. In terms the of visual arts, the Graphic and Fine Arts Workshops were able to offer training to any artist who wished to participate. A sign of the times was the return to the island of Puerto Ricans living abroad, who came back to offer their services in the creation of forms of contemporary art for the new society then emerging.

Lorenzo Homar, born in San Juan in 1913 (while Oller was still alive), left for New York with his family during his adolescent years. He returned in 1950 with a solid background learned between the ages of twenty-four and twenty-nine while a student at the Art Students' League and the Pratt Institute. His apprenticeship as a jewellery designer with Cartier was interrupted by four years in the US Army, and he completed this while pursuing his artistic studies at the art school of The Brooklyn Museum.

Rafael Tufiño was born in New York City. Five years younger than Homar, he came to Puerto Rico in 1936 when he was eighteen. There he studied with one of the few art teachers in San Juan, the Spanish painter Alejandro Sánchez Felipe (1875–1971), an excellent draughtsman who taught many aspiring Puerto Rican artists of the time. It was in the commercial sign shop known as 'L'Atelier', established in 1922 as a means of livelihood by the Puerto Rican painter Juan Rosado, that Tufiño acquired the skills from which he made a living until his departure for Mexico after the Second World War. The influence of Mexican art and that of his teachers Alfredo Zalce (b. 1908) and Leopoldo Méndez (1902–35), which is seen in Tufiño's later work, is a result of his study of painting, graphic arts and murals before returning to Puerto Rico in 1950. An artist who also came back at this time was José Antonio Torres Martinó (b. 1916), who had attended the Pratt Institute and the school of The Brooklyn Museum. He studied mural painting with Rufino Tamayo and the Ecuadorian artist Camilo Egas and also took classes at the Academy of Fine Arts in Florence.

In 1950 Julio Rosado del Valle (b. 1922)

124. Lorenzo Homar – Homenaje a Julia de Burgos (Homage to Julia de Burgos), 1969. silk-screen print, 62 x 45.7 cm.

125. Rafael Tufiño – La Botella Jazz, 1963. woodcut, 78 x 34.2 cm.

126. Julio Rosado del Valle – Silla (Chair), 1993. silk-screen print, 142 x 95 cm.

Puerto Rico

and Félix Rodríguez Báez (b. 1929), among others, joined the artists mentioned above to organize the Centro de Arte Puertorriqueño (CAP). According to the text which accompanied its first portfolio of eight prints known as *La estampa puertorriqueña*, CAP aspired 'to achieve an intimate relationship between artists and the people of Puerto Rico, a link which is indispensable for the development of an authentic and vigorous artistic movement'. CAP, which in 1953 published a second portfolio of eight silk-screen prints called *Estampas de San Juan* (*Scenes of San Juan*), achieved its goal of identifying with the people of the island and the sociopolitical problems which they were experiencing. None the less its politicization led the Partido Popular, under the leadership of Luis Muñóz Marín – in whose hands the so-called 'economic miracle' of Puerto Rico remained – to accuse it of seditious activities, resulting in CAP's premature demise in 1954.

The majority of artists were not in sympathy with followers of the political stance of the Partido Popular Democrático or that of its leader. They aligned themselves instead with the independence movement or with the nationalist efforts of activist Pedro Albizu Campos. His image figured prominently in the work of Homar and many others at that time.

Perhaps it was *Huracán del norte* (*Hurricane from the North*; fig. 123) a linocut of 1955 by Carlos Raquel Rivera (b. 1923), another distinguished artist of his generation, which epitomized the collective ideas that were being developed in the new art forms created at this time. Before spending several months in 1950 taking classes at the Art Students' League in New York and ultimately joining the CAP, Rivera had studied for two years in the Edna Coll Academy in

Puerto Rico. In 1954 he visited Mexico and was profoundly impressed with the murals he saw there. At the same time he became acquainted with the most important collective graphic project in Mexico, the Taller de la Gráfica Popular. His interest in this group confirmed his own notion of art as an ideological tool.

The allegory represented by *Huracán del norte* is embodied in a figure with a skull for a head who drops coins from a bag in his right hand to the village below. His victims, whom he has snared with money, are entangled in a backcloth of vigorously waving flags. The dollar, the true hurricane from the north, betrays the noble ideals of those who give in to it. The powerful expression and mordant caricature of this clear, simple picture are enhanced by the dynamic drawing and strong diagonal lines representing the forces of destruction. This image was internationally recognized and was awarded a prize at the First Inter-American Biennial of Paintings and Graphics of Mexico in 1958.

Virtually all the artists who initiated the modern movement in Puerto Rico during these years were painters as well as graphic artists. While they had placed special emphasis on landscape in their work (the genre which Oller had elevated to the status of national icon), they eventually incorporated the urban cityscape into their repertory.

It was through the art of the poster that the essential qualities of new Puerto Rican art were expressed. The production of posters reached such a high level in both quality and output that they became not only a principal didactic tool but were collected avidly by many people who wished to decorate their surroundings with them. In 1957 Lorenzo Homar (who had won a Guggenheim grant the previous

year) organized and directed the Taller de Artes Gráficas of the Instituto de Cultura Puertorriqueña. It was there, under Homar's tutelage, that many of the most significant artists of the next generation were formed.

The relationship between graphic arts and painting is inextricable from this point onwards in Puerto Rican art. Silk-screen prints in particular, used as posters to announce cultural events such as plays, concerts and art exhibitions, or to celebrate the achievements of important figures in Puerto Rican history, far surpassed their original objective. Posters became a favoured means of artistic expression for many and, because of the reasonable cost, could be acquired by a new class of people who formed the basis of the market needed for the growth of this form of art. The success of the Puerto Rican poster was attested not only by the proliferation of graphics studios on the island but by the international reputation which it gained in this art form.[7]

The silk-screen print *Homenaje a Julia de Burgos* (*Homage to Julia de Burgos*) of 1969 (fig. 124), in which Lorenzo Homar honours the well-known Puerto Rican poetess, reflects the artist's reputation as a 'master among masters' in this area. It also exemplifies his talent in calligraphy and in the integration of text and image, so typical of virtually all Puerto Rican posters. The importance which Homar attached to colour, as well as his use of transparent and opaque tones, demonstrates his deep concern with the pictorial elements in his posters.

Woodcuts, the medium employed by the CAP in their first portfolio, have a parallel history in art after 1950. Rafael Tufiño's *La Botella Jazz* (1963; fig. 125) portrays a popular bar in Old San Juan and is representative of his depictions of

Puerto Rico

127. FRANCISCO RODÓN – LUIS MUÑOZ MARÍN,
1974–7. oil on canvas, 268 x 201 cm. Fundación
Luis Muñoz Marín, San Juan

quiet interiors and intimate scenes during the
first years of the 1950s (before which he had
mostly worked in linocuts). Woodcuts soon
became favoured by many younger artists who
had studied outside the island and who, upon
returning to Puerto Rico, began to work with
Homar in the DIVEDCO workshops; they came to
be known collectively as the Escuela
Puertorriqueña. Among the other artists of the
Puerto Rican School were Myrna Báez, Marcos
Irizarry and Antonio Martorell (b. 1939).

While it is true that until recently the
absence of professional art schools made it neces-
sary for artists to travel abroad in search of
instruction, it is equally important to recognize
the contribution of certain North American and
Spanish artists who came to Puerto Rico. Among
the most significant outsiders were Irene Delano
(1919–82), who had directed the DIVEDCO work-
shops before Homar took them over, and Carlos
Marichal (1923–69), who arrived in Puerto Rico
in 1949 and who, during the rest of his short
but prolific career, worked as a stage designer,
professor of art at the university and initiator of
a variety of the techniques of graphic arts later
taken up by Puerto Rican masters. Other distin-
guished foreigners included Cristobal Ruíz
Pulido (1881–1962) who, after 1938 and until
his death, lived in Puerto Rico as resident artist
at the University of San Germán and, later, at the
University of Puerto Rico in Río Piedras.

It was with Ruíz Pulido (an exile from the
Franco dictatorship in Spain) that Julio Rosado
del Valle first studied. After his early art lessons,
del Valle left Puerto Rico to study with the Cuban
painter Mario Carreño at the New School for
Social Research in New York. He later spent two
years (1947–9) at the Academy of Fine Arts in
Florence, a time during which he also travelled

128. Manuel Hernández Acevedo – La Plaza de Colón
(Colon Square), 1986. oil on board, 122 x 122 cm. Corporación
de Seguros Multiples de Puerto Rico, San Juan

throughout Europe. Rosado del Valle, like Francisco Rodón and Domingo García, preferred to work on his own, practising painting rather than graphic art.

The varied production of Rosado del Valle – drawings, graphic work, paintings and sculpture – reflected an affinity for analytic forms which is reminiscent of the work of Braque and Picasso as well as of the Mexican Rufino Tamayo. His highly keyed palette with its warm tonalities is employed to produce a dynamic in which figuration and abstraction always seem to be in competition with each other. This is a constant feature in his art, even in his most recent work, represented here by the 1993 *Silla* (*Chair*; fig. 126).

Domingo García (b. 1932) was born in Puerto Rico, although he was brought up in New York. He studied with the British painter William Locke at the National Academy of Design and later at the School of The Art Institute of Chicago. After returning to the island in 1958 he founded the Campeche Workshop and Gallery and acted as director during the ten years of its existence. The work of García has been consistently identified with the human figure, whether full-length or bust-length images, portraits or female nudes. His most recent work has included a series of idealized monumental portraits of mythical–historical figures from the history of Puerto Rico, in which he combines his singular capacity for drawing with aspects derived from North American Abstract Expressionism.

Francisco Rodón (b. 1934) is the Puerto Rican artist most closely associated with portraiture, often of monumental proportions. His portrait of Governor Luis Muñoz Marín of 1974–7 (fig. 127) is the culmination of an extraordinary series entitled *Personajes* (*Personages*)

which included notable figures in Latin American arts and letters such as Alicia Alonso, Jorge Luis Borges, Rubén Darío, Juan Rulfo, Marta Traba and Rómulo Betancourt.

Since the 1960s, when Rodón painted a highly successful series of still lifes, he has been able to make the surface of his paintings take on an intensity of light and colour which seems to create an architectural structure for the image. Whatever the subject of his paintings, all of his works appear to be imbued with a sense of psychological anguish or a search for retreat or privacy.

Among those artists associated with the Generation of 1950, Manuel Hernández Acevedo (1921–88) occupies a place of distinction as the most accomplished 'naïve' artist to have emerged in Puerto Rico. As a young man he moved from his home town of Aguas Buenas in the Puerto Rican mountains to San Juan where he worked as a caretaker in the Commission of Parks and Public Recreation which produced educational materials for the rural areas of the island. It was there, under the supervision of the painter Irene Delano (director of the Taller Gráfico), that Hernández Acevedo received his first lessons in painting and the techniques of silk-screen prints. He later worked with the artists associated with DIVEDCO. His oil painting entitled *La Plaza de Colón* (*Colon Square*; fig. 128) of 1986 is an eloquent example of his expressive, spontaneous work. This artist's favourite themes revolve around scenes of the old city – ancient buildings, children flying kites, red and purple cars, vendors, interior courtyards – and portraits of friends.[8]

Luis Hernández Cruz and Noemí Ruíz have been identified with abstraction since the beginning of their careers. Abstract art has tradi-

tionally been considered as inimical to Puerto Rican visual expression and, by the public at large, has often been thought to lack artistic and intellectual merit. Both Hernández Cruz, who from 1968 until 1993 was professor of art at the University of Puerto Rico, and Noemí Ruíz, who is currently teaching at the Inter-American University, made of their professorships vehicles for the promotion of abstraction in Puerto Rico.

In his paintings of the 1960s, Hernández Cruz (b. 1936) employed large areas of colour to give structure to the composition and evoke abstract landscape. He gave these works suggestive titles such as the 1961 *Landscape of Guajataca*. His so-called 'figure landscapes' are a blending of organic and geometric forms. In *Gran mangle* (*Great Mangrove*, 1993; fig. 128), we see local shrubs typical of the Puerto Rican coasts through a screen of vertical lines (a technique that lends a strong kinetic and optical effect to the work and has been used by this artist in some of his paintings of the 1990s). Suggestions of the figure have been emerging in Cruz's paintings throughout the past three decades and have become more pronounced during the last ten years. None the less, they remain masked by abstract structures. In collaboration with several other artists, including Lope Max Díaz (b. 1943), Antonio Navia (b. 1945) and Paul Camacho (b. 1929), Hernández Cruz formed the Frente group in 1977. In 1984 he was named president of the Abstract Artists' Congress, of which he was a founding member. Both of these organizations attempted to advance the much maligned cause of abstract art in Puerto Rico.

Noemí Ruíz (b. 1931) is one of the many important women artists who emerged in the 1960s. She developed a highly personal style in which the fusion of geometric forms with very

Puerto Rico

defined planes (yet with an organic, almost vegetal dynamism) is emphasized through spatial effects suggested by the play of monochrome tonalities with which she structures her works. *Mágia del trópico* (*Magic of the Tropics*; fig. 130) of 1993 is an excellent example of her recent art; in it we observe the important role given to the central section of her compositions as a generating vortex of the images.

Contemporary Art in Puerto Rico: 1968–1995

The confrontation of two artistic groups – those principally concerned with national identity as a means of expression against those aligned with avant-garde movements essentially concerned with formal elements and abstraction – was a sign of significant social and political change in Puerto Rico. In the 1968 elections, the victory of the Partido Nuevo Progresista or New Progressive Party's candidate Luis A. Ferré signalled the beginning of a new political system which, at the same time, represented the end of the populism of the Muñoz Marín regime.

In the visual arts there occurred a diversification and reorientation of the forces which had nurtured their development until that time. The resistance shown to all avant-garde artistic manifestations by a considerable sector of the art world, and above all by the public at large, drove various artists to assume an openly confrontational stance with conservative groups while others left the island for long periods or even permanently.

Rafael Ferrer (b. 1933) is perhaps the most significant case of an avant-garde artist who confronted the provincial smugness of Puerto Rican society, rejecting politically engaged art. In 1961 he had an exhibition at the University of

Puerto Rico along with his colleague and friend José ('Chefo') Villamil, which caused a scandal due to its sexual references and the uninhibited style of the works. After having travelled to Europe and the United States (where he met Robert Morris), Ferrer mounted, along with Morris, an exhibition of sculptures in the College of Agriculture and Mechanical Arts at the University of Puerto Rico. The same year he returned to the United States where he would eventually be recognized as an artist of the international avant-garde, opening the way to other young Puerto Ricans who found the new international fashions both stimulating and helpful in their revolt against the Generation of 1950.[9]

The recent work of Ferrer, who has spent a great part of his creative life in the United States, curiously (and ironically) represents a return to the Caribbean. His oil painting *Narciso y los elementos* (*Narcissus and the Elements*, 1993; fig. 131) shows a nude adolescent amidst seaside foliage, while bonfires illuminate the scene, adding an evening light which lends it a magical and primal quality. Although painted in Santo Domingo (Dominican Republic) where the artist lives for at least three months of the year, the painting reflects a tropical ethos, a mixing of primitive innocence and the paradisiacal garden which is about to be lost. This is an extraordinary and poetic synecdoche of Caribbean reality; a critical commentary as well as a fantasy by an artist who, while a part of this reality, can also observe it from the outside.

Marcos Irizarry (1936–95) was another of those semi-exiled artists who, since the time of Oller, have oscillated between their lives outside and inside Puerto Rico. During the 1970s and later, Irizarry created a series of engraved murals

129. LUIS HERNÁNDEZ CRUZ – GRAN MANGLE (GREAT MANGROVE), *1993. acrylic on canvas, 183 x 142 cm. private collection*

130. Noemí Ruiz – Mágia del trópico (Magic of the
Tropics), *1993. acrylic on canvas, 152 x 183 cm. private collection*

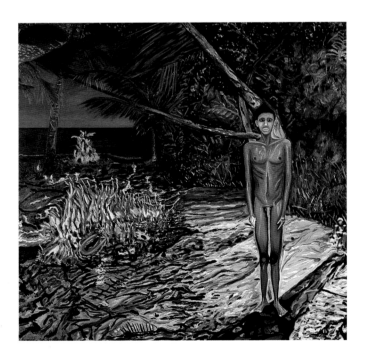

131. Rafael Ferrer – Narciso y
los elementos (Narcissus and
the Elements), *1993. oil on canvas,
183 x 183 cm. Compañía de Turismo
de Puerto Rico, San Juan*

skill and testify to the geographical polarity that
was an integral part of his life and art and signals
the direction that his later work would take.
Asilah of 1994 (fig. 131), from the *Suite marocaine*,
represents a synthesis and a purification of the
characteristics of his earlier work, while introduc-
ing new elements to it. This painting, created
with an analytical and conceptual rigour,
reflected in its abstract patterns, represents an
integration of the diverse graphic motifs that
the artist had employed in his earlier work.

Beginning in 1970, the Bienal de San
Juan del Grabado Latinoamericano (San Juan
Biennial of Latin American Graphic Arts) stimu-
lated a special interest in the graphic arts from
Latin America, Europe and the United States.
The artists of the island reaped the benefits of
this expansion of interest, as a result of which
those who were unable to travel were brought
into contact with many forms of contemporary
art and ideas.

The decade of the 1970s was a period of
unprecedented cultural openness and growth in
Puerto Rico. A favourable climate for the arts
produced a larger number of art students in the
Department of Fine Arts of the University of
Puerto Rico and in the Escuela de Artes Plásticas
of the Institute of Puerto Rican Culture (founded
in 1966), which instituted a system of grants
for advanced study in the United States and
elsewhere.

This migration from the island to the
large cities of the United States (principally New
York) had a pronounced effect on the develop-
ment of the careers of many Puerto Rican artists
which was principally manifested in the variety
of styles and subjects in their work. Two notable
examples of this phenomenon are Carlos Irizarry
and Jaime Romano.

Puerto Rico

Carlos Irizarry (b. 1938), born in Puerto Rico but raised in New York where he studied at the School of Art and Design, returned to the island in 1963. His art, which developed in accordance with diverse international tendencies (including the works with acrylic and plexiglass which he exhibited in his Galería 63), did not find favour in San Juan and he returned to New York in 1969. In his painting *Transculturación* (*Transculturation*) of 1975, showing the peasant that appears in Frade's *Pan nuestro* on one side of the painting, along with a spectral, macabre figure on the other, Irizarry creates a symbol of the disintegration of Puerto Rican society. His change from avant-garde to socially committed art reflected the ideas of many of the artists of the Puerto Rican community in New York.

Jaime Romano (b. 1942) has been identified with abstraction ever since his years as an undergraduate at the University of Puerto Rico in the 1960s; he later completed a Master's degree in Fine Arts at the American University in Washington, DC. His lengthy stays in Washington and New York between 1975 and 1986 allowed him to concentrate on subtle abstractions in which harmonies of light and colour are outstanding features; these elements combine with pure geometric forms and expressive outlines to produce a sensual play of textures, transparencies and surfaces. On returning to the Puerto Rico in the mid-1980s, Romano encountered a much more cosmopolitan climate and an art market that had not previously existed.

Towards the end of the 1970s and during the 1980s, the art scene in Puerto Rico was dominated by the plurality of styles – abstract and figurative – that arose internationally. None the less, the organizations which were formed during this period, such as the Congreso de Artistas Abstractos (Congress of Abstract Artists), Mujeres Artistas de Puerto Rico (Women Artists of Puerto Rico) and the Hermandad de Artistas Gráficos (Fraternity of Graphic Artists), predominantly reflected the political tensions of the nation.

Myrna Báez (b. 1931), one of Puerto Rico's most distinguished artists, known both on the island and abroad for her graphic work and painting, is a good example of this concentration on the image as a self-referential icon in both the formal and the thematic sense. After studying painting for six years at the Academia Real de San Fernando in Madrid, Báez returned to Puerto Rico and joined the Graphic Arts Workshop directed by Lorenzo Homar, where she learned the techniques of woodcut and silk-screen printing. During the 1960s she was active in printmaking and painting and her early prints show iconography based on everyday life in Puerto Rico. Her graphic work varied widely, both in its subject-matter and in the materials she used – linoleum blocks, woodcuts, plexiglass, silk-screen and collograph. Báez's work exemplifies yet another constant in Puerto Rican graphics: impeccable technique.[10]

During the 1970s Báez took middle-class people as her subjects, setting them in ambiguous spaces, defining them with unreal colours and dream-like light to remove them from the mundane reality of their surroundings. Indefinite space is one of this artist's principal concerns; another is the picture within the picture which she uses as a device to catch the attention of the spectator, as has been done by modern artists for generations. The use of mirrors or the simulation of photographic techniques, which Báez employs more as a thematic than as a simple optical mechanism, relate to what Marta Traba has described as 'painting conceived as theatre and scenography but also as the solid institution of visual impossibilities' and inform the varied aspects of her artistic production.[11]

La hora azul (*The Blue Hour*; fig. 133) of 1993–4 represents a contemporary synthesis of Báez's characteristic play of interior and exterior space: natural light seen through a window contrasted with shadowy, artificial interior light; eccentric colours which are themselves the focus of attention; the island landscape; the female nude and the exotic flora of the tropics.

In addition to the generations of artists who, since mid-century, had helped to shape the character of Puerto Rican art, there arose a younger group comprising artists who work in a variety of styles and embody the eclecticism that characterizes the Post-modernist world. Wilfredo Chiesa (b. 1952) and Julio Suárez (b. 1947) are outstanding for their abstractions. Chiesa went to the United States where he is Professor of Fine Arts at Boston University, while Suárez also works as professor in various arts institutions in Puerto Rico. None the less, it is in the area of figurative art that many of the most talented young Puerto Rican artists have excelled.

Nick Quijano (b. 1953), born in New York, came to the island at the age of fourteen, later studying at the Escuela de Arquitectura. Since 1980 (when the ingenuous, folkloric works in which he idealizes family and village life in Puerto Rico were first exhibited) Quijano has dedicated himself to creating unusual large-scale still lifes as well as to figural sculpture made with found objects. Mari Mater O'Neill (b. 1960) obtained her Bachelor of Arts degree from the Cooper Union School of Art and Science in New York in 1984. Her art reflects a variety of

132. MARCOS IRIZARRY – ASILAH, 1994.
acrylic on canvas, 173 x 118 cm. private collection

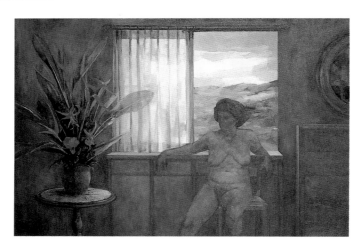

133. MYRNA BÁEZ – LA HORA AZUL
(THE BLUE HOUR), 1993–4. *oil on
canvas, 108 x 157 cm. private collection*

134. ARNALDO ROCHE-RABELL – LIKE A THIEF IN THE NIGHT,
*1990. oil on canvas, 243.5 x 243.5 cm. The Hirshhorn Museum and
Sculpture Garden, Washington, DC*

Puerto Rico

influences from Neo-Expressionism. Carlos Collazo (1956–90), during his relatively brief career, passed through various artistic modes from abstraction to figuration. In 1989 he exhibited a series of brilliant self-portraits, first in La Tertulia Museum at Cali, Colombia, and later in Puerto Rico. These works evoked the most intimate aspects of the dying artist. In their fantastical colours and their depictions of a fictional persona, the artist as an older man, Collazo created images that are among the most eloquent in contemporary Puerto Rican art.

Arnaldo Roche-Rabell (b. 1955) has been considered an outstanding figure in Puerto Rico, the United States and Mexico. Among the many awards and honours garnered by Roche have been the Third Prize for Painting at the 1989 Bienal at Cuenca, Ecuador. He was one of the ten artists included in the exhibition *Awards in the Visual Arts*, seen at the Hirshhorn Museum in Washington, DC, in 1991, and he was given a retrospective exhibition (*Arnaldo Roche: The First Ten Years*) at the Museo de Arte Contemporáneo in Monterrey, Mexico, in 1993, and another at the Museo de Arte Moderno in Mexico City in 1995.

From the beginning, Roche's work demonstrated his intense search for an appropriate form in which to express dream-like states of being. His paintings are like exorcisms in which his own image is seen as protagonist, either a victim of himself or of his models or victimizing them. Self-portraiture is the central theme of the art of Roche, which has undergone countless changes of appearance and scale.

The importance of Roche's application of colour and the manner in which he executes his works is almost as important as the images themselves. His frottage technique, which involves covering his models and objects with canvas or prepared paper in order to create the image by rubbing the form beneath with his paint-covered hands, spatulas or other instruments, is his principal means of artistic creation. In *Like a Thief in the Night* (1990; fig. 134), we observe not only the effects of the frottage of the pieces of wood which surround and give structure to this image of a face, but also the application of tropical leaves referring specifically to Puerto Rico – another essential feature of the art of this painter. Although Roche does work in small format, he prefers monumental canvases.

The conspicuous absence of sculpture from this essay is due to its minimal production in Puerto Rico during the first fifty years of the twentieth century and its relatively late appearance on the scene in the 1970s. Pablo Rubio (b. 1944) graduated from the Escuela de Artes Plásticas in San Juan and later obtained a Master of Arts degree from the State University of New York in Buffalo. In the first fifteen years of his career he passed through a small-scale figurative stage to abstract work on a monumental scale. In the last ten years he has distinguished himself in Puerto Rico as a creator of commemorative public sculpture. His preference for metals (unoxidized steel, bronze and aluminium) and his use of laser beams to cut his plates have allowed him to create works of spontaneous geometric forms on an impressive scale and of great formal poetry. Rubio's public monuments can be found in the Sculpture Park in Seoul, South Korea, and the Olympic Museum in Lausanne, Switzerland; his work *Cristales de la paz* (*Peace Windows*) was chosen to stand at the entrance of the Puerto Rican Pavilion at the Universal Exposition held in Seville, Spain, in 1992. Rubio has been tireless in his support of sculpture in Puerto Rico. As professor at the

Puerto Rico

University of Puerto Rico he has served as mentor to a promising group of younger artists.

Alegoría de una cultura (*Allegory of a Culture*, 1993; fig. 136), by Melquiades Rosario Sastre (b. 1953) is representative of his unpolished wood sculptures into which metal elements and other components from nature are integrated. Rosario began his studies at the Escuela de Artes Plásticas in San Juan in 1976 and, since then, the countless exhibitions of sculpture and graphic arts in which this virtually self-taught artist has participated have served almost as his classroom. His work is highly personal and cannot be identified with any specific trend in contemporary sculpture. This does not mean, however, that Rosario Sastre has not learned a great deal from masters such as Picasso, Brancusi and others. Critic Ricardo Pau Llosa has written that 'his sculptures, installations and graphics explore the relationship between time and form within a ritualistic context, revealing a link between reverential and creative activities...'[12]

In any essay on contemporary art in Puerto Rico it is necessary to point out the important position that ceramics have assumed on the island. Beginning in the 1970s with the founding of the Asociación de Cerámica Artística, a growing number of artists emerged who were integrating various forms of this genre of art into their work. The ACA ensured that standards were raised to a level which had not previously been achieved.

The *Totem telúrico* (*Telluric Totem*, 1992; fig. 135), a commemorative monument in ceramic dedicated to the 500th anniversary of the founding of America, which stands in the square of Old San Juan, is an important example of the work of Jaime Suárez (b. 1946). In a wider sense,

it represents the significance and development of ceramic art in Puerto Rico during the last twenty-five years. Suárez, who trained as an architect, is one of a distinguished group of Puerto Ricans who bridge the traditional artistic genres to create important works in the areas of architecture, painting, sculpture and ceramics – frequently combining several of these elements. As well as ceramic pieces on a heroic scale, Suárez's work has included stage sets for theatre and ballet. His work as a ceramicist exemplifies his interest in ecological concerns, manifested through his ceremonial vessels, plaques, murals, altars, ritual tables and various related objects in which the erosion of the surface either by the forces of nature or the interference of man, points up the vulnerability of the natural world today. Suárez's experiments with *barrografías* (pictures made with clay) and, more recently, constructions with found objects in which the form and colouring are often the products of accidents in the making process, underline his fondness for the use of raw materials with little or no embellishment.

Other important ceramicists in Puerto Rico have gained significant reputations both at home and abroad. Prizes have been awarded to Sylvia Blanco (b. 1943), Susana Espinosa (b. 1933) and Bernardo Hogan (b. 1921). Suárez himself won the prestigious international ceramics competition held in Faenza, Italy, and an award in a similar competition held in Mino, Japan, was won by Toni Hambleton (b. 1934).

Both Espinosa and Hogan are natives of Argentina and Hambleton is from Mexico, although all of them have lived in Puerto Rico for more than three decades. Their ceramic work is extremely diverse. Espinosa demonstrates her free form of figuration on everything from plates and murals to the fantastical animals she also

makes. Hogan's principal form of expression is the vase executed with a classical elegance, while Hambleton combines pieces of ceramic on a metal armature to created a variety of totemic forms.[13]

These artists founded, collectively, the Casa Candina in 1980, an institution that functioned as a school, workshop and ceramics gallery, becoming a significant force in the promotion and development not only of ceramics but of art in general throughout the island.

135. Jaime Suárez – Totem telúrico (Telluric Totem), 1992.
Concrete column with ceramic tiles, height 16.7 m, diameter 1.5 m.
Plaza del Quinto Centenario del Descubrimiento de América, San Juan

136. Melquiades Rosario Sastre – Alegoría
de una cultura (Allegory of a Culture), 1993.
wood with metal, 66 x 137 x 127 cm. private collection

Rina Carvajal

Venezuela

LATIN AMERICAN ART IN THE TWENTIETH CENTURY

From turn-of-the-century academicism to contemporary multimedia installations, Venezuelan art has been characterized by the struggle to assimilate its own cultural traditions and influences from abroad. This struggle, in turn, has been shaped by the striking social and political changes marking Venezuela's efforts to modernize in the twentieth century, particularly the cultural politics instituted by different governmental regimes.

Academic painting

The nineteenth century in Venezuela was marked by constant warfare as regional strongmen (*caudillos*) fought among themselves for control of the national government. Cultural and artistic life developed very slowly in the midst of the continuing social and political instability, centred on the capital, Caracas, and its premier academic institution, the Instituto de Bellas Artes (the Institute of Fine Arts).[1]

The Institute was founded in 1870 and with it a system of scholarships permitting selected artists to study in Europe. The government served as the principal source of commissions as well as of the funds to enable artists to study abroad. However, it imposed conditions on such grants, requiring artists to study the themes and techniques of French realist painting, an emphasis which coincided with the high point of academic style in the country.

The most important painters of this period, Martí Tovar y Tovar, Arturo Michelena and Cristóbal Rojas, lived and worked for a time in Paris. Michelena and Rojas studied at the Académie Julian, absorbing the language of academic realism under the tutelage of Jean-Paul Laurens.

Tovar y Tovar (1827–1902) was a great portraitist and the most renowned illustrator of Venezuelan history. Formed in the Academia de San Fernando in Madrid and at the École des Beaux-Arts in Paris, he served as painter to Caracas high society and portraitist to President Antonio Guzmán Blanco, a great lover of French culture and art whose presidency lasted (with a brief hiatus of two years) from 1870 to 1888. Tovar was commissioned by Guzmán to paint a gallery of portraits of the heroes of the War of Independence as well as his most important work, the paintings in the Elliptical Hall of the National Congress in Caracas, whose unusual energy and dynamism capture the epic theme of national emancipation.

Arturo Michelena (1863–98) absorbed the academic techniques of his master Laurens, painting historical, allegorical and genre pictures which brought him wide renown. The gold medals he won for *The Sick Child* (1887) and *Charlotte Corday* (1889) at the Salon des Artistes Français and at the Grande Exposition Universelle respectively, made him Venezuela's most famous artist of the time.

Michelena utilized his particular talent for virtuoso drawing in narrative paintings to create the illusion of large volumes in motion.

Cristóbal Rojas (1857–90), in contrast, followed the dramatic vein of numerous academic painters and employed generally dark tones in a series of compositions with the themes of sickness and misery. Although well painted, these works appear overly theatrical and anecdotal. Rojas's expertise, particularly his refined colour sensibility, is much more evident in his *intimiste* paintings, still lifes, portraits and informal scenes.

After the deaths of Rojas and Michelena in the late 1890s, Tovar y Tovar remained active as a painter until 1902. Two other important academic painters of note, Emilio Mauri (1855–1908) and Antonio Herrera Toro (1857–1914), were professors at the Instituto de Bellas Artes, where they taught the themes and techniques of traditional painting.

The Movement for Cultural Renewal

The political instability of the nineteenth century effectively ended in 1903 when a group of military officers from the Venezuelan Andes, among them Juan Vicente Gómez, defeated the last of the regional *caudillos* and consolidated the power of the national government in Caracas. Gómez assumed the role of dictator in 1908 and governed all aspects of national life – including the forms and content of artistic expression – with a firm hand until his death in 1935. He inherited a country whose regional economic and social structures – vestiges of the previous century – had produced unfavourable conditions for artistic and cultural development. These structures changed dramatically, however, with the discovery and commercial production of oil in the 1920s. The effects of the oil boom were already evident in the late 1920s and early 1930s, when oil replaced agriculture as the primary source of national economic wealth in Venezuela. Cities grew rapidly, transforming urban life and social structures and generating the conditions necessary for the growth of political opposition and new paths for artistic production. While the arrival of modernity in Venezuelan art would thus be closely linked to the changes driven by oil, its roots were actually formed at the beginning of the Gómez era with the creation of the Círculo de Bellas Artes (the Fine Arts Circle).

The Círculo, formed in 1912, sought a

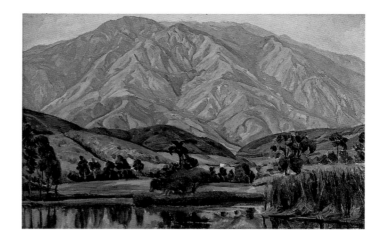

137. Manuel Cabré – Laguna de Boleíta: El Avila desde el Marquéz (The Lake of Boleíta: El Avila Seen from el Marquéz), n.d. oil on canvas, 39 x 61 cm. private collection, Caracas

renewal of Venezuelan painting, a rethinking of the national tradition, while at the same time opening up the country to the international currents of the time. In 1909 a group of students pressing for reform had rebelled against the official teachings of the Academia de Bellas Artes (the Academy of Fine Arts) and staged a strike to protest against the techniques and themes of traditional *fin-de-siècle* academic painting still dominant at the Academia. The demands for change were rejected and the students expelled. Three years later, this same group of young painters, led by Antonio Edmundo Monsanto, Manuel Cabré and Leoncio Martínez, was joined by musicians and writers to form the Círculo as an open artistic association which did not promote any specific style or movement. The Círculo organized three Salons and innumerable concerts, recitals and lectures on art and literature during its six-year life. Impressionism, Cubism and Futurist literature were discussed. The writers participating in this group would later constitute a literary avant-garde known as the 'Generation of 1918'; their questioning of the literary modernist movement initiated a new era in Venezuelan letters.[2]

Although the painters of the Círculo worked in different styles, they shared similar ideas about the nature and techniques of painting, seeking to create works of a non-anecdotal nature which would have great visual impact. They painted outdoors, looking at the Venezuelan landscape and its tropical light with a new vision and sensibility, experimenting with Impressionist and Post-Impressionist styles which each artist would later abandon in order to develop a more personal language. Many of the Círculo painters were strongly influenced by three European artists – the Russian painter

Nicolás Ferdinandov (1886–1925) and two Post-Impressionists, the Romanian Samy Mützner (1869–1958) and the French-Venezuelan Emilio Boggio (1857–1920) – who arrived in 1916 and freely shared ideas and techniques with the Venezuelan group. The most important Círculo members were Cabré, Monsanto, Federico Brandt, Armando Reverón (1889–1954) and Rafael Monasterios (1884–1961).

Manuel Cabré (1890–1984) was one of the principal exponents of the Círculo. With an artistic eye trained in Paris, he was able to capture the variations of light and colour in the Venezuelan landscape. For the Impressionists, light tended to dematerialize objects; for Cabré, the light he found in Caracas – dense, textured and weighty – had the opposite effect. Consequently, his style was characterized by structural solidity and volume, chromatic variation and acute observation of form (fig. 137).

Antonio Monsanto (1890–1948), the theoretician of the Círculo, had ample knowledge of modern painting and was a great admirer of El Greco and Cézanne. He constructed his work on the basis of subtle distributions of planes and plays of light. The high standards he demanded of himself and others led him to abandon painting in 1925 in order to dedicate himself to teaching. Years later he was to play a vital role in implementing the educational reforms which helped to broaden the perspectives of Venezuelan art.

Federico Brandt (1878–1932), who was in Europe at the time of the 1909 student protest, joined the Círculo somewhat later than his colleagues and participated only sporadically in its events. During the Círculo period he painted *plein-air* landscapes whose sinuous contours describe volume with a particularly graphic line.

Venezuela

He reached artistic maturity after 1922 when his work became *intimiste*, evoking the poetics of everyday objects in the silent spaces of corners and solitary rooms (fig. 139).

Rafael Monasterios (1884–1961) studied in Spain at the Escuela de Artes y Oficios in Barcelona between 1911 and 1913, returned to Caracas in 1914 and participated in the Círculo for a time. He based his work on carefully crafted chromatic principles derived from his study of the different gradations of light and colour found in nature.

Armando Reverón (1889–1954), like Monasterios, studied in Barcelona and Madrid between 1911 and 1913. On his return he re-established contact with his former colleagues of the Academy and joined the Círculo, which became the scene of much of his activity. His European experience left him with a great admiration for Cézanne, Degas, Sisley, Martin, Goya and some of the Spanish modern artists: Sorolla, Zuloaga, Nonell and Rusiñol. This admiration is evident in his paintings from the 1910s and early 1920s. He used this period to assimilate the techniques of late Impressionism – a style he would later synthesize and transform into its antithesis.

In 1918 the last of the Círculo's studios was closed by the police under the orders of Gómez, who alleged that the organization had become a centre of political agitation. The members dispersed, although some of them would continue to meet sporadically over the years. It was only after the closing of the Círculo that the artistic paths that each member would take were defined.

A second generation of landscape painters succeeded those of the Círculo. Dubbed by the critic Enrique Planchart the Escuela de Caracas (the Caracas School), the group included artists working in a variety of styles for whom landscape was the principal means of expression. Among them were Antonio Alcántara (1898–1991), Luis Alfredo López Méndez (b. 1901), Marcos Castillo (1897–1966), Pedro Angel González (1894–1975) and Elisa Elvira Zuloaga (1900–80). Even though all of them painted out-of-doors and displayed a preference for the Caracas landscape, they were not an homogeneous group. Some remained faithful to the interests of the Círculo while others, such as Zuloaga and Castillo, led a newer generation in different artistic directions.

The Rupture: The Beginnings of Modernism

Reverón was the only member of the Círculo whose work came to reflect a truly modernist temper. He moved beyond the late Impressionism of his Círculo years, not because of any deliberate exploration of the theoretical and technical issues which came to define modernism but rather as a result of constant experimentation and synthesis carried out in relative isolation and the expressive character of his pictorial language.

In 1921 Reverón abandoned Caracas in search of a place that would allow him to dedicate himself exclusively to his work. With his model and companion Juanita Ríos, he settled in Macuto, a small village on the Caribbean, far from the traditional and restrictive ambience of the capital. He would live there until his death in 1954. He built a *rancho* (small hut) from natural materials, including palm fronds, tree trunks, branches, earth, stones from the sea, and burlap. He also constructed rudimentary furniture and fashioned his brushes, tools and pigments from similar materials. Over the years his home was expanded to resemble the name he gave to it – the Castillete ('Little Castle') – and to hold a series of objects he created to populate his world: masks, musical instruments and scores, wings, a bird-cage, a telephone and the life-size dolls which, from the late 1930s, would become the principal source of the female images in his paintings.

From this haven Reverón carried out a process of incessant visual experimentation, ultimately forging his own personal and highly original visual language. He studied the effects of the tropical light on nature, discovering that its blinding intensity tends to dissolve objects in its own incandescence, translating and giving visual form to this light for the first time.

The themes of his works were the landscape and the female figure, to which he brought new interpretations always subject to the notion of the canvas as a surface and flat plane on which to explore visual and expressive concerns (fig. 138). Through a continuous process of simplification and synthesis Reverón developed a free and concise style marked by a very personal use of materials and an accentuated chromatism: a painting of limits, stripped of everything but its visual essence.

Until Francisco Narváez (1905–82) began to develop his career as a sculptor in the 1930s, sculpture in Venezuela was extremely academic and traditional. It was directed towards the production of images of historical, military and civic heroes for governmental purposes as well as portraits and funerary monuments for an upper-class clientele. Pedro Basalo (1885–1948), Cruz Alvarez García (1870–1950), Lorenzo González (1877–1948) and Andrés Pérez Mujica (1873–1920) were among the more notable academic sculptors.[3]

It was Narváez who initiated the break

138. Armando Reverón – Amanecer en el Pozo de
Ramiro (Dawn at the Pozo de Ramiro), *c. 1938.
oil on canvas, 91 x 103 cm. private collection, Caracas*

139. Federico Brandt – Interior con mecedora
(Interior with a Rocking Chair), *1931. oil on board,
46.8 x 35 cm. Galería de Arte Nacional, Caracas*

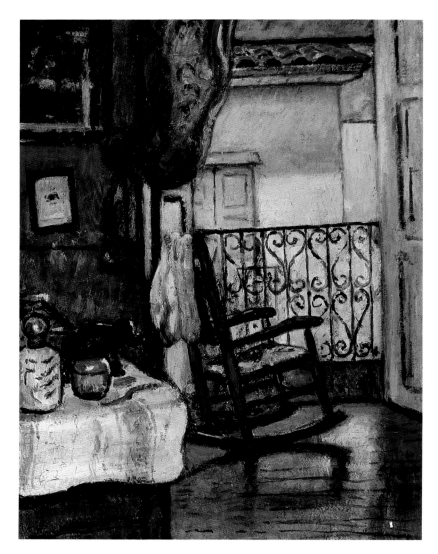

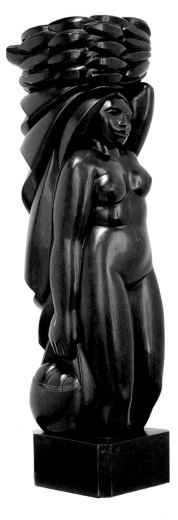

140. Francisco Narváez – La criolla (The
Creole), 1936. carved wood, 171 x 41 x 40.2 cm.
Galería de Arte Nacional, Caracas

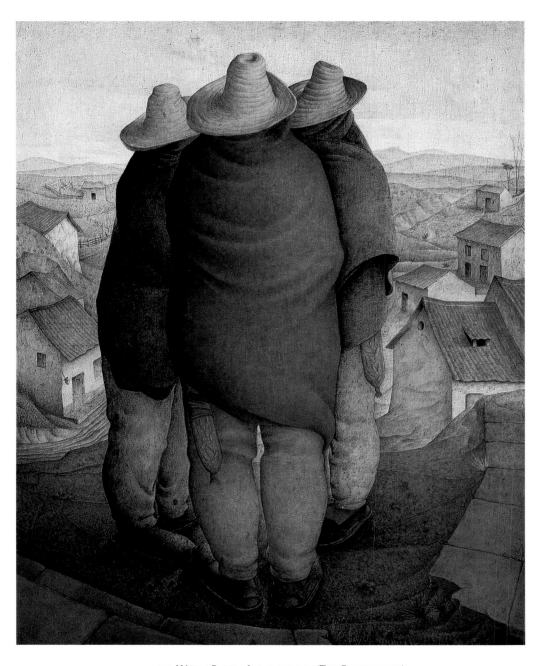

141. Héctor Poleo – Los comisarios (The Comissioners),
1942. oil on canvas, 90 x 70 cm. Galería de Arte Nacional, Caracas

with the academic figurative tradition in Venezuelan sculpture. He studied first in Caracas at the Academia de Bellas Artes and later at the Académie Julian in Paris (1927–30). He returned to Venezuela in 1930, developing a career as a painter and sculptor although it was in the latter capacity that he came to be particularly recognized. As a contrast to the clay and plaster modelling taught at the Academy, Narváez reinvestigated the possibilities of wood- and stone-carving – techniques used in colonial times. His experiences in Europe led him to develop a formal style that moved from the early treatment of social and Indigenist themes towards (after 1954) geometric abstraction. His figures, conceived with ample, rhythmic volumes (solid and sinuous at the same time), reflected the growing contemporary interest in pure form (fig. 140).

Modernity

The movement towards political and artistic change gathered momentum in 1928 with the outbreak of the first student protests against the Gómez dictatorship. The leaders of these protests, members of the 'Generation of 1928', would eventually bring democracy to Venezuela; writers of the Generation would initiate the first avant-garde literary experiments in the country, seeking new forms of national expression to supplant the genre tendencies and the restrictive, conservative modes of literary expression of the era.

Gómez died in 1935 after enforcing peace and political silence on Venezuela for 27 years. His death ushered in a 25-year period of great political, social, economic and artistic change. The political–intellectual élite and the public at large were unanimous in their desire to modernize Venezuelan government and society. After

1936, the slowness that had characterized the Gómez era was replaced by a state of accelerated activity. It was Gómez's successor, General Eleazar López Contreras (President 1936–41), who initiated the transition towards democracy. Political parties, unions and associations were created as forums for public debate.

Art was included in this climate of change. In 1936 the first important reforms in Venezuelan art occurred. The old Academia de Bellas Artes was transformed into the Escuela de Artes Plásticas y Artes Aplicadas under the direction of Antonio Edmundo Monsanto who, together with various foreign and Venezuelan teachers, introduced important changes in teaching methods. Great emphasis was placed on studying the work of Cézanne and Cubism. Despite criticism of the Escuela's teaching practices, it was the initiative of Monsanto himself that led to the beginnings of abstraction in Venezuela. The earliest forms of abstraction were based on the Constructivist lessons of Cézanne's œuvre and of Cubism. The Museo de Bellas Artes opened in 1938 and shortly afterwards, in 1940, the first officially organized art exhibitions, known as the Salones Oficiales, were held.

Artists such as Pedro León Castro (b. 1913), César Rengrifo (1915–80), Gabriel Bracho (b. 1915) and Héctor Poleo played an active critical role in the social and ideological questioning which emerged from the political ferment of the post-Gómez years. The individual amidst social contradictions was their major theme. Mexican Muralism, testimony to the social struggles throughout Latin America, served as a major source of influence. A number of artists – including Poleo – went to Mexico to study mural painting and later travelled to other parts of the continent.

Héctor Poleo (1918–89) was one of the outstanding artists working at the end of the 1930s and beginning of the 1940s. Rural themes and social protest constituted the bulk of his subject-matter. After finishing his studies at the Escuela de Artes Plásticas in 1937, he went to Mexico on a fellowship to study mural painting, perfecting his drawing techniques and absorbing the Mexican brand of social realism. He principally concentrated on the human figure, utilizing an essentially linear technique to create solid sculptural forms (fig. 141).

Despite the popularity that landscape enjoyed at the Escuela de Artes Plásticas until the early 1940s, the growing interest in socially committed art contributed to the diversification of themes. The ending of the Second World War also marked the end of Venezuela's isolation: from this time onwards the younger generations of artists travelled abroad, read foreign art magazines with great interest, and enthusiastically formed a variety of artistic associations in their search for a new modern spirit. These younger artists reacted against the traditional teaching methods of the Escuela, particularly the continuing emphasis on landscape.

At the end of 1945, a series of conflicts and confrontations erupted between teachers and students at the Escuela. The students demanded the reform of the Impressionist and Post-Impressionist styles of art that were still in favour, and asserted that the study of Cézanne and Cubism did not satisfy their aspirations to pursue contemporary issues and forms. Those responsible for the strikes were expelled. A number of them were determined to continue their studies independently and formed, for a time, a group which met at a place known as the Barraca de Maripérez (Maripérez's Shack), an

Venezuela

142. ALEJANDRO OTERO – COLORRITMO 39
(COLOUR-RHYTHM 39), 1959. *enamel on
wood, 200.1 x 53 cm. private collection, Caracas*

old shed converted into an art studio. Gradually,
however, discontented students left for Mexico
and Paris to work and study, financed by the
prizes awarded by the Salons and by official
government grants. Alejandro Otero (1921–90),
the leader of the artists of his generation, left for
the French capital in 1945.

The tensions between the old and the
new at the Escuela mirrored the growing conflict
in the political arena. López was succeeded in the
presidency by General Isaías Medina Angarita,
who quickened the pace of modernization but
was opposed in his efforts by a political and
military élite which sought immediate change.
Medina was ousted in a civil–military *coup d'état*
in 1945 and a Junta Revolucionaria de Gobierno
was established to bring about a civilian-led
democratic government. Rómulo Gallegos, a
novelist, was chosen as the transitional President
but was overthrown in 1948 by military officers
led by General Marcos Pérez Jiménez, whose
dictatorship would last until 1958.

The young artists who left–or had been
expelled from–the Escuela, but remained in
Venezuela, formed the Taller Libre de Arte (the
Free Art Studio) in 1948, an association dedi-
cated to challenging established ideas and experi-
menting with new artistic forms. The Taller
served as a workshop as well as an exhibition
centre and became an important forum for
debates and discussions among artists and intel-
lectuals. Many different artistic strategies were
initiated and promoted at the Taller, especially
those forms with inherent 'Americanist' or social
content, free drawing and abstraction.

Apart from showing the work of its
members, the Taller also organized significant
national and international exhibitions. In 1948
it presented a show of the Concreto Invención

143. Alejandro Otero – Cafetera rosa (The Pink Coffee Pot), 1948. *oil on canvas, 80 x 64 cm. Galería de Arte Nacional, Caracas*

group from Buenos Aires, the first abstract–Concrete art exhibition to be held in Venezuela. Alejandro Otero returned from Paris in 1949 to present his exhibition called *Las Cafeteras (The Coffee Pots)* in the Museo de Bellas Artes and then at the Taller, provoking enormous controversy (fig. 143). This series, illustrating the transformation of an object as it moves towards abstraction, became the point of departure for debates about figuration versus abstraction as well as the forum for a wider discussion of the place of Venezuelan art in the contemporary international context.[4]

The Taller organized a show of the art of Reverón in 1948 and presented the first exhibition of the work of Jesús Soto (b. 1923) in 1950. It also published a magazine dedicated to the dissemination of information about contemporary art and literature.

Venezuela continued to experience enormous upheavals in the late 1940s and the early 1950s as the booming oil economy accelerated a process of modernization in which artists avidly sought to participate. While the members of the Taller created the initial conditions for artistic renewal, another group of young Venezuelan artists, living in France, found in geometric abstraction a way to insert themselves into the artistic currents of the time and – with a new aesthetic language – declare their opposition to the traditionalism that still reigned in Venezuelan art and culture despite the reforming efforts of the Taller and other bodies. These same artists would create the first Venezuelan artistic vanguard when they returned to South America in the early 1950s.

The vanguard movement actually began in Paris, which had become home to a group of Venezuelan artists after the confrontation at the Escuela in 1945. This group, led by Otero, called

itself Los Disidentes (the Dissidents) and began to publish a magazine of the same name in Paris in 1950 to disseminate its views there and in Venezuela.

The Manifiesto de los NO (the Manifesto of the NOs) of 1950 expressed the group's philosophy. More than a simple statement of theoretical and visual premises, it represented a vehement and combative critique sharply focused against the teachings of the Escuela, the teachers of landscape painting in Caracas and the conservatism of the official Salons and the Museo de Bellas Artes.[5] The real contribution of the Disidentes to the consolidation of the geometric abstraction movement in Venezuela lay in the efforts of these young artists after they returned to Caracas from 1952. The architect Carlos Raúl Villanueva had received a commission to design a new university in Caracas and his invitation to a number of the Disidentes to prepare projects for the campus (along with Léger, Pevsner, Arp, Laurens, Sophie Teuber, Lam, Calder and Vasarely) was a key event in the incorporation of the group into the Venezuelan art world.

Abstraction in the 1950s

During the 1950s and early 1960s abstraction developed in different directions, especially towards Neo-plasticism, free abstraction and kinetic art. Venezuelan artists, depending on their expressive needs, often moved among these currents. Otero, Soto and Carlos Cruz-Diez carried out original experiments in geometric abstraction and kinetic art which would make them the most outstanding figures in these fields in Venezuela.[6]

Otero was the great theoretician of his time. His *Cafeteras* series of the 1940s inaugurated a new period of abstraction in Venezuelan

painting. He participated in Villanueva's project to integrate the arts in the design and construction of the new university, creating, among other works, two excellent polychrome pieces at the Faculty of Architecture. He also worked on an extraordinary sequence of serial abstractions known as *Los Colorritmos (Colour-Rhythms;* fig. 142) from 1955 to 1960.

The first *Colorritmos* were elongated tablets with parallel bands of white and pure, brilliant dark colours. The colours between the lines produced a sensation of vibration, creating an active dialogue of dimensions, rhythms and spaces. The forms that appeared beneath the dark bands in the early examples were transformed into elongated rectangles in subsequent versions and brought together in large schema in which the dark bands lose their sense of continuity and appear to form one solid block. While the first of these works had directed the viewer's vision towards the interior of the plane, the later ones directed the gaze from the plane towards the exterior. Some years later, Otero turned to sculpture as the culmination of a series of rigorous experiments extending from the *Colorritmos* to assemblage and collage.

Although Otero's work developed principally in the Neo-plasticist mode, at the end of the 1960s he began to do large-scale kinetic-like sculptures in which he combined technological materials with elements such as colour, wind and space. These sculptures moved, shifting form with the motion of the spectator, transforming volume into vibration and energy.

Soto is Venezuela's most significant kinetic artist. In Paris in the 1950s he developed an important body of work based upon optical experiments, superimposing and repeating serial elements to produce vibrations which, in turn,

144. FRANCISCO HUNG – PINTURA NO. 5
(PAINTING NO. 5), *1964. acrylic, gravel and
plaster on canvas, 148 x 230 cm. private collection*

modify space and affect the perceptual universe of the spectator. In 1953 Soto created his *Estructuras cinéticas* (*Kinetic Structures*), constructions made of two superimposed and separated planes. The back plane was generally painted with thin vertical bands of black and white; the plane closest to the spectator was made of Plexiglass and painted with vertical and diagonal bands of varying colours. When these planes were placed together, even the slightest movement of the spectator seemed to produce new forms, a 'moiré' effect suggestive of movement and vibration (fig. 146).

Soto sought to create environmental situations whose impact would depend upon the spectator's participation. The resulting series of *Penetrables*, created during the 1970s, were spaces constructed from hanging vertical rods of nylon, metal or cord and designed to be entered by the spectator. Penetrating, walking through, the space triggered the movement of the cords in many directions, an effect which surrounded the spectator with a fluid sensation of motion and tactility, the dematerialization of volume and the perception of great energy.

Carlos Cruz-Diez (b. 1923), on the other hand, began to experiment with colour perception – the starting point of his entire body of work – at the end of the 1950s. His *Fisicromías* series consists of constructions of fine laminated sheets with different colours on each side placed perpendicular to the plane. The pieces generate a sensation of movement, transforming shape and colour, as the spectator moves around them.[7]

Mercedes Pardo (b. 1922) has dedicated her work to a thorough exploration of the subjective and expressive possibilities of colour (fig. 145). Although Pardo's work draws on the Constructivist language of her contemporaries, her approach to form and abstraction is much freer. In her paintings, which are a dense combination of moods, tensions and chromatic harmonies, colours become, above all, energy and space.

Although the kinetic movement captured the exhilarating climate of modernization in Venezuela of the 1950s, its novel and experimental nature gave way to rigidity as it found wide favour with the political and social élites. Kinetic art would be officially recognized and financially supported by the democratic governments of the 1960s and 1970s, perhaps due to its apolitical content and obvious link with technological advancement. During those decades kinetic art grew to assume a hegemonic position in the cultural world, dominating the major institutional and public spaces of Caracas and leaving little room for new and different art forms. Sculpture has not attracted many Venezuelan artists. Its renewal was slower than that of painting and it was not until the 1950s that abstraction developed in this field. Víctor Varela (b. 1927), Carlos González Bogen, Lia Bermúdez (b. 1923) and Omar Carreño (b. 1927), all working in an abstract mode, were the first Venezuelan sculptors to work in iron during the 1950s and 1960s.

The 1960s

The dictatorship of Marco A. Pérez Jiménez fell in 1958, leading to the establishment of Venezuela's first fully democratic government in 1960. The transition to democracy was marred, however, by the violence accompanying great sociopolitical conflicts which had been held in check during the dictatorship. Under the influence of the Cuban Revolution of 1959, the radical Venezuelan Left consolidated and launched guerrilla activity. Protest movements in various sectors of Venezuelan society – particularly the universities – were violently suppressed by the Government.

New forms of art began to appear at the beginning of the 1960s in response to the political and social changes shaking the fragile democracy. Young artists sought instinctive and irrational aesthetic languages within which the freedom of artistic methods would be as important as the demystification of the role of the artist and the work of art as having unique and original values.

The 1960 exhibition *Los espacios vivientes* (*Living Spaces*) was a point of departure for these new trends. Organized by the artist and critic Juan Calzadilla (b. 1929) and presented in Maracaibo and later in Caracas, the show was conceived from the need for an open and liberating language which could be viewed as a sort of 'counter-painting', a cathartic, provocative experience. It sought to display the range of different modes of free abstraction which had developed throughout the 1950s in the shadow of geometric abstraction and kinetic art. One such alternative movement, Informalism, had emerged by the end of the 1950s. Although short-lived (1957–64), it attracted a considerable number of artists.[8]

Informalism grew out of matter painting and its thick, tactile textures and generally sober colours. It combined elements of chance and an interest in experimentation with the use of extra-pictorial elements, especially organic materials and rubbish. Francisco Hung (b. 1937) took the idea of graphic freedom and liberty of colour and materials to a point never reached by other Informalist painters. His special treatment of colour and materials allowed him to develop a type of gestural painting of great dynamic force (fig. 144). Among the other outstanding painters

145. Mercedes Pardo – Tú (You), 1969. *acrylic on canvas, 170 x 170 cm. Galería de Arte Nacional, Caracas*

of this movement are Luisa Richter (b. 1928), Maruja Rolando (1923–70), Humberto Jaimes Sánchez (b. 1930), Teresa Casanova (b. 1932) and Gabriel Morera (b. 1933).

The political ferment of the 1960s gave rise to numerous artistic groups animated by political issues. El Techo de la Ballena (The Whale's Roof), which flourished from about 1960 to 1964, was particularly noted for its spirit of provocation and violent, public aggression. For a brief time this group brought together important artists (most of them Informalists), writers and intellectuals. Among them were some of the poets and writers responsible for the contemporary revitalization of Venezuelan letters.

El Techo de la Ballena became the literary and artistic equivalent of the armed violence scarring the country in the early 1960s.[9] This group organized numerous exhibitions, most memorably the 1961 shows *Para restituir el magma* (*To Restore Magma*) and *Homenaje a la cursilería* (*Homage to Vulgarity*) and, in 1962, the controversial and satirical *Homenaje a la necrofilia* (*Homage to Necrophilia*) by Carlos Contramaestre (b. 1933). This last exhibition presented a group of scatological collages, works constructed of viscera and the bones of freshly slaughtered cows, rubbish, throw-away objects and underwear. The obvious political allusions of these pieces compelled the authorities to close the exhibition and confiscate the catalogue.

In spite of the brief duration of the Techo, its importance lay in its questioning of official culture and its attempt to incorporate the contradictions of Venezuelan urban reality into contemporary artistic forms. Its pioneering work in the use of non-artistic materials also represented an important contribution to the initiation of new processes and towards developing rela-

146. Jesús Soto – Estructura cinética de elementos geométricos (Kinetic structure with Geometric Elements), 1955. *acrylic, plexiglass and wood, 60.9 x 58.8 x 15.2 cm. private collection, Caracas*

tions to objects and fragments of reality. The art of assemblage so popular during this period contributed to the projection of the object into other realms, leading, in a variety of ways, to the birth of conceptual art in the 1970s.

The Círculo del Pez Dorado (Circle of the Golden Fish) paralleled the life of the Techo (1960–5). It was an experimental and political group whose space functioned as a meeting-place, workshop, bookshop and gallery, and included young artists of divergent tendencies – such as Régulo Pérez (c.1929), Manuel Espinosa (b. 1937) and Jacobo Borges – under the tutelage of the Venezuelan Neo-figurative vanguard.[10]

Even when associated with the artists of the Techo, Jacobo Borges (b. 1931) took a radically new approach to the figure – satirical, profoundly provocative, critical, pictorially rich and reflecting many of the social and political contradictions of the country. At the beginning of the 1960s his technique was vigorously Expressionistic, with brusque and rapid gestures used to create violent and deformed images of politicians, military officers, clergy and the upper classes of society (fig. 147). His inquisitive spirit led him to experiment with theatre, cinema and photography while still continuing his painting. In 1966 he was invited to co-ordinate a multimedia production entitled Imagen de Caracas (Image of Caracas), an ambitious spectacle which questioned vital aspects of the political history of Venezuela. Borges then stopped painting for five years, devoting himself full-time to experiments with the new audio-visual communication technologies, taking it up again only in the 1970s.

Mario Abreu (1919–93), from the time of his relationship with the Taller Libre de Arte and his European sojourn from 1952 to 1961, sought to combine high art with folk art, the urban with the symbolic sources of Venezuela's religious myths. In 1960 he began executing a series of 'magical objects' which he initially called santerías. These works, ensembles of cast-off objects collected by the artist himself (household utensils, bottles, shells, dolls, mirrors and other thrown-away things), evoke a powerful ritualistic feeling with their unusual configurations (fig. 148). On the other hand, the viscerally forceful and expressive sculptural assemblages of Miguel von Dangel (b. 1946) evoke the natural world, urban detritus as well as mystical-religious roots, with their combinations of transparent plastic resins, embalmed animals and the most incongruous objects retrieved from the dustbin.

At the end of the 1960s Gabriel Morera, one of most renowned of Venezuelan Informalist abstract painters, took up residence in New York and experimented with new artistic directions, executing a moving series of satirical and poetic boxes and assemblages. His Orthos represent small universes made with objects, images and concave mirrors, in which he evokes a rich, complex imagery in an optical play completely different from that of kinetic art.

The career of Marisol (Marisol Escobar; b. 1930) has developed outside the country, thus making it impossible to place her work in a Venezuelan context. In New York, where she has lived since 1950, Marisol has created a body of work that has been associated with North American Pop art: highly original sculptures and sculptural assemblages imbued with a sharp critical satire of society and contemporary politics.

Finally, Gertrudis Goldschmidt, called Gego (1912–94), a German-born architect and engineer who immigrated to Venezuela in 1939, began to produce her Recticuláreas (Nets), an extraordinary series of large-scale environmental sculptures, towards the end of the 1960s. One of the most intriguing of these is a room-size net-like mesh built up out of finely modelled triangular steel components hooked and joined at the ends. It forms a discontinuous equilibrium whose lines and planes cross each other in a dynamic rhythm of tensions, forces and transparencies, producing an infinite multiplicity. It expands as if it were a fragment of an immense organic structure projecting an architectonic energy into space. The piece establishes a balance between the logic and rigour of geometry and an unlimited subjective field (fig. 149).

The Reticuláreas marked the maturity of Gego's artistic production and served as the point of departure for her later work which took a highly individual path that was out of step with the abstract geometric tendencies so popular at the time. Although less well known than many of her contemporaries working in geometric abstraction and kinetic art, Gego ended up producing one of the most original bodies of work in modern Venezuelan art.

The 1970s

The 1970s were dynamic years, due in great part to the vast new resources made available to cultural institutions in the wake of Venezuela's OPEC-increased oil wealth. The artists who began their experiments during this decade thus had access to information on, and exhibitions reflecting, the most up-to-date art forms. Moreover, the Museo de Bellas Artes, the only institution in Venezuela dedicated to the visual arts, had been re-evaluating and altering its programmes since the 1960s, opening itself up to the latest tendencies in various media and thus helping to support the work of artists across the generations.[11]

147. Jacobo Borges – Ha comenzado el espectáculo
(The Show has Begun), 1964. oil on canvas, 180.8 x 270.4 cm.
Galería de Arte Nacional, Caracas

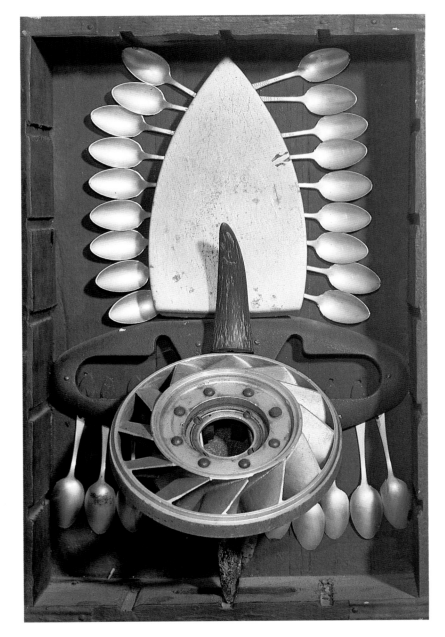

148. Mario Abreu – Extractor de la conciencia
(Extractor of Conscience), n.d. mixed media assemblage.
46.5 x 30.5 x 18.5 cm. Galería de Arte Nacional, Caracas

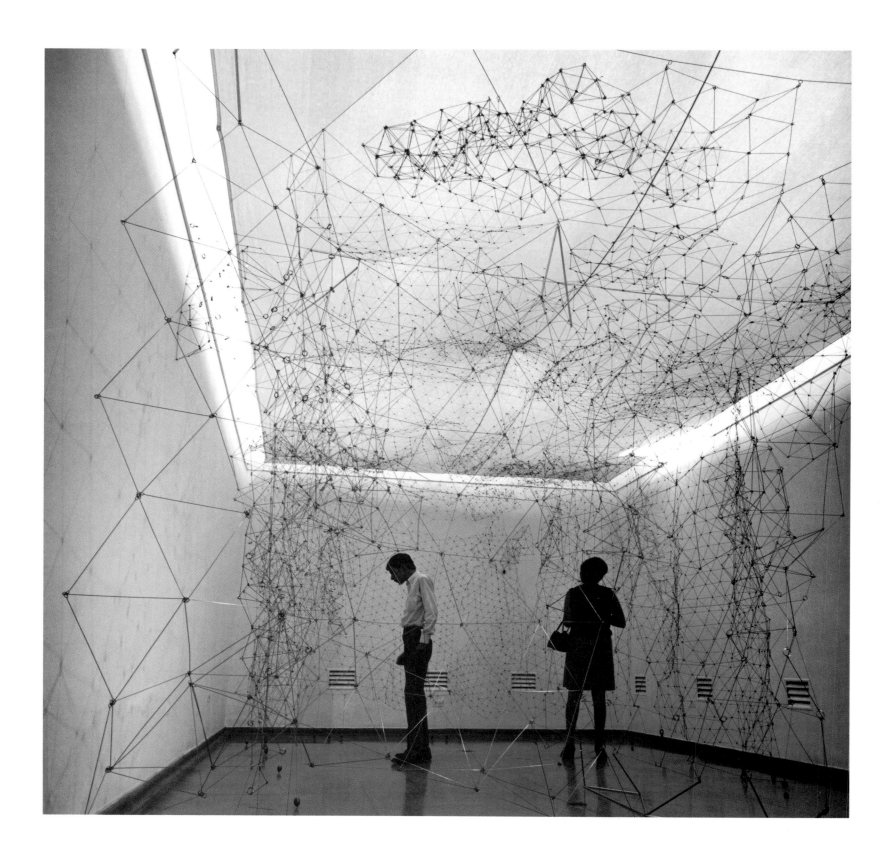

149. GEGO – RETICULÁREA (NET), 1969. *wire, dimensions variable.
installation at the Galería de Arte Nacional, Caracas*

Until the mid-1970s the Museo de Bellas Artes served as the most important centre for new visual languages and diverse artistic tendencies. In addition, three new museums dedicated to contemporary art opened in Venezuela: the Museo de Arte Moderno Jesús Soto (Ciudad Bolívar, 1973), the Museo de Arte Contemporáneo de Caracas (1973) and the Galería de Arte Nacional (Caracas, 1976).

The decade also witnessed the beginning of a new stage in Venezuelan art–the questioning of modernity and the subsequent surge of change and renovation. Younger artists reacted against the kinetic–Constructivist domination and the politicization of Neo-figurative art, enthusiastically exploring new expressive possibilities and media, arguing for a radical reappraisal of processes and techniques, across a spectrum ranging from new approaches to the figure and the object to experiments with conceptual art.[12]

Las sensaciones perdidas del hombre (*The Lost Sensations of Man*), presented at the Sala Mendoza in Caracas in 1972, was one of the first collective undertakings of the decade. It combined the work of nine young artists, among them William Stone, Margot Rõmer (b. 1938) and María Zabala. The project, spanning eight rooms, invited the spectator to become immersed in a living, sense-affirming experience in which the perception of urban noise and chaos was reduced to its most elemental, permitting the visitor to re-encounter sensations lost in the alienating experiences of city life. The same group presented, with similar motives, two other projects entitled *Para contribuir a la confusión general* (*To Contribute to the General Confusion*), shown at the Ateneo de Caracas in 1972 and *Piel a piel* (*Skin to Skin*), seen at the 1973 São Paulo Bienal.

Sculpture during this decade became highly varied and experimental. The work of Valerie Brathwaite (b. 1940) and William Stone (b. 1945) ranked among the most interesting of the period, their projects demonstrating a mysterious and organic sensibility. The experiences and participatory sculptures of Víctor Lucena (b. 1948) sought to alter the conventions of the viewer's perceptive reality while, at the same time, increasing his cognitive potential through dialogues which included the widest possible combinations of sensory experience (fig. 150). María Zabala (1945–92), on the other hand, used graphics, computers, photography and painting to create sculptures in which diverse types of primary structures were synthesized in works whose realization depended upon the participation of the observer.

Manuel Mérida (b. 1939) constructed transparent coloured boxes playfully filled with incongruous materials – paint pigment, sawdust, discarded objects, metallic dust and fragments of wallpaper. The boxes were rotated by built-in motors or could be moved by hand, creating rhythms and forms which – in contrast to the effects of kinetic objects – offered an organic and sensual vision of movement and the machine. Héctor Fuenmayor (b. 1949), Eugenio Espinoza, Claudio Perna, Diego Barboza, Pedro Terán (b. 1943), Antonieta Sosa (b. 1940) and Roberto Obregón (b. 1946) also pursued important conceptual projects. Claudio Perna (b. 1938), a cardinal figure in Venezuelan conceptual art, used new technology and other diverse media to create a vast interdisciplinary œuvre which touched on aspects of politics, geography, sociology, education and culture.

Eugenio Espinoza (b. 1950) was one of the most notable artists of the 1970s. Basing his work on the grid pattern, he used a variety of materials and expressive methods to carry his experiments with plane and surface from the museum and gallery to environmental and social milieus, staging 'actions' and 'interventions' and creating grid structures in spaces of a very diverse nature (fig. 152).

Diego Barboza (b. 1945) constructed his playful, celebratory outdoor participatory experiences out of conceptual elements mixed with folklore. In the events entitled 'Art Events Like People–People Like Art', the spectator on the street played a key role. The piece called *The Box of the Armadillo,* for instance, was a collective festival 'celebrated' in working-class neighbourhoods, in which passers-by were invited to form a single body, dressed in a large coloured cloth with the shape of an animal, in which they danced to the rhythm of music (fig. 151).

Although Luis Chacón (b. 1927) and Elisa Elvira Zuloaga had both worked in the field of printmaking, it was not until the 1960s, with the opening of the graphics workshop of Luisa Palacios (1923–90), that the medium drew serious attention and was cultivated by artists in a systematic way. The 1970s represented a high point for printmaking in Venezuela with the creation of the CEGRA (Centro de Enseñanza Gráfica, or Centre for Graphic Teaching) and the TAGA (Taller de Artístas Gráficos Asociados, or Workshop of Associated Graphic Artists) groups.[13] Painters and graphic artists of different generations explored, with great freedom, the materials and expressive possibilities of this medium. Traditional printmaking proliferated alongside the techniques of photocopying, photoengraving, frottage and rubbing.

In addition to the important contribution of established artists to the development of the graphic media, younger figures such as Rolando

151. Diego Barboza – La caja del cachicamo
(The Box of the Armadillo), 1974. collective
action, mixed media. Caricuao, Caracas

150. Victor Lucena – Shock K6, 1977. polished metal,
dimensions variable. collection of the artist, Caracas

152. Eugenio Espinoza – Impenetrable, 1972 mixed media,
dimensions variable. installation at the Ateneo de Caracas

153. Roberto Obregón – WDT, 1991.
linoleum, photocopy and graphite on canvas,
3.3 x 10 m. Museo de Bellas Artes, Caracas

Dorrego, José Antonio Quintero (b. 1946), Héctor Fuenmayor, Claudio Perna, Eugenio Espinoza, William Stone and María Zabala also stood out for their experimentation with different mediums and a variety of graphic materials.

The 1980s

Although the affluence of the 1970s carried over into the new decade, major economic imbalances led to a huge monetary devaluation in 1983, seriously undermining the financial strength of the country's cultural institutions. As a result, museums chose to devote much of their attention and a large part of their programmes to the art of the younger generations. At the same time, the local art market became unexpectedly buoyant as dealers, galleries and collectors also promoted the work of young artists.[14]

From approximately 1979 until 1984 the movement known as 'New Drawing' enjoyed a position of prominence, thanks to the support of critics, institutions and galleries. The painters associated with this movement sought to reinvigorate drawing in Venezuela; they placed particular emphasis on technical virtuosity in works of large format, especially those dealing with the figure. Francisco Quilici (b. 1954), Julio Pacheco (b. 1953), Ernesto León (b. 1956) and María Eugenia Arria (1951) were among New Drawing's most outstanding members.

Conceptual art, also called 'non-conventional art' during the 1980s, continued to develop along various paths including installation, video, conceptual objects, happenings and 'actions'. No longer in the official shadows of the previous decade, conceptual art now often received serious institutional backing. Representative artists in this field during the decade included Pedro Terán, Antonieta Sosa, Marco Antonio Ettedgui

(1958–81), Alfred Wenemoser (b. 1954) and Roberto Obregón.

Antonieta Sosa (b. 1949) has undertaken an extensive investigation using diverse media to challenge the traditional notions of limits in visual and social spaces. Her performances, installations and objects seek to provoke sensations of tension and opposition, experiences which have a cathartic effect on the spectator. Roberto Obregón, on the other hand, created one of the most dense and enigmatic bodies of work of the decade. He documented and classified the gradual evolution of the landscape, the rose, his own life, registering in an obscure circularity the imperceptible pulse of time. His chronicles, processes and dissections trace the cycles of life and death in a complex mapping of interior territories and private sorrows (fig. 153).

From 1970 until the beginning of the 1980s many Venezuelan artists received fellowships (awarded by official organizations or for participation in Salons) to study abroad, especially in Europe and the United States; these individuals returned to Venezuela sporadically throughout the 1980s, having absorbed the influence of international currents such as German Neo-Expressionism or the Italian *Transvanguardia*.

In the mid-1980s painting again assumed a strong position in the Venezuelan art world. While the younger painters pursued a variety of approaches and subjects, their art was particularly linked to the emerging Neo-Expressionist tendencies. Ernesto León (b. 1956) became one of the most prolific and versatile painters in this mode. After returning from a lengthy stay in New York he executed a number of large-scale works reflecting his interest in gestural painting, marked by a wide range of

colours. In these, he mixed elements of popular culture and tropical flora and fauna with his personal iconography.

León, Carlos Zerpa (b. 1950), Jorge Pizzani (b. 1949), Oscar Pelligrini (1947–91) and Carlos Sosa (b. 1951) became the best known artists of their day. Their work, however, supported by the market and a powerful group of critics, was heavily influenced by the most popular trends of the time.

The 1990s

The last decade of the century began in crisis. Ten years of growing government debt and declining oil revenues left Venezuela almost bankrupt in 1989; the government implemented dramatic changes intended to replace the country's state-directed economy with a system that was market-led. The resulting devaluations, price increases and reductions in public spending ignited great social unrest and led to two coup attempts against the government and the forced resignation and trial of a sitting president for corruption. Even though the political situation stabilized in 1994, the economic problems continued unresolved.

While museums generally continued the long Venezuelan history of institutional conservatism, perpetuating a modernist vision of art, they slowly began to open up towards more contemporary concerns and forms of expression. The exhibitions *Uno, dos, tres, cuatro* (*One, Two, Three, Four*), presented at the Museo de Bellas Artes in 1991, *Venezuela. Nuevas cartografías y cosmogonías* (*Venezuela. New Cartographies and Cosmogonies*) and *CCS-10: arte actual venezolano* (*CCS-10: Recent Venezuelan Art*) at the Galería de Arte Nacional in 1991 and 1993 respectively, were the first to receive full institutional support for

artists working on experimental installation and multimedia projects.

Meyer Vaisman (b. 1960), Alfred Wenemoser (b. 1954), and José Antonio Hernández Diez (b. 1964) created some of the most interesting work in the early years of the new decade.

Vaisman, who has lived in New York since the 1980s, joined with Jeff Koons, Peter Halley and Ashley Bickerton to form the Neo-Geo Movement (Neo-Geometric Conceptualism). In an *œuvre* developed around the idea of the artist's identity crisis, Vaisman satirized, with mordant ambiguity, both himself and the viewer, reflecting on the uncertain values of the present-day. More recently he has become active in the artistic life of his own country, participating in various exhibition projects in Venezuela and producing works which reflect on the contemporary Venezuelan reality. In *Verde por dentro, rojo por fuera* (*Green Inside, Red Outside*), presented at the Galería de Arte Nacional in 1993, he continues discussing the idea of the artist's identity crisis but the focus has shifted to the Venezuelan sociopolitical realm. In the ambiguous image of a cinderblock shack – the precarious and humble dwelling of the country's poorest inhabitants – containing the comfortable yet oppressive middle-class bedroom of the artist's youth, he interweaves important social, political and personal issues (fig. 155).

Alfred Wenemoser, an Austrian-Venezuelan artist, has been producing a rich and paradoxical body of work since the late 1970s. His objects, installations and distinctive architectural configurations (fig. 154) are fragments whose forms and meanings take shape on interacting with the visual and sensory experiences of the viewer. The psychic life, the memory, the

154. ALFRED WENEMOSER – R.M., 1994. *wood, iron,
wall painting, dimensions variable. installation at the
Catedral Metropolitana de Ciudad Bolívar*

Venezuela

cultural ethos of each spectator, endows the form
with its true identity.

Finally, José Antonio Hernández Diez
has created a work critical of religious, technolog-
ical and social issues. *Los tres X* (*The Three Xs*), a
multimedia installation presented at the Galería
de Arte Nacional in 1993, is a commentary on
the violence and social tragedy of children who
live on the streets in various urban centres of
Latin America. In this three-part installation,
Hernández uses museological devices to
camouflage images of dramatic impact. The deaf-
ening rhythmic noise of a basketball, the video's
images of three underprivileged children trying
to shoot a ball into a basketball net and the
ascetic, orderly table with three bodies made out
of the skin of fried pork, suggest in a forceful,
powerful way, a space that is highly charged with
tensions and life-and-death energies (fig. 156).

155. MEYER VAISMAN – VERDE POR FUERA, ROJO POR DENTRO (GREEN ON THE OUTSIDE, RED ON THE
INSIDE), *1993. mixed media, dimensions variable. installation at the Galería de Arte Nacional, Caracas*

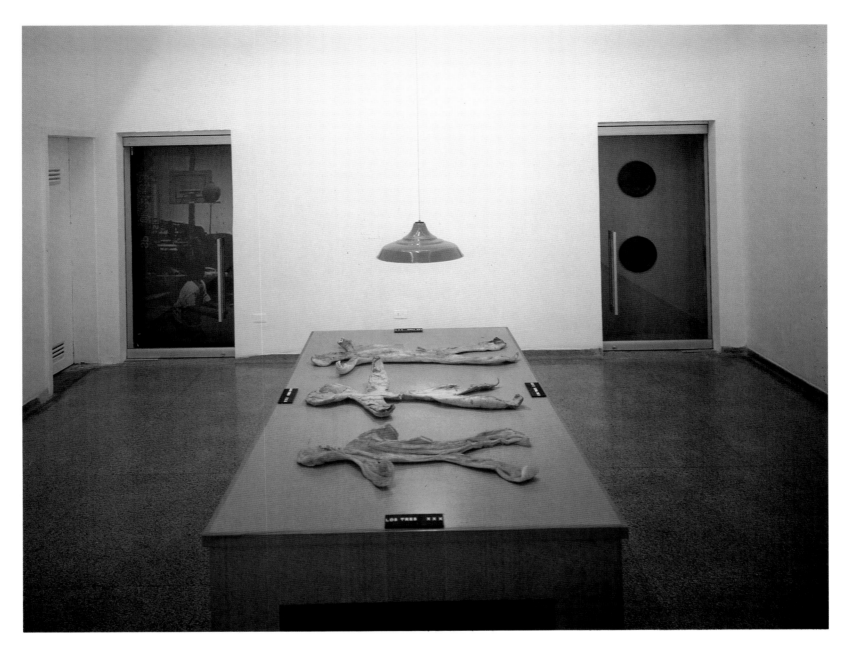

156. José Antonio Hernández-Diez — Los tres X
(The Three Xs), *1993. mixed media, dimensions variable.*
installation at the Galería de Arte Nacional, Caracas

Ivonne Pini

Colombia

Latin American Art in the Twentieth Century

Colombia

1900–1930: A Time of Transition

At the beginning of the twentieth century, Colombia, with slightly more than four million inhabitants, was still a rural nation. There was little industrialization and so there were few urban areas of any significance. Bogotá, for example, had 120,000 inhabitants, Medellín 70,000 and Cali 50,000.[1] So far as politics was concerned, the early years of the century coincided with the republican conservative era and with two particularly significant events. The first of these was the 'War of the Thousand Days' of 1899–1901, precipitated by widespread dissatisfaction with the conservative Constitution of 1886 as well as by a slump in coffee prices. The second was the secession of Panama which declared itself independent from Colombia in 1904.

The comments of historian Eugenio Barney Cabrera reflect the attitude of the painters of the period: 'The greatest ambition of Colombian artists at the end of the [nineteenth] century was to copy European painters of earlier periods although they did not surpass them. Artists were not concerned with such factors as the anachronism, mediocrity or inappropriateness of their styles. Nor were they concerned that other aesthetic factors were coming into play owing to political and economic changes in the country. None the less, this dryness and imitation in art was not the most deplorable feature of the situation. What was worse was the lack of even a single artist who could foresee what the future would bring. All [artists] were submissive to, and compromised and ruled by, the system then in vogue as well as by a patriarchal, sometimes rural society. Vain and complacent in their self-created superiority, they lived in an era that the world had long since left behind.'[2]

In common with other Latin American countries, art in Colombia was dominated by figurative academicism and a corresponding lack of enthusiasm for the avant-garde tendencies developing in Europe. Impressionism had some influence but the majority of Colombian artists, tied to their academic training, continued to work in a strictly traditional vein. With few exceptions, Spanish humanism and the French school constituted the basis of the formal education of these artists, many of whom had studied at the Julian and Colarossi academies in Paris or that of San Fernando in Madrid.

Turn-of-the-century artists in Colombia were at the mercy of the country's provincial mentality. Those of the bourgeoisie who purchased art preferred the work of painters who kept to traditional styles and confined themselves to landscape and portraiture where strict representation was demanded.

One painter proved an exception to this rule. The landscapist and portraitist Alfonso González Camargo (1883–1941) depicted banal urban views with an acute artistic vision. González Camargo was more interested in evoking the essential qualities of things, synthesizing them in well-composed, freely coloured compositions. His most outstanding contribution to Colombian art is in the area of landscape, both rural and urban, in which colour, distinguishing local characteristics and formal composition are the most notable features. A painting such as the undated *Calle 13, carrera 14, esquina (At the Corner of 13th Street and 14th Avenue*; fig. 158) offers a straightforward evocation of a place with few extraneous details. Camargo's sensibility was far removed from that of his contemporaries, making him one of the first modernists in the history of Colombian art.

Epifanio Garay (1849–1903) was the most representative and positive artist of the late academic manner and the best *fin-de-siècle* portraitist. His portraits of Bogotá society are true to their subjects, concentrating on facial expression and the rendering of textures such as satin, silk and lace.

The portraits of Ricardo Acevedo Bernal (1867–1930) were done some twenty years later. Despite numerous trips to Europe (where he lived between 1903 and 1906) Bernal was little influenced by Impressionism and its variants. His likenesses are excellent technical achievements, defining the characteristics of each individual through the play of light on their faces. In addition to portraits Bernal also painted genre, historical and religious themes including murals in various churches.

Although landscape and portraiture predominated in Colombian art at the turn of the century, genre painting came to represent an alternative current here as well as in the rest of Latin America. Miguel Díaz Vargas (1886–1956) painted festivals and everyday activities, especially those of rural people, often inserting a certain amount of social commentary. His work is characterized by strong, precise drawing, sensitive colour and a keen observation of the world around him.

Andrés de Santamaría (1860–1945) stands out among the artists of the period. Born in Bogotá, Santamaría left Colombia with his family at the age of two, living in London, Brussels and Paris. With the exception of two later periods of residence in Bogotá, the artist spent most of his adult years in Brussels. In his youth he was interested in the Impressionists and the Nabis although his work does not reflect this influence in a direct way. During his Bogotá

157. ANDRÉS DE SANTAMARÍA – AUTORRETRATO
(SELF-PORTRAIT), *1923. oil on canvas, 70 x 60 cm.
Museo Nacional de Colombia, Bogotá*

years many influences shaped his artistic development, among them the French Barbizon painters and the Spanish seventeenth-century Tenebrists. In a manner somewhat reminiscent of the Spanish masters Santamaría painted torsos and heads (among his favourite subjects) with special attention to the richness of textures. After his return to the Colombian capital when he was director of the Escuela de Bellas Artes his work provoked lively controversy (which continued even after his death) for its pronounced modernity.

Returning to Europe, Santamaría's interest in surface and texture evolved along Expressionist lines, evidenced by his rich use of impasto and brilliant colours. Absorbing the diverse influences of Spanish and Dutch seventeenth-century portraiture and the art of the French landscapist Adolphe Monticelli, Santamaría now embarked on one of the most important phases of his career, creating a series of portraits, still lifes and flower studies exclusively on the merits of their colour and texture, painting the brilliantly hued (usually green or red) image close to the picture plane against a neutral background. In his *Autorretrato* (*Self-Portrait*; fig. 157), for example, he revels in the possibilities of colour, light and impasto. Here the figure dominates the space; there are very few additional pictorial elements and the background is a chromatic play of neutral tones.

Sculpture also developed from a strictly academic approach, neo-classicism retaining a strong hold on Colombian sculptors in both themes and styles. One artist, however, escaped these confines. Marco Tobón Mejía (1876–1963) began his studies in his native city of Medellín, continuing them later in Paris. His reliefs in pewter and electroplate represent an important

158. ALFONSO GONZÁLEZ CAMARGO – CALLE 13, CARRERA 14,
ESQUINA (AT THE CORNER OF 13TH STREET AND 14TH AVENUE),
n. d. oil on canvas, 20 x 12.9 cm. Museo Nacional de Colombia, Bogotá

Colombia

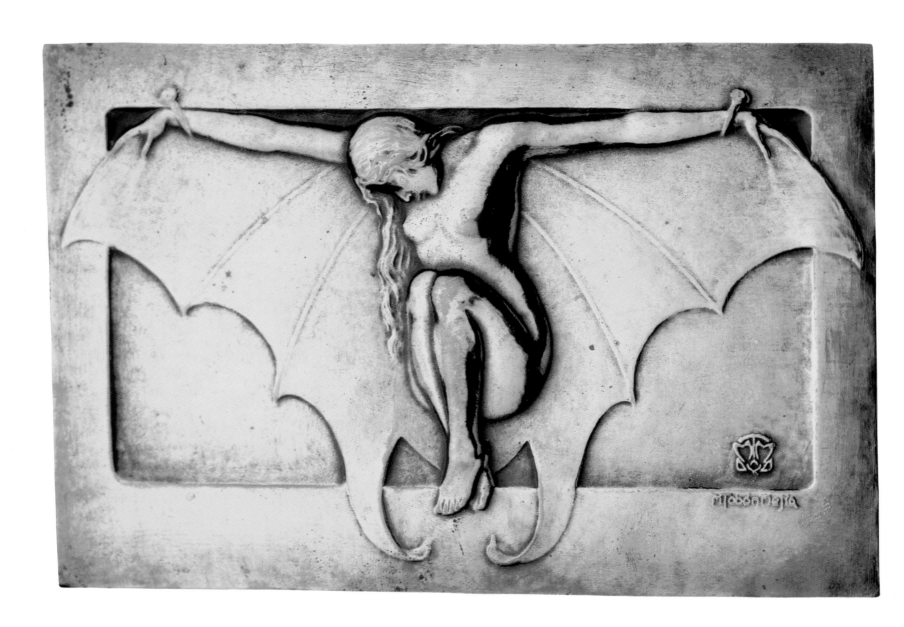

159. Marco Tobón Mejía – Murciélago (Bat), c.1910.
bronze, 18.5 x 27 cm. Museo Nacional de Colombia, Bogotá

160. RÓMULO ROZO – MATER DOLOROSA (SORROWFUL MOTHER), 1929. bronze, 16 x 13 x 23.5 cm. Museo Nacional de Colombia, Bogotá

contribution to Colombian sculpture. Mejía employed the curvilinear line to emphasize the sensual qualities of his works, which included representations of female figures and animals as well as landscapes and depictions of historical subjects. *Murciélago* (*Bat*; fig. 159) is an excellent example of the suggestive, voluptuous art of Mejía, which went far beyond the mundane, academic output of most of his contemporaries. The figure, with its legs against its body and its enormous wings, contributes an enigmatic and mysterious quality to this work which distances it from Mejía's usual neo-classical depictions of the nude form in marble. His willingness to mine the possibilities of the expressive qualities of Art Nouveau put him on a plateau well above other Colombian sculptors of his day.

1930–1940: Modernity and Nationalism

While the end of the 1920s witnessed multiple social conflicts (such as the banana strike of 1928 featured in Gabriel García Márques's novel *One Hundred Years of Solitude*) the 1930s opened with a number of subtle changes. The republican conservative government came to an end and the Liberal Party initiated a series of modernizing reforms that stimulated industrial production. The higher education system was restructured in 1932 and two years later the Confederación de Trabajadores Colombianos (Confederation of Colombian Workers) was founded and a land distribution act was passed.

Modern Colombian art established itself against this social backdrop, although not without difficulty. Discussions of aesthetic issues even reached the floor of the Senate, where defenders of the new confronted those who upheld traditional values and argued for the need

to remain faithful to a classical stance and a strict representation of nature in art.

It was not surprising that this debate came to a head in 1934, the year that saw the rise of a new generation of Colombian artists. During the 1930s and 1940s a number of artists broke out of the academic mould, creating a form of modern art strongly tempered with nationalistic sentiments inspired by Mexican Muralism. The Mexican School, headed by Diego Rivera, José Clemente Orozco and David Alfaro Siqueiros, also exerted a strong influence throughout Latin America during these decades, compelling many artists to question the viability of European academic modes.

This new generation of Colombian artists created a spirit of renewal through their interest in the everyday life of the people and their varied racial cultures and myths. They were the first to abandon definitively the outmoded lessons of the academy and to observe what European art had to offer in the wake of Impressionism. They were inspired by Expressionism, the early Paris School, late Pointillism and later Cubism, and their eyes were also open to non-Western forms of aesthetic expression.[3]

Although these artists shared many thematic and conceptual concerns, they cannot be looked upon as a group. And despite the fact that painters like Luis Alberto Acuña insisted on giving them the title Bachués,[4] this name, derived from a sculpture of the pre-Columbian goddess Bachué by Rómulo Rozo (1899–1964), was rejected by the majority who did not want to be seen as part of a homogeneous unit. Rozo represented the sculptors of a nationalist tendency. After a period in which he produced work characterized by excessive emphasis on

Colombia

decoration (typified by the Bachué), he did a series of pieces depicting female figures, including mothers and children, in a more simplified, synthesized manner. His intermediary phase between the two extremes was developed during a stay in Mexico and is represented by a sculpture of 1929 entitled *Mater dolorosa* (*Sorrowful Mother*; fig. 160).

Luis Alberto Acuña (1904–93), an artist inspired by the variants of Post-Impressionism (such as Divisionism) as well as by Mexican mural painting, developed a body of work embracing a variety of techniques and subjects. References to themes found in both indigenous mythology and Spanish literature appear in his murals. Acuña also painted landscapes and genre pictures.

The modernizing government of President López Pumarejo from 1934 until 1938 supported those artists interested in introducing social and nationalistic subjects into their increasingly important mural art, which included the struggle for subsistence of Indians and rural and urban workers. The most prolific artists to develop this type of subject-matter included Pedro Nel Gómez, Ignacio Jaramillo, Alipio Jaramillo and Carlos Correa.

Pedro Nel Gómez (1889–1984) returned to Medellín in the 1930s after years of study in Europe. In his many murals he portrayed the hardships of those people living in the inhospitable region of Antioquia. His strongly narrative and symbolic images emphasize the relationship between human beings and their surroundings. His four major thematic concerns were population and the family structure, the history of the region and its mining, popular myths and legends, and political violence. Women, depicted in a variety of ways (with a concentration on the nude), invariably appear as protagonists representing the idea of maternity and labour. The nudes of Nel Gómez are free from idealization and emphasize the strength of the female form. Such an example is seen in the watercolour entitled *Barequera melancólica* (fig. 161). Nel Gómez also did easel paintings and sculptures which repeated his favourite themes.

Ignacio Gómez Jaramillo (1910–70) followed Cézanne in eliminating all extraneous elements from his rigorously structured compositions. His favourite themes were nudes, portraits and landscapes. In 1936 Gómez Jaramillo went to Mexico to study Muralism; returning to Bogotá the following year, he executed frescos depicting both landscape and figures which are noted for their realism and objectivity.

Alipio Jaramillo (b.1913) began his studies in Bogotá, subsequently travelling throughout South America. His various murals in Chile – where he worked on a project with David Alfaro Siqueiros – and Argentina demonstrate his concern with the down-trodden masses. Murals subsequently produced in his native Colombia, as well as canvases, watercolours, drawings and prints, also dealt with the plight of the working classes and bear witness to the fact that, despite some relatively minor gains in class equality made in the 1930s, political and social unrest continue to mark Colombian history up to the present day.

Carlos Correa (1912–85), a student of Nel Gómez, painted in a realistic manner depicting the struggles of the workers. In the 1940s he broadened his art to include such subjects as popular festivals, the nude and landscape. Gonzalo Ariza (b. 1912) and Sergio Trujillo Magnenat (b. 1911), both members of the same modernist generation, are particularly known for their landscapes. Ariza, the pioneer of contemporary landscape painting in Colombia, studied in both Bogotá and Tokyo and worked in oil and watercolours. In his art, often strongly influenced by Japanese landscape painting, Ariza was able to evoke the atmosphere of specific sites in the Colombian countryside.

In sculpture there was also a dramatic departure from academic practices in the 1930s and 1940s. The younger sculptors expressed an interest in nationalist themes with numerous references to pre-Columbian legends and types drawn from popular culture.

1950–1970: Internationalization in Art
In Colombia as well as in the rest of Latin America, the 1950s and 1960s saw a shift towards internationalization in art. Artists for the most part veered away from academically oriented styles inherited from the nineteenth century and embraced a wide variety of avant-garde forms that were to a greater extent inspired by events in the United States than in Europe. Concepts of figurative art were questioned and there was a subsequent move towards non-objectivity. The Colombian versions of forms such as geometric and lyrical abstraction, Pop art, kinetic art and others, developed in response to local realities, were not as radical as in the centres from which they originated. None the less, this reinterpretation by Colombian artists of elements coming from outside the country did not represent a simple recasting of nationalist themes. On the contrary, there was a serious questioning of the thematic rigidity of earlier times. Artists no longer felt themselves bound to depict only themes of Colombian history or the Colombian landscape. The academic-based homogeneity

161. Pedro Nel Gómez – Barequera melancólica, c.1950.
watercolour, 140 x 103 cm. Museo Nacional de Colombia, Bogotá

162. GUILLERMO WIEDEMANN – TONOS
APAGADOS (EXTINGUISHED TONES), 1961.
watercolour, 62.5 x 84 cm. private collection

which had thus far characterized the country's art was rejected; the previous single-mindedness of artistic vision was supplanted by a marked plurality.

In the mid-1940s, a point in Colombia's history which marks the beginning of the period known as La Violencia, the political crisis worsened. Two successive conservative governments had developed a repressive political strategy that signalled the loss of basic human rights, persecution and death to those who opposed them. The peasant, petit-bourgeois and working classes were especially affected. The situation became even more polarized with the assassination of the liberal leader Jorge Eliecer Gaitán in 1948. Even though Gaitán's death provoked a popular uprising in the principal cities of Colombia, its lack of organization led to an increase in repression.

These events created a political situation of great complexity in the 1950s, with continued partisan violence, a *coup d'état*, and the establishment of the left-wing Frente Nacional (which alternated in power with the Liberal and Conservative parties). In the realms of culture, however, many significant steps forward were taken. New venues of creativity were established as part of a general desire to open up the country to the latest international trends. Such events as the reinstitution in 1957 of the Salones Nacionales de Artistas (National Artists' Salons) and the opening of new commercial galleries, as well as other exhibition spaces, allowed the visual arts to reach wider audiences. Art criticism became much more sophisticated at this time. Critics such as Walter Engels and Marta Traba wrote penetrating books and essays on matters relating to Colombian art, and newly founded publications such as *Plástica* and *Prisma* were influential in disseminating information both

about the new art at home and developments in the visual arts throughout Latin America.

Abstraction

By 1957 abstraction in Colombia was barely five years old. Before the early 1950s only Marco Ospina (1912–83) had experimented sporadically with geometric abstraction while continuing his semi-figurative art. In 1952 Eduardo Ramírez Villamizar returned from Paris, marking the establishment of geometric abstraction in Colombia. However, it was not the geometric approach that predominated but a more expressive form of abstraction such as can be seen in the work of the German artist Guillermo Wiedemann (1905–68).

Arriving from Germany in 1939, Wiedemann first painted the figure as well as tropical landscapes, gradually developing towards a more schematic figuration and finally attaining pure abstraction. By the late 1950s he was painting in a mode of lyrical Expressionism, exploring the possibilities of colour, line and form. At the beginning of the 1960s Wiedemann turned his attention to humbler materials, developing at this time a non-rigid geometric style characterized by chromatic harmonies. His interest in watercolour was a constant, bringing into play all the possibilities of his expertise at spatial relationships, light and colour in his abstract works done in this medium. Abstraction for Wiedemann represented the possibility of expressing the concept of inner necessity; nothing was gratuitous and everything should be the result of a profound reflection. The watercolour *Tonos apagados* (*Extinguished Tones*; fig. 162) of 1961 is a good example of Wiedemann's work of this period.

Even though figuration was back in

favour by the early 1960s, abstraction continued to attract the significant talents of artists like Manuel Hernández, Carlos Rojas, Omar Rayo and Fanny Sanín. The early work of Hernández (b. 1928), in a figurative mode, displayed his interest in textured surfaces but he gradually evolved his characteristic use of basic forms, concentrating, by the end of the decade, on ovals and rectangles. All extraneous elements gradually disappeared from his art, giving way to a body of work in which precise shapes and colours create a contemplative mood. His conception of defined forms and signs, which dominates his *Signo doble negro* (*Double Black Sign*; fig. 164) of 1990, relies on the use of black to emphasize contours and create contrasts, a concern which is evident in much of his recent work.

Omar Rayo (b. 1928) also developed his emblematic motifs in the 1960s. These included abstract forms derived from Op art painted in acrylics. In his intaglio series such as *Erótica* (1962–9) and *Papel herido* (*Wounded Paper*) of 1963–78, Rayo comes close to depicting actual objects and suggesting certain mundane subjects, while never altogether forsaking abstraction.

Carlos Rojas (b. 1933) has displayed, since the early 1960s, a strong interest in colour and texture in works which border on both Abstract Expressionism and Informalism. At the end of the decade he abandoned all figural references, concentrating on concrete forms reminiscent of Minimalism. Colour plays a predominant role, derived in certain cases from native Colombian textiles. His 1975 series called *Horizontes* (*Horizons*) explores one of his principal concerns: colour, its possible combinations and its organization in linear rhythms. In his sculptural work Rojas has created the equivalent

Colombia

163. EDGAR NEGRET – SOL NEGRO (BLACK SUN)
FROM THE SERIES MITOS ANDINOS (ANDEAN MYTHS),
1984. *painted aluminum, height 110 cm. private collection*

of abstract drawing in space. Fanny Sanín (b. 1935), who has lived for a number of years in New York, worked in a manner close to Expressionism in the mid-1960s but she later evolved a geometric language which still dominates her art.

Other Colombian artists attracted to abstraction include Antonio Grass, Samuel Montealegre (b. 1940), Pablo Solano and Alberto Gutiérrez (b. 1935). Along with his painting and graphic art, Grass (b. 1937) has also produced ceramics, sculpture and jewellery in which he utilizes pre-Columbian motifs.

Among the most important Colombian abstract sculptors to emerge at this time were Edgar Negret and Eduardo Ramírez Villamizar. Negret (b. 1920) began by executing figurative sculpture in plaster. In the mid-1950s he turned to aluminium, the medium in which he created his first 'magical devices': abstract constructions alluding to the presence of the machine in modern society. These polychrome works are assembled with nuts and screws, a constant feature of Negret's art. His work of the 1970s incorporated a new element – interior space formed by folded sheets of aluminium[5] – which became the basis of his sculptural *œuvre*, comprising both small- and large-scale pieces in either horizontal or vertical format. In the sculptures of the 1980s vertical and horizontal elements are combined, as in the series dedicated to the Andes. In many examples of Negret's art the sensual curved lines are an integral part of his geometric structures. *Sol negro* (*Black Sun*; fig. 163) forms a part of the *Mitos andinos* (*Andean Myths*) series executed between 1982 and 1986. The most outstanding feature of these works is their interest in undulating forms to suggest references to pre-Hispanic elements.

164. MANUEL HERNÁNDEZ – SIGNO
DOBLE NEGRO (DOUBLE BLACK SIGN),
1990. *acrylic on canvas, 200 x 170 cm.
private collection*

Colombia

165. ALEJANDRO OBREGÓN – BODEGÓN EN AZULES (BLUE STILL LIFE), *1962. oil on canvas, 200 x 140 cm. Galería El Museo, Bogotá*

166. EDUARDO RAMÍREZ VILLAMIZAR – FROM THE SERIES HOMENAJE A LOS ARTÍFICES (HOMAGE TO THE ARTISANS), *1984–7. oxydized iron, height 130 cm. collection of the artist*

167. ENRIQUE GRAU – LA ALACENA
OLVIDADA (THE FORGOTTEN CUPBOARD),
1981. oil on canvas, 140 x 200 cm. private collection

The work of Eduardo Ramírez Villamizar (b. 1923) represents the beginning of pictorial abstraction in Colombia. At the end of the 1950s, after years as a painter, Ramírez Villamizar began to do reliefs and was dedicating himself entirely to sculpture by the mid-1960s. At this point he embarked on a series of works with acrylic panels which included *Construcciones emergiendo* (*Emerging Constructions*) and *Construcciones tipológicas* (*Typological Constructions*). From this, he went on to utilize a variety of materials including wood, aluminium, iron and steel according to the needs of the individual project.

By the 1970s Ramírez Villamizar had started to observe nature more closely and was incorporating forms such as the spiral snail shell into his art. His more recent work, of the 1980s, may be understood as a homage to pre-Columbian patterns. Not wishing merely to re-create the motifs of the past, he has achieved a body of work which demonstrates his admiration for ancient artistic traditions. In a series such as the *Homenaje a los artífices* (*Homage to the Artisans*; fig. 166), completed between 1984 and 1987, Ramírez Villamizar looked back on ancient art with reflective admiration. Archaeological sites such as Machu Picchu in Peru inspired in him a profound poetical response to the past. He has also executed numerous large-scale public commissions both in Colombia and in the United States. Ramírez Villamizar's art continues to celebrate formal invention disassociated from strict geometric structure.

After a brief period during which abstraction had captured the imagination of most young artists, the figure returned to the fore in Colombian art. Despite the fact that artistic traditions were seriously questioned during the 1950s

and 1960s, some of the most representative contemporary artists in Colombia continued to work in a figurative mode. Thus it is not surprising that Fernando Botero, the 1958 prize-winner at the Salón Nacional de Artistas, stated: 'Realism is the true vanguard.' A new approach to realism can also be seen in the work of two other major artists, Enrique Grau and Alejandro Obregón. The careers of both Grau and Obregón had begun in the 1940s while Botero started exhibiting in the 1950s.

Enrique Grau (b. 1920) began as an abstract artist but later turned to the solid figure in space, surrounded by objects drawn from popular culture, often evoking a certain kitsch nostalgia. His taste for exaggerated gestures, his depictions of a multiplicity of objects seemingly resurrected from the attic, and scenographic sense are all exemplified in *La alacena olvidada* (*The Forgotten Cupboard*; fig. 167) of 1981. An excellent draughtsman, Grau has worked through a variety of phases, from drawings and oil paintings to assemblages created from diverse objects as well as theatre sets and costumes.

Alejandro Obregón (1920–92) returned from France in the mid-1950s, becoming one of Colombia's leading artists and gradually moving away from naturalism. His vision of a tropical world was expressed in his use of vivid colour and depictions of symbolic animal subjects such as condors, barracudas and bulls. His brilliant tones and fantastical subjects make it easy to understand why the term Magic Realism has been applied to Obregón's art which incorporates elements derived from international realist trends as well as specific references to the spirit of the Caribbean world along Colombia's coast. Obregón's talent for transforming landscapes and objects into spots and areas of colour to

create a world where the magic of the South American landscape is always present is seen in his *Bodegón en azules* (*Blue Still Life*; fig. 165) of 1962. The representation of discord was a significant theme in the art of this period, explored by Obregón in a subtle, unsensational fashion in works such as *Violence*, also of 1962. In the early 1970s he abandoned oil, working instead with acrylics. Yet the mystery, warmth and non-reality of his earlier canvases is lacking in his later phase when the artist tended to repeat aspects of his already well-known repertory. In addition to his paintings, Obregón also developed a significant body of work as printmaker and muralist.

Fernando Botero (b. 1932) is undoubtedly the best-known Colombian painter and sculptor in the international arena. In his extensive visual repertoire he has shown himself to be immune from the influence of any of the avant-garde trends in figurative art. A serious student of art history and admirer of (among others) Paolo Uccello, Piero della Francesca, Andrea Mantegna, Diego Velázquez and Peter Paul Rubens, Botero concerns himself with the exaltation of form and the exploration of new realities based on his studies of the old masters.

In addition, Botero has studied and absorbed certain elements from both popular art and colonial sculptural forms. The concept of monumentality appeared early on in his work and has continued to capture his imagination, compelling him to search for highly defined forms and rounded figures. In exploring the characteristic features of the continent, Botero creates images that reflect, with a certain ironic humour, the Latin American realities that he observes around him. His limitless imagination is the by-product of his relationship with Colombia. He

Colombia

conceives of the nation not only as the place of his birth, but as a endless source of images, as exemplified in his oil of 1983 entitled *Colombiana* (*Colombian Woman*; fig. 168). Still life or animal elements are often treated in the same exaggerated, ecstatic fashion as the human beings in his paintings. Another characteristic is the silence that pervades them; time seems to have stopped in most of Botero's compositions.

A number of realist artists of the 1960s worked in various graphic media to create socially committed images. These include Luis Angel Rengifo, Augusto Rendón (b. 1933), Pedro Alcántara (b. 1942), who initially worked in the medium of drawing, Umberto Giangrandi (b. 1943) and Alfonso Quijano (b. 1927). Others, such as Carlos Granada (b. 1933), Jim Amaral (b. 1933) and Leonel Góngora (b. 1932), painted in an Expressionist mode . In Granada's work, violence and eroticism are combined. Erotic elements are also central to the art of Amaral and Góngora. Amaral often fragments the human body, concentrating on breasts and phalluses, while Góngora creates sensual images of both the female figure and of couples.

In his early work, Juan Antonio Roda (b. 1929) briefly flirted with both Expressionism and abstraction. His more recent art is characterized, however, by a figuration which mixes the unreal and the everyday. In addtion to creating many works on canvas, Roda developed a significant range of graphic series during the 1970s and the early 1980s.

Luis Caballero (1943–95) began, in the mid-1960s, to exhibit work characterized by violently contorted, highly eroticized figures inspired by the Neo-figuration of Francis Bacon as well as the art of such old masters as Michelangelo, Caravaggio and Géricault.

Caballero's main concern is to show the figure in extreme situations – in the ecstasy of passion or in acute pain – in which Eros and death are found together. Boundaries are eradicated and the idea of the sublime permeates the scene, as in his *Sin título* (*Untitled*; fig. 168) canvas of 1989

In her work of the 1960s, Beatríz González (b. 1938) confronted the figure in a peculiar way. Drawing on elements from art history as well as folk art, she deconstructs cultural myths in general and those of Colombia in particular. In her highly ironic images, she feels free to depict familiar religious symbols in addition to well-known sporting and political figures. González's art represents a visual panorama that reflects the cultural realities not just of Colombia but of any Latin American nation.[6] González's most recent work has emphasized the juxtaposition of serenity and violence. Her paintings are composed in a way that is reminiscent of medieval images, even though the subjects remind us of everyday events in Colombia, as in her 1990 triptych entitled *El Altar* (*The Altar*; fig. 172).

Alvaro Barrios (b. 1945) also incorporates historical references in his work. In his erotic nostalgia we perceive clear autobiographical allusions. References to Dadaism, Surrealism, Neofiguration, Pop and conceptual art appear in his drawings, prints and assemblages, which are executed with great technical skill and precision.

Santiago Cárdenas (b. 1937), whose work accurately reflects situations and circumstances drawn from everyday life and is notable for its fidelity to nature, has been active in the fields of painting, drawing and printmaking. Hooks, electric sockets, boards, mirrors, boxes, all replace the human figure in his art. In his interplay of reality and illusion the anecdotal is strictly

168. LUIS CABALLERO – SIN TÍTULO (UNTITLED), *1989. oil on paper, 190 x 130 cm. private collection*

169. FERNANDO BOTERO – COLOMBIANA (COLOMBIAN
WOMAN), *1983. oil on canvas, 115.5 x 90.5 cm. Museo
Nacional de Colombia, Bogotá*

Colombia

170. SANTIAGO CÁRDENAS – PIZARRA CON MUSA (BLACKBOARD WITH MUSE), *1991. oil on canvas, 86 x 130 cm. private collection, Caracas*

171. BERNARDO SALCEDO – PASEO MARÍTIMO (SEASIDE PROMENADE), *1994. assemblage, 27 x 29 x 19 cm. Galería El Museo, Bogotá*

172. BEATRIZ GONZÁLEZ – EL ALTAR (THE ALTAR), *1990. oil on canvas, 170 x 150 cm. collection of the artist*

173. MIGUEL ANGEL ROJAS – JERARQUÍAS (HIERARCHIES), *1991. acrylic on canvas, 180 x 400 cm. collection of the artist*

avoided. Cárdenas's interest in objects with surfaces, such as blackboards, discernible in his early works of the mid-1970s, is a theme he has returned to in the 1990s. In them the outlines are delineated upon a surface accompanied by another realistic element, as seen in *Pizarra con musa* (*Blackboard with Muse*, 1991; fig. 170).

Juan Cárdenas (b. 1939) and Alfredo Guerrero (b. 1936) have both focused their work on the human figure. Cárdenas principally depicts his own image, while central to Guerrero's work is a scrupulous analysis of his self-portrait as well as the image of the female nude.

There were very few experiments in conceptual art in Colombia in the 1960s, although the following decade witnessed experimentation in the use of new materials, especially in three-dimensional art. The incorporation of junk, plastics and other perishable materials which undermine the traditional stability of sculpture paved the way for a redefinition of the art form itself. Among those who experimented in this area are Bernardo Salcedo (b. 1939) with his white boxes filled with various objects. Assemblage has long been an important part of Salcedo's art. In his more recent work, such as *Paseo marítimo* (*Seaside Promenade*; fig. 171) of 1994, he demonstrates with characteristic humour and irony his interest in harmonious relationships between disparate objects. Hernando Tejada (b. 1925) created relief objects, forerunners of his later anthropomorphized furniture, and Feliza Bursztyn (1933–82) created a highly personal morphology with her junk sculptures which conveyed the idea of formal and conceptual anarchy, her use of discarded materials referring to the detritus of Colombian society.

1970–1990: A Time of Rapid Change

Colombia changed dramatically in the 1970s. A number of cities grew rapidly and some of them (Cali, Medellín, Barranquilla) challenged the cultural hegemony of Bogotá. Increasing prosperity among some sectors of society stimulated the art market. New museums were established and Bienals, retrospective exhibitions of the work of Colombian artists and group shows featuring international artists were all launched. Interest in art burgeoned, stimulated in part by the newly published art magazines such as *Revista* and *Arte en Colombia*. Art in Colombia in the 1970s became increasingly international, yet the pluralism of the 1960s still prevailed and no single tendency predominated. Two-dimensional art (paintings, prints and drawings) retained a favoured position. Experimental forms such as conceptual art, which were introduced to Colombia at this time, assumed increasing significance throughout the 1970s.

In the field of sculpture, greater emphasis was placed on a variety of approaches to figuration (from Neo-Expressionism through Symbolism and realism) than on abstraction. Among those artists who produced abstract sculpture there was a marked interest in rational compositions in which colour and texture played a dominant role, following the lead of sculptors who had made their mark in recent decades. Other diverse paths opened up for sculpture at this time: junk material became significant for its self-referential potential, bringing this genre of sculpture within the realm of conceptual art. A taste for assemblage and for natural materials was accompanied by increased interest in installation. At the beginning of the 1990s Colombian art followed international trends, with a diversity of aspects and leaning towards the revival of

former tendencies.

During the 1970s figuration held its own in the face of abstraction. Among those artists who remained tenaciously faithful to realism were Darío Morales (1944–88) who concentrated his attention on the suggestive potential of the female nude. Miguel Angel Rojas (b. 1946) started as a draughtsman and printmaker whose early work displayed a self-referential erotic realism and extended, in the seventies, to conceptual issues. Having experimented in the fields of graphic art and photography, Rojas now concentrates on painting. In his recent work he has returned to the human figure which he often places in urban settings with intimations of violence permeating the scene. His large-scale acrylic canvases deal with urban subject-matter representing everyday events as well as important happenings on a national scale. Without becoming excessively descriptive, Rojas creates a world of his own through the use of allegory and symbolism, as seen in *Jerarquías* (*Hierarchies*, 1991; fig. 173).

Gregorio Cuartas (b. 1936), Mariana Varela (b. 1947) and Cecilia Delgado (b. 1941) were also interested in close observation of the human figure and of objects. Saturnino Ramírez (b. 1946), Oscar Muñoz (b. 1951) and Ever Astudillo (b. 1948) chose to feature the more sordid aspects of urban reality in their drawings and paintings while Manuel Camargo (b. 1939) and Maripaz Jaramillo concentrated on idiosyncratic renderings of the human form. Jaramillo (b. 1948) uses the progressively more aggressive and seductive female figure as the principal subject in her paintings and extensive expressionistic graphic work. Recently she has dealt with images of couples as well as the solo male figure.

Colombia

Post-1960s art concentrated less and less on politics. In their silk-screen prints, Nirma Zárate (b. 1936) and Diego Arango (b. 1946) explored situations of social violence, they also supported the creation of the Taller 4 Rojo (4 Red Workshop), one of the few attempts made in Colombia to bring together artists of similar tendencies. Luis Paz (b. 1937) used graphic design elements in his prints to criticize the social and economic inequalities of the country. Gustavo Zalamea (b. 1951) utilized newspapers and photostat copies of original drawings for the same purpose, later translating his images into gigantic billboards as a medium for his symbolic questioning of aspects of social conditions in Colombia.

Dioscórides Pérez (b. 1950) combines fantastical and folkloric elements to create a dreamlike atmosphere. Alicia Viteri (b. 1946) explores her own inner life in her images of insects metamorphosed into humans. Heriberto Cogollo (b. 1945) depicts fragmented bisexual figures in strange landscapes that show a marked African influence.

Among the most outstanding Colombian landscapists are María Cristina Cortés (b. 1949), who continue to exploit elements derived from her study of the old masters and the Impressionists, and Antonio Barrera (1948–90). In creating his own perceptions of places rather than a true picture of a given locale, Barrera's main concern was to convey a poetic atmosphere in his works.

There has always been a reluctance in Colombia to embrace the most recent innovations in international art. The continued strength of figuration in the 1980s, however, owed more to the importance of Botero, Beatríz González, Santiago Cárdenas and others than to ambiva-

lence towards Neo-Expressionism or other avant-garde forms. This does not mean that Colombia has ignored what is happening in the art world abroad; merely that Colombian artists are not prepared to follow wholesale the tendencies originating in the great international capitals.[7]

Representational painting has continued to take diverging paths. Among those artists who developed an Expressionist style are Lorenzo Jaramillo (1955–93) who shows himself more interested in the gestural aspects of the canvas than in strict representation of the model in his displays of figures drawn from literature, music and colonial history. Víctor Laignelet (b. 1955) initially worked in a manner derived from important figures in the history of art, later producing manipulated images and finally portraits and symbolic images embodying universal principles. Diego Mazuera (b. 1950) has produced an impressive body of work characterized by the results of his careful visual research. His art can be described as free figuration exploring the problems of humanity in the world at large today.

Artists such as Luis Luna (b. 1958), Rodrigo Facundo (b. 1958) and José A. Suárez (b. 1955) treat history in a variety of ways in their work. Luna has derived his stimulus from the history of twentieth-century art, using Picasso, Klee and Matisse as sources for his symbolic narrative works. Facundo is interested in history as a record of human achievement, depicting objects and situations in his search for the effects these things have brought about. Suárez has created a body of work in the graphic media, comprising small-scale pieces in which he reinterprets events derived from national history by associating them with figures drawn from contemporary life or with specific references to the history of art. His work may be considered as

the artist's own personal diary. In the drawings and prints of Suárez, created with a precision reminiscent of a miniaturist, there exists a complex world of figures, texts and other types of reference. Each of his works, such as the print *Sin título* (*Untitled*, 1994; fig. 174), represents part of a sequence in which the action has a life of its own although it is almost imperceptibly linked with the next work in the series.

Non-figurative art went from strength to strength in Colombia during the 1970s and 1980s, showing that abstraction was by no means dead. Hard-edge, non-objective art, sometimes based on pre-Columbian forms, or abstraction in which colour, texture and surface played a key part, continued to be created. Abstraction had a more prominent role in the sculpture of these decades than it did in the field of painting. The guiding forces in much of this work (which consisted predominantly of metal constructions) were the concepts of order and rationalism emphasized through geometric form. This mode was promoted by artists interested in a Constructivist approach to sculpture, such as Edgar Negret and Ramírez Villamizar.

Artists such as John Castles (b. 1946), Ronny Vayda (b. 1954) and Germán Botero (b. 1946) are significant figures in the field of geometric sculpture which began to develop in the 1970s and continued to be an important factor in Colombian art during the following decade. The main characteristics of Germán Botero's art are his interest in machinery and his use of diverse materials. His 1990 installation entitled *Guerreros y tumbas* (*Warriors and Tombs*; fig. 175) represents a conceptual reflection on the world of machines.

In the 1980s the number and variety of alternative materials grew. Artists continued to

174. José Antonio Suárez – Sin título
(Untitled), 1994. engraving, 20 x 29 cm.

175. GERMÁN BOTERO – GUERREROS Y
TUMBAS (WARRIORS AND TOMBS), 1990. *ceramic,
700 x 800 x 25 cm. Museo de Barro de América, Caracas*

176. DORIS SALCEDO – DETAIL FROM THE INSTALLATION ATRABILIARIOS
(INTIMATIONS OF MELANCHOLY), 1991–2. *animal skin, shoes, thread. private collection*

Colombia

177. HUGO ZAPATA – ARCA (COFFER), 1992–3.
sculpted rock and water, 60 x 60 x 22 cm.
private collection

be interested in metal, as may be seen in the work of Consuelo Gómez (b. 1956) and, more recently, in that of Cristóbal Castro (b. 1962). The interest that artists have shown in natural materials, such as rocks, stones and marble, has also continued to grow. Hugo Zapata (b. 1945) combines these with metal and glass. His interest in specifically local materials stems from a preoccupation with cultural and geographical matters. Zapata's works, while forming part of the international language of experimental sculpture, also seek to investigate phenomena related to the earth and the effects of the passage of time, as in his work of 1993–4 entitled *Arca* (*Coffer*; fig. 177).

When the first works of Antonio Caro (b. 1950) appeared on the scene in Bogotá in the early 1970s they confirmed this artist's unconventional stance. Since then, using ephemeral materials in his art, Caro has insistently created a body of work which is critical of society as well as of the art market. Caro as well as Juan Camilo Uribe (b. 1945) and Gustavo Sorzano (b. 1944), opened the path to conceptualism. Although their experiments represented individual cases, there were exceptions to this rule, as seen in the art of the group known as El Sindicato (The Syndicate) from Barranquilla, promoted by Alvaro Barrios who championed the trio's concept of 'art as idea'.

By the mid-1980s many more individual artists (and fewer groups) had developed an interest in conceptual art, taking widely different approaches. Among the most outstanding were Doris Salcedo and María Fernanda Cardoso. Salcedo (b. 1958) has been engaged in three-dimensional work since the early 1980s. The theme of violence is always just below the surface in her installations and they affect the viewer in a highly emotional, intimate way. Such is the case

in her work entitled *Atrabiliarios* (*Intimations of Melancholy*; fig. 176) in which the shoes placed in niches appear to be abandoned and unrecognizable while it is implicit that they once belonged to someone who has disappeared. Cardoso (b. 1963) also works in mixed media, employing cement, plastics, women's stockings and desiccated animals, all of which have biographical meanings. Intimations of death are never very far from the essential message of her work.

The 1990s opened with a reaffirmation of the importance of those tendencies which emerged in Colombia during the previous decade and an interest in understanding and assimilating many aspects of international art. Virtually all artistic works of the present day demonstrate the use of the widest possible diversity of materials and a concentration on philosophical principles. Yet the specifically Colombian context is rarely absent and the complex social and cultural realities of the nation play a vital role, as they do elsewhere in South America, in shaping the national character of the country's art.

Lenín Oña

Ecuador

LATIN AMERICAN ART IN THE TWENTIETH CENTURY

178. EDUARDO KINGMAN – LOS GUANDOS
(THE HAULIERS), 1941. oil on canvas, 150 x 200 cm.
Museo de la Casa de la Cultura Ecuatoriana, Quito

When independence from Spain came in 1822 Ecuador formed part of what was called Gran Colombia (incorporating present-day Colombia, Venezuela, Ecuador and Panama). Ecuador emerged as a nation when this confederation ended in 1830. Nineteenth-century Ecuadorian art consisted of portraiture, landscape, romantic genre and historical painting, which supplanted the religious art predominant during the colonial era when Ecuador had been one of the most important centres of artistic production in Latin America. During the course of some three hundred years, the Quito School had produced paintings and sculptures which satisfied local needs as well as those of the other Spanish colonies of the Americas. Many examples of Quito School art were also exported to Europe.

In 1849 the French draughtsman Ernest Charton established the Liceo de Pintura, a precursor of the Escuela Democrática de Miguel de Santiago, founded in 1852. The latter institution was created by intellectuals and artists who believed that 'painting in our country is mired in the realm of servile imitation. But we wish to branch out into new areas of invention and originality in order to establish a national character in art.' Two decades later, the short-lived Escuela de Bellas Artes was organized under the conservative government of Gabriel García Moreno.

A liberal revolution occurred in Ecuador in 1895. Shortly afterwards, in 1904, secular education was established and the Escuela de Bellas Artes was once again opened. At this time Ecuadorian art still clung to the tenets of academic realism imported from Europe, but in the second decade of the century the Escuela was reorganized and the art produced there took on a more modern cast. The French professor Paul Bar introduced his students to Impressionism

and the Italian artist Luigi Casadio began to make sculptures in bronze and marble – techniques which were practically unknown in the country at the time.

With the assassination of the liberal revolutionary leader Eloy Alfaro in 1912, the rule of the oligarchy formed by the agricultural exporters and the bankers of the coastal region was assured. Supported by the landowners in the mountainous sectors of the country, this conservative front effectively brought any economic and social changes to a standstill. The complete decline in the 1920s of the cacao industry, the principal export of Ecuador, precipitated another political crisis which led to the Guayaquil Massacre of 15 November 1922. Committed by the army and the police, this massacre led to the beginnings of an organized working class and the formation of leftist political parties. The massacre was followed by numerous changes of government, from dictatorships to constitutional civil and military administrations. Despite the political chaos which prevailed until the 1940s, an enthusiastic revisionist spirit regarding intellectual, artistic and literary matters characterized Ecuadorian cultural life.

The standard of living of the majority of Ecuadorians inevitably worsened during this time. The small working class, product of an incipient industrializing process, the urban sub-proletariat and the great masses of indigenous peoples (centred, as was traditionally the case, on the mountainous rural areas) lived a life of grinding poverty. This contrasted starkly with conditions in the coastal regions, which benefited from the effects of technological progress initiated to open up the country to international markets.

Popular revolutions in both Mexico and Czarist Russia served to awaken the conscious-

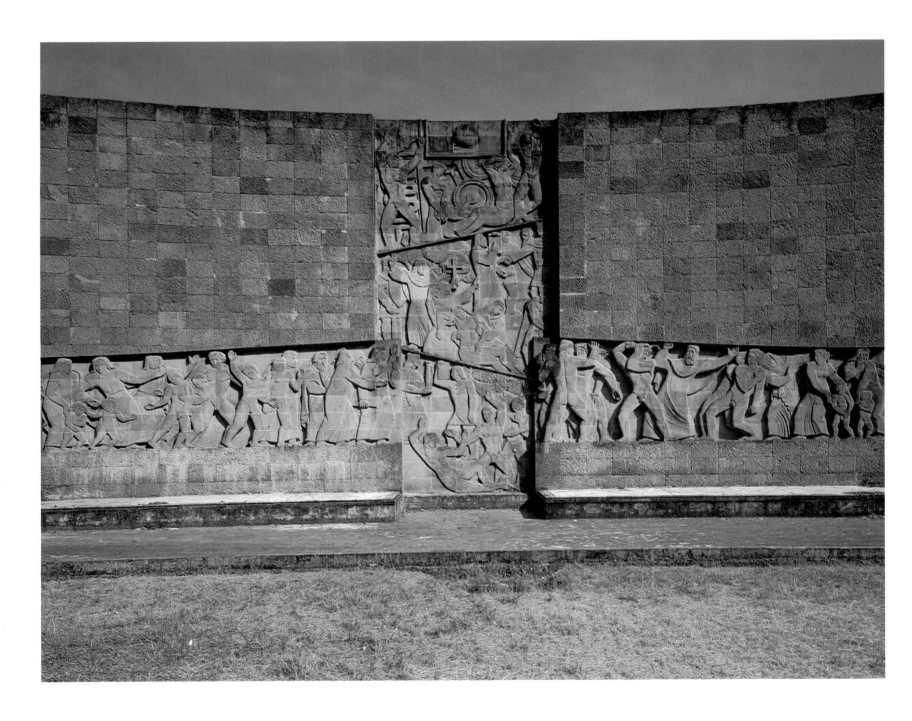

179. Jaime Andrade Moscoso – Historia del hombre (The History
of Man), 1949–54. stone, 9 x 18 m. Universidad Central, Quito

181. Oswaldo Guayasamín – Fusilamiento (Execution by
Firing Squad), 1943. oil on wood, 80 x 120 cm. Museo de la
Casa de la Cultura Ecuatoriana, Quito

ness of Ecuadorian intellectuals and artists with
regard to national and social problems. As a
result, there arose in both literature and art an
atmosphere of social protest during the 1930s
and 1940s and even later. Social realism was the
predominant tendency of artists and writers,
and within it the Indigenist Movement in
painting grew up.

Indigenismo in art, as embodied in the
work of Eduardo Kingman, Diógenes Paredes
and others, attempted to reflect the position of
servitude into which the entire Indian population
(which had, at least partially, resisted mestizaje or
miscegenation) had been thrust since the time of
the Spanish conquest. Yet this Indigenist vision
in art had little to do with the Indians themselves.
One could even say that as a movement
Indigenism remained unconscious of the exis-
tence of these various groups as distinct cultures
within a nation of people of predominantly mixed
race. None the less it implied a recognition of
a problematic social situation which had also
become the subject-matter of painters and
writers from abroad.

The theme of the Indian had already
been treated in nineteenth-century genre paint-
ing. In the first half of the twentieth century
Víctor Mideros (1888–1969), the last artist to
practise a mystical–religious brand of genre art,
created images still redolent of the nineteenth
century, while Camilo Egas (1889–1962) devel-
oped a type of Nativism which endowed the
indigenous peoples with a poetic aura, emphasiz-
ing the exotic and picturesque aspects of their
cultures. Only in the work of the Indigenist
painters do we find the misery of contemporary
Indian life represented.

Even more than in Peru (a nation with a
higher Indian population) the influence of the

180. Camilo Egas – Estación 14 (14th Street
Subway Station), 1937. oil on canvas, 137 x 100 cm.
Museo de la Casa de la Cultura Ecuatoriana, Quito

mural and canvas painters of the nationalistic Mexican School shaped the development of Ecuadorian art. Eduardo Kingman (1913–98) stands out as one of the major cultivators of Indigenism. He began as a painter of social-realist scenes of workers in Guayaquil, the city with the highest proletarian concentration in Ecuador. Noted for his expert draughtsmanship and colouring and for his psychological insight, this 'painter of anxiety', as Kingman has been called, has made the depiction of hands his speciality, often isolating them in eloquent gestures. Kingman generally achieves his effects with a minimum of detail even though his colours often reach dramatic extremes. *Los guandos* (*The Hauliers;* fig. 178) of 1941 is the most representative example of Ecuadorian Indigenism. Its symbolism is clear. The spiral form of the exhausted group of men represents the circularity of unending exploitation. In the painting's composition and surface treatment it is possible to see references to the colonial Baroque tradition. Both colour and line have become more intense and exaggerated in Kingman's later work which includes murals, woodcuts and chalk and pen drawings as well as paintings.

Kingman's obsession with Indigenism was shared by other artists of his generation as well as by younger painters. Diógenes Paredes (1910–68) produced images depicting coarse, garishly coloured figures. Pedro León (1884–1956) was Ecuador's first Impressionist and one of the first of the country's artists to understand the contributions of Cézanne as well as of Cubism and Fauvism. For many years director of the Escuela de Bellas Artes of Quito, Léon painted numerous landscapes including *Cangahua* (1940), a tribute to the indigenous

agricultural workers, which bridges the gap between a realistic subject-matter and the Expressionistic manner of its depiction. Leonardo Tejada (b. 1908) is a somewhat more multifaceted artist. His art consists not only of folkloric scenes of indigenous types which reflect a reproachful attitude towards Indian servitude, but of delicate, colouristically rich drawings in which his lively compositions are sometimes executed with a liquid-like brush-stroke and at other times with a thick and painterly texture.

Jaime Andrade Moscoso (1913–90) is the most significant Ecuadorian sculptor of this century. Although not, strictly speaking, an Indigenist, he did several important works in this vein. While his early sculptures demonstrated a tempered Expressionism, he later developed a more personal approach with references to archaic forms. Passing through a Cubist phase he ultimately developed as an abstract sculptor, working largely in stone, wood and soldered metal. Andrade Moscoso was also a notable draughtsman and muralist, producing highly praised mosaics that often incorporated natural stones. A prime example of his work is the relief mural executed for the theatre of the Universidad Central in Quito (fig. 179).

The internationally acclaimed work of Oswaldo Guayasamín (1919–99) deserves to be discussed apart from that of other Ecuadorian artists. Although Guayasamín is often considered to be at the head of the Indigenist and social-realist movements, it is only his earliest works that, strictly speaking, fit into these categories. He has developed a highly personal style, based in part on elements from both tendencies. His art is characterized by firm drawing defining emaciated figures and faces that are often deformed in highly expressive ways. Instead of colouristic

richness, his abundantly symbolic canvases are defined by a predominance of neutral white and black tones.

The uniqueness of Guayasamín's style was evident as early as 1943 when he painted *Fusilamiento* (*Execution by Firing Squad*; fig. 181), in which the dark, brooding colours serve as a metaphor for pain and suffering. Eight years later he created the series known as *Huacayñán* (the Quechua word for 'path of tears') dealing with the ethnic diversity of the Ecuadorian people. This series, comprising over one hundred works, won the grand prize at the Third Bienal Hispanoamericana (Barcelona, 1956) as well as recognition as 'the best South American painter' at the Bienal de São Paulo (1957). With the series *La edad de la ira* (*The Age of Anger*), which he still considers unfinished, Guayasamín pursues the thematic concerns initiated in *Huacayñán*. 'I must paint to express my indignation,' he has said. In these large-format canvases, fearful faces, twitching hands and contorted, tortured figures predominate. If, in *Huacayñán*, both the sombre colours and social protest refer to aspects of everyday life in Ecuador, the elements present in *La edad de la ira* can be considered as a condemnation of such universal issues as the atrocities of war and dictatorship, racism and exploitation of the masses.

Recently Guayasamín has begun another series entitled *La edad de la ternura* (*The Age of Tenderness*), exploring the themes of maternal love and childhood. With these paintings his art returns to a chromatic brilliance. Guayasamín has also produced many successful genre paint-ings, portraits and landscapes. His unusual views of Quito constitute a radically distinct, non-tradi-tional approach to landscape in which he recom-poses the geography of the city with fiery, sharp

Ecuador

lines. Guayasamín attaches great importance to his drawings and exhibits them alongside his paintings. He has also done numerous sculptures based on themes first developed in his two-dimensional work. He has executed murals (including frescos, glass mosaics and movable acrylic panels) not only in Ecuador but also at Madrid's Barajas Airport and the headquarters of UNESCO in Paris. The body of Guayasamín's work confirms him as the most important Ecuadorian practitioner of socially and politically committed art.

 Most Ecuadorian artists of the 1930s to the 1950s living within the country practised styles related to social realism or Indigenism. However, those who were able to travel to Europe or the United States during these years absorbed elements of the latest avant-garde and thus became pioneers in the development of a new national art. The first artist to assimilate aspects of a European-based Expressionism as well as Cubism, Surrealism and abstraction was Camilo Egas. Egas spent many years in the United States and became director of the art programme at the New School for Social Research in New York City. In his art he touched on a multitude of themes dealing with the under-development of his native country, the plight of indigenous peoples and the effects on Ecuador of the Great Depression of 1929, the Spanish Civil War and the Second World War. He also explored the dehumanization of life in the industrialized nations and the pernicious effects of technological progress and unchecked capitalism, as in *Estación 14 (14th Street Subway Station,* 1937; fig. 180).

 Manuel Rendón (1894–1982), who was born and who studied in Europe, introduced Informalist Abstraction to Ecuadorian painting.

182. ARACELI GILBERT – FORMAS EN EQUILIBRIO (FORMS IN EQUILIBRIUM), *1952. oil on canvas, 90 x 97 cm. Museo de la Casa de la Cultura Ecuatoriana, Quito*

183. Manuel Rendón – Juego entre columnas (Game between the Columns), 1947. *oil on canvas, 100 x 81 cm. Museo de la Casa de la Cultura Ecuatoriana, Quito*

184. Enrique Tábara – Rojo supersustancial (Over-substantial Red), 1971. *oil on canvas, 152 x 152 cm. private collection*

Ecuador

186. OSVALDO VITERI – AMÉRICA, EN TORNO A
MÍ LA NOCHE SUENA (AMERICA, AROUND ME
THE NIGHT SOUNDS), *1976. mixed media,*
99.5 x 99.5 cm. private collection

**The VAN Group was composed of Tábara, Villacís,*
Maldonado, Almeida, Cifuentes, Muriel and Molinari. Their
only common denominator was their anti-indigenist sentiment
as well as their desire to search for new artistic paths in accor-
dance with the current international trends.

'anti-biennial' organized by the VAN* group, of
which Tábara was a member. Both were impor-
tant for Ecuadorian art, the biennial because it
allowed the public to see what was happening
in Latin American art of the time and the anti-
biennial because it underlined the substantial
contribution of those artists who had rejected
Indigenism. Four years later the Salón de la
Independencia (which was also held only once)
again offered Ecuadorians a view of what was
happening elsewhere in Latin America.

A military dictatorship with a nationalist
philosophy assumed power in Ecuador in 1972.
It took over the control of the oil industry which,
since its beginnings, had become a principal
bulwark of the country's economy. Despite the
short duration of this government (which lasted
for less than ten years), economic growth in
Ecuador was dramatic. The middle class and the
national consumer index level expanded. A new
art market started to emerge in the country.
Artists' competitions, galleries and museums
proliferated and anthropological research
acquired a new momentum. The number of
artists also grew. In 1968 the old Escuela de
Bellas Artes in Quito became the university's
Facultad de Artes.

Four important younger artists, three
of them products of the Escuela de Bellas Artes
and one self-taught, emerged around 1969.
This group of the Cuatro Mosqueteros (Four
Musketeers) as they were known, consisted of
Nelson Román, Washington Iza, José Unda
and Ramiro Jácome. From their 'anti-salon' in
Guayaquil they developed a Neo-figurative style
of painting, a mode of art which already had a
leading exponent in Latin America: the Mexican
José Luis Cuevas. These artists were sensitive to
the inspiration of Cuevas and, to a lesser degree,

to that of Francis Bacon. Yet this influence was
merely a formal one, for in terms of subject-
matter the Four Musketeers ventured much
further afield.

Nelson Román (b. 1947) is perhaps the
artist who has felt the impact of Cuevas most
keenly. His paintings of fantastical subjects as
well as those drawn from everyday life display
both solid drawing and a masterly handling of
colour. Román has also been touched by the
current of Magic Realism in Latin American liter-
ature. Washington Iza (b. 1947) began his career
as a Neo-Expressionist, passing through a phase
of geometric abstraction and finally developing
the theme of the realist nude painted in sensuous
surroundings that might be tangentially
connected to Surrealism. José Unda (b. 1948)
has lived for many years in Canada where his art
matured. He initially worked in a style related to
the grotesqueries of Cuevas but finally developed
a personal version of gestural Abstract
Expressionism. Ramiro Jácome (b. 1948), the
self-taught artist of the group and also an expert
draughtsman, engraver and painter, is the most
multifaceted of the Four Musketeers as well as
the most artistically mature. In his work, which
often deals with city themes, he has focused on
the undeniably ugly aspects of urban existence.
The intensity of Jácome's artistic vision is typified
in *Fumador* (*Smoker,* 1993; fig. 187).

Post-abstract tendencies of the 1970s
were late in arriving in Ecuador. There are few
echoes of Pop, Minimalist or kinetic art. The
success of Neo-figuration and the various Neo-
Expressionist tendencies in Ecuador is explicable
in terms of their references to traditional figura-
tive art. Although younger artists rejected the
strident sociopolitical imagery of Guayasamín
there remained an aura of protest in Ecuadorian

art, expressed through irony, grotesquerie and distortion of the figure. At the same time there was a rebirth of the spirit of nationalism which had previously manifested itself in Indigenism, in a form of Magic Realist art directly related to popular arts and crafts. This had great success in the art market, particularly with the new bourgeoisie. Images with hints of Surrealism or bucolic lyricism appealed to these new collectors. This tendency was headed by the artist Gonzalo Endara (b. 1936), champion of a sweetened form of Indigenism. Given the commercial success of this movement, the rise in popularity of certain of the primitivizing native Quechua artists (called the Tigua painters) is understandable.

None the less, we cannot look at all recent Ecuadorian art as a 'return to origins'. Other, more experimental tendencies are represented by artists like Mauricio Bueno (b. 1939). Bueno studied conceptual and technological art in Colombia and the United States, returning to Ecuador at the end of the 1970s where he continued his visual experiments. His art represents his reflections upon local geography, as in his series of post-conceptual landscapes depicting both architectural elements and what could be called ancestral Andean 'land art'. In Bueno's work there are sporadic references to specific historical events and ancient monuments.

As the art market expanded, so did the possibilities for artists of working in a variety of media, thus producing a renaissance in printmaking, drawing and sculpture. Nicolás Svistoonoff (b. 1945), originally from Russia but trained in Spain and Ecuador, is a printmaker who has also experimented with painting. His works have fluctuated in style between Informalist abstraction, Expressionism and realist cityscapes. In sculpture the architect

Milton Barragán (b. 1934) has become an outstanding figure for his abstract forms and anthropomorphic figures in metal. All of his works retain specific references to space and architectural structure.

In the 1980s and 1990s the consequences of economic depression and inflation, as well as the collapse of the oil market, have left their marks on the art world of Ecuador. Artistic activity within the country has been maintained by the many Ecuadorian artists who have shown their work abroad and by the stimulus of the Inter-American Biennial Exhibition at Cuenca which was held for the first time in 1987 and repeated in 1989, 1991 and 1994. Another encouraging factor for art in Ecuador has been the success of those artists trained at the Facultad de Artes in Quito and, to a lesser degree, of those who studied in Guayaquil and Cuenca. Among them are Marcelo Aguirre (b. 1956), painter, draughtsman and printmaker working in avant-garde Expressionist modes; Hernán Cueva (b. 1957), a printmaker who creates large-format works in which local (although not folkloric) elements can be observed; Pablo Barriga (b. 1948), a post-conceptual painter; Jesús Cobo (b. 1953), a neo-organic sculptor; and Gabriel García (b. 1952), *art brut* sculptor and printmaker.

All of these younger artists are conscious of entering into a dialogue with events and tendencies that is international in scope. Very few seem to be interested in translating elements of national identity into the international language of art. It is obvious that each artist wishes to forge a highly personal style, although it is as yet too early to judge the success of their efforts.

187. Ramiro Jácome – Fumador (Smoker), 1993. *Ink on paper, 100 x 70 cm. collection of the artist*

Peru
Latin American Art in the Twentieth Century

Natalia Majluf

Peru

188. José Sabogal – Varayoc, or the Indian Mayor
of Chincheros, 1925. oil on canvas, 170 x 105 cm.
Pinacoteca Municipal Ignacio Merino, Lima

189. Mario Urteaga – La riña (The Fight), 1923.
oil on canvas, 95.5 x 81 cm. private collection, Lima

In the twentieth century art in Peru holds both a privileged and a fragile position; its role is always being questioned. In a country such as this, with its superimposed cultures and multiple artistic traditions, art has had to define itself in various directions. Working principally in Lima, many artists have turned to themes relating to the contemporary Indian and to the Peruvian landscape, while others have sought formal inspiration in popular rural traditions, pre-Columbian forms of expression and European art. Yet what most defines modern Peruvian art is its separateness from all the traditions that have inspired it.

The fine arts in modern Peru were born from a break with colonial traditions that occurred in the middle of the nineteenth century. As the role of the Church declined, the religious function of art gave way to more secular concerns. The artists themselves, whose status as artisans had previously confined them to the lower sectors of society, now began to emerge from the middle and upper classes. This new understanding of artistic practice, however, gained ground in a society which lacked the structures of patronage, museums and exhibition spaces needed to sustain it. The founding of the Escuela Nacional de Bellas Artes (ENBA) in 1919 represented the end product of a long series of attempts to institutionalize this new artistic tradition in Peru. The mere existence of the ENBA served to transform the artistic ambience and redefine the meaning of painting for the country. Until that time Peruvian artists had worked in isolation, often seeking outlets and recognition in caricature and magazine illustration. Daniel Hernández (1856–1932), an academic painter who enjoyed a certain success in European salons, returned to Lima to direct the new art school. The ENBA, whose teaching methods were based upon those of the French Academy, also incorporated specifically Peruvian artistic concerns that had been previously articulated by the painter and critic Teófilo Castillo (1857–1922). It is these elements which in great part define the essential character of the new institution. One of its first professors, the Spanish sculptor Manuel Piqueras Cotolí (1886–1937), designed the façade of the school's building in a style which would become known as 'neo-Peruvian', combining elements derived from both pre-Columbian and colonial art, and thus confirming, from the outset, the nationalist aspirations of the ENBA.

The important role played by Hernández and Piqueras Cotolí would soon be obscured by the return to Lima of the Peruvian painter José Sabogal (1888–1956), who arrived in the capital from Argentina via Cuzco. In 1919 Sabogal mounted his first exhibition in Lima which he entitled *Impresiones del Ccoscco* [sic]. This show was well received, even though a mythology later developed around it according to which it posed a scandalous affront to the public of the time, which rejected Sabogal's art because of its native themes. After this exhibition Sabogal's career experienced a meteoric rise. He was made first professor of painting at the ENBA in 1920, its second director in 1931, and became one of Peru's few commercially successful artists of the first half of the twentieth century.

Varayoc, or the Indian Mayor of Chincheros of 1925 (fig. 188) typifies the best aspects of Sabogal's work. Its colours, which unify the forceful composition, are vividly applied wih a fluid brush-stroke. His style, characterized by a certain self-conscious technical crudeness, earned him the undeserved title of

Peru

'the painter of the ugly'. Sabogal's art would at times verge on caricature. His stylized figures embodied a sense of power which formed an essential quality in his art. The interest in the Andean peoples and landscape manifested by Sabogal and many of his followers earned them the label of Indigenists. Among his closest disciples were Camilo Blas (1903–85), Julia Codesido (1892–1979), Enrique Camino Brent (1909–60) and Teresa Carvallo (1895–1988). The artistic nationalism they projected from the ENBA at times approached the official Indigenism promoted by the nationalist regime of President Augusto B. Leguía (1919–30). But Sabogal and his group also collaborated in more radical vindications of the Peruvian peasantry. They participated closely with José Carlos Mariátegui, founder of the Peruvian Socialist Party, in the publication of the magazine Amauta (begun in 1926), which they helped to illustrate. Aside from these political associations, Sabogal's work was also marked by aestheticist tendencies which were far removed from the social realism or political imagery that characterized Mexican art of that time. The Peruvian Indigenists sought to create a rural world in their art and were thus attracted to Peruvian folk art, which they believed represented a syncretic fusion of pre-Columbian and colonial elements.

It was also the painters of Sabogal's group who promoted the work of the unknown provincial artist, Mario Urteaga (1875–1957). In Urteaga, a self-taught painter who worked in isolation in the provincial Andean city of Cajamarca, the Indigenists found an intuitive talent whose provincial roots linked him closely to the world that they were attempting to validate. But Urteaga, far from being a primitive, based his compositions on the most famous works of the European masters. While some of Urteaga's images may appear to be placid, bucolic views of everyday life in the Andes, other pictures adopt a different attitude toward this subject, such as *La riña* (*The Fight*; fig. 189), in which the formal pictorial organization emphasizes the rigid social structure of his native city.[1]

Among the Indigenists working independently of Sabogal's group, Jorge Vinatea Reinoso (1900–31) is perhaps the artist who developed the most original language. His images of Lake Titicaca (fig. 190) create a sensation of vast flat space, in which the brush-strokes, dragged across thickly laden canvases, seem to form the substance of a great decorative tapestry. A product of urban artists, the Andean Arcadia created by the Indigenists represented the first collective attempt to forge a national form of expression.[2] But Sabogal's group was only part of a much broader nationalist phenomenon, which found expression in diverse cultural manifestations, not only in painting, but also in the other arts.

When Sabogal was forced to retire from the ENBA in 1943, Indigenism there had assumed the proportions of orthodoxy, displacing other innovative styles such as the post-Cubist art of Carlos Quízpez Asín (1900–83), the expressionism of Macedonio de la Torre (1893–1982) and the Surrealism of the painter and poet César Moro (1903–56).[3] The growing hostility towards Indigenism was soon articulated by the painter Ricardo Grau (1907–60), who became director of the ENBA. Along with the critic Raúl María Pereira, Grau supported the first important collective exhibition held outside the Escuela, the Salón de Independientes of 1937.[4] The term 'Independents' signalled neither a style nor an artistic programme. A number of

190. JORGE VINATEA REINOSO – BALSAS DEL TITICACA (LAKE TITICACA MARSHES), c. 1929.
oil on canvas, 79 x 99 cm. Banco de Crédito del Perú, Lima

191. Emilio Rodríguez Larraín – Le con d'or, *c. 1982. mixed media and wood, 89 x 72.5 cm. private collection, Lima*

192. Sérvulo Gutiérrez – La quema de la
caña (The Burning of the Cane), 1954. oil on
canvas, 74 x 96 cm. private collection, Lima

193. Fernando de Szyszlo – Puka Wamani,
1968. acrylic on wood, 150 x 150 cm. Museo de
Arte de Lima, gift of Manuel Cisneros Sánchez

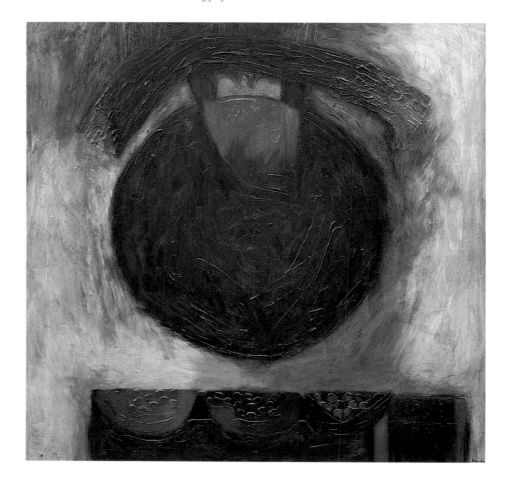

194. Jorge Eduardo Eielson – Quipus, 1964–7.
oil on canvas with knotted fabric, 200 x 145 cm.
private collection, Lima

Peru

artists who took part in the exhibition were more conventional painters, and many others also dealt with Andean themes. What they demanded, however, was the freedom to explore these and other subjects in different ways from those defined by Sabogal.

In order to distance themselves from Indigenism, artists who were interested in local landscape gradually eliminated specifically Andean references from their paintings. Signs of an anti-Indigenist localism, such as depictions of the arid Peruvian coast or the Amazon region, soon entered the artistic panorama with particular vigour.[5] Other themes which had been marginalized by the Indigenists, such as the still life, the nude and pure landscape, began to be tackled with new sophistication. Such are the subjects developed in the work of Sérvulo Gutiérrez (1914–61). In his *La quema de la caña* (*The Burning of the Cane*, 1954; fig. 192) the rigid structure of his earlier paintings, developed as a consequence of his study with the Argentinian painter Emilio Pettoruti, began to diminish. Also at this time Gutiérrez embarked on a violent 'dematerialization' of form, developing an Expressionist vocabulary that would bring him to the brink of abstraction. Although he attracted few followers, Gutiérrez established himself as a celebrated bohemian figure who was able to create in his art a simulacrum of his own personal world, something which would become an essential element for many Peruvian artists in later years.

During the 1940s and 1950s, when Peruvian artists were more receptive than before to foreign influences, Mexican muralism (the Latin American movement with the greatest success abroad) exerted a strong influence there. Artists such as Alfredo Ruiz Rosas (b. 1926)

worked for the first time in the area of social realism, while others, such as Juan Manuel Ugarte Eléspuru (b. 1911), Teodoro Núñez Ureta (1914–88) and Sabino Springett, participated in the decoration of large public buildings, in the short-lived Peruvian muralist movement.[6]

It was only during the period after the decline of Indigenism that the notion of an avant-garde came to gain wide currency in the visual arts. Ricardo Grau's development as a painter best expresses the changing aspects of his time. When he arrived in Lima from Paris in 1937 his work was little more than a local variation upon the themes of the School of Paris. None the less, he soon effected dramatic stylistic changes that led him to abstraction in the 1960s. Grau's pictorial experiments answered in large part to the new demands and expectations of the Lima art world, who turned him into a symbol of artistic renewal. His art was the natural complement of an emerging bourgeoisie, whose modernizing projects stood opposed to the traditional structures of Peruvian society. From the mid-1940s to the early 1950s, the mouthpiece of this artistic renewal was the magazine of the Agrupación Espacio, a group of architects, artists and intellectuals who conducted an aggressive campaign in favour of modernist art and architecture.[7]

In 1951 Fernando de Szyszlo (b. 1925) had his first exhibition of abstract paintings in Lima. Although artists such as Enrique Kleiser (1905–77) and Emilio Goyburu (1897–1958) had previously made incursions into abstraction, Szyszlo can truly be called its founder in Peru and the catalyst for the emergence of an entire social group searching for a renovation of modern art. Architects, businessmen and intellectuals gravitated to the Galería de Lima, founded in 1947 and later becoming the Instituto

de Arte Contemporáneo. From there a local market grew which would facilitate the presentation of important international exhibitions in Peru.

During these years, significant changes also occurred in sculpture. With the exception of the work of two Spanish artists, Manuel Piqueras Cotolí and Victorio Macho, both of whom had worked in Peru, sculpture had not attained the importance of painting – the art form which provoked the most vigorous aesthetic debates. Dominated by conventional attitudes to public monuments and subject to the limitations of official commissions, sculpture had been seriously constrained by the needs it was expected to fulfil. During the 1950s, however, sculptors such as Joaquín Roca Rey (b. 1923), Alberto Guzmán (b. 1927) and Jorge Piqueras succeeded in gaining the support of the galleries of Lima with their modernist works. Emilio Rodríguez Larraín (b. 1928), who began as a painter during this period, later explored the limits of sculpture in large projects and installations, but also in small, conceptually charged objects (fig. 191).

The debate regarding abstraction which erupted in the early 1950s around the work of Szyszlo had been defined by two important critics. The architect and theorist Luis Miró Quesada defended a universalist formalism which was opposed by the nationalist (although innovative) demands of the writer Sebastián Salazar Bondy.[8] Abstraction only became the dominant mode of art in Peru around 1958, the year that witnessed the first Salón de Arte Abstracto. As in the other Andean countries, abstraction in Peru would be closely linked with European Informalism and North American Abstract Expressionism. It was consistently distinct from the type of Constructivism which

Peru

had developed in the Southern Cone of South America, a mode which would exert virtually no influence over Peruvian art.

References to pre-Columbian art, easily identifiable by international audiences, were employed as an important strategy to differentiate Peruvian abstraction. Around 1960 Alberto Dávila (1912–88) began to give his abstract paintings titles evoking pre-Hispanic cultures. Others, like Gastón Garreaud (b. 1934), even incorporated actual archaeological fragments, such as ceramic sherds and textiles, into their works. But it was the poet and painter Jorge Eduardo Eielson (b. 1923) who most successfully combined allusions to the ancient American world with contemporary forms. His *Quipus* (fig. 194) refers to the system of knotted and coloured cords used by the ancient Peruvians as a mnemonic aid. Eielson's use of knotted fabrics stretched across the surface of the canvas metaphorically evokes a similar, cryptic and suggestive language. These works produce images of condensed energy with strong conceptual foundations that question the traditional structures of painting. It was Szyszlo, however, who defined the direction that references to the ancient world would take in lyrical abstraction. *Puka Wamani* (fig. 193) is one of his most characteristic works, in which archetypal forms such as the circle are imbued with magical allusions.[9] Drawing inspiration from Quechua poetry and local epic history, Szyszlo came to represent a paradigm of that tendency which the critic Marta Traba defined as an 'art of resistance', an alternative path between the perils of acculturation and folkloristic nationalism.

Traba's definition responds to a specific set of circumstances. Peru, like other Latin American nations in the middle years of the 1960s, demonstrated an increasing receptivity to international tendencies in art. Artists' groups such as Señal and Arte Nuevo, supported by the critic Juan Acha, had created, by the mid-1960s, an internationalist avant-garde dominated by technological optimism and futuristic visions of Peru's place in a new world order. Luis Arias Vera (b. 1932), Jesús Ruíz Durand (b. 1940) and Rafael Hastings (b. 1942) are among the artists who experimented with Pop art, Op art, happenings and geometric abstraction. At the beginning of this phase, Pop art in Peru would come to be defined by its response to international mass culture and would rarely employ images of local products.

The military dictatorship of Juan Velasco Alvarado (1968–75) put an end to these outward-looking attempts at modernization. The populist fervour of the times favoured the emergence of aesthetic projects of doubtful validity, which included a variety of superficial Indigenist revivals. Yet this period also witnessed great intellectual foment and a renewed, radical interest in engaging with an ever-widening mass audience. In 1976 the Premio Nacional de Arte was given to Joaquín López Antay, an artist of the popular *retablo* (a kind of portable altar) form of folk art. The debate that raged among artists regarding the validity of naming an 'artisan' for an 'artistic' prize tore away the illusion of any possible equivalence between these two spheres of creativity, and dispelled any belief that art could serve as an integrating element in a multi-cultural nation.[10] Folk art produced in rural regions could no longer be admired without raising a number of critical social and aesthetic issues. A different ideal of the popular now sprang up, based upon an urban culture, the product of successive waves of migration from the provinces which, since the 1950s had doubled the population of Lima. The misery of the lower-class districts housing the many immigrants became the subject of the art of the super-realist painter Bill Caro (b. 1949). Subtly expressed in sepia tones, the aestheticism of Caro's work did not satisfy the need felt by other, younger artists who demanded that art should not simply depict, but should participate in this new aspect of urban life.

From the many popular artistic events (in particular the Contacta total-art festival of 1979) and organizations formed during the military dictatorship arose the group known as Paréntesis (comprising Lucy Angulo, Fernando Bedoya (b. 1952), José Antonio Morales (b. 1954), Rosario Noriega (b. 1957), and Juan Javier Salazar). Other artistic projects included the opening of the Huayco EPS workshop under the leadership of the Swiss-Peruvian artist Francisco Mariotti. The members of Paréntesis, along with Mariela Zevallos, Herbert Rodríguez (b. 1959) and Armando Williams (b. 1956) formed part of this short-lived group which experimented with techniques and genres of art in order to create radically new public forms of artistic expression. The image of Sarita Colonia, a popular saint not accepted by the Catholic Church, was displayed on a hill beside the Pan American Highway, imitating the political and commercial signs and announcements so commonly seen along the roads of the Peruvian capital. The materials used to make this figure – empty milk cans – represent a homage to urban recycling culture, and also form a powerful metaphor for the basic needs of an impoverished population.

During the 1970s various new figures emerged in the field of painting, including Tilsa Tsuchiya, Alberto Quintanilla (b. 1934), Carlos Revilla (b. 1940) and Gerardo Chávez (b. 1937),

195. Tilsa Tsuchiya – Soledad (Solitude), 1971.
oil on canvas, 117 x 90 cm. private collection, Lima

196. José Tola – Elena 24-2-87, 1988. mixed
media, 219 x 126 cm. private collection, Lima

all of whom re-created in their art the myths and
dreams derived from Surrealism, a movement
which had previously exerted only an indirect
influence on Peruvian painting. Among these
painters, the universe created in the art of Tilsa
Tsuchiya (1936–84) is undoubtedly the most
extraordinary. *Soledad* (*Solitude*; fig. 195), a transi-
tional point in her series of Mitos (Myths) – land-
scapes with a strong, magical telluricism popu-
lated by undefinable characters – displays a
successful combination of forms used earlier in
her career with the erotic and poetic introspec-
tion that is present in all her work.[11]

The return to figuration during the 1970s
renewed the dialogue with the grand traditions of
European painting. An example of this is the
hyper-real Surrealism of Humberto Aquino (b.
1947) and the formal allusions in the art of Bill
Caro. Paradoxically, Herman Braun (b. 1933)
initiated a more violent dialogue with the old
masters of European art. Translating characters
taken from Manet or Goya into exotic scenes or
incorporating into old master paintings such
things as newspaper print, Braun achieves
disconcerting juxtapositions. Through them he
questions, within their own parameters, the
supposed universality of these images, making
them powerfully relevant for audiences living on
the periphery of European art.

The interest in figuration, inherent in
the development of Surrealism, was accompa-
nied by the rise of Expressionism, begun by
Sérvulo, brilliantly explored in the sculptural
work of Cristina Gálvez (1918–82), and institu-
tionalized by Adolfo Winternitz (1906–94) at the
Escuela de Artes Plásticas of the Universidad
Católica. José Tola (b. 1943) was able to escape
the pitfalls of a codified Expressionist language;
Elena 24-3-87 (fig. 196) does not represent a

deformed figure, but rather incorporates
evidence of violence in its forms and materials.
The expression of anguish and horror inherent in
the work of Tola is both universal and at the same
time a poignant allusion to a convulsive period in
the country's history.

At the beginning of the 1980s there was
still an optimistic attitude in Peru. In this mood
of expectation, populist fervour mingled with a
belief in the possibilities of change and the hope
of a new democracy. These illusions were soon to
be dashed with the violence unleashed by
Sendero Luminoso (Shining Path) faction and
the ensuing military repression. At the same
time, self-censorship and general disorientation,
the economic crisis, the lack of exhibition space
and the collapse of the art market served to crush
numerous artistic initiatives. Many artists left
Peru to live in large cities abroad, emigration
soon becoming the rule rather than the excep-
tion. The most recent decade has been a time for
individual rather than collective efforts, an eclec-
tic period with few programmatic movements.
The dramatic growth of the commercial gallery
circuit during this period has not been accompa-
nied by substantial transformations in other
spheres. Art criticism is still a minor activity, and
artists still have to contend with problems similar
to those which their early twentieth-century
predecessors confronted.

Ivo Mesquita

Brazil

LATIN AMERICAN ART IN THE TWENTIETH CENTURY

Brazil

One of the most important legacies of modernism in Brazil is the concept of *Antropofagia* (anthropophagy, cannibalism),[1] a term coined in 1928 by the poet and writer Oswald de Andrade (1890–1954) and published in the *Revista de Antropofagia* of May 1928. According to Andrade, Brazilian culture should be able to devour all external influences, digesting, transforming and creating its own meaning and vision. Andrade was probably influenced by the Italian Futurist poet Filippo Tommaso Marinetti (who visited São Paulo in 1926) or by his friend the French painter Francis Picabia who created the magazine known as *Cannibale* in Paris in 1928. For Andrade, Brazilian culture would thus be the result of devouring all that was found or that arrived in the country. It is in this light that one must understand Brazilian art.

The formation of contemporary Brazil is distinct from that of other Latin-American countries. Brazil did not have a pre-Columbian past with advanced civilizations like the Inca, the Maya and the Aztec. Its natives were virtually wiped out during the various stages of colonization. From the native Indians – described by sixteenth-century travellers as gentle (although some were, in fact, warriors or cannibals) – Brazilians inherited the habits of bathing, contemplating nature and eating roots. Unlike the Spaniards, the Portuguese colonizers did not come to stay, but only to plunder and sell, to become rich and return to Portugal. They did not seek to penetrate the interior of the country, but remained along the coast. Nor did they build stately colonial cities such as those found in Spanish America. Brazilian Baroque architecture is more an expression of the desire of the religious orders, seeking to spread the Word, than a manifestation of the ambitions of the Portuguese crown. Consequently, the most important buildings of the colonial period are churches, convents and schools rather than public buildings such as palaces or barracks.

Black Africans, displaced from their land to become slave labour, were forced to establish new roots under the vigilant eyes of slave-owners and the Catholic Church. They produced syncretic religions and a mixed race. The European immigrants who began to arrive during the second half of the nineteenth century brought the final contribution to modern Brazil: the organization of labour and labour relations, the concern with schooling and professional training, and a cosmopolitan outlook.

Brazilians are the result of a mixture, even the promiscuity, of all these races. Something has been absorbed from each race to forge the Brazilian identity. In the cities of Brazil, the various ethnic groups and races are not isolated in specific areas, as in a Little Italy or Chinatown. It is also important to remember the significant contribution of the Japanese who arrived in Brazil in the early twentieth century. Working first in agriculture, they eventually moved to the cities and made their mark on urban and cultural life.

The prejudices of Brazilian society have led to a perversion of capitalism, caused by the economy rather than by race or culture. I do not want to promote the myth of the noble savage (which has long since ceased to exist) or of a society living in perfect harmony, or even the notion that Brazilians are victims of colonization and capitalism. Rather, the ability to parody others as well as ourselves separates us from the tragic sensibility of our Hispanic neighbours. Yet this characteristic also springs from the anxiety of not knowing our place, of being discarded as an error of European colonialization. To appease the conscience of the Europeans, Brazil must be placed on the periphery. As a result, we can be everywhere, for we know we are the fruit of what is called Western civilization. From it we have derived all our schools of thought and accumulated knowledge, in order to imagine a utopia for ourselves and ask: What are we? Where do we come from? Where are we going?

The Advent of Modernism

Since the founding of the Republic in 1888, which ended the reign of the House of Orleans e Bragança, a new political, social, economic and cultural order emerged in Brazil. Progressive thought flourished alongside a burgeoning industrialization, which was lent momentum by the great influx of immigrants arriving in the country's southern states. These would form a middle class that would become established during the first decades of the twentieth century.

The displacement of the economic centre from Rio de Janeiro, the administrative and political heart of the country, to São Paulo, where the Republican Party was formed in 1875, was the determining factor in the changes that have since occurred. The accumulated wealth of the coffee 'barons' led to new investment possibilities and, together with the growing presence of the immigrant work force, to new commercial and financial ventures. By employing German and Italian anarchist immigrants, the manufacturing industry, though owned by local investors, brought with it socialist ideas, culminating in the formation of the Communist Party in 1922. The new economy changed customs and ideas further by bringing about a shift from rural to urban life.

Since the time of the Portuguese empire,

Rio de Janeiro had taken pride in its Academia Imperial de Belas Artes, founded in 1826 along the lines of orthodox neo-classicism. From then on the development of new styles of painting – Romanticism, realism and Impressionism – always occurred as an echo from Europe. While Rio de Janeiro remained the capital of the Republic, society was politically controlled by the powerful oligarchy of landowners, who always conformed to antiquated European aesthetic models, and strongly permeated by the ideas of Positivism. São Paulo, on the other hand, was a city experiencing rapid growth financed by the export of coffee. It desperately aspired to become an urban centre. Unlike Rio de Janeiro, which followed the model of Haussmann's Paris, São Paulo adopted the architectural aesthetics of Art Nouveau and eclecticism. Its élite aristocratic landowners visited Europe annually, bringing back contemporary art and the latest aesthetic ideas which circulated with unparalleled speed. The lack of artistic and cultural institutions in a city undergoing rapid urban transformation fostered a new aesthetic, in reaction to conservative tendencies in Brazilian art.

The first stirrings of modernism were discernible in the work of writers and poets such as Oswald de Andrade and Mário de Andrade, Manuel Bandeira and Menotti del Picchia, and in the early musical compositions of Heitor Villa-Lobos. However, it was the art of Anita Malfatti (1889–1964), exhibited in 1917 in São Paulo, that unleashed the modernist movement in Brazil. A student of Lovis Corinth and Bischoff Culn in Germany, and Homer Boss at the Independent School of Art in New York, Malfatti's vigorous paintings broke the conventions of form, colour and perception to emphasize subjectivity, in accordance with the ideas of the Expressionist movement, as in *A boba* (*The Fool*, 1917; fig. 197). Less radical than Nolde and Kirchner, and at times inspired by Cubist and Futurist structuring of space, Malfatti's works none the less shocked the artistic world of São Paulo and provoked the wrath of conservatives. The writer Monteiro Lobato, a representative of the artistic status quo, published a long article in which he acknowledged the artist's talent but vehemently refused to accept new artistic movements such as Cubism and Futurism. Although Malfatti received support from young intellectuals, the conservative reaction to her exhibition deeply affected her development. The audacious (by local standards) quality of her art, which was the product of her visits abroad, was gradually replaced by a restrained attitude, focusing on intimate and feminine issues and creating compositions that were no longer representative of the aesthetic avant-garde.

The 1917 exhibition of Malfatti's work, however, served as a catalyst for a group of intellectuals who embraced the revolutionary ideas of modernism and rebelled against academic art. The young artists from São Paulo, including Emiliano di Cavalcanti (1897–1976), were joined by those returning to Brazil after studying in Europe, including Oswaldo Goeldi (1895–1960), Victor Brecheret (1894–1955), Zina Aita (1900–68) and the brothers Vincente (1899–1970) and Joaquim (1903–34) do Rêgo Monteiro, as well as the Swiss painter John Graz (1891–1980), a student of Ferdinand Hodler who moved to Brazil in 1920. With the end of the First World War, international cultural exchange had been resumed, along with industrial development and the growth of urban life. This was progress, and the art world could not ignore it. The time was ripe for a break with the past.

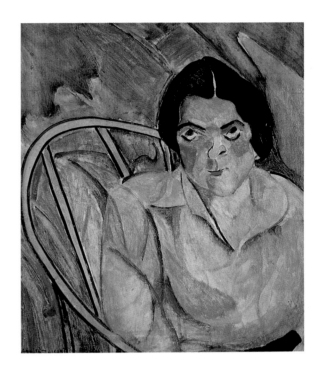

197. ANITA MALFATTI – A BOBA (THE FOOL), 1917. *oil on canvas, 61 x 50 cm. Museu de Arte Contemporânea da Universidade de São Paulo, São Paulo*

Brazil

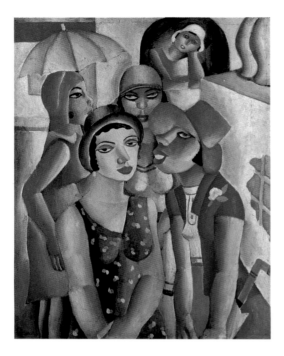

198. EMILIANO DI CAVALCANTI – CINCO MOÇAS DE
GUARATINGUETÁ (FIVE GIRLS FROM GUARATINGUETÁ),
*1930. oil on canvas, 92 x 70 cm. Museu de Arte de
São Paulo Assis Chateaubriand, São Paulo*

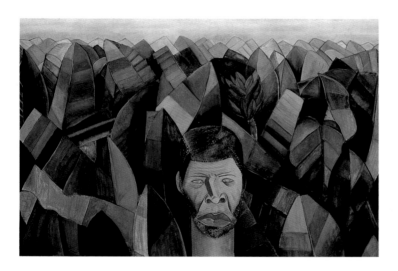

199. LASAR SEGALL – BANANAL (THE BANANA PLANTATION),
1927. oil on canvas, 87 x 127 cm. Pinacoteca do Estado, São Paulo

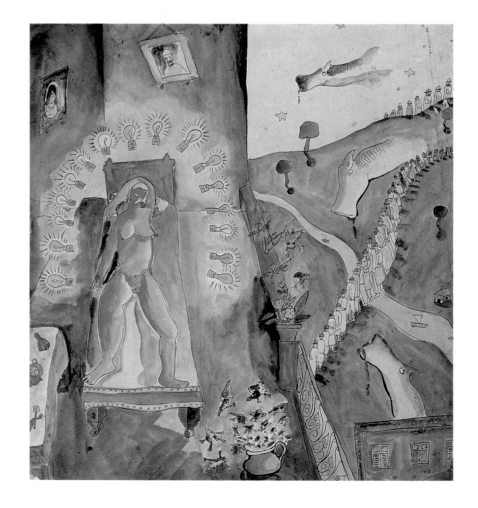

200. CÍCERO DIAS – O SONHO DA PROSTITUTA (THE PROSTITUTE'S
DREAM), *1930. watercolour on paper, 55 x 50 cm. Coleção Gilberto
Chateaubriand, Museu de Arte Moderna, Rio de Janeiro*

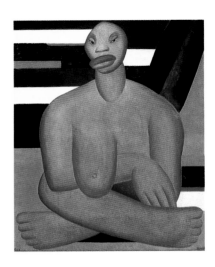

201. TARSILA DO AMARAL – A NEGRA
(THE BLACK WOMAN), *1923. oil on canvas,
100 x 81.3 cm. Museu de Arte Contemporânea
da Universidade de São Paulo, São Paulo*

In 1922, the year in which Brazil celebrated 100 years of political independence from Portugal, a group of young artists, writers and musicians from São Paulo and Rio de Janeiro announced the Semana de Arte Moderna (Modern Art Week), to be held at the Teatro Municipal de São Paulo, proclaiming Brazil's cultural independence. The event, which took place between 11 and 18 February, included an art exhibition[2] and three evenings of poetry readings, concerts, lectures and debates. The anti-academic and generally rebellious approach embraced the various aesthetic tendencies of the beginning of the century, from residual forms of Art Nouveau and Post-Impressionism to a mild Expressionism and Cubist geometrical renderings of classical themes in painting and sculpture. This lively event would be classified by the public and the media as 'Futuristic'. The term would later be used both by conservatives about the young modernist uprising against the established order, and also by the modernists themselves as a way of combining their ideals of aesthetic renewal and their combative strategies, without implying any affiliation to Italian Futurism.

One cannot regard Brazilian modernism in its early years merely as an attempt to emulate, more than a decade later, the European avant-garde. Although almost all the participants of the Semana de Arte Moderna had spent time in Europe, and although European aesthetic ideals were largely responsible for the transformation in Brazilian music, literature and art, the modernist artists sought to create a genuine Brazilian form of expression that would embody the country's cultural diversity. In addition to the influence of French Cubism, Italian Futurism and German Expressionism, the modernist

group was committed to incorporating national elements such as the local colour, light and landscape, as well as artistic and cultural archetypes, to express an awareness of Brazilian identity.

The works of Emiliano di Cavalcanti and Cícero Dias (b. 1908) epitomize these concerns, the first because of his adherence to figurative art, always portrayed in geometric forms yet without ever entirely eliminating the separation between figure and ground. In its intensity and its chromatic variety, di Cavalcanti's work sought to achieve a uniformity that emphasized the flat surface of the painting. The woman is always the central figure, acting as a metaphor for the sensuality and lyricism of tropical culture, as in *Cinco moças de Guaratinguetá* (*Five Girls from Guaratinguetá*, 1930; fig. 198). His 'mulatas' reflect the existence of a nationality forged by the coming together of different races and cultures, yet are equally stereotypes and consequently become the simplification of a would-be Brazilian imagination. For his part, Cícero Dias proposed to fuse Surrealism with the memory of dreams associated with the region in which he had lived before going to Europe. Until the 1940s, when he turned to abstract painting, Dias's work portrayed his native state of Pernambuco in the north-east of Brazil in a naïve and dream-like manner, as in *O sonho da prostituta* (*The Prostitute's Dream*, 1930; fig. 200), creating unique representations of an unreal space with unexpected asymmetries, filled with strange motifs and displaying a magical yet earthly feeling.

During the years which followed the Semana de Arte Moderna, other artists joined the group and contributed to the establishment of modernism in Brazil. After many trips to Europe, where she studied with André Lhote, Albert

Gleizes and Fernand Léger, Tarsila do Amaral (1886–1973) participated in a trip, organized by the modernist group, to the historical towns of the interior state of Minas Gerais, accompanied by the French poet Blaise Cendrars. They visited Baroque churches built during the eighteenth century's gold rush, and observed popular festivals, both religious (Easter) and secular (carnival). After this experience, modernism, in the full sense of the term, corresponding to the aesthetic ideals of Oswald de Andrade in the *Pau Brasil* and *Antropofágico* manifestos of 1924 and 1928 respectively, appeared for the first time in Tarsila do Amaral's painting. Colours taken from popular sensibility and a clear sense of form are characteristic of this artist's first truly modern works, notably *A negra* (*The Black Woman*, 1923; fig. 201). During her so-called anthropophagic phase of the late 1920s, the Cubist ideals are infused with a vision of nature portrayed as the unreachable 'other', beyond reason. The result is a strangeness that superficially resembles some European Surrealist works. However, an amorous and lyrical quality is always present, evoking a child's day-dreams and suggesting a longing for Brazil's farms and rural landscape, distinguishing Tarsila do Amaral's paintings from the radical Surrealist compositions of her contemporaries.

In 1923 the Lithuanian Jewish artist Lasar Segall (1891–1957) moved to São Paulo, after having actively participated in the Expressionist Movement in Germany where he had lived since 1906. His initial paintings in Brazil reflect the passion for his new country, portraying its landscape and human types without any suggestion of the tensions and scepticism that marked his work in Germany, as can be seen in *Bananal* (*The Banana Plantation*, 1927;

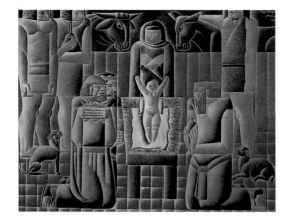

202. VICENTE DO RÊGO MONTEIRO – ADORAÇÃO DOS REIS MAGOS
(THE ADORATION OF THE MAGI), *1925. oil on canvas, 81 x 101 cm. Coleção
Gilberto Chateaubriand, Museu de Arte Moderna, Rio de Janeiro*

fig. 199). However, his art – comprising paintings, sculptures, drawings and engravings – remained faithful to Cubist form, to an Expressionist emotion and to a true representation of the human condition. Segall is a painter of misfits, the exiled and the dispossessed. His contribution to Brazilian art is less due to his technique than to his ethical stance and the example he set of earnest dedication to his work.

Fundamental to the consolidation of the modernist ideal in Brazil is the art of Oswaldo Goeldi, Ismael Nery, Vicente do Rêgo Monteiro and Victor Brecheret. Goeldi is known for his drawings and engravings. Having studied in Europe under the influence of Expressionism, he created in Brazil an upside-down world where humans are threatened by nature (their houses seem to have an independent reality in the urban landscape and fish are forever rebelling against the fishermen), forming a vision of a world marked by a deep and bitter schism, impotent in the face of social reality. Characterized by deviations which endow his art with sudden and unexpected strangeness, Goeldi created a form of representation which 'plunged into images of the unconscious, of still nights outside of time'.[3]

Ismael Nery (1900–34) also studied in Europe where he became acquainted with the work of the Surrealists and, above all, of Marc Chagall. He left a strongly autobiographical *œuvre* that explored the human psyche and articulated a bizarre mixture of religious fervour and eroticism, as in *Figura* (*Figure*, 1927–8; fig. 204). The work of Vicente do Rêgo Monteiro, with his spare representations, is closer to the Muralist spirit, ordered by methodical geometricization where expression gives way to the essentials of constructing the pictorial surface, as in *Adoração dos Reis Magos* (*The Adoration of the Magi*, 1925;

fig. 202). Propelled by the need for structural rigour, seeking the monumental dimensions of Egyptian, Assyrian and pre-Columbiàn art, Vicente do Rêgo's work incorporates regional and native themes, workers, athletes and still lifes. Victor Brecheret was responsible for introducing modern aspects of sculpture to Brazil. Acquainted with Brancusi's work, Brecheret created pieces outstanding in their assimilation of Cubist teachings; his sculptures, such as *Tocadora de guitarra* (*The Guitar Player*, c.1925; fig. 203) are also notable for abandoning all psychological references and focusing entirely on the formal problems inherent in Art Deco, the style to which his work is most directly related.

The years following the Semana de Arte Moderna, which introduced the ideals and aspirations of modernism to Brazil, were marked by a continuous flow of its members to and from Europe. They simultaneously sought both to make known and to establish modernist ideals in Brazil as a way of recording their interest in the essential characteristics of Brazilian life, and to distinguish the country from the dominant European cultures. Exhibitions by modernist artists in cities outside São Paulo were fundamental to this aim, as were the debates and the circulation of ideas generated by magazines such as *Klaxon* (São Paulo, 1922), *Estética* (Rio de Janeiro, 1924), *Novíssima e terra roxa e outras terras* (São Paulo, 1924), *Madrugada* (Porto Alegre, 1925), *A revista* (Belo Horizonte, 1925), *Verde* (Cataguases, 1927) and *Revista de antropofagia* (São Paulo, 1928). The impetus started by the Semana de Arte Moderna in 1922 represented a decision to leave academic art behind and deepened the Brazilian resolve to renew all areas of human activity: in art,

politics, 'street' aesthetics, advertising, furniture and fashion.

If a combative spirit and dedication to far-reaching renewal characterized the country during the 1920s, the 1930s and 1940s were marked by changes in the international political order, with significant repercussions in Brazil. The revolutionary fervour that transformed the world from Mexico to Russia during the first two decades of the century began to wither. It was replaced by the effort to ensure the continuation of such hard-won victories, given the rise of Nazi Fascism in Europe and the violent economic crisis that followed the crash of the stock market in 1929.

Brazil responded to international events, and lived through them, in its own way. The nonconformism of the 1920s was followed by a period of national conciliation that started with the Revolution of 1930 which placed the dictator Getúlio Vargas in power until 1945.

In art, the politically right-wing Vargas period was characterized by a clear support of cultural activities. These were seen as manifestations of state power and a way of promoting nationalism. Rio de Janeiro once more became the cultural centre, a position that had been lost to São Paulo during the previous decade. The visits of Le Corbusier, in 1929, and Frank Lloyd Wright, in 1930, signalled the need for a new architecture, viewed as an opportunity for integrating the arts.[4] The forward-thinking Lúcio Costa was chosen as Director of the Escola Nacional de Belas Artes. He also organized the Salão Nacional de Belas Artes which, from 1931 onwards, promoted and rewarded modernist artists. These events were decisive in bringing modernism to the federal capital of Rio de Janeiro.

Brazil

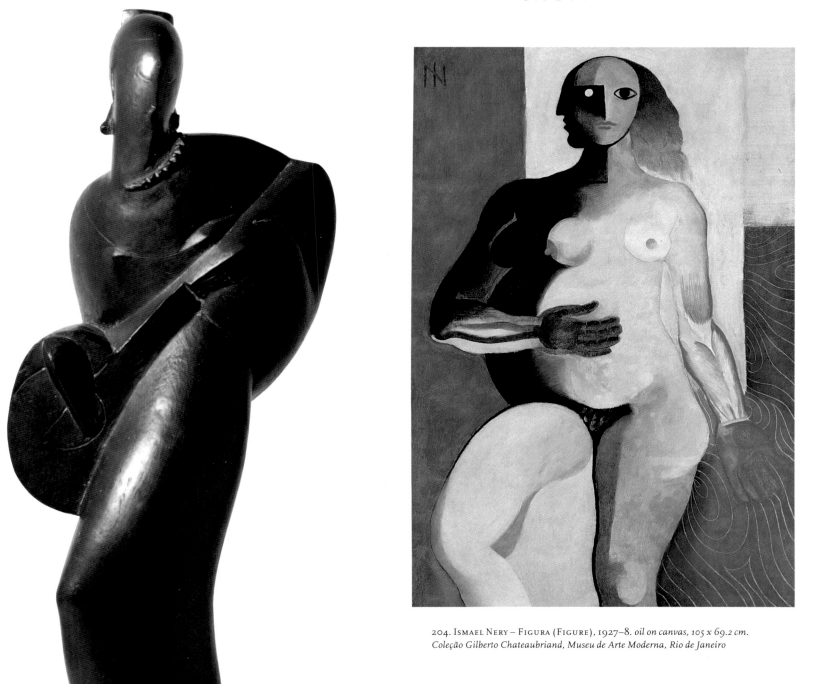

204. ISMAEL NERY – FIGURA (FIGURE), 1927–8. *oil on canvas, 105 x 69.2 cm.*
Coleção Gilberto Chateaubriand, Museu de Arte Moderna, Rio de Janeiro

203. VICTOR BRECHERET – TOCADORA DE
GUITARRA (THE GUITAR PLAYER), *c.1925. bronze,*
75 x 21 x 16 cm. Pinacoteca do Estado, São Paulo

Brazil

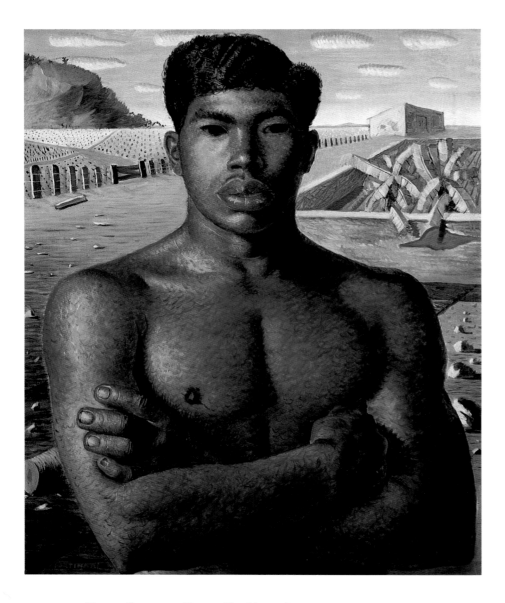

205. CÂNDIDO PORTINARI – MESTIÇO (THE MESTIZO), 1934.
oil on canvas, 81 x 65 cm. Pinacoteca do Estado, São Paulo

Cândido Portinari (1903–62) is, perhaps, the artist whose work most eloquently expresses the spirit of the period. He became the official artist of the Vargas government. A member of the Communist Party, Portinari dedicated himself to exploring national historical themes in order to reveal various aspects of social injustice, as in *Mestiço* (*The Mestizo*, 1934; fig. 205). His paintings of immigrants and workers spoke directly to the population, in the form of huge murals done both in Brazil and abroad, mixing Mexican Muralism with the formal solutions presented by Picasso between the wars, and inspired by Portinari's great admiration for the Renaissance masters of perspective. His conception of art and his world-vision saw the community as the basis of contemporary life, integrating art with daily living. Portinari headed a group of artists which included Thomaz Santa Rosa (1909–56), Orlando Teruz (1902–84), Enrico Bianco (b. 1918) and Proença Sigaud (1899–1979), all of whom were concerned with social themes. His influence was also felt by those artists in Rio de Janeiro who engaged in figurative art with national themes, and rebelled against the academic leaning of the Escola Nacional de Belas Artes. These included, among others, Milton Dacosta (1915–88), José Pancetti (1904–58) and Ado Malogoli (1906–94).

The guiding principles of the various engraving groups which appeared throughout the country in the second half of the 1940s also bore Portinari's mark. The artist's phenomenal influence (referred to as 'Portinarismo') during this period would only diminish with the arrival of artists fleeing from Nazi Europe, such as Maria Helena Viera da Silva (1906–94), Arpad Szenes (1897–1984), Emeric Marcier (1916–92) and Axl Leskoschek (1889–1975), all of whom were

206. ALBERTO DA VEIGA GUIGNARD – PAISAGEM DE OURO PRETO (OURO PRETO LANDSCAPE), *n.d. oil on wood, 38.5 x 62.5 cm. private collection, São Paulo*

dedicated to teaching art and stimulating the intellectual life of Rio de Janeiro.

In São Paulo, the unrest of the 1920s deepened with the political and economic crisis created by the repression which followed the 1930 Revolution, and by the plunge in coffee prices after the Great Depression. This served to break up the group of modernists, who attached themselves to various other associations with distinct political and ideological inclinations. Debates shifted from aesthetic issues to professional concerns, such as the artist's social responsibility, the art market, institutions and cultural policy. In 1932 the Sociedade Pró-Arte Moderna (SPAM) and the Clube dos Artistas Modernos (CAM) were founded.

SPAM, comprising a group of artists led by Lasar Segall, put together two exhibitions: the first included work by artists of the School of Paris from various São Paulo collections, alongside the work of Brazilian artists; the second showed the work of modern artists from Rio de Janeiro. SPAM's artistic activities also included two fund-raising carnival parties. On both occasions the artists, helped by musicians and dancers, created the scenery, costumes, choreography and music. This participation on the part of SPAM's membership is proof of the organization's dedication to the tenets of modernism. Internal dissension caused by the 'Integralistas' (the Brazilian version of Italian Fascism), who discriminated against fellow Brazilians, foreigners and especially Jews, imposed an intolerable strain on the membership and led to the group's demise in 1934.

CAM was characterized by a greater independence and a more aggressive and clearly defined programme. The group put together various exhibitions, including those dedicated

to Käthe Kollwitz, Gráfica da Rússia (Russian graphics) and Desenhos de Crianças e Loucos (Drawings of Children and the Insane), as well as concerts of modern music and a series of lectures and debates on a variety of subjects but focusing mainly on social problems. In charge of these events were Tarsila do Amaral, Mario Pedrosa, the Mexican painter David Alfaro Siqueiros and Caio Prado Júnior, to name just a few. CAM was headed by Flávio de Carvalho (1899–1973), assisted by di Cavalcanti, Carlos Prado (b. 1908) and Antonio Gomide (1895–1967).

Flávio de Carvalho, engineer and architect (he was considered one of the precursors of modern architecture in Brazil), painter, sculptor, sketcher, scenographer and writer, who had participated in Oswald de Andrade's Anthropophagic Movement, created a vast body of work, marked by philosophical considerations and employing a style between Expressionism and Surrealism. He was the first artist in Brazil to be interested in the art of the insane, having stated that he would like to be able to draw like them. His paintings focus on the psychological aspects of the human condition, often resulting in strange forms of representation where fields of colour dilute form, defining a figure that is immediately exploded, devolving into absurd arabesques and arbitrarily juxtaposed planes, as in *Ascençio definitiva de Cristo* (*The Definitive Ascension of Christ*, 1932; fig. 207). In 1933 he initiated the theatrical section of CAM, called Teatro da Experiência (Theatre of Experience). Its first production, Flávio de Carvalho's *Bailado do Deus Morto* (*Dance of the Dead God*), was closed by the Vargas police and all of CAM's activities were terminated.

Other important artistic events of this period in São Paulo included the three Salões de

Maio (May Salons), from 1937 to 1939, organized by Flávio de Carvalho and Quirino da Silva (1902–81), as well as the three exhibitions of the group known as the Família Artística Paulista (the Artistic Family of São Paulo), in 1937–8 and 1940, put together by various artists, mostly second-generation Italian immigrants belonging to the Grupo Santa Helena. The Salões de Maio presented Brazilians and foreigners side by side, anticipating the form of the São Paulo Bienals. The presence of artists like Ben Nicholson, Alberto Magnelli and Alexander Calder was fundamental to broadening the aesthetic debates in the São Paulo artistic community, which had shown no inclination towards the artistic avant-garde or abstract art. The Salões de Maio demonstrated the need to break this cultural isolation.

The exhibitions of the Família Artística Paulista, on the other hand, presented São Paulo artists interested in developing a vocabulary using regional colours and based on the teachings of the great masters in art history, above all the Italians and Cézanne.[5] Coming from proletarian families or from the lower middle class, these artists portrayed the landscape surrounding São Paulo or painted classical religious themes, still lifes, and portraits with the same earthy tones. Aldo Bonadei (1923–74), Francisco Rebolo (1903–80) and Alfredo Volpi (1896–1988) are the most important artists of this group. Volpi had one of the strongest careers in Brazilian art. Initially a figurative painter, his work became abstract by reducing the elements of the landscape to structural lines, geometric forms and chromatic fields. Volpi became interested in the purely aesthetic elements of art during the 1950s, focusing on coloured structures and utilizing tempera and texture in his paintings which almost invariably portrayed houses, façades and

Brazil

207. FLÁVIO DE CARVALHO (1899 – 1973) – ASCENÇÃO DEFINITIVA DE CRISTO (THE DEFINITIVE ASCENSION OF CHRIST), *1932. oil on canvas, 75 x 60 cm. Pinacoteca do Estado, São Paulo*

popular festivities, as did *Casas* (*Houses*, 1955; fig. 210). His work, which paralleled the Concrete art movement in Brazil, did not lend itself to intellectual speculation or demand any theoretical knowledge from the artist, who claimed that his only interest was colour. 'Volpi stands at a mid-point between transcendent vision and the popular substrata of his origins.'[6]

In other Brazilian states the consolidation of the modernist achievements would only happen, in general, during the 1940s. Although there were sporadic events that enabled the renewal or creation of policies to popularize modernism, a systematic debate on modern art had to await the emergence of modern artists' associations and clubs, including the engraving clubs inspired by the Mexican Taller de la Gráfica Popular,[7] in cities outside the axis of Rio de Janeiro–São Paulo.

During the period immediately prior to the renewal prompted by the creation of art museums and the São Paulo Bienals of the 1950s, four artists played a fundamental role in helping to establish a uniquely Brazilian sensibility and imagination: Alberto da Veiga Guignard, Maria Martins, Lívio Abramo and José Pancetti.

Guignard (1896–1962), who studied in Europe and became the mentor of later generations of Brazilian artists, 'created a body of work that stood as a lone island in the development of the modernist movement from the thirties onwards ... one can glimpse, beneath [his] conventional figurative representation, a sophisticated vision of nature where the artist's lyrical subjectivity is apparent.'[8] Although Guignard's art resembles that of 'primitive' artists in its innocent vision and skilful representation of reality, the sum of his *œuvre*, on the contrary, portrays on its thin surfaces the efforts of a sophisticated eye

to attain such a vision, a conquered innocence, as in *Paisagem de Ouro Preto* (*Ouro Preto Landscape*; fig. 206).

The organic expansions and contractions of the sculptures of Maria Martins (1900–73), a close friend of André Breton, Marcel Duchamp and Piet Mondrian, express in two different ways the original disorder of Brazilian life, as suggested in *O impossivel* (*The Impossible*, 1945; fig. 208). 'The first presents itself, in a series of works dedicated to the Amazon, as the Brazilian soul's mythical unconscious, arising from the painful efforts of a generous and exuberant, yet also ignorant and indomitable, nature in trying to be born. The second, bursting forth as the flooded dam of the psychological unconscious, surrenders unashamedly to the rhetoric of its images.'[9]

Lívio Abramo (1903–92) was one of the founders, with Segall and Goeldi, of modern engraving in Brazil. The son of working-class immigrants, his work is profoundly humanistic and concerned with social issues, including the life of factory workers, the Spanish Civil War and Afro-Brazilian culture. Influenced by the Expressionist engravings of Käthe Kollwitz and Franz Masereel, Abramo's woodcuts are his most important accomplishments. Structured through sequences of contrasting white and black areas, the lively cuts of the surface intensify the effect. In time his expansive gestures became more vigorous and disciplined, encompassing lines and planes, full and empty spaces, until every element conveyed movement, similar to the methods of composition of the abstract art of the 1950s.

Though he is better known for his landscapes, especially marine scenes, José Pancetti's real modernism is present in his self-portraits,

such as *Auto-vida* (*Self-life*, 1945; fig. 209), which
he painted almost obsessively. While his land-
scapes are infused with a Post-Impressionist
aesthetic with references to Cézanne, resulting in
simple and balanced compositions, his portraits
are clearly Expressionistic and have great spiri-
tual intensity, communicating the artist's melan-
choly and a profound sense of loneliness.

The Second Phase of Modernity: 1950–1985

Although the group organized around
the Semana de Arte Moderna of 1922 inaugu-
rated the debate on modernism in literature,
music, architecture and the visual arts, until
the 1950s this movement was never defined as
having relevance to Brazilian society as a whole.
The formal experimentation with modernism
which had been occurring since the 1920s found
no echo outside the circle of intellectuals, art
collectors, friends and the artists themselves.
This fact does not invalidate the pioneering
aspects of artists such as Tarsila do Amaral,
Oswaldo Goeldi, di Cavalcanti, Lasar Segall,
Guignard and others who, although having no
followers to establish a lineage, planted the seeds
of what would constitute a specifically Brazilian
aesthetic. Their works, with powerful images and
remarkable vitality, are seen today as paradigms
of this rich and fertile influence. Since the 1960s,
when a truly systematic writing of Brazilian art
history took place, they have been a source of
inspiration and a continuous source of reference
for artists, critics and historians.

Like other Latin American countries,
Brazil accumulated wealth by providing raw
materials and agricultural products to the Allied
forces during the Second World War. As a result,
in the mid-1940s Brazil was ready for a period of

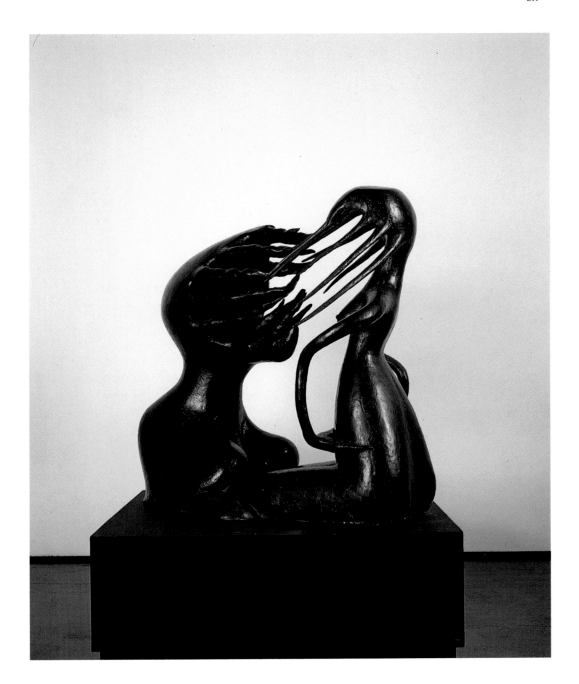

208. MARIA MARTINS – O IMPOSSIVEL (THE IMPOSSIBLE), *1945.
bronze, 79 x 80 x 47 cm. Museu de Arte Moderna, Rio de Janeiro*

Brazil

rapid development, investing in heavy industry and large-scale consumer goods, inviting foreign investment and importing sophisticated technologies. This was the beginning of the 'development years'.

The construction of the new capital, Brasilia, is the strongest symbol of the effort to bring the country up-to-date and into the modern world – as represented by the United States in its economic, political and social aspects. The new capital city embodied the aspirations of a society that, while having a strong presence of landowners in government and in public administration, a short memory and few traditions, wanted to break with its past as an agricultural economy. The location of the new capital in the middle of the country was intended to emphasize the importance of the interior as an integral part of the nation's huge territory, signalling a change from the colonial heritage that had promoted only coastal development. For the first time there was a sense that Brazil was being built by the work and effort of Brazilians.

São Paulo, a city which had never been at the centre of political decision-making (even though it had been Brazil's financial centre and had witnessed important decisions in Brazilian history), now became the *de facto* capital where national and international money would be invested for the purposes of transforming the country. This programme of modernization involved traditional Brazilian families as well as the newly affluent descendants of Italians, Spanish, Jewish, Lebanese and German immigrants. Society as a whole proposed a general plan to direct all of the country's developmental activities. This underlined the need for a professional training for the technicians and intellectuals who would be required to identify and tackle

the pressing problems inherent in the project. Technical schools and universities were therefore created, together with professional training and learning centres.

The prosperous Brazilian middle class also invested in its own cultural development, seeking to satisfy newly refined tastes. In the arts and humanities, there were important cultural initiatives such as the foundation of the Museu de Arte de São Paulo (1947) together with its Escola de Artes; the modern art museums of São Paulo and Rio de Janeiro (1948); the Teatro Brasileiro de Comédia (1948); the Companhia Cinemátografica Vera Cruz (1949); the Rede Tupi de Televisão (1950); and the Escola Superior de Desenho Industrial (1963).

The ending of the Second World War brought about profound changes in artistic creation throughout the world and Brazil was no exception. Here the artistic debate, interrupted during the war years, was resumed; it now concerned the hegemony of aesthetic tendencies between Europe and New York where Abstract Expressionism was gaining in importance. Little by little abstraction, in its two forms – informal and geometric or Concrete – became the new international aesthetic. In Brazil, the prize given to the Swiss artist Max Bill at the first Bienal de São Paulo, in 1951, was a recognition of this mode. It opened the way for the internationalization of Brazilian art, which now included abstraction as a principal tendency.[10]

After this first large show of international art in Brazil, pure abstraction and the rigorous rationalism represented by Concrete art came to dominate the Brazilian art scene. All figurative work was supplanted by a visual aesthetic which was functionally integrated with the spirit of modernism. Art now stood for

scientific and technological progress in its purest forms, similar to that found in the work of Mondrian and the Bauhaus. In 1952 the manifesto and exhibition held by the Grupo Ruptura was launched in São Paulo. This group was headed by Waldemar Cordeiro and included Geraldo de Barros (b. 1923), Lothar Charoux (1912–87), Luiz Sacilotto (b. 1924), Kazmer Féjer (b. 1922), Leopoldo Haar (1910–54) and Anatol Wladislaw (b. 1913). They proposed an art that was opposed to naturalism and hedonistic figuration, favouring 'the renovation of the essential values of visual art (space–time, movement and matter)', emphasizing 'artistic intuition that followed clear and intelligent principles and offering possibilities for practical development'. Art was considered by Grupo Ruptura as 'a means of knowledge deductible from concepts'.[11] In Rio de Janeiro, the Grupo Frente appeared, during the same year and with the same ideals, headed by Ivan Serpa and including Aluísio Carvão (b. 1918), Lygia Clark, Lygia Pape, Décio Vieira (1922–88) and Abraham Palatnik (b. 1928).

Both groups actively promoted their programmes and artistic ideals, putting together exhibitions and generating heated debates. The active involvement of the critic Mario Pedrosa, an expert in Gestalt theory, was fundamental, as was that of the Concretist poets Décio Pignatari, Ferreira Gullar and the brothers Haroldo and Augusto de Campos.

Within Concretism, the works of Waldemar Cordeiro (1925–73) and Ivan Serpa (1923–73) were considered models of the movement's ideals, as in *Pintura 206* (*Painting 206*, 1957; fig. 213). They were continually engaged in an active creative process, constantly renewing their artistic outlook and exerting a strong influence on other artists. Serpa, after experiments

209. José Pancetti – Auto-vida
(Self-Portrait), *1945.oil on canvas,*
65 x 45 cm. Coleção Gilbert Chateaubriand,
Museu de Arte Moderna, Rio de Janeiro

210. Alfredo Volpi – Casas (Houses), *1955. tempera on canvas, 115.5 x 73 cm.*
Museu de Arte Contemporânea da Universidade de São Paulo, São Paulo

Brazil

211. WALDEMAR CORDEIRO – MOVIMENTO (MOVEMENT), 1951.
*tempera on canvas, 90.1 x 95.3 cm. Museu de Arte Contemporânea
da Universidade de São Paulo, São Paulo*

213. IVAN SERPA – PINTURA 206 (PAINTING 206),
*1957. oil on canvas, 102 x 102 cm. Museu Nacional
de Belas Artes, Rio de Janeiro*

212. LYGIA CLARK – BICHO: CARANGUEIJO DUPLO (BICHO: DOUBLE CRAB),
1961. aluminium, 53 x 59 x 53 cm. Pinacoteca do Estado, São Paulo

214. HELIO OITICICA – BÓLIDE 18, B-331: HOMENAGEM A CARA DE CAVALO (METEOR 18, B-331: HOMAGE TO CARA DE CAVALO), 1967. wood, photo, fabric and plastic, 39 x 30 x 30 cm. Coleção Gilberto Chateaubriand, Museu de Arte Moderna, Rio de Janeiro

with gestural abstraction, returned in the mid-1960s to a strongly Expressionist, often erotic, figurative art. His last works comprised drawings and paintings involving optical experiments, similar to the constructive orientation of his early works. After initially engaging with Concrete Abstraction, Cordeiro turned to figurative art via Pop, in its Brazilian version of the 1960s, and finally became involved with computers and other electronic and cybernetic media as a result of artistic research, as, for example, in *Movimento* (*Movement*, 1955; fig. 211). Both Serpa and Cordeiro utilized their work as the basis for investigating and reflecting on art and its place in urban-industrial societies.

In 1959 the Manifesto Neoconcreto by Ferreira Gullar was published in Rio de Janeiro, coinciding with the first Exposição de Arte Neoconcreta, both events constituting a break with the Concrete artists. Criticizing the excessive rationality and total exclusion of emotion from Concrete art, the manifesto suggested general principles for the visual arts, poetry and prose through a harmonization of sensory and mental experiences. 'The Neo-Concrete artists opened themselves to the environment and gradually turned away from easel painting and static sculpture, demystifying the artistic object. In this way original artistic propositions were born, based on experiments with chromatic values, cinechromatism, viewer-manipulated work, as well as the original tactile–visual work of Lygia Clark, which resulted in [the creation of] a sensory universe and a new subject–object relation'.[12] This group of Neo-Concrete artists included Amílcar de Castro, Aluísio Carvão, Franz Weissmann (b. 1914), Lygia Pape, Willys de Castro, Hércules Barsotti (b. 1914) and Hélio Oiticica.

The first paintings of Lygia Clark (1920–88) in the Concretist vein aspired to eliminate the pictorial space as representation by utilizing modulated surfaces and creating the illusion of three-dimensional planes. Next she created a series of 'Casulos' (cocoons) and 'Trepantes' (creepers), flat surfaces unfolding into three-dimensional objects which sought integration with the surrounding space. With the series *Bichos* (*Animals*) – sheets of metal connected by hinges – Clark was the first Brazilian artist to use spectator participation to give shape to a work which was in a state of perpetual re-creation, as she did in *Bicho: carangueijo duplo* (*Bicho: Double Crab*, 1961; fig. 212). From the mid-1960s onwards, she became increasingly interested in the poetics of the body, using sensory experiences and related objects to reawaken the spectator. This finally led to her total dedication to art therapy.

Taking a similar path, Hélio Oiticica (1937–80) began within the Concretist movement, trying to break the two-dimensional pictorial surface and creating 'spatial relief' in the form of monochromatic objects arranged in space. This was followed by his *Penetráveis* (Penetratables), spaces created by arranging monochromatic objects; then by the *Bólides* (*Meteors*), boxes and containers with organic elements such as shells, dust, sand and water, to be touched by the public, which included *Bólide 18, B-331: Homenagem a Cara de Cavalo* (*Meteor 18, B-331: Homage to Cara de Cavalo*, 1967; fig. 214); and, finally, the *Parangolés*, garments of coloured fabric to be used by the spectator in developing movements in space. Oiticica's works have ranged from a purely visual experience of the object to a tactile, moving experience of the sensual significance of materials in which the whole body participates. Art, for Clark and Oiticica, was above all an existential strategy.

The production of Concrete and Neo-Concrete artists led to the appearance of a group of works that, for the first time, constituted a specifically Brazilian art as a system of knowledge. Among other artists who followed a similar approach were Amílcar de Castro (b. 1920), whose iron and steel sculptures are reduced to their essential form, modulated and cut by gestures that combine intuition and rigorous order, as in *Sem título* (*Untitled*, 1967; fig. 217); Rubem Valentim (1922–92) who, with exuberantly colourful paintings and three-dimensional objects, constructed a geometry based on Afro-Brazilian symbols, as in his *Composição* (*Composition*, 1960; fig. 216); Lygia Pape (b. 1937), whose woodcuts in single editions explored the dialectical relationship between figure and ground, challenging the spectator's perceptions, as in *Tecelares* (1958; fig. 218); Sérgio Camargo (1930–90), whose wooden relief surfaces explored the effects of modulation and repetition as a continuous game between form and its perception, as in *Relevo 124* (*Relief 124*, 1966; fig. 215); and Willys de Castro (1926–88) who, with his 'active objects', sought to make evident the problems intrinsic to the object – its nature and essential characteristics.

As an alternative to geometrical abstraction, an abstraction of an informal character was developed, influenced by French *Tachisme*, action painting, and Expressionist gesturism. Antonio Bandeira (1922–67), whose abstraction championed the notion of 'painting-painting' as a reaction to the 'painting-architecture' of the Concretists, once said: 'I never paint pictures. I try to make paintings.' His thick surfaces express a vision of the world as a continuous

Brazil

215. SERGIO CAMARGO – RELEVO 124 (RELIEF 124), 1966.
painted wood, 170 x 120 cm. private collection, São Paulo

216. RUBEM VALENTIM – COMPOSIÇÃO (COMPOSITION),
1960. oil on canvas, 50 x 35 cm. private collection, São Paulo

217. Amílcar de Castro – Sem título (Untitled), 1967. iron,
71 x 108 x 96 cm. Museu Nacional de Belas Artes, Rio de Janeiro

218. Lygia Pape – Tecelares,
1958. woodcut, 23 x 23 cm.

Brazil

abstract registering of objective reality. For this reason, his work at times evokes landscapes (trees, cities, starry nights) and transmits a joyful and magical feeling of the concrete existence of things, while bringing together reality and imagination, as in *A grande cidade iluminada* (*The Illuminated Big City*, 1953; fig. 219). Iberê Camargo (1914–94) covers the surface of his paintings with thick paint, in dark and dense colours and strokes that provide texture and shape to the surface. Repeating calligraphic gestures and employing free signs, his paintings – such as *Objêto em tensão I* (*Strained Object I*, 1967; fig. 221) – seem to integrate an expanding space and express, above all, his disillusion with the human condition. In the painting of Flávio Shiró Tanaka (b. 1928), a Japanese-Brazilian artist, a sense of great drama prevails, as in the 1969 *Máquina humana* (*Human Machine*; fig. 220), creating a pictorial surface (not unrelated to some aspects of Abstract Expressionism) filled with metaphors of a fragmented world.

The 1960s were among the most productive years for Brazilian art. The coup of 1964 that put the military in power was followed by a cycle of intense creative activity and cultural transformation which made itself felt in cinema with the Cinema Novo, in music with the Bossa Nova and Tropicalismo, and in theatre with groups such as Arena, Oficina, Ipanema and Opinião. Also important was the creation of the Centro Popular de Cultura, or CPC, for the purpose of rethinking Brazilian culture and planning a programme to raise popular consciousness of it. These events were symptomatic of the combative spirit that dominated the 1960s throughout the world.

In this decade, figurative and narrative painting reappeared in Brazil, influenced by Pop art and Nouvelle Figuration. Both movements brought an explosive liberation of media and format to art while promoting a Dadaist attitude in the art world through happenings, installations, objects and assemblages. The exhibitions entitled *Opinião 65* and *Opinião 66*, at the Museu de Arte Moderna in Rio de Janeiro, and *Proposta 65* and *Proposta 66* at the Museu de Arte Moderna in São Paulo, reflected the spirit of the time. The country's political and social climate made artists increasingly concerned with social issues without, however, engaging in the explicit political messages characteristic of the realist art of the 1940s and 1950s. Brazilian Pop art, unlike American, sought to define its identity, in opposition to the international trends, by focusing on the country's urban and political realities and an awareness of suburban and displaced popular culture.

The best assessment of the artistic concerns of this period appears in the catalogue of Hélio Oiticica's exhibition entitled *Nova objetividade brasileira* (*New Brazilian Objectivity*) held at the Museu de Arte Moderna in Rio de Janeiro in 1967: 'Nova Objetividade [New Objectivity] means shaping the Brazilian artistic avant-garde, whose main characteristics are: (1) a general tendency towards constructivism; (2) emphasis on the object, having exhausted the possibilities of easel painting; (3) an interest in spectator participation: corporal, tactile, visual and semantic; (4) addressing and taking a stance on all political, social and aesthetic issues; (5) a tendency towards collective art and abolishing the various "isms" characteristic of the first half of the century; and (6) the re-emergence of new formulations of the concept of "anti-art".'[13] Among those following this tendency were not only Oiticica and Waldemar Cordeiro but also Antonio Dias (b. 1944), Antonio Henrique Amaral

219. Antonio Bandeira – A grande cidade iluminada (The Illuminated Big City), 1953. oil on canvas, 72.4 x 91.4 cm. Museu Nacional de Belas Artes, Rio de Janeiro

220. Flávio Shiró Tanaka – Máquina humana (Human Machine), 1969. oil on canvas, 126 x 203 cm. Pinacoteca do Estado, São Paulo

221. Iberê Camargo – Objeto em tensão I (Strained Object I), 1967. oil on canvas, 93 x 123 cm. Coleção Gilberto Chateaubriand, Museu de Arte Moderna, Rio de Janeiro

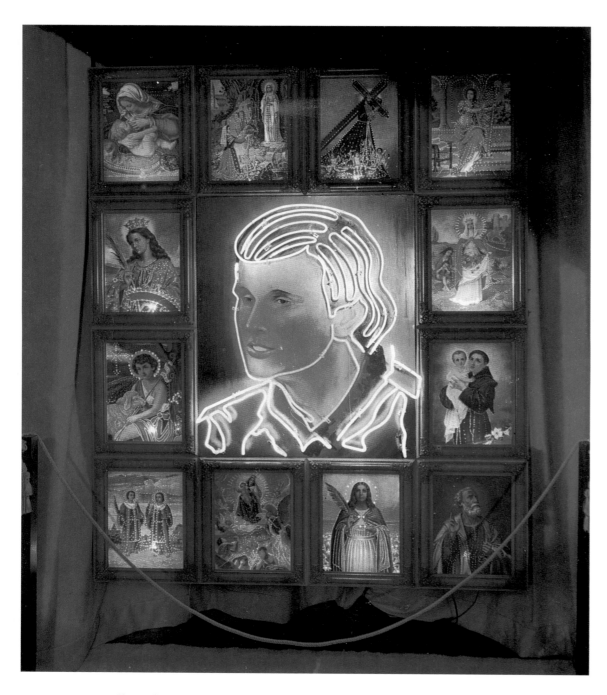

222. NELSON LEIRNER – ADORAÇÃO: ALTAR DE ROBERTO CARLOS (ADORATION: ALTAR OF ROBERTO CARLOS), *c.1966. mixed media, 201 x 160 x 260 cm. Museu de Arte de São Paulo Assis Chateaubriand, São Paulo*

223. ANTONIO HENRIQUE AMARAL – QUOQUE TU, BRUTUS! (AND YOU, BRUTUS!), *1967. woodcut, 70 x 45 cm.*

Brazil

224. ANTONIO DIAS – UM POUCO DE PRATA PARA
VOCÊ (A LITTLE MONEY FOR YOU), *1965. mixed media,*
124 x 122.7 cm. Coleção Gilberto Chateaubriand, Museu
de Arte Moderna, Rio de Janeiro

(b. 1935), Amélia Toledo (b. 1926), Raymundo
Collares (1944–86), Rubens Gerchmann
(b. 1942), Nelson Leirner (b. 1932), Ana Maria
Maiolino (b. 1942), Carlos Vergara (b. 1941),
Cláudio Tozzi (b. 1944), Glauco Rodriges
(b. 1929), Lygia Pape, José Roberto Aguillar
(b. 1941) and Antonio Manoel (b. 1947).

The works of Antonio Dias during this
period, together with the *Parangolés* and *Bólides*
of Oiticica, can be seen as the most significant
achievements of the Brazilian Nova Objetividade.
Inspired by comic books, Dias created surfaces
saturated with cut images and body parts
projected into space. Alluding to urban violence
and with a strong erotic charge, his works are
situated somewhere between the limits of chance
and deliberation, including *Um pouco de prata*
para você (*A Little Money for You*, 1965; fig. 224).
Dias's later work focused on the conceptual ques-
tioning of language and metaphor.

The work of Nelson Leirner, on the other
hand, critically attacks the processes of mass
culture and fetishism. Its hallmark is the 'appro-
priation' of material culture through ready-
mades or *objets trouvés*, or even art, as in the
series *Homenagem a Fontana* (*Homage to*
Fontana; 1967). Filled with irony and sarcasm,
Leirner's works incorporate chance elements
introduced through spaces filled with industrial
products, requiring spectator participation to
confirm their existence, as in *Adoracão: altar de*
Roberto Carlos (*Adoration: Altar of Roberto Carlos*,
*c.*1966; fig. 222). In addition to his art, which is
exemplary both in ethical terms and in its coher-
ence, Leirner is a university professor who was
responsible for shaping various artists in São
Paulo during the 1980s. The woodcuts of
Antonio Henrique Amaral during the 1960s
mixed figuration based on Pop art with popular

engravings of Brazilian 'cordel' literature as, for
example, in *Quoque Tu, Brutus!* (*And You,*
Brutus!, 1967; fig. 223). Whether denouncing the
world's frauds or satirizing human behaviour
and the misuse of power, Amaral showed the
process of contemporary cultural homogeniza-
tion and loss of individuality through govern-
mental control and an oppressive work-routine.
Executed in a direct and dry language in keeping
with the objectivity of the medium, Amaral's
woodcuts, like his later work, are rich in allegory
and metaphor.

Two other artists, Wesley Duke Lee and
Mira Schendel, were fundamental in establishing
a Brazilian contemporary spirit in the 1960s. The
first, a member of the Grupo Rex, along with
Geraldo de Barros and Nelson Leirner, was
responsible for various exhibitions, publications
and happenings in São Paulo between 1965 and
1967. Wesley Duke Lee (b. 1931) also taught
Carlos Fajardo, José Resende and Luis Paulo
Baravelli (b. 1942). His work developed through
a series of experiments with techniques, materi-
als and processes, in combination with an obses-
sive investigation of themes including birth, reli-
gion, sexuality, death and art itself, as demon-
strated in *A zona: considerações – retrato de Assis*
Chateaubriand (*The Red-Light District:*
Considerations – Portrait of Assis Chateaubriand
(fig. 226). The uniqueness of Duke Lee's
contribution is due to the 'multiplicity of anar-
chic and contradictory gestures of which he is
capable, and which cannot be reduced to any
constructive meaning or system. The uncon-
scious, for Duke Lee, is above all the repository
of memory, a secret contraption, a fantastic and
useless machine which operates separately from
the will to know, showing itself only through
Revelations.'[14]

Brazil

Mira Schendel (1919–88)was born in Switzerland and moved to São Paulo in 1952. Due to the rigour and coherence of her aesthetic, she became a crucial figure for future generations of Brazilian artists from the 1970s onwards. Her art has passed through several distinct phases – geometric compositions, organic and accidental form, and the use of graphic signs. It possesses a unique sensibility and is concise and radical in exploring visual semantics – line, plane, colour, space, emptiness. Schendel eventually reached the point of dematerializing her work and shattering the hierarchy of language, as she did in *Desenho 2* (*Drawing 2*, 1972; fig. 225).

The censorship imposed by the military government towards the end of 1968 blocked the cultural effervescence in Brazil, forcing its most radical intellectuals into exile and isolating the country. An international boycott was imposed on the São Paulo Bienal of 1969, which ceased to be a centre of artistic production and went through a period of decadence during the 1970s. However, a new cycle of prosperity in Brazil, known as the 'economic miracle', not only guaranteed the continuation of military rule but led to the consolidation of the art market and the appearance of specialized magazines. For the first time since the era of modernism, the work of Brazilian artists fetched high prices, ensuring their recognition.

With the creation in 1975 of FUNARTE, the official organization for the arts, the government adopted a strongly nationalistic artistic policy towards Brazilian culture, with a view to preserving and promoting the country's historical and artistic heritage. As this favoured the appearance of arts centres outside Rio de Janeiro and São Paulo, Belo Horizonte, Curitiba, Recife, Salvador and Porto Alegre also became places of intense

225. MIRA SCHENDEL – DESENHO 2 (DRAWING 2), 1972.
Indian ink on Japanese paper, 49.5 x 25.1 cm. Museu de Arte Contemporânea da Universidade de São Paulo, São Paulo

226. Wesley Duke Lee – A zona: considerações – retrato de Assis Chateaubriand (The Red-Light District: Considerations – Portrait of Assis Chateaubriand), 1968. mixed media, 200 x 200 x 200 cm. Coleção Gilberto Chateaubriand, Museu de Arte Moderna, Rio de Janeiro

227. CILDO MEIRELES – EUREKA BLINDHOTLAND, 1970–5.
installation: wood, black rubber, nylon net, felt, newspaper,
sound tracks, 100 x 100 m. collection of the artist, Rio de Janeiro

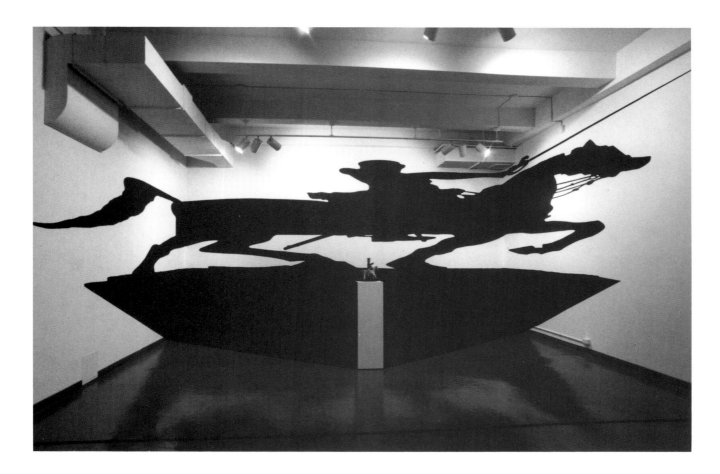

228. REGINA SILVEIRA – O PARADOXO DO
SANTO (THE SAINT'S PARADOX), 1994.
painting on walls and floor, with pedestal,
c. 8 x 16 m. Museo del Barrio, New York

Brazil

artistic and cultural activity. In a country of continental proportions such as Brazil, these new centres, with a few exceptions, were able to establish their own artistic infrastructure, including galleries, markets, schools, critics, historians and publications. Some of the artists who emerged from these regional centres to gain national recognition were Francisco Brennand (b. 1927), João Câmara (b. 1944), Paulo Bruscky (b. 1949), Humberto Espindola (b. 1943), Sérvulo Esmeraldo (b. 1929), Mário Cravo Jr. (b. 1923) and Siron Franco (b. 1947).

Although conditions did not favour large artistic manifestations, the 1970s were marked by various outdoor events such as *Do corpo a Terra* (*From the Body to the Earth*; Belo Horizonte, 1970), *Domingos de Criação* (*Creation Sundays*; Rio de Janeiro, 1971), *Manifestação de Rua* (*Demonstration in the Street*; São Paulo, 1973) and *Mitos Vadios* (*Vagrant Myths*; São Paulo, 1978). As in other parts of the world, Rio de Janeiro and São Paulo promoted conceptual artists; a succession of exhibitions of conceptual and 'mail art', in which both Brazilian and international artists participated, was organized in São Paulo, including *Jovem Arte Contemporânea* (*Young Contemporary Art*; 1972 and 1973), *Expo-Projeção* (*Expo-Projection*; 1973), *Prospectiva 74* (*Prospective 74*; 1974), *Poéticas Visuais* (1977) and, completing the cycle, the large *Arte Postal* (*Postal Art*) show of 1981. The artists involved were all concerned with experimentation and the processes of dematerializing art, similar to those promoted by such movements as Land art, Body art and Arte Povera. They organized performances and used photocopying, books, photography, video and the cinema as artistic elements. This was a period of expansion of the visual arts vocabulary and reflection on the possibilities of social partici-

pation. Art as a commodity was rejected, having been redefined as a 'conceptual language' with a specifically educational role. Artists who followed this tendency included Anna Bella Geiger (b. 1933), Julio Plaza (b. 1938), Regina Silveira, Luiz Alphosus Guimarães (b. 1948), Mario Cravo Neto (b. 1947), Arturo Alíppo Barrio de Souza, called Barrio (b. 1945), Cildo Meireles, Regina Vater (b. 1943), Iole de Freitas, Ivens Machado, Carmela Gross (b. 1946) and Rafael França (1957–92).

The work of Cildo Meireles (b. 1948) is marked by a profound reflection on established values, the different forms of power and the systems of producing art and culture, inviting the spectator to consider the fundamental aspects of social conditioning, as in *Eureka Blindhotland* (1974–5; fig. 227). As the critic João Moura Jr. has explained it, 'The artist's function [in his work] consists of challenging, even destroying, certain relationships – for example: that between the use-value and exchange-value of merchandise, geographical boundaries, art history, history itself – and proceeding to invert their meaning. Re-reading the accepted meaning, and then subverting it – to provide an alternative interpretation.'[15]

Regina Silveira (b. 1939) focuses on forms of perception and the understanding of images, taking into account all the accumulated knowledge of the theories of representation and artistic production. With a strong conceptual base, and utilizing an extremely objective language, her installations, such as *O paradoxo do santo* (*The Saint's Paradox*, 1994; fig. 228), and objects explore the process of image-constructing, through their actual or virtual projections, distorting them with humour and an acute intelligence. The work of Iole de Freitas (b. 1945)

based on a consciousness of the body as the limit of experiencing reality, derives from her experience as a dancer during the 1960s. Using her own body as a point of reference, she deals with the possibilities of various media in establishing an expressive contemporary symbolism. Freitas's work also addresses women's issues, without militancy, whether in photo-performances, films, or, more recently, in sculptures.

In addition to the type of art that manifested these 'dematerializing' tendencies, there also appeared in the 1970s in Brazil (as in other parts of the world) art forms based upon traditional models. Artists became engaged in 'new groupings of pictorial space, in developing new ways of organizing the surface of the canvas, in rejecting the old metaphors, transforming the work itself into an equivalent of reality.'[16] Learning from American Minimalism and Italian Arte Povera, these artists also sought to preserve the uniqueness of the visual arts as a field of knowledge. This tendency strongly influenced the generation which emerged during the 1980s, including Eduardo Sued (b. 1925), Carlos Fajardo, Antonio Dias, José Resende, Waltércio Caldas, Dudi Maia Rosa (b. 1946), Luiz Paulo Baravelli, Saint-Clair Cemin (b. 1949), Milton Machado (b. 1947) and Tunga (b. 1952).

The work of José Resende (b. 1945) utilizes organic (stone, leather, wood, fabrics) and industrial (rubber, iron, lead, wax) materials to demonstrate his preoccupation with their physical properties in the construction of sculptures, without being interpretative or illusionistic. His pieces, including *Sem título: 11* (*Untitled: 11*, 1991; fig. 229), reflect their own materiality and the constructive effort of the artist in creating form. In spite of this effort at rationality, however, the conflict between materials and the

229. JOSÉ RESENDE – SEM TÍTULO: II (UNTITLED: II), *1991. nylon, paraffin and lead, 300 x 150 x 500 cm. collection of the artist*

Brazil

artist's gesture allows his subjectivity to become apparent, resulting in emotional and tense work which demonstrates the uncertainty of the process itself. The sculptures of Carlos Fajardo (b. 1941), who also works with organic and industrial materials, derive from his paintings of large monochromatic surfaces. Fajardo's pieces, by contrast, display a subtle, almost feminine, sensibility. They explore the tension that results from mixing different materials (tulle and marble, wax and granite), or the action of time in modifying the works (glycerin or humid clay), or the interaction of materials with their physical surroundings, including the presence of spectators.

Although the early work of Ivens Machado (b. 1942) is identified with the dematerializing tendencies of the 1970s, his sculptures, including the 1987 *Sem título* (*Untitled*; fig. 231) arise from three-dimensional spatial relations, without attempting to impose any order. On the contrary, by utilizing iron, glass and cement mixed with coloured pigments, Machado's works are created by a pulsation that annihilates any or all spatial or Cartesian rationale, taking on the form of unexpected and erotic shapes.

The sculptures and drawings of Waltércio Caldas (b. 1946) endeavour to reveal the problems inherent in the creation and meaning of art, as does his *Sem título* (*Untitled*, 1994; fig. 230). There is insufficient coherence between the pieces to make it possible to identify this artist with any particular stylistic tendency. On the contrary, they are the result of reasoning in action, based on a metaphysics of objects, and thus acquire a closed autonomy.

The essential components of Tunga's sculptures and installations are the concepts of nature and culture, the dichotomy between life and art, a Dionysian intoxication with artistic creation, which characterize his work of 1983, *Les Bijoux de Madame de Sade* (*The Jewels of Madame de Sade*; fig. 232). Using physical elements such as electricity, magnetism and thermodynamics, Tunga establishes relations between various materials, such as copper, iron, magnets, rubber and other properties, to create pieces and situations whose physical reality provokes feelings of perplexity and estrangement. While bearing some resemblance to the 'anthropological art' of Joseph Beuys, the works of Tunga, like those of Caldas, defy all categorization.

Coming of age during the 1970s, the painter Jorge Guinle (1947–87) developed a career independent of his generation and became a guide of sorts for the emerging artists of the 1980s. His work, such as *Bella Ciao!* of 1985 (fig. 233), anticipated a 'citational' wave that exploded in Brazil at the time, without claiming any ideological affiliation with it. 'My iconography is abstract,' he says: 'It's an iconography of the history of art and not an iconography based on the German or Italian Neo-Expressionists, or even [Julian] Schnabel who, using an image, reduces its function to zero ... In my case, for emotional and aesthetic reasons, there is a mixture that ranges from gestural Abstract Expressionism, de Kooning and Matisse, to automatist Surrealism. But with each appropriation of a style, of an initial idea, the original objective of the movement is subverted by the inclusion of another movement that represents its negation ... The possibility and the pleasure of always broadening and feeding these contradictions form the praxis of my art.'[17] Deeply versed in the history of art, Guinle was, in addition to being a prolific artist, an astute art critic, having contributed to numerous publications.

New Perspectives: the Present

In 1985, with the return of a civil government and the re-establishment of democratic freedom in Brazil, the historical cycle of military rule, dictatorship and censorship of the press and of art came to an end. Having been forced during that dark period of its history to reflect, criticize and understand itself, the Brazilian cultural world now sought to expand its activities and reclaim what it had lost.[18] The São Paulo Bienal was removed from public management in the early 1980s. It is no longer organized by the participating countries themselves, but by a curatorial concept. Works are grouped according to style, theme or medium, so as to create more productive and direct confrontations, providing a sharper focus on current issues.

The 1984 exhibition *Como vai você, geração 80* (*How are You, Generation 80*) in Rio de Janeiro, gathering the work of 123 artists from all over the country, marked the rise of a new generation of Brazilian artists. Though well-informed regarding international tendencies such as Neo-Expressionism, the Italian Transvanguardia and the numerous other styles that appeared in the 1980s, this group established, for the first time, a fruitful dialogue with artists of previous generations.[19] Among those who have developed bodies of work based on the great artistic traditions of Brazil's past, retrieving and preserving their essential qualities without the nostalgia of many contemporary European artists are the following: Karin Labrecht (b. 1957), Esther Grinspun (b. 1955), Daniel Senise (b. 1955), Luiz Zerbini (b. 1959), Leda Catunda (b. 1961), José Leonilson Bezerra Dias, called Leonilson (1957–93), Angelo Venosa (b. 1954), Carlito Carvalhosa (b. 1961), Nuno Ramos (b. 1960), Eliane Prolik (b. 1960), Sergio Romagnolo (b. 1957), Paulo Monteiro

Brazil

(b. 1961), Ana Tavares (b. 1958), Beatriz Milhazes (b. 1960), Mônica Nador (b. 1955) and Adriana Varejão (b. 1964).

The beginning of the 1990s has produced a new group of artists, differing from its predecessors in being less attached to tradition. Their imagination is marked by Neo-Dadaism, sensory experimentation and the exploration of materials of the 1960s. Trying out different media and means of expression, they work within the framework of high and low culture, with electronic printing and industrial design, to explore issues raised by anthropology, sociology and psychoanalysis, as well as art. Among those who align themselves with a tradition that includes not only Western art but, within it, the works and teachings of Lygia Clark, Helio Oiticica, Antonio Dias, Nelson Leirner, Regina Silveira, Julio Plaza, Mira Schendel and others, are: Ricardo Basbaum (b. 1961), Edgard de Souza (b. 1962), Lia Mena Barreto (b. 1959), Caetano de Almeida (b. 1964), Jac Leirner (b. 1961), Arthur Lescher (b. 1962), Jorge Barrão (b. 1959), Fernanda Gomes (b. 1960), Ernesto Neto (b. 1966), Sandra Tucci (b. 1964), Alex Ceverny (b. 1963), Valeska Soares (b. 1957), Emmanuel Nassar (b. 1949), Gustavo Resende (b. 1960), Iran do Espírito Santo (b. 1963), Adriano Pedrosa (b. 1965), Rosângela Rennó (b. 1962) and Rubens Mano (b. 1960).

The last ten years have witnessed the slow and gradual appearance of Brazilian artists, above all those have emerged since the 1960s on the international art circuit. The impetus for this clearly derives from the efforts of people working in the important centres of the international art world. Motivated by the ideology of political correctness, they look to the art and culture of the 'peripheral' countries, seeking what has been termed multiculturalism, a North–South dialogue, to extend post-colonial relations and so on. Although Brazil's regional centres are primarily concerned with reproducing local reality in art without searching for external models, the phenomenon called 'Brazilian art' has always had an essentially international flavour. It is not a matter of reproducing the various 'isms' (those who have done so have already been forgotten) but of confronting the visual issues based on a repertoire common to the Western world, to which Brazil, with its unique mix of races, religions and cultures, belongs. For this reason anthropophagy is a fundamental touchstone of Brazilian culture, while also, perhaps, representing its most original contribution to Western civilization. It is not the case that all artistic movements in Brazil can be defined as an act of anthropophagy. Rather, this is a cultural strategy that serves as a reference point in our history, indicating the astuteness of Brazilian artistic production in forming a modern and contemporary visual aesthetic.

231. Ivens Machado – Sem título (Untitled), 1987. iron, cement
and pigment, 110 x 115 x 40 cm. Galeria Luisa Strina, São Paulo

230. Waltércio Caldas – Sem título (Untitled), 1994.
steel and copper, 90 x 115 x 22 cm. Raquel Arnaud collection, São Paulo

Brazil

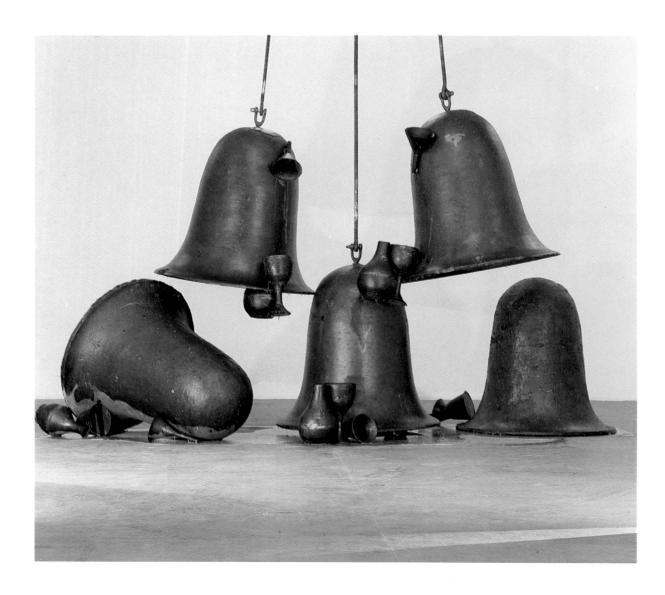

232. TUNGA – LES BIJOUX DE MADAME DE SADE (THE JEWELS OF MADAME DE SADE),
1983. *bronze (10 pieces), 30 x 10 cm. Galeria Luisa Strina, São Paulo*

233. JORGE GUINLE – BELLA CIAO!,
1985. oil on canvas, 190 x 190 cm.
private collection, São Paulo

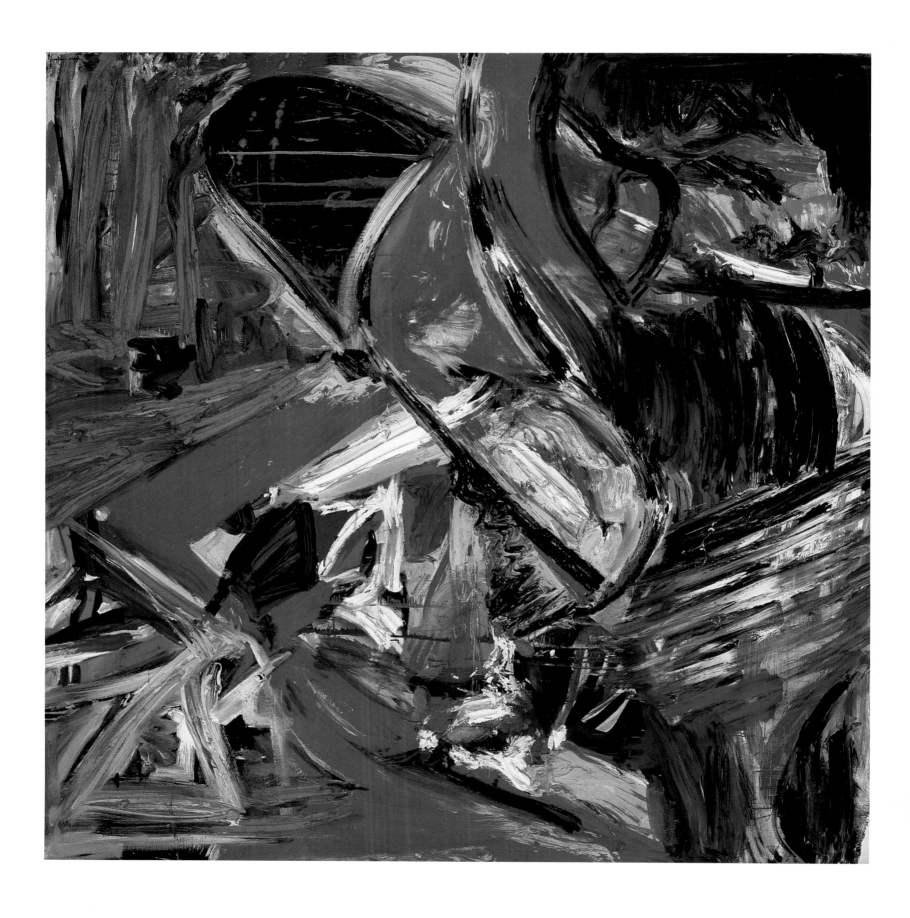

Pedro Querejazu

Bolivia
LATIN AMERICAN ART IN THE TWENTIETH CENTURY

Bolivia

Introduction

As a nation in the middle of the South American continent with a rough, mountainous terrain, little is known of Bolivia's culture abroad. This seclusion is, in many ways, welcomed by the Bolivians who are, to a great extent, of indigenous blood and by nature reclusive, adhering closely to traditions and ancestral customs.

Bolivian art has developed through time along an uneven path, stimulated both from inside and outside the country. Among the influences derived from national sources are those that survive from the complex and still little understood pre-Hispanic world. Apart from archaeological remains, these elements endure in the aesthetic expression of the distinct indigenous ethnic groups and can be seen in their textile and feather arts as well as in their philosophical and contemplative outlook on life. This manifests itself in the personality and the art of Bolivians today just as it has done throughout history. It also lives on in the country's rich folklore and musical heritage as well as in clothing and cookery.

The nineteenth century was a period of cultural alienation and adherence to French forms, whereas twentieth-century Bolivian artists have addressed issues of ethnicity in the nation's population and responded to the imposing geographic features of the country, the high mountain and valley regions as well as the tropical lowlands. Moving away from the nineteenth-century taste for official portraiture, Bolivian artists developed their own form of Indigenism as a response to the social situation of the nation. Modern art in Bolivia is, like the colonial art of the Baroque era, the result of cultural mixing and blending, yet it has developed a personality and language of its own in its fusion of the ancient and the contemporary. It would be short-sighted, however, to conceive of twentieth-century Bolivian art in these simple terms and to overlook its ethnic, cultural, social and economic aspects.

The Transitional Period and First Half of the Century

After suffering defeat and the loss of its coastal region in the 1879–80 War of the Pacific due to the expansionist interests of Chile, Bolivia (whose constitution had been drawn up by its liberator Simón Bolívar in 1826) experienced twenty years of 'conservative' governments which, despite their political ideologies, could be considered progressive. During this period the country's first railways were established, roads were improved, bridges built and the mining industry prospered through the use of modern technology.

At the same time Bolivia had a very rigidly defined social structure. The descendants of those Spaniards who arrived in the colonial period as well as the immigrants who came to Bolivia during the nineteenth century were at the top of the social pyramid. They were the principal landowners and controlled the mines. There was a modest independent liberal middle class composed of professionals and other members of the bourgeoisie who also made a living through small mining properties and other minor landholdings. The mestizos (people of mixed race, whether indigenous or European) were artisans or worked in the burgeoning industries, while the indigenous peoples represented the lowest rung on the social ladder, labouring as miners or working on the land. These people had no access to education, took no part in national decision-making and possessed none of the civil rights enjoyed by others. The upper and middle classes lived in the cities, maintaining a way of urban life that had existed since colonial times, while the Indians and other dispossessed individuals either lived in the countryside or on the poorest fringes of the towns.

In the later nineteenth century, the then-popular Positivist philosophy, which concentrated on scientific reasoning and demanded proof for all phenomena, dictated that the Indian should be incorporated into the fabric of Western 'civilization'. It was thought that by this means alone the nation could effectively develop. This era ended with the civil war of 1898, at which time power was transferred from the cities of Sucre and Potosí to La Paz where the seats of Parliament and the central government were established. After this the country was governed by so-called liberal governments. Although these were constitutional administrations, voting was limited to those who could read and write and who possessed at least a minimal land-holding. The railways were expanded at this time and a telegraph system installed. Tin mining was also initiated on a large scale.

The cities of Sucre, Potosí and especially La Paz witnessed significant cultural developments. Fine arts organizations, literary salons and cafés where art, culture and politics were discussed proliferated in the late nineteenth century. French was the preferred language and was even used in the publications of the day. In 1909 Alcides Arguedas published *Pueblo enfermo* (*Infirm Society*), and in 1919 *Raza de bronce* (*Race of Bronze*); in both these books he analysed Bolivia's social situation and postulated reasons for the social and cultural backwardness of the indigenous peoples. Franz Tamayo wrote newspaper articles relating to educational problems,

later publishing a book *Creación de la pedagogía nacional* (*Creating a National Pedagogy*) which proposed a new system of public education. Bautista Saavedra's work *El Ayllu* dealt with indigenous social structures. These and other books had a profoundly disturbing impact on the comfortable strata of Bolivian society. In 1918 the intellectuals and artists of Potosí founded a group known as Gesta Bárbara (Fierce Action), which was followed by similar societies in Oruro and La Paz. This was a time when a socialist consciousness was being developed in the country which would ultimately result in the establishment of the Bolivian Left.

After 1920, when the Republican Party (founded in 1914) won power, until the Chaco War of 1932–5 (fought with Paraguay in the sparsely populated Chaco region), Bolivia was ruled by governments which maintained the social status quo. Yet the influence of the Mexican Revolution of 1910 had an impact at this time, as did the ideas of the Peruvian Alianza Popular Revolucionaria Americana or APRA (American Popular Revolutionary Alliance) and of the Peruvian politician and writer José Carlos Mariátegui and the painter José Sabogal.

From the time of the Chaco War (which resulted in Paraguay acquiring three-quarters of the disputed Chaco border area according to a treaty of 1938) until 1952, military administrations alternated with constitutional governments in Bolivia. During the Chaco War men from all geographic regions and sectors of society found themselves thrown together to fight at the front. From this experience was born the spirit of national renewal that would prove crucial for the significant changes from the mid-1900s. In 1940 the Marxist Partido de Izquierda Revolucionario (Revolutionary Leftist

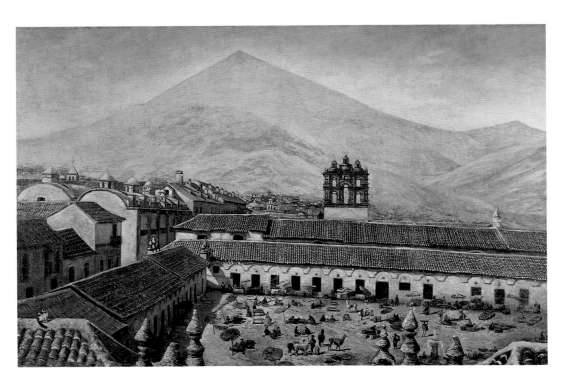

234. José García Mesa – Vista de Potosí (View of Potosí), *1898. oil on canvas, 150 x 224 cm. private collection, La Paz*

Bolivia

235. Raúl G. Prada – Eucaliptos
(Eucalyptus Trees), *c.1950. oil on canvas,
45.5 x 56.5 cm. private collection, La Paz*

236. Arturo Borda – Crítica de los ismos y triunfo del arte clásico
(Critique of 'isms' and the Triumph of Classical Art), *1948. oil on
canvas, 120 x 142 cm. Museo Municipal del Tambo Quirquincho, La Paz*

237. Cecilio Guzmán de Rojas –
Ñusta (Inca Princess), 1931.
oil on canvas, 64.5 x 54.5 cm.
private collection, La Paz

Party or PIR) was established and soon gained support among the electorate. In 1942 the Movimiento Nacionalista Revolucionaria (Nationalist Revolutionary Movement or MNR) was formed. Inspired by Nazism, this party paradoxically incorporated socialist ideological elements in its political agenda. President Toro nationalized the Standard Oil Company in Bolivia in 1937, creating the state oil organization known as YPFB.

During these difficult years Bolivia was obliged by the nations that would later constitute the Allied forces in the Second World War to sell her raw materials at ridiculously low prices. In 1935 Oscar Cerruto's novel *Aluvión de fuego* (*Rain of Fire*) was published, and the following year Augusto Céspedes's *Sangre de mestizos* (*Mestizo Blood*), a series of stories based on events of the Chaco War. Both of these books had a strong impact on Bolivian society. Unrest among the Indians at this time took the form of flight from virtual slavery as well as numerous uprisings in protest against the abuses to which they were subjected. In 1945 the Faculty of Philosophy and Letters of the University of La Paz was created and the following year the Normal Rural School of Warisata was opened to train educators to teach in Aymara (their native language) in the schools of the Altiplano region and the area around Lake Titicaca. Carlos Montenegro, who formulated the ideology of the MNR, published an important book, *Nacionalismo y coloniaje* (*Nationalism and Colonization*) in 1945, and Augusto Céspedes's *Metal del diablo* (*The Devil's Metal*) appeared in 1946. The important fine arts schools of La Paz and Sucre were also founded at this time.

The Artists of the Early Twentieth Century

José García Mesa (c.1840–1905), who represents the transition from one century to another, was born in Cochabamba. Travelling to Europe, where he lived in Rome and Paris, he participated in both official and independent Salon exhibitions. A notable academic painter who also did religious and historical compositions, García Mesa introduced the art of landscape (especially urban scenes), often relying for his realistic compositions on photographs. He painted views of cities such as *Vista de Potosí* (*View of Potosí*, 1898; fig. 234), the main square at Cochabamba and the Paseo del Prado in La Paz in 1903 (the latter works both executed in Paris with the aid of photographs).

Arturo Borda (1883–1953), one of the principal figures of Bolivian art of the first half of this century, was known for his portraits, landscapes and allegorical compositions. Among his best-known early works are portraits done in an eclectic turn-of-the-century manner, often displaying a keen attention to detail. These include portraits of his brother Héctor (1915), that of his mother watering plants (1930) and the 1943 portrait of his parents, one of the most significant of its time in the Americas. His sense of social commitment also led him to depict the lives of the indigenous peoples, as in the idiosyncratic painting entitled *Yatiri* (1918), which shows three women of different ages listening while their fortunes are read in coca leaves by a wise old man. Borda's work in this genre represented the first initiative in art to deal with such subjects and marked the beginning of a gradual recognition by the members of the élite of the values inherent in the alienated native cultures.

Borda also executed many landscapes,

Bolivia

especially of the Altiplano and the Andes, in which the Indian often appears as a central figure, integrated with nature. These included views of Mount Illimani, the snow-capped peak that overlooks La Paz, which the artist considered a symbol of the grandeur of nature. Tropical landscapes were another part of Borda's repertory. In his allegorical compositions he conveyed severe and bitter criticism of society, as in the 1918 *Filicidio*, a condemnation of the insensitivity and hypocrisy of his time. Most of Borda's allegorical pictures belong to the second phase of his development and represent themes that he had already dealt with in his autobiographical novel, *El loco* (*The Madman*), published posthumously in 1966.

In *Crítica de los ismos y el triunfo del arte clásico* (*Critique of 'isms' and the Triumph of Classical Art*, 1948; fig. 236), Borda illustrates his aesthetic ideals through the depiction of specific places and people: Mount Illimani, the Parthenon, the Venus de Milo, Homer and Pericles. In addition, Borda presents the viewer with a criticism of those 'isms' which he abhors in art. Among them is Indigenism which, in this painting, is mocked by the forces of nature, represented by the head of a woman. Although he had painted Indigenist scenes like his 1918 *Yatiri*, in *Crítica de los ismos* he rejected Indigenism as a vapid and lifeless movement which actually betrayed the Indians and undermined their cultural, social and economic revitalization. Between 1950 and 1953 Borda began his experimentation with colour abstraction in preparation for classes that he wished to teach (although he never had the opportunity). These works may be seen as forerunners of Op art.

Cecilio Guzmán de Rojas (1899–1950) was a charismatic personality and a highly talented artist who brought the depiction of

indigenous types and situations to its highest level. After early study in Bolivia he went to Spain, returning to South America in 1930 after ten years in Europe. In Spain he met and stayed in close contact with Julio Romero de Torres, the painter from Córdoba best known for his Symbolist images of gypsies and evocations of the religious fervour of Andalusia. Torres introduced Guzmán de Rojas to his idiosyncratic vein of genre painting, which the Bolivian artist absorbed, transforming it into his own brand of Indigenism. In many of the paintings done in Spain during the 1920s, Guzmán created an unusual combination of Art Nouveau and Art Deco, as well as a type of Indigenist imagery that drew upon Symbolist sources. Upon returning home he painted numerous society portraits, urban landscapes of Potosí and views of the steep hills around La Paz peopled by Indians with exaggerated features.

In the years following the Chaco War the essentially decorative style of Guzmán was transformed into an aggressive Expressionism, as seen in a 1934 series depicting the suffering of the Indians of the high Andes in the dry landscape of the Chaco. After the war he returned to more conventional landscapes and portraits of society women with stylized Indian features, as in the 1931 *Ñusta* (*Inca Princess*; fig. 237). Also dating from this time is the *Cristo Aymara* (*Aymara Christ*). Based upon a series of self portraits, this painting is one of the most significant examples of Bolivian Indigenism. It is reminiscent of colonial Baroque art in its colour, composition and the artist's enthusiastic use of gold brocade.

During the 1940s Guzmán was inspired by the Inca archaeological site of Machu Picchu to produce a series of paintings done in a manner

resembling Synthetic Cubism. In these he tempered his former technique of painting with thick textures and warm colours. In a similar manner he also painted landscapes with the theme of Lake Titicaca. His final years were taken up with research into both technical and aesthetic matters. A passionate but contradictory artistic personality, Guzmán chose Indigenism as his main form of expression, and this he also championed in his posts as director general of Fine Arts and professor in the Academy of Fine Arts. This mode of artistic vision soon became the favourite of the wealthy classes who had no contact with the ethnic, cultural, social or economic problems of the Indian. Guzmán was also interested in the Spanish past of his country, and effected a revival of interest in colonial art in addition to supporting the rise of a neo-colonial style.

Among the numerous Bolivian artists who embraced Indigenism were Jorge de la Reza (1901–58), who treated it in a more sober and solid way, Genaro Ibañez (1903–83) and Mario Illanes (c. 1900–60) who painted popular renderings of Indians and stylized high-society portraits.

In the 1920s and 1930s a number of foreign artists came to Bolivia. Many of them were responsible for promoting Indigenism, especially through their work as teachers in the schools of art. Chief among them was the Lithuanian artist Juan Rimsa (1898–1975), who arrived in 1937, bringing with him the German Expressionist manner of painting. His work caused a great stir among many artists, especially the younger painters in Sucre, Potosí and La Paz. Rimsa was impressed by what he saw as the symbiotic relationship between man, nature, the Indian and the landscape. He was immensely

prolific, especially in the area of landscape in which he produced numerous highly charged pictures painted with a dramatic, heavily laden brush. Other foreigners who had an impact on the Bolivian art world at this time were the Ecuadorian Luis Enrique Toro Moreno (1897–1955) and the Austrian Victor Tchvatal (1900–c. 1953), who became well known for his landscapes and watercolours.

Landscape was an important element in Bolivian painting during the first half of the century. Cityscapes were also popular, particularly those of Potosí and Sucre, colonial citics always considered to be imbued with a special aura. Artists from the Cochabamba Valley, such as Mario Unzueta (1905–84), a Post-Impressionist, also became significant landscapists. The most important master in this genre was Raúl G. Prada (1900–89) who worked there in the 1940s and 1950s, specializing in scenes of the countryside such as the *Eucaliptos* (*Eucalyptus Trees*, c.1950; fig. 235). From the city of Santa Cruz de la Sierra emerged the singular talent of Armando Jordán (1893–1982), a self-taught artist who, in his small-format pictures, evoked the landscape as well as the customs of the inhabitants of the region surrounding his native city.

This period of artistic activity came to an end with the death of Guzmán in 1950 as well as that of Borda in 1953, and the departure to Mexico in 1950 of Rimsa (who died in San Francisco in 1975).

Economic and Political Changes at Mid-Century

On 9 April 1952 the MNR took control of the government during the so-called National Revolution in Bolivia. This event, which consid-erably changed the course of politics in the nation, had several major effects. The mines, formerly controlled by the industrialists Patiño, Aramayo and Hochschild, were nationalized. An agrarian reform was implemented by which property was given to the Indians. The vote was given to all Bolivians. The state assumed control of health services and education and regulated virtually all important areas of the economy, also making significant advances in the sphere of communications to unite such far-flung territories as the Departments of Beni and Santa Cruz de la Sierra with the rest of the nation. A strong sense of nationalism developed, as did a movement towards the recovery of ethnic identity on the part of indigenous peoples. This was counterbalanced, however, by governmental efforts to coerce the Indian population into farm work, ultimately robbing them of their regained identity.

The 'National Project' of the MNR was clouded by the persecution of political opponents. Corruption and factionalism also disrupted the efforts of MNR, which came to an abrupt end with the *coup d'état* of 1964. From that moment until 1982, Bolivia was ruled by a series of military governments which dragged the country into an economic morass, creating a large national debt and curbing civil rights.

The 1950s represented an even more open and progressive period in Bolivian cultural life than the previous decade. The central government supported art, as did regional and municipal authorities. The Premio Nacional de las Artes was established and annual Salons were initiated. All of this activity led to a group of younger artists uniting in the so-called 'Generation of '52'. Indigenism as an artistic style died out at the same time as its members began to adopt new political options and ideologies, especially those associated with the radical Left. Artists became polarized in two distinct camps: the *sociales* (socially committed artists), influenced by revolutionary politics, as opposed to the *abstractos* (abstractionists), who favoured an international orientation towards non-objective art.

After the triumph of the MNR and their Revolución Nacional, a significant Muralist Movement arose to bring art to the people through paintings on the walls of public buildings, universities and schools. Many public monuments were also erected for the same purpose. Themes related to the class struggle were treated in works of art in which indigenous mine-workers appeared as protagonists. Colonial history was vilified and the positivist view that lessons should be learned from past experience formed the core of national philosophy at this time. The pre-Hispanic past was, inappropriately, venerated as a period when the nation experienced something of an egalitarian Marxist Eden.

In 1950 the Anteo (Antaeus) Group was formed in Sucre under the influence of Guillermo Francovich (1901–88), Rector of the University of Chuquisaca. Supported by the city's Academia de Bellas Artes, Anteo promoted a positive atmosphere for the visual arts. Two important painters emerged at this point: Walter Solón Romero and Gil Imaná. Solón Romero (b. 1925) began his career in 1950 with an ambitious mural in the office of the university's Rector with the theme of the uprising of 25 May 1809, which marked the beginnings of independent revolutionary activity against Spain. He later painted other murals such as *El Quijote y la educación* (*Don Quijote and Education*; Escuela Normal, Sucre) and, in 1957, *Mensaje a la juventud* (*Message to Youth*; Colegio Junín, Sucre). When mural painting was forbidden during the

Bolivia

238. MARÍA LUISA PACHECO – COLINAS (HILLS), 1978.
oil on canvas, 122 x 148 cm. private collection, La Paz

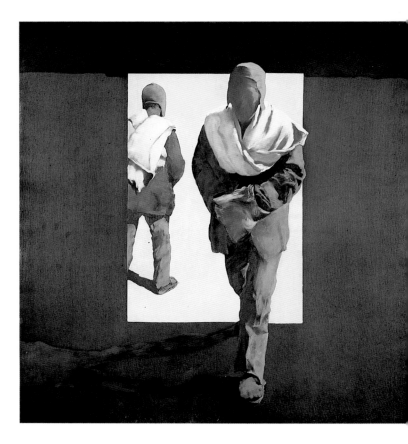

239. ENRIQUE ARNAL – LABERINTO (LABYRINTH), 1975. *oil on canvas, 129 x 122 cm. INBO (Inversiones Bolivianas), La Paz*

240. MARINA NÚÑEZ DEL PRADO – MUJERES ANDINAS AL VIENTO (ANDEAN WOMEN AT THE WIND), *1970. granite, height (left to right) 73.5, 74, 77cm. Museo Casa Núñez del Prado, La Paz*

241. GIL IMANÁ – SU SOLEDAD HORADA, GOTA A GOTA, LA
PIEDRA (HIS SOLITUDE PIERCES THE STONE, DROP BY
DROP,), 1974. *oil on canvas, 81 x 60 cm. Museo Municipal
del Tambo Quirquincho, La Paz*

Bolivia

military dictatorship, Solón turned to tapestry (utilizing the methods of indigenous weavers) to express his (sometimes stereotypical) national allegories.

Gil Imaná (b. 1933) is the most important of the socially committed artists. His work deals with issues of injustice among the disenfranchised classes while avoiding the extremes of exaggeration of other artists of a similar outlook. He painted numerous murals, such as that in the headquarters of the Sucre Telephone Company (1955) and in the medical college in La Paz (1980). In these works, which exude an atmosphere of the Andes, the artist employs landscape as a means of expressing both the solitude of the individual and the solidarity of mankind. He often uses the female figure as his principal symbolic image, basing his inspiration on peasant women and mine-workers as well as on the open-mouthed mummy-figures found in pre-Hispanic graves. For Imaná, the woman represents life and the continuity of cultural tradition and embodies the duality and singularity of Pachamama, the Indian earth-mother deity. Imaná's art refigures and reinterprets certain primordial Andean signs and symbols such as the cruciform pattern derived from the Tihuanaco culture, as seen in his 1974 canvas *Su soledad horada, gota a gota, la piedra* (*His Solitude Pierces the Stone, Drop by Drop*; fig. 241).

In 1956 the first Salón de Arte Abstracto was held, signalling the pre-eminence that abstraction would enjoy in the artistic panorama of the country. None the less, virtually all Bolivian abstract artists felt the weight of landscape, making reference to it in most of their works with varying degrees of subjectivity. María Luisa Pacheco (1918–82) created a kind of luminous poetry in her art. Studying at the Escuela

de Bellas Artes in La Paz in the 1940s, Pacheco absorbed Indigenism, a mode she had rejected by the end of her career. In 1951 she travelled to Madrid to study at the Academia de San Fernando under Daniel Vázquez Díaz. This proved to be a fundamentally important period for the artist, who also came into contact with Antoni Tàpies and other members of the Spanish avant-garde. Pacheco slowly made her way towards Informalist Abstraction, finally showing works in this style at the 1959 São Paulo Bienal.

Soon afterwards Pacheco took up residence in New York. During the 1960s she painted in a style related to gestural abstraction, later developing in a manner which allowed certain references to mountain landscape to emerge. This subject-matter becomes most clear in the titles of her paintings, such as the 1978 *Colinas* (*Hills*; fig. 238). Pacheco's work is self-affirmingly expressive and even aggressive. The paintings done in the last decade of her life were especially dynamic, playing with the concepts of absence and presence and usually centred around a stabilizing form such as a cross or a central void. In terms of colour her works have progressively moved towards an overall whiteness.

Government support of the arts dried up after the defeat of the MNR by a military coup in 1964. Many socially minded artists had to flee the country or face persecution by the military regime. Some of the abstract artists also left Bolivia. Following the example of María Luisa Pacheco, they looked for international outlets for their art, particularly in New York.

Beginning in 1958–60, a new trend arose in Bolivian art which has been referred to as a national tendency. It grew among those artists who were neither particularly politically oriented in their philosophy nor committed to abstraction

in their painting. Although a stylistic and ideological plurality characterized this trend there was a preference for depicting subjects derived from contemporary Bolivian reality including urban dwellers, peasants, Indians (their culture and beliefs) and landscape. This movement went almost unrecognized at the time of its beginnings but ultimately became the principal artistic tendency in Bolivia during the 1970s and 1980s. Among its most important exponents are Enrique Arnal, Fernando Montes (b. 1930), Ricardo Pérez Alcalá (b. 1939), Raúl Lara, Alfredo Loaiza (b. 1927), Inés Córdoba and Gustavo Medeiros (b. 1939).

Enrique Arnal (b. 1932), the most important member the Generation of '52 group, was initially inspired by Cubism but slowly turned his attentions towards the Andean world which he depicted in all its varied aspects. After 1960 he began to paint urban workers, as in the 1975 painting *Laberinto* (*Labyrinth*; fig. 239) which shows hauliers in the La Paz markets. Later Arnal did a series dealing with condors, Andean birds of prey traditionally the subjects of mountain myth and legend. His work in the 1980s consisted of a number of paintings of the female nude (sometimes posed before a mirror in a manner reminiscent of Velázquez). In his paintings done after 1985 the women were transformed into large, even ominous, mountain-like forms. Arnal comes close to total abstraction in his most recent series, begun in 1990, exploring the theme of the interiors of mountains, depicting the cavernous tunnels and shafts of the mineral-rich Bolivian peaks in order to suggest many of the dark, emotional states of mankind. His works are done with somewhat meagre materials and his images are defined with a dramatic brush-stroke.

Philosophical polemics developed
with the advent of the Generation of '52 and,
consequently, art criticism arose as a discipline
in Bolivia. A number of publications were initi-
ated at this time and many symposia, seminars
and congresses were organized to fulfil the need
for critical discussion of artistic issues. Among
the most outstanding figures to participate in
these debates were Rigoberto Villarroel Claure
(1900–74), Roberto Prudencio (1908–75) and
Guillermo Francovich (1901–88).

Sculpture

While there are many Bolivian painters,
there are relatively few sculptors. From the end
of the Baroque period through the years that
witnessed the founding of the Escuela de Bellas
Artes, sculpture was a virtually undeveloped field.
Among those who began the three-dimensional
tradition in the city of La Paz were Alejandro
Guardia (1898–1977), Emiliano Luján
(1919–*c*.1975) and Marina Núñez del Prado,
followed in the 1960s by Ted Carrasco and his
wife, the Swiss sculptor Francine Secretan
(b. 1948), and, in the 1970s, by Marcelo Callaú
(b. 1946). Núñez del Prado and Carrasco created
monumental, totemic works, while more conven-
tional large-scale pieces were done by Luján,
including excellent interpretations of the theme
of the condor. All of these artists were sensitive
to both the mountainous and jungle regions
of Bolivia, and their sculpture reflected many
aspects of life in the nation, sometimes in a way
more satisfactory even than painting.

Marina Núñez del Prado (1910–95)
forms a link between those artists active during
the first part of the century and the members of
the Generation of '52. In virtually all of her work
she has reflected certain elements inextricably
linked with Bolivia. Her earliest training took
place at the Escuela de Bellas Artes, where
Indigenism was the principal mode of expres-
sion. The effects of this can be seen in her sculp-
ture *Pachamama* of 1935. Soon afterwards,
however, she effected a synthesis and a styliza-
tion of the elements inherent in Indigenism in
pieces such as *El peso de la vida* (*The Weight of
Life*) of 1952 as well as in her series of Madonnas
and the *Mujeres andinas al viento* (*Andean Women
at the Wind*; fig. 240), done between 1960
and 1970. Núñez's work continued to evolve
(although never to the point of total abstraction)
in her Venus sculptures of 1958–60, her land-
scapes and condor figures and, finally, her
Andean Women in Flight series, *c*.1985. In the
course of her long career Núñez del Prado has
always concerned herself with innately Bolivian
and Andean themes, redefining in her art
certain essential cultural symbols. Among these
are the image of the female, including the
indigenous woman walking in the solitary high-
lands of the Altiplano (as in *Andean Women at the
Wind*) or the sensuality and erotic potential of
women in her *Venus* series. In a similar vein
Núñez del Prado has developed an iconography
of other forms associated with the landscape
such as mountains, the moon, the condor,
llama and bull.

Ted Carrasco (b. 1933) has produced a
body of work based upon his understanding of
traditional Andean subjects and their relation-
ship with nature. The power of the mountainous
landscape as a symbol of life itself is suggested in
many of his sculptures. A mythic Andean world
pervades his art and he seems to comprehend
intuitively the meanings of the images created by
the ancient American civilizations. As in the art
of the pre-Hispanic peoples, Carrasco captures

Bolivia

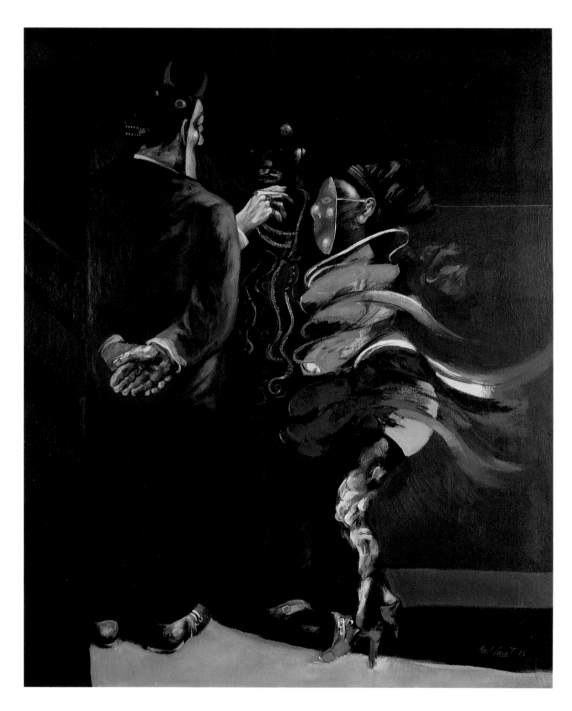

243. RAÚL LARA – DOMINGO DE TENTACIÓN (TEMPTATION SUNDAY),
1975. acrylic on canvas, 130 x 100 cm. private collection, La Paz

a profoundly emotive quality in his sculptures
which deal, above all, with the ritual relationship
between man and nature in the Andean regions.
In his earliest pieces he depicted the timeless
forms of Indian women who patiently spend
their days seated on the ground in markets or at
fairs. Another theme which he has introduced is
that of the *munachi*, an implement depicting the
image of a man and woman joined together in the
act of creation, used in ritual offerings to guaran-
tee life and fertility.

After a long period spent in Europe
during the 1970s Carrasco returned to Bolivia
and began incorporating themes such as the
condor, the winged man transformed into a
Prometheus-type figure, women protecting
themselves from the Andean wind, the *yatiri* –
celebrant of magical rituals dedicated to
Pachamama – and Pachamama herself, as in
the 1988 *Andes* (fig. 242) which shows the earth
goddess as a reclining woman-mountain with
an altar in her belly, her genitals serving as a
doorway to the secrets of life. She is conceived as
fecund, generous, abused and sensuous woman,
embodying all of nature itself.

Ancestralism

Ancestralism is a recurrent thematic
preoccupation in Bolivian culture and it is partic-
ularly prevalent in work done in the 1960s and
1970s by numerous artists of diverse stylistic
tendencies. It represents an awareness of the
powerful formal and conceptual aspects of ances-
tral Andean culture. Some of the works of María
Luisa Pacheco, such as *Petreo* (*Stony*) of 1968
or *Arkana* of 1977, fall into this category, as do
notable works by painters such as Oscar Pantoja
(b. 1925), Gustavo Medeiros and Inés Córdoba.
Ancestralism also manifested itself in the use by

many artists of themes derived from colonial art, such as that of Santiago Matamoros (St James the Moor Killer), Santiago Mataindios (St James the Indian Killer), images of the Virgin Mary, archangels with guns, and so on. Motifs related to the symbolism in indigenous textiles appear as an element in ancestralism as well.

Gonzalo Ribero (b. 1942) is an important leader of the ancestralism movement who conceptualizes and stylizes themes suggested by archaeological sites in the valley of Cochabamba. He has created a quasi-abstract series related to the theme of the *batán*, or traditional indigenous grinding-stone, which he transforms into a consecrated element placed upon a ritual altar.

Inés Córdoba (b. 1927) works in collage done with coarse wool or other types of discarded textiles to create images often suggesting space or earthscapes with no hint of sky. Her montages of cloth, tin and other metals suggest the bird's-eye views seen by those dwellers of the high mountain regions of Bolivia; they also reveal her profound understanding of the indigenous Andean world. The work of Gustavo Medeiros (b. 1939), an architect and sculptor, expresses a concern with rural and urban space. His art is often based on the concepts of space inherent in Indian textiles and he has borrowed from the symbolism of the *munachi* figures which the indigenous peoples have traditionally used to guarantee their future as well as to ensure their ownership of housing, cattle and cultivated land.

Throughout the twentieth century, but especially in the 1970s and 1980s, there has been a tendency among some Bolivian artists to create genre art. The audiences for this work are often among the middle classes in cities like La Paz, Cochabamba and Santa Cruz, who desire some means of identifying with traditions and popular customs that are not those of their own social rank. This tendency is even seen in architecture, where a neo-neo-colonial style has become popular. Among the artists identified with genre art are Herminio Pedraza (b. 1935), Ricardo Pérez Alcalá and Alfredo Loaiza.

The work of the painter Raúl Lara (b. 1940) embodies many of the elements usually identified with the Latin American literary phenomenon known as Magic Realism. Lara spent a number of years in Argentina where he became a part of the Espartaco artists' group. On returning home he immersed himself in popular Bolivian traditions and folklore, demonstrating this interest in his art by painting many images derived from colonial art, including scenes of Baroque saints tempted by sensual demons, imposing archangels and courtesans surrounded by a blue haze. Even more characteristic are his intriguing figures of Indian men magically transformed into mythic beings, as in *Domingo de tentación* (*Temptation Sunday*; fig. 243).

More Recent Art

During the eighteen years of military dictatorship (1964–82) Bolivia, like many Latin American nations in a similar situation, experienced numerous social and economic changes. State bureaucracy grew to outsized and unmanageable proportions and the economy went into a sharp decline. Cities grew too fast while the population of rural areas decreased. The Oruro and Potosí mines were less productive than the oil, agriculture and cattle-producing regions of the western part of the country, especially those around the city of Santa Cruz which became, along with La Paz, the new economic centre of the nation.

Bolivia, essentially an agrarian and mining country, was now becoming a more diversified economy. In 1982 the nation returned to a constitutional democracy and, more recently, has assumed a 'neo-liberal' economy. There has also been a push to establish a decentralized system of government in which the various regions would assume a greater degree of efficient self-control.

As interest shifted from a concern with ancient myths to a focus on contemporary urban life and its problems, the subject-matter of art also underwent an evolutionary process. Despite the increasing price of oil there was only a minor increase in the prices of works of art . With the exception of Muralism, all aspects of the visual arts flourished. The artists of the Generation of '52 gained international recognition as they continued to develop a national iconography in their work, gradually eliminating what had formerly been the marked differences between the politically committed Bolivian artists and those devoted to abstraction. A transformed type of ancestralism also seemed to take hold as a particularly strong manifestation of a national spirit in art. At the same time, however, the Salones Nacionales (national exhibitions) began to diminish in importance, while there was a steady increase in the number of commercial galleries.

The new generation consisted of young artists born during the regime of the Revolución Nacional. In their search for new ways of making art the INBO biennial exhibitions (organized by the private investment firm Inversiones Bolivianas), held in 1975, 1977 and 1980, served as an important springboard. Their careers grew as those of the older social-realist and abstract painters and sculptors were beginning to wane, and they were able to perceive their subjects in a

Bolivia

clearer light. They also employed a variety of new media, liberating their art from the traditional techniques. Art made from found materials (similar in spirit to Italian Arte Povera), ephemeral art and conceptual art, happenings, performance and installation art all began to develop in Bolivia. Drawing took on renewed importance as a means of expression, and photography came to be considered as an art form in itself.

Indigenous people featured less and less as the subjects of works of art. Artists concentrated instead on developing a wider repertory of themes including urban labour, Indians in city settings, political subjects, students, prostitutes, the burgeoning drugs trade and many other aspects of contemporary life. Depictions of many of these subjects served as a form of social protest, of course. At the same time, the interest in ancestralism was as strong as ever. In the art of many of the younger painters, traditional mythology was given new life. Many aspects of religious belief were also appropriated as subject-matter for artists. This paralleled the renewed national consciousness in Bolivia which generated a greater interest in, and understanding of, popular customs and acceptance of a wide variety of forms of expression.

Roberto Valcárcel (b. 1951) opened a new chapter in Bolivian art. He employed his hyper-realist technique (with an emphasis on precise drawing) to create images of social criticism including scenes of torture victims and other such subjects. He has vigorously denounced the recent military dictatorships in works which are sometimes close to the German schools of Darmstadt and Düsseldorf, as in the 1981 *Campo de alcachofas* (*Artichoke Field*). Intense colour highlights his sharp parodies of middle-class

complacency. Valcárcel is also an architect and his training in this area is reflected in his art. He is concerned with the symbiotic relationships between the individual and his surroundings. Spaces themselves seem to take on a life of their own in many of Valcárcel's paintings, as in his recent series known as the *Casas-rostros* (*Houses-Faces*). At times all of these characteristics come into play in Valcárcel's work, as in *Bolívar* (1994; fig. 244).

Other artists of this new generation include Gastón Ugalde (b. 1946), a sensitive and spontaneous practitioner of Neo-Indigenism. His art employs non-traditional media such as clay, wood, organic materials and other Arte Povera-related elements. In his recent series of sculptures and montages called *Coca* of 1992 (similar in subject-matter to the work of Arturo Borda) Ugalde alludes to the ancient pre-Hispanic site of Tihuanaco and to the Uru-Chipayas Indians. Marcelo Callaú is a sculptor who deals with metamorphosis. Humans dissolve into vegetal forms; wood is transformed into the shapes of men and women. He has also produced *trompe l'oeil* geometric sculptures. Recently Callaú has dealt with the subject of the coca leaf as a national symbol as well as that of the potato. Edgar Arandia (b. 1951) was one of the principal artists to protest against the abuses of power during the military regimes in works such as *Crónica de un tiempo oscuro* (*Chronicle of Darkness*) or *Piedra libre* (*Free Stone*). His more recent work reflects a picaresque view of society. The dream-like settings of these pictures suggest the Magic Realist Tradition. Other younger artists of this new scene include Sol Mateo (b. 1959), Guiomar Mesa (b. 1961) and Marcelo Suaznábar (b. 1970).

Bolivian art of the twentieth century is the product of a complex search for identity. The

end result, however, is the affirmation of a multitude of national characteristics. Contemporary art in Bolivia, concentrating on the individual and his confrontation with the present, is a testimony to this traditional encounter with, and acceptance of, the national character, achieved in part through an understanding of the mythological substructures of the country.

244. Roberto Valcárcel – Bolívar, 1994. *mixed media on wood, 66.5 x 163.5 cm. private collection, La Paz*

Latin American Art in the Twentieth Century

Paraguay

Ticio Escobar

Paraguay

Following the War of the Triple Alliance (1865–70) which pitted the forces of Paraguay against those of Brazil, Argentina and Uruguay, the nation was virtually destroyed. The reconstruction of the country affected all aspects of society, including culture. The history of modern art in Paraguay dates to fairly recent times and corresponds to four approximate periods.

The Beginnings

The renaissance of art in Paraguay was played out against a background of national devastation. At the end of the last century Paraguay was very much in the orbit of the Río de la Plata region, especially influenced by Buenos Aires, a fact which tended to delay recovery and exacerbate economic backwardness. This period, corresponding with an era of liberal government lasting from the end of the nineteenth century until the 1930s, was strongly influenced by Argentinian aesthetic modes, including the predominance of an Italian-inspired naturalism and the introduction of French Impressionism.

Although historians often stress the importance of British economic power in Argentina in the early twentieth century, Paraguayan culture was very much dominated by that of Italy. The most important art educators were Italian and they encouraged their students to study there. Héctor Da Ponte (1870–1956), who arrived in the late 1800s, was responsible for the artistic development of several generations of painters. His own art typifies the concerns of the day in its anecdotal approach to landscape, portraiture and historical scenes. Inspired by this master, a group of younger artists left Paraguay for Italy in 1906 where their Beaux-Arts academic training (combined with certain elements of

romanticism and naturalism) differed little from that which they had received in their native country. On their return they were unable to offer much in the way of novelty to Paraguayan art but merely reinforced the traditional forms that were securely in place.

In 1910 some of the first Paraguayan artists to study in Europe participated in the large-scale Exposición Internacional de Arte held in Buenos Aires to mark the centenary of Argentina's independence from Spain. The exhibition itself confirmed the overwhelming influence that French artistic styles had on taste in the area. Impressionism and Post-Impressionism became the fundamental artistic modes in the Río de la Plata region during the following decade. These styles had an equally strong impact on Paraguayan painting.

The most representative case is that of Juan A. Samudio (1880–1935), who showed in the Exposición and subsequently transformed his art by painting more energized compositions with a looser brush. Although this change of direction owed much to the impact of Impressionism, Samudio cannot be regarded as having a true Impressionist vocabulary at this point since his rapid application of paint and the division of his palette into basic colours was still essentially naturalistic. None the less these advances represented a major step beyond the rigid academic approach that had dominated Paraguayan art for so long.

Another artist who rejected pre-established traditions was Andrés Campos Cervera (1888–1937). Unlike most artists of his day who went to Italy, Campos Cervera studied in Madrid and Paris and an exhibition of his work in Paraguay in 1920 demonstrated his strong affinities with Impressionism and Post-

Impressionism. While the show had a great impact in the art world of Asunción it seems to have had little effect on his fellow painters.

The Foundations of Modernity

The Chaco War with Bolivia, which began in 1932 and ended with a cease-fire in 1935, gained for Paraguay much of the disputed Chaco region on the western border. Soon afterwards, thirty-two years of liberal rule came to an end when a group of army officers overthrew President Eusebio Ayala and installed Colonel Rafael Franco as head of the government. The period from the end of the Chaco War until the beginning of the dictatorship of Alfredo Stroessner, who came to power in 1954 (and whose leadership lasted until 1989), was one of backwardness in cultural terms; in terms of the country's art, it was an era of transition which saw the end of naturalism and the beginnings of modernism.

Modernism demanded an emphasis on the aesthetic rather than the descriptive qualities of art. Jaime Bestard (1892–1965) and Wolf Bandurek (1906–c.1970) were two painters whose work embodied these requirements. Bestard concentrated on form while Bandurek focused on expressive content in his art. As their careers developed, the popularity of Post-Impressionist styles in Paraguay waned and the stage was set for the evolution of a more avantgarde vision.

Jaime Bestard studied in Paris and his first-hand experience of Post-Impressionism is plain to see in *Paisaje* (*Landscape*; fig. 245). Yet his enthusiasm for the solid forms of Cézanne and the colour experiments of the Fauvists was, above all, influenced by the popularity of these artists in Buenos Aires. After his return to

245. Jaime Bestard – Paisaje (Landscape), *c. 1940.*
oil on canvas, 39 x 47 cm. private collection

246. WOLF BANDUREK – PAISAJE (LANDSCAPE), *c. 1945.*
oil on canvas, 51 x 59 cm. private collection, Paraguay

247. OLGA BLINDER – PAREJA TRISTE (SAD COUPLE), *1957.*
oil on canvas, 80 x 100 cm. private collection

Paraguay

Paraguay in 1935 he paid strict attention to formal values in his paintings: their firmly modelled figures are set within tightly constructed compositions in which light plays an important structural role. None the less, Bestard's art still evokes a certain air of literary descriptiveness.

Wolf Bandurek came to Paraguay in the mid-1930s to escape Nazi persecution. The intensity of his compositions was undoubtedly enhanced by his experiences during the build-up to the Second World War. Misery, fear and pain were elements that, until this time, had been absent from Paraguayan painting. Now, in the art of Bandurek, they exploded upon the scene with a particularly expressive vigour, as seen in his *Paisaje* (*Landscape*; fig. 246).

The other artists active in the 1930s responded to the tensions inherent in the work of both Bandurek and Bestard. The art of Ofelia Echagüe Vera (b. 1904), characterized by its structured approach to disturbing subjects, represents something of a synthesis of the schematic formalism of Bestard and the dramatic content of Bandurek. The career of the other significant Paraguayan artist of this period, Andrés Guevara, developed principally in Brazil and Argentina and must be considered in relation to the traditions of those countries.

The Revolution of 1947 was waged between the 'Febreristas', or followers of the ex-military dictator General Franco, and the Liberals. The revolt was put down by the military leader Juan Natalicio Morínigo who ruled Paraguay from 1940 to 1948. The Revolution coincided with a climate of marginalization and persecution of intellectuals and artists as well as a dependence upon artistic models from abroad. Such an atmosphere produced a counter-cultural reaction in Paraguay from which a creative resis-

tance movement emerged. Morínigo lost the 1948 presidential election to Juan Natalicio González, who stayed in power for only one year. In 1949 the leader of the Colorado party, Dr Federico Chávez, became provisional president, winning the election of 1953. He was in office for less than a year before the 1954 coup which brought General Alfredo Stroessner to power for 35 years.

The new art which was produced at this time, running against the grain of officially sanctioned culture, was achieved in an ambience of adversity, fear and hope. This period witnessed a consolidation of Paraguayan modernism in three stages.

The First Avant-Gardes

The new artistic climate in Paraguay was heralded by the 1952 exhibition of the work of Olga Blinder (b. 1921), whose art is characterized by her use of geometric forms and arbitrary colours, as seen in the 1957 painting *Pareja triste* (*Sad Couple*; fig. 247). The catalogue of the show, written by Josefina Plá and calling for an updating of Paraguayan art, was effectively a manifesto of the new artistic outlook that was developing in the nation. In 1954 Blinder and Plá, together with Lilí del Mónico (b. 1910) and José Laterza Parodi (1915–81), were the founders of the group known as Arte Nuevo. Its tenets had already been defined in Plá's 1952 manifesto calling for the resolution of two basic issues in order to create a new national art. Firstly it was necessary to resolve the opposition between the autonomy of form and the expression of meaning peculiar to the period. The second unresolved issue concerned the conflict between the universality demanded by modern art and the inherent topicality of the work.

Paraguay

248. CARLOS COLOMBINO – PASIÓN Y SIMULACRO (PASSION AND SIMULACRUM), 1993. polychromed wood, 2.5 x 2.5 m. Museo Paraguayo de Arte Contemporáneo, Asunción

There were two basic stylistic options open to those Paraguayan painters who wished to make their work 'modern': Cubism (seen as the solution to the problem of formal structuring), and Expressionism (through which the content of the image could convey the specific realities to which it corresponded). The end result was an art that was schematic but forceful. The figuration that emerged in Paraguayan art at this time affirmed the internal organization of the image itself while also reflecting the turbulence of the period.

Towards a Greater Modernity

While Paraguayan art of the 1950s struggled with problems arising from the tension between form and content, the main concern in the 1960s was the difficulty of unifying the 'universal' and the 'particular'. Several artists whose careers had begun in the fifties sought, in the sixties, to deal with the most momentous historical and social issues of their times. In his wood sculpture, Carlos Colombino (b. 1937) created ferocious caricatures symbolizing his strong support of human rights in the face of the excesses of the dictatorship, as in the polychromed wood piece called *Pasión y simulacro* (*Passion and Simulacrum*; fig. 248). Olga Blinder's work also acquired powerful social connotations in the 1960s, yet the dramatic elements in her art were more subjective and existential. The striking woodcuts of Edith Jiménez (b. 1921) became the most outstanding examples of Paraguayan graphic art of her time, as in the 1961 *Los ojos de la madera* (*The Eyes of the Wood*; fig. 249). Their imagery made ingenious use of organic and earthy references to convey the artist's message. Herman Guggiari (b. 1924), obsessed with the themes of liberty and destruc-

tion, expressed his anxieties in the medium of metal sculptures which suggest a sense of torment through tension and fractures.

This new generation of artists was also anxious to bring Paraguayan art into the orbit of the latest avant-garde tendencies developing throughout Latin America. Although the influence of Buenos Aires was particularly strong, the impact of Brazilian culture was also being increasingly felt.

The artists' group known as Los Novísimos, founded in 1964, comprised José Pratt (b. 1943), William Riquelme (b. 1944), Angel Yegros (b. 1943) and Enrique Careaga (b. 1944), while other artists such as Fernando Grillón (b. 1931), Alberto Miltos (b. 1941) and Hugo González shared its aspirations. In Careaga's 1992 work *Construce, espacio – temporalis E.C.L.O.S. 1992* (from the series *Los caminos, The Roads*; fig. 250) we can see an example of the styles developed by the Novísimos. This group took a stand against many of the preoccupations of the time, questioning, for example, cultural isolation and championing a cosmopolitan attitude that would open up the nation's art to the latest international avant-garde. None the less, the stylistic methods employed by the Novísimos differed little from those who were working outside the group. It was the combative, nonconformist attitudes of the Novísimos that distinguished them from their peers.

Bernardo Krasniansky (b. 1951) and Ricardo Migliorisi (b. 1948) developed a repertoire of images based on montage (utilizing found objects) as well as film, as seen in Migliorisi's untitled acrylic on canvas (fig. 251). Nourished by Pop art, psychedelic art and rock music, they surpassed their contemporaries in their audacity, ultimately becoming

249. Edith Jiménez – Los ojos de la madera (The Eyes of the Wood), 1961. woodcut, 60 x 100 cm.

251. Ricardo Migliorisi – Sin título (Untitled), 1991. acrylic on canvas, 100 x 80 cm. Museo Paraguayo de Arte Contemporáneo, Asunción

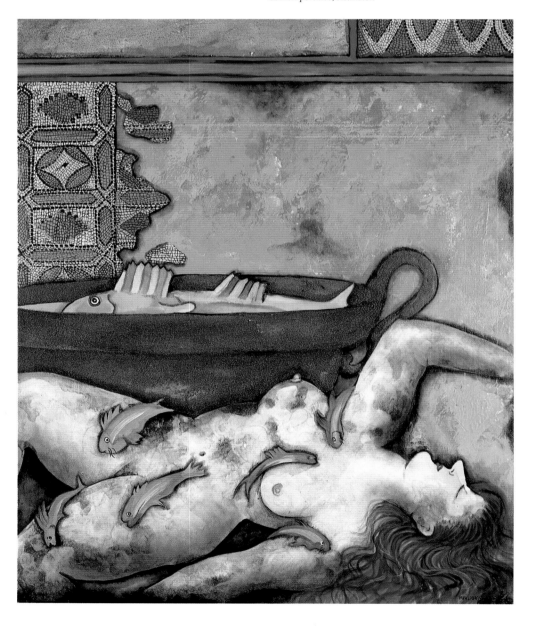

250. Enrique Careaga – Construce, espacio – temporalis e.c.l.o.s. 1992, from the series Los caminos (The Roads), 1992. acrylic on canvas, 120 x 110 cm. Museo Paraguayo de Arte Contemporáneo, Asunción

Paraguay

well known in Asunción for their 'happenings' and body art.

New modes of art and creative techniques were developed in the last years of the 1960s. Laura Márquez (b. 1929), Michael Burt (b. 1931), Carlos Colombino and Enrique Careaga created geometric and Constructivist works. At the same time Livio Abramo (1903–92), a central figure in the development of printmaking in Brazil, opened the Taller de Grabado Julián de la Herrería (the Julián de la Herrería Graphic Workshop) in Asunción. The next generation of graphic artists emerged from the Taller to work alongside older masters such as Blinder and Jiménez. Artists like Jacinto Rivero (b. 1932), Miguela Vera (b. 1920), Leonor Cecotto (1920–81) and Lotte Schulz (b. 1925) became well known for their black-and-white woodcuts in which specific references to popular art were often present.

Maturity

The 1970s and 1980s were decades of adjustment and maturation for the nation's artists. Finally liberated from their frenetic efforts to become 'international' and their urge to cast off references to the past, they set to work to establish a firm artistic personality for Paraguayan art. The stronger national economy produced an upsurge in the art market, permitting many artists to live by their work and develop their own special areas of expertise. The need to appeal to collectors also had the effect of making art somewhat more conservative. None the less, Paraguayan art had never experienced such a prolific period as this.

Despite the vogue for experimenting with new media and techniques, there was a revival of traditional art forms and methods. Art made with found commercial objects, body art, installations and happenings diminished in importance. Drawing became the principal mode of expression among young artists in the 1970s and painting, which had lost ground in the previous decade, once again emerged with vigour. Graphic artists experimented with new processes. Osvaldo Salerno (b. 1952) made prints from real objects, as in his 1976 untitled work (fig. 252); Carlos Colombino and Edith Jiménez created multiple large-format woodcuts and Olga Blinder employed photomechanical methods in her printmaking. The traditional woodcut format continued to flourish under the inspiration of Livio Abramo, well known for his dramatic, severe evocations of the Paraguayan landscape.

The 1970 exhibition of the work of Jenaro Pindú (1946–94) not only marked the resurgence of drawing but also demonstrated the variety of fantastical Expressionism that had been growing in Paraguayan art for a number of years and would remain one of its chief characteristics for years to come. Figuration, with intimations of hidden terrors, is also a feature of the drawings of artists such as Luis A. Boh (b. 1952), the delirious imagery of Ricardo Migliorisi, the cryptic world of Fernando Grillón (b. 1931), the obsessive art of Lucio Aquino (b. 1953), and even the more refined art of Mabel Arcondo (1940–76), with its hints of a dream-like magic.

Abstraction developed as a parallel movement. Its two most representative artists are Edith Jiménez, who depicted organic forms in her large-scale prints, and Enrique Careaga, whose geometric style was influenced by the Op art of Victor Vasarely. The Op-related drawings of Mabel Valdovinos may also be associated with this tendency.

The so-called 'Refiguration' Movement

252. Osvaldo Salerno – Sin título (Untitled),
1976. print from real objects, 70 x 100 cm.

253. Félix Toranzos – Serie de la hipocresía 1,2,3,4 (Hypocrisy
Series 1,2,3,4), 1994. *mixed media, 37 x 26 cm (each). private collection*

Paraguay

combined a rigorous analysis of visual vocabulary with a sober consideration of the human condition. Artists such as Osvaldo Salerno, and, later, Luis A. Boh, participated in this phase of modern Paraguayan art in which dramatic content and existential philosophical concerns were combined with a renewed commitment to figuration.

Several movements associated with the rise of a popular (often mistakenly labelled 'naïve') spirit in modern art also come to the fore in Paraguay at this time. Works by Ignacio Núñez Soler (1891–1983) embody the interest expressed by many artists in portraying aspects of the lives of the working classes. None the less, this was also a period when the general enthusiasm for art, so strong until the early seventies, began to wane, with a consequent decline in the quality of work. Many artists fell into the trap of repeating the most successful aspects of their earlier production while some stopped working altogether. It was as if the dramatic flowering in the art of the 1960s, which had coincided with the rise of a modernist spirit in Paraguay, had come to an end and artists were unsure of the next steps to take.

This apathetic climate was accentuated by the collapse of the Stroessner dictatorship in February 1989. After almost four decades of oppression and censorship a new era was dawning for civil liberties and individual rights. Initially promising the opening of new doors, this political change only served to emphasize the disorientation of Paraguayan culture. Artists and intellectuals were obliged to accommodate themselves to a new and unknown system of values as the traditional points of reference vanished.

This decadence, however, did not result in a complete paralysis. Despite the general

lassitude, some artists maintained their standards and were able to come up with new aesthetic ideas. A number of the well-known figures of past decades (Colombino, Blinder, Migliorisi, Jiménez, Romero and Careaga) continued to produce original works in the post-dictatorship era. The artists of the so-called 'intermediate generation' (Salerno, Boh and Krasniansky) also provided stability in a changing age. Félix Toranzos (b. 1962), who emerged at the end of the 1970s and Oscar Centurión, whose career began in the 1980s, should be included among those making an important contribution to recent Paraguayan art. An example of Toranzos' highly original mixed media pieces is the *Serie de la hipocresía 1, 2, 3, 4* (*Hypocrisy Series, 1, 2, 3, 4*; fig. 253).

A number of young artists have established their reputations through the workshops, galleries and cultural spaces that emerged in the wake of the dictatorship. The IDAP (Instituto de Desarrollo Armónico de la Personalidad), directed by Olga Blinder, and the Centro de Estudios Brasileiros have both offered additional sources of promotion, as has the Centro de Artes Visuales. Annual exhibitions such as Obrabierta and competitions like the Benson and Martel prizes are testing-grounds for new talent such as that of Feliciano Centurión. Although he has done much of his work in Buenos Aires, Centurión's name is still associated with the art world in Asunción. The El Aleph Gallery has consistently exhibited artists of a more experimental post-conceptual tendency, such as Marité Zaldívar (b. 1955), Mónica González Oddone (b. 1952) and Fátima Martini (b. 1959). Printmaking also has its younger exponents, many of whom have chosen the woodcut as their favourite medium, including Marcos Benítez

(b. 1973), Alejandro García (b. 1965), Carlos Spatuzza (b. 1966) and Gustavo Benítez.

Conclusion

The first three decades of the century were characterized to a great extent by the hegemony of academic realism which was partially relieved by the interest taken by some artists in Impressionism and Post-Impressionism.

The second phase in the development of modern art in Paraguay took place between the 1930s and 1950s. It was a period of transition from traditional naturalism to a variety of new artistic modes. Only in the 1960s did a true modernity emerge. The rise of avant-garde art coincided, paradoxically, with the period of dictatorship. During this time, many contemporary approaches were tried by artists in search of their own formulae for aesthetic maturity.

The most recent period of development, which can be dated from the mid-1980s, could be called Paraguay's Post-modern era. It is a time of ambiguity, dispersion and disenchantment. There is an absence of strong direction among artists and this has tended to cause a certain disorientation. The great challenge has been to reformulate aesthetic principles in order to satisfy contemporary needs. Much of what is produced today might seem to reflect a diffusion of artistic ardour and a general lack of enthusiasm. Yet, on the other hand, the works of contemporary Paraguayan artists may be regarded as heralding a process of renewal, a gathering of forces in the search for new forms of expression of the collective experience.

Alicia Haber

LATIN AMERICAN ART IN THE TWENTIETH CENTURY
Uruguay

Uruguay

Uruguay is an essentially 'open country', particularly susceptible to foreign influences.[1] Uruguayan art has strong European roots and its eye is always trained on the contribution of outside means of expression. 'While the close relationship with Europe exists, this does not imply a fault which has to be hidden or eradicated,' stated the critic Fernando García Esteban in his definition of the characteristic features of Uruguayan art.[2]

In order to understand this peculiar situation it is important to realize that the heritage of both the aboriginal peoples and the legacy of the Spanish colonial period have left few traces in Uruguay. After independence in 1825 the population increased with waves of immigrants from Italy, Spain, France and elsewhere, determining the European outlook of the nation.

Another important factor is the formation of the artist. Study trips to Europe were, in the nineteenth century and for much of the twentieth, essential, in view of the limitations of local museums and of art education as a whole. Later, even when the options open to the art student were more numerous, travel abroad was still necessary to facilitate the study of the great collections of foreign art which were (and still are) unavailable at home. Travel to Europe and other continents was (and still is) also important, given the difficulty of contact with other Latin American countries. The differences between the Latin nations make a common identity difficult and reciprocal influences are sporadic. It is also significant to note that there is not, nor has there been in Uruguay, a craft or folk art tradition such as exists elsewhere in Latin America.

In the last four decades cultural information has become more readily available in Uruguay through the mass media. Additionally, there have been a greater number of international exhibitions in Montevideo. Uruguayan artists have also benefited from direct contact with international art and wider participation in biennial exhibitions. Uruguay is one of the few Latin American countries that, since the 1950s, has had its own pavilion at the Venice Biennale. The relation of Uruguay to the São Paulo Bienal is particularly relevant: since its founding in 1951 Uruguayan artists and art critics have made a cultural pilgrimage to this international event. In the last three decades the Uruguayan art world has also developed a stronger relationship with that of the United States.

Almost all significant cultural activities in Uruguay take place in Montevideo, the capital city in which, with some notable exceptions, the majority of artists live and where artists' groups and workshops have been set up. This fact accounts for the marked urban, sophisticated character of much Uruguayan art. It also tends to accentuate the alienation of art from popular or folk elements which are very hard to identify, even though in the work of a few Uruguayan artists these stem from personal experience.

Despite its openness to foreign influence, Uruguayan art possesses its own peculiarities and specific differences which can be perceived to separate it from the movements which have inspired it. Foreign elements have been retained or discarded by Uruguayan artists on a selective basis, and integrated in a syncretic and eclectic manner. It is therefore difficult to categorize Uruguayan artists within the parameters of any international tendency, as they generally escape strict definitions.

The first fissures in the prevailing academic mould of art were discernible at the turn of the century when the history of modern art in Uruguay began. The *Modernista* painters Carlos Federico Saéz, Carlos María Herrera and Pedro Blanes Viale absorbed innovative styles as students in Europe (particularly in Spain and Italy) and altered the artistic panorama upon their return home. Their modernizing spirit was expressed through an innovative use of staining and gesture, their sensual use of colour and light, and an accentuation of the subjective interpretation of reality. They were able to fuse the lessons of the Italian realist-Impressionist painters of the Macchiaioli Movement, the luminism of the painters of Valencia and the *Modernista* styles of the Catalan School. The Círculo de Bellas Artes (Fine Arts Circle) was founded in 1905, with Herrera and Blanes Viale as teachers. This institution played a fundamental role in the development of Uruguayan art, as did the support of the literary avant-garde. Among the members of the so-called 'Generación del 90' (Generation of the 90s) was a widespread *Modernista* spirit, akin to Art Nouveau, which is reflected in literature, music, the visual arts, dress and decoration.

The painting of Carlos Federico Saéz (1878–1901), who was most important as a portraitist, was closely tied to that of the Macchiaioli painters. The portrait of Juan Carlos Muñoz (fig. 254), of *c.*1899, for instance, shows a screen in the background (painted by Saéz himself), a device often used by the artist to add an openness to the structure of the backgrounds of his pictures. He was thus able to obtain surprising effects that prefigured abstract painting. Oscillating rhythms define form, the accumulated clothing on the sofa is delineated with spots of paint, the face of the sitter is represented in a free manner, emphasizing the force of the colour, the agility of the brush-stroke and the thickness of the impasto.

The portraits of Carlos María Herrera (1874–1914) are poetic, vaporous visions reflecting the artist's skill with pastel. Pedro Blanes Viale (1879–1926) introduced the Spanish manner of out-of-doors painting with bursts of colour and blue and violet shadows to define landscapes dense with thickly applied paint.

From 1905 the art world of Uruguay developed in a climate of democracy. As a civic-minded, model welfare state it was a strictly secular country, due largely to the reformist efforts of the former President José Battle y Ordoñez.[3] The reforms carried out under his influence were so important that the period between 1900 and 1930 is known as the 'Battlista' era. During the 1920s, a great artistic flowering occurred[4] in which serious efforts to modernize coincided with a search for national identity through an appreciation of the country's landscape. At this time the teachings of the Círculo de Bellas Artes became important, as did the influence of those artists who had recently returned from their study trips to Europe. As a consequence of this profound and systematic artistic renewal *Planismo* (Planeism) was born, a school of painting based on a study of the local landscape depicted in planes of chromatic intensity, a legacy of both Fauvism and Post-Impressionism. Planeism projected an image that reflected the optimism and prosperity experienced by Uruguay during these decades. The critical support for the movement came from the Agrupación Teseo (the Teseo Group), from the critic Eduardo Dieste, and from the generally dynamic cultural ambience which also saw the creation of forward-looking magazines and the formation of artists' groups that mirrored the equally stimulating climate in literature, music and other arts.

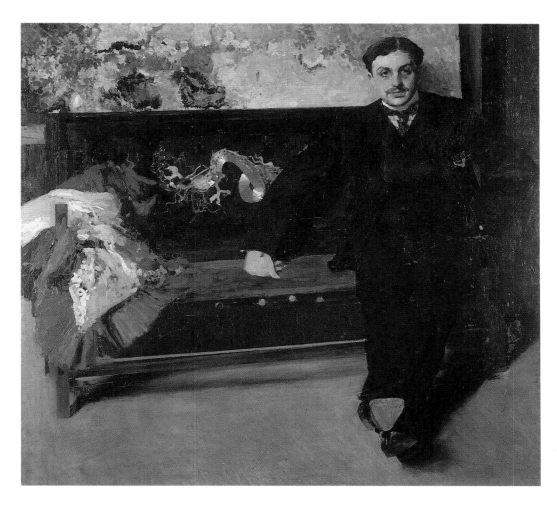

254. Federico Sáez – Retrato de Juan Carlos Muñoz (Portrait of Juan Carlos Muñoz), *c. 1899. oil on canvas, 129 x 139 cm. Museo Nacional de Artes Visuales, Montevideo*

255. PEDRO FIGARI – CAMBACUÁ, *c.1923. oil on board,*
69 x 99 cm. Museo Nacional de Artes Visuales, Montevideo

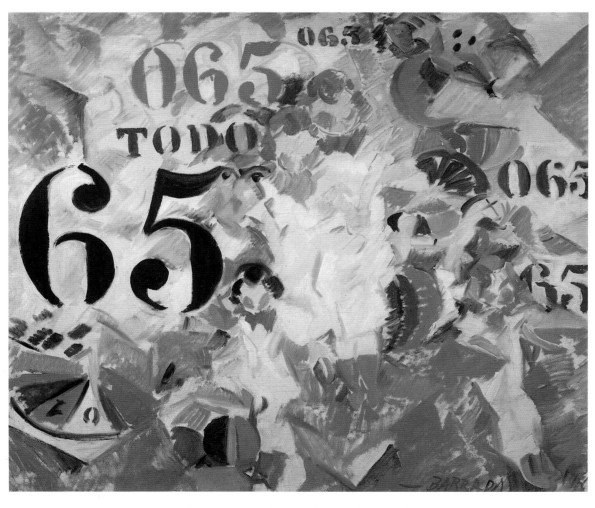

256. RAFAEL BARRADAS – TODO AL 65 (ALL TO 65), *1919. oil on*
canvas, 73 x 84 cm. Museo Nacional de Artes Visuales, Montevideo

Uruguay

It was during the Battlista era that Uruguayan painting definitively entered the modern era. Among those artists to embody these new values were José Cúneo, Humberto Causa (1890–1924), Petrona Viera (1894–1960), Carmelo de Arzadun (1886–1968) and Guillermo Laborde (1886–1940).

Nativism emerged in the 1920s as an important component of cultural expression. It was a literary, musical and visual movement which arose from a desire to search for the essence of national culture. Pedro Figari (1861–1938), known for his lively colourism and vibrant drawing, is the most important embodiment of this trend in modern art in Uruguay and one of the country's outstanding painters. Figari strongly believed in the need to create regional cultures in Latin America and his painting should be understood not only as an aesthetic element but also within his vast intellectual concept.

A prominent lawyer, judge, intellectual, teacher and philosopher, Figari played an influential role in Uruguayan culture even though he had virtually no artistic disciples. In 1921 he began to paint exclusively, re-creating the past in his work with nostalgia, humour and irony.[5] In his oils on cardboard he captured the urban colonial society of the Río de la Plata region, the solitude of the countryside, the life of the gauchos of yesteryear and, above all, the rich folklore of the black community. Yet Figari's works cannot be classified as realist. They are, instead, lyrical, suggestive and affective evocations of the things and people he painted. His pictorial methods achieve a general impression of things, free from specific detail. Figari shows his subjects (and especially his blacks) in expansive attitudes, paying particular attention to the creative, ener-

getic nature of their religious practices, their dances and their everyday life. He depicts, as well, their funeral and other rituals. In *Cambacuá* (*c.*1923; fig. 255) the rhythmical sequences, the arabesques that describe the figures, the abandonment of traditional perspective, the sketchy drawing, use of blotches of freely applied, intense colour and the sureness of the brush-strokes evoke an almost dreamlike scene. The black participants display a theatrical, emblematic attitude; their faces are defined by spots of colour, thus creating subtly expressive masks.

In his paintings Figari sought to define those individuals (blacks, gauchos and other types) in whose lives pretence and artifice played no part and who in themselves affirmed the strength of nature. Figari thus reveals to us his Latin American consciousness. For him, Latin America and its most authentic inhabitants represented primal natural forces which would form a new culture. It is this peculiar energy that permeates his art.

Modernity in Uruguayan painting received a decisive stimulus from the multifaceted artist Rafael Pérez Barradas (1890–1929). Barradas was a draughtsman, caricaturist, scenographer, illustrator, poster designer and painter and is one of the key figures of the first decades of the century. His career developed principally in Spain. Even though Barradas did most of his work in Europe, where he experimented with a number of avant-garde tendencies, he eventually returned to Uruguay, leaving an important legacy observable in a variety of ways. Between 1916 and 1918 he developed a style known as 'Vibrationism', one of his most important contributions. It represents an aesthetic of temporal and spatial discontinuity with which to define urban life. Vibrationism is related, in

an idiosyncratic way, to the characteristics of Cubism and Futurism. It is defined by dynamic drawing, intersecting planes, complex visual games, syncopated rhythms and a chromatic display of the type observed in such a typical work as *Todo al 65* (*All to 65*, 1919; fig. 256).

The 1930s witnessed three essential contributions to the modern spirit of art in Uruguay. One of these was Neo-Cubism. The second was social realism, whose development coincided with a period of social and economic difficulty in Uruguay as a consequence of the Great Depression and the *coup d'état* by Gabriel Terra in 1933, as well as the turbulent events that were taking place in Europe and, later, the Civil War in Spain. This art emphasized social and popular subject-matter and was nurtured by the Marxist ideology and the aesthetic concerns of Mexican Muralism, especially that of David Alfaro Siqueiros who visited Uruguay in 1933. Social-realist art in Uruguay, as practised by Felipe Seade (1912-69) and others, was also influenced by the social realism of Argentine artists such as Antonio Berni and the Brazilians Emiliano di Cavalcanti and Cándido Portinari as well as by Soviet social realism and German Neue Sachlichkeit. At this time artists' groups such as the AIAPE (Agrupación de Intelectuales, Artistas, Periodistas y Escritores) or Intellectuals, Artists, Journalists and Writers Group, which supported social realism, also flourished.

Although Carlos González (1905-93) could be associated with social realism he was, in fact, an independent artist. He was an unusual figure in every way, one of the few who could make intelligent incursions into the earthy subject-matter associated with this artistic movement without becoming demagogic or falling into the trap of either sentimental folklorism or

Uruguay

257. CARLOS GONZÁLEZ – TRABAJO,
HOMBRADA O PELEA (WORK,
CONFRONTATION OR FIGHT),
1942. woodcut, 40 x 32 cm.

moralizing didacticism. Between 1933 and 1944 González depicted various facets of peasant life, emphasizing the economic neglect of the people and, at the same time, re-creating their myths and legends. In order to preserve a certain austerity in his art he worked in the medium of the woodcut, even insisting on hand-printing techniques, reminiscent of a pre-technological era.

In *Trabajo* (*Work*; fig. 257), also called *Hombrada* (*Confrontation*) or *Pelea* (*Fight*), of 1942, the participants are about to begin a knife fight. Surrounding the central composition is a virtual synthesis of the history of Uruguay. In the lower zone is a scene referring to the greed of the conquerors, the plundering of the indigenous population and their terrible final destiny. The scene above alludes to the history of independence, while at the sides are references to both work and rest, including such elements as the plough, the *mate* tea vessel, mortar, cycle and spade. An open book exhorts: 'Workers, study!' by which they could rise above their outcast status. In the four corners ploughs and crucifixion scenes with unusual Christ–Indian figures appear, symbolizing the two poles of rural existence in Latin America: work and suffering. The synoptic Expressionism of González represents archetypes with a persuasive presence that is emphasized by strong areas of black and white.[6]

The most significant movement that emerged in Uruguay in the 1930s is Constructive Universalism (*Universalismo Constructivo*), created by Joaquín Torres-García (1874–1949). No one in the history of Uruguayan art had the impact of Torres-García, whose aesthetic principles still remain at the centre of intellectual debates. Although a history of art exists both before and after Torres-García, he stands as a singular phenomenon: a celebrated artist who

returned to Uruguay in 1934, after a long career in Europe, to initiate the School of the South.

An imposing presence, writer, teacher and theoretician, Torres-García created the Asociación de Arte Constructivo (Association of Constructivist Art) in 1935 and, in 1943, the Taller Torres-García (Torres-García Workshop) that remained open after his death until 1963. He acquired an almost mythical status among his disciples, who followed him like a divine presence revealing great, indisputable truths; the impact of his aesthetic programme was felt throughout Latin America and even in the United States.

Torres-García devised his Constructive Universalism in Montevideo. This visual language integrated at the same time Universalism, Americanism, Constructivism and Symbolism. It was based on a visual grammar that attempted to define the essence of the American spirit (Americanism) while utilizing elements derived from classicism, primitivism, pre-Columbian art, Neo-Platonism, Cubism and Surrealism. This combination of elements may be observed in Torres-García's theory as well as in his paintings, sculptures and objects.

Torres-García created an original art based upon the grid and intersecting lines, in whose non-perspectival spaces are placed symbols alluding to the world of reason as well as to the material and the emotional realms. In *Arte universal* (*Universal Art*, 1943; fig. 259), some of the key elements of this language are seen, including the circle, square, triangle, ruler, golden compass, numbers, heart, spiral, boats, anchors, clocks, stairs, fishes, houses, the cosmic couple, universal beings, and stars. Torres-García employed the Golden Section, yet the geometry in his painting does not negate its human and

259. JOAQUÍN TORRES-GARCÍA – ARTE UNIVERSAL
(UNIVERSAL ART), *1943. oil on canvas, 106 x 75 cm.*
Museo Nacional de Artes Visuales, Montevideo

258. ALFREDO DE SIMONE – LA CALLE (THE STREET), *1942. oil on canvas, 80 x 85 cm. Museo Nacional de Artes Visuales, Montevideo*

emotional qualities. In *Arte universal* these traits are observed in the subtly warm, gestural line separating each form and delineating the signs. This sense of humanity can also be seen in both the brush-strokes and the strong line.

Torres-García did a well-known drawing of a map of South America in which the continent is inverted. He also coined the phrase '*Nuestro norte es nuestro sur*' ('Our north is our south'), thus affirming both local and continental identity. The artist's strong belief in the ancestral power of Latin America lies behind his Constructive Universalism.

While Torres-García left his mark on a vast sector of Uruguayan culture of the 1930s and 1940s, some other outstanding artists chose to follow their own paths. Among them were Alfredo De Simone and José Cúneo.

Alfredo De Simone (1896–1950) depicted with intensity, melancholy and lyricism the Montevideo urban landscape in his thickly impastoed paintings done after 1930. His art looks forward to matter painting with his use of the spatula and densely modelled pictorial surfaces which approximate true bas reliefs, as seen in his 1933 work, *La calle* (*The Street*; fig. 258).

José Cúneo (1887–1977) passed through various stages of development in his long and multifaceted artistic career. He worked in the style of *Planismo* and did a number of Expressionist landscapes as well as series of abstractions. He painted his 'Moons' (his most notable subject) between the 1930s and the 1950s. In them Cúneo depicted with Expressionist vigour the emotional impact of an encounter with the uncontrollable forces of the cosmos. In *Luna nueva* (*New Moon*, 1933; fig. 261), the Uruguayan countryside is brightened by

Uruguay

260. José Gurvich – El hombre astral
(Astral Man), *c. 1967. oil on canvas,
164 x 104 cm. private collection*

a lunar glow, seemingly sinking before the cata-
clysmic cosmic power. The majestic sky, the
moon itself, the rain-swollen clouds and the
ominous presence of blackbirds are the most
outstanding elements in this representation of a
world in which everything is agitated and trans-
formed. The moon plays the role of protagonist,
symbolizing the constant repetition of the cycles
of nature, alluding further to the energy of the
spheres. Humanity's smallness is emphasized;
the limits of mankind before the overwhelming
forces of nature are evident. Buildings are
distorted in empathy with the scene. The oblique-
ness of the composition is a predominant
element of *Luna nueva*, as are the contrasts
between light and dark. The density of the paint
itself emerges as if in a dialogue with spots of
scintillating colour.

From this ambience emerged the
'Generation of '45', a sophisticated modernizing
force that radically transformed the cultural
scene of the nation. Working within a framework
of international currents, these artists and intel-
lectuals were interested in accentuating both
national and international characteristics in their
art. They were strict, rigorous and severe to the

Uruguayan art continued to develop
through political crises such as the coups d'état
of 1933 and 1942 and afterwards, during the era
of democratic consolidation, in the context of a
secularized society with a strong middle class
that espoused a liberal political philosophy. This
'model society' enjoyed an economic boom
between 1945 and 1955 – a period known as the
'glorious years'. During this time Uruguay expe-
rienced an extraordinary climate of optimism. It
was then that the myths of 'contented Uruguay',
the 'Switzerland of the Americas', and
'Montevideo, the Athens of the Plate', were born.

point of intransigence. A critical consciousness
developed which challenged the contradictions of
the Establishment, denouncing its provincial
limitations. Thus the Generation of '45 is also
known as the 'Critical Generation'. Despite
the optimism of the time, its representatives could
recognize the contradictions of the socioeconomic
situation of the country. Later they denounced the
increasing deterioration in the social system that
first became evident in 1955, when the nation
started to feel the effects of the stagnation of the
cattle industry, the decline of industrial develop-
ment, the fiscal deficit and growing inflation. The
election of 1958 when the ruling Colorado Party,
in power for ninety-three years, was defeated by
the Blancos (now known as the National Party),
was a political symptom of this crisis.

The intellectuals and artists of the
Generation of '45 contributed many crucial
elements to the history of creativity in Uruguay.
Within this atmosphere of cultural ferment
diverse avant-garde artistic movements devel-
oped, competitions and annual national salons
were held and rigorous art criticism increased
and developed.

The Taller Torres-García, the artistic and
intellectual centre that formed an essential part
of Uruguayan culture, had particular relevance at
this time. As an inexhaustible radical and fervent
preacher, Torres-García himself was able to
secure the unconditional allegiance of his pupils,
among whom several figures stood out from the
others. Torres generated an aesthetic system that
had an incalculable impact in many areas and
enjoyed its time of greatest splendour from
1944 to 1963.

After the closing down of the Taller
Torres-García, each of its members sought to
create their own personal style although some

did not range too far from the teachings of the master, whose spiritual presence continued to be a source of inspiration. Torres-García's most outstanding pupils included Gonzalo Fonseca, Francisco Matto, Julio Alpuy, Horacio Torres, Augusto Torres, Manuel Pailós and José Gurvich.

The sculptures of Gonzalo Fonseca (b. 1922), who has lived in New York since 1957, derive in part from the tenets of Torres-García. His enigmatic habitats radiate a potent symbolic energy. Embodied in these structures are allusions to eternity, the impossibility of absolute knowledge, nostalgia, memory and the communion between the cosmos and the material world. In them the artist demonstrates his love for the richness of archaeology and his fascination with the esoteric and mysterious elements of cults.

The planar sculpture of Francisco Matto (1911–95) exerts an ancestral splendour, profound harmony, carefully planned structure and organic strength. In his flat totem poles executed between the 1960s and 1980s, inspired by both pre-Hispanic art and Catholic symbolism, Matto monumentalized some of the symbols of Constructive Universalism. He then isolated the symbols by placing them on poles, allowing them to achieve a particularly potent iconographic power.

In the work of José Gurvich (1927–74), done since the 1960s, we observe a world in which the artist places great emphasis upon the integration of the heritage of Torres-García with a progressive search for his Jewish identity. This art is characterized by luminous colours enhancing undulating compositions of dynamic rhythmic curves and ovoids. The painting entitled *El hombre astral* (*Astral Man*, c.1967; fig. 260) depicts such a metamorphosed reality and a fluctuating world imbued with lyricism.[7]

Other important contributions were those of Augusto Torres (1913–92), the second son of Torres-García, who assimilated his father's manner in his metaphysical painting; Horacio Torres (1924–76), the youngest son of Torres-García, who opted for figuration; Manuel Pailós (b. 1918), who subscribed to the doctrines of Constructive Universalism in his lyrical paintings and powerful sculptures; and Julio Alpuy (b. 1919), whose search for primal essential qualities is observed in his prints, paintings and sculptures.

Yet the influence of Torres-García and his workshop is not limited to these figures. In the artistic climate of Uruguay as a whole there remains much that derives from this master. Among its fundamental elements are the continuation of the cult of ancient Latin American cultures, the creation of an art that reflects the spirit of Montevideo, the importance attached to modest materials and the emphasis placed upon craftsmanship.

The 1950s and 1960s witnessed the development of new and experimental forms of art among both groups and individuals. It was a stimulating time in all areas of culture and Uruguay experienced a particularly strong flowering in the visual arts. There was a spirit of renewal and an acceptance of new languages on the part of the Generation of '45 and, later, among those of the so-called 'Generation of 1960' who expanded into areas of even greater innovation in figuration as well as abstraction in painting, sculpture and the graphic arts. There was also a greater tolerance in art criticism, which was increasingly open to the avant-garde. The culture of Uruguay became less complacent and searched for new horizons which entailed greater expressive and intellectual risks, a more radical

261. José Cúneo – *Luna nueva* (New Moon), *1933. oil on canvas, 146 x 97 cm. Museo Nacional de Artes Visuales, Montevideo*

262. JOSÉ PEDRO COSTIGLIOLO – RECTÁNGULOS MCMLIV (RECTANGLES
MCMLIV), *1972. acrylic on canvas, 136 x 136 cm. private collection*

Uruguay

form of modernization and a greater openness to foreign aesthetics. At the same time, both a national and a Latin American perspective in art was sought which would more adequately reflect social realities. All of these elements created the necessary framework for the evolution of such movements as geometric abstraction, Concrete and Informalist art, matter painting, Expressionist and grotesque figuration as well as other, daring forms of sculpture.

Groups such as the Grupo Carlos F. Saéz (Carlos F. Saéz Group, 1949), the Grupo La Cantera (Quarry Group, 1954) and the Grupo 8 (Group of 8, 1958) were established for the benefit of artists who wished to investigate the international avant-garde as well as form their own pictorial language, although they were not bound by any specific aesthetic system. In 1952 the abstract artists also began to come together, and the following year saw the foundation of the Club de Grabado (Print Club) whose membership included the most important artists in the graphic medium. A number of other artists developed their own distinctive aesthetic outlooks. This modernizing dynamism was accentuated by exhibitions of Uruguayan and foreign avant-garde artists organized by the Centro de Artes y Letras de 'El País' (the 'El País' Centre for Arts and Letters) (1959–66) and the Instituto General Electric (General Electric Institute) (1963–9).

Although Uruguayan art had important precursors of abstraction, as in the constructive art of Joaquín Torres-García, it was only after 1950 that non-figurative currents established themselves. A key participant in this movement was José Pedro Costigliolo (1902–85). Through the use of multiple highly coloured elements in his compositions, Costigliolo created irregular, complex images that excite the eye of the viewer.

The perpetual variation of the size of elements in his compositions plays an important role in his painting. Costigliolo never systematized his artistic strategy: employing the simplest, irreducible formal compositional elements, especially after 1964, he began to create series of squares, rectangles and triangles unfolding in two-dimensional space. In these, colour vibrates in visual fields which evolve from the oblique, asymmetrical composition, as in *Rectángulos MCMLIV* (*Rectangles MCMLIV*, 1972; fig. 262).[8] Among other outstanding artists in the area of geometric art are Carmelo Arden Quin (b. 1913), Rod Rothfus (1920–72) and María Freire (b. 1917).

Informalist art became especially important in the 1960s in the hands of such artists as Nelson Ramos, Jorge Páez Vilaró (1922–95), José Gamarra, Américo Spósito (b. 1924), Hilda López (b. 1922), Vicente Martín (b. 1911) and José Cúneo (who assumed his mother's surname 'Perinetti' when painting abstract works).

A type of Informalism in which the material properties of the work are of particular importance (as they are in the art of Antoni Tàpies or Alberto Burri) had a widely respected place in Uruguay. One of the most significant representatives of this tendency is Juan Ventayol (1915–71) who rigorously modulated his works using dense impasto applied with vigorous gestures. His paint was often thickened with granular elements such as sand and he would at times incorporate non-traditional materials such as scraps of old metal, wood or other discarded objects.

The emergence of non-figurative art paved the way for a rupture within the Uruguayan art community, creating various opposing factions throughout the mid-1960s. Despite this climate of factionalism, many artists

kept themselves apart, declaring allegiance with none of the established tendencies and, when they saw fit, merging both figuration and abstraction in their work.

Miguel Angel Pareja (1908–84), a prolific and multifaceted artist whose work spanned painting, drawing, mosaic and serigraphy, as well as a celebrated teacher, passed through both non-objective and figurative phases during his career. He emphasized the importance of colour both in his art and in his teaching, especially after the 1950s. Through the vigorous application of paint, gestural stroke and vibrating geometric forms, he creates dynamic plastic structures in his art.

At this time the creativity of another of Uruguay's greatest artists, Luis Solari (1918–93), reached its peak. In 1948 Solari began to develop his brand of Magic Realism with reference to myths, folklore, oral traditions and the knowledge embodied in popular refrains spoken at village festivals. It is not difficult to decode the metaphors used by Solari in the titles of his works, or inscriptions on them, since these were associated with the aphorisms and proverbs typical of those people who inhabit the Río de la Plata region.

Solari's thematic repertory was expressed in prints, fantastical objects, paintings, drawings, assemblages and collages. Especially adept at metal engraving, Solari began to experiment in this medium in 1967, using some of the techniques of the Informalists, including the superimposition of plates and other spontaneous elements. *Un día y una historia* (*A Day and a Story*, 1972; fig. 263) shows the construction of his non-perspectival spaces in which are situated serene figures with anthropomorphic masks, actors in the carnival of life. The low-key palette

Uruguay

accentuates the spectral atmosphere, distilling the aura of mystery which here becomes ominous with the figure flying above the scene.

The 1960s was a seminal era in Uruguay for the development of sculpture, which, throughout the century, had tended to play a secondary role to painting. Among its most outstanding practitioners was Eduardo Díaz Yepes (1910–78), a Spaniard who developed an important career as artist and teacher in Uruguay. In his Expressionist sculptures there are hints of a vital organic flow, biomorphism and references to universal life-forces that permeate all things. In his bold, powerfully modelled and textured works, the effect of pulsating surfaces is an outstanding feature, as seen in the dramatic *Homenaje a los marinos de la Armada Nacional* (*Homage to the Sailors of the National Navy*, 1960; fig. 264).

Germán Cabrera (1903–90) was a sculptor constantly open to changes and new ideas. It was his work of the 1960s and later that marked him out as a modernist. From that time onwards, there appeared an integration of spaces in Cabrera's sculptures, offering the spectator the challenge of participating in the dialogue between diverse elements of abstraction, figuration, geometry, organic forms, the static and the dynamic. Cabrera has created many multifaceted series in iron, bronze, bricks and ceramic. The expressive series *Cajas ocupadas* (*Occupied Boxes*, 1966–80; fig. 265), in which he ingeniously combines wood and iron, represents a high point in this artist's innovative formulations. Within an open prism of natural wood are powerful protruding bulbous organic iron forms which extend upwards and towards the sides. Bursting dramatically out of the structure that contains them, the iron forms suggest a continuous

growth that defies limits, being a visual metaphor for freedom.

There was a strong flowering of the graphic arts in the 1960s which persisted well into the 1970s, when it eventually died back and was confined to a few individual artists. Its decline paralleled the downturn in the fortunes of the country, which had experienced a severe crisis in the previous decade. Among the outstanding artists working in the graphic media during this period were Leonilda González (b. 1923), Miguel Bresciano (1937–76), Luis Solari, Antonio Frasconi and Rimer Cardillo. Another master was Carlos Fossatti (1928–80), who, in his woodcuts, achieved striking black and white contrasts, exploiting the grain of the wood in highly original ways and creating works on a mural-like scale. Antonio Frasconi (b. 1913) has lived in the United States for more than forty years yet he insists on maintaining his Latin American and, specifically, Uruguayan identity. In his work Surrealist fantasy mixes with dramatic Expressionism, bucolic lyricism and political messages.

Drawing reached a high point at this time. A tendency known as El Dibujazo (Big Drawing) developed, with an emphasis on a grotesque Expressionist figuration. Hermenegildo Sabat (b. 1933) occupies a particularly important place in the roster of artists who excelled in this medium. He is the most outstanding caricaturist in the history of Uruguayan art and one of the most renowned figures in his field in the Río de la Plata region.

Having ventured into the area of abstract matter painting Jorge Páez Vilaró developed, after the mid-1960s, his own distinctive brand of *Dibujazo* and, until the end of his life, he produced works in a Neo-figurative manner

linked to the art of the European CoBrA movement which included artists working in an Expressionist vein in Copenhagen, Brussels and Amsterdam. During the 1970s he produced paintings with a pronounced grotesque-humorous quality dealing with innately Uruguayan themes. The exponents of the *Dibujazo* movement, as well as artists such as Sabat and Páez Vilaró, embodied a positive return to the paths of figuration which they were to follow until the end of the 1960s.

Since then art in Uruguay has developed under the increasingly difficult circumstances produced by the country's social, political and economic crises. It was at this time that many talented artists began to leave Uruguay. The difficulties gradually worsened with the crisis of democracy in 1968, culminating the military dictatorship of 1973–84. At the beginning of the dictatorship some artists remained in the country, continuing to produce work in the solitude of their studios. Others exiled themselves in what would prove to be a true Uruguayan artistic diaspora. Still others continued to exhibit in the alternative spaces that remained open to them, although under the close scrutiny of the censors.

Yet artistic creation remained strong even during the dictatorship. Artists with well-established careers also emerged in those difficult years, having developed a variety of original artistic strategies. While the nature of the country's crisis was treated in different ways by numerous artists, in general this was through metaphor and oblique allusion rather than by incorporating specific messages into their work. A new generation of critics also emerged in the 1970s and 1980s.

Since 1985 and the recovery of democracy, a renewed air of creation was breathed into

263. Luis Solari – Un día y una historia (A Day and a Story), 1972. *etching and aquatint, 43 x 69 cm.*

265. Germán Cabrera – Caja ocupada (Occupied Box), *c. 1968. wood and iron, 225 x 1.21 x 150 cm. private collection*

264. Eduardo Díaz Yepes – Homenaje a los marinos de la Armada Nacional (Homage to the Sailors of the National Navy), 1960. *bronze, 7 x 5.3 x 5.3 m.*
Plaza de la Armada, Montevideo

Uruguay

Uruguayan art. Many of those artists who had gone into exile returned home, some to settle permanently; others have remained abroad, exhibiting from time to time in Uruguay in order to maintain their national identity. At the same time, the various public and private exhibition spaces were revitalized.

Just as the contentious spirit of the Uruguayan art world in the 1960s was reflected in the artistic output of the period, so, in various ways, the theme of suffering and disenchantment appears in the work of numerous artists who were active during the dictatorship. In large part their works respond to the disillusionment with the concept of the ideal nation which, in the collective imagination, constituted a paradise for immigrants, a model of homogeneity, democracy, tolerance, innovation, culture, economic stability and a high level of education. In the years of dictatorship, the myth of Uruguay as the 'Switzerland of the Americas' was dispelled once and for all. Artists began to deal with conflict and postulated new models for confronting the problems of identity. As was the case with artists in other parts of Latin America at the end of the 1960s, those in Uruguay were nurtured by the intensity of life in a state of crisis.

Among those artists who engaged in diverse experimentation with figurative as well as abstract languages is Jorge Damiani (b. 1931). Damiani creates simulacra of intimate life and depicts the unfathomable reality of the dream, seen especially in his collages executed since the 1970s. The artist's clarity of vision and precise drawing are evident in his terse collage *Evocación campestre* (*Evocation of the Countryside*, 1977; fig. 266), as are the subtlety of light and dark effects which underscore its seductive qualities. In the lower zone appear symbols of Creole life, while a native landscape appears above. There is a pronounced mystery as well as a dialogue between reality and fantasy, feelings of loneliness and silence together with suggestions of life and death. While the recurring theme of death in Damiani's work has personal connotations, it also carries allusions to the Uruguayan crisis.

Also outstanding as a painter and draughtsman, and notable both for abstraction and figuration, is Manuel Espínola Gómez (b. 1921). From 1975 Espínola Gómez began to create metaphysical works in which the viewer is invited to observe the scene from various points of view, disregarding traditional perspective. These are figurative canvases with disquieting and enigmatic subjects. *Sonorosas siestas lejaneras* (*Remote Reverberating Siestas*, 1975; fig. 267) depicts powerful, immobile figures amidst a fantasy landscape with statue-like trees whose geometrical forms accentuate the static and evocative aspects of the scene.

José Gamarra (b. 1934), who became known in Montevideo early in his career for his matter painting, has been active in Paris since 1963. He paints images of the Latin American forests and jungles with the focus on minute realism. His canvases are smooth and seemingly polished by the use of transparent washes. The jungle becomes, in Gamarra's work, a symbol for the primal state of the world which was sacrificed to the advanced civilization of developed countries. In his paintings Gamarra denounces the imperialism, invasions, conquests and military aggression of the past and present as well as the conflicts in Latin America between the indigenous and the European populations.

Hugo Longa (1934–90) burst on to the scene like a bomb in the mid-1960s with works of an expansive imagination and chromatic richness. His art and his teachings opened the door to unexplored regions of visual freedom for Uruguayan artists. Longa created a repertory of the grotesque and the unreal in his paintings, collages and assemblages, employing an acidic and convulsive vision to reveal the crises of his country. His Neo-Expressionist canvases of the 1980s, such as the 1987 *La muerte gorda* (*Big Death*; fig. 268), were particularly exciting for the density of material, intensity of the drawing, violence of the brushwork, alteration of scale, dramatic colouring and aggressive imagination.

Washington Barcala (1920–93) was an important figure in the Informalist mode but later, during his years of exile in Spain, developed along a more expressive path although he always maintained strong links with the Uruguayan spirit of Constructivism. In Spain he created pictorial boxes with modest materials, allowing the structures to be visible. In these carefully made Constructivist objects, harmonious rhythms are observed in both form and colour.

After a career in pure abstraction, Expressionist figuration and Object art, Nelson Ramos (b. 1932) has been defined, since 1982, as a maker of boxes, displaying in these abstract three-dimensional compositions his constant interest in monochromy and use of a limited palette. Employing different types of paper, small pieces of wood and varying sizes of straws, all of which he handles with a jeweller's expertise, Ramos has established a craftsman's relationship with these materials whose potential he ceaselessly investigates. In a vast series of works, *Pandorgas y claraboyas* (*Old Kites and Skylights*, 1991; fig. 269), the diverse, complex forms offer new solutions to pictorial problems. Rich in rhythms and structural spaces, these boxes impress the viewer with their immaculate ochres

266. Jorge Damiani – Evocación campestre (Evocation of the Countryside), 1977. mixed media collage and acrylic, 92 x 73 cm. private collection

268. Hugo Longa – La muerte gorda (Big Death), 1987. acrylic on canvas, 150 x 120 cm. Museo Nacional de Artes Visuales, Montevideo

267. Manuel Espínola Gómez – Sonorosas siestas lejaneras (Remote, Reverberating Siestas), 1975. oil on canvas, 130 x 224 cm. private collection

269. NELSON RAMOS – VIEJO BARRIO
(OLD NEIGHBOURHOOD) FROM THE SERIES
PANDORGAS Y CLARABOYAS (OLD KITES AND
SKYLIGHTS), *1985. wooden box and paper,
82 x 111 cm. private collection*

271. LUIS CAMNITZER – EL MURO DE LAS IDENTIDADES
PERDIDAS (THE WALL OF LOST IDENTITIES), DETAIL OF
INSTALLATION EL LIBRO DE LOS MUROS (THE WALL OF
BOOKS), *1993. glass, plastic, resin. collection of the artist*

270. ERNESTO AROZTEGUI – RETRATO ANAMORFOSEADO DE SÁBATO CASI CIEGO
(ANAMORPHIC PORTRAIT OF [ERNESTO] SÁBATO WHEN ALMOST BLIND), *1980.
drawing on Gobelins tapestry, 180 x 310 cm. private collection*

272. Hugo Nantes – Los jugadores del truco (The Players of the Game), 1980. *assemblage with scrap iron, 135 x 200 x 225 cm. Edificio Libertad, Presidencia de la República, Montevideo*

and whites. In them, Ramos nostalgically evokes the urban landscape of Montevideo. With a critical eye, the artist condemns the loss of important buildings suffered during the dictatorship period and the subsequent excesses of property speculation. He pays particular attention to the skylights and doorways of those now-demolished neighbourhoods. In 1992 Ramos began to create 'Expressionist' boxes with the use of figures. In these more recent works he takes an even more critical stance in pronouncedly figurative works censuring of the devastating effects of the conquest of the Americas.

Ernesto Aroztegui (1930–94) is distinguished for his hyper-realist anamorphic portraits on Gobelins tapestry as well as drawings done in grease-stick. His works, of monumental proportions, are notable for their colouristic richness, although in some cases the expressive potential is realized through stark contrasts of black and white. Aroztegui specializes in the irrational, as seen in his series *Retratos reales y retratos fantásticos* (*Real and Fantastical Portraits*; fig. 270) on which he worked from the end of the 1970s and during the 1980s.

Luis Camnitzer (b. 1937), Uruguay's chief exponent of conceptual art, has lived in the United States since 1964. Since 1969 he has completed a series of political–conceptual installations centred on themes relating to Uruguay or to Latin America in general and exploring the subjects of identity, language, freedom, ethical debates and the discourse of art. Each work is accompanied by a text. This is a subtle art form, redolent of silence as typified by a detail of the 1993 installation *El muro de las identidades perdidas* (*The Wall of Lost Identities*; fig. 271). In his work, Camnitzer establishes unusual relationships between words and objects; the

texts challenge the images, taking them to an interpretive level far from everyday banality. The illusionism of the photograph or the object is contradicted by enigmatic combinations. The meticulousness with which the object appears to be rendered is deceptive: the 'realism' of the compositions is challenged by the obscurity of the titles or by the ambiguity of the effects of the combined elements.

Since the end of the 1970s and beginning of the 1980s sculpture in Uruguay has developed in many non-traditional areas, including those subjects which touch upon the crises experienced by the country, as seen in the work of Hugo Nantes, Agueda Dicancro, Jorge Abbondanza and Enrique Silveira.

The brooding suggestions of Hugo Nantes (b. 1932) are achieved through his use of the materials that define his 'funk art' assemblages. Among the components he uses are cast-off scraps of metal and animal bones, to which he has added polyester resins. Through these materials and the predominant use of black he is able to transmit his ominous vision of life, as in *Los jugadores del truco* (*The Players of the Game*, 1980; fig. 272), one of his many works which refer to the social and political plight of Uruguayan society.

'No one can imagine what is inside an old piece of wood,' states the sculptor Wifredo Díaz Valdéz (b. 1932). Few people understand this subject as well as he. In his work he employs large pieces of wood which he then cuts into sections, exploring the possibilities that lie within it. Díaz Valdéz rescues ancient objects from their immovability, transforming the raw wood into the most complex of sculptural forms, as in his *Objeto de taller N 8* (*Studio Object N 8*, 1984; fig. 274).

Uruguay

This craftsmanlike relationship with materials has also been a guiding force in the creativity of glass artist Agueda Dicancro (b. 1938). With it, however, she merges her interest in architectonic structure and, since the 1980s, the desire to create monumental symbolic 'environments'. In later works, such as her installation entitled *Otras visiones* (*Other Visions*, 1988; fig. 273), the artist integrates oxidized and fissured pieces of glass and mirror. Neon also enhances the form, colour and the play of illumination in pieces which suggest the paradox of the fragility of human existence. These installations by Dicancro have a critical edge with their allusions to the dictatorship, excesses of power, the 'vanished ones' and ecological destruction.

Jorge Abbondanza (b. 1936) and Enrique Silveira (b. 1928) began to create sculptural groups in 1982. Their *La faz de la tierra* (*The Face of the Earth*) of that year is composed of small statues and masks in groups of 100 to 150 pieces. These are made of unenamelled plaster which lends them an ascetic look, appropriate to their theme which is concerned with the passage of time. In such works these ceramic sculptors consider the circular reality of life, growth and decay, the primordial and the obsolete. There is an atmosphere of universal meaning in their ceramics which exude a gravity and dramatic force suggestive of the situation experienced in Uruguay during the 1980s. Like an army of automatons, the small figures in *Todo en orden* (*All Is In Order*, c.1982; fig. 275), merge into the multitude while, with a controlled geometry, they split apart and, growing progressively dehumanized, become completely fragmented.

Various painters such as Lacy Duarte (b. 1937), Virginia Patrone (b. 1950), Carlos Musso (b. 1954), Carlos Seveso (b. 1954) and Fernando

López Lage (b. 1964) began, in the 1980s, to express themselves with an ease and audacity unheard of in the local genre. Loosely associated with Neo-Expressionism, these artists demonstrate the rebellion and nonconformity which emerged in the midst of the country's political conflicts. They are stimulated by the desire to challenge the caution, contentiousness, melancholy and nostalgia that are so characteristic of the collective Uruguayan imagination. Their work delves into the areas of the irrational, emotive self-expression, psychosexual problems and mythology, all expressed in paintings with violent gestural qualities, chromatic density and distorted figures. The use of heightened colour and the audacious images bespeak a desire for liberty felt by these exponents of the so-called 'generation of the dictatorship'.

The collages of Ernesto Vila (b. 1936), with their subtle, melancholic evocations and matt colours, fall into quite a different category from the work described above. With their timeless sensibility they allude to the fragility of memory, human vulnerability, and the transient quality of life. With cuttings, strips of fabric, folds and fissures and with the use of very fragile and colouristically evanescent paper, Vila suggests a taciturn world connected with the painful experiences of the era of dictatorship.

Since 1980 a peculiar phenomenon has arisen in Uruguayan art related to the traumas of the period of dictatorship and the socioeconomic problems of the nation. This can be observed in installations that deal with Uruguayan identity and include such themes as the search for roots, experiences of exile and the diaspora, or the permanent nostalgia for the past. An example is the 1991 installation *Made in Uruguay* (fig. 277) by the conceptual artist Mario Sagradini

274. WIFREDO DÍAZ VALDÉZ – OBJETO DE TALLER N 8
(STUDIO OBJECT N 8), 1984. *wood, 66 x 140 x 43 cm.*
Museo Nacional de Artes Visuales, Montevideo

275. ENRIQUE SILVEIRA AND JORGE ABBONDANZA – TODO EN ORDEN
(ALL IS IN ORDER), *c.1982. biscuit, 150 x 160 x 12 cm. private collection*

Uruguay

276. RIMER CARDILLO – GRAN CUPI, DETAIL FROM THE INSTALLATION CHARRÚAS Y MONTES CRIOLLOS (CHARRÚAS AND CREOLE MONTES CRIOLLOS), *1991. 1.6 x 5.4 m. Museo Fernando García, Montevideo*

(b. 1946). It deals with the theme of disenchantment and the paralysis induced by nostalgia. With strict geometry, this work consists of ten tables from the mythical Café Sorocabana; upon each of them is a panel made of grass, evoking Uruguay's reputation as an agricultural nation. On this grass are placed small figures drawn from Uruguayan traditions. Each table is linked to the next by catheters and equipment used for blood transfusions, representing the mythical Uruguay nourished by serum in an intensive-care ward. Works such as this are done in a 'low-tech' manner, avoiding any impressive technologies or lavish visual effects which would separate them from the socio-economic realities of the country.

As a homage to the Charrúa and Guaraní people respectively, the works of Rimer Cardillo (b. 1944) and Nelbia Romero (b. 1938) represent novelties in a nation which considers itself virtually bereft of an indigenous past. Cardillo creates ceremonial situations suggestive of pilgrimages into Uruguayan history and as a conduit to the recognition of the roots of cultures, as occurs in *Charrúas y Montes Criollos* (*Charrúas and Creole Montes Criollos*, 1991; fig. 276). Nelbia Romero produces emotive conceptual pieces based on the Guaraní people. In her work entitled *Más allá de las palabras* (*Beyond Words*) of 1992, Romero underscores the heritage of Guaraní culture, one of the nation's most vital legacies remaining from the past. In this installation the artist employs photography, photocopies, furniture and, especially, texts in both Spanish and Guaraní.

Carlos Capelán (b. 1948), has lived in Sweden since 1974 but his work deals with Latin American themes and his most important installation piece was done in Montevideo. As is the case with other Uruguayan and Latin American artists, he explores subjects related to rootedness and displacement, fractured memories and the conflicts that arise between the hegemonic West and the rest of the world. Capelán's art is rooted in anthropological thought as well as being linked to Arte Povera, Primitive Expressionism, conceptual art and mural painting.

Other artists who started their careers more recently are working with similar intensity in numerous avenues of expression; many of them are equally committed to the problematical search for identity as well as for ways to represent in their art the crisis of the nation in which they live. Despite the economic limitations of Uruguay, the country continues to produce a dynamic art scene.

In general, one may perceive an absence of the most radical vanguard art forms in Uruguay. In a country where circumspection and moderation are the defining aspects of the national character, artists opt for controlled forms of experimentation to avoid provoking a violent rupture with local idiosyncrasies. It is obvious that economic stagnation and lack of funding have impeded the development of technically sophisticated art such as video and high-tech environments. Thus painting, drawing, mixed media on paper and objects continue to be Uruguay's predominant art forms.

277. MARIO SAGRADINI – MADE IN URUGUAY (DETAIL), *1991.*
installation, mixed media, 130 x 100 x 1000 cm. Museo Municipal
Juan Manuel Blanes, Montevideo

Marcelo Pacheco

Argentina

LATIN AMERICAN ART IN THE TWENTIETH CENTURY

Argentina

One of the problems in considering the art of Argentina is that of reconciling the history of art produced specifically in Buenos Aires, the federal capital, with that created in the rest of the country. Important centres of artistic production include such cities as Rosario, Córdoba, Mendoza, La Plata and Tucumán. In many cases artists working in Buenos Aires came from the provinces in the interior.

The first twenty years of this century witnessed the establishment of the artistic panorama in Buenos Aires. A system of scholarships given both by the National Congress and the provincial governments allowed many young artists to study in Europe, especially in Paris. The Academia de la Sociedad Estímulo de Bellas Artes (the Academy of the Society for the Promotion of the Fine Arts) was nationalized in 1905 and has since functioned as an official centre of learning with strong academic (particularly Italian) roots. The growing number of galleries accounted for an increasingly dynamic art market in which nineteenth-century Spanish, French and, to a lesser degree, Italian works of art were favoured. The market for the work of local artists, who were largely supported by the middle class that emerged in the 1920s as well as by certain sectors of traditional high society, was slower to develop.

Institutions such as the Museo Nacional de Bellas Artes, which opened in 1896, became factionalized along political lines and were soon outmoded. In 1911 the Salón Nacional de Bellas Artes was created in its place but by 1914 its viability was questioned with the emergence of a Salon des Refusés.

Within this artistic framework the International Centenary Exposition of 1910 was a decisive event, with official entries from twelve countries. Spain's was the largest in the exhibition, with 260 works, and also proved to be the most popular with both the critics and the public. The work of Ignacio Zuloaga earned the highest praise. Three of his paintings were acquired by the Museo Nacional de Bellas Artes and his art was to influence an entire generation of Argentine painters. Local genre subject-matter took on a peculiarly Spanish cast in a combination of image and forms of representation.

At this point art in Argentina may be seen as having developed along two lines: the more modern mode, as exemplified by the work of Martín Malharro (1865–1911) and that of Ramón Silva (1890–1919), and the traditional approach of painters such as Cesáreo Bernaldo de Quirós (1881–1958). The moderns worked in an idiom that questioned standard techniques, combining Post-Impressionist characteristics with pre-Fauvist elements. Quirós, on the other hand, employed Post-Impressionist methods in a benign, non-confrontational way. The problem of national identity lay at the heart of artistic polemics. A solution was found in an anecdotal, literary genre of art with little aesthetic value. Running parallel with this type of genre painting was a local variation of Indigenism which elaborated on Spanish pictorial traditions, giving them a modern character, as occurred in the case of Alfredo Gramajo Gutiérrez (1893–1961), and which also had its reverberations in Bolivia and Peru, especially in the work of the Peruvian José Sabogal (1888–1956) who had studied in Buenos Aires from 1912 to 1918.

In 1916, with the adoption of the Universal Suffrage Act, the Conservative government which had ruled the country since 1880 lost power to the Partido Radical, led by Hipólito Yrigoyen. The middle class (and, especially, a generation comprising the children of mostly Italian immigrants) gained political control. During the 1920s Argentina witnessed a decade of dynamic artistic activity; it was an era of euphoria, a time when the definition of modernity was developed. One of the key events of the period was the return from Europe of Emilio Pettoruti (1892–1971). His first exhibition to be held in Buenos Aires came at a critical moment, provoking a very positive reaction in the (limited) avant-garde press, in contrast to the more conservative reviewers who wrote ironically and dismissively about the 'Futurist' or 'Cubist' tendencies in Pettoruti's works in order to dismiss them. The year 1924 was one of key importance for Argentine art. Apart from Pettoruti and Alejandro Xul Solar (1887–1963), the artist Norah Borges and her brother, the literary genius Jorge Luis Borges, also returned to Buenos Aires from Europe. In the same year the Primer Salón Libre was established, open to all, as was the Asociación Amigos del Arte, and the influential magazine Martín Fierro was founded.

The 1920s also saw a growth in the number of journals (especially literary magazines, which often devoted sections to the visual arts), critics and exhibition spaces as well as Argentine submissions to exhibitions abroad. It was a decade during which artists explored a wide variety of stylistic and theoretical options in their work. The market was dominated by turn-of-the-century Spanish painting (such as that of Joaquín Sorolla) and by the work of the Argentine painter Fernando Fader (1882–1935). Fader, who lived in isolation in the town of Ischilín in the province of Córdoba, held successful annual exhibitions at the Mueller Gallery in Buenos Aires. His landscapes and figure compositions became the epitome of Argentine Impressionism, a classic

278. Fernando Fader – Tarde serena
(Quiet Afternoon), 1922.
oil on canvas, 100 x 120 cm.
private collection, Buenos Aires

example being the 1922 canvas entitled *Tarde serena* (*Quiet Afternoon*; fig. 278). From this time onward, Fader embodied the artistic ideal of the Argentinian upper and middle classes.

Working at the same time as these painters were a body of artists who established a different mode of vision, employing social themes and a style close to Expressionism. Among them were those who constituted the Artistas del Pueblo group, which included the printmakers Adolfo Bellocq (1899–1972), Abraham Vigo (1893–1957), Facio Hebequer (1889–1935) and José Arato (1893–1929), and the sculptor Agustín Riganelli (1890–1949). They based their work on the ideas of Guyau and Tolstoy and their art focused especially on the urban and rural types of the marginalized classes. They believed in the transformation of society through art and sympathized with the goals of anarchist groups and of the Partido Radical. The Artistas del Pueblo were opposed to the 'moderns' and the formalism that they represented. Also significant at this time was the independent painter Benito Quinquela Martín (1890–1977) (who later adopted a repetitive and populist style). Other artists created a more personal idiom, including Gramajo Gutiérrez and Augusto Schiavoni (1893–1942), both from the interior of the country, who kept themselves independent from the artistic circles of Buenos Aires and created alternative images of the cosmopolitan nature of the capital city.

One of the problems of trying to define the essential character of the 1920s arises from the strategies used by the artists themselves. Norah Borges (1901–98), for example, spent many years in Spain in the circle of artists and writers who represented the avant-garde movement known as *Ultraismo*.[1] Pettoruti, who arrived in

279. Emilio Pettoruti – Pensierosa (Thinker), 1920.
oil on canvas, 64 x 49 cm. private collection, Buenos Aires

Argentina

280. ALEJANDRO XUL SOLAR – PUERTO AZUL (BLUE PORT), 1927.
watercolour on paper, 28 x 37 cm. Museo Xul Solar, Buenos Aires

281. ALFREDO GUTTERO – COMPOSICIÓN RELIGIOSA
(RELIGIOUS COMPOSITION), 1928. *chalk and colour on
board, 184 x 121 cm. private collection, Buenos Aires*

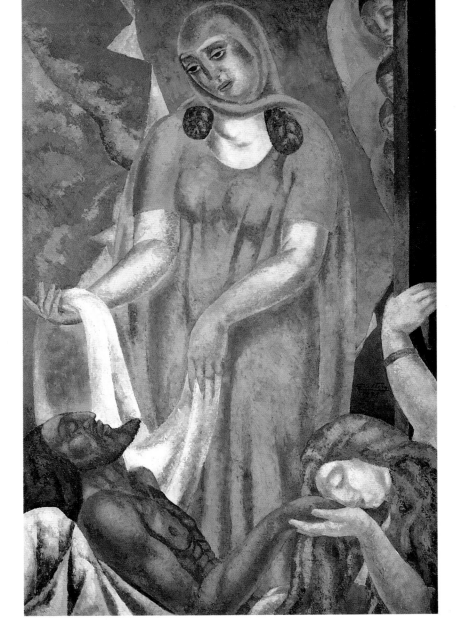

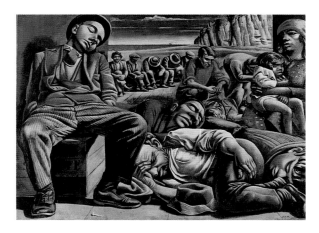

282. Antonio Berni – Desocupados
(Unemployed), 1934. tempera on burlap,
218 x 300 cm. private collection, Buenos Aires

Florence in 1913, was soon meeting many of the Futurist artists with whom he would remain in constant contact. His abstract work of 1914 demonstrates their influence, as does his participation in Salons and group exhibitions organized at that time in various Italian cities. The painter Alfredo Guttero (1882–1932) spent most of the years between 1904 and 1925 in Paris. His brief stay in Spain (1917–18), his trips to Germany, Austria and Belgium, and his later residence in Italy from 1925 to 1927 (the year he returned to Buenos Aires) gave him an intimate knowledge of European art movements.

Pettoruti, Guttero and Borges employed the strategies of the European avant-garde which they had absorbed abroad in seeking to incorporate their art into the local scene. They sought different sources of influence in order to establish themselves within the cultural milieu of Buenos Aires, which involved confrontation with existing modes.[2] A case in point is the Uruguayan painter Pedro Figari, who lived and worked in Buenos Aires between 1921 and 1925. In his paintings Figari unites a modern style with themes that evoke different aspects of the Creole past of the Río de la Plata region.

An examination of the work of such artists as Pettoruti, Xul Solar and the sculptor Pablo Curatella Manes (1891–1962), for instance, allows us to understand how such European forms as Cubism and Surrealism were assimilated and adapted. The various ways in which artists at this time would imbue what they had learned abroad with elements drawn from the literary, artistic and visual culture of Argentina, may be seen in Pettoruti's 1920 canvas *Pensierosa* (*The Thinker*; fig. 279), Guttero's *Composición religiosa* (*Religious Composition*, c.1927; fig. 281) and Xul Solar's 1927 *Puerto azul* (*Blue Port*; fig. 280).

The Pan-American or Andean references in the watercolours of Xul Solar, the allusions to the popular tango music of Buenos Aires in the paintings of Pettoruti and the sculpture of Curatella Manes also demonstrate this point.

The world economic crisis of 1929 coincided, in Argentina, with internal factors that culminated in the conservative military *coup d'état* which caused the fall of President Yrigoyen during his second term in office. The consequent growth in the political power of the army, the burgeoning conservatism of large sectors of the population, the strength of the cattle-raising bloc, the advance of Fascism, the growing influence of corporations, were all factors that contributed to the success of the coup. The so-called 'Conservative Republic' (also known as the 'infamous decade') came into being, supported by electoral fraud and shored up by the might of the armed forces and other state organizations that controlled the economy. Workers, on the other hand, began to organize themselves into syndicates at this time but they were ineffective in opposition.

The 1930s is a period of fundamental transition for the history of Argentine art. Most of the artists active at this time had studied in Paris in the studios of Othon Friesz and André Lhote. Unlike the aggressively modern generation of the 1920s, art now underwent a process of transformation in which a new artistic generation, of modest size, gradually imposed its own criteria. A variety of approaches and styles were now combined: the avant-garde attitude of an artist like Pettoruti, for example, was replaced by eclectic artistic vocabularies. There was, however, one group of artists – the Grupo de París – which maintained a relatively cohesive character. Its members included Héctor Baldasua (1895–1978),

Pedro Domínguez Neira (1894–1970), Raquel Forner, Horacio Butler (1897–1983), Aquiles Badí (1894–1976), Antonio Berni, Lino Spilimbergo and Alfredo Bigatti (1898–1964). In the art of many of these painters we find references to Italian mural painting of the fifteenth century and to de Chirico's *pittura metafisica*, as well as an interest in Surrealism and humanitarian subject-matter related to everyday life in Argentina, and to the events of the Spanish Civil War and the Second World War.

From the late 1920s onwards Antonio Berni (1905–81) painted, with distemper on rough canvas, a series of Surrealist works that explored social themes. Such images as *Desocupados* (*Unemployed*, 1934; fig. 282) and *Manifestación* (*Demonstration*) can both be seen as a South American painter's answer to Mexican Muralism. This approach to social art is different from that practised by the artists of the Artistas del Pueblo group. Berni's political leanings were influenced by Marxism as well as by his contacts with French intellectuals at the end of the 1920s. The figures in his canvases are placed in artificial spaces. They appear exaggeratedly foreshortened with their faces close against the picture plane. The perspective is unusual, the forms are monumental and the spaces, suggested by strong white lights and dry colours, are ambiguous. Berni employs a technique influenced by film stills and also incorporates elements of religious iconography.

The most audacious artistic ideas were those of Juan Del Prete (1897–1987) who, after working in the Concrete style in Paris, presented an exhibition of strictly formal Neo-figurative works in Buenos Aires, after which he came to be seen as a significant figure in the art scene of that city.

Argentina

The relationship of Argentine artists to Surrealism is an issue that is still open to debate. Throughout the 1920s Argentine artists applied the edicts of André Breton to their work, although in a much altered form. The paintings of Spilimbergo (1896–1964), Berni and Forner (1902–88), play with elements of artifice and absurd juxtapositions of objects, yet the flavour of their work is basically Expressionistic as in Raquel Forner's 1939 *Victoria* (*Victory*; fig. 284) from her series on themes relating to the Spanish Civil War. Juan Battle Planas (1911–66), on the other hand, announced his affiliation with Surrealism in 1934, mixing psychic automatism with his experiences of Zen Buddhism and his own psychoanalytic studies in drawings, collages and tempera paintings before turning to anecdotal Surrealism. His 1936 *Radiografía paranóica* (*Paranoid X-ray*; fig. 283) is one of the key works of the early phase of his career.

The decade of the 1940s was a complex time for creativity in Argentina. A variety of approaches to non-figuration dominated the scene, eclipsing the work of artists still faithful to the figure who, in one way or another, either maintained or modified the traditions of earlier decades. On the political front, tension was increased by a new *coup d'état* supported by pro-Nazi groups within the army and, later, by the ascendancy of the new president, Juan Domingo Perón. The socio-economic and demographic reordering of the country created a new industrial and manufacturing zone surrounding the capital, populated by a mass of factory workers. An incongruous alliance between the Church, the army and the unions (which were organized into the Confederación General de Trabajadores (CGT) or General Confederation of Workers) gave Perón a power base on a hitherto unequalled scale.

Among those elements contributing to the character of the new regime were a gigantic official propaganda machine, a sentimental style of political discourse, the development of a new labour policy, direct social action on the parts of Perón and his wife Eva, compulsory religious instruction, and a halt to the growth of public services as well as of the military and police forces.

The Perónist government announced itself in opposition to 'degenerate art'. In a speech delivered at the opening of the Salón Nacional in 1948, the Minister of Education, Oscar Ivanissevich, declared: 'Express beauty! It is very clear! Expressing beauty is rejecting ugliness, abnormality and perversion! Perversion of the eye, of ideas, of the heart and soul! ... the madness of Cubism, Futurism, Fauvism and Surrealism has been the work of those audacious, abnormal people who wanted to draw attention to themselves at all costs!'[3]

At the same time, a group of young artists brought Concrete art to the fore in Buenos Aires. Their work combined European sources – including Constructivism, the Bauhaus, Concrete art, Kazimir Malevich, Piet Mondrian, Max Bill, László Moholy-Nagy and Georges Vantongerloo – with the influence of Joaquín Torres-García, working from his studio in Montevideo, and that of the Creationist poet Vicente Huidobro. Despite these influences, the Buenos Aires Concrete artists quickly forged their own paths, and created new approaches to formal problems.[4]

After their association with the magazine *Arturo* (1944) and their two important exhibitions of 1945, the artists Gyula Kósice (b. 1924), Rod Rothfus (1920–72) and Carmelo Arden Quin (b. 1913) began to work together, forming the nucleus of the Grupo Madí, which held its first

283. Juan Battle Planas – Radiografía paranóica (Paranoid X-ray),
1936. tempera on paper, 35 x 25 cm. private collection, Buenos Aires

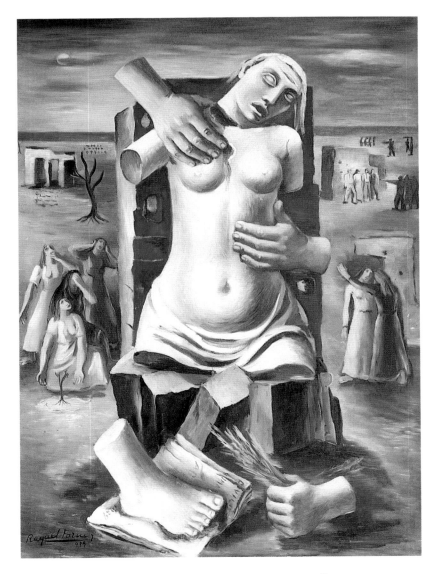

284. Raquel Forner – Victoria (Victory), 1939. oil on
canvas, 140 x 102 cm. Fundación Forner-Bigatti, Buenos Aires

Argentina

285. GYULA KÓSICE – RÖYI,
1944. wood, 99 x 80 x 15 cm.
private collection, Buenos Aires

show in 1946. They were joined by, among others, Diyi Laañ (b. 1927), Martín Blaszko (b. 1920) and Juan Bay (1892–1978). The manifesto written by the group stated: 'Madí painting is colour and two-dimensional in form. Its frames are cut down and irregular, surfaces flat, curved or concave. Its planes are articulated with linear, revolving or shifting movements.' Madí artists reassessed the importance of fantasy in their work, thus liberating it from the strict parameters of international Concrete art (initiated in Europe in the 1920s by artists such as Piet Mondrian, Theo Van Doesburg and Kazimir Malevich) which was primarily concerned with controlled organization, both in the work of art and in the creative process. Kósice's *Röyi* (1944; fig. 288) is an articulated wood sculpture which looks forward to some of the later works developed by the Madí Group.

 In 1945 Tomás Maldonado created the Asociación Arte Concreto Invención together with Alfredo Hlito (1923–92), Raúl Lozza, Manuel Espinosa (b. 1912) and Lidy Prati (b. 1921). Later, the sculptors Claudio Girola (b. 1923) and Enio Iommi (b. 1926) joined this group. All these artists signed the Inventionist Manifesto entitled 'To Neither Search Nor Find: To Create.' In 1947 Raúl Lozza (b. 1911) founded the Perceptismo Group which rounded out the rich panorama of this time. Lozza's 1945 sculpture *Relieve* (*Relief*; fig. 287) belongs to this period of artistic and theoretical reflection, as does Alfredo Hlito's *Curvas y series rectas* (*Curves and Straight Lines Series*, 1948; fig. 286).

 The aesthetic ideas of these three groups of Concrete artists acquire an even greater density when their thinking is contrasted with the tensions of the cultural politics of the Perónist period. In their manifestos, the

286. ALFREDO HLITO – CURVAS Y SERIES RECTAS (CURVES AND STRAIGHT
LINE SERIES), *1948. oil on canvas, 70 x 70 cm. Barry Friedman Ltd., New York*

287. Raúl Lozza – Relieve (Relief), 1945. polished
oil on wood, 42 x 57 cm. Galerie von Bartha, Basle

Argentina

289. RUBÉN SANTANTONÍN – COSA (THING), *1961. mixed media, 192 x 147 x 15 cm. private collection, Buenos Aires*

288. ALBERTO HEREDIA – ADÁN LENGUA, EVA LENGUA (ADAM TONGUE, EVE TONGUE), *1974. wood, paint, glue, canvas, nails, dentures, screws. Adam: 168 x 57 x 46.5 cm., Eve: 167 x 60 x 38 cm. private collection, Buenos Aires*

290. ALBERTO GRECO – SIN TÍTULO (UNTITLED), *c.1964. collage, ink, pencil and oil on canvas, 180 x 159 cm. private collection, Buenos Aires*

291. JORGE DE LA VEGA – DANZA DE MONTAÑA (MOUNTAIN DANCE), *1963. collage and oil on canvas, 195.5 x 129.5 cm. Jorge and Marion Helft Collection, Buenos Aires*

Concrete artists constantly referred to the idea of a collective art with a social message. In their eyes, art could be the means to construct a new world order.

The photography of Grete Stern (b. 1904) was related to that of the different groups which practised Concrete art in Buenos Aires. Stern was formed in the atmosphere of the Bauhaus. In 1949 she created a series of photo-montages entitled *Sueños* (*Dreams*) which became landmarks in the development of art in Buenos Aires at the time. Between 1939 and 1946 Lucio Fontana (1899–1968) worked in Buenos Aires, publishing his *Manifiesto blanco* (*White Manifesto*) in association with students at the Escuela Altamira. The conceptual and plastic tension of Fontana's 'cut' canvases, which he had completed in Milan, explored issues of density and space. Their relationship with Argentinian art of the period has not yet been fully explored.

As an alternative to Concrete art, some painters such as Sarah Grilo (b. 1921) and Miguel Ocampo (b. 1922), worked, at the beginning of the 1950s, in a freer abstract mode. Yet it was not until 1957 that a radical break with Concrete art occurred: this was brought about by the arrival on the scene of artists associated with the complex international movement known as Informalism. Argentine Informalism was initiated with the works of Luis Alberto Wells (b. 1939), Mario Pucciarelli (b. 1928) and Alberto Greco (1931–64). In Argentina this style may be best understood through its characteristic violence, in terms both of the underlying theory and of the method of creation, reflecting a nation whose history and everyday life were so marked by violent occurrences. In a similar vein, a clear line of development in terms of inherent tensions can be traced from Fontana's 'cut' paintings through

the recent work of artists such as Oscar Bony (b. 1941), whose work incorporates gunshots.

One of the principal pioneers of this new, radicalized art was Alberto Greco who wrote, in his manifesto, *Vivo Dito*, of July 1962: 'Living art is the adventure of the real. The artist teaches people to see not with his painting but with his finger.' His untitled work of *c*. 1964 (fig. 290), exemplifies the spirit of his writings.

The art of those associated with the Otra Figuración (Other Figuration) group can be related to such international movements as CoBrA and Informalism. Beginning in the early 1960s, the New Figuration of Luis Noé (b. 1933), Ernesto Deira (1928–86), Rómulo Macció (b. 1931) and Jorge de la Vega (1930–71) sought to reinstate the figure into artistic discourse, provoking the viewer by emphasizing its materiality on the one hand and fragmenting it on the other. Other artists, such as Carlos Alonso (b. 1929) and Antonio Segui (b. 1934), were also closely involved with this 'return' to figuration. De la Vega created ever more intense and fantastical collages in which he exorcized his monsters on surfaces made of glued-together rags, as in the 1963 *Danza de montaña* (*Mountain Dance*; fig. 291). The violence of his subjects and textures was contemporaneous with the change in direction of the art of Antonio Berni who, since 1960, had been creating series of works based on two archetypal, marginalized characters: Juanito Laguna, a boy from the city slums, and the prostitute Ramona Montiel. Berni makes use of actual rubbish in his collage paintings and woodcut engravings, of which the thrown-away objects affixed to the wood are an integral part.[5]

The tension created by de la Vega's rags and the debris employed by Berni find their perfect counterparts in the terse *arte-cosa* (art-

object) works by Rubén Santantonín (1919–69). These are canvases or pieces of cardboard that define objects which are hung or take the form of reliefs with craters, protuberances or holes. 'My objects pierce your eyes, invade your skin through all its pores …' wrote Santantonín in 1961,[6] the year of the creation of the mixed-media piece *Cosa* (*Thing*; fig. 289).

During the same years, Emilio Renart (1925–92) displayed, in the imagery of his *Biocosmos* series, another example of the radical nature of Argentine art of the time. Desire, sexuality, struggle, official and creative liberty, are all elements embodied in these works. When, in 1963, Alberto Heredia (b. 1914) mounted a display of Camembert boxes at the Galería Lirolay in Buenos Aires, he placed before the public a profoundly poignant emblem of life in the country. These recognizable containers symbolized the game of life, death and fear, defying the spectator to open, and thus defile, them. Since then Heredia has developed into one of Argentina's most provocative local artists. A good example of his aesthetic is *Adán lengua, Eva lengua* (*Adam Tongue, Eve Tongue*, 1974; fig. 288).

At the same time Argentine art witnessed the development of geometric abstraction, as practised by Ary Brizzi (b. 1930), Eduardo MacEntyre (b. 1929), Miguel Angel Vidal (b. 1928), Rogelio Polesello (b. 1939) and Carlos Silva (1930–87). Kinetic art was represented by the triumph of Julio LeParc (b. 1928) at the 1966 Venice Bienale[7] and by the opening of the famous Instituto Torcuato di Tella with the works of Marta Minujín (b. 1943), Delia Cancela (b. 1940), Dalila Puzzovio (b. 1942) and Pablo Mesejean (b. 1937). The objects and paintings of Roberto Aisenberg (1928–96), the 'sinister art' of the polychromed wood pieces of Libero Badí

Argentina

292. VÍCTOR GRIPPO – ANALOGÍA IV (ANALOGY IV), 1972.
wooden table with mixed media and objects, 76 x 94.5 x 59 cm.
Jorge and Marion Helft Collection, Buenos Aires

(b. 1916), the geometry and elemental vision of Alejandro Puente (b. 1933) and César Paternosto (b. 1931), and the formal experiments of Marcelo Bonevardi (1929–94) (the last two of whom lived for years in New York), were equally significant for the art scene in Buenos Aires in the 1960s. The period also saw the rise of Pop art with the painting of Nicolás García Uriburu (b. 1937), an artist who did an 'ecological work' in the canals of Venice in 1968, together with happenings, environments, objects, Neo-Surrealism, Neo-Dadaism, political art and early conceptualism. It was notable, too, for the development of radical experimentation in the works of Margarita Paksa (b. 1933), Ricardo Carreira (1942–93), Roberto Jacoby (b. 1944), Pablo Suárez (b. 1937), Oscar Bony, Leopoldo Maler (b. 1937), David Lamelas (b. 1944), Antonio Vigo (b. 1928) and León Ferrari (b. 1920).[8] Many of the artists working at this period ultimately abandoned experimental art, however. Some returned to traditional concepts of painting while others stopped working, in some cases for many years, a phenomenon that could be labelled the 'collective suicide' of a generation of artists.

To fill the void in the early 1970s, those artists associated with the Centro de Arte y Comunicaciones (CAYC) began their own visual experimentation.[9] Working there was a group known as the Grupo de los Trece (Group of 13) including, among others, Víctor Grippo (b. 1936), Luis Fernando Benedit (b. 1937), Jacques Bedel (b. 1947) and Clorindo Testa (b. 1923). Most representative of the experiments of these artists are Benedit's *Boleadoras* (1990; fig. 294) and Grippo's table with objects, including place-settings and potatoes, entitled *Analogía IV* (*Analogy IV*, 1972; fig. 292).

Also at this time Juan Carlos Distéfano

(b. 1933) began to use polyester resin as a medium in works which seek to define the collective fate of Argentina. His images, with their absurdly literal interpretation, attempted to transform contemporary situations, to create a testimony to events that otherwise would have passed unrecorded. *Teleraña* (*Spider's Web*, 1973–4; fig. 296) is a good example of his powerful work. Aldo Paparella (1920–77) created, in his *Useless Monuments* series (1971–6; fig. 293) and *Phantasmal Objects* (1971–6), clear narratives of a disjointed community. The plaster, cardboard and white columns represent the mystery of a nation without hope.

The military regime of General Onganía, which took over in 1966, represented a last gasp of Perónism and created a collective sensation of a nation of survivors. In response to the circumstances faced by Argentina at that moment, Norberto Gómez (b. 1941) created works in resin representing intestines and skeletons. He subsequently developed his torture instruments, and his 'Gothic' images in plaster, painted to imitate bronze funerary monuments, such as the 1988 *Sin título* (*Untitled*; fig. 295).

The 1970s also saw the development of a variety of approaches to realism, especially after the military dictatorship of 1976 which seized power from Isabel Perón who had become President of Argentina following the death of her husband in July 1974. The artists involved in this realist movement included Ricardo Garabito (b. 1930), Mildred Burton (b. 1943) and Antonio Seguí.

In the early 1980s, between the Falklands War and the return to democracy, a type of Post-modernity grew up in Buenos Aires. Painters such as Alfredo Prior (b. 1952) and Guillermo Kuitca (b. 1961) found their own

293. ALDO PAPARELLA – MONUMENTO INÚTIL NO. 92 (USELESS MONUMENT NO. 92), 1971–2. *wood and mixed media, height 183 cm. collection of the family of the artist, Buenos Aires*

294. Luis Fernando Benedit – Boleadoras, 1990. *mixed
media (pencil, watercolour, boleadoras, balls, sculpture),
dimensions variable. collection of the artist, Buenos Aires*

296. Juan Carlos Distéfano – Telaraña (Spiders Web), 1973–4.
*reinforced polyester and enamelled epoxy, 110 x 55 x 65 cm. Jorge and
Marion Helft Collection, Buenos Aires*

295. Norberto Gómez – Sin título (Untitled), 1988. *polychromed
plaster, 90 x 52 x 32 cm. private collection, Buenos Aires*

297. ROBERTO ELÍA – KOSMOS (COSMOS), *1993.*
mixed media on wood, 64 x 123 x 7 cm.
collection of the artist, Buenos Aires

Argentina

298. GUILLERMO KUITCA – HOUSE WITH AIDS, 1987. *acrylic on canvas, 157 x 214 cm. Jorge and Marion Helft Collection, Buenos Aires*

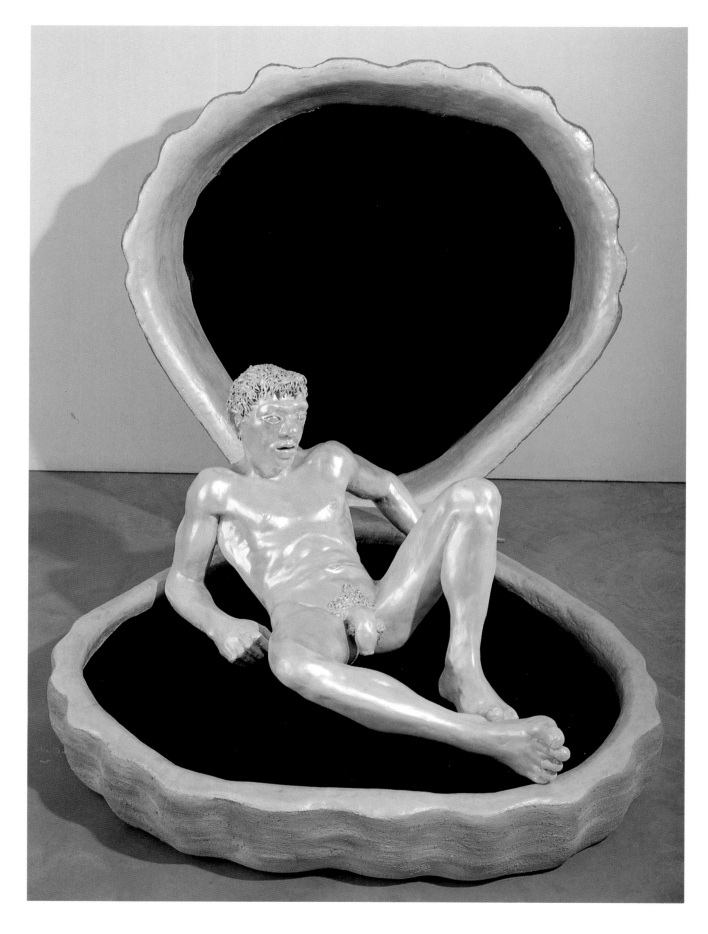

299. PABLO SUÁREZ – TAXI BOY EL PERLA, 1992. *polyurethene,*
paint, synthetic leather, metal and wood, 102 x 96 x 135 cm.
Jorge and Marion Helft Collection, Buenos Aires

Argentina

300. LILIANA PORTER – EL SIMULACRO (THE SIMULACRUM), *1991. acrylic, silk-screen and collage on paper, 101.7 x 152.4 cm. collection of the artist, New York*

solutions to artistic problems amidst the stifling climate of conceptualism and the international emphasis on Neo-figuration. An example of Kuitca's characteristic 'house-plan' paintings may be seen in the 1987 *House with AIDS* (fig. 298). Yet, we might ask, what Post-modernity did these artists create and to what modernity were they responding? In New York, Liliana Porter (b. 1941) made prints and assemblages with a conceptual base in the spirit of Jorge Luis Borges, such as *El simulacro* (*The Simulacrum*, 1991; fig. 300). Pablo Suárez (b. 1939) exhibited works whose images and titles reflect a corrupted visualization of observed and recorded reality, as in *Taxi Boy El Perla* (1992; fig. 299).

At the same time there arose a number of artists not associated with any 'ism', such as Hernán Dompé (b. 1946) who invented objects of sticks and stones as well as niches enshrining bones. Roberto Elía (b. 1950) creates everyday objects with allusions to alchemy, the cabala, the writings of Julio Cortázar and his own secret imagination, as displayed in his 1993 mixed-media piece *Kosmos* (*Cosmos*; fig. 296). The growing hermeticism of these artists is in stark contrast to the public nature of street activities or performances such as that called the *Siluetazo* (*Large Silhouette*) of 1983, and the actions of the Resistance Marches of 1984 and 1985, protesting against the actions of the government.[10]

Contemporary Argentine art continues its process of self-examination in the 1990s. Artists continue to produce their work in a climate of fragile equilibrium between the national and the international. Memory is suppressed through the necessity to transform reality. Art continues to be made in an anxious environment where the future is nervously anticipated.

Milan Ivelic

Chile

LATIN AMERICAN ART IN THE TWENTIETH CENTURY

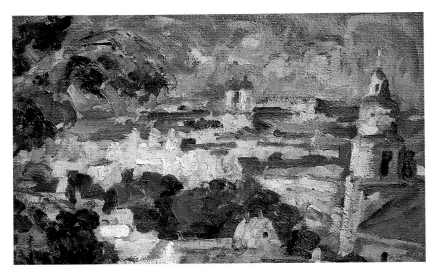

301. Juan Francisco González – Panorama de Santiago
(View of Santiago), *n.d. oil on canvas, 18 x 32 cm. Museo
Nacional de Bellas Artes, Santiago*

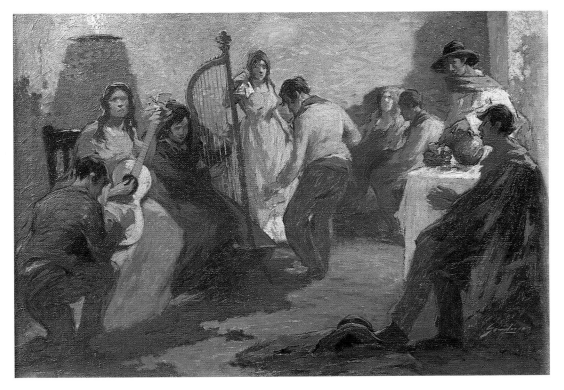

302. Arturo Gordon – Zamacueca, *n.d. oil on canvas,
56 x 77 cm. Museo Nacional de Bellas Artes, Santiago*

Ruptures in a System

The International Exposition of 1910 presented in the Museo Nacional de Bellas Artes in Santiago, organized to celebrate the centenary of Chile's independence, did little more than confirm the aesthetic orientation of the majority of artists at the time and validate the taste of the high society that subscribed to it.

Since the founding of the Academia de Pintura in 1849, an artistic system which was self-sufficient in its production, reception and legitimization had become institutionalized in Chile. It represented the inclinations and aesthetic perceptions of the ruling class. Within this artistic system the responsibility for the establishment of norms and the diffusion of art rested with two organizations: the Consejo de Bellas Artes (Council of Fine Arts) and the Escuela de Bellas Artes (School of Fine Arts).

The works shown at the Exposición del Centenario in 1910 were by various academic artists from a number of countries, who had been selected by the Consejo de Bellas Artes on the principle of their adherence to the canon of European styles that had been established in Chile. Numerous Chilean painters and sculptors had travelled to Europe to further their talent in official artistic circles, absorbing concepts which they considered to be the only means of expressing the essence of beauty. They then brought these systems back with them to Chile and thus combined them with traditional modes of taste.

This stance was explained with particular clarity by the French critic, resident in Chile, Ricardo Richon-Brunet (1866–1946), in his introduction to the catalogue of the Exposición del Centenario.[1]

Writers often affirm that Chilean art only dates back to the mid-nineteenth century,

Chile

omitting any references to painting of the colonial period and overlooking the work of the early nineteenth-century painter José Gil de Castro (1785–1841), a figure of undoubted importance for his portraits done in both Chile and Peru at the beginning of the period of political emancipation from Spain. According to Richon-Brunet, the happy circumstance of the arrival of the French painter Raymond Monvoisin (1790–1870) was important for Chilean artistic aspirations. In his analysis of the 1910 exhibition, Richon-Brunet bases his commentary on perceptions of style or associations with the European schools. He recognizes, for example, the quality of the work of the painter Alberto Valenzuela Llanos (1869–1925) as 'impregnated with the spirit of the French school of landscape painting'; or, in discussing the art of Nicanor González Méndez (1864–1939), states that '[his work] recalls paintings of the best period of the French master Gervex'.

Despite the enthusiasm of this apologist for European academic art, Chilean painting and sculpture did manage to escape the domination of imported styles. After half a century of uninterrupted sway, the academic tradition began to be undermined by various artists working during the last decades of the nineteenth century. Painters like Alfredo Helsby (1862–1933), the aforementioned Alberto Valenzuela Llanos, the sculptor Lorenzo Domínguez (1901–63) and especially Juan Francisco González (whose work was omitted from the Exposición del Centenario) were especially important for their roles in the renewal of Chilean art. González's *Panorama de Santiago* (*View of Santiago*; fig. 301) demonstrates the refreshingly novel qualities which González brought to art in Chile at this time.

The Exposición Internacional del Centenario represented the culmination of an artistic system, and, at the same time, the end of a lengthy aesthetic phase. After this turning-point, new ideas gained in strength and vigour, causing violent discord in the art world during the early decades of the twentieth century.

The first indications of renewal in the early twentieth century appeared with a group of young painters who had been taught at the Escuela de Bellas Artes by the Spanish artist Fernando Alvarez de Sotomayor. As their first group show took place in the exhibition hall of the newspaper *El Mercurio* in 1913, they became known as the Generación del Trece (Generation of 1913). Among the most outstanding artists of the Generation of 1913 were Arturo Gordon (1883–1944), whose painting entitled *Zamacueca* (fig. 302) typifies this tradition, Exequiel Plaza (1892–1947), Pedro Luna (1896–1956) and Agustín Abarca (1882–1953).

Alvarez de Sotomayor encouraged his students to intensify their colour, showing them the rich possibilities of impasto and the use of pure tones. He also directed them to the observation of details of everyday life, stressing the importance of straightforwardness and the avoidance of pretence and sociological content in art: values which reflected the social conditions of the painters themselves, all of whom had come from humble backgrounds. This fact tended to reinforce the group's break with the attitude of exclusivity which prevailed among artists from the upper levels of society who had previously enjoyed huge popularity. Another important influence on this group was Juan Francisco González (1853–1933), a sort of spiritual father, who based his artistic philosophy on creating mobility and dynamism in his images and

distancing himself from the rigid and immutable structures of academicism.

By 1913 the Escuela de Bellas Artes had become more democratic in its admissions policy, offering free tuition to students of modest circumstances. A system of fellowships benefited the most talented artists, allowing them to perfect their art in Europe. This patronage by the state gradually diminished until the 1970s saw its complete withdrawal.

The Generación del Trece carried on the artistic revolution initiated by Juan Francisco González. They rejected academic demands, such as the use of the model, basing their art on their own experiences and observations of life in Chile as well as its landscape. This coincided with an awakening of nationalist sentiment in artistic circles in opposition to the cult of Europeanism. This nationalistic fervour, which was also demonstrated by the appearance of native themes in literature and music, may be observed – with much greater intensity – in the cultural life of other Latin American countries. It contributed towards the Mexican Revolution of 1910 and was taken up by the Muralists in the 1920s. Indigenism would also appear in the culture of other nations with significant native populations, as would the reconsideration of African roots in those societies where this ethnic element had been introduced through successive waves of forced immigration.

The avant-garde was born in Latin America in the 1920s on the basis of European modes. The Week of Modern Art, a festival of the most outstanding new forms in painting, sculpture, architecture and other art forms held in São Paulo in 1922, represented a significant step in the direction of Latin American modernism. In Chile the most outstanding break with

Chile

tradition was produced in 1923 by the Grupo Montparnasse comprising Luis Vargas, Julio Ortiz de Zárate (1885–1946), Henriette Petit (1894–1983) and José Perotti (1898–1956). This group, named by Luis Vargas who had spent a long period of time in Europe, led the way in breaking with the representational concepts of painting, under the influence of Cézanne and later of Fauvism and Cubism. In fact, two years later, in 1925, the Montparnasse Group, which by then included two other members, Camilo Mori (1896–1924) and Manuel Ortiz de Zárate, participated in another exhibition in which works appeared by Gris, Léger, Marcoussis, Lipchitz and Picasso. Also shown were the calligrams of the poet Vicente Huidobro, founder of a movement known as Creationism and an important member of the literary avant-garde.

The work of Luis Varga (1897–1977), which featured compact, stable structures, strove to suggest the objective values of the things painted, as in the 1924 *Naturaleza muerta* (*Still Life*; fig. 303). Manuel Ortiz de Zárate (1887–1946) expressed similar concerns. During his many years in Paris he came to know Modigliani, Gris, Derain and Braque. Henriette Petit created firmly structured works based on the human figure from which all extraneous elements were eliminated. The versatile Camilo Mori also participated in the modernist movements, including Cubism, Constructivism and Surrealism, in his tireless search to express a personal aesthetic.

The controversy between those who believed in the conventional academic system and those who promoted a renewal of Chilean art was brought to a head with the closure by the government of the traditional Escuela de Bellas Artes. The official reason given for this was the

urgent need to train art teachers working in urban centres. Twenty six artists were selected to travel to France in 1928, some of whom had shown their support for the successful Montparnasse Group by participating in the controversial Salon held earlier in the year. Among them, and of particular significance, were two members of the Generation of 1928: Hernán Gazmuri (1900–79) and Agusto Eguiluz (1893–1969). The work of Eguiluz, influenced by his acquaintance with the art of Cézanne as well as with Fauvism and Cubism, was shown in a recent retrospective exhibition at the Museo de Bellas Artes in Santiago.

From Post-Impressionist Figuration to Geometric Abstraction

Two basic approaches to the development of Chilean art in the first decades of the twentieth century may be discerned. The first is based on a subjective artistic vocabulary. Gesture as well as staining techniques are of prime importance. The precursors for this approach can be found in the work of Juan Francisco González and that of the artists who comprised the Generation of 1913, as well as in the art of some of the painters of the Generation of 1928. It is equally important later in the work of a number of the artists of the Generation of 1940 including, among others, Ximena Cristi (b. 1920), Sergio Montecino (b. 1916) and Carlos Pedraza (b. 1913).

The master of the Generation of 1940 was Pablo Burchard (1873–1964), an artist who distanced himself from the most significant influences of his day, taking refuge in his own solitude and encounters with nature, as reflected in his painting *Otoñal* (*Autumnal*; fig. 304). His teaching had a strong influence on those members of the Generation of 1940 who took

up landscape painting, one of the most prolific themes in Chilean art. At the same time these artists utilized techniques derived from Post-Impressionism such as saturated colour, the use of rapid sketches and thick impasto. Like most of the artists of their time, they de-emphasized the accurate rendering of observed reality.

The second approach is related to the inclination (derived from Cézanne) of the Montparnasse Group to fix on the conceptual aspects of artistic phenomena. The Generation of 1940 concentrated on formal problems as an autonomous activity. The first indications of this autonomy of form, which later culminated in geometric abstraction, can be seen in the work of Luis Vargas prior to 1930 and in some of the paintings of Hernán Gazmuri and Augusto Eguiluz.

The year 1955 witnessed the formation of the Grupo Rectángulo, which sought to eliminate natural forms through rigorous composition, pure colour harmonies and flat, schematic drawing. The group evolved as a 'reaction to the emotive, sentimental attitude', according to its founders, alluding to such artists as the members of the contemporaneous Generation of 1940.

Rectángulo had affinities with the vast abstract movement in Latin America whose forerunners were the Uruguayan Joaquín Torres-García and the Argentinian Emilio Pettoruti. The exhibition of Pettoruti's paintings in the Museo de Bellas Artes in 1950 captured the attention of the future members of Rectángulo and his work continued to reinforce their convictions.

In 1965 a crisis occurred in the Grupo Rectángulo, attributed by Ramón Vergara to the triumph of Informalist Abstraction which 'turned its back on all forms of artistic discipline'. Vergara had correctly perceived that Informalism

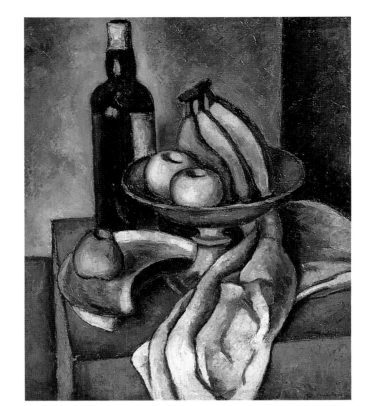

303. Luis Vargas – Naturaleza muerta (Still Life), 1924.
oil on canvas, 65 x 54 cm. Museo Nacional de Bellas Artes, Santiago

304. Pablo Burchard – Otoñal (Autumnal),
*n.d. oil on canvas, 96 x 96 cm. Museo Nacional
de Bellas Artes, Santiago*

Chile

was directly opposed to the type of geometric-Constructivist painting that had been developed by the original members of Rectángulo. Informalist abstraction expressed its emotional content not in the subject but through pictorial materials, textures and the use of non-traditional elements. Despite this period of crisis for Rectángulo, its most orthodox members regrouped around carefully articulated ideas, rejecting any artists who wished to join the group but would not work with 'pure' elements or cultivate the Constructivist aesthetic and the rigour of geometric abstraction. The Grupo Forma y Espacio, which was established in 1965, included some of the former members of Rectángulo as well as a number of younger artists.

Geometric abstraction did not develop in Chile as it did in other Latin American countries such as Argentina, Venezuela, Brazil or Mexico. This may have been because it was not much encouraged by teachers in university art departments or possibly because the highly formalized language of abstract art demands a rigorous discipline and the development of a pictorial logic that is alien to national art traditions. The arrival in Chile in 1958 of the Cuban Mario Carreño, who had been exploring Abstract Constructivist painting, proved to be a stimulus to the members of Rectángulo. From 1950 onwards, Carreño simplified and schematized his paintings in order to perfect their formal values. He worked with geometric forms with extreme rigour, overlapping the planes in his pictures. Transparency and subtle colour became ends in themselves for Carreño and the members of the Grupo Rectángulo. This phase, which would endure throughout the 1950s, was described by Carreño as: 'Abstract Constructivist (non figurative) painting based on pure, essential

values, free from influences extraneous to painting itself, manifested in an independence comparable to that enjoyed by music.'[2] Elements of this aesthetic can be observed in a somewhat later work, *Imágenes del comienzo* (*Images of the Beginning*, 1961; fig. 305).

Sculpture did not remain on the periphery of the changes that were occurring in Chilean art, although its development was slower due to the weight of the academic traditions that had been in place since the nineteenth century and seemed to prolong neo-classical models into the first three decades of the twentieth. Thanks to the influence of some forward-looking younger sculptors, as well as to the artists' first-hand knowledge of the work of important international figures, a definitive break with the heritage of the nineteenth century occurred after the 1940s.

Two women artists, Lily Garafulic and Marta Colvin, students of Lorenzo Domínguez and Julio Antonio Vázquez respectively, completed their formative periods in Europe. Garafulic (b. 1914), who knew Constantin Brancusi, came to understand how the language of volume could be divorced from any representational element to achieve a pure play of forms. In Europe, Colvin (b. 1917) had such teachers as Henri Laurens and Ossip Zadkine and also knew Henry Moore. Her visits to the pre-Columbian archaeological sites of Chile and to Easter Island led to her adoption of a mode related to her Latin American roots in her non-figurative work. She fashioned her art from blocks of wood, stone or metal put together to form a constructive system, or ensemble, composed vertically and expanding horizontally. Deep incisions, especially in her wood pieces, accentuate the directions of the columns, rhythms and tensions. The international reputation of Marta Colvin was confirmed

in 1965 when she was awarded the prize for sculpture at the seventh São Paulo Bienal. Many of her monumental works are to be found in Europe, especially in France.

It is difficult to establish stylistic groupings or schools in Chilean sculpture because of the diversity of approaches. Because the individual working alone in his studio has been the norm, there has been a lack of dialogue among artists and, at the same time, a paucity of theoretical discourse initiated by the sculptors themselves. The dearth of exhibiting opportunities, the costliness of making sculpture and the lack of a market have all served to limit the number of sculptors and also help to explain why sculpture has remained on the margin of historical or critical writing in Chile.

Strategies for Modernism

During the first half of the twentieth century Chilean art was noted for assimilating international art movements which had already lost their novelty abroad. Owing to the country's geographical distance from international art centres, as well as Chile's peculiar cultural, sociopolitical and economic circumstances, these artistic trends bore little relationship to the settings from which they had emerged. In addition, these international movements were embraced in a fragmentary manner in Chile.

It is important to point out the weak relationship between art and Chilean society during the first half of the century. Within the artistic milieu, an 'art for art's sake' attitude had been predominant which tended to distance art from historical reality. Only the incipient Mexican-influenced Mural Movement of the 1940s and 1950s, developed by such artists as Gregorio de la Fuente (b. 1910), Julio Escaméz (b. 1926) and

José Venturelli (1924–88), and the efforts of socially concerned printmakers like Carlos Hermosilla (b. 1905), made any headway in integrating the precarious social and economic conditions of the working classes into the subject matter of art.

In the early 1960s a definitive rupture with the Post-Impressionist tenets of the first half of the century, as well as a break with the geometric abstraction of the Grupo Rectángulo, came about. This was initiated by the proposals of the Grupo Signo, comprising José Balmes, García Barrios (b. 1930), Eduardo Martínez (b. 1932) and Alberto Pérez (b. 1928). The group assimilated the Informalist abstraction of the Catalan painters Antoni Tàpies and Modest Cuixart, causing a profound change in the Chilean artistic scene. This was reinforced by the presence of uncompromising anti-academic painting that liberated pictorial material from unpremeditated gesture, accident and chance, and also incorporated unusual elements, undermining the notion of beauty and the virtuosity of abstract execution.

Soon the Grupo Signo were incorporating their Informalist experiences into the political situation of the times, problematizing Chilean and Latin American historical realities. An iconography of denunciations flourished in the art of the group, together with a certain epic tone stemming from the triumph of the Cuban Revolution and its undoubted repercussions on the South American continent.

Methods of production were not based exclusively on the traditional materials of painting. Other means were employed to memorialize specific incidents, such as photographs in newspapers and magazines; headlines or newspaper texts that described dramatic or terrifying news

305. Mario Carreño – Imágenes del comienzo (Images of the Beginning), 1961. oil on canvas, 91 x 76 cm. Museo Nacional de Bellas Artes, Santiago

306. JOSÉ BALMES – PROYECTO PARA UN RETRATO
(PROJECT FOR A PORTRAIT), *1967. oil on canvas,*
180 x 150 cm. Museo Nacional de Bellas Artes, Santiago

items; urban detritus of a variety of types to connote poverty and marginalization, and a number of techniques derived from collage.

In this way, for instance, the artist José Balmes (b. 1927) combines graphic elements with painting and imposes a vital movement on every stroke and every stain of the canvas by utilizing the thickness and density of his materials, as seen in his 1967 *Proyecto para un retrato* (*Project for a Portrait*; fig. 306). At the same time Balmes selects and places words, numbers and symbols like a sort of clandestine graffiti as if to simulate a wall which has been the receptacle for the anonymous protest writings of a nation.

The political climate of the 1970s in Chile undoubtedly contributed to the creation of an art whose iconography denounced the national situation and, in its execution, served as a form of renewal, as the Signo Group demonstrated. Urban Muralism also sprang up in the hands of members of the 'urban brigades': Ramón Parra of the Communist Youth Group and 'Inti' Peredo and Elmo Catalán of the Socialist Party. This had its origins in the electoral campaign of 1964, when the brigades had begun to create visual propaganda for the Socialist candidate Salvador Allende. Their efforts were renewed in 1970 when Allende, in his second attempt, won the presidential election.

Urban Muralism is a cultural phenomenon that has tended to be ignored by art historians and the media, given the assumption that it did not arise from the work of professional artists or because of its political content. Such works, by amateurs or art students, do indeed have a debatable relationship to 'high art', as opposed to the Mexican or the Chilean murals already discussed.

Chile

Urban murals were, in effect, an uneven and apparently inferior appropriation of institutionalized pictorial modes: they were the result of a collective project and employed techniques which were far removed from the careful methods of easel painting.

During President Allende's term of office, the programme of the Unidad Popular (the multi-party leftist organization that brought him to power) was illustrated in large urban formats in which text and image co-existed to promote unequivocal adherence to the government. After the military coup of 11 September 1973 which overthrew Allende, the members of the urban brigades went underground, only to reappear in the 1980s in suburban locations or in protected surroundings, such as union headquarters, with murals protesting against the military government.

Not until the plebiscite of 5 October 1988, when the proposed continuation of General Pinochet in government was put to the public vote, did the brigades return to the streets in opposition to the military, clearly demonstrating their staying power. If the earlier murals had displayed a strong epic, denunciatory and messianic content, in a monumental format vaguely recalling Mexican Muralism, after the plebiscite and the demonstration of popular support for the candidate who opposed the military government, Patricio Aylwin, their iconography dealt with images much closer to the characters in comic books and animated cartoons, or the images of popular music bands, intermixed with situations and facts of Chilean history. There was an odd symbiosis between elements of national identity and culture and signs and symbols from mass culture (preferably American), especially those derived from television. After the triumph of Aylwin in the 1990 elections, urban Muralism disappeared, largely due to the absence of political confrontations following the re-establishment of democracy and the end of the military government.

Critical Revision

The military coup of September 1973 was a dramatic historical event which affected most of the nation and had repercussions in all areas of artistic activity. The art world in Chile was profoundly altered by the dismissal of numerous professors from the Escuela de Bellas Artes of the Universidad de Chile, censorship of free expression of ideas, surveillance of the universities and the appointment of members of the armed forces as Rectors. All this produced a true paralysis in artistic life which momentarily crippled Chile's creative capacity.

With the passage of time and the gradual recovery of artists from this traumatic experience, certain tendencies began to develop. One of these, which could be called an 'aesthetic of expiation', arose through a feeling of collective guilt over the loss of democratic values. Another, which might be termed an 'aesthetic of rejection', was born of reflections and judgements arising from the contemplation of a shattered democracy.

Both orientations, which were interconnected, were not only linked to historical circumstances (which became more and more machiavellian in dividing Chileans into 'good' and 'bad' camps); they were also related to the critical analysis to which the language of art submitted itself. Thus, the tendencies of the Signa Group were prolonged as well as those of such artists as Francisco Brugnoli (b. 1935), Juan Pablo Langlois (b. 1936) or Hugo Marín (b. 1930) who, in the 1960s, had developed visual experiences marginal to painting or sculpture in their use of objects as a means and an end in their experiments, prefiguring the art of installation.

But there was an important difference between then and now. Whereas, in the previous decade, artistic renewal was undertaken in a spirit of optimism, in the present decade it was the product of a desperate, pessimistic and anguished mood.

One group of Chilean artists who arose in the 1970s developed artistic practices based on their conscious realization of the historical conditions of the milieu. They established a close relationship between the materiality of their work and the social and political realities of their lives. Those who opted for this critical and self-critical stance were obliged to rethink the artistic process in its totality in order to reorientate it within a context marked by the loss of democratic values: the violation of human rights, repression, and censorship by a regime that proclaimed a supposed single and exclusive truth.

This group had lost confidence in the artistic circuit of which its members had been a part during their apprenticeship as well as in the creation of their works. They considered that this heritage was incompatible with the insecurity, uncertainty and the risks that they were now taking in their lives. They therefore renounced painting, printmaking and sculpture in their traditional forms and put into practice processes based on their own bodies as a means of autobiographical expression. They utilized urban space (Grupo Colectivo de Arte), gave new meaning to everyday objects, created precarious channels for disseminating their work and proposed a counter-discourse for the history of Chilean art. In each of these cases, the point of reference was

Chile

307. EUGENIO DITTBORN – PIETA (PRE-SYDNEY), *1983.
paint and photo silk-screen on polypropylene, 120 x 150 cm.
Museo Nacional de Bellas Artes, Santiago*

the social body, whether with allusion to autobiography – as with Carlos Leppe (b. 1952); in the subversion of domesticated human behaviour through urban signs – as in the case of Lotty Rosenfeld (b. 1943); in the use of rubbish to signify economic and social marginality – as with Francisco Brugnoli; in emphasizing the peripheral nature of Chilean artistic circles – as with Eugenio Dittborn (b.1943), creator of 'airmail paintings' such as *Pieta* (*Pre-Sydney*) of 1983 (fig. 307); or through criticism of the 'sentimentalism' of Chilean painting – as in the case of Gonzalo Díaz (b.1947).

None of these proposals was realized as an organic whole. They were, rather, mounted in segments which, in part, reflected the fact that Chilean art was made up of bits and pieces of international culture. This fragmentary approach also emphasized the inarticulacy of the social body and political institutions under the military regime.

Artists, no longer pursuing traditional methods of production, aligned themselves with those procedures adopted by the international neo-avant-garde: the reactivation of the proposals of Duchamp, the use of installation, performance or the body, or the combination and interaction of multimedia (photography, prints, serigraphs, video). The appropriation of these methods was neither an imitative gesture nor did it reflect a submissive attitude towards international influences. It constituted, rather, a process of recontextualization in a specifically Chilean milieu.

When this new critical vision arose, one could sense on the part of artists a re-evaluation of certain recurrent phenomena in the history of Chilean art, such as servility towards foreign movements, dependency on influences from abroad and the ineffectuality of the internal arts

circuit in making Chile's presence known in an international market. Artists took their subjects from all of these references, stripping them of the significance with which international discourse had imbued them, and claiming their right to invest them with new values, thanks to a process of continually evolving meanings.

This new vision was the most radical departure that Chilean art had experienced in the twentieth century, both in the practice of art and in the theoretical and critical discourse which analysed and validated it.

Parallel Paths

Painting continued to play a key role in Chile even during the years of the greatest conceptual and confrontational innovations. Pictorialism, put to the test by the new visual concepts just discussed, proved indomitable thanks to the powerful influence of Roberto Matta (b. 1911) with his enormous international prestige. Matta represented a beacon across the generations. His work, with its ambiguous, poetic qualities typified by the 1942 canvas *El día es un atentado* (*The Day is a Transgression*; fig. 308), suggested new paths for certain Chilean artists.

As we have seen, at the beginning of the 1960s the Signo Group had turned towards gestural abstraction, a mode to which other artists, such as Guillermo Núñez (b. 1928) and Roser Bru (b. 1923), adhered. In this same decade, the search for visual imagery imbued with surrealist poetry was explored by Rodolfo Opazo (b. 1935), Mario Toral (b. 1924) and Ricardo Yrarrázabal (b. 1931). Opazo considers artistic creation 'a mystical act through which we attempt to recapture a reality which, at some point, was lost to humanity'. For him,

308. ROBERTO MATTA – EL DÍA ES UN ATENTADO (THE DAY IS
A TRANSGRESSION), *1942. oil on canvas, 76 x 91 cm. Museo
Nacional de Bellas Artes, Santiago*

309. RODOLFO OPAZO – GENERATTIO, *1979.
oil on canvas, 130 x 97 cm.
Museo Nacional de Bellas Artes, Santiago*

Chile

recovering this higher absolute and primordial reality is an obsession. One of the elements that characterizes Opazo's expressive modality is an unmistakable iconic symbol: vague, unidentified outlines without fixed direction, in a limitless space, as seen in the 1979 work entitled *Generattio* (fig. 309).

Contemporary with this generation of artists, although moving in a quite different aesthetic direction, is Claudio Bravo (b. 1936). His pictorial realism, stemming from a solid representational tradition based on his virtuosity in demonstrating truth to nature, has made him a figure of international repute. His mode of vision incorporates elements from many phases in the history of art. His images seduce with their obvious proximity to the known world (fig. 311).

In the 1970s, some Chilean artists emerged who began an exploration of the essential qualities of painting through an analytical examination of its language or a critical revision of its history. Francisco Smyth (b. 1953) tests traditional systems of visual representation through a distinct counterpoint between the rigorously ordered and gestural staining techniques. Juan Dávila (b. 1946) takes painting through a process of fragmentation by quoting forms taken from the history of art, especially Pop, and resignifying them to give them a new meaning. Dávila often imbues his art with controversial eroticism. Quotation from art history is also a strategy of Gonzalo Cienfuegos (b. 1949), whose work assumes a playfulness through, dealing with different times, spaces and confluences, combining persons and objects belonging to different periods and historical scenarios. Patricia Israel (b. 1939) uses quotations from Latin American history to fragment spaces and times in which she incorporates both

conquerors and the conquered, as in her canvas *Procer anónimo de país desconocido* (*Anonymous Grandee of an Unknown Country*, 1994; fig. 310).

These examples of paths which continuously unfolded and developed alongside the 'non-painting' forms described above, continued to strengthen the position of painting in Chile in the 1980s. Its importance was enhanced by the return from exile of artists who had never stopped working in this medium, such as José Balmes, García Barrios, Guillermo Núñez or Nemesio Antúnez (1918–93). The recovery in the prestige of painting was also helped by a commitment on the part of the international art market to safeguarding its value, as opposed to that of conceptual art forms with their scant commercial potential due to ideological content or fragility of materials.

The new artistic generation which emerged in the 1980s had known no other political system but that imposed by the military dictatorship. They were not motivated by the desire to recover the aura of the 1960s or the revolutionary programme of the early 1970s and they likewise felt free from the guilt caused by Chile's loss of democracy. These younger artists were neither attracted by the progressive concept of artistic investigation nor to any particular ideology. And they were not interested in imposing any dominating mode or determining logic upon artistic creation.

The artists of the 1980s – Samy Benmayor (b. 1956), Carlos Maturana Piña, called Bororo (b. 1954), Jorge Tacla (b. 1958), Omar Gatica (b. 1956), among others – depoliticized the tense atmosphere in which they lived, focusing their attention on the canvas as a space both uninhibited and free from repression. They employed impulsive gesture as well as virtually

uncontrolled vigour in brushwork and staining, as in Benmayor's large painting of 1992, *El sistema digestivo de la vaca* (*The Digestive System of a Cow*; fig. 312). From this emerged subjectivity combined with colouristic richness and formal insouciance – characteristics also found in the work of some young sculptors including Francisca Núñez (b. 1961). This re-evaluation of subjectivity and the emotional dimension reflects a revival of the national tendency to seek refuge in privacy (although for different reasons) as well as a proclivity for dispensing with theoretical discourse that validates or justifies it. Traditionally, painting, in its self-sufficiency as a process and as a means of communication, seems to need no theoretical framework.

310. Patricia Israel – Procer anónimo de país
desconocido (Anonymous Grandee of an Unknown
Country), *1994. oil on canvas, 150 x 150 cm. Museo Nacional
de Bellas Artes, Santiago*

311. Claudio Bravo – Wrapped Canvas, *1973.
oil on canvas, 78 x 46 cm. private collection*

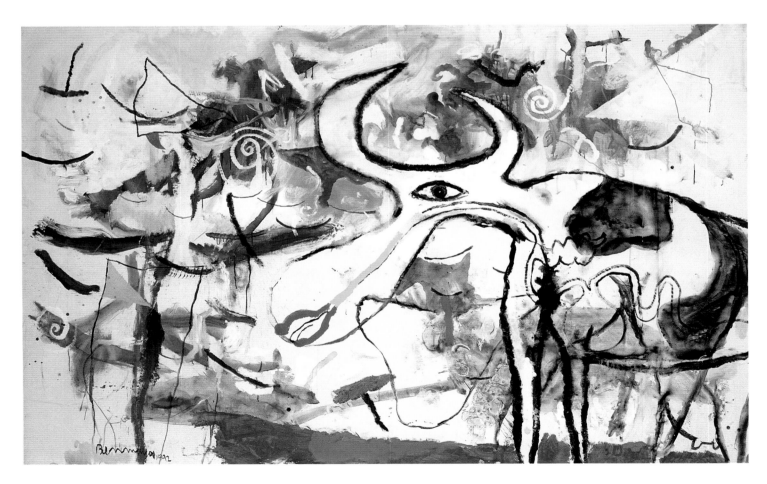

312. Samy Benmayor – El sistema digestivo de la vaca
(The Digestive System of a Cow), *1992. acrylic on canvas,
189 x 295 cm. Museo Nacional de Bellas Artes, Santiago*

Chicano Art

LATIN AMERICAN ART IN THE TWENTIETH CENTURY

Victor Zamudio-Taylor

313. ASCO INSTANT MURAL (ASCO MEMBER PATSSI
VALDEZ TAPED TO A WALL BY GRONK), 1974.

*Pachuco: 'Pachucos or Mexican-American zoot suitors were
depicted as Mexican hoodlums by the press during the so-called
Los Angeles Zoot Suit Riots of 1943. Chicano artists and scholars
view the pachucos' defiance of assimilation as an early model of
cultural resistance ...' (Richard Griswold Del Castillo et al., ed.,
Chicano Art. Resistance and Affirmation, 1965-1985, exhibi-
tion catalogue, Wright Art Gallery, Los Angeles, 1991, p. 364).

**Cholo/Chola: 'Usually associated with contemporary life-style
descendants of the Pachuco culture of the 1940s. Cholos and
cholas follow strictly ritualized dress and behaviour codes partic-
ular to Chicano youth-gang culture. The term has been used
historically to designate poor working-class Mexican-Americans
in the United States and individuals of mixed racial heritage in
Mexico and some parts of Latin America' (Griswold Del
Castillo, op. cit., p. 362).

Latino-Americans in the United States
form a heterogeneous culture with
different histories shaped by indigenous, African
and European miscegenation (*mestizaje*). The
sharing of a colonial past, a historical link to post-
colonialism with its projects of modernity and
diverse forms of neocolonial relations with and
in the United States, have forged diverse experi-
ences and responses to the postmodern present.
Yet discourses and exhibitions of Latino-
American art continue to be based on a notion
of an ethnic identity. Such operations take place
and function in both the peripheries and centres.
Such cultural constructs, articulated by multicul-
turalism and postmodernism, blur and collapse
specificities founded in and marked by a multi-
plicity of races, class conditions and nationalities,
that in turn fashion and determine positions and
perspectives with respect to the dominant culture
in the United States.[1]

Chicanos descend from Mexicans
who opted to stay in lands north of the United
States–Mexico border as demarcated by the 1848
Treaty of Guadalupe Hidalgo, when Mexico lost
more than half its territory to the United States.
With the treaty, Mexicans became Mexican-
Americans, and to a lesser or greater degree,
second-class citizens in the regions they had
known, in some cases, for more than two and a
half centuries. Joined by Mexicans who have
migrated north over the years, Chicanos now
form the largest Latino-American group across
the United States.

Chicano culture is characterized by a
tenacious capacity to resist and survive. The
experience of annexation, internal neocolonial-
ism, migration and forced relocation has forged
varied strategies of survival and transformation,
producing a translational culture. The dynamics

Chicano Art

of translation have allowed Chicano culture to operate in many registers and produce a social imagery nurtured in and between the United States, Mexico, and most recently Latino-American immigrant cultures. Chicano practices of self-representation share the centrality of memory, which is both a defining and a defiant aspect of Chicano art. Chicano art has expressed and forged different versions and visions of the Chicano experience understood as a heterogeneous one marked by differences of class, gender, sexuality, *mestizaje* and geo-cultural location.

The origin of Chicano art in the Chicano movement in the 1960s and 1970s determined its development and, to a lesser degree, still continues to mark its perspectives. From the start, Chicano art was conceived as mirroring 'el Movimiento': the movement of civil rights, land and water rights, labour organization and cultural affirmation. In the arts, el Movimiento sought to model an ethnic identity through 'Chicanismo', understood as 'the sum total of historical patterns of resistance derived from cultural values of survival which formed the base of struggles towards self-determination'.[2]

Alongside this 'remaking' of history was the invention and forging of tradition. The Chicano movement of 'cultural reclamation', composed of artists, cultural workers, activists, and intellectuals, set out to reclaim and establish links to a real and imagined history that encompassed the topographies of the annexed Southwest and Mexico through a nationalist project of identity. Aztlán, the mythical zone of origin and cultural exchange of pre-Conquest Native Americans, in particular of the Aztecs, became the reclaimed nation of the Movimiento. The indigenous Mesoamerican

past and the Mexican Revolution were the privileged and romanticized sites of history that were woven into the nationalist narratives. 'Mexicanidad', the modernist discourse on the nation in post-Revolution Mexico, was the ideological model for Chicanidad. 'Chicanidad' proposed a nationalism with egalitarian and utopian impulses forged in an invention of tradition and a politics of social and cultural change.

Such a construct tended to determine Chicano artistic practices by defining the basis and ultimate goal of art in terms of an ethnic identity. This construct rapidly became dominant as an aesthetic model both for Chicano and Latino-American art, within the cultural location of Chicano artistic practices and outside in the mainstream centres such as universities, museums and other cultural institutions. Discourses and exhibitions framed Chicano art in a purported essentialism, a practice that brought together cultural nationalism, multiculturalism and postmodern trends. Alongside the exclusionary notion of quality, both within Chicano locations and in the mainstream, artistic expressions were judged by their depiction of 'Chicanismo'; art outside of this perspective remained marginalized, fitting in neither essentialist nor 'universalist' paradigms.

Given the cultural position of el Movimiento, and absence of a link to the developments of modernism until the 1960s, with the exception of the Mexican School, many Chicano artists began to research sources, forms and strategies within traditional and popular Chicano culture that had historically nurtured difference. The 'corrido' (historical ballad); oral tales and myths; popular and religious theatre; the 'capillas' (yard shrines); the home altar and 'ofrenda' for the Day of the Dead; the 'bulto' and 'santo'

(religious sculptures); the 'caja' (box/reliquary) and 'nicho' (wall shelf); the 'retablos' (devotional paintings); the legacy of the 'pachuco'* and the subcultures of the 'cholo'** – all these produced alternative narratives and chronicles of the self and the community at large . Through allegory, Chicano art shifts icons and signs from their established meaning, allowing them to slide and glide, expressing the passage of history as discontinuities and dislocations. At work also was an aesthetic strategy that sought to challenge dominant distinctions of 'folk' and 'fine' as well as 'high', 'low' and 'mass' cultures. Tomás Ybarra-Frausto has denominated this form, stance and strategy based in the vernacular as 'rasquachismo'. Rasquachismo is irreverent and carnavalesque, using signs and codes that defy and transgress hierarchies and boundaries. Rasquachismo, as a 'Chicano sensibility', involved disowning 'imposed categories of culture and identity to create a Chicano self-vision of wholeness and completion. Signs and symbols that those in power manipulated to signal unworthiness and deficiencies were mobilized and turned into markers of pride and affirmation.'[3]

In artistic practices the ideology of the Chicano movement was most important in muralism. Chicano muralism, inspired by the Mexican muralists, the WPA projects of the 1930s, and 'barrio placasos' (wall graffiti), emphasized the collective and community base of art. By the late 1960s and 1970s muralist collectives were organized and began to work: Los Four, East Los Streetscapers and Congreso de Artistas Chicanos en Aztlán in Los Angeles; Las Mujeres Muralistas in San Francisco; The Royal Chicano Air Force in Sacramento; Los Toltecas en Aztlán in San Diego; and Los Artes

Chicano Art

Guadalupanos de Aztlán in Santa Fe. 'Centros' such as La Galería de la Raza in San Francisco and the Centro Cultural de la Raza in San Diego were instrumental in promoting muralist activities. The more important muralists like Juana Alicia (b. 1953), Judith Baca (b. 1946), Willie Herrón (b. 1951) and Raymond Patlán (b. 1946) organized collaborations and teams for site-specific projects. Muralism, given its nationalist content and social realist figuration, rapidly became the art form privileged by the Chicano movement. As a vehicle of protest, in mystifying Mesoamerican and idealizing Mexican and Chicano life, and in indicting socio-economic and political inequalities in the United States, muralism insisted on a directly social and didactic function of art. In contrast to Mexican murals, which were state-sponsored and executed in government-sanctioned public spaces, Chicano murals appropriated public spaces, often without authorization, and were for the most part community organized and supported by local merchants and residents. Oriented towards political messages, Chicano muralism served key functions in the communities and in el Movimiento, and soon became a dominating aesthetic model for Chicano art in general.

Disenchanted by cultural nationalist discourses and artistic practices, a group of East Los Angeles multimedia artists in 1971 formed the collective, ASCO (disgust, nausea). Founded by Harry Gamboa Jr. (b. 1951), Gronk (b. 1954), Willie Herrón and Patssi Valdez, ASCO was active until 1985, and later included Barbara Carrasco (b. 1955), Diane Gamboa (b. 1957) and Daniel J. Martínez (b. 1955). The first and most important conceptual and performance Chicano group, ASCO utilized writing, painting, photography, video, performance and costume design

and sets to express postmodern Chicano urban life. ASCO reclaimed the performative dimension of muralism through 'instant murals' on walls and walking murals on streets and boulevards in East Los Angeles (fig. 313). These performances engaged the community and disrupted socio-cultural spaces including churches. Humorous and bitterly sharp, ASCO's actions were critical of dominant cultural institutions. ASCO members' names were as tagged graffiti on the Los Angeles County Museum of Art (LACMA); the Vietnam war with its disproportionate number of Chicanos drafted and killed was the target of the East Los Angeles US Marine Recruitment Depot piece; and mass culture was subverted by manipulation of the media in the circulation of information on art exhibitions that never took place, or the distribution of photos simulating film stills of movies never produced (the 'no' movies). Chicano art and culture were also an object of critique and satire, provoking debates on both Chicanismo and the function and issues of contemporary aesthetic practices.

'Gráfica Chicana', or printed art, was important in depicting symbols and ideals of el Movimiento while conveying information and acting as a historical record. Using sources as varied as the printed broadsides of José Guadalupe Posada; popular forms such as the 'almanaque' (calendar), in particular those inspired by the Mexican artist Jesús Helguera; and the Taller de la Gráfica Popular in Mexico, Gráfica Chicana began to produce an iconography that through protest celebrated cultural difference. Movimiento Chicano graphic artists were part of collectives such as Self-Help Graphics in Los Angeles and the Royal Chicano Air Force in Sacramento. Artists such as Rupert Garcia (b. 1941), Malaquías Montoya (b. 1938)

and Amado Murillo Peña utilized diverse styles of printed matter including the Cuban poster, popular barrio advertisements and Pop art to create a frank visual style.

Rupert Garcia, born and raised in northern California, is a painter and graphic artist whose works are characterized by their political content and formal experimentation. Garcia fuses in his works diverse aspects of modernism, particularly the Mexican School, hard-edge abstraction and Pop art. In both his prints and paintings, Garcia's imagery universalizes particular conditions of specific figures and historical events. Garcia's extensive body of prints deal with such Movimiento issues as civil rights and struggles, historical figures and cultural and political events. In an emblematic work, *El grito del rebelde* (*The Cry of the Rebel*; fig. 314), the individual is an icon of the oppressed and their empowerment. The abstract composition, minimal forms and bold flat colours call attention to the expression of the figure and to its bonds.

Ester Hernández (b. 1944), considers herself primarily a printmaker, finding in the graphic tradition a form that is accessible and direct. Her indignation at the pesticides contaminating the water in her birthplace, the centre of raisin production, inspired *Sun Mad* (1992), an icon of Gráfica Chicana. Inspired by a Day of the Dead tradition, Hernández appropriates the design and package of a popular raisin brand product, Sun Maid. *Sun Mad* subverts by way of the image of a skeletal pastoral maid harvesting grapes and through subtracting a vowel; it functions in a multiplicity of signification. Along with its direct socio-ecological commentary as a tribute to all those who died and are dying as a result of unsafe labour conditions in the fields, the work is also a personal 'memento mori', a recognition

of death as a social and natural condition.

Luis Jimenez (b. 1940) is primarily a sculptor engaged in working with images, sources and materials accessible to a wide audience. Known primarily for his monumental public works that appropriate, parody and transform Southwest icons, particularly those of the Mexican and Chicano traditions, Jimenez was born in El Paso, Texas, into a family with a tradition in craftsmanship. Jimenez assisted his father, a sign painter and neon maker, eventually learning commercial techniques and receiving first-hand experience with the lexicon of popular imagery. Initially studying architecture, he turned to drawing and sculpture, and after a stay in El Paso and Austin, Texas, in 1966, gravitated to New York City, where he worked in programmes involving Latino youth. There he began to produce figurative fibreglass sculptures influenced by social realism, Pop art and New Figuration. Returning to El Paso in 1971, Jimenez executed a series of neon 'spectaculars' in his father's workshop, *The End of the Trail*. In these works, which are his first large pieces, Jimenez reworks the stereotypical icon of the American Indian, whose fate is the result of territorial expansion. For Jimenez, this icon, which he had seen throughout the Southwest, was more important than the *Mona Lisa*, and he said that 'this was "Art" to me as a young kid'. Incorporated into the series is electric lighting and light bulbs from an old movie house marquee flasher, which forms the sunset that anchors the figure of the Indian riding a horse.

Jimenez's sculptures link the Chicano social imagination to a wider cultural framework that includes regional, popular and mass cultures. Recasting the myths and stereotypes of popular culture through the use of such materials

314. Rupert Garcia – El grito del rebelde (The Cry of the Rebel), *1975. silk-screen, 66 x 51 cm. collection of the artist*

315. CARLOS ALMARAZ – CRASH IN PHTHALO GREEN, 1984.
oil on canvas, 146 x 184 cm. Los Angeles County Museum of Art

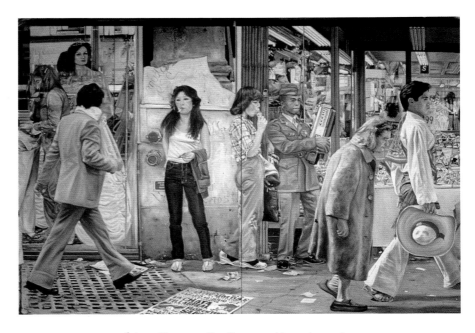

316. JOHN VALADEZ – THE BROADWAY MURAL (DETAIL),
1981. oil on canvas. Victor Clothing Collection, Los Angeles

as spray paint and fibreglass, Jimenez historicizes the icon. Public sculptures such as *Vaquero* (1981), *Southwest Pietà* (1984) and *Steelworker* (1986), like Judith F. Baca's murals, are expressions that research and rewrite popular histories. In this sense Jimenez is an artist who conceives of his work as pedagogical, community-oriented and involved; it challenges set perceptions of history regarding the making of America.

Carlos Almaraz (1941–89) is a paradigmatic figure within Chicano art. Born in Mexico City and raised in Chicago and Los Angeles, he spent five years in New York City, where he painted monochromatic large-scale works. Returning to Los Angeles in the early 1970s, Almaraz involved himself in the Chicano movement. A co-founder of *Chismearte* magazine and the Concilio de Arte Popular, he joined with Gilbert 'Magu' Luján (b. 1940), Frank Romero (b. 1941) and Roberto de la Rocha to form Los Four. Los Four were the first Chicanos to have an exhibition at LACMA in 1974; they are key in the development of an urban Chicano iconography through the appropriation of Mesoamerican motifs and such symbols as the sacred heart and crucifixes, that were incorporated into forms inspired by the Mexican School and Chicano graffiti. Disenchanted with Chicanismo, Almaraz began to work on canvas and paper.

Almaraz's return to painting, and figuration in particular, needs to be addressed in the context of ruptures and disputes concerning the development of modernism and its self-referentiality, and the crisis of socially activated art without solid conceptual foundations. In the late 1970s and early 1980s, painting began to privilege history as subject as it moved away from formal self-examination. Almaraz, along with such Chicana/o painters as Rolando Briseño

(b. 1952), Gronk, Carmen Lomas Garza (b. 1948), César Martinez (b. 1944), John Valadez (b. 1951), and Patssi Valdez; along with other artists in the United States with similar positions but in different cultural locations such as Luis Cruz Azaceta, Jean-Michel Basquiat and Ismael Frigerio; and with Italian and German Neo-Expressionists, discovered what Thomas Lawson referred to as the 'discursive nature of painting', given 'its characteristic of being a never-ending web of representations'.[4]

Almaraz's work is dominated by two dynamically related themes: car crashes and urban/mythological scenes such as the polyptych *Echo Park 1-4* (1982) and *Europe and the Jaguar* (1982). Much more than depicting the 'constant duality of life and death' in Chicano culture, the car crash series expresses and triggers densely rich signs and metaphors of the Chicano urban experience. In *Crash in Phthalo Green* (fig. 315), the car, out of the barrio and not low-riding, the progeny of the traditional paseo, is annihilated against the backdrop of a southern Californian sun-drenched and smog-ridden urban landscape. The city is a stage set in a dynamic composition, a Calderonian theatre of the world. Almaraz has stated that in the series he wanted 'to paint profoundly frightening, disturbing, anxiety provoking art, but to be positive about it'. A heavy use of impasto, painterly application, a bold palette and passionately charged brushwork led to Almaraz being categorized as a Neo-Expressionist.

John Valadez was born and raised in Los Angeles, and studied painting and art history. In contrast to his fellow Chicanos, he is not only inspired by Mexican Social Realism but also by Reginald Marsh and the academic Surrealism of Salvador Dalí. Valadez began to paint and partici-

pate in diverse murals and public projects; in 1978 he collaborated with Carlos Almaraz, Barbara Carrasco and others in *Zoot Suit*, the Mark Taper Forum production of the acclaimed musical by Luis Valdez. *The Broadway Mural* (fig. 316), commissioned by the Victor Clothing Company for its store, is a monumental achievement. Oil on canvas, measuring 8 feet (2.5 metres) high and 60 feet (18 metres) long, the mural depicts disquieting aspects of everyday life in one the most important downtown and latinized Los Angeles streets. Recently Valadez has been executing government-sponsored large-scale public works in California and Texas.

Working in a vein of a hyper-realism and with a palette that evokes Hollywood films, Valadez has developed a visual inventory of barrio life, what he calls a 'Chicano image bank'. Two pastels, *La Butterfly* (1983), which is a portrait of a highly stylized and tattooed chola, and *Clavo* (1983), a portrait of a cholo outfitted in gang attire, have become icons of Chicano art. *Going out of Business* (1990) depicts an uncanny urban experience. Like a *flâneur*, the viewer attracted to the shop window receives the Baudelairean gaze of the white-haired male figure as a shock. Dust and decay contrast with the rasquachi 'horror vacui' of the store display. The piling up of signs in a disturbing logic of accumulation creates extended metaphors on religiosity, as well as gender relations, that transgress and border on violence. Although Valadez's painting of experience is brutal at times, it seduces through the shallow pictorial space and thinly applied oil paint, yet provokes through its sinister subject-matter.

Carmen Lomas Garza, born and raised in Kingsville, Texas, is a painter who deploys memory to create a visual language that depicts

Chicano Art

Chicana/o rural life. Trained as both a teacher and an artist, she depicts celebrations, myths, healing ceremonies, family stories and everyday life in her work. Working as a chronicler, Lomas Garza recollects and recasts reminiscences in a visual narrative. The chronicle of things past is grounded in a polyphony of tales and 'chisme' (gossip) that make up the oral tradition. Lomas Garza's 'monitos' (doll-like figures), as well as her insistence on narrative, have led many to categorize her work as 'naive'. While inspired by the tradition of popular votive and folk painting, Lomas Garza chooses to work with a figuration that creates a rich visual language centred on storytelling.

In *Abuelitos piscando nopalitos* (*Grandparents Cutting Cacti*, 1980), Lomas Garza depicts the harvest of a poor yet delectable delicacy cherished since pre-Columbian times. Three generations of rural 'Tejanos' (Chicano Texans) participate in a seasonal and family ritual. 'Nopalitos' (cacti), apart from their place in the Chicano culinary tradition, are also symbols of the greatness and adversity of life; if not cut and handled with care, they prick. Also pictured is a barbed-wire fence dividing the arid landscape which has been opened to allow the family to cross and cut the cacti. This division mirrors the geo-historical as well as spiritual experience; it is a sign that triggers diverse layers of signification, from imposed borders that divide families and demarcate the usurpation of land to contemporary reclamations of space.

The home altar and the ofrenda (offering) for the Day of the Dead are popular narrative forms that are, by definition, constantly reworking and editing their lexicon. Both the home altar and the ofrenda have their origin in the *mestizo* experience. Chicano artists have

317. YOLANDA LOPEZ – PORTRAIT OF THE ARTIST AS THE VIRGIN OF GUADALUPE, *1978. oil pastel on paper, 66 x 77 cm. collection of the artist*

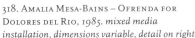
318. AMALIA MESA-BAINS – OFRENDA FOR
DOLORES DEL RIO, *1985. mixed media
installation, dimensions variable, detail on right*

appropriated the popular form of the domestic altar and ofrenda to realize site-specific installations. Chicanas were the first to translate and transfigure the feminine space of the domestic altar. The ofrenda, created on the eve of Day of the Dead, in homage to deceased loved ones, deals with death as a spectacle and everyday reality. Home altars, in contrast to ofrendas, function all year round and have an accumulative ceremonial and memorial nature.

Amalia Mesa-Bains (b. 1943), is a Bay Area Chicana and pioneer of the genre of the ofrenda and altar as a source and form of installation. Through the home altar, Mesa-Bains dedicated the first phase of her artistic career to creating didactic installations that were also a quest for self-definition. Mesa-Bains (de)constructs feminine and Chicano past and present denied by the dominant culture. From the mid-1970s onwards, Mesa-Bains installed altars dedicated to landmark dates (Cinco de Mayo, Day of the Dead), figures of a feminine historical pantheon (Santa Teresa de Avila, Sor Juana Inés de la Cruz, Frida Kahlo, Dolores del Rio (fig. 318), Rita Cancino Hayworth), and deceased family members (Luis Mesa).

From *Grotto of the Virgin* (1987) onwards, Mesa-Bains has worked with large-scale site-specific installations that integrate the altar genre in broader formal concepts characterized by allegory and postmodern 'spatialization'. Works that come under this rubric include: *Numbers* and *Borders* of the series *Emblems of the Decade* (1990, 1992); *Venus Envy, Chapter Two: the Harem and Other Enclosures* (1994); and *Library of Sor Juana Inés de la Cruz* (1994). Within this aesthetic strategy, Mesa-Bains joins Chicano traditions with art movements that she followed closely in her formative years such as Arte Povera and Land

Art, as well as contemporaries with whom she shares similar artistic concerns, such as Christian Boltanski (b. 1944).

In *Queen of the Waters, Mother of the Land of the Dead*, Mesa-Bains challenges the concept of the cult of the Virgin of Guadalupe as an example of purely *mestizo* religious syncretism. In this work Mesa-Bains unravels the myth whereby origin, trajectory and circumstance appear as natural facts divorced from culture and history. Mesa-Bains unearths archaeological signs, metaphors and histories which make up the complex attributes of Tonantzin/Guadalupe* that have been discriminated against and silenced by the *mestizo* myth. In this manner, Mesa-Bains is an allegorist, creating parallels between Tonantzin/Guadalupe and the tenacity of Chicano culture. The installation works with an aesthetic of a remote sense of the present and a vivid sense of the past.

Yolanda López (b. 1942) is a multimedia artist from San Francisco who works in conceptually based video and installation. Since the beginning of her artistic career, López has been involved in the Chicano community, which has become the subject of her art. Her primary aesthetic concerns revolve around the dynamics of identity fashioned by both tradition and mass culture. One vein of López's work has focused on the image of the Virgin of Guadalupe. The series uses the Virgin of Guadalupe as an icon to be translated into contemporary experience and critique, particularly regarding representations of women and gender relations. In a work which is part of a triptych from the series, *Portrait of the Artist as the Virgin of Guadalupe* (fig. 317), López depicts herself as an athletic woman supported by cherub wings. For the June–July cover of the Mexican feminist magazine *Fem*, López repre-

*The word 'Tonantzin' literally means, in Nahuatl, 'our true mother'. The term was usually applied to the Aztec deity Coatlicue, mother of all the gods and mediator between life and death.

Chicano Art

sented the Virgin of Guadalupe as dark-skinned and middle-aged, praying with her shawl covering her head and attired in a dress and high-heeled mules. The cover caused a scandal and protests; the *Fem* office received a bomb threat.

Interested in developing and teaching 'visual literacy' through her art, López appropriates from current images that express and perpetuate racism and sexism. Estranged from their context and reinserted as quotations in her texts, these images in her art convey a radical social message. In her multimedia installation, *Things I Never Told my Son about Being a Mexican* (1984–93) López elaborates a thought-provoking diatribe on mass media and advertising, including product design and packaging, as perpetrators of prejudice and misinformation. The artist aspires for the work to trigger desires and different modes of perception regarding the self and the other. In this sense, the accumulative installation functions as a momentary antidote both to the marginalizing of the Chicano and Mexican people and to those who have internalized such an image of themselves.

Celia Alvarez Muñoz (1937), born and raised in Texas, is a multimedia artist engaged in conceptual work. Alvarez Muñoz is particularly interested in deconstructing language and family dramas as a process of researching and questioning Chicana identity. Utilizing text–image strategies to address gender and cultural relations, Alvarez Muñoz works on the margins.[5] In her work, there exists a Borgian paradigm of double identities and simulations of the self, with the criss-crossing and switching of languages and the juxtaposition of paradoxical modes of knowledge. Her recent mixed media installation *Postales/Postcards* has four components: paintings with frontal views of houses with doors without knobs;

narratives on scrolls with hybrid insect imagery; street signs; and lawn furniture. The piece, in the words of the artist, 'is like a big barrio storyland scrapbook'. The words 'north' and 'south' in the street signs play around names in English spoken by Spanish-speakers and vice-versa. Mapping childhood memories, Alvarez Muñoz highlights the flux of identity in a multiplicity of meanings, at times obscure and subtle or without references to Chicano culture. In the text, Alvarez Muñoz narrates the move from Canal Street to Evergreen Road, a move that crosses boundaries: whereas streets with references to rivers, railroads, products, industries and patriotic figures usually demarcate the barrio, pastoral names like 'evergreen' conjure up class distinction for Alvarez Muñoz, as does the proximity to a zoo.

The San Antonio-born 'Tejano' Jesse Amado (b. 1951), like Celia Alvarez Muñoz, undermines set expectations of Chicano art. Amado is an artist who works in a variety of media and styles that are consistent and conceptually grounded. Inspired by Joseph Beuys, Arte Povera and minimalism, Amado's work combines ritual and material self-referentiality with linguistic play. Layering a multiplicity of signs with an economical use of forms, his work makes references, often opaque and oblique, to eros, the body and social life.

In *To Be Engaged* (1991) and *To Circumspect* (1991), two sculptures made with felt and metal zippers, Amado worked the industrial materials into shapes that evoked in an ambiguous manner anatomy and sexual imagery. In the installation, *White Floating* (1994), hundreds of bars of soap were arranged in various ways in meticulously constructed steel shelves, tables and basins. Mirrors were arranged strategically to bring the viewer into the conceptual matrix of

the work that revolved around a postmodern 'curanderismo': cleansing ritual and purification. The soap bars, some floating in water and changing over the days into a viscous milky liquid, included the generic type and those available at a 'botánica' that claimed to wash away bad luck and illness, or aid in love, sexual performance or monetary problems.

A Flirtation with Fire (1995) is an installation organized around the sense of seduction, change and potential destruction.[6] Creating a web of associations involving desire and repression, knowledge and risk, the piece consisted of drawings on paper with pencil and fire, and attached and mounted steel frames; free-standing steel sculptures in the form of high tables; and wall pieces. The wall pieces, *A Body's Privileges* and *A Body's Uncertainties* (fig 319), were composed of a monochromatic painting and glass shelves with a stainless steel mechanical device attached to it. On the top shelf was a pneumatic piece, that referred to a balloon blown up by the artist's breath or by gas, or to laboratory paraphernalia; and charred pieces of meat in the shape of feet with the aroma of Texas-style barbecue. In Amado's work, procedure and gesture are interrelated, the production of identities results from desire and labour; metaphors originating in pre-modern and post-industrial languages crisscross around a deliberate and instrumentalized approach with a material causality working with chance and process, namely, outside of the artist's control. A post-minimalist aesthetic charged with subjective and socio-cultural references is at work in Amado's *œuvre*; it seeks to short-circuit established notions of difference, experience and artistic process.

Armando Rascón (b. 1956), born in California and spending his formative years on

319. Jesse Amado – A Body's Uncertainties, *1995. wall shelf piece with red ground; charred meat; glass; copper string, 51 x 32 x 163 cm.*

the US–Mexico border at Calexico/Mexicali, is an artist who dislocates language, writing and identity. Initially a painter, Rascón works in site-specific installations. Appropriating images, documents and media that have forged stereo-types of Chicanos and discourses of self-repre-sentation, Rascón's work confronts the viewer with a myriad of familiar, controversial and forgotten information and images out of their established context.

In his multimedia installation, *Xicano Aesthetic: Taking Issue with Mrs Belcher's American History Lesson, Fourth Grade, Jefferson Elementary, Calexico, California, School Term 1966–1967* (1993), Rascón addresses the question of how documents and education fashion identity. Like his site-specific *Occupied Aztlán* (1995), *Xicano Aesthetic* traces his very own formative process in the postcolonial borderlands. The installation comprised a learning centre with available docu-mentation on Chicano history; projected slides of aspects of the visual culture of the borderlands; film stills of Orson Welles's film *Touch of Evil* (1958); a soundtrack of 'Chicano' applause; found Mexican hats; and two sets of documents: the artist's graded and commented exams and essays, and the Treaty of Guadalupe Hidalgo. Back again in circulation, the treaty can be read in the context of its aftermath; it loses its aura of authenticity. By recalling and articulating the text that legitimized the usurpation of lands that created Mexican-Americans, in a dislocated site and temporal frame, the work is both an act and a process of empowerment. Exuberant with imagery, the installation produces a phan-tasmagoric effect due to its sensorial overload. With its Duchampian readymades, it adopts the broader scope and strategy of signification that has characterized conceptual art from

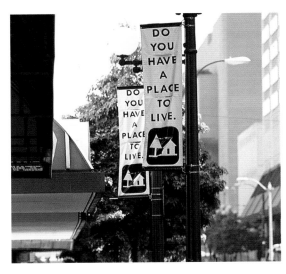

320. DANIEL J. MARTINEZ – NINE WAYS TO IMPROVE
THE QUALITY OF YOUR LIFE, *1991. artist's photograph of
the installation for In Public, Seattle*

321. JUDITH F. BACA – DEVELOPMENT OF THE BARRIOS AND CHAVEZ RAVINE,
DETAIL FROM THE GREAT WALL OF LOS ANGELES, *1983. acrylic on cast concrete.*

Latin America. As Mari Carmen Ramírez has
suggested, the Latin American works do not
seek to replace the 'discrete object of art' with
a 'linguistic or analytical proposition'; instead,
'the readymade is always charged with
meanings related to functions within a larger
social circuit'.[7]

Departing from and transgressing
formal boundaries established by modernist
discourse, contemporary public art strategies
were inspired by the postmodern impulse and
aesthetic practices of the 1960s and 1970s that
disputed, challenged and ultimately destabilized
modernism. These strategies differ qualitatively
from traditional public art, that for the most part,
entails placing or installing a work in a public
space. 'New genre public art', a term placed
in circulation by the feminist artist and critic
Suzanne Lacy, 'uses both traditional and non-
traditional media to communicate and interact
with a broad and diversified audience about
issues directly relevant to their lives'. Based
on the intervention of the art into public space
understood as social spatiality, new genre public
art redefines the role and function of the work,
the artist and the audience. While ASCO may be
considered a forerunner of new genre public art
created by Chicanos, the practitioners of these
new aesthetic strategies include but are not
limited to: the Border Art Workshop/ Taller
de Arte Fronterizo (BAW/TAF); David Avalos
(b. 1947); Judith F. Baca; and Daniel J. Martinez.

Judith F. Baca is an artist and teacher
who directs the world's most extensive mural,
The Great Wall of Los Angeles. Baca first became
engaged in muralism and its meta-artistic func-
tions in East Los Angeles. Influenced by 'los tres
grandes', Diego Rivera, José Clemente Orozco
and David Alfaro Siqueiros, Baca eventually

Chicano Art

studied with Siqueiros in Mexico. Her first projects entailed the involvement of barrio youth in mural-making not only to self-represent themselves and Chicano culture at large, but also to nurture a sense of self-esteem, pride and affirmation that neocolonial conditions undermined. Art-making for Baca involves the transformation of profound emotions that are social in origin, and interactive mural projects were a means and process of healing psychic wounds inflicted by marginalization and a sense of exile from cultural locations. Founded by Baca in 1974, Citywide Mural Projects executed about 250 youth interactive murals in Los Angeles.

Baca is also the founder and artistic director of the Social and Public Art Resource Center (SPARC). Since 1976, SPARC has documented, facilitated, directed and provided leadership for muralism. *The Great Wall of Los Angeles* is currently 2,435 feet (741 metres) long by 13 feet (4 metres) high. Sponsored and organized by SPARC, the mural is located in the Tujunga Wash Flood Control Channel of the Los Angeles Flood Control District. The ongoing mural, painted with acrylic paint on cast concrete, depicts the multicultural history of California. Bringing together urban youth from diverse cultural backgrounds, Baca has them discuss and learn each other's shared perceptions before they begin collaboratively to execute the section with artists. The mural rewrites, in a strong and direct visual language, aspects of the history of California that have been blurred, hidden and/or forgotten in the official narratives and popular mentalities. Such painful chapters as the severing of the important and historic Chavez Ravine barrio and the subsequent building of Dodger Stadium occupy a section (fig. 321). Among the themes of other sections are: Native American cultures; the

Spanish Conquest; diverse migrations (Black, Chinese, Japanese, Mexican and Anglo); women's suffrage; the Zoot Suit riots; Japanese internment camps; and Jewish refugees. Given the monumentality of the project, Baca has enlisted, among others, the Army Corps of Engineers, the City of Los Angeles and teenage gang members to facilitate such a ground-breaking educational process and artistic endeavour.

In 1990 Baca executed a four-panel work developed with local participants called *Guadalupe Mural Project*. Commissioned by the City and County of Santa Barbara, California, the mural depicts aspects of the history and imagined future of Guadalupe as the historic farming area. In Los Angeles, Baca recently completed the public art work *Danza indígena* (1993) for the Baldwin Park Metrolink commuter rail station. The work is a tribute to the Gabrielinos and Chumash, who were native inhabitants of the area and endured the extreme suffering of colonization. Baca is currently working on an international project, *World Wall: a Vision of the Future Without Fear*, a participatory mural that 'explores the material and spiritual transformation of a society towards peace'. For each country that exhibits the portable mural, a native artist will add a panel.

Daniel J. Martinez, born and raised in Los Angeles, was associated with ASCO. Through ASCO, he became engaged in public art that subverted social spaces. Inspired by the Brazilian artist Hélio Oiticica, and 'Situationisme', Guy Debord's *Society of Spectacle* in particular, Martinez elaborates an aesthetic grounded in the interruption of experience rendered through spectacles. Through an art that researches and interrupts representations involving and producing power, his goal is, in his own words, 'to

strategically challenge city structures and mediums that mediate our everyday perception of the world'.

Martinez's site-specific public works intervene in social space and create situations of controversy. *Nine Ways to Improve the Quality of your Life* (fig. 320), his work for *In Public*: Seattle 1991, Martinez installed a series of banners hung from city-owned signposts in Seattle's gentrified downtown. In the same style as other banners announcing cultural events, Martinez posed questions derived from his field research. Written in the form of haiku, there were questions without question marks involving the 'haves': 'Do you have a beach house or a mountain house'; and on the reverse, the 'have-nots': 'Do you have a place to live'. The nine banners, which were sited in a nine-square-block area, caused an uproar. The camouflaged, provocative and socially activated banners generated wide press coverage and a campaign on the part of the Seattle Chamber of Commerce to have them removed. A flood of letters to the editor in the local newspapers debated the 'artistic quality' of the piece, the exhibition and event, and role of public art. Local artists, upset that they had been excluded from the international project, and Martinez's work in particular, set up 'guerrilla' banners hung from toilet plungers with xenophobic overtones such as 'Do you know the way to San José?'

Celia Alvarez Muñoz and Daniel J. Martinez collaborated on a site specific work, *A Gust of Wind through the Mexican Apple Tree*. Their work for the exhibition *Revelaciones/ Revelations* transformed the Johnson Museum on the Cornell University Campus, Ithaca, New York, into a 'Chicano base-media station'. From the site, using four powerful lamps and a

Chicano Art

computer driven control system, they broadcast messages in Morse-coded light beams. The messages were Nahuatl riddles collected by Fray Sahagún from his native informants in the 1540s for his fundamental inquiry into Aztec life, the *Florentine Codex*.

Conceptually, the piece was organized around cross-media translation. The signs could only be deciphered through numerous steps of translation. Yet this operation did not guarantee their comprehension, or correct answers to such riddles as 'What is that which is a small mirror in a house made of fir branches?' – our eye – which were published in the local newspapers the following day. In this sense, the piece worked like a parable involving the subjugating dimension of language and not its pretended communicability. If one wanted to know and act one had to translate and negotiate the terms by which Chicanos/as, by definition, live daily. Chicanos as an exoticized culture inverted power relations by setting the terms and location of the enunciation. The real and invented Mesoamerican past is quoted to estrange and disorient; the work sought to place language in a state of crisis by reverting to process and action and not to representation.

David Avalos, co-founder of the Border Art Workshop/ Taller de Arte Fronterizo, is a public and conceptual artist engaged with activist aesthetic practices. Born just miles from the United States–Mexico border in San Diego, California, Avalos is interested in using art to provoke and nurture a border consciousness. His *Hubcap Milagro* series (1985–7) are a 'rasquachi' assemblage of found hubcaps and mixed media that rework icons – Catholic, Chicano and stereotypical – to comment on conditions of survival as made livable through humour. A similar operation was at work in his

assembled sculpture, *San Diego Donkey Cart* (1986), which raised issues regarding the plight of economic migrants and prompted debates on the function of art. Replicating the carts that zebra-painted donkeys haul and where tourists who flock to Tijuana, Baja California, have their picture taken, Avalos depicted, in place of the stereotypical backdrops, a Border Patrol agent frisking an undocumented worker. The work, on exhibition in the courtyard of the San Diego Courthouse, was censured and forcibly removed by a Federal judicial order. The installation *Café mestizo* (1989) and his collaborative installation with Deborah Small, *Mis-ce-ge-NATION/ mes-ti-za-je-NACION* (1992), both dealt with discourses and representations of *mestizaje* as fundamental myths that explain the culture.

Avalos has collaborated with various artists throughout his career. *Arte reembolso/Art Rebate* (1993; fig. 322), executed by Avalos, Louis Hock (b. 1948) and Elizabeth Sisco (b. 1954), could be considered emblematic of 'new genre public art'. Avalos, Hock and Sisco signed $10 bills that they photocopied along with information on taxation and undocumented labour, and then distributed the information to undocumented workers in Encinitas and other towns of San Diego County. The workers, who pay much more into the Federal tax and social security system than they receive, signed a receipt of the rebate in order to obtain the $10. The $10 came out of a $5,000 National Endowment for the Arts grant Avalos, Hock and Sisco received for the creation of a public art work for the exhibition, *La frontera/The Border*. By returning tax dollars to undocumented workers, the artists inscribed themselves into a tradition of using the symbol of money or actual currency to make art. Avalos, Hock and Sisco, in contrast to Marcel Duchamp's

Monte Carlo Bond (1924), do not use it to address chance and retinal-centred art, nor to focus on 'meaning' and 'banality' like Andy Warhol's silkscreened paintings of the early 1960s. *Arte reembolso/Art Rebate* is more aligned with the work of Brazilian artist Cildo Meireles (b. 1948), who in his *Insertions into Ideological Circuits* projects (1970), stamped political messages on to bank notes and Coca-Cola bottles, reintroducing them into circulation. Avalos, Hock and Sisco, like Meireles, focus on the interruption and subversion of the ideological and political circuit as an artistic strategy in a time of crisis. The performance and conceptual piece described in their press release as 'an art process that envisions public art as an engagement of the social imagination rather than the presentation of monumental objects', provoked debates in the media at a national level on the role, condition and human rights of undocumented labour as well as on the function of art.

To approach Chicano art with categories and terms set by either exclusionary modernist constructions or multiculturalist and postmodernist perspectives that bind Chicano artistic practices to ethnicity and the mere celebration of difference, reduces and neutralizes the complexity of Chicano art and its capacity to depict, express and challenge the Chicano experience. Chicano art requires categories and terms that are related to and result from historical as well as contemporary critical debates and practices that are producing qualitatively different ways of understanding, teaching, curating and exhibiting artistic expressions. Chicano art as a field of art history also operates with discourses on and representations of national allegories. To be sure, Chicano history, like its art, is defined and characterized by flux, negotiation and trans-

formation of two cultures and two languages; it belongs to more than one location and crosses more than one border: art from Latin America and art from the United States.

322. David Avalos, Louis Hock and Elizabeth Sisco – Arte reembolso/Art Rebate, 1993. *detail from conceptual/performative public art work: signed 10-dollar bill*

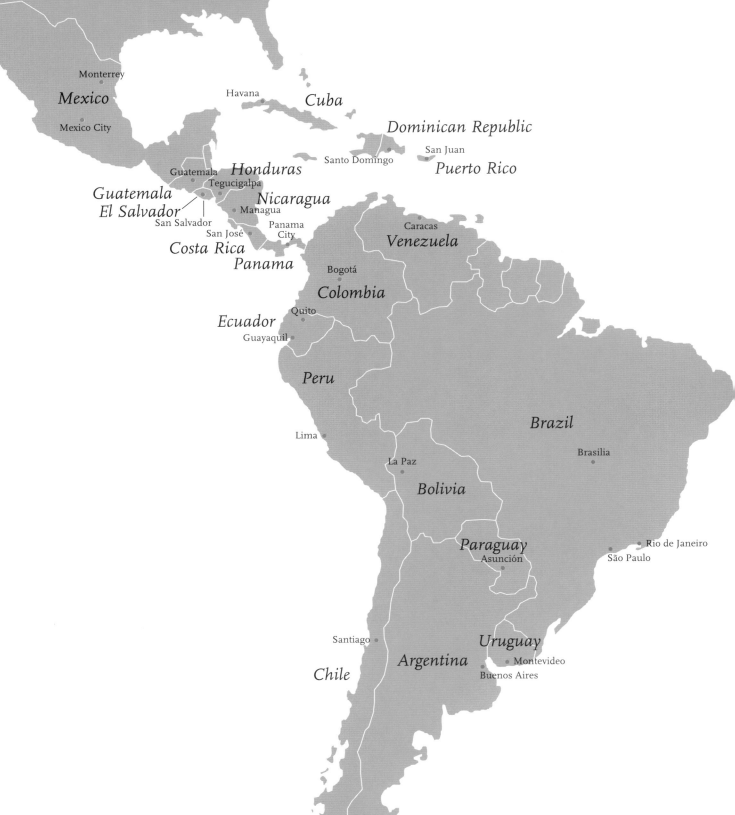

United States of America

Monterrey

Mexico

Mexico City

Havana

Cuba

Dominican Republic

San Juan

Santo Domingo

Puerto Rico

Guatemala

Honduras

Tegucigalpa

Guatemala

El Salvador

Nicaragua

San Salvador

Managua

San José

Panama
City

Costa Rica

Caracas

Panama

Venezuela

Bogotá

Colombia

Ecuador

Quito

Guayaquil

Peru

Brazil

Lima

Brasilia

La Paz

Bolivia

Paraguay

Rio de Janeiro

Asunción

São Paulo

Santiago

Uruguay

Argentina

Montevideo

Chile

Buenos Aires

Notes

This volume has been planned with a minimum of notes. The notes are intended principally to provide source references for quotations, and some of the individual authors have presented their chapters in such a way that notes are not required. For further study, readers are referred to the Bibliographies below.

Introduction

1. Shifra Goldman, *Dimensions of the Americas* (Chicago, 1994), pp. xxi, xxii.

2. See the essays on these subjects in Margarita Sánchez Prieto (ed.), *Visión del arte latinoamericano en la década de 1980* (Lima and Havana, 1994).

3. Jean Franco, *The Modern Culture of Latin America. Society and the Artist* (Harmondsworth, 1967), p. 11.

4. On this phenomenon see Helen Delpar, *The Enormous Vogue for Things Mexican. Cultural Relations Between the United States and Mexico, 1920–1935* (Tuscaloosa, Alabama, 1992) and James Oles, *South of the Border. Mexico in the American Imagination 1914–1947* (Washington, DC, 1993).

Mexico

1. Manuel de Olaguíbel, cited by Ida Rodríguez Prampolini, *La crítica de arte en México en el siglo XIX*, vol. I, *Estudios y documentos* (Mexico City, 1964).

2. José Clemente Orozco, *Autobiografía* (fifteen articles originally published in the newspaper *Excelsior*; Mexico City, 1945).

3. Laura González Matute, *Escuelas al Aire Libre y centros populares de pintura* (Mexico City, n.d. [1979]). See also Sylvia Pandolfi and Raquel Tibol (and others), *Homenaje al movimiento de Escuelas de Pintura al Aire Libre* (exhibition catalogue, Palacio Nacional de Bellas Artes, Mexico City, 1981).

4. Various authors, *José Vasconcelos, de su vida y su obra. Textos selectos de las Jornadas Vasconcelianas de 1982* (Mexico City, 1984).

5. Jean Charlot, *El renacimiento del muralismo mexicano, 1920–25* (Mexico City, 1985). See also Milena Kaprovitzka, John Charlot, Ramón Favela and Blanca Garduño (co-ordinators) *México en la obra de Jean Charlot* (exhibition catalogue, Consejo Nacional para la Cultura y las Artes y Departamento del Distrito Federal, Mexico City, 1994).

6. Aurelio de los Reyes, *Manuel Gamio y el cine* (Mexico City, 1991). See also Tessa Corona del Conde, *Trayectoria de Francisco Goitia 1882–1960* (Ph.D. dissertation, Universidad Nacional Autónoma de México, Mexico City, 1994).

7. Octavio Paz, *Los privilegios de la vista* (exhibition catalogue, Centro Cultural/Arte Contemporáneo, Mexico City, 1990).

8. Luis Mario Schneider, *El estridentismo. México 1921–1927* (Mexico City, 1985).

9. Agustín Arteaga (ed.), *Escuela Mexicana de escultura. Maestros fundadores* (exhibition catalogue, Consejo Nacional para la Cultura y las Artes, Instituto Nacional de Bellas Artes y Museo del Palacio de Bellas Artes, Mexico City, 1990).

10. Edward J. Sullivan, *Aspects of Contemporary Mexican Painting* (exhibition catalogue, The Americas Society, New York, 1990).

11. The phrases 'Cactus curtain' and 'marble bastion' were coined by José Luis Cuevas in a letter published by Fernando Benítez in the newspaper *Novedades*, 7 March 1958. See also Teresa del Conde, 'Presences: a Story of Debate' in the exhibition catalogue *Mexican Painting 1950–1980* (IBM Gallery, New York, 1990).

12. Jean-François Lyotard, *La condition postmoderne: rapport sur le savoir* (Paris, 1979). See also Arthur Kroker and David Cook, *The Postmodern Science. Excremental Culture and Hyper-Aesthetics* (New York, 1986).

13. Willie van den Busshe and Teresa del Conde, *Actualidad plástica en México* (exhibition catalogue, Provinciaal Museum voor Moderne Kunst, Ostend, 1993).

Central America

1. I would like to acknowledge the valuable help received from artists and art collectors throughout Central America, and give special thanks for their assistance with the research and illustrations in this chapter to: Angel A. González of the Fundación Paiz, and Lionel Méndez in Guatemala; Roberto Galicia and the Patronato Pro-Patrimonio Cultural in El Salvador; Bonnie García of Galería Portales, Leticia Oyuela, and the Consejo Nacional de la Juventud in Honduras; María Dolores Torres, Juanita Bermúdez of Galería Códice, Mimí Hammer of the Fundación Internacional Rubén Darío, and the Instituto Nicaragüense de Cultura in Nicaragua; Carlos F. Echeverría, Virginia Vargas, and the Museo de Arte Costarricense in Costa Rica; COPA Airlines, Hoitt Calvo Artes, and the Museo de Arte Contemporáneo in Panama.

Belize is not included in this study because of its cultural ties to the English-speaking Caribbean rather than to Spanish-speaking Central America.

Cuba 1900–1950

1. See Loló de la Torriente, *Estudio de las artes plásticas en Cuba* (Havana, 1954), for a useful summary of Cuban art from colonial times to the 1950s.

2. See Juan A. Martínez, *Cuban Art and National Identity: the Vanguardia Painters 1925 to 1950* (Gainesville, 1994), for a discussion of the Cuban avant-garde in a historical context.

3. Alfred H. Barr Jr., 'Modern Cuban Painters', *Museum of Modern Art Bulletin* (April 1944), p. 4.

Puerto Rico

For full references to publications mentioned in the notes see the Selected Bibliography for Puerto Rico.

1. *Francisco Oller. Un realista del impresionismo* (exhibition catalogue, Museo de Arte de Ponce, 1983), p. 200.

2. See Osiris Delgado Mercado, *Francisco Oller y Cestero*.

3. Petra t.-D. Chu has pointed out (in her essay 'Francisco Oller, Realista' in the catalogue for the 1983 Oller exhibition) that no evidence has been found to suggest that Oller studied in the workshop of Courbet.

4. Francisco A. Scarano, *Puerto Rico: Cinco siglos de historia*, p. 624.

5. See Osiris Delgado Mercado, *Artes plásticas: Historia de la pintura en Puerto Rico*, p. 162.

6. Mari Carmen Ramírez, in *Puerto Rican Painting between Past and Present*, p. 19.

7. For example, the International Poster Exhibition held in Canada in May 1960 contained a selection of 17 Puerto Rican posters.

8. Ramírez, in *Puerto Rican Painting*, p. 65.

9. Marimar Benítez, 'The Special Case of Puerto Rico', pp. 95–6.

10. Benítez, 'The Special Case', p. 91.

11. Marta Traba, in exhibition catalogue *Myrna Báez: diez años de gráfica y pintura 1971–1981*, p. 12.

12. Ricardo Pau-Llosa in the exhibition catalogue *Alegoría de una cultura: Melquiades Rosario Sastre*, n.p.

13. For history of sculpture in Puerto Rico see the essay by José David Miranda in the exhibition catalogue *Cerámica puertorriqueña hoy*.

Venezuela

1. The Instituto de Bellas Artes was formed by the Academia de Bellas Artes and the Academia de Música y Declamación. Its name was later changed to the Academia de Bellas Artes.

2. See Nelson Osorio, *La formación de la vanguardia en Venezuela. Antecedentes y documentos* (Caracas, 1985), pp. 121–5.

3. See Luis LaCorte and Iris Peruga, 'La escultura en Venezuela 1900–1950', *Tiempos de Gallegos. 1910–1950. Cuatro décadas de creación en Venezuela* (exhibition catalogue, Museo de Bellas Artes, Caracas, 1985), pp. 11–42.

4. On the polemical nature of Otero's *Cafetera* series and his participation in the Tenth Salon exhibition, see *Alejandro Otero* (exhibition catalogue, Museo de Arte Contemporáneo, Caracas, 1985), p. 16.

5. The 'NO Manifesto' was published in *Los Disidentes*, no. 5 (Paris, September 1950), p. 3.

6. See Juan Calzadilla, 'Tendencias figurativas a partir de 1950', *La indagación de la imagen* (exhibition catalogue, Galería de Arte Nacional, Caracas, 1980), p. 148; Perón Erminy, 'Las nuevas corrientes en Venezuela', in Calzadilla (ed.), *El arte en Venezuela* (Caracas, 1967), pp. 134–5.

7. See Marta Traba, *Mirar en Caracas* (Caracas, 1974), pp. 123–33.

8. See Calzadilla, op. cit., and Erminy, op. cit.

9. See Angel Rama, *Antología de 'El Techo de la Ballena'* (Caracas, 1987), pp. 11–36.

10. See Katherine Chacán, *Círculo Pez Dorado* (Caracas, 1986).

11. Starting in the 1960s and continuing throughout the 1970s, important exhibitions of modern and contemporary artists such as Braque, Picasso, Matisse, Ensor, Duchamp, Schwitters, Moore, Tàpies, Motherwell, Christo, Le Parc, Burgin, Flanagan, Haacke, Nauman and others were held at the Museo de Bellas Artes.

12. During the 1970s, the Ateneo de Caracas, the Sala Mendoza and the Banap Gallery in Caracas took the leading role in the support and exhibition of the experimental work of younger artists.

13. TAGA was created in 1976 as a graphic artists' workshop. CEGRA opened in 1977. It was the first Venezuelan institution dedicated to teaching the graphic arts.

14. For a summary of artistic activity in Venezuela in the 1980s see Mariana Figarella, 'Los años ochenta. Panorama de una década', *Los ochenta, panorama de las artes visuales en Venezuela* (exhibition catalogue, Galería de Arte Nacional, Caracas, 1990), pp. 90–100.

Colombia

1. J. O. Melo, 'La República conservadora', in *Colombia hoy* (Bogotá, 1978), p. 85.

2. E. Barney Cabrera, *Temas para la historia del arte en Colombia* (Bogotá, 1970), p. 65.

3. Germán Rubiano, *Arte colombiano del siglo XX* (exhibition catalogue, Centro Colombo-Americano, Bogotá, 1981).

4. The sculpture was executed for the Exposición Iberoamericana held in Seville, Spain, in 1929.

5. G. Rubiano, *Escultura colombiana del siglo XX* (Bogotá, 1983), p. 81.

6. Marta Traba, 'Beatríz González', *Revista Eco* (Bogotá, 1978).

7. See the text of the exhibition catalogue *Arte colombiano de los 80s* (Centro Colombo-Americano, Bogotá, 1990).

Peru

l. G. Buntinx and L. E. Wuffarden, *Mario Urteaga. Catálogo razonado* (Lima, 1987), pp. 24–5.

2. The best critical assessment of Indigenism is found in M. Lauer, *Introducción a la pintura peruana del siglo XX* (Lima, 1976).

3. César Moro attempted to disseminate Surrealism in Peru in the 1930s. In 1935 he organized the first Surrealist exhibition in Latin America in Lima. He emigrated to Mexico and helped organize the 'Exposición International del Surrealismo' in 1940 along with Wolfgang Paalen and André Breton. From Mexico Moro began the publication, with Emilio Adolfo Westphalen, of the magazine *El uso de la palabra*. His prose writings and art criticism have been collected in *Los anteojos de azufre*, edited by André Corné (Lima, 1958).

4. A fundamental text for understanding the discussion of this period is that of Raul María Pereira, 'Consideraciones sobre la pintura peruana', *Mercurio peruano*, 151 (1939), pp. 397–403.

5. The jungle as a theme in art was short-lived and had few practitioners. On the other hand, representations of the coast became and remain popular.

6. This debate is discussed in L. M. Quesada G., *Arte en debate* (Lima, 1966). Many of the critical essays of Sebastián Salazar Bondy have been published in *Una voz libre en el caos. Ensayo y crítica de arte* (Lima, 1990).

7. Mirko Lauer has dealt with this debate in his study of the categories *arte* ('art') and *artesanía* ('folk art') in Peru. See *Crítica de la artesanía. Plástica y sociedad en los Andes peruanos* (Lima, 1982).

8. This work was created as a homage to the rebel poet Javier Heraud.

Brazil

1. Lasar Segall, an artist associated with the Dresden Secession, presented the first exhibition of non-academic art, in São Paulo and Campinas, during his first visit to Brazil in 1913. The works exhibited at the time, however, were not characteristic of German Expressionism but were in a Post-Impressionist style and did not draw the attention of the public or the critics.

2. The catalogue of the exhibition indicates the following participants, divided into three groups: Architecture – Antonio Garcia Moya (1891–1949) and Wilhelm Przyrembel (1885–1956); Sculpture – Victor Brecheret and Wilhelm Haarberg (1891–?); Painting – Anita Malfatti, Di Cavalcanti, John Graz, Alberto Martins Ribeiro (?), Zina Aita (1900–68), Yan de Almeida Prado (1898–1982), Ferrignac (Ignácio da Costa Ferreira, 1892–1958), Vicente do Rego Monteiro, Antonio Paim Vieira (1895–1988), Hildegardo Leão Velloso (1899–1966) and Oswaldo Goeldi (1895–1960).

3. S. Salzstein-Goldberg and I. Mesquita, 'Imaginários Singulares', in *Imaginários singulares* (exhibition catalogue, Fundação Bienal de São Paulo, São Paulo, 1987), p. 20.

4. The building which housed the Ministério da Educação e Saúde in Rio de Janeiro, designed in 1936 by Lúcio Costa and Oscar Niemeyer, with Le Corbusier as consultant, is considered a paradigm of modern Brazilian architecture. It influenced much of Niemeyer's later work, such as his designs for the Parque da Pampulha (1944), the Parque Ibirapuera (1954) and Brasilia (1959).

5. The creation, in 1935, of the Grupo Seibi brought together various artists of Japanese origin. Apart from a hiatus during the Second World War, the group was active until the 1970s. Their leaders – Walter Tanaka (1910–70), Yuji Tamaki (1916–79) and Yoshiya Takaoka (1909–78) – helped form many generations of Brazilian artists, especially during the 1950s, when abstraction was being developed in Brazil.

6. Walter Zanini, 'Arte Contemporânea', in Zanini (ed.), *História geral da arte no Brasil* (São Paulo, 1983), vol. 2, p. 679.

7. Frederico Morais, *Panorama das artes plásticas séculos XIX e XX* (São Paulo, 1991), p. 118.

8. Salzstein-Goldberg and Mesquita, op. cit., p. 18.

9. Ibid.

10. In studying the important contributions to the abstract movement in Brazil, it is important to mention the lectures on abstract art given by the Argentine critic Jorge Romero Brest in São Paulo in 1948; the exhibition *Do figurativismo ao abstracionismo* of 1949, organized by the French-Belgian Léon Degand, curator of the Museu de Arte Moderna de São Paulo; and the cultural exchange between Brazilian and Argentine artists associated with the Grupo de Arte Concreto-Invención, established by Tomás Maldonado, in 1945.

11. 'Manifesto Ruptura', in Ana Maria M. Belluzzo (ed.), *Modernidade: vanguardas artísticas na América Latina* (São Paulo, 1990), p. 298.

12. Aracy Amaral in *Modernidade: arte brasileira do século XX* (exhibition catalogue, Museu de Arte Moderna, São Paulo, 1988), p. 63.

13. Frederico Morais, op. cit., p. 118.

14. Salzstein-Goldberg and Mesquita, op. cit., p 19.

15. João Moura, Jr., *Obscura luz* (exhibition catalogue, Galería Luisa Strina, São Paulo, 1983).

16. Zanini, op. cit., p. 776.

17. Jorge Guinle, 'Jorge Guinle', in the exhibition catalogue *Artistas brasileiros da 20a Bienal Internacional de São Paulo* (São Paulo, 1989), p. 90.

18. During the period of isolation imposed by the military dictatorship, the art world was forced to find new ways to ensure its survival. Indeed, this is the perpetual battle for Brazilian intellectual circles, which survive in precarious conditions. In any case, during this period there was intensified historiographical research on Brazilian art. Critics and curators emerged, art schools improved (or at least became more attuned to the country's reality), and books and magazines were published. It was a time dedicated to self-knowledge, to reclaiming the past and to discovering the essential values of Brazilian identity. The art market, although still suffering from the economy's uncertainties, also played an important role, by showing contemporary works, promoting new values and styles, and often filling the void left by the lack of any governmental museum policy.

19. Agnaldo Farias, 'Breve roteiro para um panorama complexo: A produção contemporânea (1980 a 1994). Brief Guide to a Complex Panorama: Contemporary Art Production (1980 to 1994)', in Nelson Aguilar (ed.), *Bienal Brasil século XX* (exhibition catalogue, São Paulo, Fundação de São Paulo, 1994), pp. 426–7 states: 'The clear intelligence of this production whether unstable, whether suffering from the deficiencies of a precarious environment which obliges, in the very end, each work to have as its central theme the struggle for its own survival, while denying our supposed inclination to the illogical and confirming the content of our capacity of reflection, demonstrates that it finds its strength in the fact that it goes beyond the timid limits imposed by the label "Brazilian Art", with its nationalist vein and innocuous search for an inexistent identity it is nourished by the direct confrontation with the existing canons, that is, exploring and expanding the aesthetic operations which are ratified in the universe of art.'

Uruguay

1. We refer here to the two types of artistic areas in Latin America, the 'open' and the 'closed', as defined by critic Marta Traba in *Dos décadas vulnerables en las artes plásticas latinoamericanas 1950–1970* (Mexico City, 1973), p. 36.

2. Fernando García Esteban, *Panorama de la pintura uruguaya contemporánea* (Montevideo, 1965), p. 41.

3. During both presidential terms, 1903–7 and 1911–15.

4. The Battlista era comprises the period from 1904 to 1929. The rest of Uruguayan history is also deeply influenced by Battle's reforms which made this a model nation in Latin America.

5. In Figari's work we observe his admiration

for the styles of the Spanish painters Hermen Anglada Camarassa and Joaquím Mir, the French *Intimistes* Pierre Bonnard and Edouard Vuillard, as well as his interest in the art of Honoré Daumier and, in some ways, that of Paul Gauguin.

6. The case of González is unusual in Uruguay. He did not travel to Europe during his formative years, going there only in his old age after his most productive years were passed. He distanced himself from European forms. There is some relationship between his art and the drawings of the Argentine Florencio Molina Campos.

7. Gurvich, like other Uruguayans, looked simultaneously to the past and the present, recalling the heritage of Torres-García and Chagall as well as that of Brueghel and Bosch.

8. An important source for Costigliolo was the work of Friedrich Vordemberge Gildewart. He was also inspired by his direct contacts with Neo-plasticism at the São Paulo Bienal of 1953.

Argentina

1. See Patricia Artundo, *Norah Borges. Obra gráfica 1920–1930* (Buenos Aires, 1994).

2. See Patricia Artundo and Marcelo Pacheco, 'Estratégias y transformaciones. Una aproximación a los años 20', *V jornadas de teoría e historia de las artes. Arte y poder* (text of lecture published in conference papers, Centro Argentino de Investigadores de Artes (CAIA), Facultad de Filosofía y Letras, Universidad Nacional de Buenos Aires, 1993), p. 85.

3. Cited in Elba Pérez, *Distéfano* (Buenos Aires, 1991), p. 10.

4. There was much discussion among the members of the group, making it difficult to identify them with a clear programme of action. See Gyula Kósice, *Arte Madí* (Buenos Aires, 1982) and Nelly Perazzo, *El arte concreto en la Argentina* (Buenos Aires, 1983).

5. A group of Berni's prints of this subject was the Grand Prize at the Venice Biennale of 1962.

6. Laura Buccellato, *Greco-Santantonín* (exhibition catalogue, Fundación San Telmo, Buenos Aires, April 1987), n.p.

7. For a discussion of the development of these neo-avant-garde trends, see Néstor García Canclini, *La producción simbólica. Teoría y método en sociología del arte* (Mexico City, 1988).

8. See Jorge Romero Brest, *Arte visual en el Di Tella* (Buenos Aires, 1992) and John King, *El Di Tella* (Buenos Aires, 1985); Silvia Sigal, *Intelectuales y poder en la década del sesenta* (Buenos Aires, 1991); Oscar Terán, *Nuestros años sesentas* (Buenos Aires, 1991). See also the indispensable texts published by the CAIA in

its conference papers for the five *Jornadas sobre teoría e historiografía del arte*, held in Buenos Aires since 1989, which contain the most up-to-date information on contemporary Argentine art.

9. During the military dictatorship imposed in 1976 many varieties of 'realism' proliferated in the work of such painters as Ricardo Garabito, Hugo de Marziani, Mildred Burton and Seguí.

10. See Roberto Amigo, 'La Plaza de Mayo, la plaza de las Madres', *III Jornadas de teoría e historia de las artes. Ciudad/campo en las artes en Argentina y Latinoamérica* (CAIA, Buenos Aires, 1991), pp. 89–99; Gustavo Buntinx, 'Desapariciones forzadas/Resurrecciones míticas', *V Jornadas de teoría e historia de las artes* (CIAIA, Buenos Aires, 1993), pp. 236–55, and Amigo, 'La resistencia estética', ibid., pp. 265–73.

Chile

1. Official illustrated catalogue, *Exposición Internacional de Bellas Artes* (Santiago, 1910).

2. Gaspar Galasz and Milan Ivelic, *La pintura en Chile. Desde la colonia hasta 1981* (Santiago, 1981).

Chicano Art

1. See the contributions of Mari Carmen Ramírez, Gerardo Mosquera and Nelly Richard in *American Visions/Visiones de las Américas*, ed. Noreen Tomassi, Mary Jane Jacob and Ivo Mesquita (New York, 1994).

2. Tomás Ybarra Frausto, 'Introduction', in Inverna Locpez (ed.), *Chicano Expressions: a New View in American Art* (exhibition catalogue, INTAR Latin American Art Gallery, New York, 1986), p. 4.

3. Tomas Ybarra-Frausto, 'Rasquachismo: a Chicano Sensibility', in *CARA: Chicano Art: Resistance and Affirmation, 1965–1985* (exhibition catalogue, Wight Art Gallery, University of California Los Angeles, 1991), p. 159.

4. Thomas Lawson, 'Last Exit: Painting', in Brian Wallis (ed.), *Art after Postmodernism: Rethinking Representation* (New York, 1984), p. 164.

5. Amalia Mesa-Bains has analysed this phenomenon and coined the term 'domesticana' and used the notion of 'domestic allegories' to describe it. See Amalia Mesa-Bains, 'El mundo femenino: Chicana Artists of the Movement: a Commentary on Development and Production', in *Chicano Art: Resistance and Affirmation*, op. cit.

6. *A Flirtation with Fire*, installation at Carla Stellweg Gallery, New York, October–November 1995.

7. Mari Carmen Ramírez, 'Blueprint Circuits: Conceptual Art and Politics in Latin America', in *Latin American Artists of the Twentieth Century* (exhibition catalogue, The Museum of Modern Art, New York, 1993), p. 159.

Selected General Bibliography

The Selected General Bibliography includes works of a panoramic nature. The emphasis has been placed on sources in English. For the Selected Bibliographies by Country, each author has determined the criteria for the inclusion of items. Some additions have been made by the General Editor.

Acha, Juan, *Arte y sociedad en América Latina: el producto artístico y su estructura* (Mexico City, 1974).

—, Adolfo Comombres, and Ticio Escobar, *Hacia una teoría americana del arte* (Buenos Aires, 1991).

Ades, Dawn (ed.), *Art in Latin America: the Modern Era, 1820–1980* (New Haven and London, 1989).

America: Bride of the Sun, trans. Arte Belas *et al.* (exhibition catalogue, Koninklijk Museum voor Schone Kunsten, Antwerp, 1992).

Art d'Amérique Latine. 1911–1968 (exhibition catalogue, Musée National d'Art Moderne, Centre Georges Pompidou, Paris, 1992).

Baddeley, Oriana, and Valerie Fraser, *Drawing the Line: Art and Cultural Identity in Contemporary Latin America* (London and New York, 1989).

Barnitz, Jacqueline, Florence Bazzano Nelson, and Janis Bergman Carton, *Latin American Artists in New York since 1970* (exhibition catalogue, Archer M. Huntington Art Gallery, University of Texas, Austin, 1987).

Bayón, Damián, *Artistas contemporáneos de América Latina* (Paris and Barcelona, 1981).

—, *Aventura plástica de Hispanoamérica* (Mexico City, 1974).

—, *Historia del arte hispanoamericano. Siglos XIX y XX*, vol. 3 (Madrid, 1988).

— (ed.), *América Latina en sus artes* (Paris, 1974).

Beardsley, John, and Jane Livingston, *Hispanic Art in the United States; Thirty Contemporary Painters and Sculptors* (exhibition catalogue, The Museum of Fine Arts, Houston; New York, 1987).

Bedoya, Jorge M., and Noemi Gil, *El arte en América Latina* (Buenos Aires, 1973).

Belluzzo, Ana Maria de Moraes (ed.), *Modernidade: vanguardas artísticas na América Latina* (São Paulo, 1990).

Biller, Geraldine P., *et al.*, *Latin American Women Artists 1915–1995: Artistas latinoamericanas* (exhibition catalogue, Milwaukee Art Museum, 1995).

Braun, Barbara, *Pre-Columbian Art and the Post-Columbian World. Ancient American Sources of Modern Art* (New York, 1993).

Brett, Guy, *Transcontinental: Nine Latin American Artists* (London and New York, 1990).

Bulhoes, Maria Amélia, and Maria Lúcia Bastos Kern (eds.), *Artes plásticas na América Latina contemporânea* (Porto Alegre, 1994).

Cancel, Luis, *et al.*, *The Latin American Spirit: Art and Artists in the United States, 1920–1970* (exhibition catalogue, Bronx Museum of the Arts, New York, 1988).

Castedo, Leopoldo, *Historia del arte iberoamericano, vol. 2, Siglo XIX-siglo XX*, (Madrid, 1988).

—, *A History of Latin American Art and Architecture, from PreColumbian Times to the Present* (New York, 1969).

Catlin, Stanton, and Terence Grieder, *Art of Latin America since Independence* (New Haven, 1966).

Chaplik, D., *Latin American Art: an Introduction to Works of the 20th Century* (Jefferson, 1989).

Chase, Gilbert, *Contemporary Art in Latin America: Painting, Graphic Art, Sculpture, Architecture* (New York, 1970).

Daly Heyck, Denis Lynn, *Barrios and Borderlands. Cultures of Latinos and Latinas in the United States* (New York, 1994).

Day, Holliday T., and Hollister Sturges (eds.), *Art of the Fantastic: Latin America, 1920–1987* (exhibition catalogue, Indianapolis Museum of Art, 1987).

Findlay, James, *Latin American Art: a Bibliography* (Westport, 1983).

Fletcher, Valerie, *Crosscurrents of Modernism: Four Latin American Pioneers: Diego Rivera, Joaquín Torres-García, Wifredo Lam, Matta* (exhibition catalogue, Hirshhorn Museum and Sculpture Garden, Smithsonian Institution, Washington, DC, 1992).

Franco, Jean, *The Modern Culture of Latin America: Society and the Artist*, revised edn. (Harmondsworth, 1970).

Fusco, Coco, *English is Broken Here: Notes on Cultural Fusion in the Americas* (New York, 1995).

García Canclini, Néstor, *Arte popular y sociedad en América Latina* (Mexico City, 1977).

—, *Hybrid Cultures. Strategies for Entering and Leaving Modernity* (Minneapolis, 1995).

Goldman, Shifra M., *Dimensions of the Americas: Art and Social Change in Latin America and the United States* (Chicago, 1994).

Kirstein, Lincoln, *The Latin-American Collection of The Museum of Modern Art* (Museum of Modern Art, New York, 1943).

La Duke, Betty, *Compañeras: Women, Art, and Social Change in Latin America* (San Francisco, 1985).

Leenhardt, Jacques, and Pierre Kalfon, *Les Amériques Latines en France* (Paris, 1992).

Lucie-Smith, Edward, *Latin American Art of the Twentieth Century* (London, 1993).

Mesquita, Ivo, *Cartographies* (exhibition catalogue, Winnipeg Art Gallery, 1993).

Messer, Thomas, and Cornell Capa, *The Emergent Decade: Latin American Painters and Painting in the 1960s* (Ithaca, 1966).

Morais, Frederico, *Las artes plásticas en la América Latina: del trance a lo transitorio* (Havana, 1990).

—, *Panorama das artes plásticas. Seculos XIX e XX* (São Paulo, 1991).

Mosquera, Gerardo (ed.), *Beyond the Fantastic. Contemporary Art Criticism from Latin America* (London, 1995).

—, Rachel Weiss, Carolina Ponce de León *et al*, *Ante América* (exhibition catalogue, Banco de la República and Biblioteca Luis Angel Arango, Bogotá, 1992).

Paternosto, César, *The Stone and the Thread. Andean Roots of Abstract Art* (Austin, 1996).

Rasmussen, Waldo (ed.), *Latin American Artists of the Twentieth Century* (exhibition catalogue, The Museum of Modern Art, New York, 1993).

Rowe, William, and Vivian Schelling, *Memory and Modernity. Popular Culture in Latin America* (London, 1991).

Rubiano Caballero, Germán, *La escultura en América Latina (siglo XX)* (Bogotá, 1986).

Sánchez Prieto, Margarita (ed.), *Visión del arte latinoamericano en la década de 1980* (Lima and Havana, 1994).

Stofflet, Mary, *et al.*, *Latin American Drawing Today* (exhibition catalogue, San Diego Museum of Art; Seattle, 1991).

Sullivan, Edward J., *Artistas latinoamericanos del siglo XX* (exhibition catalogue, Comisaría de la Ciudad de Sevilla para 1992, Seville, 1992).

Tomassi, Noreen, *et al.* (eds.), *American Visions: Artistic and Cultural Identity in the Western Hemisphere* (New York, 1994).

Traba, Marta, *Art of Latin America: 1900–1980* (Baltimore, 1994).

—, *Dos décadas vulnerables en las artes plásticas latinoamericanas 1950–1970* (Mexico City, 1973).

Voces de ultramar: arte en América Latina y Canarias: 1910–1960 (exhibition catalogue, Centro Atlántico de Arte Moderno, Las Palmas de Gran Canaria, 1962).

Wood, Yolanda (ed.), *Las artes plásticas en el Caribe. Pintura y grabado contemporáneos* (Havana, 1993).

Yudice, George, Jean Franco and Juan Flores (eds.), *On Edge. The Crisis of Contemporary Latin American Culture* (Minneapolis, 1992).

Supplement 2000

Barnitz, Jacqueline, *Twentieth-Century Art of Latin America* (forthcoming, Austin, 2001)

The Experimental Exercise of Freedom. Lygia Clark, Gego, Mathias Goeritz, Hélio Oiticica, Mira Schendel (exhibition catalogue, Museum of Contemporary Art, Los Angeles, 1999).

Kirking, Clayton C., and Edward J. Sullivan, *Latin American Still Life: Reflections of Time and Place* (exhibition catalogue, Katonah Museum of Art, 1999).

Poupeye, Veerle, *Caribbean Art* (London, 1998).

Selected Bibliographies by Country

Mexico

Arteaga Domínguez, Agustín, *et al.*, *Escuela mexicana de escultura. Maestros fundadores* (exhibition catalogue, Instituto Nacional de Bellas Artes, Mexico City, 1990).

Cardoza y Aragón, Luis, *México. Pintura de hoy* (Mexico City, 1964).

—, *Pintura contemporánea de México* (Mexico City, 1974).

100 pintores mexicanos (exhibition catalogue, Museo de Arte Contemporáneo de Monterrey, essay by Luis Carlos Emerich, Monterrey, 1993).

Charlot, Jean, *The Mexican Mural Renaissance, 1920–1925* (New Haven, 1963).

del Conde, Teresa Corona, and Enrique Franco Calvo, *La pintura del México contemporáneo en sus museos* (Mexico City, 1991).

El corazón sangrante/The Bleeding Heart (exhibition catalogue, Institute of Contemporary Art, Boston, 1991).

Debroise, Olivier, *Figuras en el trópico: plástica mexicana, 1920–1940* (Barcelona, 1984).

Delpar, Helen, *The Enormous Vogue for Things Mexican. Cultural Relations Between the United States and Mexico, 1920–1935* (Tuscaloosa (Alabama), 1992).

Emerich, Luis Carlos, *Figuraciones y desfiguros de los 80s. Pintura mexicana joven* (Mexico City, 1989).

Espíritu (exhibition catalogue, California Center for the Arts, essay by Luis Carlos Emerich, Escondido (California), 1995).

Ferrer, Elizabeth, and Alberto Ruy Sánchez, *Through the Path of Echoes: Contemporary Art in Mexico/Por el camino de los ecos: arte contemporáneo de México* (exhibition catalogue, Independent Curators Inc., New York, 1990).

Franco, Jean, *Plotting Women. Gender and Representation in Mexico* (London, 1989).

Frérot, Christine, *El mercado del arte en México 1950–1976* (Mexico City, 1990).

Goldman, Shifra M., *Contemporary Mexican Painting in a Time of Change* (Austin, 1981).

Helm, MacKinley, *Modern Mexican Painters* (New York, 1941; reprint, 1989).

Hurlburt, Laurance P., *The Mexican Muralists in the United States* (Albuquerque, 1989).

Imagen de México. Images of Mexico (exhibition catalogue, Schirn Kunsthalle, Frankfurt-am-Main, 1987; English version, Dallas Museum of Art, 1988).

Jalisco. Genio y maestría (exhibition catalogue, Museo de Arte Contemporáneo de Monterrey, essays by Carlos Monsiváis, Jorge F. Hernández, Alberto Ruy Sánchez and Jaime Moreno Villarreal, Monterrey, 1994).

Manrique, Jorge Alberto, and Teresa del Conde, *Una mujer en el arte mexicano. Memorias de Inés Amor* (Mexico City, 1987).

—, *et al.*, *El geometrismo mexicano* (Mexico City, 1977).

Mérida, Carlos, *Modern Mexican Artists* (Mexico City, 1937).

The Mexican Muralists (exhibition catalogue, Museum voor Schone Kunsten, Ghent, 1993).

Mexico: the New Generations (exhibition catalogue, San Antonio Museum of Art, essay by Teresa del Conde, San Antonio, 1985).

Mexico. Splendors of Thirty Centuries (exhibition catalogue, Metropolitan Museum of Art, New York, 1990).

Modernidad y modernización en el arte mexicano 1920–1960 (exhibition catalogue, Museo Nacional de Arte, Mexico City, 1991).

Myers, Bernard S., *Mexican Painting in Our Time* (New York, 1956).

Nelken, Margarita, *El expresionismo mexicano* (Mexico City, 1966).

Nuevos momentos del arte mexicano. New Moments in Mexican Art (Madrid, 1990).

O'Gorman, Edmundo, Justino Fernández, Luis Cardozo y Aragón, Ida Rodríguez Prampolini and Carlos G. Mijares, *Cuarenta siglos de plástica mexicana. Arte moderno y contemporáneo* (Verona, 1971).

Oles, James, *South of the Border. Mexico in the American Imagination 1914–1947* (Washington, DC, 1993).

Paz, Octavio, *Essays on Mexican Art* (New York, 1993).

Rodríguez, Antonio, *A History of Mexican Mural Painting* (London, 1969).

Rodríguez Prampolini, Ida, *El surrealismo y el arte fantástico de México* (Mexico City, 1969).

Rooted Visions: Mexican Art Today (exhibition catalogue, Museum of Contemporary Hispanic Art, essay by Carla Stellweg, New York, 1988).

Ruptura 1952–1965 (exhibition catalogue, Museo de Arte Alvar y Carmen T. Carrillo Gil, Mexico City, 1988).

Schmeckebier, Laurence E., *Modern Mexican Art* (Minneapolis, 1939).

Schneider, Luis Mario, *México y el surrealismo (1925–1950)* (Mexico City, 1978).

Sullivan, Edward J., *Aspects of Contemporary Mexican Painting* (exhibition catalogue, The Americas Society, New York, 1990).

—, and Linda Nochlin, *Women in Mexico/La mujer en México* (exhibition catalogue, National Academy of Design, New York, and elsewhere, 1990); French version, *Regards de femme* (Musée d' Art Moderne, Liège, 1993).

Tibol, Raquel, *Confrontaciones. Crónica y recuento* (Mexico City, 1992).

—, *Historia del arte mexicano: época moderna y contemporánea* (Mexico City, 1964).

Yamawaki, Kazuo, Teresa del Conde and others, *Renacimiento en el arte mexicano* (exhibition catalogue, Nagoya City Art Museum, 1989).

Central America
General

Dunkerley, James, *Power in the Isthmus. A Political History of Central America* (London, 1988).

Flores Zúñiga, Juan Carlos, *Magic and Realism: Central American Contemporary Art* (Tegucigalpa, 1992).

Land of Tempests: New Art from Guatemala, El Salvador and Nicaragua (exhibition catalogue, Harris Museum and Art Gallery, Preston, 1994).

Rodríguez, Bélgica, 'Aproximación al arte de Centroamérica': I (Guatemala), II (Honduras), III (Costa Rica), *Art Nexus*, 46 (January 1991), pp. 78–82; 47 (May 1991), pp. 84–7; 50 (April 1992), pp. 127–31.

—, *Arte centroamericano. Una aproximación* (Caracas, 1994).

Guatemala

Galería Guatemala: muestra de pintura del siglo XX (Guatemala, 1990).

Méndez, Lionel, *Elmar Rojas* (Guatemala, 1993).

— (ed.), *Arte vanguardia Guatemala* (Guatemala, 1969).

Mobil, José A., *Historia del arte guatemalteco* (Guatemala, 1988).

Nuñez de Rodas, Edna, *Evolución de las artes plásticas en Guatemala* (Antigua, 1993).

Honduras

Antología de las artes plásticas de Honduras (Tegucigalpa, 1993).

Catálogo de la colección de obras de la Escuela Nacional de Bellas Artes (Tegucigalpa, 1991).

Honduras: El Banco Atlántida en la historia de la pintura (Tegucigalpa, 1991).

López, Evaristo, and Longino Becerra, *Honduras 40 Pintores* (Tegucigalpa, 1989).

de Oyuela, Leticia, *La batalla pictórica: síntesis de la historia de la pintura en Honduras* (Tegucigalpa, 1994).

El Salvador

Cea, José Roberto, *De la pintura en El Salvador: panorama histórico crítico* (San Salvador, 1986).

Lindo, Ricardo, *La Pintura en el Salvador* (San Salvador, 1986).

Pintura salvadoreña del presente siglo (San Salvador, 1984).

Salazar Retana, Luis *Cien años de pintura en El Salvador* (exhibition catalogue, VII Festival de Arte, San Salvador, 1988).

Zeitlin, Marilyn A., *Art under Duress. El Salvador 1980–Present* (exhibition catalogue, Arizona State University Art Museum, Tempe, 1995).

Nicaragua

Arellano, Jorge Eduardo, 'Pintura y Escultura en Nicaragua', *Boletín nicaragüense de bibliografía y documentación*, 8 (November-December 1975), pp. 3–188.

Armando Morales: pintura (exhibition catalogue, Museo Rufino Tamayo, Mexico City, 1990).

Kassner, Lily, *Morales* (n.p. [Américo Arte de C.V.], 1995).

Lacayo, Sofia, *Patria. Contemporary Nicaraguan Painting* (exhibition catalogue, Duke University Museum of Art, Durham, 1995).

Pintura contemporánea de Nicaragua (exhibition catalogue, Instituto Nacional de Bellas Artes, Mexico City, 1981), with essays by Marta Traba and Mercedes Gordillo.

de Torres, María Dolores García-Jamart, *La modernidad en la pintura nicaragüense, 1948–1990* (Managua, 1995).

Valle-Castillo, Julio, 'Los primitivistas de Nicaragua o el inventario del paraíso', *Revista Nicarauac*, 12 (April 1980), pp. 101–75.

Costa Rica

Cabrera, Roberto, and Victor H. Fernández, *Veinte años de la pintura costarricense 1970–1990* (San José, 1990).

Echeverría, Carlos Francisco, *Historia crítica del arte costarricense* (San José, 1986).

Ferrero, Luis, *La escultura en Costa Rica* (San José, 1982).

Lentini, Luigi, *et al.* (eds.), *Arte y critica en el siglo XX* (San José, 1986).

Ulloa Barrenechea, Ricardo, *Pintores de Costa Rica* (San José, 1974).

Vargas, Virginia, and Alvaro Zamora, 'Diversidad en los Ochenta' in *Arte costarricense hoy: nuevas tendencias* (exhibition catalogue, Museo de Arte Costarricense, San José, 1989).

Zavaleta, Eugenia, *Los inicios del arte abstracto en Costa Rica, 1958–1971* (San José, 1994).

Panama

Kupfer, Monica, *Encuentro de escultura* (exhibition catalogue, Museo de Arte Contemporáneo, Panama City, 1987).

Miró, Rodrigo, *Lewis, Amador, Ivaldi* (Panamá: *Revista Lotería* (Separata), May 1974).

Pascual, Maricel (ed.), *Tiempo y color: 16 pintores de Panamá* (Caracas, 1991).

Prados, Pedro Luis, 'La Pintura en Panamá', *Katedra*, 1, no. 1 (Universidad de Panamá, December 1990).

Wolfschoon, Erik, *Las manifestaciones artísticas en Panamá* (Universidad de Panamá, 1983).

Cuba 1900–1950

Alonso, Alejandro G., *Amelia Peláez* (Havana, 1988).

Amelia Peláez, exposición retrospectiva 1924–1967 (exhibition catalogue, Fundación Museo de Bellas Artes, Caracas, 1991).

Barr, Alfred H., 'Modern Cuban Painters', *Museum of Modern Art Bulletin*, 1 (1944), pp. 2–14.

Blanc, Guilio V., Herzberg, Julia P., and Sims, Lowery S., *Wifredo Lam and His Contemporaries, 1938–1952* (exhibition catalogue, The Studio Museum in Harlem, New York, 1992).

—, et al., *Amelia Peláez: a Retrospective, 1896–1968* (exhibition catalogue, Cuban Museum of Arts and Culture, Miami, 1988).

Carreño, Mario, *Mario Carreño: cronología del recuerdo* (Santiago, 1991).

de Castro, Martha, *El arte en Cuba* (Miami, 1970).

Fouchet, Max-Pol, *Wifredo Lam* (Barcelona, n.d. [1976]).

Gómez Sicre, José, *Pintura cubana de hoy* (Havana, 1944).

de Juan, Adelaida, *Pintura cubana: temas y variaciones* (Havana, 1978).

Leopoldo Romañach (Havana, 1952).

Luís, Carlos M., *Cundo Bermúdez* (Miami, 1987).

Mariano: uno y múltiple (exhibition catalogue, Sala de Exposiciones Centro Cultural Cajacanarias, Santa Cruz de Tenerife, 1988).

Martínez, Juan A., *Cuban Art and National Identity: the Vanguard Painters, 1925–1950* (Gainesville, 1994).

—, 'Afrocuban and National Identity: Modern Cuban Art 1920s–1940s', *Athanos*, 11 (1992), pp. 70–3.

Núñez Jiménez, Antonio, *Wifredo Lam* (Havana, 1982).

Pogolotti, Graciella, *Carlos Enríquez 1900–1957* (Havana, 1979).

—, et al., *Victor Manuel* (Havana, 1969).

René Portocarrero (exhibition catalogue, Museo Español de Arte Contemporáneo, Madrid, 1984).

Sánchez, Juan, *Fidelio Ponce* (Havana, 1985).

Thomas, Hugh, *Cuba, or the Pursuit of Freedom* (London, 1971).

de la Torriente, Loló, *Estudios de las artes plásticas en Cuba* (Havana, 1954).

Wifredo Lam (exhibition catalogue, Museo Nacional Centro de Arte Reina Sofía, Madrid, 1992).

Wifredo Lam. A Retrospective of Works on Paper (exhibition catalogue, Americas Society, New York, 1992).

Cuba 1950–1995

Alvarez Martínez, Enrique, 'Primer volumen de una renovación esperanzadora', *Temas*, 15 (1988), pp. 137–55.

Blanc, Giulio V., *Cuban Artists of the 20th Century* (exhibition catalogue, Fort Lauderdale Museum of Art, 1993).

Camnitzer, Luis, *The New Art of Cuba* (Austin, 1994).

Cuba siglo XX. Modernidad y sincretismo (exhibition catalogue, Centro Atlántico de Arte Moderno, Las Palmas de Gran Canaria, 1996).

Cuba–USA: the First Generation (exhibition catalogue, The Fondo del Sol Visual Arts Center, Washington, DC, 1991).

Fernández (Tonel), Antonio Elijio, 'Acotaciones al relevo', *Temas*, 22 (1992), pp. 81–8.

—, 'Arte cubano: la llave del Golfo y cómo usarla', *Temas*, 22 (1992), pp. 3–14.

Kuba OK (exhibition catalogue, Städtische Kunsthalle, Düsseldorf, 1990).

Kunzle, David, 'Public Graphics in Cuba: a Very Cuban Form of Internationalist Art', *Latin American Perspectives*, 7, supplement 75, vol. 2 (1975), pp. 89–100.

Made in Havana: Contemporary Art from Cuba (exhibition catalogue, Art Gallery of New South Wales, Sydney, 1988).

Mosquera, Gerardo, 'Africa in the Art of Latin America', *Art Journal*, 54, no. 4 (winter 1992), pp. 30–8.

—, *Exploraciones en la plástica cubana* (Havana, 1983).

—, *Los hijos de Guillermo Tell* (exhibition catalogue, Museo de Artes Visuales Alejandro Otero, Caracas, 1991).

—, 'New Cuban Art: Identity and Popular Culture', *Art Criticism*, 6 (1989), pp. 57–65.

The Nearest Edge of the World. Art and Cuba Now (exhibition catalogue, Institute of Contemporary Art, Boston, 1990).

No Man is an Island. Young Cuban Art (exhibition catalogue, Pori Art Museum, Finland, 1990).

Outside Cuba. Contemporary Cuban Visual Arts

(exhibition catalogue, the State University of New Jersey, Rutgers, 1989).

Pintores cubanos (Havana, 1962).

Poliester, 4 (1993).

Signs of Transition: 80s Art from Cuba (exhibition catalogue, Museum of Contemporary Hispanic Art, New York, 1988).

Third Text, 20 (1992).

de la Torriente, Loló, *Imagen de dos tiempos* (Havana, 1982).

Wood, Yolanda, *De la plástica cubana y caribeña* (Havana, 1990).

Dominican Republic

Adróver de Cibrán, Belkis, 'Celeste Woss y Gil Ricart', *Revista ahora*, 993 (1962).

Cartagena Portalatín, Aída, *Galería de Bellas Artes* (Santo Domingo, 1964).

de Juan, Adelaida, *En la galería latinoamericana* (Havana, 1979).

Ferrer, Elizabeth, and Edward J. Sullivan, *Modern and Contemporary Art of the Dominican Republic* (exhibition catalogue, The Spanish Institute and Americas Society, New York, 1996).

Gil, Laura, 'Es un museo nuestro Museo de Arte Moderno?', *El Caribe* (Saturday supplement, 19 December 1992), p. 13.

—, 'Signos de Utopía. Teoría, clasificación e historia de la abstracción pictórica en Santo Domingo', in *100 años de la pintura dominicana* (exhibition catalogue, Santo Domingo, 1989).

Gerón, Cándido, *Obras maestras de la pintura dominicana/Masterpieces of Dominican Painting*, 4 vols. (Santo Domingo, 1994).

La impronta española en la pintura dominicana contemporánea (exhibition catalogue, Centro Cultural Hispánico, Santo Domingo, 1995).

Jaime Colson. Memorias de un pintor trashumante. Paris 1924/Santo Domingo 1968 (Barcelona, 1978).

Liz, Domingo, 'Los jurados', *Hoy* (5 November 1972), p. 1-B.

Miller, Jeannette, *Arte dominicano contemporáneo/Contemporary Dominican Art* (exhibition catalogue, The Signs Gallery, New York, 1981).

—, *Fernando Peña Defilló: desde el orígen hacia la libertad* (Santo Domingo, 1983).

—, *Historia de la pintura dominicana* (Santo Domingo, 1979).

—, *Paul Giudicelli, sobreviviente de una época oscura* (Santo Domingo, 1983).

—, and Freddy Gatón Arce, *El paisaje dominicano. Pintura y poesía* (Santo Domingo, 1992).

Mujer y arte dominicano hoy. Homenaje a Celeste Woss y Gil (Santo Domingo, 1995).

Otras visiones. Cuatro artistas dominicanos contemporáneos (exhibition catalogue, Casa de Francia, Santo Domingo, 1994).

Peguero, V., and Danilo de los Santos, *Visión general de la historia dominicana* (Santo Domingo, 1978).

Rodríguez Demorizi, Emilio, *Pintura y escultura en Santo Domingo*, vol. 49 (Santo Domingo, 1972).

de los Santos, Danilo, 'El Premio Nacional de Artes Plásticas', *El Siglo* (11 December 1993), pp. 4–5.

—, *La pintura en la sociedad dominicana* (Santo Domingo, 1979).

Somoza, María Emilia, 'Sinopsis cronológica de la abstracción en Puerto Rico', *Primer Congreso de Artistas Abstractos de Puerto Rico* (catalogue, San Juan, 1984).

Suro, Darío, *Arte dominicano* (Santo Domingo, 1969).

Puerto Rico

Arnaldo Roche. Los primeros diez años (exhibition catalogue, Museo de Arte Contemporáneo de Monterrey, essay by Enrique García-Gutiérrez, Monterrey, 1993).

The Art Heritage of Puerto Rico/La herencia artística de Puerto Rico (exhibition catalogue, El Museo del Barrio and The Metropolitan Museum of Art, New York, 1973).

Benítez, Marimar, 'The Special Case of Puerto Rico', in *The Latin American Spirit: Art and Artists in the United States, 1920–1970* (exhibition catalogue, Bronx Museum of the Arts, New York, 1988), pp. 72–105.

Bloch, Peter, *Painting and Sculpture of the Puerto Ricans* (New York, 1978).

Campeche, Oller, Rodón. Tres siglos de pintura puertorriqueña/Three Centuries of Puerto Rican Painting (exhibition catalogue, Pabellón Nacional de Puerto Rico en la Exposición Universal Sevilla '92, organized by the Instituto de Cultura Puertorriqueña, San Juan, Seville, 1992).

Carlos Raquel Rivera, obra gráfica 1951/1990 (exhibition catalogue, Museo de las Américas, San Juan, 1993).

del Conde, Teresa, and Edward J. Sullivan, *Arnaldo Roche Rabell* (exhibition catalogue, Museo de Arte Moderno, Mexico City, 1995).

Delgado Mercado, Osiris, *Artes plásticas: historia de la pintura en Puerto Rico*, in *La gran enciclopedia de Puerto Rico*, vol. 8 (Madrid, 1976).

—, *Francisco Oller y Cestero (1833–1917), pintor de Puerto Rico* (San Juan, 1983).

—, *Ramón Frade León. Pintor puertorriqueño (1875–1954). Un virtuoso del intelecto* (San Juan, 1989).

—, *Sinopsis histórica de las artes plásticas en Puerto Rico* (San Juan, 1972).

Francisco Oller: un realista del impresionismo (exhibition catalogue, Museo de Arte de Ponce, 1983).

Gaya Nuño, Juan Antonio, *La pintura puertorriqueña* (Madrid, 1994).

González, José Luis, *El país de cuatro pisos* (Río Piedras, 1989).

Nuestro autorretrato. La mujer artista y la autoimágen en un contexto multicultural (San Juan, 1992).

De Oller a los cuarenta: la pintura en Puerto Rico de 1898 a 1948 (exhibition catalogue, Museo de la Universidad de Puerto Rico, essays by Osiris Delgado Mercado and José Antonio Torres Martinó, Río Pedras, 1988).

Pérez Lizano, Manuel, *Arte contemporáneo de Puerto Rico, 1950–1983. Cerámica, escultura, pintura* (Bayamón, 1985).

Picó, Fernando, *Historia general de Puerto Rico* (San Juan, 1986).

Ramírez, Mari Carmen, *Puerto Rican Painting Between Past and Present* (exhibition catalogue, Squibb Gallery, Princeton, 1987).

Rios Rigau, Adlín (ed.), *Las artes visuales puertorriqueñas a finales del siglo XX* (Santurce, 1992).

Scarano, Francisco A., *Puerto Rico: cinco siglos de historia* (New York, 1993).

Sturges, Hollister, *New Art From/Nuevo arte de Puerto Rico* (exhibition catalogue, Museum of Fine Arts, Springfield, Mass., 1990).

Tió, Teresa, *El cartel en Puerto Rico: 1946–1985* (exhibition catalogue, Museo de la Universidad de Puerto Rico, Río Piedras, 1985).

—, *El portafolios en la gráfica puertorriqueña* (exhibition catalogue, Museo de las Américas, San Juan, 1995).

Traba, Marta, *Propuesta polémica sobre arte puertorriqueño* (Río Piedras, 1971).

Tres décadas gráficas de Myrna Báez (exhibition catalogue, Museo de Arte de Puerto Rico, San Juan, 1988).

Venezuela

Alejandro Otero (exhibition catalogue, Museo de Arte Contemporáneo de Caracas, 1985).

Armando Reverón (exhibition catalogue, Museo Nacional Centro de Arte Reina Sofía, Madrid, 1992).

Arroyo, Miguel, *Arte, educación y museología. Estudios y polémicas 1948–1988* (Caracas, 1989).

Ashton, Dore, *Jacobo Borges* (Caracas, 1983).

Blanco, Lourdes, 'Manuel Mérida: de la naturaleza muerta a la materia en movimiento', in *Manuel Mérida, obras* (exhibition catalogue, Museo de Bellas Artes, Caracas, 1976).

—, 'Claudio Perna. Fotocopias', in *Claudio Perna. Autocopias* (exhibition catalogue, Museo de Bellas Artes, Caracas, 1975).

Boulton, Alfredo, *Historia de la pintura en Venezuela*, 3 vols. (Caracas, 1964–72).

—, *La obra de Armando Reverón* (Caracas, 1966).

Calzadilla, Juan (ed.), *El arte en Venezuela* (Caracas, 1967).

—, *El grabado en Venezuela* (Caracas, 1978).

—, *Movimientos y vanguardia en el arte contemporáneo en Venezuela* (Caracas, 1978).

—, 'Reverón: su universo como idioma', in *Armando Reverón: exposición iconográfica documental en el centenario de su nacimiento* (exhibition catalogue, Galería de Arte Nacional, Caracas, 1991).

Capriles, María Cristina (ed.), *Arturo Michelena. Su obra y su tiempo, 1863–1898* (Caracas, 1989).

Carvajal, Rina, 'Armando Reverón', *Latin American Artists of the Twentieth Century* (exhibition catalogue, Museum of Modern Art, New York, 1993), pp. 40–5.

D'Antonio, Francisco, *Textos sobre arte: Venezuela 1682–1982* (Caracas, 1980).

Diccionario de las artes visuales en Venezuela, 2 vols. (Caracas, 1982).

Esteva Grillet, Roldán, *Guzmán Blanco y el arte venezolano* (Caracas, 1986).

Flores, Elsa, *Convergencias* (Caracas, 1983).

Gego (exhibition catalogue, Museo de Arte Contemporáneo de Caracas, 1973).

Guevara, Roberto, *Arte para una nueva escala* (Caracas, 1978)

—, *Ver todos los días* (Caracas, 1981).

Indagaciones de la imagen: la figura, el ámbito, el objeto (exhibition catalogue, Galería de Arte Nacional, Caracas, 1981).

Jacobo Borges (exhibition catalogue, Staatliche Kunsthalle, Berlin 1987).

Los ochenta. Panorama de las artes visuales en Venezuela (exhibition catalogue, Galería de Arte Nacional, Caracas, 1990).

Proposiciones de Victor Lucena 1969–1980 (exhibition catalogue, Museo de Arte Contemporáneo de Caracas, 1980).

Rama, Angel, *Antología de 'El Techo de la Ballena'* (Caracas, 1987).

Rodríguez, 'Bélgica, Arte geométrico – arte constructivo. Venezuela 1945/1965', *Arte constructivo venezolano 1945–1965. Génesis y desarrollo* (Caracas, 1980).

—, *Breve historia de la escultura contemporánea en Venezuela* (Caracas, 1979).

—, *La pintura abstracta en Venezuela 1945–1965* (Caracas, 1980).

60 obras de/60 Paintings by Jacobo Borges (exhibition catalogue, Museo de Monterrey, 1987).

Tiempo de Gallegos. La pintura y el dibujo (exhibition catalogue, Galería de Arte Nacional, Caracas, 1985).

Traba, Marta, *Mirar en Caracas* (Caracas, 1974).

Colombia

Arte colombiano del siglo XX (series of 5 catalogues published by the Centro Colombo Americano, Bogotá, 1980–2).

Barney Cabrera, Eugenio, *El arte en Colombia, temas de ayer y de hoy* (Bogotá, 1980).

—, *Temas para la historia del arte en Colombia* (Bogotá, 1970).

Giraldo Jaramillo, Gabriel, *La miniatura, la pintura y el grabado en Colombia* (Bogotá, 1980).

Historia del arte colombiano (various authors) (Barcelona, 1975).

Manual de la historia de Colombia (various authors), vol. 3 (Bogotá, 1980).

Medina, Alvaro, *Proceso del arte en Colombia* (Bogotá, 1978).

Ortega Ricaurte, Carmen, *Diccionario de artistas en Colombia* (Bogotá, 1979).

Quiroz, Fernando, José Hernán Aguilar and Carolina Ponce de León, *Nueva Imagen* (Bogotá, 1994).

Rubiano Caballero, Germán, *Escultura colombiana del siglo XX* (Bogotá, 1983).

Serrano, Eduardo, *Cien años del arte colombiano* (Bogotá, 1985).

—, *Still-Life in Colombia* (Bogotá, 1992).

Traba, Marta, *Historia abierta del arte colombiano* (Cali, 1974).

—, *Mirar en Bogotá* (Bogotá, 1976).

— (ed.), *Museo de Arte Moderno de Bogotá* (Bogotá, 1984).

Zalamea, Jorge, *Literatura, política y arte* (Bogotá, 1978).

Ecuador

Areán, Carlos, *Tábara* (Quito, 1990).

Arte ecuatoriano, 4 vols. (Navarra, 1978).

Arte sacro contemporáneo del Ecuador (Guayaquil, 1985).

Arte vial. I museo de arte vial en la mitad del mundo (exhibition catalogue, La Galería, Quito, 1985–6).

Barnitz, Jacqueline, *Abstract Currents in Ecuadorian Art* (exhibition catalogue, Center for Inter-American Relations, New York, 1977).

I Bienal internacional de pintura de Cuenca (exhibition catalogue, Museo de Arte Moderno, Cuenca, 1987).

II Bienal internacional de pintura de Cuenca (exhibition catalogue, Museo de Arte Moderno, Cuenca, 1989).

III Bienal internacional de pintura de Cuenca (exhibition catalogue, Museo de Arte Moderno, Cuenca, 1991).

Camilo Egas (Museo Camilo Egas, Quito, n.d.).

Camón Aznar, José, *Guayasamín* (Barcelona, n.d.).

Catálogo del Salón de la Independencia (exhibition catalogue, Casa de la Cultura Ecuatoriana, Quito, 1972).

100 artistas del Ecuador (Quito, 1990).

Club de la Unión, M. Rendón/Araceli Gilbert (Guayaquil, 1989).

II Concurso nacional de artes plásticas (exhibition catalogue, Museo del Banco Central del Ecuador, Quito, 1978).

III Concurso nacional de artes plásticas (exhibition catalogue, Museo del Banco Central del Ecuador, Quito, 1979).

Grupo Experimental de arte, Jaime Andrade. Obra escultórica y gráfica (Quito, 1977).

Iza, Jácome, Román, Unda. Los Cuatro Mosqueteros (Quito, 1993).

Lasaigne, Jacques, *Guayasamín* (Barcelona, 1977).

Libro del Sesquicentenario. II tomo: arte y cultura. Ecuador: 1830–1980 (Quito, 1980).

Monteforte, Mario, *Los signos del hombre. Plástica y sociedad en el Ecuador* (Quito, 1985).

More, Humberto, *Actualidad plástica ecuatoriana* (Guayaquil, n.d.).

Navarro, José Gabriel, *Artes plásticas ecuatorianas* (Mexico City, 1945).

Rodríguez Castelo, Hernán, *Diccionario crítico de artistas plásticos del Ecuador* (Quito, 1992).

—, *Kingman* (Milan, 1985).

—, *El siglo XX de las artes plásticas en Ecuador* (exhibition catalogue, Museo de Arte del Banco Central, Guayaquil, 1988).

Salón exposición Mariano Aguilera. 65 años de plástica ecuatoriana, 1917–82 (Quito, 1982).

Salón Nacional Vicente Rocafuerte para jóvenes creadores de las artes visuales (Guayaquil, 1983).

Vargas, José María, *El arte ecuatoriano*

(Quito, 1964).

Viteri (Casa de la Cultura Ecuatoriana, Quito, 1985).

Peru

Acha, Juan, *Peru* (Washington, DC, 1961).

Argan, G.C., Enrico Crispolti and Jean Dypréau, *Enigmi e formi di Roca-Rey* (Milan, 1973)

Braun Vega. Rétrospective 1950–1989 (exhibition catalogue, Galerie Pascal Gabert and Musée de Maubeuge, Maubeuge, 1989).

Buntinx, Gustavo, 'Arte joven peruano. El post-velasquismo pictórico', *Arte en Colombia*, 26 (1985), pp. 42–7.

—, and Luis Eduardo Wuffarden, *Mario Urteaga. Catálogo razonado* (Lima, 1987).

Castrillán Vizcarra, Alfonso, 'Teófilo Castillo o la institución de la crítica (1914–1919)', *Hueso húmero*, 9 (1981), pp. 58–70.

—, 'Escultura monumental y funeraria en Lima', in *Escultura en Perú* (Lima, 1991).

Felices Alcántara, Dora, 'Nuestros grandes maestros: Vinatea Reinoso', *Kantú. Revista de Arte*, 5 (1989), pp. 8–12.

Huayhuaca, José Carlos, *Martín Chambi. Fotógrafo* (Lima, 1991).

Jorge Eielson. Il linguaggio magico dei nodi (exhibition catalogue, Gallerie del Credito Valtellinese, Milan, 1993).

Lauer, Mirko, *Intruducción a la pintura peruana del siglo XX* (Lima, 1976).

—, *Crítica de la artesanía* (Lima, 1982).

—, J. Sologuren and E. A. Westphalen, *Szyszlo, indagación y collage* (Lima, 1975).

Miró Quesada, G. Luis, *Arte en debate* (Lima, 1966).

Morley, Grace L. McCann, 'An Introduction to Contemporary Peruvian Painting', *Quarterly Bulletin of the San Francisco Museum of Art*, 2 (1942), pp. 17–36.

Moro, César, *Los anteojos de azufre* (Lima, 1958).

Un pasado incompleta. A Past Incomplete. Moico Yaker. Pinturas, The Paintings 1986–1994 (exhibtion catalogue, Museo de Arte Contemporáneo de Monterrey, 1996).

Pereira, Raúl María, 'Consideraciones sobre la pintura peruana,' *Mercurio peruano*, 151 (1939), pp. 397–403.

Poole, Deborah, 'Figueroa Aznar and the Cusco Indigenists: Photography and Modernism in Early Twentieth-Century Peru', *Representations*, 38 (1992), pp. 39–75.

Raygada, Carlos, 'The New Peruvian Painting', *Bulletin of the Pan American Union* (1933),

pp. 907–22.

Ríos, Juan E., *La pintura contemporánea en el Perú* (Lima, 1946).

Rodríguez Saavedra, Carlos, *Sérvulo Gutiérrez* (Lima, 1980).

Salazar Bondy, Sebastián, *Una voz libre en el caos. Ensayo crítico de arte* (Lima, 1990).

Szyszlo in his Labyrinth/Szyszlo en su laberinto (exhibition catalouge, Art Museum of the Americas, Washington, DC, 1996).

Tola (Mexico City, 1991).

Torres Bohl, José, *Apuntes sobre José Sabogal. Vida y obra* (Lima, 1989).

Ugarte Elespuru, Juan Manuel, *Pintura y escultura en el Perú contemporáneo* (Lima, 1970).

Unruh, Vicky, 'Mariátegui's Aesthetic Thought: a Critical Reading of the Avant-Gardes', *Latin American Research Review*, 24 (1989), pp. 45–69.

Vargas Llosa, Mario, Ana María Escallón, Ricardo Pau-Llosa and J. Alanis, *Fernando de Szyszlo* (Bogota and New York, 1991).

Wuffarden, Luis Eduardo, *Tilsa Tsuchiya* (Lima, 1981).

Brazil

Aguillar, Nelson (ed.), *Bienal Brasil século XX* (São Paulo, 1994).

Almeida, Paulo Mendes de, *De Anita ao Museu* (São Paulo, 1976).

Amaral, Aracy, *Artes plásticas na semana de 22* (São Paulo, 1970; commemorative edition 1992).

—, *Arts in the Week of '22* (São Paulo, 1992).

—, *Tarsila: sua obra e seu tempo*, 2 vols. (São Paulo, 1975).

— (ed.), *Projeto construtivo brasileiro na arte: 1950–1962* (Rio de Janeiro and São Paulo, 1977).

—, and Paulo Herkenhoff, *Ultramodern. The Art of Contemporary Brazil* (exhibition catalogue, National Museum of Women in the Arts, Washington, DC, 1993).

Amarante, Leonor, *As bienais de São Paulo: 1951–1987* (São Paulo, 1989).

Andrade, Mario, *Aspectos das artes plásticas no Brasil*, 3rd edn. (Belo Horizonte, 1984).

—, 'O movimento Modernista', in *Aspectos da literatura brasileira*, 4th edn. (São Paulo and Brasília, 1972), pp. 231–55.

Aranjo, Emanoel (ed.), *A mão afro-brasileira. Significado da contribuição artística e histórica* (São Paulo, 1988).

Bento, Antonio, *Panorama da pintura moderna brasileira* (Rio de Janeiro, 1966).

Brazilien. Entdeckung und Selbstendeckung (Bern, 1992).

Brito, Ronaldo, *Neoconcretismo: vértice e ruptura do projeto construtivo brasileiro* (Rio de Janeiro, 1985).

Buarque de Holanda, Sérgio, *Raízes do Brasil*, 9th edn. (Rio de Janeiro, 1976).

Cavalcanti, Carlos (ed.), *Dicionário brasileiro de artistas plásticos*, 4 vols. (Brasília, 1973–80).

Cocchiarale, Fernando, and Geiger, Anna Bella, *Abstracionismo geométrico e informal: a vanguarda brasileira dos anos cinquenta* (Rio de Janeiro, 1987).

Da Matta, Roberto, *Carnavais, malandros e heróis. Para una sociologia do dilema brasileiro*, 2nd edn. (Rio de Janeiro, 1980).

Gullar, Ferreira, *Vanguarda e subdesenvolvimento* (Rio de Janeiro, 1965).

— (ed.), *A arte brasileira hoje* (Rio de Janeiro, 1973).

Journal of Decorative and Propaganda Arts, vol. 21, Brazilian Theme Issue (1995).

Leirner, Sheila, *Arte como medida* (São Paulo, 1982).

—, *Arte e seu tempo* (São Paulo, 1966).

Leite, José Roberto Teixeira, *A gravura brasileira contemporânea* (Rio de Janeiro, 1966).

Lemos, Carlos, et al., *The Art of Brazil* (New York, 1983).

Marino, João (ed.), *Tradição e ruptura. Síntese de arte e cultura brasileiras* (São Paulo, 1984).

Modernidade: art brésilien du XXème siècle (exhibition catalogue, Musée d'Art Moderne de la Ville de Paris, Paris, 1987); Portuguese edn., *Modernidade: arte brasileira do século XX* (Museu de Arte Moderna, São Paulo, 1988).

Morais, Frederico, *Artes plásticas: a crise da hora atual* (Rio de Janeiro, 1975).

—, *Núcleo Bernadelli: arte brasileira nos anos 30 e 40* (Rio de Janeiro, 1982).

Moreira Leite, Dante, *O caráter nacional brasileiro* (São Paulo, 1969).

Pedrosa, Mario, *Mundo, homem, arte e crise* (São Paulo, 1976).

—, *Dos murais de Portinari aos espaços de Brasília* (São Paulo, 1985).

Pontual, Roberto, *Entre dois séculos: arte brasileira do século XX na coleção Gilberto Chateaubriand* (Rio de Janeiro, 1987).

Schwarz, Roberto, 'As idéias fora do Lugar', in *Ao vencedor as batatas*, 4th edn. (São Paulo, 1992), pp. 13–28.

Teles, Gilberto Mendonça, *Vanguarda européia e modernismo brasileiro*, 4th edn. (Petrópolis, 1977).

Zanini, Walter, *A arte no brasil das décadas de 1930–40: o Grupo Santa Helena* (São Paulo, 1991).

— (ed.), *História geral da arte no brasil*, 2 vols. (São Paulo, 1983).

Zílio, Carlos, *A querela do Brasil* (Rio de Janeiro, 1982).

Bolivia

Archondo, Rafael, 'El mestizaje, una bala perdida', in 'Lo mestizo, lo nacional', *Revista autodeterminación, de análisis histórico, político, y teoría social* (1989).

Arze, Silvia, 'Marco cronológico del arte boliviano en el siglo XX', in *Pintura boliviana del siglo XX* (La Paz, 1989).

Botelho Gosalvez, Raúl, 'Cecilio Guzmán de Rojas, pintor del Ande', *Khana*, 33–4 (1959), pp. 261–9.

Calvo Valda, Marcelo, *Mística y paisaje. Ensayos sobre la obra de Guzmán de Rojas* (La Paz, 1986).

Centeno, Ricardo, 'Bolivia: lo pluri-cultural y multi-étnico como identidad', *Presencia*, section I (6 August 1993), p. 3.

Chacón Torres, Mario, *Pintores del siglo XIX* (La Paz, 1963).

Fernández Naranjo, Nicolás, José de Mesa and Teresa Gisbert, *Arturo Borda* (exhibition catalogue, Alcaldía de La Paz, 1977).

Francovich, Guillermo, *El pensamiento boliviano del siglo XX* (Mexico City, 1956).

—, *Los mitos profundos de Bolivia* (La Paz, 1980).

Granados Valdés, Antonio, *Artistas de América* (Madrid, 1993).

Guiomar Mesa (exhibition catalogue, Museo de Arte Contemporáneo de Monterrey, essay by Elizabeth Ferrer, 1995).

Mesa, José de, and Teresa Gisbert, *La pintura en los museos de Bolivia* (La Paz, 1990).

Núñez del Prado, Marina, *Eternidad en los Andes* (La Paz, 1972).

Querejazu, Pedro, 'Las artes plásticas y 1952', in 'Segundo encuentro de estudios bolivianos: la cultura del 52', *Presencia literaria* (August 1984).

—, 'El arte en Bolivia entre 1920 y 1960', in *Voces de ultramar. El arte en América Latina y Canarias: 1910–1960* (Las Palmas de Gran Canaria, 1992), pp. 33–41.

—, 'Ensayo crítico en torno a Arturo Borda y su obra', *Revista Municipal de Cultura* (nueva época), 21 (1989).

—, *Ted Carrasco* (La Paz, 1988).

—, et al., *Pintura boliviana del siglo XX* (La Paz, 1989).

Salazar Mostajo, Carlos, *La pintura contemporánea en Bolivia* (La Paz, 1989).

Sanjines, Javier, *Literatura contemporánea* (La Paz, 1992).

Soriano Badani, Armando, *Medio siglo de pintura* (La Paz, 1975).

Villarroel Claure, Rigoberto, *Arte contemporáneo: pintores, escultores y grabadores bolivianos* (La Paz, 1952).

Paraguay

Alsina, Arturo, *Paraguayos de otros tiempos* (Asunción, 1983).

Báez, Jorge, *Artes y artistas paraguayos* (Asunción, 1941).

—, 'La plástica paraguaya contemporánea', *La Tribuna* (Asunción, 10 June 1962), p. 15.

Bestard, Jaime, *La ciudad florida* (Buenos Aires, 1951).

Blinder, Olga, Josefina Pla and Ticio Escobar, *Arte actual en el Paraguay 1900–1980*, 2 vols. (Asunción, 1983).

Centurión, Carlos R., *Historia de la cultura paraguaya*, vol. 2 (Asunción, 1961).

Díaz Pérez, Viriato, *Del arte* (Palma de Mallorca, 1982).

—, 'Un estudio sobre pintura y escultura en el Paraguay', *El Liberal* (Asunción, 28 February 1974), p. 16.

Domínguez, Ramiro, 'Por un arte nuevo', *La Tribuna* (Suplemento Cultural, Asunción, 7 April 1954), p. 4.

Fernández, Miguel Angel, *Art in Latin America Today: Paraguay* (Washington, DC, 1969).

Ortiz Mayans, Antonio, *Sorazábal, su vida y su obra* (Buenos Aires, 1946).

Other Sensibilities. Recent Developments in the Art of Paraguay (exhibition catalogue, Inter-American Development Bank, Washington, DC, 1994).

Pla, Josefina, 'El arte en el Paraguay', *Enciclopedia del arte en América*, vol. 2 (Buenos Aires, 1969), pp. 241–70.

—, *El espíritu de fuego. Biografía de Julián de la Herrería* (Asunción, 1977).

—, *El grabado en el Paraguay* (Asunción, 1963).

—, *Treinta y tres nombres en las artes plásticas paraguayas* (Asunción, 1973).

Prieto, Juan Manuel, 'Una década sin historia', *Ultima Hora* (Suplemento Cultural, Asunción, 3 January 1980), p. 6.

Salerno, Osvaldo, *Paraguay: artesanía y arte popular* (Asunción, 1983).

Uruguay

Abbondanza, Jorge, *Manuel Espínola Gómez* (Montevideo, 1991).

Argul, José-Pedro, *Pintura y escultura del Uruguay. Historia crítica* (Montevideo, n.d.).

—, *Proceso de las artes plásticas del Uruguay* (Montevideo, 1975).

Barradas. Exposición antológico 1890–1929 (exhibition catalogue, Gobierno de Aragón, Zaragoza, 1992).

Diccionario de artistas plásticos en el Uruguay, 2 vols. (Montevideo, 1992).

12 pintores nacionales (Montevideo, 1979).

Di Maggio, Nelson, 'Literatura y artes plásticas', *Capítulo oriental*, 41 (Buenos Aires, 1968).

—, *Literatura y artes plásticas* (Buenos Aires, 1975).

Duncan, Barbara, *Joaquin Torres-García. Chronology and Catalogue of the Family Collection* (exhibition catalogue, University of Texas at Austin Art Museum, Austin, 1974).

García Esteban, Fernando, *Artes plásticas del Uruguay en el siglo XX* (Montevideo, 1970).

—, 'El arte nuevo', in *Enciclopedia uruguaya*, no. 45 (Montevideo, 1969).

—, 'Dibujantes y grabadores del Uruguay', in *Colección pueblos, hombres y formas en el arte*, 31 (Buenos Aires, 1975).

—, 'Panorama sucinto del desarrollo de las artes uruguayas de Blanes a nuestros días', in *De Blanes a nuestros días* (exhibition catalogue, Punta del Este, Comisión Nacional de Bellas Artes, Ministerio de Instrucción Pública, 1961).

—, *Panorama de la pintura uruguaya contemporánea* (Montevideo, 1965).

García Puig, María Jesús, *Joaquín Torres-García y el Universalismo Constructivo. La enseñanza del arte en Uruguay* (Madrid, 1990).

Haber, Alicia, 'Al encuentro de las cultural subyacentes', in *Más allá de las palabras* (exhibition catalogue, Intendencia Municipal de Montevideo, División Cultura, 1992).

—, *Carlos González* (exhibition catalogue, Intendencia Municipal de Montevideo, Departamento de Cultura, 1988).

—, *Cúneo Perinetti: la lección del maestro* (exhibition catalogue, Galería Latina, Montevideo, 1990).

—, *De lo vivencial a lo metafísico: el arte de Jorge Damiani* (exhibition catalogue, Intendencia de Montevideo, Departamento de Cultura, 1991).

—, 'Detrás de un vidrio claroscuro', in *Agueda Dicancro: Otras visiones* (exhibition catalogue, Intendencia Municipal de Montevideo, Departamento de Cultura, 1989).

—, *Ernesto Vila, Works on Paper* (exhibition catalogue, Museum of Modern Art of Latin America, Washington, DC, 1990).

—, 'El escenario de la memoria', in *Rimer Cardillo Charrúas y Montes Criollos* (exhibition catalogue, Intendencia de Montevideo, Departamento de Cultura, 1991).

—, 'Estructuras mágicas', in *Francisco Matto. Retrospectiva* (exhibition catalogue, Intendencia Municipal de Montevideo, Departamento de Cultura, 1988).

—, *Germán Cabrera: paradigma de artista investigador* (exhibition catalogue, Intendencia Municipal de Montevideo, División Cultura, 1992).

—, *Joaquín Torres-García, Construcciones en madera y oleos* (exhibition catalogue, Galería del Sur, Punta del Este, 1993).

—, 'Luis Camnitzer: evocación y lirismo', in *El libro de los muros* (exhibition catalogue, Intendencia Municipal de Montevideo, División Cultural, 1993).

—, *6 propuestas pictóricas uruguayas. Primera semana cultural iberoamericana* (exhibition catalogue, Intendencia Municipal de Montevideo, Departamento de Cultura, 1991).

—, *Torres-García y la tradición mediterránea* (exhibition catalogue, Museo Torres-García, Montevideo, 1988).

—, 'Una formulación antropológica', in *Carlos Capelán Mapas y paisajes* (exhibition catalogue, Intendencia Municipal de Montevideo, División Cultura, 1992).

—, *Vernacular Culture in Uruguayan Art. An analysis of the Documentary Functions of the Works of Pedro Figari, Carlos González and Luis Solari* (Latin American and Caribbean Center, Florida International University, 1981).

—, et al., *Arte uruguayo contemporáneo, cinco propuestas: Alamón, Costigliolo, Lorieto, Solari, Testoni* (Montevideo, 1984).

de Ignacios, Antonio, *Historial Rafael Barrados* (Montevideo, 1953).

Jardí, Enric, *Rafael Barradas a Catalunya y les altres que passaren la mar* (Barcelona, 1992).

—, *Torres García* (Barcelona, 1974).

Joaquín Torres-García. Epoca catalana, 1908–1928 (exhibition catalogue, Museo Nacional de Artes Visuales, Montevideo, 1988).

Kalenberg, Angel, *Arte uruguayo y otros* (Montevideo, 1990).

Larnaudie, Olga, and María Luisa Torrens, *El Dibujazo* (exhibition catalogue, Museo de Arte Contemporáneo, Montevideo, 1989).

Laroche, W.E., *Pintores uruguayos en España 1900–1930* (Montevideo, 1992).

Parpagnoli, Florio, 'Los retratistas del país', in *Enciclopedia Uruguaya*, no. 33 (Montevideo, 1968).

Pedro Figari 1861–1938 (exhibition catalogue, Pavillon des Arts, Paris, 1992).

Peluffo Linari, Gabriel, *Historia de la pintura uruguaya – De Blanes a Figari* (Montevideo, 1993).

—, *El paisaje a través del arte en el Uruguay* (Montevideo, 1994).

—, *Realismo social en el arte uruguayo, 1930–1950* (exhibition catalogue, Museo Juan Manuel Blanes, Montevideo, 1992).

Pereda, Raquel, *Barradas* (Montevideo, 1989).

—, *Blanes Viale* (Montevideo, 1990).

—, *José Cúneo, retrato de un artista* (Montevideo, 1988).

—, *Saéz* (Montevideo, 1986).

—, *Torres García* (Montevideo, 1991).

Plásticos uruguayos (biographies) (Montevideo, 1975).

Ramírez, Mari Carmen and others, *La Escuela del Sur. El Taller Torres-García y su legado* (exhibition catalogue, Museo Nacional Centro de Arte Reina Sofía, Madrid, 1991); English version, *El Taller Torres-García. The School of the South and its Legacy* (Austin, 1992).

Seis maestros de la pintura uruguaya (exhibition catalogue, Museo Nacional de Bellas Artes, Buenos Aires, 1987).

Torrens, María Luisa, *12 pintores nacionales* (Montevideo, 1979).

—, *Hugo Longa* (exhibition catalogue, Museo de Arte Contemporáneo, Montevideo, n.d.).

El Universalismo Constructivo y la Escuela del Sur. Constructive Universalism and the School of the South (exhibition catalogue, Art Museum of the Americas, Washington, DC, 1996).

Argentina

Areán, Carlos, *La pintura en Buenos Aires* (Buenos Aires, 1981).

Argentina en el arte (Colección Fasciculos, Buenos Aires, n.d.).

Art from Argentina 1920–1994 (exhibition catalogue, Museum of Modern Art, Oxford, 1994).

Arte argentina dalla indipendenza ad oggi 1810–1987 (exhibition catalogue, Istituto Italo Latino Americano, Rome, 1987).

Atalaya (Alfredo Chiabra Acosta), *Críticas de arte argentino* (Buenos Aires, 1934).

Baker, Sally (ed.), *Art of the Americas: The Argentine Project* (Buenos Aires, 1981).

Bedoya, Jorge, and Noemi Gil, *Aproximaciones al arte de los años veinte en Argentina* (Buenos Aires, 1972).

Brughetti, Romualdo, *De la joven pintura*

rioplatense (Buenos Aires, 1942).

—, *Geografía plástica argentina* (Buenos Aires, 1958).

—, *Historia del arte en Argentina* (Mexico City, 1965).

—, *Italia y el arte argentino, itinerario de una emulación plástico-cultural* (Buenos Aires, 1952).

Burucúa, José Emilio and Ana María Telesca, *El impresionismo en la pintura argentina. Análisis y crítica* (Buenos Aires, 1989).

150 años de arte argentino (exhibition catalogue, Museo Nacional de Bellas Artes, Buenos Aires, 1960).

Cordova, Ituburo, Cayetano, *80 años de la pintura argentina: del preimpresionismo a lo novísima figuración* (Buenos Aires, 1978).

Chavarri, Raúl, *Del objeto al sistema. Una introducción a la historia del arte argentino* (Barcelona, 1980).

Dellepiane, Antonio, *Estudios de historia y arte argentino* (Buenos Aires, 1929).

Enciclopedia del arte en América, 5 vols. (Buenos Aires, 1968).

Foglia, Carlos, *Historia de la pintura argentina* (Buenos Aires, 1961).

Gesualdo, Vicente et al, *Diccionario de artistas plásticas en la Argentina*, 2 vols. (Buenos Aires, 1988).

Glusberg, Jorge, *Del Pop a la Nueva Imágen* (Buenos Aires, 1985).

Haedo, Oscar Félix, *Pintura argentina, 1900–1960* (Buenos Aires, 1977).

Jornadas de teoría e historia de las artes (Centro Argentino de Investigadores de Arte, Buenos Aires, 1989–93; 5 fascicules thus far printed).

The Journal of Decorative and Propaganda Arts. Argentine Theme Issue 1875–1945, vol. 18 (1992).

Levinas, Gabriel (ed.), *Arte argentino contemporáneo* (Madrid , 1980).

Lopez Anaya, Jorge, *Los comienzos de la escultura* (Buenos Aires, 1966).

—, *Una visión de la plástica argentina contemporánea 1940–1990* (exhibition catalogue, Sala Forum Patio Bulhich, Buenos Aires, 1990).

Merlino, Adrián, *Diccionario de artistas plásticos de la Argentina, siglos XVII–XX* (Buenos Aires, 1954).

Nessi, Angel O., *Situación de la pintura argentina. Siglos XIX y XX* (Buenos Aires, 1956).

Pacheco, Marcelo, 'Aproximación a la pintura argentina. Necesidad de una construcción teórica nueva', in *Primeras jornadas de teoria e*

historia de las artes: Teoría y historiografía del arte argentino (Fundación San Telmo, Buenos Aires, 1989), pp. 30–8.

Pagano, José Léon, *El arte de los argentinos*, 3 vols. (Buenos Aires, 1937).

—, *Historia del arte argentino de los aborígenes al momento actual* (Buenos Aires, 1944).

Palomar, Francisco, *Primeros salones de arte en Buenos Aires* (Buenos Aires, 1960).

Payró, Julio, *22 pintores argentinos, facetas del arte argentino* (Buenos Aires, 1945).

Pellegrini, Aldo, *Argentina Arte Nuevo* (Buenos Aires, 1955).

—, *Panorama de la pintura argentina contemporánea* (Buenos Aires, 1967).

Perazzo, Nelly, *El arte concreto en la Argentina* (Buenos Aires, 1983).

Pintores argentinos del siglo XX (Buenos Aires, 1981).

Presta, Salvador, *Arte argentino actual* (Buenos Aires, 1960).

Romero Brest, Jorge, *Arte en la Argentina: últimas décadas* (Buenos Aires, 1969).

San Martín, María Laura, *Pintura argentina contemporánea* (Buenos Aires, 1969).

Taverna Irigoyen, J.M., *Aproximación a le escultura argentina de este siglo* (Santa Fe, Argentina, 1967).

Chile

Aguilo, Osvaldo, *Propuestas neovanguardistas en la plástica chilena. Antecedentes y contexto* (Santiago, 1983).

Alvarez de Sotomayor y la Generación del Trece (exhibition catalogue, Museo de Arte Contemporáneo, Universidad de Chile, Santiago, 1992).

15 elegidos en la pintura chilena (exhibition catalogue, Instituto Cultural de Las Condes, Santiago, 1984).

Contemporary Art from Chile/Arte contemporáneo desde Chile (exhibition catalogue, Americas Society, New York, 1991).

Cruz de Amenábar, Isabel, *Historia de la pintura y escultura en Chile desde la Colonia al siglo XX* (Santiago, n.d.).

Galaz, Gaspar, and Milan Ivelic, *La pintura en Chile desde la colonia hasta 1981* (Santiago, 1981).

—, *Chile. Arte actual* (Santiago, 1988).

Ivelic, Milan, *La escultura chilena* (Santiago, 1978).

Kay, Ronald, *Del espacio de acá* (Santiago, 1980).

Ocho pintores chilenos (exhibition catalogue, Museo de Arte Moderno, Mexico City, 1994).

Recovering Histories: Aspects of Contemporary Art in Chile since 1982 (exhibition catalogue, Center for Latino Arts and Culture of Rutgers, the State University of New Jersey, New Brunswick, 1993).

Richard, Nelly, 'Margins and Institutions: Art in Chile since 1973', *Art and Text*, no. 21 (Melbourne, May/June 1986), special edition.

Chicano Art

Arcero-Frutos, René, Juana Guzmán, and Amalia Mesa-Bains (eds.), *Art of the Other Mexico: Sources and Meanings* (exhibition catalogue, The Mexican Fine Arts Center Museum, Chicago, 1993).

Beardsley, John, and Jane Livingston (eds.), *Hispanic Art in the United States: Thirty Contemporary Painters and Sculptors* (exhibition catalogue, The Museum of Fine Arts, Houston, 1986).

Brookman, Philip, and Guillermo Gómez-Peña (eds.), *Made in Aztlán: Centro Cultural de la Raza, Fifteenth Anniversary* (San Diego, 1986).

Chavez, Patricio, and Madeleine Grynsztejn (eds.), *La Frontera/The Border: Art About the Mexico/United States Border Experience*, (exhibition catalogue, San Diego: Centro Cultural de la Raza, Museum of Contemporary Art, San Diego, 1993).

Cockcroft, Eva, and Holly Barnet-Sánchez (eds.), *Signs from the Heart: California Chicano Murals* (Venice, California, and Albuquerque, 1990).

Goldman, Shifra, and Tomás Ybarra-Frausto, *Arte Chicano: a Comprehensive Annotated Bibliography of Chicano Art 1965–1981* (Berkeley, 1985).

Griswold del Castillo, Richard, Teresa McKenna, and Yvonne Yarbro-Bejarano, *CARA: Chicano Art: Resistance and Affirmation 1965–1985* (exhibition catalogue, Wight Art Gallery, University of California, Los Angeles, 1991).

Letelier, Pascal, *Le Démon des Anges: 16 Artistes Chicanos autour de Los Angeles* (exhibition catalogue, Centre de Recherche pour le Developement Culturel, Nantes, and Generalitat de Catalunya, Barcelona, 1989).

Mesa-Bains, Amalia, Tomás Ybarra-Frausto, and Victor Zamudio-Taylor, *Ceremony of Memory: New Expressions in Spirituality Among Hispanic Artists* (exhibition catalogue, Center for Contemporary Arts, Santa Fe, 1988).

—, Arturo Lindsay, and Victor Zamudio-Taylor, *Ceremony of Spirit: Nature and Memory in Contemporary Latino Art* (exhibition catalogue, The Mexican Museum, San Francisco, 1993).

Partch, Elizabeth (ed.), *Body/Culture: Chicano Figuration* (exhibition catalogue, University Art Gallery, Sonoma State University, Rohnert Park, California, 1990).

Rascón, Armando (ed.), *Xicano Progeny* (exhibition catalogue, The Mexican Museum, San Francisco, 1994).

Ybarra-Frausto, Tomás, *Lo del Corazón: Heartbeat of a Culture* (exhibition catalogue, The Mexican Museum, San Francisco, 1986).

—, and Inverna Locpez (eds.), *Chicano Expressions: A New View in American Art* (exhibition catalogue, Latin American Art Gallery, New York, 1986).

Supplement 2000
Mexico
Leonard Folgarait, *Mural Painting and Social Revolution in Mexico 1920–1940* (Cambridge, 1998).

Kassner, Lily, *Diccionario de escultores mexicanos del siglo XX* (2 vols), (Mexico City, 1997).

Central America
Panama
Kupfer, Monica E., and Edward J. Sullivan, *Crosscurrents. Contemporary Painting from Panama, 1968–1998* (exhibition catalogue, Americas Society, New York, 1998).

Cuba 1950–2000
Zeitlin Marylin (ed.), *Contemporary Art from Cuba: Irony and Survivial on the Utopian Island/Arte contemporáneo de Cuba: ironía y sobrevivencia en la isla utópica* (exhibition catalogue, Arizona State University Art Museum, Tempe, 1998).

Puerto Rico
Hermandad de Artistas Gráficos de Puerto Rico, *Puerto Rico. Arte e identidad* (San Juan, 1998).

Peru
Tello Garust, Guillermo, *Pinturas y pintores del Perú* (Lima, 1997).

Uruguay
Peluffo Linari, Gabriel, *Pintura uruguaya* (Buenos Aires, 1999).

Argentina
Amigo, Roberto, Patricia Artundo and Marcelo Pacheco, *Pintura argentina* (Buenos Aires, 1999).

Ramírez, Mari Carmen et al., *Cantos Paralelos. La parodia plástica en el arte argentino contemporáneo: Visual Parody in Contemporary Argentine Art* (exhibition catalogue, Jack S. Blanton Museum of Art, Austin, 1999).

Verlichak, Victoria, *El ojo del que mira. Artistas del los noventa* (Buenos Aires, 1998).

Chicano Art
Gaspar de Alba, Alicia, *Chicano Art. Inside/Outside the Master's House. Cultural Politics and the CARA Exhibition* (Austin, 1998).

Index

The Contributors

Photographic Acknowledgements

The General Editor

Edward J. Sullivan is Professor of Art History and Chairman of the Department of Fine Arts at New York University, and a leading expert on Latin American art. He has written widely on the subject and curated many exhibitions. His recent publications include *Botero: Sculpture* (1986), *Julio Larraz* (1989), *La Mujer en México/Women in Mexico* (1990) and *Adolfo Riestra, Pintor, Escultor, Dibujante (Painter, Sculptor, Draftsman)* (1998).

The Authors

Giulio Blanc (d. 1995) was an independent scholar based in Miami who specialized in Cuban art of the twentieth century.

Rina Carvajal is an independent curator based in New York. She was formerly affiliated to the Department of Education at the Metropolitan Museum of Art, New York.

Teresa del Conde is the Director of the Museo de Arte Moderno in Mexico City.

Ticio Escobar is the Director of the Museo de Arte Indígena in Asunción and the Director of the Department of Culture of the Municipality of Asuncíon.

Enrique García-Gutiérrez is an independent scholar based in San Juan. He was formerly Professor of Art History at the University of Puerto Rico.

Alicia Haber is the Director of the Museo Virtual de Artes, El País, Montevideo.

Milan Ivelic is the Director of the Museo Nacional de Bellas Artes in Santiago.

Monica Kupfer is an independent scholar based in Panama.

Natalia Majluf is Head Curator of the Museo de Arte de Lima.

Ivo Mesquita is an independent scholar based in Sao Paulo.

Jeanette Miller is Professor of Art History at the Universidad Autónoma de Santo Domingo and the Escuela Nacional de Bellas Artes (Santo Domingo).

Gerardo Mosquera is an independent curator and critic based in Havana, and Curator at The New Museum of Contemporary Art in New York.

Lenín Oña is Director of the Museo del Indio in Quito.

Marcelo Pacheco is the Director of the Fundación Espigas, Buenos Aires, independent curator and art historian.

Ivonne Pini is Professor of Art History at the Universidad Nacional de Columbia and Executive Editor of *Arte en Columbia/Art Nexus*.

Pedro Querejazu is an independent scholar based in La Paz. He was formerly Director of the Museo Nacional de Arte in La Paz.

Victor Zamudio-Taylor is an independent scholar based in Mexico City and New York.

Numbers refer to the figures

Introduction

Mary-Anne Martin/Fine Art, New York 7; Ralli Foundation 10; Carla Stellweg Gallery 2

Mexico

Andrés Blaisten 16, 18, 20; Francisco Castro Lenero 48; Teresa del Conde 11, 24, 52; commissioned by the Trustees of Dartmouth College, Hanover, New Hampshire 22; Manuel Felguérez 36; Galería de Arte Mexicano 34; photo: José Ignacio González Manterola 14; photo: Javier Hinojosa 25, 41; INBA 12, 21, INBA/Museo de Arte Moderno 15, 19, 26, 27, 28, 30, 44–5, 51; Furna Palacios 47

Central America

photo: Samuel Barreto 67, 69, 70; photo: Rodrigo Castillo 54, 56; photo: María Teresa Diaz Colocho 64–5; photo: Max Fernández 58–62; photo: Alfonso Gomez Santos 78; photo: Guillermo Guevara 77, 80; photo: Warren León 76; photo: Roberto Rubi 71–5; photo: Walter Valenzuela 53, 57, 63, 66, 68

Cuba

Rogelio Alvarez 93–6; Giulio V. Blanc 81–3, 85–6, 89–92; The Museum of Modern Art, New York. Inter-American Fund. Photograph © 1995 The Museum of Modern Art, New York 84, 87; photo Will Drescher 97; photo: Gerardo Suter 101

Dominican Republic

photo: Sally Pelleramo 116; photo: Eligio Pichardo 110; photo: Máximo Pou 104–9, 111–14, 117–19; photo: José Rincon Mora 115

Puerto Rico

photo: Antonio de Jesús 122; Jaime Suárez 135

Venezuela

Archivo CINAP 139, 141, 143, 145, 148, Archivo CINAP, photo: Petre Maxim 140, 147; photo: Ricardo Armas 144, 155–6; Diego Barboza 151; Engenio Espinoza 152; Fundacion Galeria de Arte Nacionas, Caracas 137; Fundacion Museo de Bellas Artes, Caracas 146; photo: Paolo Gasparini 149; Victor Incerna 150; Roberto Obregon 153; Patricia Phelps de Cisneros 138, 142; Alfred Wenemoser 154

Colombia

Fotografia Luis Eduardo Cruz Arte Dus Grafico 175; Galería El Museo, Bogotá 165, photo: Oscar Mansalve 171, 173; Galeria Sexante, Bogota 174; photo: Germán Ramirez 161–3, 166–8; photo: Juan Camilo Seguro 157–60

Ecuador

photo: Cristóbal Corral 178–87

Peru

photo: Daniel G. Succar 188–96

Brazil

photo © Rodrigo Benavides Photography 218; photo: Romulo Fialdini 230–1; photo: Nelson Kon 197, 199, 201, 203–7, 210–12, 215–17, 223, 225, 233; photo © Vicente de Mello 200, 202, 208–9, 214, 221, 224, 226; photo: Wilton Montenegro 227; photo: Miguel de Rio Branco 229; photo © Lila Schwair 228; Luisa Strina 227

Bolivia

photo: E. Jáuregui 234–9, 241, 243–4; photo: P. Querejazu 240, 242

Uruguay

Luis Camnitzer 271; photo: Grupo 936 276; Engelman Ost 262; Testoni Studios 254–61, 263–70, 272–5

Argentina

Focus 283–5, 291–2, 296, 299, photo: Oscar Balducci 298, Collection Ricardo Esteres 281; Barry Friedman Ltd, New York 286; photo: Christopher Markwalder 287; Bruce M.White 300

Chile

photo: Elisa Diaz 301–10; photo: Bruce C. Jones 312